Epstein

Stephen Gardiner is an architect and writer. He pursues these parallel activities with equal vigour, on the one hand designing, for example, residential and educational buildings, while also writing extensively for the *Observer*, *Spectator*, *London Magazine* and other periodicals both in England and the United States. He has broadcast on radio and television, published poetry, and lectured widely in the United States. His books include *Death is an Artist* (1958), *Evolution of the House* (1974), *Le Corbusier* (Fontana Modern Masters, 1974), *Kuwait: The Making of a City* (1983) and *Introduction to Architecture* (1984). He is married and lives in London.

STEPHEN GARDINER

Epstein

Artist Against the Establishment

Flamingo

An Imprint of HarperCollins*Publishers*

To David Methuen and Joan Scotson

Flamingo
An Imprint of HarperCollins*Publishers*
77-85 Fulham Palace Road,
Hammersmith, London W6 8JB

Published by Flamingo 1993
9 8 7 6 5 4 3 2 1

First published in Great Britain by
Michael Joseph Ltd 1992

Author photograph by Peter Williams

ISBN 0 00 654598 X

Set in Bodoni Book

Printed in Great Britain by
The Guernsey Press Co. Ltd, Guernsey, Channel Islands

The author and publishers would like to thank the following for
permission to use copyright material:
John Murray (Publishers) Ltd for three lines from *Summoned by Bells* by
John Betjemen; Faber & Faber Ltd for 'Burnt Norton' from *Collected
Poems 1909-1962* by T.S. Eliot

Contents

Illustrations

(Copyright holders are indicated in brackets.)
* Epstein Archive, The Henry Moore Centre for the Study of Sculpture, Leeds City Art Galleries. Presented by the Epstein Estate and Miss Beth Lipkin 1987–88.
† Walsall Museum and Art Gallery, The Garman Ryan Collection.
‡ Tate Gallery Archive, Epstein 8716.

Acknowledgements

I am indebted to the Hon. Kitty Godley for permission to quote from her father's letters to her mother, Kathleen, and also for letting me have information about her family; in the same way, my thanks go to Peggy-Jean Lewis for permission to quote from her father's letters to her between 1948 and 1959, and from letters she received from Kathleen Garman and from Jackie Epstein, and also for searching her memory for recollections of her life in Guilford Street and later in Hyde Park Gate, information that was invaluable to the writing of this book. Particular thanks go to Beth Lipkin for the great trouble undertaken by her in unearthing the mass of papers, correspondence and cuttings held by the Epstein Estate, all containing information that was again invaluable to the writing of this book.

Special thanks go to other members of the family and to those closely connected with it: in particular, to the artist's son, Jackie Epstein, for his recollections; Maria Donska, the pianist; Roland Joffé for permission to quote from Esther Garman's letters to his father, Mark Joffé, and for other information; Alice Keene for permission to quote from letters to Matthew Smith from Epstein, Mrs Epstein and Kathleen Garman (Lady Epstein); Lord Kennet for permission to quote from letters he received from Esther Garman. I am also indebted to John and Susan Lade for their help, advice and corrections of detail when reading through the last chapters; to Lady Epstein's niece, Cathy Lee, for similarly advising on this period and to her nephew, Walter Sarfatti, for providing excellent family photographs.

Among the staff of museums, galleries and other bodies who have been extremely helpful with material, I am most grateful to Jennifer Booth and Adrian Glew at the Tate Gallery Archives; Mary Bowling, chief Librarian of the Department of Rare Books and Manuscripts at

the New York Public Library; Dr Stephen Bury and Lis Ward, Librarian and deputy Librarian at the Chelsea College of Art and Design; Lawrence Campbell, archivist of the Arts Students League of New York; Catherine Dalton, archivist of New College, Oxford; Ian Dawson, Head Librarian at the Royal Society for the Protection of Birds; William Fagg, specialist in ethnological art; Dr Terry Friedman, Principal Keeper of Leeds City Art Gallery, and his deputy, Ben Dhaliwal; Cathy Henderson, Librarian of the Harry Ransom Humanities Research Center, University of Texas at Austin; Nevil James, archivist of Llandaff Cathedral; Malcolm McLeod, Director of the Hunterian, University of Glasgow, for providing a copy of the unpublished *Jacob Epstein Collector* and for permission to quote from this source; Bernard Meadows, Henry Moore Foundation; Steve Mills, Assistant Librarian, Trades Union Congress; Sister Joan Robson, archivist, Theology College of the University of London, Cavendish Square; Nick Savage, Librarian, Royal Academy of Arts; Dr Evelyn Silber, Assistant Director at Birmingham Museums and Art Gallery; Ellen Slack, Librarian of the Fairmont Park Association, The Historical Society of Pennsylvania, Philadelphia; and Jennifer Wood, Librarian of the Imperial War Museum.

My thanks also go to Lord Bernstein, Anthony Blee, Tsapy Britneff, H. T. Cadbury-Brown RA, Lady Cavendish, Jean Cook RA, A. E. Ellis, Professor James F. Feibleman, John Finch for permission to quote from a letter to Epstein from Bernard Shaw and for other most helpful information, Aubrey Grandon, Lord Harewood, Sir William and Lady Hayter, Teresa Henry, Norman Hornstein, Molly Izzard, Agi Katz, Sir William Keswick, The Reverend Prebendary Harold Loasby, Sir Robert Lusty, Noel Mander, Anne Martin, Janiffer Moya, Maria Oliver, Granville C. Pyne, Isabel Rawsthorne, Brian Reade, Alan Rowlands, Jan Smith, Betty Swanwick RA, Arthur and Nicholas Tooth, Lady Anne and Sir Michael Tree, Carel Weight RA, Professor Bernard Williams and John Norris Wood.

In addition, I am most grateful to my brother, Patrick, and his wife, Susan, for reading through sections of the book, for their great encouragement and for making excellent suggestions, and also to my son, Andrew, and daughter, Rebecca, for doing likewise. I would like to thank David Methuen for giving me the benefit of his considerable knowledge, and Joan Scotson: without her organizational flair I could not have met my deadlines. Finally, it was Lady Epstein's wish that I should write this biography and it was her encouragement which above all else inspired me to carry out this important task.

'There are a lot of good sculptors around.
They're the priests. Epstein was God.'

—*Cathy Lee*

'Epstein is not an artist of his period,
he is an artist for all time.'

— *Kenneth Clark*

Foreword

EPSTEIN first came into my life when I was about ten. My mother, a painter and one-time student of Sickert's, was dragging me round a West End gallery in London one day – the Redfern in Cork Street, I think – when I stopped suddenly in front of a bronze head of a girl named Meum. Even now, I can remember the scene absolutely clearly: the girl struck me as astonishingly beautiful, and I suppose it was her delicate features, so lovingly modelled, which I found utterly breathtaking. Anyway, I said, 'Why don't you buy that?' My mother, who had no intention of buying anything, stared at me in amazement. '*Stephen*,' she said, 'I can't buy that. It's by *Epstein*.'

Here is an indication of the reverence with which disciples of the sculptor regarded him – as a hero-figure, an old master in his lifetime: I might have been pointing at a Rembrandt or a Donatello. His work evokes many associations: with the Greco-Roman antiquities in the British Museum which drew him to London in 1905 after three years in Paris; with Egyptian, Assyrian and Indian carvings, and the exotic forms of African and other non-European examples of which he made a unique collection; with the imagination of the Old Testament, the Book of Genesis, the Song of Solomon; with everything living. Perhaps above all else, it evokes associations with the fundamental themes of life – nature, birth and creation – as conveyed through the universal order of art. His work was dedicated to the absolute importance of continuity, and in this way could be used to illustrate the theme which T. S. Eliot, one of his sitters, set down in 'Burnt Norton': 'Time present and time past/Are both perhaps present in time future/And time future contained in time past.' Epstein was registering a parallel point when he wrote:

The modern sculptor without religion, without direction, tradition and stability is at a terrible disadvantage compared with the sculptors of previous periods. He has to invent even his subject matter, and he has at last been driven into the cul-de-sac of 'pure form', where he is either making works which are totally meaningless or repeating endlessly the same set of forms with slight variations.

He said that the artist must have faith in truth, must be positive; better to be positively wrong than negative. He had never regarded himself as controversial, yet it was partly because his views, and their expression through his work, were so forthright that he became the most vilified artist of the century, the subject of every kind of abuse from malicious rumour-mongering to the ridicule and vandalism of his sculpture. In the first place, he was in collision with the arch-traditionalists, the Church and narrow English nationalism: to the dead academicism of the art Establishment he *was* modern art, all that was destructive to English art, to traditional, academic art. Beyond him, the English had no terms of reference to follow on twentieth-century art: this monster – and, worse, this American-Jewish monster – was the embodiment of everything that was going to reduce English art to ruins. Thus he became a target for hate, from the right-wing press when, after the First World War, England was in the grip of fascist tendencies, of which the Blackshirts were the public face; and from the new Establishment that replaced the old. Yet, despite those envious forces which did their damnedest to put him down and dim the brilliance of his achievements, the shrapnel from this bombshell which hit the English scene was still flying years after he died. When his *Jacob and the Angel* was on show at the Royal Academy's exhibition of British art in 1987, people still skirted it with caution. The animal was still wild: the two struggling figures might still turn on the English and tear them apart.

Epstein's working life spanned an epoch that can be defined by two important events which were dissimilar in aim yet singularly alike in substance; both had dramatic consequences for English art. While his arrival led directly to the exposure and destruction of the worst and most depressing influence of neo-classical revivalism, at the end of his life the art world was on the edge of another traumatic event – the collapse of continuity, the destruction of the very principles which he regarded as the fundamental frame for all art. With the beginning of the Sixties, a decade of unparalleled aesthetic confusion, the past and present

were, for some unaccountable reason, seen as two separate beings that had nothing to do with each other. In art schools, essential traditions in teaching were systematically eliminated; working from the antique was abolished; the study of anatomy, vital to an understanding of the human figure as structure is to that of a building, was dismissed as old hat; and drawing from life, central to the mastery of an artist's means of expressing his ideas, was seen as so irrelevant that students were threatened with failing their diplomas if caught attending classes. Worst of all, because the damage was irreparable, many of the plaster casts made by expert craftsmen in the nineteenth century – casts of inestimable value from works at the Acropolis, of sculptures by Michelangelo, Donatello and others (the very works from which Epstein himself had drawn when a student in Paris) – were destroyed at art schools up and down the country. At London's Goldsmith's College, for example, on the orders of the management, the school's complete collection was taken to the bottom of the grounds and broken up with hammers.

The muddle-headedness which may be read into this rebellion against the teaching and masters of the past in turn clarifies, it seems to me, Epstein's position in the twentieth century. Like Picasso, his influence was, and is, one of orientation; he was an artist on his own, as immune to the vagaries of fashions and movements of his day as he was actively concerned with the protection of the foundations of art; and for these reasons, as much as any others, one comes away from a study of his work with the certainty that one has been in the company of a supreme vision of the world.

1
Lower East Side

EVERYONE, in some way or other, is a product of their background, and Epstein is an interesting case in point. When he was born at 102 Hester Street in Manhattan's Lower East Side on 10 November 1880, this island city presented a very different picture to the vast, hyperactive, booming metropolis it presents now. Then, a great part of it was concentrated at the southern end in a square mile from 14th Street to the docks in one direction, and between the Hudson and East rivers in the other, and this was populated by the tens of thousands of refugees who poured in throughout much of the nineteenth century, very many of whom were Jews fleeing the pogroms in Eastern Europe. This exodus had, however, suddenly accelerated following the assassination of Alexander II, Czar of All The Russians, by a Polish student in 1881, after which there was a wave of terror, the Jews being used as scapegoats for any disaster and deprived of their rights. By 1914, at least a million had arrived and established themselves, and for Epstein, growing up in the Jewish quarter between the Italian immigrants on the east side, and the Irish on the west, 'the New York Ghetto was a city . . . transplanted from Poland', alongside which was 'the world of the "intelligentsia", the students, journalists, scholars, advanced people, socialists, anarchists, free-thinkers, and even "free-lovers".'

At first glance, Hester Street looks much the same today as it did in 1870 when Epstein's father, Max, arrived from Augustow in Poland, after first calling in at Whitechapel when the ship docked in London on its way to America. Besides being still there (now, of course, set against the shadowy skyscrapers of Wall Street), Hester Street is as packed with

activity, little businesses, pedlars and different nationalities as ever. There the likeness ends: today, it's turning over, fast becoming a smart place to live; then, it was a high-density slum, the back-to-back tenements facing on to yards lined with strings of outside lavatories, five in a row, that were cleaned out once a month by Poles. Even when improvements did come, they didn't amount to much – one internal lavatory, for instance, sited in a hall common to four families per floor, was a hole in the ground; and, as Harry Golden pointed out in his notes for Hutchins Hapgood's *The Spirit of the Ghetto*, the families were large – 'father, mother, approximately five children and three boarders'. There was a wash tub in the kitchen where, according to a local born in Hester Street in the 1920s, you washed the bits that mattered. To get a hot shower, he said, you had to go to the ones in the public baths operated by steam – 'that made you feel rich, like you earned four dollars a week!'

If these were the conditions in the Twenties, they must have been far, far worse when Epstein was a boy. People were very poor indeed on the Lower East Side and to survive at all, dumped off the boat to make their own way, required a supreme effort of will as well as good health in those filthy and frightful buildings. The dingy tenements, unheated, desperately cold in winter and horrifically hot in summer, crammed with tailors' sweatshops (the main refuge of the 'eternal aliens', as the Jews called themselves), old men humping heavy sacks of cloth and people everywhere, conjures up a scene of unimaginable squalor. In fact, these buildings were regarded as both fortresses and prisons – as safety from the violence and persecution suffered in the home country, but offering little hope of an escape to a better life. The only symbolic escape route to this was out through the front doors to the street into which the mass of nationalities streamed to work, to meet, to peddle goods, to sell the much sought-after gold watches and chains that were seen as being truly American. A Jewish characteristic, and a key to their survival over the centuries, is the ambition to merge with Western society, and with those they regard as advanced and intelligent; while retreating to the isolation of their own community when among the illiteracy of the peasants of their homelands, in America they wanted to become, above all else, 'one of them'. So great was this urge that the nineteenth-century author Israel Zangwill wrote a play around the subject called *The Melting Pot*. The quicker immigrants could melt into the background and pass as Americans, and appear a part of the

New York scene, the faster they would make it to the better life, the Great American Dream of opportunity. This explains why Max's elder brother, the first of the family to emigrate, changed his name from Chatskel Barntovsky to his wife's, Epstein, this being automatically transferred to the younger brother on his arrival: all signs of nationality had to be erased if outward appearances of the 'true American' were to be achieved. The addition of Max as a first name would have sounded suitably international – even anonymous – in his adopted country, while maintaining the Jewish identity. The next phase in the process, acknowledged by Jews, was to learn English and talk like the Irish, the biggest, most popular and outgoing of the East Side communities; so great was the Jews' admiration of them that they even wanted to look like the Irish.

As it happened, the Epstein children did look Irish, largely on account of Mary Solomon's colouring, the rather fat red-head with blue eyes whom Max married: all the children had blue eyes, and most, like Jacob, had very dark hair. Mary was a girl Max had known in Augustow, and whose parents, mill owners, went out to America a few years earlier, in 1865. They were as wealthy in New York as they had been in Poland, and Max, even as a boy, had made up his mind to marry their daughter. After leaving Augustow at the age of eleven (to avoid the army call-up at thirteen), and, on arrival, working as a tailor's assistant, he realized his ambition six years later. Then, settling into the Lower East Side before the real influx of refugees began, Max and Mary got away to a good start. A combination of hard work and her family's money did it: after the marriage in 1877, he bought 102 Hester Street, a five-storey red-brick building in a block of tenements, and opened two shops, one for groceries, the other, following his wife's family trade, a bakery. He let off the three floors above their six-room apartment, in which he put a bathroom – the only one, apparently, in the district. They needed plenty of space: over the next twenty-two years, they had eight children: Louis, Ida, Jacob, Hyman, Chana, Irving, Susie and, in 1899, Harold. During this period, Max moved into property in a big way, owning forty-two tenements on the Lower East Side (picked up for a song because of their derelict condition) and developing empty sites both there and in Harlem. 'My father ruled the roost,' Susie said. 'He was a stout, pompous man, but rather good looking.' He had met the challenge – common to all Jews – to get out to the better life; by the Eighties he was well on his way to what his conception of America, 'the golden

land', as he called it, offered. Yet although successful, learning to speak English with a private tutor, and to look American, Mr Epstein never relaxed the rigid rules of the Jewish faith. 'As the family was large,' his son Jacob said, 'I saw a great deal of Jewish orthodox life, traditional and narrow.' Something of a tyrant, Mr Epstein saw that everything proceeded strictly in accordance with that faith – reading in Yiddish from the Old Testament, home prayers, daily visits to the Synagogue, fasts, Sabbath on Friday and Saturday, out to work on Sunday, and a rabbi calling every day to teach religion to the boys (but not to the girls). Life, for the most part, amounted to an intense religious routine where father was boss, who could reprimand or silence with The Look and to whom no one spoke until spoken to, a Jewish rule. But the rituals didn't end there: on Fridays, their mother's parents, much loved by their grandchildren for their kindness, simplicity and presents of sweets, blessed each of them.

Jacob, the odd-child-out, was touched by these Friday visits, if by little else, except Chana, to whom he was close in age and temperament. He had been seriously ill for two years or more when he was very young, had recollections of being carried about a great deal and was known as the 'sick one'. 'Whether this illness gave me a twist away from ordinary paths I don't know,' he said, 'but it is possible. Sometimes my parents wondered at my being different from the other children, and would twit about my lack of interest in a great many matters that perhaps I should have been interested in, but just wasn't . . .' He was certainly not interested in following the Jewish faith: he found the hours devoted to the Synagogue utterly boring, the wailing prayers got on his nerves, giving up both as soon as possible to escape into his imagination, already highly developed. 'I cannot recall a period when I did not draw,' he said. Although the religious teaching, and his knowledge of Hebrew and the Bible, established a foundation for research much later on in his work, Jewish orthodoxy never had an influence on him. His thoughts were, after all, elsewhere – they were on the extraordinary world in which he found himself:

This Hester Street and its surrounding streets were the most densely populated of any city on earth, and looking back on it, I realize what I owe to its unique and crowded humanity. Its swarms of Russians, Poles, Italians, Greeks and Chinese lived as much in the streets as in the crowded tenements, and the sights, sounds and smells had the vividness and strange impact of an Oriental city.

He described Hester Street as an open-air market from one end to the other, adding:

> I imagine that the feeling I have for expressing the human point of view, giving human rather than abstract implications to my work, comes from these early formative years. I saw so much that called for expression, that I can draw upon it now if I wish . . .

Epstein, of course, did make it to the better life. Living in his imagination was one way, and exploring his surroundings and drawing their inhabitants was another. Then there was school: children of immigrants were impelled by law to go to the free public schools where, with learning English and the absence of all religious teaching, Americanization rapidly took hold. For a new generation and the child with an independent mind, the break with the set views of the narrow parental background was finally made. Epstein, however, wasn't much good at school: mathematics and English grammar in particular bored him. He was interested in English literature – together with art, reading was his recreation. History was his other favourite subject. And since the teachers were so proud to have a real artist prodigy about the place, they were prepared to overlook his distaste for certain subjects. That was a very different reaction to his father's – Max Epstein couldn't understand how he had been landed with such a son. To him, he was an utter mystery, like art: all he did, Mr Epstein complained, was draw and read – reading like that, late into the night, by a green-shaded lamp, was bad for the eyes. He had a habit of disappearing for whole days – to the suburbs of Harlem, Yonkers, Long Island, and swimming at Rockaway or roaming over the hills in New Jersey; or to the docks –

> New York was at this period the city of ships of which Whitman wrote. I haunted the docks and watched the ships from all over the world being loaded and unloaded. Sailors were aloft in the rigging, and along the docks horses and mules drew heavy drays; oyster boats were bringing in their loads of oysters and clams, and the shrieks and yells of sirens and the loud cries of overseers made a terrific din. At the Battery, newly arrived immigrants, their shoulders laden with packs, hurried forward, and it must have been with much misgiving that they found their first steps in the New World greeted with hoots and jeers from hooligans. I can still see

them hurrying to gain the Jewish quarter, and finding refuge amongst friends and relatives.

These were a few of the pleasures of the open-air life enjoyed when playing truant, something he loved to do. The news of his exploits didn't please his father: he should have been at school, or doing a proper job. He was a Problem Boy: there was that curious incident, for instance, in the great blizzard of 1888, when he hid bread and rolls he had taken from the shop when his father was handing out food to neighbours. When his hoard was discovered, he said: '*I'll* have enough to eat.'

Mr Epstein tried everything to push his son into some respectable profession; offered him a university education if he would agree to that: 'If you want to be a lawyer, if you want to be a doctor – but an *artist*! You'll starve.' Had he thought about those hoarded rolls and bread, he might have had some flash of insight about his son; for there he was, at the age of seven, showing some common sense and spirit, and already aware, possibly, of his father's unreliability so far as he was concerned. He was a survivor, could look after himself; single-minded, he trusted his instincts, was determined to go his own way. His drawing continued regardless of his father's prejudices and hang-ups: women with babies, old Jews with long beards, girls in coffee houses – 'Anything my father thought ugly,' Susie said, 'Jacob would draw.' He was particularly interested in what he called 'the plastic quality in coloured people', and in the young Chinamen 'with smooth faces like girls' whom he gazed at with wonder, trying to draw them before they spotted him – when they did, they would immediately vanish, having 'a curious way of slipping into their houses, suddenly, as into holes', like lizards. It was the multiplicity of races which, packed tight in such a small area, so captivated him. This knowledge of them, mentally and minutely recorded by the sheer effort of observation when drawing them, and by the intense concentration required to memorize their special features from fleeting glimpses ('I would follow a character until his appearance was sufficiently impressed on my mind for me to make a drawing'), widened his vision of the world in an extraordinary fashion. The East Side was a microcosm: arranged before him were the sharply contrasting, international cultures from all the faraway countries. He was gripped by what he saw – the differences of form, the peculiarities unique to a race, characteristics of the bone structure and colour, walk and posture.

Here, just in Hester Street, he could study physiognomy as though in a museum of mankind; one cannot help seeing, in this packed corner of Manhattan, the human material from which sprang his obsessive passion for the art of African, Polynesian, Indian, Eastern and other peoples.

> The Jewish quarter was on one side bounded by the Bowery, and this street at that time was one long line of saloons, crowded at night by visitors to the city, sailors, and prostitutes. As a boy I would watch through the doors at night the strange garish performers, singers and dancers; and the whole turbulent night-life was, to my growing and eager mind, of never-ending interest. I recall Steve Brodie's saloon with its windows filled with photographs of famous boxers, and the floor inlaid with silver dollars ... the Bowery, for a boy, was full of excitement, and when you reached Chinatown, crooked Mott Street, leading to Pell Street, you could buy a stick of sugar-cane for one cent and, chewing it, look into the Chinese shop windows, and even go into the temple, all scarlet and gilding, with gilded images ... Along the West Front, on the Hudson side, you saw wagons being loaded with large bunches of bananas, and great piles of melons. Bananas would drop off the overloaded wagons; you picked them up, and continued until you came to the open-air swimming Baths with delightful sea water ...

Written fifty years later, the past peels off the page with these vivid memories of a place which would have been depressing and sordid for those unable to experience its imaginative possibilities. For him, the neighbourhood was an adventure like reading, another way of escaping the imprisoning routine of family life in the search for knowledge outside the rigidity of the Jewish faith. He was an insatiable reader: *Les Misérables*, like the works of Dickens, a standard book in East Side lending libraries; Dostoyevsky's *Brothers Karamazov*; Tolstoy's novels; the New Testament, Walt Whitman's *Leaves of Grass* – all these he read among the rocks and lakes of Central Park. Reading was another excellent escape for the imagination and so was the park. Although still populated by goats, geese and other farm animals, and littered with shacks in places, this picturesque landscape, opened to the public in 1859 and inspired by the visit Frederick Law Olmstead had made to England in 1850 when he saw Joseph Paxton's Birkenhead Park, was already well on its way when Epstein began going there: he always managed to find 'a secluded place far away from crowds and noise'

where he could read throughout the day and come home burnt by the sun. Although far away, too, from the Lower East Side, it was easily reached by the steam driven Elevated Railroad (another adventure), starting from the Battery, running along Sixth Avenue and ending on Columbus Circle and 59th Street; there was a second railroad up Third Avenue and, in the 1890s, horse-drawn double-deckers along Fifth for ten cents a trip, all fascinating experiences for a boy who, exploring his city surroundings, had a capacity for wonder. And New York was of course expanding rapidly along the grid squares by this time. The building of Brooklyn Bridge, an amazing event, had been completed in 1883; that, a piece of engineering hailed as 'the Eighth Wonder of the World' in its day, was round the corner from home, down the Bowery, and a breathtaking experience. The overwhelming size of its structure suddenly appearing above rooftops and at the end of streets, was irresist- ible to him – he was constantly down there, marvelling at its tremendous spans: 'I crossed a hundred times on foot, and watched the wonderful bay with its steamers and ferry-boats. The New York of the pre- skyscraper period was my foundation ground.' This extraordinary city in the making that shot up to astonishing heights alongside the develop- ment of lifts and cast-iron, and was the product of spectacular individual enterprise, had the vitality to inspire ambition in a young boy with a head full of ideas and visions. The impossible was possible, and what took the boom-time real estate man in one direction, took the artist in another – the Dakota apartment block overlooking Central Park on the Upper West Side, an isolated, massive investment in land of the 1880s, could have looked like a fairytale chunk of sculpture in space to Epstein.

It showed considerable initiative, and was certainly ambitious, to sign up at the Henry Street Settlement after leaving school and winning the Cooper Union drawing prize at eleven; this Settlement was one of a number of liberal-minded foundations set up as colleges for the poor, and run by volunteers from the better-off Uptown neighbourhoods. From this, a year later, he went to the Educational Alliance to study drawing, and, at not yet thirteen, managed to get himself accepted at the Arts Students League in their big new building on 57th Street. That was a dramatic step forward: not only was it away from his locality, to attend Life Classes in this atelier school, something like the École des Beaux Arts or the Julian Academy in Paris, the student had to have acceptable experience from drawing from the antique to be considered

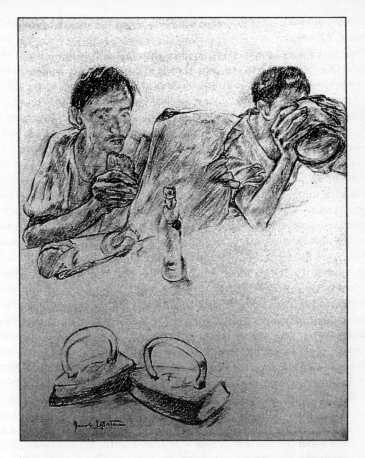

Lunch in the Shop or *The Sweat Shop*: one of the sequence of remarkable drawings in black chalk Epstein carried out for Hutchins Hapgood's *The Spirit of the Ghetto* when he was about twenty. His mastery of space and form is already expressed in the organization of hands, a bottle and two irons.

eligible. His work must therefore have been regarded as very impressive indeed.

He was there for the winter months, drawing and painting from the model, but then left to return to Hester Street where his main area of research remained — the cosmopolitan people of the market. By now, despite his extreme youth, he had emerged as a distinctive presence in the community, as an energetic, independent young artist respected as an influence for the good in the neighbourhood, much involved with local affairs. In his quarter, there was much to be involved in — 'Newspapers in Yiddish, Yiddish theatres, literary societies, clubs of all kinds for educational purposes, night-classes . . .' He organized an exhibition of paintings and drawings for others, helped out the teachers at the Educational Alliance and gave the money he had from selling his drawings to his mother (who discreetly returned it to him). There were many wanting to buy his work — he found he never had any difficulty over this — and his circle of collectors widened rapidly when, through his activities at the Henry Street Settlement, he met Mrs Stuyvesant Fish. This rich woman immediately took him up, buying his drawings and paintings, and introducing him to friends who did the same and among whom there may have been a certain Mr Edward William Ordway, a future patron. She was so taken with Epstein (and, doubtless, by his dramatic good looks, his dark blue eyes, black curly hair and powerful physique) that she used to send her horse-drawn carriage to collect him for tea at her house: and then, unknown to him, she wrote to his father, praising his work and saying that she could do a great deal to further him as an artist. Moreover, she wanted to adopt him (her own son had died), a suggestion that enraged Mr Epstein who may have suspected, perhaps correctly, she was in love with him. But the money made from the works she bought, and sold to others on his behalf, was put to a constructive use: he invested it in a studio on the corner of Hester Street in a ramshackle wooden building over 100 years old. There he could work without interruptions, making drawing after drawing of the market below, and paint.

However, with the summer over, he was back at the Arts League, this time for the full year, starting in September and ending the following May, in 1895. According to the school records, he was doing morning and afternoon classes in composition, the antique, life drawing, painting and, for the first time, sculpture. He had studied for so long on his own down on the Lower East Side that he was now ready for some intensive

training from a qualified art master, possibly John H. Twatchman, now regarded as one of America's best Impressionist painters. He found the students irritating; there were some, he said, who bought his studies from the model 'for a dollar or two' (students can usually be relied on to recognize a rare gift), but, on the whole, he didn't get on with them, feeling 'something of a fish out of water'. Although the League has always accepted students of an unusually early age, he was younger than most of them. 'The students' life was distasteful to me. I could not join in with their rags and their beer, and their bad jokes got on my nerves.' He was already too old in mind for them, too preoccupied with his ideas, and, being imbued with the Jewish faith in hard work, found them boring. As ever, his art came first; he preferred the teachers who were interested in what he told them about life on Lower East Side, and in his drawings of it which 'to the up-towner was like the life of the jungle for its strangeness'. The six months' course had other uses: his uptown trips led to many important discoveries. For a start, there was music: he went to concerts, heard *The Ring* at the Metropolitan Opera House ('naturally from the gallery, miles away from the stage'), a momentous event to which, years later, Epstein may have looked back with some awe when Wagner's predictions of the fearful threats awaiting the twentieth century began to materialize. He became involved with left-wing political debating societies (he could never make out the 'ivory tower' kind of artist who was cut off from reality), although 'as an observer only, and never as a participator': he was careful not to become too involved, begrudging time given to anything but art and reading. He didn't, he said, want to follow Courbet's example whose external distractions affected the quality of his work and left him embittered.

Possibly the most important discovery during this period was the remarkable Paul Durand-Ruel's gallery on nearby Fifth Avenue where, for the first time, he saw the astonishing paintings of the French Impressionists whom Durand-Ruel was indefatigably trying to promote against great odds in France, England, Holland and Germany, and had, in America alone, arranged two exhibitions. The first, in Boston in 1882, had failed disastrously, an outcome anticipated by Durand-Ruel's old friend, Pissarro, who had said, 'What will it be like in Boston if in Paris they treat us as sick and crazy?'; the other, a show of 300 paintings in New York's Madison Square in 1886, created so much interest, on the other hand, that it was extended by a month and moved to the National Gallery of Design: Durand-Ruel's faith that Americans would be more

receptive to new ideas than the tradition-bound French public had at last been rewarded. Of course there were the familiar cries of 'unfinished', 'lumpy and obnoxious creations' and 'lewd and obscene' from certain sections, but something of the genius of Pissarro, Monet, Manet, Renoir, Sisley and others had been recognized; perhaps Durand-Ruel's determination to get their work put on at all, 3,500 miles from Paris, had something to do with its success. Epstein, who later remarked laconically that such paintings were 'not so sought after in those days', was of course overwhelmed by what he saw in this gallery when he dropped in one day; suddenly, the gloomy academic scene around him that had little to offer (no modern sculpture of interest, and nothing much in the way of antiquities to inspire him) was eclipsed by a brilliant light from across the seas.

His excitement is not difficult to imagine; the meetings with Durand-Ruel revealed, first-hand, the extraordinary revolution in progress outside America, in Europe; and he was having it explained by a dealer who was in the centre of things, the prime mover in the Impressionist movement, a man to whom artists like Pissarro, struggling against entrenched traditionalism in France, owed their survival. Durand-Ruel was, in return, clearly most struck by this teenager's singularly inquiring eye, since he gave him special opportunities to see masterpieces that went back to Europe, ending up, sometimes after many, many years, in the Louvre, the National Gallery in London, and also the Metropolitan in New York and elsewhere, and sometimes very much sooner in private collections in America. This introduction to the Impressionists fixed the ultimate objective of going to Paris firmly in Epstein's sights: he knew about its treasures and ancient history from his reading, but now painting had an immediacy that was irresistible. 'I observed, drew a great deal, and dreamed a great deal more,' Epstein said of this time. He could well have been dreaming of travelling to Europe.

He didn't return to the League in September 1895; he was working in Hester Street again. The magnetism of the Jewish quarter remained inescapable. His ties with it were so strong that long after, when he had been in England for some years, he still felt so drawn to it, and his memories of its people were so dear to him, he should have remained in New York and never left for Europe, at all. At this point, he had become inseparable from Bernard Gussow, a young Russian painter who had emigrated recently; this was another reason for his absence of a year from the League: they went on drawing expeditions together,

shared the studio, and Gussow was often observed cooking meals there while Epstein stood at the window making sketches of the crowds below. With one or two artists who joined them, Epstein thought they might have established a Ghetto School, had he stayed. The material was all there, in New York – there was, he believed, material 'far beyond anything that Americans hunt for abroad'. Rembrandt, for instance, would have delighted in the East Side, he said, and he regretted there was no such artist to capture the inspiration of the quarter before it was too late – the life there was 'fast disappearing in contact with American habits'.

Then, one day, all his unique records of the quarter suddenly disappeared: he came round to his studio and was horrified to find it burnt out, his 'charred drawings (hundreds of them) floating about in water with dead cats'. He said little about this disaster in his autobiography, almost as though, monumental as the calamity was, he didn't attach much importance to the cause of the incident; it seems that his only thoughts then, with that unfailing determination which carried him through the strife and trouble that followed him in life, were of getting another place to work, and starting all over again. In the end, he found a room in a tenement filled with clothing workers.

Was it arson? Was this his first experience of the jealousy which his genius inspired, and with which he became so familiar later on? It is most probable this was the explanation: he had become regarded as a boy with outstanding gifts, a precocious artist, the leader of his Ghetto Group; he was, without question, the dominating force in the quarter, sure in his judgement, his name already known in more fashionable circles Uptown, to teachers at the League, and possibly to dealers, too. People were collecting Epsteins, he was given commissions; and, while fellow students managed to support their serious studies by making a precarious living colouring photographs and touching them up in crayon for shops that did a thriving trade out of their labours (a 'hateful' industry, Epstein called it), he was selling illustrations to periodicals like the Century Company, and was moving on to draw people like Jacob Adler, a famous actor living in the quarter. Had he known the experiences he was to endure in the future he might have suspected that this mysterious fire was no accident: the sabotage of his work became the story of his life.

Epstein had made a friend of James Kirk Paulding, a friend of Abraham

Kahan, editor of the left-wing Yiddish newspaper *Vorwarts*, at one of the many local clubs, 'a man', he said, 'of fine literary discernment' who made 'a habit of reading to four or five of us boys on a Sunday morning, and this was my first introduction to Conrad's work. In this way I heard *The Nigger of the Narcissus* and *Typhoon*, also most of Turgenev.' In the meantime his father, now a property developer on a big scale, tried to involve his son in various ventures, but with no success. Max, for instance, retained a very soft spot for the Jewish quarter, and, always generous, had knocked down some of the blocks on the corner of Hester and Essex Streets to make a playground for Ghetto children, installing his artist son as gym instructor, a job he promptly passed on to Gussow, who was in greater need of money. 'I was not a gymnast,' he said, 'and now they have a gymnast.' Then he was put in charge of inspecting his father's tenements, a job he again passed on to his friend after getting into trouble for criticizing the fire escape arrangements (the homeless were using them to sleep on). After that, he paid for a summer holiday by taking a job as a farm labourer. Then the thought occurred to him and Gussow that they should have a spell living close to nature, and in the winter of 1895 they rented a chalet on Greenwood Lake in New Jersey.

> In this mountain country, I spent a winter doing little but tramping through snow-clad forests, cutting firewood, cooking meals and reading. To earn a little money we both helped to cut the ice on the lake, the work lasting about two weeks. This was very hard but congenial work, as we were taken to the ice-fields by sledges drawn by a team of horses in the early morning over the hard frozen lake, and returned in the evening on the sledges, when we saw wonderful snow views of mountain sides ablaze with sunset colours. It was a physical life full of exhilaration and interest.

It was here Epstein became very friendly with a couple who were the only people around who had a liking for art, a Mr and Mrs Wells. Mr Wells painted in the winter and took photographs in the summer. His wife was a little Welsh woman with psychic powers; she prophesied a great future for him . . .

It was on his return from Greenwood Lake that he decided to work at sculpture. He said that this change of direction was due to 'the great desire to see things in the round, and to study form in its different aspects from varying angles, and also the love of the purely physical

side of sculpture.' Here, he felt, could be a full outlet for his energy, both physical and mental, and far more satisfying for one so ambitious than drawing: since he made this highly important decision while at Greenwood Lake, it's possible that cutting the ice may have brought his thoughts round to sculpture. This slender young man had grown immensely strong, and seemed to have suddenly realized he was capable of giving his ideas a much greater range through carving. 'This physical side of sculpture is a very important factor that is often overlooked.' So when he returned to the Arts League in September 1896 it was to study sculpture in the evenings. He had now moved away from his parents and was living in a room at 26 Delancy Street, again well-known in the history of Jewish immigration, and a few blocks from his beloved Hester Street where he still had his studio. The sculpture class, then called 'modelling', was run by a leading American sculptor of the time, George Grey Barnard, who had, like almost all the League's instructors between 1870 and 1915, trained at the Ecole des Beaux Arts; the seated *Lincoln* in the Lincoln Memorial in Washington is his, a cast of which is in London, opposite the Abbey in Parliament Square. Epstein liked Barnard and, because he was his teacher, very serious, ascetic in his habits, open-minded, and not a typical Beaux Arts product, always regarded him with a certain respect. And, for someone who saw no future in New York, what Barnard told him about Paris made his impatience to get there increase. As he said, 'I looked forward to the day when I would be able to see the Ancients and Rodin. I longed to see the originals by Michelangelo and Donatello, and Europe meant the Louvre and Florence.'

While at the League, he entered a foundry to learn the craft of bronze casting, and this, together with continuing drawing down on the East Side, made the evening class an exhausting experience. All the same, he had to earn money to keep himself; and it was in an exhibition of Jewish art, which he had arranged at the Hebrew Institution in 1898, that Hutchins Hapgood, a reporter on the New York *Commercial Advertiser*, living in the Lower East Side's University Settlement House, had first seen his work. He was so struck by the sense of character in his drawings, and by their plasticity that they remained fixed in his mind, so that, two years later, when collecting material for his articles on the neighbourhood, he went to see the young artist. He had to keep himself: his father, contemptuous of his son's work as ever, never contributed to his expenses, and, even had he offered to, his son would have refused

any donation from him, partly on account of the friction between them, but also no doubt because he had to preserve his independence, so necessary to his freedom as an artist. Mr Epstein was now a rich man, moreover; he had done so astonishingly well in real estate by the time he was a mere forty that, in 1899, he had graduated to a much grander part of Manhattan, 1661 Madison Avenue. But his son didn't go with the family: he regarded this as a dull respectable part of the expanding city, now fast filling the grid squares northwards, and had no wish at all to leave the vitality and friends of the Lower East Side. The family kept a room for him at the new address but he rarely went there, and, when he did, it was to see his mother. He had gone back to Hester Street, to live and work at the top of a house on the corner of Forsyth Street. Hapgood wrote:

> The stairs that ascend to the garret are pestiferous and dingy. In what is more like a shed than a room, with the wooden ribs of the slanting roof curtailing the space, is the studio of an East Side artist. A miserable iron bedstead occupies the narrow strip of floor beneath the descending ceiling. There is one window, which commands a good view of the pushcart market in Hester Street. Near the window is a diminutive stove, on which the artist prepares his tea and eggs. On a peg on the door hang an old mackintosh and an extra coat – his only additional wardrobe. About the narrow walls on the three available sides are easels, and sketches and paintings of Ghetto types.

Hapgood, evidently saddened by what he saw, was in fact looking at the kind of surroundings that were typical of Jacob Epstein's living and working conditions throughout much of his life: he was no more concerned with them than he was with the clothes he wore. He needed space to draw and to make his sculptures as he needed clothes for their usefulness: both performed a function, but beyond that he had no interest in them. All he required was somewhere to sleep, somewhere to eat, somewhere to work: laid out before Hapgood was the diagrammatic frame of his existence.

He found an artist with 'a melancholy, wistful face', living alone and paying four dollars a month; cooking his own meals, twelve dollars a month was enough to see him through, an amount he could usually manage through the sale of drawings. If that lifeline failed, 'he went to bed', as he put it. But Hapgood found him full of idealism, optimism and ambition, a characteristic of his race. He had enjoyed his visit to

Greenwood Lake, he told the writer, but there was nothing that inspired him to draw. 'Clouds and trees are not satisfying,' he said. 'It is only in the ghetto, where there is human nature, that I have ideas for sketches.' Speaking of the countryside, he went on, 'There is no nature in the sweatshop, and yet it is there and in the crowded street that my love and my imagination call me. It is only the minds and souls of my people that fill me with a desire to work.'

And so Hapgood signed up Epstein to illustrate articles on the area. His drawings had exactly what he wanted, expressing the typical life of a community. He preferred them to Gussow's and couldn't think of any American artist who had an equivalent sympathy with ordinary people. 'Where is the typical, the nationally characteristic, in our art?' he asked. Most of it, he claimed, boiled down to mere essays in painting, 'of more or less skill, showing no warm interest in any one kind of life.' This was, of course, an important breakthrough for Epstein. Hapgood's discovery was promoted widely in the press. The nineteen-year-old artist was commissioned to do five drawings for the first of his articles on the Lower East Side, called 'Four Poets of the Ghetto', and appearing in *The Critic* in March 1900. The illustrations were dramatically credited: 'Each sketched from Life by Jacob Epstein.' This success was followed by another, published a few months later in *The Bookman* – Hapgood's 'The Foreign Stage in New York', a piece through which Epstein met and drew the Jewish playwright Jacob Gordon, the actors Kessler and Moscowitch, and the poet Moritz Rosenfeld, who had spent his early life in sweatshops. It was after this that Hapgood's essays were collected in the form of the book, *The Spirit of the Ghetto*, and, for this, almost fifty of Epstein's drawings were reproduced, all in his favourite black chalk. Some of these were astonishingly good: *Lunch in the Shop* is a supreme example of his mastery of the medium, telling the story of life in the Ghetto with the arrangement of two working men, huge hands, a newspaper and a bottle as objects in space. Many of the illustrations are so atmospheric they have an affinity with late Pissarros of the 1890s. For this commission, Epstein was paid $400, a tidy sum indeed in those days. While he was working on these drawings, between 1901 and 1902, he was back at the League again, Barnard's student once more. And that was not all: publicity from the articles in *The Bookman*, *The Critic*, *Boston Transcript*, *Evening Post* and other periodicals brought a considerable commission of eight drawings for the *Century Magazine*, illustrating a short article by Hapgood called 'The Picturesque Ghetto'.

There was a continuous flow of orders from then on: the Ghetto had become, if not big, certainly fashionable business.

In 1900, Epstein had made one of his most beautiful drawings; it was a self-portrait in red chalk, a work of such strength and vigour that it is impossible to imagine the creator of it in the same frame as Hapgood's picture of him as 'melancholy' and 'wistful'. Yet both describe the man – in one, the artist in the midst of an inspired vision, in the other, the diffident artist receiving a stranger in the privacy of his workshop. This drawing, among his finest, may have been one of those he left for a Mr Davis to look at in the William Macbeth gallery on West 114th Street the year that Hapgood came to see him. The rest were probably the first purely imaginative experiments he made on the theme of Walt Whitman's 'Calamus', and which he continued to work out over a long period. His passion for his poetry can, one imagines, be explained in a number of obvious ways: both men were American, both very complex characters, both – yes, you could say that – romantics. Without doubt he would have been most interested in his writings on the American Civil War of so short a time before, and in which Whitman was personally involved. Yet particularly interesting, perhaps, was the fact that the poet was a homosexual, and Epstein's awareness of this is clear from his work from 'Calamus'; not many so young, and with relatively limited experience, would have detected that. Epstein did, and it was these drawings of the subject which he specifically mentioned in his letter to Macbeth. And so at this time he was heavily engaged with commitments of numerous kinds. He was working for magazines, at the bronze foundry, studying at the Arts League, and working from models in the theatre for Hapgood – he had so many commissions that he passed on some to the devoted Gussow. And, when the session at the League ended in May 1902, he was ready for the next stage: with the money he had earned, and the promises of assistance from wealthy patrons, he bought his ticket to Paris.

He couldn't wait any longer: the excitement that the turn of the century inspired, the celebrations, exhibitions, the news of the success of the tremendous *Exposition Universelle* of 1900, had brought him to the edge of his greatest ambition – getting to Europe, the source of art and literature. For him, every decision he made, whether to do with changes of places of work or living, even of countries, was always immediate and irreversible. Yet the parting with New York was of course difficult.

Besides his profound affection for the Lower East Side, for the city itself, for Central Park (now becoming surrounded with magnificent apartment blocks), and for his friend, Gussow, there were further complications. He had fallen in love with the beautiful Adele Rabinowitz, a school teacher in the Jewish quarter with whom, much to the horror of his parents, he wanted to live, but not to marry. His mother took the girl aside and told her to have nothing to do with her son. She was distraught enough as it was on hearing of his impending departure, when he gave her his drawings of the Lower East Side to look after while he was away; and, as he climbed the gangway ('with,' he said, 'unthinking heedlessness of youth') to the boat that was to take him from America, there was a terrible scene as she tried to pull him back.

But there was no stopping him: he felt set to conquer the world. He had to have experience, however, to develop his ideas. To judge by the Ghetto drawings and the self-portrait, he had reached a sophistication exceptional in one so young. There is, too, an indication of this in his hurrying, even handwriting: his signature on his illustrations, and in letters to Macbeth, doesn't appear to change from then onwards. It was as though he had arrived at complete maturity with a sudden jolt by the time he departed for France; and then spent the rest of his life expanding his powers.

2

Montparnasse

Dear Mr Ordway,
Since I last wrote to you I have made some changes. For one thing, I
have left the modelling class at the Beaux Arts as I found I could not
continue there with any advantage. There were too many things
against it.

So began, on 12 April 1903, Epstein's first recorded letter to Edward
Ordway in New York. Ordway was one of those with whom he kept in
touch while in France, in this case chiefly, it seems clear, because Ordway
had guaranteed him financially during his stay in Paris. Epstein had
arrived in Paris six months before, on 3 October, and had at once enrol-
led at the art school, managing to pass the entrance examination despite
speaking no French: he put this success down to the training he had at
the Arts League under Barnard – it had sufficiently prepared him for the
ordeal. He went on to say that it might be all right for French students
to waste two years as a 'nouveau' if they wished 'but as I have not the time
to fag for the "anciens", I thought it best to leave.' Throughout his life he
felt the insistent pressure of shortage of time to carry out his ideas, and
in this instance precious hours would have been lost indulging in such
futile rituals as 'fagging'. Nor did he waste time going into unimportant
details with Ordway, but this refusal to abide by the traditions of the
school led to arguments with other students. At the Beaux Arts, new
students were supposed to fag for the men who had entered for the Prix
de Rome Scholarship, carrying clay and stands to the studios and
generally, he recalled, 'waiting upon these immured geniuses'. As this

would rule out any morning's work for him, he refused point-blank, astonishing the French students; they could 'hardly believe their ears'.

But there were plenty of school officials to do that sort of menial job, as he pointed out to the students. His refusal to conform, however, prompted the familiar punishment that society often anonymously doles out to offenders, as he discovered later in life when his sculpture was vandalized, damaged or daubed with paint and swastikas. When he arrived at the school the following morning, he found the study he had been working on smashed to pieces, 'a ruined mass on the ground'. Yet he ignored the incident and immediately set about building up a new study, only to find, the next day, that this too had been destroyed: 'The French men stood silently around, watching me', a threatening presence of angry adversaries. He must have wondered again about the burning of his pathetic little studio in Hester Street: was that then arson, after all, a token of extreme jealousy?

This latest attack was about that, about his fanatical determination to get on with his projects, to hurl himself, as he put it, at the clay, to concentrate feverishly and entirely on his studies. He was a student in search of art; his wandering through Paris took him to the museums – the Louvre; the Trocadero for its primitive sculpture; the Cernusi for its Chinese collection; Gustave Moreau's studio; the Guimet for Indian and Far Eastern art – and gardens, to the old church at St Denis and the galleries of Durand-Ruel, Ambroise Vollard and Berthe Weill. He discovered works in the Louvre that, even then, were not famous, like early Greek and little-known Cyclades sculpture, saw the paintings of Cézanne and the Impressionists, those of the up-and-coming revolutionary, Picasso, and of the Fauve; the images of that movement, inspired by Gauguin and led by Derain and Matisse, showering out like fireworks, must have been startling. 'The time I was in Paris was a most interesting one artistically,' he recalled. That was an understatement, and the artistic turmoil underway was perhaps dramatized by the extraordinary scene he witnessed on his second day there when he followed the procession of Emile Zola's funeral to Cimetière Montmartre – furious clashes with right-wing extremists thronging the streets with 'victory' gestures and shouts of 'none too soon' in anti-semitic demonstrations. Dreyfus was there: Epstein, watching the violence put down by squads of riot police, may have felt it was a sharp reminder of what his parents' generation had endured in Poland; he might have remembered it, too, when his sculpture was smashed up. He didn't wait about for further trouble

after that happened the second time; saying nothing, he picked up his modelling stand, walked out and went elsewhere.

'I have taken three months at the Julian Academy,' his letter to Ordway went on, 'where you have a chance to work. I will be able to make up the money for the academy course out of what I have now; at any rate, I will not need anything beyond my everyday expenses.' He never went to the cafés: he had neither the money nor the inclination. It was a simple life: Bernard Gussow, his friend from New York, had come over to join him, and they shared a studio in a rambling block of buildings in the Rue Belloni at the back of the Gare Montparnasse; they bought food from a nearby cook-shop, lived off tea and rice for weeks on end and in the evenings occasionally went to a Russian students' restaurant near the Jardin des Plantes where a meal cost a franc and a half, bread was free and Russian tea was the only drink. 'The Julian Academy is as good as one can find' – some serious students, some otherwise – 'and so it is preferable to the other academy.' However, he was going to continue in the marble class at the Beaux Arts where he had made a number of drawings from a 'splendid' collection of Michelangelos they had there. Ordway evidently knew Paris for Epstein added:

> The casts are in a little alcove by themselves; if you were ever in the École you would remember them; there is also a copy of the *Last Judgement* with which I am not greatly impressed. As for the work I do . . . my chief faults lie in over accentuating and exaggerating . . . My object to start with was chiefly to get life into my figures, to have them look living. I think I have got that in all the ones I have made at the school, but I have neglected proportions and got lots of exaggeration into the figures, so that now I will have to put my attention to that. At the school, one cannot see good work done by students and so you must go to the Luxembourg Gardens and look at the figures there.

He loved the Gardens, relaxing on a Sunday afternoon listening to the band, and studying the statues of the Queens of France. He particularly admired Rodin's two bronzes –

> *St John the Baptist* and the *âge d'amain* – the age of bronze because it is so subtly modelled . . . without exaggeration; the St John for its masterly modelling of muscle and flesh. It is certainly a masterpiece

technically. However, one may not care for it as an artistic expression
... As to Rodin, you will be interested to know that Gussow and I
went to visit him at his studio a short time ago.

That introduction was arranged by an elderly fellow student at Julian's,
an Englishman named Cayley-Robinson, who wasn't, according to
Epstein, much good at sculpture but did have the entrée to the great
artist.

> We found Rodin in and he was showing his works to some people
> who were there. There were fine things that you would have liked to
> see; for one of his Hugo monuments, still unfinished in marble, Hugo
> is seated, nude, heroic with one arm outstretched in a powerful move-
> ment while into his ear a genius pours his voice as a genius flies past.
> The other figure was still more unfinished than the Hugo, with a
> tremendously sweeping movement like a great huge bird. There were
> other figures of all kinds in marble and bronze, and his large doors
> called the Gates of Hell which illustrates the *Divine Comedy*. He has
> worked on these doors for upward of a quarter of a century ... Rodin
> himself gives you an impression of a great, strange personality. His
> manner was quiet and he did not speak much, only showing something
> in one or other of his works, a beauty here and there ...

Judging from the length and frequency of his letters to Edward Ordway,
and from the details of his experiences contained in them, this New
Yorker was very important indeed to Epstein at that time – after all, he
had arrived in Paris without a single contact save, possibly, Durand-
Ruel. Yet it was not simply that Ordway supplied money when he
needed it, or when his elder brother Lou failed to do so (he had, some
say, promised help); from the nature of the letters, he was interested in
Epstein's work, in his progress, views and reports on what was happen-
ing in art in Paris; he appears as a substitute father, and if his patronage
is mysterious, that is because he is never heard of outside Epstein's
correspondence with him. There is the feeling that he entered the young
artist's life to perform a certain duty, and that, when this was ac-
complished, he vanished; as a benefactor who was ready to fund his
training because he had seen in him rare gifts that would enable him to
realize an ambition of which he himself was incapable – the making of
great art. During the time Epstein knew him he was Secretary of the
Philippine Independence Committee, which suggests that he was

left-wing as well as rich, and there seems to be the likelihood, too, that the wealthy Mrs Stuyvesant Fish, who took him up in New York, bought his drawings and recommended him to others, was a close friend; that, between them, they had encouraged Epstein to go to Paris and had paid for his ticket. The money Ordway supplied, moreover, would explain Epstein's ability to begin collecting African sculpture. This was in 1904, before it had been 'discovered', and was considered the correct thing to have and admire, Epstein said. 'Perhaps at that time one of its greatest attractions was the fact that it was the only sculpture I could afford' – a piece could be picked up for as little as seventy-five francs. It is probable, too, that he bought one, if not both, of the Rouaults he owned (again, of course, very cheap then), since this rich colourist, who had, like Henri Matisse, been one of Moreau's students, may well have met Epstein when he called in at the Moreau Museum where Georges Rouault was curator. However, from hints dropped in the correspondence, Ordway was certainly generous; for example, in a letter that went off on 16 April, Epstein says,

> I am returning the fifty dollars you sent me as I find I have money enough and will not need this. I should have written to you not to send it. I have no trouble in getting on. As I wrote to you, I am now going to Julian's for modelling. I had taken it for three months but I believe I will stay throughout the summer and it will be cheaper to take the course for six months . . .

He was hopeful of the new art school: although the modelling had been a good training at the Beaux Arts, he had learnt more from the best of his contemporaries than from the teaching staff – they were more interested in picking up models than in teaching, something which went for most of the students too – they couldn't understand how he and Gussow could do without women! The French all had mistresses. The marble class was better because the instructors seldom turned up and he could do what he liked: professional carvers did the same, dropping in to use free marble to make copies of Renaissance heads that were sold for large sums. Apart from that, he was glad to see the back of the place. Julian's had its drawbacks, of course: Jean Paul Laurens, who ran the life drawing, seemed to take an instant dislike to him: he went from student to student giving criticisms, but, coming to Epstein, he sat down on the stool, looked at his drawing, then up at him, before passing

on without a word. It was Laurens who was on Le Comité d'Esthétique de la Préfecture de la Seine that condemned his Oscar Wilde tomb nine years later. And there was Cézanne's *bête noire*, the academic Bouguéreau, France's Alma-Tadema, who, obsessed with his feet, and very old and feeble, had to be assisted by students into and out of his chair in front of the work, followed, like Laurens, by an assemblage of Frenchmen: his paintings, just on the acceptable side of pornography, sold for thousands of dollars in the United States, a reason why Henri Rousseau's declared ambition was to paint like him. When he spoke to Epstein, his nonsensical criticisms were so irritating that he took to covering his figure when the Great Man approached, an act which brought exclamations of anger: *'Ce sauvage Américain!'*

Still, Paris was nice; he described the markets to Ordway, the parks, saying: 'Just now, Paris is all green. The trees have bloomed and certainly they are good to look at. The weather though is cold and today it has been snowing . . .' He had been to an exhibition of Impressionists, he reported in May, where he saw paintings by Manet, Monet and Degas, but that there wasn't much to look forward to in the approaching *Salon* 'as there seems to be a lot of poor trash accepted'. He was beginning to settle in. Although the weather was as cold as ever, he had been spending some time on the Seine, a good deal of it at night. 'Sometimes I have been up the river in one of those small steamers and then you are in fairyland,' he wrote; from the moment he first walked out across to Notre Dame, and over the Pont des Arts to the Louvre, he thought it was a wonderful city for a student to wander in. He loved everything about it except the quarter round the Arc de Triomphe and the Elysées, both of which he found excessively dull; they were, and remained so for him always, 'a desert of boring streets' – the width of the avenues, the pretentiousness of Haussmann's architecture couldn't compare with the richness of the old neighbourhoods round the Place des Vosges, the Hôtel de Ville, Rues Rollin and Voltaire, or St Sulpice, every bit of which was magical. Above all, he was, he said, 'sustained by a wonderful health and strength', looking back on the period as 'a rage of work' during which he acted 'in a frenzied, almost mad manner, achieving study after study, work after work', always destroying it and starting something new each Monday. One student, a Czech, warned him he would burn himself out early, another was astonished at the way he worked, darting round the model with a measuring tape 'to get different, almost simultaneous views' (he found the tape extremely

helpful, using it to check sizes throughout his life). In between, he did
take time off – went to concerts on Sundays, saw Paderewski play,
Richard Strauss conduct and Isadora Duncan dance to Beethoven's
Seventh – 'She looked puny,' he wrote, 'at the Trocadero with a full-
sized orchestra on a vast stage.' At weekends, he liked trips out to the
woods of Chaville, coming back refreshed to start at the art school with
renewed energy.

In the letters, no clues were given about a more private life, although
clearly one existed, if spasmodically – there was, he once told his plaster
moulder, Jan Smith, years later, always someone to cook him a meal;
and a young Englishwoman named Celia Jerome moved into his studio
complete with a hip-bath, but she departed soon enough; also, there was
his devoted girl-friend, Adele Rabinowitz to whom he wrote often, and
who came over from New York for a spell to look after him when he
was suddenly taken ill. And he did have holidays – at least, in his letter
to Ordway of 18 August he does appear to have recently taken one: 'I
have been to London and up the Thames on a river boat with friends
...' This trip occurred, unfortunately, but perhaps too conveniently,
just at the moment when Mr Ordway had taken it into his head, without
warning, to turn up in Paris with his wife, hoping to see him. The
Thames, he said in the letter written from London, was 'peaceful and
thoroughly beautiful'. One of the friends was Gussow, another undoubt-
edly Margaret Dunlop, a woman he'd met that year at a dinner in Passy
given by a Belgian publisher named Victor Dave who had been
imprisoned for two years for activity in anarchist propaganda. But then
when Ordway wrote to him from Paris to say he was going on to
London, Epstein had replied, unusually apologetically, to say he was
unable to meet them in either city – London was impossible because 'I
leave tomorrow morning to go to Wales ...' He'd sent him another
letter, care of Baring Brothers, the bankers (but fears he may have got
the address wrong), in which he says he climbed Snowdon. It seems that
the news of the Ordways' trip had put him in something of a panic, and
that, preferring the relationship with his kindly benefactor to remain in
correspondence form only, he had taken immediate avoiding action.

On 4 September he wrote again: 'I am so sorry that the gods were
unwilling we should meet; but so it was. I cannot say I did Snowdonia
in the week that I was in Wales. For one thing, I was quite unprepared
as to shoes ...' They had given out. But he loved the mountains. 'I
liked their bareness and as it was the first really high mountain I had

ever seen it was something new for me.' Back in Paris, and with neither the Beaux Arts nor Julian's open yet, he was going to another atelier to attend an afternoon class modelling from the antique. 'As for the Rodins,' he wrote, 'I go now daily to study the *St John the Baptist*, not that it is the most likeable of Rodin's works, but from the point of view of fine modelling, it is by far the finest thing I must believe that has been done. It is a revelation of modelling after nature.'

For a very young and intense artist with a dedication and energy of the Renaissance artists' kind, Paris was a continuing inspiration. A month after he had arrived, Picasso had had his first successful exhibition at Weill's gallery; it was there, too, that Matisse and Rouault launched the Fauve movement in 1903, and the nineteenth *Salon des Indépendants* had works of Matisse, Derain and others of the group. Then came news of Gauguin's death, and that led to the first *Salon d'Automne* and Gauguin Memorial Exhibition, again arranged by Matisse, and where Van Gogh, whose work had been ignored at the *Exposition Universelle*, was also represented. 'The time I was in Paris saw the first and finest *Salon d'Automne*, and introduced Gauguin and Van Gogh to a wider circle,' Epstein told Arnold Haskell in the Twenties. Then, of course, Pissarro's death in November led on to his memorial exhibition in the following year, this time arranged by Durand-Ruel. Epstein, however, mentioned none of the great events in his letters to Ordway, concentrating solely on his work, future and ambitions. Whether he attended Rodin's school, started after the artist's runaway success at the *Exposition Universelle*, is not clear: he never saw Rodin again following his visit with Gussow, yet was given a letter of commendation by him. This suggests a number of possibilities: that he went to the school, was taught by others and his studies were noticed; that Cayley-Robinson arranged it; or that Rodin saw the results of two competitions he entered, one at Julian's, the other at the Beaux Arts. After thanking Ordway for a money order, Epstein mentions these in his letter of 19 October:

Today was the first day as the Beaux Arts concours begins at twelve sharp . . . I arrived just as my name was called, my clay and stand on my back. So far this week I will be at the figures from eight to four without any interval. As for my future plans, I will want this winter at the school; I will need that quite, for I am not strong enough as yet to think of doing something on my own account . . . I will then have had two years at school. This is not too much.

He points out that Rouault was at the Beaux Arts for three years before producing his first work. Nevertheless, Epstein was now thinking about a composition he wanted to start after the end of the school year – that he would like to find an atelier of his own where he could carry it out; he had already made some sketches. 'I wish to work on this for at least six months – I do not think it wise to come back to America with nothing but my technique in my fingers. If I have something to exhibit and show that I have in me – the ability to model my conception – I will gain much.'

With Ordway having tried to persuade him to think about returning home, Epstein went on:

> Besides this, if I were to exhibit at the Salon here and receive a
> mention or a medal it would go a long way to introducing me to
> America. I think myself that the Salon honours do not mean anything
> as poor things get them as well as good things, but they mean much
> in America. I do not think I am in danger of forgetting America. I
> think though that one can work here in Paris cheaper than in New
> York. To do anything in New York, to hire a studio and get models
> costs much more than in Paris and one could work on a group or a
> figure for far less here, and with more advantages. As for the
> Metropolitan Museum hall of sculpture, I will have my eye on it. I
> have been told though that it is filled with those horrors made by our
> early American sculptors . . . like some of those imitation Greek and
> Roman works.

One can imagine it. 'I am sorry to hear that they have not all been smashed up as they ought to be.'

A passage followed devoted to his ideas for a group of figures which, he says, have changed considerably in the sketches: his sights had moved beyond his studies at the school, becoming focused firmly on conceptions of his own: hence a sudden determination to find a studio: 'I would want to make either my figure of the "sculptor" . . . or another group of two young men I have in mind. I know the models for them and could get them.' He breaks off to tell Ordway that his ex-teacher at the League, Barnard, has been to see him, adding, 'I think he will be able to advise me better than anyone else as he knows the situation for a sculptor in America.' The letter ended with a surprising reference to Wales again: 'So you went to Snowdon?' – he could have felt he was being followed by the Ordways – 'I should not wonder but you passed the little Welsh cottage that I stayed in . . .'

*

The following January, Epstein was still working on the idea and his next letter continued his thoughts on this:

> I am preparing now to take a studio for myself and start on something that I have been thinking of for some time. I am quite prepared to do this now. I know that you believe I have been perhaps too long at the school and you might think that I would have done better to come back and work in America, but everything considered, I think one works better here.

No wonder, then, he gave Ordway the slip in Paris and left for London, since it's clear from this that a meeting was going to lead to arguments about where he should be living: the trip to Wales expresses once more his total commitment to his art – nothing, not even one of his own countrymen's concern for his welfare, was allowed to get in its way; as he said: 'I have always begrudged the time that is given to anything but that.' And strangely enough, it was this visit to England, forced on him by the presence of the Ordways, that gave him his first sight of the beautiful quiet of the countryside, one of the factors which eventually attracted him there, for good. He went on: 'For one thing, models are cheaper.' He was referring to those in Paris. 'I have not yet found the studio at the price I can pay that is satisfactory, but I hope not to be too long on the search. I am anxious to begin on what I want to do; I don't like to speak of it at this stage when nothing is even begun and so will say nothing.' One can imagine Ordway's look of despair as he read this on the other side of the Atlantic. However, he would, he said, send 'photos' if it worked out well.

Epstein believed his time at Julian's had been good for him. 'I am not afraid of becoming academic. I don't think there is any danger of that. If I were academic, I would have taken prizes at Julian's before this, but as it is I cared less for the prize than for the work I was doing and so worked as I thought right.' He is still living with Gussow, and hoping to find the studio in the building where they were staying. And he has got hold of the models he wants, 'so will not have any trouble on that score'. He repeats that the composition he wants to start will take at least six months, and that when he has done something on it, will ask Barnard, who was still in Paris, to come and see it. 'I have not seen him for some time now. I have been busy every day.'

At last he found a studio, and it was probably at this point that he

carried out two of his most beautiful works, the babies' heads, *Asleep* and *Awake*, now that he had space of his own in which to work: a young girl model had arrived one day with a baby and these were the result of her visit. However, in an undated letter from Paris written in pouring rain, he says that he wishes the studio was larger for a new group of figures he is planning. He wants a model for about four months and to make the work in marble. But there were problems – 'a piece of marble of even a quite small size would cost 250 francs': here was the first intimation of his specific interest in the material that later became such a passion it prompted his remark that 'to stand in front of a stone is like standing in front of a woman you love.' Then, he was thinking of the 'group as representing primitive men greeting the sun ... I was caught by the lines that the arms of two figures like this make, and if I were to translate it into marble I could make the hands transparent so that the light would glow through them ... when facing the light.' This was to be a life-size work; he knows 'a lad with a splendid figure, long and slender, a negro model' whom he can get. Then he comes to the point: 'I will ask you for another loan if you can spare it just now?' In the meantime, until he has some money, he will be working on sketches for it. He sounds impatient to start and says he 'would like to carry out one thing quite quickly. I cannot afford to have models at present ...' He says something about Japanese prints he has seen in a big collection belonging to a Mr Stein on show in Paris which he was very interested in (he was surprised there are so few in the Louvre) and then adds: 'Another artist whom I have come to know recently is Degas. He is really a supreme artist.' He had also met Gertrude Stein, who was most taken with him.

Ordway, of course, sent him what he needed: 'I have your note with the money order enclosed and thanks very much. I believe I shall be able to purchase a small piece of marble and hammer out my "sun-rise" group, although I am thinking of doing this quite large; it would be more impressive the size of life,' Epstein wrote. He had found an out-of-work negro who came to pose for him on Sunday mornings, and he said he would make as many drawings of him as he possibly could – he was

> a splendid fellow, came from Martinique ... I shall have him to pose for me for the group when I begin on it. However, there are many many things I want to do. I do not have to seek far for ideas; as I think no artist need seek far if he has the eyes to see, only left alone

. . . Much of what I want to do is experimental: that is, I will not
expect arrival at final results: the school technique is very well as far
as it goes but one has to search for much that the school structure
cannot offer one.

'I am glad that you like my studies' – he has sent him photos taken by
him with a friend's camera – 'especially that of the old man. That was a
study made in two days. That and the young girl with the sweet face I
made in the same week.' The sculpture of the old man was a full-length
nude suggesting the influence of Rodin; the girl was probably Adele. He
went on to say that he will keep Ordway informed on the main study
after he gets down to it. As for the sculpture society in America that
Ordway suggests might be of use to him, he says,

> from all I know of them they are nothing but corps of business
> sculptors who are looking out for the fattest jobs. I hope I may never
> have anything to do with them. If I can do my own work in my own
> way, I will not see the threshold of any of them. I know the kind of
> men who are at the head of the sculpture society.

Epstein was only in his early twenties, but he had no illusions about the
way the worldly worked in the world of art. There was no tempting him:
his integrity was, and always remained, total and uncompromising: his
vision of his place in art absolutely clear and real, and he never hesitated
in letting his friends know it.

After this letter, his thoughts about leaving Paris began to harden. In
his next, 4 February 1904, in which he says he hasn't much to report,
he tells Ordway that he has been working on 'a kind of fragment' of
two figures. He was not really satisfied with the result but hopes to send
it to the *Salon*. He had two excellent models for the group – a man and
a woman (the woman, he said, had 'the best arms of any model I saw') –
both from London. 'If I do,' he went on, significantly, 'I may go to
London to work as I have made friends there who think I could get on
in London. At any rate, I am going early in September, or the middle,
to look about to see what can be done by way of an exhibition and also
about a studio.' So there was something to report, after all. 'If there is a
good prospect of doing something there, I will go. I know that you
think I ought to return to America as soon as I can'; however, he wants
to stay in Paris at least until the *Salon*. He appears uncertain: having

said that 'it will be time, I think, then to go back to New York', he
adds, 'If I can do good work in London and think I ought to go;' he
didn't believe his expenses would be greater there than in Paris. He has,
he announces, given up his art schooling and so 'that advantage of Paris
will not be missed.' He has been told, moreover, that food was cheaper
in England and that friends there had promised to pose for him for
nothing. This meant a great deal as he was, as usual, very short of
money – 'that is the greatest expense, models' – and said he should
make use of the offer. As usual, too, when writing to Ordway, he went
into the minutiae of his costs – 'models are paid twenty-four francs a
week' (not much by today's standards perhaps, but a lot then,
particularly to a struggling young artist) – and the expense of his group
he was planning: in models' fees, it would cost fifty francs a week, 'so
that now I am left high and dry, and have to live closely.' These
remarks are in character: with only patrons to depend on, and sculpture
so heavy in overheads, he was always, from his beginnings in Hester
Street to almost the very end, consumed with anxieties about money.

He was of course very generous (took after his father here, his sister
Sylvia said) and at least some of what Ordway sent him was spent on
meals for his starving artist friends. And he remained so: later on in
life, he enjoyed taking people out to restaurants for a good meal, to the
Café Royal, and would, almost absent-mindedly, pull a wad of notes
from his hip pocket and hand it to some depressed friend who claimed
to be desperately in need of a holiday: he was completely unworldly
about money, never signed a cheque or paid bills (which he left to his
wife), and cared little about the pricing of his work (often determined
by some ancient object or a painting he had seen and wanted to buy).
As his letters show, his mind was focused simply on the making of his
sculpture, its problems and little else; only occasionally is there some
passing remark about other things like 'Gussow has gone to Scotland
for a week' and then would be staying in London. 'I wish I could have
gone with him' – he was dreading Paris in the summer – it was
'tremendously hot and dusty . . . I envy him in the mountains of
Scotland . . .'

Perhaps this was a reminder to Ordway that he had made up his
mind to leave for England – in fact, his constant references to London
and Scotland, to the cheapness of working there, free models and other
things, might suggest that Margaret Dunlop, who came from the
Western Isles and was already married, had now fallen in love with him,

and that she was trying to persuade him to join her in London. The uncertainty expressed in his letters indicates he was at a point when a decision had to be made that would influence the entire direction of his life, and was thus fundamental to his future fortunes. While Ordway was putting the pressure on him to return to America, friends in England were calling him to come there; and then, between the two of them, there was his art, his sculpture, about which he was in any case full of doubts, feeling he had reached some kind of impasse. 'I had, so it seemed to me, come to a dead end in Paris. I felt that if I went somewhere else and got into new surroundings, I would make a new start. It was in this mood that I debated in my mind whether to return to America or go elsewhere, perhaps to London.'

He certainly went to London, possibly early on in the year, for a quick visit, since it was in 1904 that he saw the head of the Demeter of Cnidus at the British Museum for the first time. However, he was in Paris in March, writing to Ordway to say that he had at last begun his group – there had been hold-ups, of course (one of which could have been a visit to London); otherwise he would have started before. His model had vanished, he had had trouble in finding a studio – studios were all taken at this time of year and he'd wasted a lot of time looking for one – and the man who was making his stands and a cross for his armature had been extremely slow. In the end, his landlord had agreed to let him have a studio 'for six months at least'. He had now, apparently, put all thoughts of leaving out of his mind, anyway for the time being. He was very ambitious for his work, wanted it to go to the *Salon* and, later, to London possibly before sending it to America. It was to be over life-size, he said, because 'a life-size figure always looks smaller than life when placed in a large hall like that of the *Salon* or in a museum.' This group, which he eventually destroyed, was extremely important to him. He didn't know how it would affect others and he hadn't talked to anyone about it. 'If I am right in doing this,' he said in his letter, 'I am very right, and if wrong, very wrong, and the only thing I can do is trust my own visions – it will show me as an artist or not one, and I trust that my faith in myself will be justified by what I will do.' So this work presented him, as he saw it, with a turning point that amounted to a crisis: everything now depended upon it, his first work on his own after leaving art school; would he convince himself that he was able to go on, or would he fail? 'I will need some money soon.' At this point he was beginning to fear that Ordway would lose faith in him, having

promised so many times that he was starting on the work, only to admit he had not done so. Coupled with the costliness of the endeavour, the task, with so much at risk, was difficult to confront, leading to endless postponements. 'I found that the expense of getting started was more than I thought it would be.' That, of course, was the most potent justification for delay. 'I am asking you to let me have fifty dollars if you can spare it. I hope that you can and that you will trust me to use the money to the best advantage.' He went into his costs again – of the model (eight francs a day), less in Paris than in New York or London – in New York, they cost 'eight cents an hour'. He insists that he lives on as little as he can, that the money is purely for the model and the studio . . . 'I do hope you will be able to let me have the money. I would not ask it for anything but for the work and I feel that I am not asking it for myself, that is why I am free to ask, I believe . . .'

As the letter went on, he sounded increasingly anxious. 'I will send this off immediately so that it will reach you as soon as it can . . .'

An undated letter follows, confirming the arrival of the money. 'I have your letter with the fifty dollars enclosed' – he doesn't waste time with 'thanks' but at once launches into a progress report. He has started on the group and has 'a very good model'. He said: 'I want to do two groups . . . another to go with the "Calamus" of Whitman's.' Things seemed to be going well at last, although he is afraid the model, delightful as he is, may desert him. His studio is excellent and Paris at its spring best with an exhibition of photographs of Rodin's work, most of which was unknown: 'He is certainly a marvellous sculptor and his variety is astounding.' And he had gone to many other exhibitions; and, not least, had visited Durand-Ruel at his home and seen his amazing collection of Impressionist paintings – he was particularly struck by his Monets and the pastels by Degas: 'Perhaps Degas is not so strictly an Impressionist. Do you know his work? It is very fine. For purely artistic qualities, he is above all painters.'

After that, the correspondence with Ordway ceased: during the summer months he had buried himself in his two big projects. However, on 16 November, about the time when he would have seen the great Cézanne exhibition of thirty paintings at the *Salon d'Automne*, the correspondence suddenly resumed: 'I have not left Paris as yet although I have moved away from my atelier and am living in a different one.' By now he had separated from Gussow and saw him only in the evenings. 'I had difficulties with my model for the group. The man I had disap-

pointed me and left me after I had begun on it and I had to give it up. Since then I have been working on other things. I am not satisfied with what I have done in sculpture thus far, and thought of going to Florence but will not for a while yet, if I go at all.' There is no evidence that he did go at this time, although the very fact that he mentioned it to Ordway suggests that he did do so. Whenever he did go, it wasn't for long: he had been given an introduction to a family who would put him up, and the sight of the great sculpture of Michelangelo (his Medici Chapel, the *Pietà* with Nicodemus), of Donatello, the architecture of Brunelleschi and others, so excited him, some have said, that he rushed back to Paris after only three days. At the same time, since his letter to Ordway suggests his departure for London was imminent, he must have wanted to squeeze in the visit that he'd planned to make long ago in New York, at the first opportunity; knowing how impulsive Epstein was, it would be no surprise to hear he was packing up for the trip the moment he finished his letter. 'I have been working at some drawings, and an English artist I know has advised me to exhibit them in London. I may do this. London seems a good place for exhibitions of work. They are drawings in pen and ink that I have made, and are compositions rather than studies of the model.' Among them would have been the drawings for Whitman's 'Calamus', but, besides these, there were the exquisite works in black chalk of babies he had been doing; all these, together with the two babies he had modelled earlier, he took with him when he left. Referring to the drawings, he said, 'I am thinking of trying to get them placed with some publisher for they are a series on one theme and I should like to publish them.

'In sculpture, I am just now making studies for a composition . . .'

This was the last letter to Ordway from Paris.

There is an interesting postscript to the two groups of which he wrote so often. In his autobiography, he said:

When I left the school and attempted to work on my own I was not at all clear in my mind as to how to work out my ideas for sculpture. I started two large works, one of which I remember as a group of 'sun-worshippers' which I should have kept. I have since seen Early Egyptian figures which bear a remarkable resemblance to this early group of mine. This and another heroic-sized group I destroyed . . .

That somewhat casual remark raises an issue which dogged Epstein – namely, the claim that he used ancient or ethnological works as sources for imitation. Epstein repudiated this suggestion: 'When I say that my work is not African, I do not rebut what I am ashamed to admit, but simply state a fact.' In this connection, the later defence of his position by T. E. Hulme, the philosopher, Imagist poet and art critic, was more analytical. Using the illustration that it was claimed that Epstein's 'carvings in Flenite' were definite 'imitations of Easter Island carvings', he wrote:

> This seems to me to depend on a misconception of the nature of formulae. Man remaining constant, there are certain broad ways in which certain emotions must, and will always naturally be expressed, and these we must call formulae. They constitute a constant and permanent alphabet ... The point is, that given the same emotion, the same broad formula comes naturally to the hands of any people in any century.

He added:

> To be legitimate, of course, the formula used must be a natural expression of the feeling you are getting at and not a mere imitation of an exotic or a romantic past. The form follows the need in each case ...'

Gussow eventually returned to New York; although Epstein saw little of him after that, they corresponded off and on for the rest of their lives.

3

Chelsea

EPSTEIN finally left Paris for London in January 1905, so arriving at a time when strenuous efforts were under way in Britain to pass the Aliens Act, the legislation devised to deny right of entry for Jewish refugees pouring out of Russia. By the time it became law at the beginning of the following year, the Government had suffered such a humiliating defeat at the hands of the Liberals that its effectiveness was washed out. The anti-semitism that had inspired it, however, remained as virulent as ever. With Jews becoming scapegoats for the impoverished and neglected east end of the city where the immigrants landed, the familiar platitudes were hammered home – they threatened jobs, took 'the bread out of the mouths ... of English wives and children', they were 'unwashed, cringing, lying and wage-cutting aliens'; Stepney was an anarchist cell populated by 'Jewish immigrants' and so on. For some reason, and perhaps of significance so far as Epstein was concerned, Polish Jews in particular were singled out for the worst attacks: they were crooks, lived in filthy conditions, stole: they were cheats.

Although the Act was of no interest to Epstein, the side-effects of anti-semitism were evident soon enough, exhibiting themselves in different guises whenever opportunities arose, as he was to find out. For the moment, however, he had far too much to do to give England's social problems a thought. He had to settle in, find somewhere to live and work. He installed himself in a studio at 217 Stanhope Street, near Regent's Park in Camden Town, and at once continued with ideas he had been exploring in Paris, rather as though he was so absorbed with them that changing cities was like changing studios; putting tools down

in one place, he picked them up in another to go on with the group he had been developing from his drawings of 'Calamus'. He wasted no time in picking up his pen to keep Ordway in touch with events, either: on 4 February, he wrote that the group was based on Whitman's poem 'Brotherly Love', expecting to have it 'finished in time for the Royal Academy which occurs in April'. He was referring to the annual Summer Exhibition: a place to show his work was an urgent need, and to find a gallery to exhibit sculpture was always difficult, even if, as a newcomer, he could find one interested in him. Things were easier for a painter in this respect: pictures could be hung anywhere.

And so hopes of the *Salon* in Paris were replaced with hopes of the Academy in London – both were among the very few galleries open to all. Or so they were in theory: he had of course a poor view of the *Salon* (which Cézanne had obliquely referred to as 'le Salon de Bouguéreau'), but soon discovered the Academy was no better – it, too, was in the grip of the arch-traditionalists. In fact, where cracks were appearing in its counterpart in France under pressure from rebels beginning to gain recognition, the Academy remained solidly blocked to outsiders who might upset the status quo. As such, it was truly representative of the mood of the times. In 1904, the National Gallery had turned down the offer of a gift of a Degas, and in 1905, the very year of Epstein's arrival, the London Exhibition of Impressionists, put on by his mentor from the New York days, Durand-Ruel, and including twenty of Monet's thirty versions of Rouen Cathedral, had gone down very badly. Of course, there were some glimmers of hope: there was another possible outlet in the New English Art Club, founded in the 1880s by Fred Brown in opposition to the Academy. This, as Augustus John said, 'sought to carry on the tradition of "Impressionism"', and favoured the work of the Camden Town Group – young painters of the 1890s like Spencer Gore, Charles Ginner, Robert Bevan and Harold Gilman, all of whom were followers of Walter Sickert, but whose paintings were somewhat faded versions of his sources of inspiration, the revolutionaries of the generation before those whom Epstein had left behind in Paris.

To academicians, nonentities like Terrick Williams, Alma-Tadema, De Glenn and many more, such so-called English Impressionists were regarded as revolutionaries. From Epstein's point of view, however major or minor as these artists may have seemed to him, there was no equivalent of them on the sculptor's scene: here, art had hit an even greater low with the New Sculpture (a phrase coined by the critic,

Edmund Gosse, in the *Art Journal* in 1894), a group which had, under the influence of Lord Leighton, set its standards by those of the *Salon*. Alfred Drury, George Frampton, Henry Poole and Charles Pibworth were among prominent members in control of most of the important public commissions when Epstein arrived, all doing an excellent business in machine-cut figures in England and around the Empire, dreaming up sentimental themes in neo-classical revivalism as they reeled off 'mermaids' and 'angels' in absurd poses with titles like *The Girdle*, *The Myrtle's Altar* and *Love the Conqueror*. These were the architects' sculptors in the heyday of the Aston Webbs, the John Belchers and other associates at the Academy who adorned their cumbersome, neo-classical edifices with figures of girls discreetly attired in drapery and pirouetting on pedestals, along parapets and friezes, on pediments and over doorways, and who undertook innumerable monuments to Queen Victoria. Frampton's *Jubilee Monument for Calcutta* was one of the biggest and most fulsome in symbolic praise of the Queen, Country and Raj ever made. *Happy in Beauty, Life and Love and Everything* – the title of one of William Reynold-Stephens's grandiose romances with 'maidens' – makes perhaps the best epitaph for this meaningless period of English sculpture.

At any rate, together with a deeply ingrained element of anti-semitism, it set the scene for the onset of Epstein's struggle against the system. England was his new adventure. Here he was, short of money but full of optimism, the Academy firmly in his sights; others, like Augustus John, could have warned him, but he was prepared to challenge, as an artist and an American, and carried along by youthful enthusiasm, a faith in merit, excellence and himself, any frontiers: excellence had to succeed somehow, somewhere. He was convinced that the group he was modelling for casting in bronze, and wanted to send in to the remote English institution, had merit. It was to be part of a series of works he had in mind. 'I have sketches for as many as twenty,' he told Ordway, 'and I am not making them large – about third full size.' He was having his usual problems of finding models – 'I cannot get them readily at the price I can afford to pay and so I have to get them on odd days when they are out of work elsewhere' – but was determined to carry on, maintaining that he wanted to stay in London after the Academy exhibition was over to 'work on one or two things' before returning to America. He was hoping for a break, had made friends with Augustus John and had a studio which suited him – 'and that counts for a great deal' (he

couldn't get one like it for the price in New York) – and, as to the future, said: 'Whether I can find any public to come for anything I do, that is to be seen.'

Epstein was not one to hang a brass plate on his door and wait for some miraculous patron to drop by out of the blue; lack of money and tremendous energy combined to make things happen. He explored London – its museums, galleries, art schools and geography, and was already spending some evenings at the Queen's Hall concerts where, he told Ordway, there were good programmes – with the urgency and excitement with which he had explored New York as a boy and Paris as a student. He had come to know a Norwegian pianist named Mme Childing who played to him at her house, and through the insatiable curiosity which had brought him into contact with people like Durand-Ruel and Rodin, he met artists. In his first week he was introduced to John Fothergill, a young painter and writer who later gave up the smart circles of Edwardian London for managing the magnificent Spread Eagle inn at Thame, and in a casual aside in his autobiography, Epstein says he did a portrait of the painter in crayon, and that he bought, and made his friends buy, 'some of my drawings'. Who were these friends? Fothergill had been a student at the Slade under Henry Tonks, Wilson Steer and Fred Brown in the late 1890s (he edited a book, *The Slade*, in 1907) where he was a close friend of contemporaries like William Orpen, Albert Rothenstein and John. He had, moreover, opened the Carfax gallery in Bury Street, St James's, just down the road from the Academy, with Albert Rothenstein's elder brother, William. This remarkable initiative, taken while Fothergill was a student, was launched to specialize in the work of unknown artists, and by 1900 the gallery had acquired a distinctly avant-garde flavour. At that point, it was bought by Robert Ross – Oscar Wilde's great friend and one-time lover – whose organizational flair gave it the necessary professional gloss. He brought in his friends More Adey and Arthur Clifton as business partners, Robert Sickert (Walter's younger brother) as manager, while William Rothenstein was in charge of the selection of artists – his brother, Albert, Charles Conder, Aubrey Beardsley, Max Beerbohm, Roger Fry, Steer, Muirhead Bone, Orpen and John all had exhibitions there. William Rothenstein, who, hardly surprisingly, did too, said it was to be 'a centre for work of a certain character'.

So another of the networks, familiar in the art world, had surfaced; within a few years the Carfax had become a most sought-after com-

mercial gallery, dealing not only in young artists but in Old Masters as well – Rembrandt's *Polish Rider*, for instance, passed through these dealers' hands before it reached Henry Clay Frick, the remarkable New Yorker who left his fine collection and spacious house on East 70th Street to the city. Hence Fothergill's immense importance as a contact: he opened the door to the Carfax set: a passing remark of Epstein's in his February letter to Ordway – 'I slept on John's studio floor last night' – confirms this. And now that Epstein was among influential young artists like Muirhead Bone and John he became convinced that the Carfax was a place, *the* place in fact, where his work could be seen. Fothergill, being a reasonably sophisticated young man, may have felt that it would be best if Epstein approached its directors from the outside; that perhaps he should try Bernard Shaw for an introduction since he knew Ross well. That suggestion would probably have appealed to Epstein: Shaw's plays had been acclaimed in New York in the 1890s, which would have interested him, long before they were accepted in London. Epstein wasted no time; wrote to Shaw, went to see him and showed him his work; and Shaw, impressed by the audacity and compelling conviction of this sculptor less than half his age, duly wrote to Ross on 13 March. For someone who had landed in England only two months before, he had moved very fast indeed.

Luck was on his side: as things turned out, his meeting with Shaw came at a good moment. Ross was Wilde's literary executor and had just published an abridged edition of his *De Profundis*, and Shaw, after a paragraph extolling Wilde's virtues (he had, he told Ross, written an article on Wilde for *Neue Freie Presse* in Vienna), and expressing horror at the book's revelations of his treatment and the continuing attacks on him in the British press, went on: 'By the way there's a young American sculptor named Jacob Epstein, of 219 [sic] Stanhope Street, NW (therefore poor), who has come to London with amazing drawings of human creatures like withered trees embracing.' Epstein had shown him his drawings for 'Calamus', of babies and, sensibly, his portrait of Fothergill, among others. Most important of all, perhaps, he had a letter commending his work from Rodin. He wanted, Shaw said, to exhibit his drawings 'at Carfax, which is to him the centre of real art in London . . . and when I advised him to get commissions for busts of railway directors, he repudiated me with such utter scorn that I relented and promised to ask you to look at his portfolio.' Railways had become a source of revenue then, and for Epstein, such a frivolous suggestion reduced his art to the level of a commercial portrait painter.

It is a bad case of helpless genius in the first blaze of youth; and the drawings are queer and Rodinesque enough to be presentable at this particular moment. If you feel disposed to be bothered with him for ten minutes send him a card and he'll call on you. There may be something in him.

He found him impossible to ignore: Epstein had a striking presence that filled a room – very handsome and strong, he generated a vigour and vitality which contrasted strangely with his soft enunciation of the New York accent. Of course Epstein wanted to make some money; he was a practical person; what he detested throughout his life was the equation of this with commercialism. John had done very well – earned thirty pounds – with a recent exhibition at the Carfax and Epstein hoped he would be given the chance to do the same. He had to gain a reputation, too – hardly an unreasonable ambition for one with great ideas for sculpture.

Despite Shaw's introduction, which was, discounting the somewhat patronizing asides, enthusiastic, the likelihood of the young artist being adopted by the Carfax, at such short notice, was doubtful. He was a foreigner, a New World New Yorker, a student from Paris whose ideas could have been identified with those of the 'dangerous' revolutionary artists emerging over there. In the circumstances, Shaw was the right person to see. If nothing dramatic immediately came of his letter to Ross, indirectly it led on to remarkable developments. Entirely unknown on arrival in London, Epstein was, three years later, presented with a job that may turn out to have been the most prestigious commission of the century – the tomb for the magical martyr, Oscar Wilde, at the Père Lachaise cemetery in Paris. More remarkable still, he was famous throughout the land by the time he received it: his name splashed headlines across newspapers, he was the centre of controversies, photographed, loathed and lionized: correspondence columns filled with vilification of him, while ardent young students of art like Nina Hamnett hung about in the hope of catching a glimpse of this *enfant terrible*, this suddenly Great Man. For a stranger from across the seas, confronted by a philistinism that was set hard as concrete, his breakthrough was, by itself, sensational.

His works were not accepted by the Royal Academy that summer; in fact, he only had one shown there in his lifetime. Shaw, however, gave

him another introduction – to William Rothenstein. This was an admirable move: besides being a founder of the Carfax and a close associate of Ross and Fothergill's, he was all over connections and contacts – Sickert, Beardsley, Conder, Burne-Jones – and had been a friend of Wilde's. This introduction in particular may have led Epstein to Muirhead Bone and Francis Dodd, both artists and members of the New English, who became, together with Ambrose McEvoy, friends and supporters of Epstein for life; Bone, initially an architect who turned to drawing and etching (which he carried out with great skill if little imagination), was his most loyal ally and admirer, which seems rather curious for so conventional a man.

'About that time,' Rothenstein recalled in his memoirs, 'a stranger came to see me with a letter from Shaw. This was Epstein, a young man with a powerful head and frame, determined looking, enthusiastic.' Epstein, knowing nothing of the contents of the letter, told him that Shaw couldn't help – thought his drawings mad, 'like burnt furze-bushes' – but that he had insisted Rothenstein, being an artist, wouldn't agree and this had persuaded Shaw to send him along. Epstein was desperate for constructive assistance; he said his parents were Polish, lived in New York, and that he wanted to work in Europe but hadn't a penny. Without money, he couldn't practise his art. As he pointed out to Arnold Haskell many years later, the reason there were whole periods in history, rich in painting, that produced no sculpture at all was largely economic. A painter might take a few days or weeks over a painting, and do many drawings in a day ('I myself have done as many as twenty,' he said), while with a sculptor it was a question of months or years with a very heavy outlay in materials, and far less chance of ultimate sales. Hence his constant anxiety about money: space to work as a sculptor was expensive, and materials were too, each subject for carving determining the precise nature of the stone required; the marble he wanted, when a student, to transform hands into transparent presences, was one especially costly example. No wonder those letters went off to Ordway from Paris about longing to begin a big group that was constantly frustrated by the lack of means to fund it – he couldn't find space he could afford, couldn't pay for the stone. Yet the tone of the letters remained admirably cool: his struggles in New York had served as training for the future; common sense prevailed – problems required solutions, and what he required as a sculptor was a patron. Ordway had been this: the Carfax could have provided another; instead, he found one of a kind in Rothenstein.

He was undoubtedly interested in Epstein's work – thought his drawings intense, full of feeling, yet felt sure he might do better in Paris or Berlin than in London. That annoyed Epstein; he replied by saying he had to go back to New York on a visit, but would return to London, somehow, because that was where he wanted to be. His reasons were simple enough: his first impressions of the English were, as he described them, 'of a people with easy and natural manners, and great courtesy'; he enjoyed Hyde Park, Speakers' Corner at Marble Arch, and seeing the Cockney types who struck him as being of a 'Hogarthian' nature; finally, his visit to the British Museum had settled the matter for him – he wanted to have 'a very good look round' at his leisure. But as far as his trip to America went, his parents couldn't bear the idea of his taking up art and would do their utmost to ruin him if he stayed there to work as a sculptor. Rothenstein, shocked to hear this, offered to write to tell them what a gifted artist their son was, which again annoyed him: this sounded like another attempt to get rid of him – if not to Paris or Berlin, why not the USA? That, he explained, was the last place he wanted to work.

Epstein did go to New York, taking up a ticket sent by his elder brother, Lou, who was tired of mailing him money, however intermittently. It was a fraught, brief visit to see his girl-friend, Adele, and his mother. His father, predictably, was unpleasant – who was this bohemian tramp with bare feet, torn trousers and long hair? No son of his. Epstein felt totally at odds with everything he found there. His mother, of course, implored him, in tears, to stay: she would never see him again, she said. She was right – she never did. But a letter came from a friend in England which proved decisive; he left immediately, having spent only two weeks in New York. The magnetism of Europe, not the love of the unfortunate Adele, had won.

Epstein made a prompt move to Stamford Studios at 412 Fulham Road on his return. These were on the edge of Chelsea in south-west London, and just along the way from No. 448 where the dazzling young French sculptor Henri Gaudier-Brzeska came later to live in 1911. The studios formed part of a collection of tumbledown buildings (as they were then, but not now) and were nicknamed 'the railway accident' because they occupied a leftover space in the recent connection of the London North Western and South Western lines across the River Thames. It was here that Epstein said he was 'first made aware of the ludicrous snobbishness

that artists are supposed to be free of.' These artists – among them an Australian sculptor and George Belcher (future caricaturist of the London cockney) – did their best to get him ejected from his studio: he was too bohemian in appearance, not 'respectable' enough. Fortunately, women artists living there at once took his side and saved him from having to search for yet another place to continue working on modelling and carving, and following up his studies of antiquities at the British Museum which so absorbed him. While he destroyed most of what he did during this period as unsatisfactory, there is one piece he referred to in his last recorded letter to Ordway of 24 January 1906, which survived; sending photographs of the work, he said, 'I intend to have a baby on its feet in front of it (the figure of the mother) if it is a "maternity" group.' He went on to talk about his new studio and appeared less restless, more settled – America seemed to have faded into the background. He said: 'The figures are life-size and I work only on this group. I expect to be here for a year and a half and then go back to America with work I have done. Just now I am calculating on getting this finished and cast. I would hope to put it later into marble.' And so he did, but as *Mother and Child*, using, apparently, the charcoal sketch of the baby being picked up that is among the drawings made in Paris. The work in clay, however, he destroyed.

He was living, of course, in a state of considerable poverty, earning a shilling an hour as a model at John's newly founded Chelsea Art School and sleeping on a mattress under newspapers for warmth. It was at this old stable of a studio that John went to see him about the posing job, sitting on the mattress with Margaret Dunlop while Epstein leaned against the wall, his familiar stance – there were no chairs. And it was here, too, that Margaret, whom friends called 'Peggy' and he had known for the past two years, implored him to marry her. This Scottish redhead, ten years older than him, was desperately in love with him and his work; she asked nothing more than the chance to look after him – nothing in return. Epstein fell in with this plan, partly, perhaps, because her homely presence would bring some order to his life and free him from domestic distractions, essential if he was to pursue his work with the total concentration it demanded. Their relationship remains misty. Was it largely the mother and son arrangement of the Gaudier and Sonia Brzeska variety? Was it platonic? Probably not, although she displayed a distaste for sex when introducing the facts of life to Epstein's teenage daughter many years later. And for his part, he may or may not

have been in love with her (she had, besides her interesting, even beautiful, heart-shaped face, considerable intelligence and knowledge), but he was sincerely fond of her; he would have been profoundly touched by her selflessness in ditching so much for him – family ties and a safe marriage. Her husband, with her when she met Epstein in Paris, was a barrister, and she came from a narrow, presbyterian upbringing on the remote island of Mull in Scotland's Hebrides. There was of course a horrendous scandal when she broke with her husband and divorce followed – then, such behaviour was unthinkable: to leave a respectable man – and for an *artist* – meant banishment. In a sense, her action matched Epstein's – both had abandoned families in the pursuit of art, he through his work, she through her love for him. This was a bond which, despite the bewildering ramifications of their life together, held good until she died, forty-one years later.

They had a hard time, as a remark dropped by John in a letter to a friend during the summer of 1906 suggests: 'I don't believe in the modern ideal of living in a cow-shed and puddling clay with someone else's wife concealed in a soap-box, like our friend Epstein.' This depressing picture was not corrected in a letter that followed a few days later: 'The soap-box or packing case is well known in Bohemia as a substitute for a bed – and if it turned over might well be used to conceal somebody else's wife, provided she was not too fat' – a reference to her plumpness, a first sign, perhaps, of the disastrous complaint that overcame her later. 'I was wrong to provide Epstein with this piece of furniture. I forgot that he used to keep somebody else's wife in his *dustbin*. I hear recently that he's married her – so it's alright.'

John was wrong there: they were married several months later at the Chelsea Registry Office in the King's Road on the 13 November of that year: and if he did hide her away, this was probably a protective move during the scandal that descended on them when they began living together. John seems to have been interested in Epstein as though he was some kind of curio: he talked too much for his liking, he was somewhat boastful, an American and, worst of all, drank milk, not beer. Besides milk being cheap, good sustenance, his profound suspicion of alcohol, a Jewish trait, arose partly from a fear of distractions. 'Perhaps,' John wrote to William Rothenstein on 16 September 1906, after learning of the announcement of Epstein's and Margaret Dunlop's engagement (curious how conventional habits still mattered in an unconventional *ménage*) 'she will coax him out of some of his unduly democratic

habits.' Yet they got on well together: John respected Epstein and was quick to defend him as an artist, while Epstein admired John's painterly skill and boldness, and his realism and humour – after the polite good taste of English post-impressionists like Ginner, his wild extravagance was as refreshing as a douche of cold water. Epstein soon took to going to the Café Royal with him to join other friends like McEvoy and Dobbs, a meeting place made famous by Wilde, Beardsley and Beerbohm, and remaining legendary for years after. It brought something of Paris to London (founded as it was by a French bankrupt named Daniel Nicol who fled from there) 'with its smoky acres of painted goddesses and cupids and tarnished gilding' (as Osbert Sitwell later remembered it), 'its golden caryatids and garlands, and its filtered, submarine illumination, composed of tobacco smoke, of the flames from chafing dishes and the fumes from food, of the London fog outside and the dim electric light within'. Many others attempted to describe it, John with words – 'the clatter of dominoes . . . writing materials supplied as readily as a cup of coffee' – and Ginner and Orpen in paintings.

And then Epstein had his job at the Chelsea Art School, only fifteen minutes' walk away in Flood Street, and it was there that John made a number of drawings of him, one of which, a dry-point, Epstein liked – a tiny thing with a touch of Rembrandt's influence about it; although somewhat sentimentalized, it is a perceptive study of character. Where Epstein's self-portrait in red chalk six years earlier suggests an artist fired with a mission, John seems to have seen him very differently – as a dreamer cut off from his roots, someone rather lost, a problem boy, a stray: nevertheless, he didn't miss the intensity of the sitter's stare, those hypnotic eyes of the photographs focused on some future dream, some vision of his destiny. All the same, if it had not been for William Rothenstein's financial help at this time (and for the assistance he procured for him from a Jewish society), Epstein's hopes of realizing his ideas in London during his first two years might have been shattered: dire poverty could have forced him back to America, all expenses paid, no doubt, by Rothenstein. As soon as he became convinced, though, that Epstein was determined to stay put, he subsidized him. For one who wanted to help young artists – he helped John when he was up against it in 1905, and others like W. H. Hudson, Eric Gill, Mark Gertler and Stanley Spencer – and was on the lookout for talented newcomers at the Carfax, it seems curious that he didn't press Ross to

show his work, particularly since both of them had had letters from Shaw. There is no record that his drawings or sculpture were exhibited there, and it can only be assumed that this kind and generous man did not trust his own judgement when it came to a young, highly individual artist who stood right outside any acceptable contemporary category; his sculpture was a new province – there was nothing around to compare him with in England except academics like Frampton. Nevertheless, he couldn't fail to be struck by him and so sent him money when he needed it. Better, he may have thought, to keep him going and see what developed from his assistance.

Epstein, however irritated by Rothenstein's earlier gratuitous advice to go elsewhere, was not slow to seize on any opportunity that could be exploited to cover the cost of day-to-day expenses and desperately needed tools and materials. He was not extravagant or greedy; in fact, Rothenstein was impressed that he never complained about managing on so little, and that he worked so very hard; and impressed, too, that, in such pathetic conditions of a shed for a studio, he could produce such fine things – he was, he said, modelling 'Rodinesque figures' with a 'strange and uncouth power'. And Epstein was quick to thank him: 'Your help so freely given me has been of the greatest service to me.' All the same, this relationship was nothing if not edgy – Rothenstein continued to irritate Epstein (as, apparently, he managed to irritate most of those around him), chiefly with comments which were uninvited. In 1907, for instance, he wrote to Epstein saying, 'I admire the conception enormously,' adding that it seemed to him unfinished – that the figures lacked 'nervous simplicity in the limbs', and 'the form had not reached the level of the conception'. As if to justify these remarks, he went on, 'I do not refer to the smooth, characterless, decadent modelling of most contemporaneous sculpture' – a reference to the work of the Framptons and Pibworths – 'but to the radiant yet nervous form to be seen in fine pieces of sculpture.' Epstein appears to have replied to this letter, acknowledging his criticism (and an enclosed cheque) by agreeing that his work was not yet satisfactory. All the same, it's unlikely that he would have taken any notice of it. If, in his judgement, a work was a failure, it was destroyed: he listened to the views of those he respected, but never allowed an outsider, breezing into his studio, as Rothenstein, in the role of the friendly bank manager, liked to do, to influence him. Of course he remained courteous; Rothenstein sent him a monthly cheque; if it was overdue, he was reminded of the fact; and when at

times Epstein was desperate, a cheque was required in advance. Now, in 1907, he was working fast – something very important was on the boil; too fast for Rothenstein, who wrote: 'I don't think I can manage to get the money for the casting this week, but will write to you directly I can promise it. I had no idea you intended having your group cast so soon . . .'

The 'something' was one of the sensational groups for the British Medical Association building in London's Strand. It was this that Rothenstein had criticized.

Epstein made his sublime head of John's son, Romilly, aged two, that year as well; this was among the best portraits he ever did; he treated the baby's soft, beautiful hair as a shining helmet, contrasting this with the face's fleeting expressions of perplexity, wonder and curiosity among the pure, mountainous contours of the fat cheeks on awakening to the world. He had created a perfect work of art: a little warrior; inscrutable, mysterious and armoured from the back, the phenomenon of babyhood is, from every other position, exquisitely conveyed. John loved it and Rothenstein probably paid for the bronze: it had an inestimable influence on modern sculpture, Gill copying it, others perceiving in it a source of inspiration for the abstract movement. In fact, of course, the little boy had simply put a remarkable idea into Epstein's head: he had a bewildering number of remarkable ideas, but this one was very special – it was a breakthrough to a higher plane of art than he had reached before. T. E. Hulme, the later discerning backer of Epstein's, hailed it as the finest work of sculpture since the Renaissance.

This turned out to be an isolated happening in a momentous year when Charles Holden suddenly walked into Epstein's life with the offer of a massive commission. Holden was a follower of the nineteenth-century reformers and a disciple of William Morris. He was one of those architects who, in the aftermath of the Arts and Crafts movement, and like Charles Rennie Mackintosh, had the interests of a building's natural sculptural properties in mind, going all out to stress functional and structural possibilities in roofs, buttresses, windows and chimneys. But while poor Mackintosh, with his far superior imagination, died in poverty, Holden swept on to worldly success. His talent for sculptural ideas first emerged in a very early design he carried out for C. R. Ashbee, another of Morris's disciples (and friend of the great American rebel, Frank Lloyd Wright), when twenty-four and working in his office

– a strange, seven-storey, artists' apartment block of studios on the corner of Danvers Street and the Chelsea Embankment, overlooking the river, and part of Ashbee's extraordinary development of houses and studios that eventually extended as far as Chelsea Old Church. Holden, however, did not stay long at Ashbee's – he wanted greater architectural freedom, was married, needed a bigger salary and said that he'd have 'to get amongst the philistines', by which he meant the most archaic and successful academicians. He intended to gate-crash their exclusive party and run off with their jobs, and this he did through taking control of the design side of an established firm. Not unnaturally, his concern for the sculptural aspects of architecture led him to bring sculpture into his work as a method of reinforcing the wider issues of aesthetics. Where Mackintosh *was* a sculptor, Holden saw design as requiring the companionship of artists as much as he did: for him, painting was far more than a common architect's hobby – he filled scores of sketch books with watercolours whenever he went on his travels. So far as decorations for his buildings were concerned, however, he started off by being burdened by the kind of traditional sculpture he didn't care for at all: copybook patterns had nothing to do with his architectural ambitions as he discovered when using Pibworth, a stock member of the usual ring, at his Bristol Library, and then at the extension to the Law Society, both designed in 1903. When the British Medical Association commission for the Strand came along in 1906 Holden was determined to find someone better. His conception for this building was derived from a combination of Portland Stone and granite, and he had the idea for a frieze of white statues set in granite that would, he believed, 'weave the two materials together, like white stitching joining a dark to a light material': the granite, he argued, would get darker with time, while the stone would bleach out white. Delighted with his scheme, Holden set about discovering someone far more creative than Pibworth or Frampton. Where could he find such a person? He asked around among friends for ideas; he went to Francis Dodd who spoke to Muirhead Bone. The three were close: Bone had married Dodd's sister and was also a friend of Holden's, having come to London from Glasgow at his suggestion in 1901. Between the three of them, and together with Muirhead's older brother James, later art critic and London Editor of the *Manchester Guardian*, they formed a solid block of support for Epstein over the next thirty or so years, for it was Muirhead who recommended asking him if he would accept the BMA commission. On

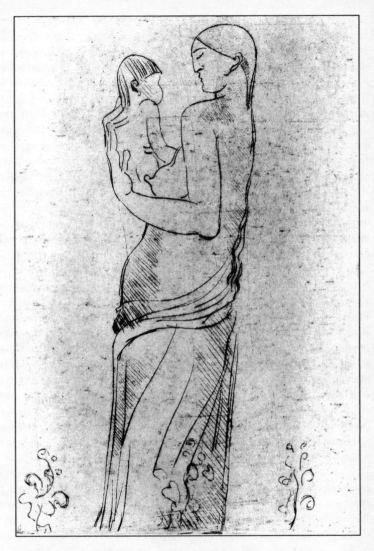

Mother and Child for the BMA frieze. This sketch of 1907, previously unpublished, resolved the relationship of the figures and was probably the final version for the carving. The print reverses the original copper drypoint from which it was taken.

hearing the sculptor's answer, Dodd came straight back to Holden: 'Get Epstein.'

Holden was thirty-two in the spring of 1907 when he went down to the scruffy workshop to find him. He had just been made a partner in his firm on account of the mass of commissions he had brought in through his winnings in prizes and competitions, and that probably gave him the confidence to make the break with influential academicians. Taking a risk with an unknown quantity proved Holden's commitment to quality and freedom of expression – if Epstein was good, then to hell with useful connections in important positions: it was the building that mattered. So that day in down-at-heel Fulham, he couldn't wait to meet the artist about whom Dodd had raved: this was a discovery, at last. Yet whatever he may have been warned to expect, Epstein's frugal working conditions must, after sculptors' studios like Pibworth's, have amazed him. What he saw was something resembling a builder's yard crammed with plaster casts and half-started carvings. He saw a life-size figure in black wax of a girl holding a dove in her hands; the drawings of it from which he was working; some pieces of African sculpture brought from Paris; a marble relief of a mother and child; the studies in black chalk of babies; and the series of 'Calamus'. These, in particular, decided him. For Holden, who published poetry anonymously in the *Architectural Review*, was a passionate admirer of Whitman, too. Epstein was the sculptor for the frieze; if Rothenstein had doubts about his extraordinary gifts, Holden had none.

Yet it was a decision which must have shocked the New Sculpture set – one can hear its members having over the news with their port at their respective clubs: this upstart from Paris is a disreputable bloody interfering bounder with new-fangled theories. What does that young whippersnapper, Holden, think he's playing at? And Frampton, for one, very possibly never did forget this intrusion on his circle's well-ploughed terrain by 'some damned foreigner', and an American Polish Jew at that.

Epstein offered to do the eighteen figures for £100 each, so certainly undercutting by half any academicians' normal charges – Pibworth would have expected at least £4,000 for the lot; in addition, he guaranteed to meet the very tight deadline of fourteen months. Both factors were, of course, a great help in getting an unknown sculptor past the BMA Board of Trustees; but it wasn't these offers which influenced

Holden – he was carried away by Epstein's excitement about the idea, by his energy, originality, conviction, sources of inspiration, and by what he had seen of his workmanlike approach to his projects. And he was not disappointed – Epstein set about planning his frieze at once: 'I remember,' Holden recalled, 'how in a very few days he was able to lay down a programme as wide in scope as Whitman, which was in fact exactly what I was hoping to find in him.' First, he made pencil and ink sketches and drypoint etchings, then maquettes for the BMA and its architects' approval: these were accepted after a few early doubts. One BMA member had suggested a theme of 'historically famous medical men' which Epstein rejected – 'I was determined to do a series of nude figures, and surgeons with side-whiskers, no matter how eminent, could hardly have served my purpose as models.' Instead, he followed Holden's vague idea for something on the lines of the seven ages of man. Then the architects had anxieties – although they had given him this big commission, they felt he might do something 'rash'.

I already had a reputation for wildness; why, I don't know. It is quite possible my appearance at this time was that of the traditional anarchist. However, later gathering strength, as the architects gathered faith, I managed to impose my own ideas upon the decoration, and had only one bad halt, when they totally rejected one of my figures, and would not have it included. I considered it one of the best.

The sites were very narrow, forcing him to give simple movements to all figures. 'In symbolism I tried to represent man and woman, in various stages from birth to old age, a primitive, but in no way a bizarre programme', he said. And so, on to the Strand, there were *Primal Energy*, *Matter* (an old man holding a lump of stone with the outline of the foetus engraved in it), *Hygiea*, Goddess of Medicine and Health, which, with nudes representing *Chemical and Academic Research*, displayed his determination to keep faith with his brief; and, among those up Agar Street, came *Mentality*, *Youth*, *New-born*, *Man* and *Maternity*. All were carefully related by positions and gestures, standing like caryatids in niches on either side of granite piers, and separated by windows. Besides the attention he gave to their form, Epstein dramatized the shape of Holden's strongly stressed, vertical conception in the structure. Thus the artist met all the conditions of his task: the works were a picture of both subject and site, a remarkably perceptive achievement.

It was indeed a heroic effort, an epic. He had invented in the heads – see particularly *Maternity*, *New-born* and *Matter* – a humanity as strikingly moving as Giotto's studies of St Francis and his followers in his decorations at Padua. *Maternity* was outstanding as a masterpiece of sculpture in its own right – calm, contemplative, gentle and compassionate – while, by comparison, the old woman carrying the infant (the natural counterpoint for *Matter*) in *New-born* possessed exceptional power and energy: together, they express two extremes of Epstein's nature as artist. There were, however, considerable practical difficulties in the production of the sculpture. This was a complex process. After the maquettes were made for approval, the full-size figures, modelled in clay, had to be cast in plaster for transportation to the building; there they would act as models for the *in situ* carving from the Portland stone by Epstein, an endeavour which required immense strength and dedication. But the figures were about eight feet tall, and that meant that there was no possibility of the models being carried out in his little place on the Fulham Road. And here, Holden saved the day – he contacted his old friend Ashbee and appealed to him for help. Did he have a studio available in Cheyne Walk? He did have one, at the back of No. 72 where James Whistler had been a leaseholder (dying there in 1903), not far from where Ashbee's mother lived at No. 37, and across the river from Battersea Old Church (where Blake was married) and the Raven pub, one of his favourite haunts for a break from work. In Epstein's words, it was 'a fine studio'. And of course it was – Ashbee was a fine architect and an unusually idealistic developer, high-minded and sensitive. He had designed this row of houses and apartments for artists, some for specific clients: it was he, as much as any other, who founded the artistic tradition of Chelsea. And, at the back of 72, he had built a sculptor's studio for a Mr Rollins in 1893 (he died in 1905), together with an apartment above. And so, with a wonderful job and a sympathetic place to work, life must have seemed suddenly to have opened up into a paradise for Epstein: 'It was a tremendous change for me to move away from "The Railway Accident"' – and from his smug and bullying male neighbours – 'and to receive an advance payment for the commission. I thought I was wealthy ... I could now pay for models and get to work on large figures.' The future looked bright, he said. However, he was a novice on money matters and, giving little thought to anything outside the excitement of the work, had certainly forgotten essentials, even for his meagre needs, when proposing a fee.

The advance soon vanished and other ways had to be found to meet emergencies – for instance, when he couldn't pay the rent on one occasion he left a male nude with an erection in lieu of it in Mrs Ashbee's garden (a reference possibly to her son's latent homosexuality) to her utter horror. 'With experience I learned how quickly funds could be depleted ... When you come to reckon up your out-of-pocket expenses against your remuneration, the balance is invariably all on the wrong side.'

Once more, he had been reminded of something which, in his rush to get at the work, he preferred to forget – that sculpture was 'about the most expensive mode of making a living'. This is seldom remembered when Epstein is criticized for being constantly short of money: 'I cannot think of any other occupation into which you put so much,' he said. Whether he ever did learn from experience is doubtful, each commission generating the single-mindedness that went into this; there was no pause for rest, no lull allowed: 'I had been like a hound on a leash, and now I was suddenly set free ... I worked with ardour, feverishly ...' If he was in a jam about paying the plaster moulders, Rothenstein was available to foot the bill: if he couldn't find a suitable model (or couldn't afford one) in his search among ordinary people around him, his wife stood in. John's description of the hectic activity in Cheyne Walk (in a letter to his mistress, Dorelia, of 1907) was vivid: 'Epstein called yesterday and I went back with him to see his figure which is nearly done.' He was living in a room just round the corner then, at 55 Paultons Square.

It is a monstrous thing – but of course it has its merits – he has now a baby to do. The Scotch girl was there – she is the one who poses for the mother – he might at least have got a real mother for his *Maternity*. He is going about borrowing babies. He suggested sending the group to the NEAC! Imagine Tonks's horror and Steer's stupefaction!

In fact, the 'Scotch girl' had posed for the finest element in the frieze, the figure which revealed more clearly than any everything he meant when he said, at the completion of the works, on time, in July 1908: 'Apart from my desire to decorate a beautiful building, I have wished to create noble and historic forms to express in sculpture the great primal fact about man and woman.'

*

The possibility that the frieze might shock the British public never seems to have struck the BMA or the architects – not unnaturally, the BMA members viewed nakedness in an anatomical and clinical light, while the architects regarded the figures as part of their architectural conception. Epstein, who always regarded nudity as entirely natural (he could never understand why models felt embarrassment at taking their clothes off), in this case saw his sculpture as a work of art inspired by the world of medicine: 'Perhaps this was,' he pointed out, 'the first time in London that a decoration was not purely "decorative"; the figures had some fundamentally human meaning, instead of being merely adjuncts to an architect's mouldings and cornices.'

And so the public's furious reaction came as a bombshell to all concerned. In June 1908, when some hoardings were removed from the first four works (the decoration as a whole was not quite finished then), people in offices opposite were astonished to see naked and semi-naked figures in the scaffolding and became curious – then very suspicious – then, Holden recalled, 'Father Bernard Vaughan got word of it and the press boomed with banner headlines "AMAZING STATUARY IN THE STRAND". People fell off buses to get a glimpse of it. A group of police and inspectors mounted the scaffolding with their notebooks to report on the scandalous doings . . .' Vaughan, a Catholic priest, was a member of the National Vigilance Society, the current so-called guardian of public morals, and the story that broke on 19 June in the *Evening Standard and St James's Gazette* could have been by him. Across the front page, headed, 'BOLD SCULPTURE', it continued: 'we draw attention with some reluctance' – it was shocking to have to do so, of course, but good for sales –

to five amazing statuary figures which are meant to adorn the fine building of the British Medical Association in course of erection at the corner of the Strand and Agar Street. From the point of view of the sculptor, they will doubtless be regarded as work of an excellent kind, but outside the studio, and one or two galleries, they represent a development of art to which the British public, at any rate, are not accustomed. With regard to their appearance, it is unnecessary to say more than they are a form of statuary which no careful father would wish his daughter, or no discriminating young man, his fiancée, to see. The degree of nudity which has been chosen for the figures to which we particularly refer, is not calculated to enhance the artistic

effect of the statuary: Art would not have suffered by more discriminating treatment. For a certain type of mind, on the other hand, it cannot but have a demoralizing tendency, and it is surely unnecessary having regard to the condition of some of our West End streets, to give further opportunities for vulgarity

– a reference to 'filthy' Charing Cross Road bookshops and prostitution.

And so the amazing verbiage continued, ending with the shocked conclusion that not even the police could intervene, and calling on the BMA to have the figures removed. 'The absence of any supervising authority as such in this case calls for revision of the building laws.' Scotland Yard had the matter under consideration, however, the paper said; it reported that a police inspector had called on the BMA to inform a representative of public objections; and quoted the views of the National Vigilance Society's secretary, Mr Coote: 'I have personally, on behalf of the Society, lodged a protest with the Secretary of the British Medical Association.' He was putting the complaint before his Committee, Mr Coote went on. The figures were a scandal. 'I am at a loss to understand the object of such representations. In no other city of Europe' – he was either visually blind or hadn't travelled –

are figures in sculpture of the nature shown on the building in the Strand thrust upon the public gaze ... We intend, unless the offending figures are removed, to take action and see whether the law is strong enough to deal with such a display. If it is not, the fact will lend additional intent to the proceedings of the Parliamentary Committee which is, at the present time, inquiring into the publication of certain exhibitions.

That comment says a good deal about perennial puritanical hang-ups of the English. The *Evening Standard*'s campaign gave vent to them, and it was back on the attack the following day. 'Work to be stopped', the paper proclaimed. The figures had been 'unreservedly condemned by Mr Edmund Owen' – a quantity surveyor and thus not necessarily knowledgeable on art –

and he intends [as the BMA's Chairman of the associations' council] at once to call a meeting of the Building Committee for the purpose of stopping the removal of any more hoarding until members of the council have had an opportunity of seeing the figures for themselves,

when he hopes they will agree with him that they ought to be very much modified, if not taken away altogether.

And so the railing went on, Mr Owen claiming that Council members had never seen the drawings of the statues and that the majority of them were unaware of the nature of the figures.

> Mr Owen had seen them only in a partially finished state . . . 'I have no sympathy with them whatsoever,' he said, 'after seeing the figures which we have condemned . . . and my own opinion is that they ought never to have been put there. I had seen some of them before they were finished, and did not like them from the physical representation point of view. They seemed to me to be poor figures . . . I think the *Evening Standard* has taken the right course in calling attention to the matter before the more objectionable statues have been exposed to public view . . .'

The paper 'welcomed this frank statement' from Mr Owen, and his support for its campaign. Work was still in progress, it said, on the figures behind the sculptor's hoardings, and, 'while the sculpture may have been appropriate in a Medical hall . . . it is entirely unsuitable, and not at all artistic or dignified in a busy thoroughfare.' Two of the statues in Agar Street, it said, could be seen from the wards of Charing Cross hospital across the way, and as 'art . . . are not beautiful . . . and would constitute a gross offence . . .'

Epstein, himself, had followed a policeman on to the scaffolding and he caught sight of notes taken down in his little book which included the word 'rude' – 'a Cockneyism', Epstein pointed out, 'meaning obscene'. Nevertheless, he had his allies who immediately defended his work. Percy Adams, Holden's partner, for instance, sent a letter straight away to the *Standard* that was printed a couple of days later: 'In my opinion, they are magnificent,' he said, a remark which angered the paper's editor who added a note repeating his belief that the Building Committee would ask for the statues to be modified. And, of course, there was John, who had himself suffered plenty of insults over his work, and knew only too well how vicious, jealous and unhelpful Royal Academicians could be when a young artist was having some success. An example was his portrait of the Lord Mayor of Liverpool, Harold Chaloner Dowdalls; when the President and members of the RA heard that John's portrait was to be exhibited at the St Louis International

Exhibition in 1904, and that it was to receive the Gold Medal for excellence, they were so furious that they withdrew the entire English contribution. This extraordinary act of sheer spite – no explanation was given – is indication enough of how affronted Pibworth and Frampton must have been by Holden's decision to drop them, and makes one wonder whether the *Standard*'s campaign was inspired by the jealousy of someone in their camp: certainly Frampton's later actions in the war years suggests this was a possibility. John knew about newspaper attacks too: in the Liverpool press, there had been the astonishing comment that

> it is 'amazing' that the travesty in paint, supposed to be a portrait of the Right Hon. the Lord Mayor of Liverpool, should be accepted by intelligent men and women in any other light than as a joke or an insult to their intelligence. The fundamental principles of art, in colour, drawing, composition, harmony and beauty of a picture as a whole, are simply ignored.

John was an old hand in the business of sticking up for art under attack from English traditionalists and was quick to act by writing to Robert Ross on hearing about the row that had blown up over the statues:

> Epstein's work must be defended by recognized moral experts. The Art question is not raised. Of course they would stand the *moral* test as triumphantly as the artistic, or even more if possible. Do you know of any intelligent *Bishop* for example? Tomorrow there is a meeting to decide whether the figures are to be destroyed or not. Much the best figures are behind the hoarding which they *refuse* to take down. Meanwhile Epstein is in debt and can't pay the workmen.

All John's generosity of spirit came to the surface when rushing to the defence of a fellow artist, sending Epstein a 'fiver' on account of the stone carving he was making of his son, Rom, as he told Dorelia, 'Epstein wrote to me in despair, his figures are being threatened by the police! It is a monstrous thing,' he wrote, adding, 'On comparing his figures standing in their austere nakedness above with the squalid hordes that pullulate beneath, leering and vituperative, one is in no doubt *which* merit condemnation, sequestration and dismemberment . . .'

John could be excellent: he wrote to others, among them the poet Arthur Symons, his friend, warning him that Epstein's figures were in

imminent danger of being pulled down or mutilated at the instigation of the 'National Vigilance Society' of sexual maniacs, supported by tradesmen in the vicinity – and the police . . . Being a foreigner Epstein is quite innocent of the parochial sentiment which is the breath of our metropolis, he has merely contrived to inform his figures with a World-Passion to which we are strangers over here. If you would view the works, or those which are visible, for the hoardings are not yet all down, I feel sure you will share some of my feelings and will do something in defence of Epstein and art itself . . .

Before his suggestion to Ross could be taken up, of course, the *Standard* had reported Father Vaughan's denouncement of the statues –

As a Christian citizen in a Christian city, I claim the right to say that I object most emphatically to such indecent and inartistic statuary being thrust upon my view in a public thoroughfare, through which I am often compelled by duty to pass . . . Let us teach self-reverence and self-respect, and not convert London into a Fiji Island . . . Let us not innovate upon our time-honoured practice in this country, and try to out-Continent the Continent in indecent statuary,

he concluded, adding – it was clearly difficult to stop him – that the eyes of the public could 'feast upon them with the hunger of sensuality.' This astonishing statement, combining racist and prurient innuendoes with familiar fantasies about a liberated Paris, suggests the possibility that the campaign, and the sheer ferocity of it, was derived from an anti-semitic source. It was followed up, moreover, by a renewed attack on the sculpture in the paper's Leader column that made pointed references to the male figures' sex – they must be 'modified', it insisted. In reality, of course, the campaign made a 'good story'. It was perfect commercial newspaper material: hints about pornography were highlighted to whip up moral wrath among hypocritical middle-class readers and make sales soar – for its editor, terrific stuff.

Events moved very fast indeed. The slightly comic, if horrific, picture of a super-puritanical society persecuting an artist was met with a correspondingly vigorous counter-attack from enlightened sections of press and public. In the next couple of weeks *The Times* had cracked down on this wretched newspaper's campaign with a Leader that said, 'We trust that this appeal to the philistinism and hypocrisy of a portion of our middle class will be met by the British Medical Association with

the contempt it deserves,' the day after the issue of 24 June when letters were printed from the Slade Professor of Fine Arts at Oxford, C. J. Holmes, Charles Ricketts, Charles Shannon, and Laurence Binyon, a barrage that was timed to influence the BMA's council meeting of the following day. And there was a stream of similarly hostile letters to the *British Medical Journal*, from, among the many, Muirhead Bone, Eric Gill, Rothenstein, Ambrose McEvoy, Sidney Colvin (Director of the British Museum), Martin Conway (Slade Professor of Art at Cambridge), D. S. MacColl (top art critic), and Alfred East, who, an ARA, called the campaign 'ill-informed and absurd'. Epstein had the big guns on his side.

Meanwhile, John's idea had been taken up by the Bishop of Stepney, Dr Cosmo Gordon Lang (later Archbishop of Canterbury); his verdict, after climbing up the scaffolding, closely inspecting the figures with the sculptor and finding there was nothing indecent or shocking to be seen, must have given Father Vaughan, well known for his platitudes, quite a jolt: he had continued his attack, singling out *Maternity* as the worst of the figures – 'The sacred subject of maternity has been treated a thousand times with idealistic beauty, but the Strand mother suggests merely brutal commonplace.' The Bishop certainly helped to bring in the sightseers – sculptors, artists, gallery owners – to catch a passing glimpse of the notorious works. They had become a part of English folk culture – there were cartoons and music hall songs about them, questions in Parliament; everyone, from doctors to newspaper boys, dustmen and businessmen, aired their views on them. Epstein laconically remarked: 'London had become sculpture-conscious.'

As quickly as the storm blew up, it blew itself out. On 25 June, Epstein was called as a witness at the BMA's meeting to decide what was to be done ('this tribunal,' Epstein said, 'resembling an ancient ecclesiastical court to consider a messy case was most impressive'). Charles Holden, another witness, also saw the funny side of it, writing later:

The Chairman opened the meeting with the usual 'Any correspondence' and the Secretary produced a huge pile and placed it in front of the Chairman. The Secretary read them out one by one – nearly all in vigorous defence of the sculptor from the foremost authorities, Slade professors and writers, and the meeting closed without any further comment.

The vigorous defence, he said, was largely due to the activities of his 'dear, old friend', Muirhead Bone. The BMA had, however, taken the point and wasted no further time: an approach was at once made to Sir Charles Holroyd, Director of the National Gallery, asking him to pronounce on whether or not the sculptures were 'indecent'. While he was considering his verdict, the art critic of the *Saturday Review* dived in on 27 June:

> When all the familiar arts of modern journalism had been employed to exploit a sensation and excite questionable curiosity, when nothing had been left undone to ruin Mr Epstein's reputation and career, the *Evening Standard* professed in unctuous phrases to be unwillingly 'forced' to continue its attacks, and offered its 'sympathy' to the sculptor. And this was a campaign in the interests of decency.

But Sir Charles's reply to the BMA letters to him of the 25th and 26th was rapid and its message simple. Having explained that 'Epstein's figures were dignified and reverend,' he said: 'From the works I have seen I believe the British Medical Association will be proud of having given him this work to do, in the future when he has made the name for himself which his work promises.'

This letter arrived on 1 July, and three days later the matter was settled: the Council instructed work to proceed. Epstein, however, said he felt like a criminal in the dock. 'This unexpected hubbub,' he wrote, 'ushered me into a publicity I have always detested. To accuse me of making sensations is the easiest way of attacking me, and in reality leaves the question of sculpture untouched.' Many believed he was a publicity-seeker, even Holden. Epstein continues:

> I had to discover for myself how superficial is the world of art, and what a wretched lot of log-rollers, schemers, sharks, opportunists, profiteers, snobs, parasites, sycophants, camp-followers, social climbers, and what my dear old American artist friend, 'Brandy Bill', called 'four flushers', infect the world of Art. It is a jungle, into which the artist is forced periodically to bring his work and live . . .

William Rothenstein put it rather differently: 'Here was a sculptor who actually attempted to say, through his work, what he meant. This was not to be tolerated. For two centuries at least sculptors in England had been saying what they didn't mean with such skill that mere

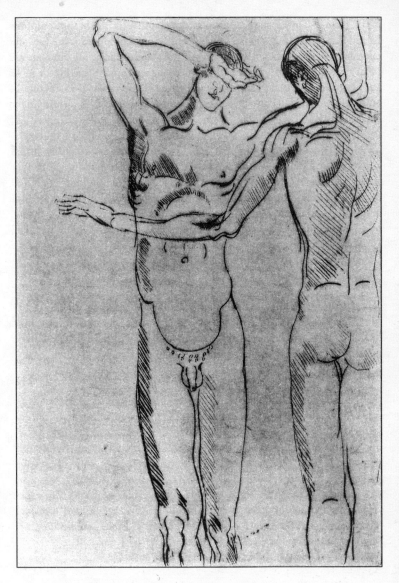

Youth: BMA frieze. The carving almost exactly reproduces this sketch from 1907 which, previously unpublished, is the reverse image of the copper drypoint from which it was taken.

empty gesture had crystallized into a tradition.' And, while the sculptor was understandably furious, there were some compensations for an experience into which he had plunged with enthusiasm, all innocence, at the beginning, and which had led to such an appalling sense of loss and disillusionment. He had made some real friends as well as enemies, and he acknowledged this: 'My Dear Friend Rothenstein,' he wrote after hearing the BMA's decision, 'I am overjoyed at the splendid result of the meeting on Wednesday and I will now go on quietly to the end. Your letter made me very happy and this great wave of sympathy from everyone has filled me with happiness.' He had also made a name for himself, a name, moreover, that brought him the kind of band of unknown admirers among the public who respected him from afar for his lifetime and after. When it was reported in the press that he'd made not a penny out of the commission and, despite Rothenstein's financial support, owed the plaster moulders £500, a mysterious Mr Fels, a chemist, appeared from the shadows and gave him a cheque to settle the debt. The gods certainly looked after Epstein.

The last Leader in the *British Medical Journal* summed up the story well: 'We are glad that a sculptor of genius awoke one morning to find himself famous, but we are sorry and not a little ashamed that he should owe the foundations of his fame to the hypocrisy with which other countries, not wholly without reason, reproach the British people.'

Was the campaign inspired by anti-semitism, egged on by jealousy from some other source? Or was it merely what it appeared to be, an outburst of moral wrath, a symptom of repressed heterosexuality, bottled up by the puritanism of narrow Victorian values? Whatever the explanation, it encapsulated the blind ignorance with which often intelligent people view art. And if it is reassuring that sanity prevailed eventually, this was not, unfortunately, the end of this deplorable episode. For the controversy exploded again in 1935 and 1937, on the second occasion with disastrous results. It was for that reason Epstein referred to the Strand affair as his 'Thirty-Year War'.

4

Père Lachaise

ON 1 DECEMBER 1908, a vast dinner was given in honour of Robert Ross at the Ritz in London. Ross, who was appointed executor to Wilde's estate when he died in 1900, had just completed the successful winding-up of the playwright's bankrupt affairs, and the dinner, on the evening of the anniversary of his death, also coincided with Methuen's publication of his collected works. *De Profundis*, published three years earlier through the efforts of Ross, had been a winner, running into eleven editions, and with these complete works in thirteen volumes, and Wilde's plays, banned since his imprisonment in 1895, back on the stage as successful as ever, Ross paid off the remainder of Wilde's creditors. So it was an evening for celebration and after-dinner speeches by H. G. Wells, William Rothenstein, Sir Martin Conway (in the chair) and others, many of which bored one of the two hundred guests, Somerset Maugham, absolutely stiff – 'especially Wells's which might have been entitled First and Last things that one would rather left unsaid', he told Ross who, in his, and which Maugham said he adored, had dwelt at length on his old, dear, dead friend. There was, however, something else to celebrate. Wilde had been buried at Bagneux and, as Georges Bazile wrote in 1912, when defending Epstein's sculpture, 'He had not lain at rest more than a few years beneath the flower-decked tombstone . . . when he was removed to be tossed under a slab of stone surrounded by chains at the cemetery of Père Lachaise.' After thanking all those friends who had shown great kindness to Wilde in his last years (remembering how many ostracized him, there appeared to be an astonishing number), Ross said, 'So I must only thank someone else

who with the cowardly generosity characteristic of anonymity sent me a few days ago two thousand pounds to place a suitable monument to Oscar Wilde at Père Lachaise.' The donor, Mrs James Carew, mother of Sir Coleridge Kennard, refused to divulge her name until the last; on the back of the monument an inscription reads: 'Given by an anonymous woman.' Ross went on: 'The condition of the gift is not one to which I have certainly any objection – the condition is that the work should be carried out by the brilliant young sculptor Mr Jacob Epstein, from whom Sir Charles Holroyd has already prophesied great things.'

The condition says a good deal for Mrs Carew: although some have said that it was Rothenstein or John who laid it down, the probability is that she had done so. This very wealthy woman, who owned a large piece of Antibes and lived in a suite at Claridges until the end of her life, may well have been moved by Epstein's experiences over the Strand sculptures. Besides being a friend of Wilde's – her donation was in memory of his treasured inscription of her copy of *The Happy Prince* ('To the Happy Princess from the Unhappy Prince, with the devotion of the Author') – and a great admirer, she was one of the outstanding art collectors of her generation. This made her a likely person to have chosen Epstein, and, by eliminating any other contenders for the job, Mrs Carew wanted to make certain that the commission didn't end up with the familiar mediocre sculptor. But the question remains: Why did Ross announce the name of the artist without first consulting him?

For this is what he did: Epstein knew nothing of the dinner, nothing of the commission and that an announcement would be made – when friends telephoned him the next morning with congratulations, he thought the whole thing was a practical joke. When it was confirmed later in the day, he thought it utterly extraordinary that he hadn't been approached to discover whether he was available – after all, Ross would have looked extremely foolish if he hadn't been. So did Ross fear that the word might get around if he spoke to Epstein about it, and therefore used the occasion as a *fait accompli*? Ross, who had been at the centre of the art scene for a very long time, and knew the workings of it, would have been aware of just how infuriated sculptors like Frampton would be by such an appointment. Charles Ricketts, for instance, would have been particularly angry at being passed over – he had actually exhibited an idea for a Wilde tomb two years before; what is more, he knew Wilde, had visited him in prison and his illustrations of Wilde's poem 'The Sphinx' (Wilde didn't think much of them) appeared with it when

it was published in 1894. So Ross might have feared that the slightest whisper of a rumour could lead to an attempt by the usual circle of academicians to wrest such a prestigious commission from Epstein by various sinister, behind-the-scenes manoeuvres. With his fame from the Strand affair still imprinted in the public mind, Epstein had suddenly become the symbol of the dreaded modern art of the new century and enemy number one of the traditional hard-liners. As Ross and his friends knew, he was a threat to their security, and it was very likely that they would try to use their power (which was considerable in establishment circles) to block the appointment.

Epstein had come to much the same conclusion – Ross's actions were otherwise inexplicable. He was, Epstein decided, 'too timid' to face the possibility of a plot to upset his plans, and, had Epstein known of her existence, Mrs Carew's. He believed that the secrecy of Ross's behaviour could only be explained by the fact that other sculptors knew about the commission and expected it to be given to one of them. He may have been right – a rumour might have got about via Rothenstein. And Ross, emotionally entangled with the memory of having been, as a seventeen-year-old, Wilde's first male lover, certainly wouldn't have wanted anything to go wrong. Epstein's suspicions, however, about corruption in the art world quickly passed out of his mind in the excitement of getting the job so soon after finishing the BMA decoration. He was only just twenty-eight and he had landed another astonishing commission after being less than four years in England; and he was being paid £2,000 for one group instead of eighteen figures; this time, despite the anxieties of the previous experience, he must have felt quite wealthy. But, above all, it was a far more astonishing commission than the BMA's – a tomb for Oscar Wilde, the great playwright who had been the rage in America in the Nineties, whose work had been performed in New York (it had been translated into Yiddish on the Lower East Side) and whose end had been so dramatically tragic: perfect Epstein material. It called for an epic and took him a long time to begin. This, he said

was an exceedingly difficult task from the point of view of pleasing people (not that I try to please anyone but myself), for Wilde's enthusiastic admirers would have liked a Greek youth standing by a broken column, or some scene from his works such as the Young King, which was suggested many times, while to his detractors he was wholly repellent, deserving of no monument. Once again the

stage was set for a discussion that was centred almost entirely on something altogether outside the sphere of sculpture. In addition to these things, cemetery sculpture rarely departs from certain very fixed forms, and in Latin countries in particular there is, far more than in England, a 'cult of the dead', so that anything original was certain to give offence of some kind.

He visited the site for the tomb at Père Lachaise where Balzac and Chopin are buried, and had seen, in this vast cemetery, the conventional structures which commemorated both the famous and the anonymous; as he said, they do indeed follow fixed patterns, the majority being in the form of minute houses with pitched roofs. Nothing of that kind was wanted by either Wilde's admirers or by Epstein, although that was precisely what the Paris authorities – the Préfecture and M. Hedequer, the cemetery's director – would have preferred.

The magnitude of the project may have been the reason why he was far longer than usual in committing himself to an idea for the tomb, although the thinking period – about the subject, or about the material he wanted to use, or both – was a highly important phase in any Epstein creation. The explanation for the speed at which he worked on the Strand decoration – eighteen over-life-size figures in fewer months – was the completion date of the building: that achievement was astounding for this alone, and Epstein can be forgiven a certain amount of repetition in features in order to meet the deadline, particularly since there was the difficulty in getting the necessary number of suitable models. (Epstein was always practical – who on earth would notice repetition forty feet from the ground?) No such limitations of time were laid down in the case of the tomb and no pressure to hurry was put on him. Having received the commission in December 1908, it was finally completed (except for a few, on-site finishing touches) and exhibited to the press in his Cheyne Walk studio on 1 June 1912. Epstein said the tomb took nine months of continuous work, and so, at this rate, it wasn't begun until around September 1911.

The tomb was, of course, an undertaking that had no similarity to the Strand commission, which was a decoration. Epstein often referred to it as a decoration – it was city sculpture, designed to embellish a building: up to a point, an organizational problem that possessed a profoundly human content, but not concerned with details, beautiful though they

were, that would detract from the architectural frame. Epstein understood well his position in the context. The tomb, however, was an example of sculpture in space, a single object where the work of art was the totality, an isolated conception of the imagination, a complete statement: quite a different matter. Where the Strand decoration was like, to use an analogy of Epstein's, a piece of writing where 'the eye only takes in a certain proportion of the words', the tomb was a work through which a vision of Wilde had to be delivered – one image only. Of course it was an exacting task, particularly since he regarded his development as a sculptor as still in its formative phase. One can imagine there was, in his estimation, much to be done before he could feel confident that he had sufficiently mastered his craft to be ready and able to proceed. Hence the lengthy period of research, study and experimental works – well over two years – that led up to the birth of an idea of true magnificence. Instead of rushing a decision on the conception for the tomb that might be wrong, he preferred to continue with things upon which he had been hard at work since the completion of the Strand commission. 'My aim', he said, 'was to perfect myself in modelling, drawing and carving.'

After devoting his energies to something as huge and physically exhausting as the BMA figures, he needed time for the revaluation of his work, for mental and emotional recuperation; to get back to the minutiae of sculpture, to return to the beginning and make studies from the model as exactly as possible; to consider the human form, his central source of inspiration since the days, not long past, when he had drawn the poor old Jews labouring in the sweat shops of Hester Street, in its complex, anatomical detail. 'I worked with great care and followed the form of the model by quarter-inches.' And, despite his reservations on his competence, he produced some beautiful pieces during an extremely prolific period: there were innumerable drawings and busts of Nan Condron, a gypsy girl and professional model he had come across at the Café Royal, a head of Euphemia Lamb, a portrait bronze of 'An English Girl' and a number of commissions. It was these that prompted Rothenstein's airy observation that 'the worst was behind him'. This was not true, a reason why an exhibition at the Carfax would have been so helpful; with this outlet, apparently blocked by the owners, he could have sold copies of his work. He needed to do that: he may have been a name now but he was desperately short of money, having nothing besides his advance on the tomb – soon spent – to live on. As it was,

procuring the commissions was entirely John's doing. John introduced him to Lady Ottoline Morrell, telling her she must commission him to do something, and she gave him the job of a fountain-figure for her garden at Garsington (modelled from Euphemia Lamb) and introduced him to Lady Gregory and Mrs Chadbourne; a bronze was commissioned by Lady Gregory and a carving in alabaster by Mrs Chadbourne. He made two heads of Mrs Ambrose McEvoy (one in bronze, one in marble), modelled Lord Howard de Walden's child and was approached to make a death mask of Swinburne by Rothenstein's wife, a task which was cancelled by the intervention of Swinburne's minder, Theodore Watts-Dunton. At the same time, he was in and out of the British Museum, as he had been since his arrival in London, studying the marvellous collections of Egyptian, Greek, Indian, Polynesian and Assyrian sculpture. He rarely noticed other artists studying – he supposed it would 'be considered as a lack of originality to be discovered there.' He was astonished – he expected the place to be crowded with people making drawings – such a loss of vital material was unthinkable: just imagine, he said, a dramatist or a poet neglecting to read Shakespeare or the Elizabethans, 'or a composer of music deliberately avoiding Bach or Beethoven.' The same could be said of architects who fail to look at the buildings of Brunelleschi or Wren on their travels. Epstein was not in the museum to copy what he found: he was there to experience the enormity of art's inspiration over the centuries from all parts of the world.

Many of the girls that the artists picked up as models at the Café Royal were prostitutes – their concern was to pick up artists. Betty May and Euphemia Lamb were examples, and Epstein made superb heads of both. Viva King, a very pretty blonde around the art set, said her father boasted that Euphemia had been his mistress; Henry Lamb was certainly her first husband, and his great friend, John, painted her repeatedly. But in Epstein's bust of her, Viva King said, 'I fancy I can hear, through the open mouth, her ugly voice. She came from a working-class Manchester family and her sister ... was married to a policeman and was her maid for a time ... Euphemia was too gay to be anyone's conception of a *femme fatale*, but she survived all her husbands and lovers, and there were many.' In his likeness of her, Epstein captured this gregarious personality, both in character and movement, brilliantly. But his continuing studies of Romilly John were, among portraiture, his most important works during this time. From the boy (or the original

plaster, drawings or whatever else was available), he made two extraordinary carvings, both as intense a picture of childhood determination as the first work modelled in clay. Both presented different interpretations – one reflective, the other, and later version, *Rom*, possessing an ancient grandeur. Now these, as much the serene likenesses of Mrs Chadbourne in alabaster and Mrs McEvoy in marble, raise questions to do with direct and indirect methods of carving, and who was responsible for the innovation of the direct method in England that revolutionized sculpture. Direct carving, as practised by Leonardo, Michelangelo, Benvenuto Cellini and other Renaissance artists, has produced works of great art; the indirect method, on the other hand, led to what Rothenstein called a 'mere empty gesture'. The two methods have, predictably, separate objectives; in one, the objective is inseparable from quality, while, in the other, indirect carving has nothing much to do with anything but quantity.

Indirect carving was universally employed by sculptors in the second half of the nineteenth century, its use continuing well after that. This method involves two operations – the sculptor makes a maquette in clay (or it could be by an assistant) and then sends it along to a firm of carvers to be executed, its size enlarged or reduced as necessary. At this point, all connection between the sculptor and the final product is removed. Different minds, hands, tools and materials produce different objects. If, say, an artist makes a sketch of a girl and then hands the pencil to another to square up the sketch and make an enlarged copy of it, the finished drawing would have little, if anything, to do with the spirit of the original. Or you could say, here is a sketch – please xerox it and blow it up to ten times the size. Don't worry if there's no connection with the original – this is business, not art. The use of a pencil in the hand of an artist is a personal act which leads to a unique image, and the same precise relationship between the mind, pencil and piece of paper can exist between the mind, chisel and a lump of stone. A sculptor never invented anything, Michelangelo maintained, that didn't lie concealed, 'resting' or 'sleeping' in the block of marble, and that no hand not animated by the spirit could extract it – 'to break the marble spell / Is all the hand that serves the brain can do' were telling lines in his beautiful sonnet on his vision of the work of excavation; a belief far distant indeed from the busy craftsmen manufacturing copies from sculptors' maquettes in their workshops.

Indirect carving was 'a stone imitation of a clay model', Gill said.

'Modelling is a process of additions; whereas carving is a process of subtraction.' He said, too, that if a maquette was 'modelled in a manner natural to clay it would be more a hindrance than help to a carver ...' Thus different materials with different properties require different processes; one material cannot be reproduced in another without destroying the meaning of the original: one might just as well say, for example, that an architect, having designed a structure to be cast in concrete, instructs a contractor to build it in stone to obtain an acceptable appearance; with different materials, forms, methods of construction and details are also different. Nevertheless, sculptors were keen to employ the indirect method because it suited them for many reasons, all of which were unassociated with art. First, it saved time and physical effort; secondly, a sculptor might know nothing of the properties of stone, and so nothing of their possibilities and limitations. He might have never picked up a mallet and chisel in his life – why bother, after all, when there were experts in the field with new machines available? But the method had a further, huge advantage over direct carving. While cutting and chiselling away at stone could take months, even years, the maquette could be made rapidly by the factory (for this is what carving firms amounted to) and another commission started; the process could be repeated ad infinitum. The introduction of new technology – mechanical instruments like pointing machines, high-speed stone cutters and sanders (following directly from the Industrial Revolution) led to a uniformity and slickness of surface finish, and to the debasement and commercialization of the art. Here is a fact that uncovers the falseness, and thus the worthlessness, of an activity paraded in the name of sculpture; the endless litter of draped nudes and cupids churned out for prestigious buildings – banks, town halls, government offices and the rest – in repro classical styles for urban situations around the country wasn't art at all, but manufactured products; adjuncts, as Epstein put it, to architectural ornament of an equally debased, meaningless and mechanized kind. The direct carver could hardly compete with these businessmen; he could only do so much and that is what his output should amount to, an explanation why there are so few sculptors compared to painters.

Here, however, was another possible reason why Epstein was dubbed as the Enemy; as the embodiment of the modern movement set to dismantle commercial methods and academicians' livelihoods, he was also a threat because he had rediscovered direct carving – if this became

sought after, he was unlikely to meet much competition in this sphere either. It is possible too, of course, that his very leadership in the medium was questioned because he was a threat (the rumour was put about that Gaudier-Brzeska and Gill were the real originators), and that the claim likewise persisted that he wasn't a carver at all (by Gill, Rothenstein and Henry Moore among others), but a modeller. If this was an attempt to reduce Epstein's importance as an artist, he had his own answer to such quibbles, saying,

> According to the modern view, Rodin stands nowhere. He is patronized as a modeller of talent, even of genius, but merely as a modeller. As a matter of fact, nearly all the great sculptors of the Renaissance were modellers as well: Verrocchio is almost entirely a modeller. Donatello modelled many of his most important works. Personally I find the whole discussion futile and beside the point. It is the result that matters, after all. Of the two, modelling . . . seems to me to be the most genuinely creative. It is creating something out of nothing.

On the other hand, whatever his envious detractors might say, the fact was that Epstein had emerged as an acknowledged master of his craft. He had done it, moreover, on his own. He had studied the antiquities in the Louvre and the British Museum; he had taken instruction in carving in Paris, following up that training with exhaustive trial projects, made in spite of his desperate money problems, both there and in London. The works speak for themselves: since he destroyed his student attempts, the marble relief of *Mother and Child*, carried out in 1906, has to be regarded as his first really achieved piece of direct carving. Then there were the Strand figures, carried out before either Gaudier or Gill had turned to sculpture, and these again are an example of the method in its true and purest sense; working within the extremely tight building programme, and using plaster casts as full-size maquettes in this vast undertaking, he carved the frieze without a single assistant. The material, Portland stone, helped here: it is uniquely easy to cut and shape, and Epstein's knowledge of it may be a reason why he rejected Holden's proposal to have them carved and built up in separate pieces. The material made it possible for him to carve the figures as complete objects, in situ; and this meant seeing them as a whole and starting from scratch, as he would in his studio, giving him a greater opportunity and freedom to depart from the plaster mock-ups. From this arduous experience he must, again, have learnt a lot.

Finally, there was his voluptuously grand *Maternity*, a real breakthrough to a new vision in sculpture, and this, together with two further works (the *Sun-Worshipper* and *Sun-God* on the theme of the sculpture he had destroyed in Paris), was underway in 1910; it was the last of the series of carvings before embarking on the Wilde tomb, and part of an enormously productive period during which he seemed to be gradually, inexorably building up to the climax when, suddenly, all his energy and imagination would shower out of him into this great and wonderful task. As yet, however, he wasn't ready for it, or he had not found the material which would clarify ideas that were forming. In 1909 he discarded as mistakes some thoughts he had had – sketches for a group of two figures which he developed as a life-size work in clay called *Narcissus* (perhaps he was trying to find some image that might satisfy Wilde's admirers) – disgusted by the *Narcissus*, he promptly destroyed it, and Holden, whom Epstein had invited to design a base for the work, confirmed that he had now decided to carve the tomb 'straight from stone'. Holden was most impressed:

> One hears many criticisms of Epstein which are merely contemptible, reflecting ill-temper, racial prejudice and vulgar spite, but I know few artists who, being given a commission of a fixed but generous sum, deliberately discarded a work of great distinction already approaching completion and proceeded to work on a new vast project involving large expenditure on material, transport and erection at a cost amounting to what was probably as much as the whole amount of the commission. That was the work of a sincere artist wholly devoted to his art and thinking nothing of profit . . .

Such an act was in total contrast to the indirect carver who would have sent his model of a clay *Narcissus* off to a factory to be reproduced in stone. Anyway, this confirmed that around the time he threw out his *Narcissus* he had decided on a stone tomb; from then on, he may have been waiting to come across the stone he needed to frame his ideas as he hammered away at the intensely hard Hoptonwood of *Sun-God* and *Maternity* in his studio.

Apparently, Rothenstein had convinced himself that it was the influence of Gill (whom, he said, he'd introduced to Epstein) which had led to the change of plan from a bronze work to a carving; in fact, of course, either material would have been suitable, provided it was right for the idea Epstein had in mind – the choice, as always in art, was

made by this, nothing else. But then the enthusiastic Rothenstein was tremendously taken with Gill who had, in various wordy epistles to Rothenstein, given a somewhat misleading picture of Epstein. Gill was a craftsman whose work was strikingly unimaginative – what mattered, he contended, was 'good workmanship', and as one who had few ideas he would have been impressed by one who had many, in this case, Epstein. Gill had started out as an apprentice to an architect, but moved on to a technical school to learn to carve lettering when he found office life boring: it is for 'Gill Sans', a simplified and weak version of classical type that omitted serifs, he is chiefly remembered. He was full of his invention, wanting to change the face of London's shop-fronts with it. From this, he launched into sculpture, turning up one day at Rothenstein's with photographs of carvings he had done: the painter and art lover was so sure he had discovered a genius that he promptly bought one, induced a friend, Count Kessler, to buy another, and sent Gill off to see Epstein – he felt the two could do wonders for each other. This was in 1909, Rothenstein having first met Gill in the spring of 1906 when he commissioned an inscription from him for his portrait of George Baker, bursar at Magdalen College, Oxford. But Epstein had already met Gill in April 1908, when Gill went overboard for the BMA figures. In his letter to the *BMA Journal*, when he described himself as a 'friend' of the sculptor, he said that Epstein was raising English sculpture from 'the dead', and it's not unlikely that his excitement over them started him off on sculpture: real imagination is infectious, however impossible to emulate. Interestingly, the relief Rothenstein bought was of a Mother and Child, the idea for which might have been suggested by Epstein's of the same subject which Gill would have seen in his studio.

Gill's letters and diaries make much of the friendship that developed between them, and it's true, of course, that Epstein would have been greatly touched by Gill's letter of support after such a short acquaintance, and by his enthusiasm for his work. He would have regarded both as a sign of a true friend, and he needed friends, and was quick to adopt them, in a world that turned out to be so hostile to his art. Flattered and pleased by Gill's admiration, he might have regarded him as a kind of student or disciple; he wouldn't have minded him copying his ideas – here was a like spirit who wanted to oust the academicians who had stifled imagination for so long; Gill was a rebel, an ally. So the Epsteins visited the Gills at their house in Ditchling, and Gill visited Epstein in

London. Epstein enjoyed a break from the city: like his wife, who was interested in botany and gardening, he loved every aspect of nature. Away from the studio, he was relaxed and convivial, and, provided all was going well with his work, the presence of people round him could transform him into an excellent raconteur as he recalled memories of America and Paris (as many of his sitters discovered), or discussed great art. He wasn't one to pick on the limitations of others – he would have regarded that as a 'petty' (a favourite word) activity – unless he felt threatened. Yet he never allowed himself to be distracted for long from the tasks that possessed him, a reason why his involvement with Gill in a wild plan to make, according to Gill, 'a kind of twentieth-century Stonehenge' from 'colossal figures' sounds unlikely. What has been made of it, and much has, is derived solely from material supplied by Gill – what he told John, letters about it to Rothenstein; that he and Epstein wanted to buy a fourteen-year lease on six acres adjoining Asheham House in Sussex; that they needed the assistance of a millionaire, he told Rothenstein; and that it was a plan to bypass commissioning agents – 'it is increasingly evident that it is no use relying on architects and patrons and agents,' he wrote.

There is nothing in Epstein's records that confirms his part in it; and while Gill might have found commissions hard to get, being new to sculpture, Epstein was always busy – he had portraits to do, ideas of his own to work out, and he had his Oscar Wilde. Gill sounds more like a predator than a collaborator. The plan came to nothing of course, but could have been blown up in importance to publicize his association with a well-known artist: his letters, egotistical, gushing and self-important, constantly harp on the first person singular – 'an obtrusive, eager and clumsy personage', Wyndham Lewis called him. He was eager – eager to get on, and, in this respect at least, Epstein was a good catch with good connections – John, Bone, Sir Hugh Lane and others – who could be useful; he had trained in Paris, was controversial and was about to carry out the Wilde tomb. And then, from this friendship, came the curious carved copy he made of Epstein's bronze of Romilly John. Although a copy, it may well have been the best thing he did. For the most part, Gill specialized in linear, tasteful, decorative and stylized reliefs – the complete opposite of everything an Epstein represents – that are a confirmation of the old maxim that the further art strays from reality the more stylized it becomes. Yet his work also had a cheap and smutty side – *Votes for Women* and *Ecstasy* (both made in 1910) – that

smacked of an obsession with sex (or as John believed, he was 'much impressed by the importance of copulation possibly because he had so little to do with that subject in practice'). Many of his woodcuts and drawings verge on the pornographic, while his pencil sketches had a slickness adopted from a 'carving' technique of heavy outlines. When his sculpture was exhibited at his first one-man show at the Chenil Galleries in the King's Road, Chelsea, it was praised by the fashionable critic, Roger Fry, fresh from New York and the notoriety of the Impressionist exhibition: perhaps the stylization of the reliefs appealed to his arty side.

Yet there was this head of Romilly: the idea for making the copy was, presumably, Gill's, and Epstein had bought it from him for £8, to protect the authenticity of the original, perhaps. When it was exhibited, it was labelled 'Head of Romilly John, carved from model by J. Epstein, lent by J. Epstein.' The wording would have been Epstein's; he would have taken care to establish it as a copy, an important point since his own carving of the boy's head was shown at the National Portrait Society at the same time. Still, Gill had his on view at a successful exhibition of only two years' work, and the Romilly, with its link with Epstein's name and ownership (and, indirectly, John's), was something of a scoop. There was, however, another mystery, and this surrounded Gill's *Cocky Kid*, also dated 1910. He claimed that this carving, only nine inches high, so interested Epstein that he ordered a version of it. This is hard to believe: even harder, an assertion that Epstein's *Sun-God* was influenced by it. The reverse is much more likely to be true – that Gill lifted the idea from Epstein's work and, not understanding it, produced the mediocre figure he did. If *Sun-God*, of the same year, eight feet tall and a statement of great power, has an obvious source for its inspiration, this could be the ancient Greek diagram of human proportion described by the circle and the square from the centrepoint of the navel. The creator of this extraordinary piece could hardly have been seduced by a stylized miniature posing as art – this puffy, anatomically clumsy little object Gill jokingly called *Cocky Kid*.

Gill's show was in January, 1911: while Epstein had not yet been offered an exhibition by the one gallery where he wanted to show his work, the Carfax, Gill rushed in to make a name at the risk of antagonizing others, and comments – 'a naughty schoolmaster' from the painter, James Innes, and 'an artist of the urinal' from John – suggest that he did. Now

this exhibition followed two events that rounded off 1910. First, there was Fry's 'Monet and the Post-Impressionists' show of November at the Grafton Gallery, the outcome of his work as adviser to New York's MET for which he travelled extensively in Europe. That established Fry – the brilliance of the mass of Cézannes, Monets, Manets, Van Goghs, Gauguins, Derains and the rest, dropped into the grey backwater of conservative London, sparked off predictably furious outcries: a display 'before which phenomenon', ran a contemporary report, 'we had seen maiden ladies diving feverishly for their smelling-salts, and impassioned quarrels arise among the more sophisticated coteries who came to scoff but sometimes remained to pray.' *The Times* said it stopped 'where the child would begin'; Ross, in the *Morning Post*, called the artists 'lunatics'; Wilfred Blunt used the words 'impotent', 'mud' and 'pornographic'; Charles Ricketts and Burne-Jones were disgusted, and various silly English jokes were communicated to Rothenstein holidaying in India by the hyperactive and garrulous Gill – in fact, the venom that greeted Epstein's statues was being aired again, and by people who should have known better. Gill even attributed critical views to Epstein that would have annoyed him. He regarded Van Gogh, for instance, as an artist of supreme genius, saying of his *L'Homme à l'Oreille Coupée* that it was a 'remarkably objective self-portrait ... It is a picture of a madman, done by a painter who realizes his madness in a cold, detached and entirely dispassionate manner.' He had admired the work of these artists since first coming across it in New York as a boy, and if the claims made on his behalf by Gill had filtered back to him they may well have contributed to the eventual break-up of their relationship, such as it was.

Shortly after the exhibition closed there was another event that turned out to have horrific consequences for Epstein in the First World War: on 22 December, he became a naturalized British subject. Bernard Shaw had put him forward as sculptor for the Shakespeare Memorial Theatre, explaining he didn't stand a chance unless he was English. 'Damned rot,' Epstein later wrote in a letter to John Quinn, the remarkable patron to whom John had introduced him in 1910, 'that nationality should be for or against an artist's chances, but there it is ...'

Shaw was right, of course; as an Irishman, he knew from personal experience how stuffy the English could be about foreigners – the reception of the Monet exhibition adequately confirmed that. He was

aware of the undercurrents of proto-fascist elements that set Americans and Jews together as objects of hate, and had, in particular, witnessed the surge of anti-semitism during the deplorable campaign to oust Russian and Polish refugees of only a few years before. This hadn't vanished with the dropping of the Aliens Act; he realized that Epstein, now a household name, could be a target for harassment and in need of protection. As it happened, despite the device, Epstein didn't get the Stratford job – the Strand scandal probably put paid to that. Yet it was somehow right and proper that the Home Secretary who signed his naturalization papers was the man who had done most to foil that disreputable Act: Churchill, a future sitter.

The year 1911 arrived but the tomb still did not materialize. There were two more commissions from admirers, the wives of Francis Dodd and Arthur Clifton, and there were the portraits of Marie Rankin (an Irish girl who walked into his studio and then disappeared immediately the head was finished), Euphemia Lamb (a great favourite) and Nan. As he said often, art critics regarded portraiture with 'a certain contempt'. Sculptors, on the other hand, didn't feel this at all, and it was as well to remember that the highest expressions of sculpture in Egyptian works were never meant to be anything but portraits. 'Personally,' he said, 'I place my portrait work in as important a category as I place any other work of mine.' Of course he preferred to choose his models, since he could then do what he liked and ignore the irritating comments of sitters, their husbands or wives, like, 'You have brought out all his worst qualities', or 'It is uncanny how you have seen into his soul', or, in the case of the delightful Lady Gregory of Coole Park, 'Poor Aunt Augusta. She looks as if she could eat her own children' (Sir Hugh Lane, on seeing the bust for the first time). All the same, he was usually able to overcome such remarks by disregarding them.

In 1911, the scene at Cheyne Walk probably looked much like the Hyde Park Gate studio Emlyn Williams saw in 1931: 'Mixed up with heaps of wood, piles of clay, stacks of old newspapers and the dust of years, there was every sort of head and limb at every height and angle . . .' But, in 1911, a huge figure dominated all else: *Maternity*. And this extraordinary creation brings the British Museum immediately into sharp focus again, its classical antiquities, the Indian and ethnological collections, all of which became central to his sources of inspiration; the special characteristics of races, each minutely observed through their

art, culture and physiognomy, were an influence, in some way, on everything he created. What he said of his sitters – 'it is always necessary to accentuate some particular trait that gives character to the face and distinguishes it from other faces' – could be applied equally to the manifestations of these peoples' traits in his work. He had been introduced to their variations in appearance on the Lower East Side as a boy, and they had fascinated him; the child's view was a microcosm of the world internalized – a microcosm within a microcosm – and the excitement of the discovery quickly developed into a passion for the art of their different cultures which he had found, entirely for himself, at the Louvre, the Musée Guimet, or with dealers in Paris. He had come to these art forms by a separate route from Gauguin, Picasso or Modigliani, and, as one might expect from a discovery of an important kind made from personal experience and research, the full meaning of them took time to clarify as he continued their study in the British Museum. After *Rom*, *Maternity* was his first really achieved work to display an assimilation of this material.

Much as Cézanne saw Provence for what it truly was, so Epstein saw these art forms; and as with our understanding of Provence in the light of his paintings, so a work like *Maternity* brings a meaning and life to Indian or Egyptian sculpture that went unnoticed before. In fact, you could say that Epstein's art communicates a completely new view of works of the past in the British Museum. In the Indian section, he would have seen the Bridge Collection donated in the 1880s: the Matsya, the fish reincarnation of Vishnu (ninth century AD); two versions of Camunda of Orissa, with children (thirteenth century AD) and without (ninth century AD); the Yasoda suckling Krishna of central India (tenth century AD); two carved panels, one with a sea monster, the other with a goose, from central India (seventh to eighth century AD); the base of Pillar Gujarat from western India (eleventh century AD); the Elephant and Rider from Sri Lanka (thirteenth century AD) – here are a few of the many remarkable exhibits that may have interested him. All generate immense vitality, are highly complex in construction and, in most cases, profoundly involved with nature, with or without people. Yet a common factor persists: the pieces portray a sculpture in evolution – three-dimensional forms emerge from the graphic diagram of the relief: in almost every instance, there is a flat back, a front sculpture and, very important, a stone frame for the whole. If *Maternity* brings the museum to mind, it is pieces like these which seem to retrace Epstein's steps through it: we

have been here before – Camunda cuts to *Maternity*, the Gujarat Pillar to one or other of the Strand figures, the Sea Monster and the Goose to *Rima*, and a serene, simple Ling head of a woman (eleventh century AD) could be an evocation of *Meum*. As with an archeological jigsaw puzzle, a corner of the mosaic suggests itself. Yet the same might be said of connections with ancient Egyptian sculpture of a couple of thousand years or more before – the red granite head of King Sesostris from Abydos (*c.* 1850 BC); the astonishing Fahon birds (1270 BC); the crouching baboons (1150 BC); the mysterious standing Hippopotamus, Goddess of Childbirth (600 BC); and the gigantic beetle, hewn from a rectangular slab, as though fossilized from a billion years ago. Epstein's *Rom*, an echo of civilizations across the space of centuries, has a place here, and so has *Maternity*: again, as with Indian, Egyptian sculpture has a recurring theme – a rough back and a beautifully carved front that expresses a preoccupation with two-dimensional form, outline, geometry and symmetry also illustrated in painting and architecture.

Epstein draws attention to this in *Maternity* – the concern, particularly in the case of pharaoh and queen, was with the front and the profile, not with the back which, because it often faced a building, was largely blocked out with stone or left rough; and although animals were rewarded with a god-like regard and shown in the round, the back was again curiously featureless and treated decoratively. A quartzite baboon (1400 BC) is an excellent example, the head displayed as a helmet of fur from the back, while, at the front, carved with great respect. This could have interested Epstein, providing him with a starting point for *Maternity*. Back and front are opposites – the abstraction of the Egyptian culture combines with the rich vitality of the Indian's. Epstein uses the themes in his own imaginative way: for instance, the commitment to exact symmetry that contributes to the static nature of Egyptian work is eliminated. Where the front is a tender, spiritual and sensual representation of the serenity of a pregnant woman, the back is a powerful abstract expression of the head and huge plaited pigtail which, like a spine, almost reaches down to the roughly cut base that starts at the thighs. Once again, Epstein interprets Egyptian associations to suit his own idea – as the infant grows in the woman, so the figure grows from the stone: the subject was creation, a grand conception that required the statement of an anatomical structure, the spine – the rough stone base is the foundation that supports a column that in turn supports its capital, the head.

The spine emerges as a vital element: strongly emphasized, it counter-balanced the weighty, pregnant body and unified a revolutionary construction in one move. *Maternity* was a really amazing work, carried out to satisfy a purely personal vision – there was no patron. It was about life, not monuments to the dead, the gulf which separates Greek and Egyptian art – as Epstein pointed out, 'Hair with the Greeks was a very living thing, not at all conventionalized.' Greek sculpture was totally real, departing from any form of stylization, preconceptions or decoration for its own sake, the Athenian artists putting as much effort into perfecting the carving of the backs of figures and horses as went into every other section of their work. So were the lessons of Greece haunting *Maternity*? Of what Epstein was particularly thinking when he said that he mentally compared every new work of his in the studio with what he had seen at the Museum is impossible to say. While he singled out the Elgin Marbles for a special mention, Mark Gertler, whom Epstein took round the following year, remarked that he 'revealed to me such wonders in the works of art that my inspiration knew no bounds and I came to the conclusion that Egyptian art is *by far, by far, by far* the greatest of *all* art . . .' Gertler was only twenty, and had been carried away by what Epstein, who very much enjoyed the company of students, had told him that day; but from this, it sounds as though he thought much the same.

And so here was *Maternity*, rooted in distant civilizations, yet a creation that was wholly his own, a true tale told in stone. In a little, however, his genius gave birth to a work that was even more memorable: his Oscar Wilde.

The precise date when Epstein met Quinn is uncertain; it was undoubtedly long before his showdown with Rothenstein whom he dismissed with a peremptory roughness that might suggest earlier attempts to terminate their relationship by more subtle means had failed. 'Dear Rothenstein,' he wrote on 20 June 1911, 'I want no more of your damned insincere invitations. This pretence of friendship has gone on far enough. Yours etc., Jacob Epstein.' There was a PS: 'It is the comic element in your attitude that had prevented me writing the above before this. I did not believe till now you could have gone on with it.'

On the face of it, this was a harsh note to send, however irritating Rothenstein may have been. Nevertheless, there was, one feels, some justification for his obvious anger: he was unable to get over the fact

that the painter had, apparently, never shown any desire to persuade Ross to give him the exhibition he wanted at the Carfax – hence the reference to the 'pretence of friendship'. Why had this never been arranged? The 'insincere invitations' were no substitute for action, and Epstein may well have felt his patron preferred to keep him on a leash rather than allow him to show his great gifts – even, perhaps, to escape the need of his patronage. After all, by then, Epstein had thoroughly proved himself, not only by carrying out, against the odds, the huge commission for the BMA, but by the many remarkable works he had done – those of Nan, Euphemia Lamb and others, followed by the superb *Rom* and *Sun God*. He must have been furious to have been so overlooked, and this treatment could have built up tension in him over a lengthy period that finally exploded in his letter. Then came Quinn: one can't help feeling that his appearance on the scene wasn't entirely unconnected with Rothenstein's disappearance; while one relationship was founded on the acceptance of gratuitous offers of assistance, Quinn used his money to buy art (not friendship, gratitude or dependence), and, difficult as he often was, could be welcomed on these terms. Epstein had to have a patron to support him (particularly since sculpture is such a very costly undertaking), and Quinn had to have works of art in order to satisfy his craving for things of value, chiefly, one suspects, for reasons that had more to do with status and investment than aesthetic quality.

Quinn was a most extraordinary man, a rich Irish New Yorker who pursued the double life of lawyer and art enthusiast with equal energy and thoroughness; the mundane routine of his business activities was balanced by the excitement, glamour and power success brought him as a much sought-after figure among artists and writers. He came out of America around the turn of the century and, following pioneers like Isabella Stewart Gardner, Frick, Dr Albert Barnes and Phillips, amassed a giant collection in a very short time – barely twenty-five years, and most of it in less than half that. He was always business-like in trans-actions, driving a hard bargain, yet clearly revelling in creating a cultured front for himself, from the building of a library (at one time, he was buying books at the rate of eleven hundred a month – did he ever read them?) to the selection of manuscripts, paintings and sculpture. The experience gave him, not unnaturally, a real sense of self-importance: he became the central American attraction of the European *avant-garde*, enjoyed the reflected glory of being associated with it, being seen in the

company of notable artists, known as their patron, and he received the *Légion d'Honneur* for his services to the Impressionists. His weakness for artists was also a strength: he saw their quality and their use as reliable advisers. He predicted, moreover, much earlier than most that art was a valuable commodity, and would increase in price: he bought Gwen John's paintings, for instance, decades before the English recognized her existence.

He began his cultural invasion of Europe in 1902 when he was thirty-two; an exchange of letters with the painter, J. B. Yeats, led to a meeting in Dublin with him and his two sons, Jack and W.B. It was a whirlwind romance: he went to Ireland three years in succession; W.B. used his apartment in New York whenever he liked, accompanied him to England, and introduced him to Shaw, James Stephens, Arthur Symons, Lady Gregory and others; books went backwards and forwards across the Atlantic, and Quinn bought the manuscripts of W.B., Symons and Stephens – James Stephens sold him 'an almighty bit of writing' of twelve days in which he claimed he had written twelve stories and twenty-five poems. 'It was a good harvest,' Stephens told Quinn in a letter, 'but just now I am leaning against a rail with a bit of straw in my mouth and feeling very contented . . .' It was good business for all concerned. Quinn built up a huge collection of Irish paintings – J.B.'s, Jack's and George William Russell's – and bought a John drawing to illustrate an eight-volume edition of W.B.'s poems. With this, John entered his life, W.B. describing him as a bohemian with hair down to his shoulders and living 'in perfect harmony' with two wives and their families. A vivid picture of the English art scene gripped his imagination – by 1909, he had to break into it, see the glamorous life at the fashionable Café Royal haunted by memories of Wilde's circle, meeting John, Lucien Pissarro and friends at Sickert's co-operative studio in Fitzroy Street. W. B. Yeats warned him: 'Do not give so much time to the mechanism of life that you have no time for life itself. You will be a millionaire when you are fifty, but you will have spoilt your digestion . . .' He was probably a millionaire already, but the prediction about his digestion was a remarkable piece of intuition, accurate almost to the year.

Quinn by now was 'sick of the Irish' whom he regarded as 'suspicious' and 'ungrateful': he was quick to suspect the worst himself, and an example, as an obsessive health fanatic and hypochondriac, was his view of Latin countries – anywhere, in fact, which lay outside the English-

speaking world, American respectability and the safety of five-star hotels was positively dangerous; America was the innocent, Europe a picture of corruption, and Stephens's assessment of Europeans as 'untrustworthy' reinforced his fears. All the same, the honeymoon with Ireland was over: much as he disliked the English for their treatment of the Irish, he had other fish to catch in London. John was the biggest of them, and he followed up a number of drawings of Quinn with a portrait that wasn't flattering and which Quinn didn't like but had to accept – after all, it *was* a John and admired by Symons and friends in the 'know'. So John became, in 1910, Quinn's first English beneficiary of his patronage with an annual retainer of £300 a year, a considerable sum then that financed an immediate trip to France for experience. Quinn's craze for art certainly left him vulnerable to exploitation: longing for paintings that never materialized, inundated with letters describing the beauty of French women (be careful of VD, Quinn advised), he was at least rewarded by John's recommendation, in an act of generosity towards other artists which was typical of him, to look out for the work of Wyndham Lewis, his sister, Gwen, and Epstein: this pleased him.

Epstein also fell out with Holden, if briefly over the tomb; this may have been when he had embarked on the final work, in the summer of 1911. He had invited Holden to design a base for the monument (with Gill carrying out the lettering), but, the architect recorded, 'relations became strained' and, in order to avoid a row, he handed over the design free of charge. 'I was well aware by this time,' ran Holden's notes, 'of his strange suspicious nature and his now familiar publicity formula but these are things which, being a part of this man of genius, must be accepted.' The reference to a 'publicity formula' displayed ignorance on Holden's part. Epstein didn't seek publicity – rather, his work brought publicity through its originality. He was dedicated to the clarification of sculptural problems and the discovery of their solutions, and in this instance may have found Holden's design an irrelevance. He had, moreover, every reason to be suspicious after his experiences: unlike Holden, an architect in a secure partnership, Epstein was entirely on his own, an artist up against society, without money, and well aware that his ideas could be blocked by establishment circles.

Epstein made two drawings of a preliminary idea for the tomb in 1911 – tentative sketches depicting a flying figure in space with curvaceous forms that hinted at the Art Nouveau of Wilde's period, and

had a vague resemblance to a male sphinx. Like other mythological stories, the imagination of this legendary symbol of royal power with Egyptian origins (later undergoing a sex-change to female when the Greeks gave the story a disturbing twist) has of course interested artists and writers for hundreds of years – Dryden, Voltaire, Ingres and Moreau, for instance; most important of all from Epstein's point of view, it inspired 'The Sphinx', Wilde's long and mysterious poem which he wrote at the Hôtel Voltaire, Quai Voltaire, when he was twenty: 'A thousand many centuries are thine/While I have hardly seen/Some twenty summers cast their green for/Autumn's gaudy liveries . . . /Come forth you exquisite grotesque! Half/Woman and half animal.'

It is possibly from this poem, eventually published in 1894 after revisions, that Epstein's idea stepped off, and, in his drawings, the story of the creature's dual sex is not forgotten. While the monument's sphinx is, naturally, male, a tiny female version in the form of a double image (her head, wings and body metamorphosing as an erection with genitals) appears to whisper in the male's ear, a possible reference to the poet calling on the sphinx to 'sing me all your memories' in Wilde's poem. Then, in one of the drawings, probably the later of the two, there is a sequence of sketched heads (one pair engrossed in a passionate kiss), below which Epstein noted a 'circlet of sins for double crown' with a list of possibilities jotted down beside them: 'Covetousness, envy, jealousy, anger, sloth, wandering thoughts, fornication, slander, sodomy, evil.' Epstein was meticulous. He drew on everything related to the problem, his research was penetrating, exact, methodical and realistic: 'to get at a subject' was a favourite expression: 'to get at' the fundamentals was his job, and it was on these, once seen, that his imagination could thrive. Any impression that he rushed at a work in the heat of some emotional brainstorm is as misleading as many of the romantic fantasies people like to have about artists. 'People see the artist as a medium, possessed by a certain force that he cannot control or reason about,' Epstein said, citing Rodin as the example of the logical mind. 'I am fully aware of what I am doing.'

Hence the chaste discipline displayed in the Wilde tomb. Its sources of inspiration, at first appearing bewildering in their ramifications, eventually evaporate, leaving behind the essence – Wilde, his greatness, messages of immortality. There was a massive fund of material to start from. In particular, possibly, there was Wilde's interest in the symbolism of the sphinx, enigmatic and remote (it led him to call his closest

woman friend, the witty and delightful Mrs Ava Leverson, The Sphinx
of Modern Life – 'Dear Sphinx', his many letters to her began after
meeting her in 1892), a preoccupation which crossed with Epstein's
knowledge of Assyrian and Egyptian interpretations of the mythological
creature at the Museum. Then there was Wilde the artist, 'the poet as
messenger,' as Epstein described his conception to Arnold Haskell later,
'a messenger swiftly moving with vertical wings, giving the feeling of
forward flight'; and there was Wilde's 'Oedipus Complex', his own
tortuous conflict which cuts to his appalling imprisonment in Reading
Gaol, the horror of which was crystallized in his poem about the
condemned man awaiting the rope – 'that little tent of blue which
prisoners call the sky'; to his cry to the Governor for books after
thirteen months in solitary confinement with nothing to read and fearing
the onset of madness. Ross would have given details of his experiences,
Epstein knew his plays and poems, and had seen the wretched grave,
the stone slab surrounded by chains symbolically still imprisoning
Wilde, a picture that in itself might have planted an idea of great
simplicity in Epstein's mind, and one so typical of him: flight; freedom;
both a manifestation of art. The trouble, unfortunately, with the Assyr-
ian sphinx in this respect was that, despite its great wings, it was land-
locked by its equally huge legs: these removed any possibility of escape
from the imprisoning stone, a factor that made the suitable grandeur of
this creature a thoroughly unsuitable springboard for a monument to
this tragic martyr whose mercurial brilliance and saintly courage Epstein
so profoundly admired. If, on the other hand, the sphinx with its 'heavy
velvet paws' and 'whose wings, like strange transparent talc,/Rose high
above his hawk-faced head' could fly like the 'Assyrian God' of Wilde's
poem, it might indeed capture the freedom of birds Wilde would have
seen fluttering in 'that little tent of blue' from 'his numbered tomb'
above Reading Gaol. With the combination of that dreadful backdrop,
his early heartbreaking death in exile and that horrible grave in mind,
to have conceived an epitaph to this marvellous writer as half man and
half bird was certainly a kind of genius which Wilde himself would have
revered.

The tomb's conception was resolved very suddenly. Gill had written
that Epstein had accompanied him to Dorset looking for stone suitable
for the Asheham project; although this may be true, as likely as not
Epstein was looking around for something that would suit his Wilde. A
year later, he found it, and the idea he had been carrying about in his

thoughts was perhaps given a form by the discovery. When he went north to a Derbyshire quarry he saw and, on the spot, bought, a twenty-ton block of Hoptonwood that was about to be broken up, and he had it transported, at once, to his Cheyne Walk studio. After this came the working drawing for the masterpiece that he dug out of the stone over the next nine months, this displaying a conception that transcended the kind of connections art historians and others might well make: the work wasn't really any more a portrait of a sphinx than it was of Oscar Wilde. It was a portrait of a poem, of imagination, the unfathomable: it had shifted from the level of literal likenesses to the abstract level of ideas. The huge calm head and great wings take total control, while, beneath these, physical strength dwindles to arms, chest and legs as spindly as his early drawings for *Calamus*; fragile as a bird's, swept back by the speed of flight. 'I conceived a vast winged figure,' Epstein said. 'It was of course purely symbolical, the conception of poet as messenger.' All the vagueness of the first sketches was gone: in one sense, it was a traditional tomb – an upright slab of stone – with a relief, yet it was also sculpture. Its simplicity was Greek, but it was the male sphinx of Egyptian origins that had destroyed itself. Five of the deadly sins were there, located above the sleeping face of the 'poet', frightening figures in a classical composition that has as its centrepiece, like an emblem or a star, the female sphinx standing on her head in a halo of wings, her circle of feathers recalling a West Indian headdress or a bird in flight. For the rest, the energy was concentrated in the great weight of the upper half of the winged figure as a single, tight, geometric diagram of astounding power. Such weight, detached from the ground plane, made the huge relief, emerging from the stone backing as in Indian sculpture, appear to float, as if supported by air. The gigantic Hoptonwood slab was the frame: as though by an act of will, it was this which determined the outcome.

The sheer scale of the epic – the fearlessness with which he picked out a block of stone so enormous, and then had it transported without hesitation to London – has the American touch: the instant recognition of it as the right piece for the job, for his vision of a figure in levitation which embodied associations of any time, ancient and modern, demonstrates how clear must have been the picture of the work in his imagination. If the figure can be called a sphinx, it was his sphinx, his creation – an original, unique form never envisaged before. When you come upon it in the vast Père Lachaise cemetery, having picked your

way between 'neighbourhoods' of tombs embedded in the undergrowth (often quite grand ones, since it was here that encouragement to respect the dead was first given), the great, white, flying figure has the startling impact of some rare work of architecture unearthed in a ragbag of turn-of-the-century villas in a sprawling suburb; of a mysterious being, incapable of explanation.

The carving of the wings, the strong horizontals of the feathers, the crown of little figures, the anatomically exact ligaments of arms and frail legs has the precision of his Athenian heroes, the calm of the face at rest at last suggests the blurred features of the remote Egyptian King Sesostris; nevertheless, it is a work that broke with every convention and defied every established rule of taste and style. Visitors to his studio must have been amazed or bewildered by the wild, extraordinary creature they saw emerging. One imagines there were many. Robert Ross will have been in constant attendance; Gill, of course, was another – he couldn't, one feels sure, resist hanging around. In fact, a caller claimed – from memory, thirty years or so later – that the sculptor seen working on the wings wasn't Epstein at all, but Gill; that it was he, this visitor felt 'sure', who carved the genitalia there was such a fuss about. It's certainly possible that Epstein handed Gill a mallet and chisel, inviting him to have a go at removing some offending fragment – artists have been known to throw out such invitations to friends – at the moment the visitor arrived. In addition, Gill, given to exaggeration where his own publicity was concerned, may have embellished the rumour with a few touches to suit himself; but it's a flawed story – the incident was dated 1913 when the monument was in Paris, and the claim that the carving of the wings was under way when 'the work was nearly done' is incorrect since the wings were the very things with which Epstein began, completing them in October 1911. In fact, Epstein never used assistants on any project. Unlike wealthy business sculptors, or his one-time disciple, Henry Moore, he couldn't have afforded assistants had he wanted them, which he didn't: for him, the mark a chisel made was as personal and precious as the brush stroke is for a painter.

At all times, he was a fastidious and serious worker, regarding the fundamentals of his job with the deepest respect, and as sacred as the immense effort needed to emulate the standards achieved by idols like Michelangelo and Gislebertus: 'Strength,' he said, 'is the reserve of true

strength,' adding, '*Potential* energy is the essence of Michelangelo's work.'

And, as Charles Holden had pointed out, he never gave a thought to the costs he was piling up – once he had seen the block of Hoptonwood stone, he had to have it, the fantastic properties of the material pushing every other troublesome obstacle, like expense, from his mind. As we have seen, his unworldliness about money matters was common knowledge; forgetting to settle a fee in the excitement of receiving a new commission; throwing in an extra work for the price of one for the opportunity of doing it; paying for some unusual casting that he regarded as essential, but which the client refused to fund; and often undercharging, perhaps because he had a sketchy idea of the value he should place on his things, but more probably because his calculations were based on some factor outside them like, say, the price of an African Fang piece he had seen and was desperate to add to his collection – and, by 1911, this was beginning rapidly to increase in size. He was, in fact, only conscious of the oppressive importance of money when it was running out, never a rare occurrence, and then had to search around for a source to keep himself and his wife going – and her anxieties must have been acute in these constant crises. It was, doubtless, running out very fast indeed when he was starting on his great work for Wilde; at this point, of course, his new-found patron, John Quinn, came in handy.

The first firm news of Quinn's patronage emerges in September of that year, soon after the tomb was begun. He had arrived on his annual visit to London, spending the evening of the 3rd at the Café Royal with Mary Morris (daughter of William, a woman to whom he had a vaguely sentimental attachment), Augustus John (full of his current affair with Mme Frida Strindberg), and the Epsteins. A little later, before going with John on a tour of the continent (a tour which turned out badly on account of Quinn's fussiness over hotels), he was invited to the sculptor's studio where he saw the Wilde under way; Epstein was working on the wings. Quinn reported back to friends that he was highly impressed – so impressed, that he bought a small bronze statue on the spot, Epstein sending it off to New York with a receipt for the £62 paid on 29 September. That wasn't all: Quinn was so struck by the carving and other things, like *Maternity*, he'd seen that he ordered a stone bust as well. Although Epstein was too deeply involved with the Wilde to break off, he agreed to do it, explaining that it would have to wait in his next

letter of the following month (31 October). However, this didn't prevent him cabling for an advance of £60 on the same day – clearly, he needed money badly. This he justified by telling Quinn that he would 'like to do the head rightaway', but was anxious 'to get finished with the Wilde tomb' first. Amazingly, the wings were already complete, he reported; and, by 29 November, when he wrote to Quinn again, he had reached the half-way stage and hoped to have it done by February. He was impatient to get it to Paris and out of his mind so that he could start work on new ideas – 'I feel I can do the biggest and most profound things,' he wrote, 'and life is short' (he was just thirty-one); in particular, he wanted 'to do a great stone representing angelic and diabolical forces.' Life seemed to be altogether too short for the grand visions crowding his mind; it was as though he resented anything – even the Wilde tomb now that its sculptural problems were resolved – that prevented him carrying them out.

Some callers must have disturbed his concentration: one unspecified visitor made him see red over a criticism of the tomb. That wound him up on his favourite topic, a letter going off to Quinn at once: John had shown a fine painting at the New English and, as usual, the critics were 'making fools of themselves' – they were 'just ignoramuses'. He had already come to detest them and longed to cut himself off from the art establishment of which he was so suspicious: 'Nature in her great designs makes all the works of man look puny, and I will take lessons from her ... How I wish I was living in an age when Man wanted to raise temples and cathedrals to Man and God and the Devil ...' In his letters to Quinn, like those to Edward Ordway, or any of a personal kind, he often appeared to be talking to himself rather than to the recipient, putting down thoughts like dates in a diary that had to be remembered: 'I am thinking of doing a Virgin and Child, among other things ...'

However, he had encouragement, too: Robert Ross was a supporter throughout, even if there were occasional disagreements arising from the length of time he had taken, and which affected payments on account – all were eventually settled in Epstein's favour. There was Gaudier-Brzeska who blew in one Sunday, young, picturesque, optimistic and filled with admiration for the carving: this was their first meeting, and Epstein asked him if he had ever carved direct; as if afraid to admit he never had, Brzeska told Ezra Pound later, he hurried home and promptly started a carving. He also had his first meeting with T. E.

Hulme while working on the monument, and recalled that Hulme immediately put his own construction on the work, comparing it to 'projectiles'; it had started some train of abstract thought for him — abstract art always had a great attraction for him, Epstein said. Then, with the bulk of the work almost finished by February, Charles Holmes, the curator of the National Portrait Gallery, called: he was impressed, writing to Ross on 19 February: 'My dear Robbie ... I was going to write to you to say how relieved I was that Epstein had actually done the greater part of the monument, and that before his Neo-Papuan enthusiasm had been born. I think it is not unworthy ...' What Epstein would have made of the reference to the Papuan culture one has no idea, for he was his modest and noncommittal self about his extraordinary work — it was a symbolic one that combined simplicity and ornate decoration, it was probably influenced by ancient sculpture, and it was a direct carving on a grand scale: and that, beyond a few remarks made later on, was all he ever said on the subject. Nevertheless, he was becoming very excited about his prospects: so buried had he been in the problem raised by the tomb, and in the exhausting business of carving the figure, he had probably quite forgotten that potentially it was a sensational assignment. Already public interest was being vigorously stirred up, even though the work was unfinished — word had got around to the newspapers about the mysterious object that was materializing from the huge stone slab in the notorious artist's Chelsea studio; after taking so long to appear, the monument had passed from most people's minds, but now, suddenly, it was a physical fact. Press notices of its imminent completion flooded the art columns (Epstein hastily forwarding cuttings to Quinn), photographers were hammering on his door to get scoop pictures, an agent from a Berlin advertising company had called, others wanted reproduction rights, a dealer was desperate to give him an exhibition, he had been invited to go out to South Africa to do two works for the principal square in Pretoria to celebrate the country's independence, and he had decided to have a month's public showing of the monument before it left for Paris — after all, the central figure in the Strand scandal and a tomb for the homosexual playwright who died under a cloud combined to make a winning card. When the show opened, it would be a dramatic occasion. He wrote to Quinn: 'Then look out for the battle of the critics.'

He had every reason to think the work would be slated. Like the BMA figures, it was bound to shock the English establishment. A

warning light had flickered on only a month or two before with Ashley Gibson's experience. Gibson, a young journalist, member of the Café Royal set and friend of Innes, John and Spencer Gore, had encountered Epstein a year or so earlier. He was invited round, writing that Epstein

> exhibited to me – a favour hitherto withheld, as he assured me, from any of his circle known to have connection with the printed word – a three-quarter finished work of his over which furious controversies were to rage in their season. This was his monumental carving for Wilde's tomb in Père Lachaise, a colossal winged bull

– writing long after the event, he had mixed it up with the sphinx in the British Museum –

> in Derbyshire marble, man-faced, the inscrutable brooding countenance it seemed of Wilde himself. Liking it or not as you found yourself, you could not, whoever you were, fail to be impressed. Actually, the verdict of the boulevards was to anticipate that of Cockaigne upon the artist's 'Rima', though not carried to such grossly outrageous lengths. I wrote my story (it was for a daily paper) in a great state of excitement, but my news editor made obscene disparaging noises and dropped it in the wastepaper-basket before my eyes, uttering, when I protested, some curious remarks. He did not want my story, or anybody's story. He had never heard of Epstein till I mentioned him, and hoped I wouldn't repeat that indiscretion. As for Wilde, that person was dead even as news now, and a good job too. We were a respectable paper.

This brand of ignorance was commonplace, and insults were all Epstein could expect of it. When the battle of the critics was joined, however, Quinn could spread the news in New York. 'I wish it to be known in America,' Epstein informed him, referring to his work in general, 'for the very good reason that I feel that my future work might be in America: I wish to gain a reputation there.' It wasn't that he missed the country or New York, although there were times when he did say he wished he'd stayed in Hester Street and made proper use of its rich material before it became smartened up and commercialized; some 'Rembrandt', as he had said, ought to turn up and paint the wonderful faces there. He didn't much mind where he worked, provided it was a

place where there were the opportunities to match his drive as an artist, and provided, too, he felt welcome, which he didn't in London. Perhaps it was because he felt an outcast that he tried to rush Quinn into action – 'I am now in the heyday of my creative strength,' he said; he laid his success on thick: he had enough commissions for portraits to last him for the rest of his life – 'but it isn't portraits I want to do,' he insisted, 'or to compromise with art lovers or aesthetes of any kind': he found the comments of the peripheral outer circle of the art world as irritating as criticism from vain sitters. At the same time, though, he was convinced that the publicity his tomb would generate – or, as he anticipated, the critics' inevitable cries of derision – could lead to jobs that would give him 'the power to create on a grand scale'. There was a pent-up energy in him which, when not directed into his work, others, like John, might have found oppressive; he really hammered home his impassioned pleas for what he wanted – and that, perhaps, was an escape route if his expectations of the worst proved correct. As it happened, they didn't.

The work on the tomb – hard at it for months without a break – was a feat of endurance that had, apparently, exhausted him. In March, he told Quinn he felt run-down and in need of a change – impossible, he added, because the dealer's offer of an exhibition might come to something, and there was the monument to put on show in his studio when 'the thing was finally complete'. Yet he did have a change of scene: probably on John's recommendation, and unknown to Quinn (still waiting patiently for his stone bust), he carried out some decorative sculpture for Mme Frida Strindberg – 'one of Strindberg's ex-wives', as Ashley Gibson described her – who was opening the outrageous Cave of the Golden Calf in a basement in Heddon Street just to the east of Regent Street, a nightclub of a kind unknown in London then, and close enough to the Café Royal (and quite unlike it) to make the place, Mme Strindberg reckoned, a real winner. It wasn't a job of much importance to Epstein, but it was a break, possibly earned him some money, and through it he met Wyndham Lewis, an artist whose work intrigued him. Lewis and three others – Gore, Ginner and Gill (probably on Epstein's recommendation) – were collaborating on the decorations: not John – his affair with the fascinating Mme Strindberg was in the cooling off phase. Epstein's part in this curious side-show was to sur-

round massive iron columns with a tangle of figures. He said of the commission:

> I proceeded directly in plaster and made a very elaborate decoration which I painted in brilliant colours. Gaudier-Brzeska came down to see these decorations while I was at work on them. This cabaret was intended to capture the youthful and elderly rich, and several of my models, amongst them Lillian Shelley and Dolores, sang and danced there.

The idea for the club seems to have been partly sparked off by Mme Strindberg's craze for the Futurists – Marinetti's roving circus had turned up in London that March to open an exhibition of Italian art at the Sackville Gallery. Marinetti, in the middle of promoting Futurism all over Europe, gave various impersonations as the innovator of, and lecturer on, the art revolution, denouncing the British as 'sycophants' and 'snobs' who were 'enslaved by old worm-eaten traditions', attacks that went down well with English 'rebels' and fashion hunters, already excited by Lewis's Vorticism and Fry's ventures with Post-Impressionism. The left-wing *New Age* also took up Marinetti when its editor, the tough Yorkshireman A. R. Orage, printed his *Futurist Manifesto* in full, while C. R. W. Nevinson was quick to seize on it as the first rung on an *avant-garde* ladder. Epstein, however, wasn't part of this admiration society. He saw the point of Futurism, but not of Marinetti; of Futurism, he said that 'though the movement died within a few years, the word "futurist", which had a definite meaning then, the depicting of movement in painting, still persists as a term of abuse that includes all non-academic movements both before and after Marinetti's time.' He went round an exhibition with him in London and found his standards of criticism most odd:

> He would pass several pictures by with a shrug of dismissal, '*Ça ce n'est pas du tout futuriste*', and occasionally pause more approvingly, '*Ça c'est un peu futuriste*'. For a long time he sent me his violently-worded manifestoes in which he damned all romantic conceptions, beautiful women and Venice by moonlight.

In fact, Epstein came to regard the band of propagandists of Futurism as proto-fascists:

With true fascist impertinence they went from city to city spreading themselves and their silly gospel, and showing their incompetent paintings and sculpture. In England, we are very ready to receive what seems novel and exciting, on condition that it is superficial enough and entertaining enough. So these Italian charlatans were received with open arms.

At the Futurists' exhibition, he remembered 'Marinetti turned up with a few twigs he had found in Hyde Park, and a tooth-brush and a match-box tied together with string. He called this "The New Sculpture", and hung it from a chandelier. This was the beginning of those monkey tricks we see elaborated today in Paris, in London, and in New York.' He was writing this in the late Thirties, going on to describe how Marinetti, before reciting one of his poems, would read something by Baudelaire, and then demolish it as he saw fit. He then imitated

the chatter of machine guns, the booming of canons, and the whirr of aeroplane engines. On this occasion, one of our 'rebels' beat a big drum for him at appropriate moments. Apart from these antics, Marinetti's 'poems' were of a commonplaceness and banality that was appalling ... Of course, he was the model for our own English futurists, abstractionists, and careerists. It became very tiresome ... and the novelty soon wore out. Marinetti went back to give birth to Mussolini, and our own rebels have since made frantic attempts to join the Royal Academy.

Marinetti apart, he was impressed by the work of those Italians of exactly that moment who, like Giacomo Balla, Umberto Boccioni and Gino Severini, communicated brilliant images of colour and movement – he was particularly impressed by movement since it was this which so preoccupied him in sculpture, but also by colour, a passion for which surfaced later in his paintings; Boccioni's sculpture wouldn't have gone unnoticed either, and not only by him, but by Brzeska too. For the Cave of the Golden Calf, however, he had little more than a passing interest, going there once or twice, but finding that sort of night life 'distasteful' to him; and it didn't last long before it was raided by the police and his decorations, together with Mme Strindberg, disappeared. Whether this masterful, intelligent Austrian of uncertain age, who had a remarkable gift (so Gibson remembered) of getting people to do things

for her, ever paid her artists is open to question. Judging from Epstein's account of her reaction to the restaurant's stupendous bill handed to her after a champagne dinner to launch the club (looking round at the assembled company, she said, 'Who will be my knight tonight?' – to which there was no response), she could have been very difficult about money.

This little interlude could explain a sudden silence of three months in Epstein's activities, otherwise fairly consistently recorded in his correspondence with Quinn. Then, a formal invitation card announcing the opening of the public exhibition of the Wilde tomb suddenly arrived on Quinn's desk: it was headed, Cheyne Walk Studio, 1 June to 30 June, from 10 a.m. to 6 p.m. The work was finished, at last: 'It actually is a tomb and not just a grave monument,' was his final comment. An assistant of Gill's had carved the writer's name on the front, and on the back, together with the note that it had been donated anonymously, some lines from the *Ballad of Reading Gaol*:

> And alien tears shall fill for him
> Pity's long-broken urn
> For his mourners will be outcast men
> And outcasts always mourn.

But if Epstein had been expecting the now familiar tirade of abuse from Fleet Street he didn't get it: instead, the *Evening Standard*, the newspaper that led the campaign attacking the BMA figures, gave his work a flattering and perceptive review two days after the opening, entitled 'Mr Epstein's Dignified Sculpture':

Seldom in this country are we permitted to see such a dignified piece of monumental sculpture as Mr Jacob Epstein has carved for the tomb of Oscar Wilde ... The first thing that strikes one is Mr Epstein's regard for his material and its purpose. From the earliest ages it has been the almost universal instinct of humanity to set up a stone for the dead, but modern sculptors are too apt to forget that every touch of the chisel ... is a destruction of the monumental character of the stone. Mr Epstein has not forgotten this, and his work, though an expression of human emotion, recognizes the rectangular solidity implied by the idea of a tomb. It is not executed but conceived in stone ... The conception embodied in this great

block of stone is that of a winged figure driven through space by an irresistible fate. The Greek rather than the Egyptian Sphinx might have been the suggestion — though the figure is male — and in this case the Sphinx has become its own victim . . .

There were many notices, a few noncommittal, but mostly enthusiastic. Some attempted a more detailed explanation of the work than the *Standard*'s; an impossible task, its source of inspiration remaining as inexplicable and mysterious as art itself:

This is only Mr Epstein's commentary, serious and profound, unobscured by conventional formulas, and inspired by an acute necessity for utterance. 'Go and see it at once', is my urgent advice to all who are interested in sculpture, and think of it, if you can, on a hilltop in Père Lachaise, dominating all those tawdry memorials of the easily-forgotten dead.
(*Pall Mall Gazette*, 6 June 1912.)

The tomb is not on a hill-top and its position had nothing to do with its dominating presence — among standardized tombs, a work of its stature could scarcely have any competition. The reviewers' comments, of course, would have passed Epstein by; he took notice of criticisms only when they represented a flagrant onslaught on the fundamentals of his art — otherwise, he was emphatic that onlookers should make up their own minds about his things: 'My works must speak for me,' he said in a letter to Georges Bazile when the furore subsequently broke out over the tomb in Paris. He refused to explain them: when a work was finished, he was as much an outsider, he said, as others were. But he knew the qualities as he knew the faults of what he did, and for this reason any reported comments, whether admiring or not, weren't of much interest. Nevertheless, discriminating as the remarks of the *Standard*'s critic were in the beginning, some curious closing ones might have struck Epstein as decidedly odd distortions of the truth — in particular, that 'the inner driving power' of the poet was 'symbolized by little figures of Intellectual Pride and Luxury above the head', and that 'Fame, with her trumpet, is carved upon the forehead': the early drawings suggest a different picture. Good taste ruled in English middlebrow society, and the conflicts churning round in the human mind — the beautiful female sphinx contrasted with the forces of evil in the menacing 'sins' grimacing like Furies above it — were conveniently

misunderstood. Perhaps that was for the best: more trouble for Epstein was avoided.

There was enough of this on the way as it was. His life for a month or two was a multiplicity of events that would have made any ordinary person's head spin. Naturally, he was relieved, if not delighted, by such a favourable press – so much so that he told Quinn in a letter of 6 June that the head he wanted had been started. At the same time, he'd had another thought. He'd heard a monument to Wilbur Wright was to be erected in America; could Quinn perhaps put his name forward as sculptor for it? It would be a heroic monument to aviation – 'I would propose putting up a great square pylon with a flying figure at the top carved out of native granite by myself,' he wrote. Here was a typically ambitious idea, which Quinn, with his usual energy and enthusiasm, took up: as a member of the Aero Club's committee, he was in a position to help, he told Epstein in reply. Could he send as many photographs of the Wilde tomb as possible? Then there was the South African commission – he had agreed to go there at the end of July; then sheer determination saw that the twenty-ton tomb was transported to Paris, but finding the money to pay for this was going to mean a delay getting it off; and, on top of that cost, there was another blow – a demand from French Customs of £120 duty to pay. Friends tried to help: Shaw, Wells, Sir John Lavery and Leon Bakst (in London for his decorations of Diaghilev's new Russian Ballets) had signed a petition to have the tomb exempted as a work of art. While Lytton Strachey was organizing this, Epstein asked Robert Ross to explain to G. M. Solomon, the South African who had ordered the works (two lions), that he would be coming later, and that this wasn't because he was doing other commissions: Ross had left the *Morning Post* after this review of the Futurist exhibition had been thrown out by the paper's new editor (who called it the work of 'madmen' or 'knaves'), and was now adviser to the Johannesburg Art Gallery, which suggests that he'd recommended Epstein in the first place. Then came the bad news that Strachey's petition had failed; and, to make matters worse, he told Quinn, he was having extreme difficulty in getting funds from the monument's trustees who 'refused with one evasion after another' to pay him 'what was due by contract'. If he'd had this, the expenses of the tomb could have been met; he must have been furious.

As usual, his anxieties were heightened by financial problems, and he must have been in a state of extreme agitation by the time the tomb

arrived at its destination. But there was a worse blow to come: the reaction of the cemetery's authorities and the Préfecture of the Seine police on seeing the work was the same – sheer horror. That, after its warm reception in London, astonished him. The French? *Shocked*? France wasn't England! He was, moreover, made aware of their disgust in a brutal way – going along to the cemetery one morning to put some finishing touches to the head, he found that a tarpaulin had been thrown over the tomb, and that a gendarme was guarding it. He told Epstein that the work had been banned and he was not to touch it. He was, of course, totally mystified by this appalling news – it was ridiculous, mad: there must have been some mistake. Not at all: the gendarme had his orders, the monument was under arrest. He couldn't believe what he was hearing, and the moment the gendarme vanished for a stroll, he pulled off the tarpaulin and started work: not for long – the gendarme, suddenly reappearing, stopped him and summarily threw the tarpaulin over the tomb again. He tried bribes to buy time for frantic and 'hurried spasms of work', but to no avail: the situation was hopeless. Nina Hamnett remembered the dreadful indignities he suffered: she was in Paris for a week and a chance encounter with her hero (she had first met him round at Sickert's Saturday Afternoon Teas with Wyndham Lewis and T. E. Hulme) led her to go along to the cemetery every day with Constantin Brancusi, Epstein and his wife, and some French artist friends of theirs, and she said that the ritual never varied: they removed the tarpaulin and the police put it back.

While the gendarme was providing peep-shows for casual passers-by to the accompaniment of sniggers, Epstein, unable to argue his case with the authorities because his French wasn't good enough (he could speak it, but not *that* well), and having completely run out of money, returned to England where he tried to borrow enough to get back again to look after his work. When that failed, he wrote in desperation to Quinn on 16 September: 'The Conservateur of the Cemetery said that I should change the monument to suit his taste. This I will never do. I must get whoever is influential in Paris in artistic and literary circles to defend the work as it stands. But I must be there to see to it. I cannot see the work of so long a time defaced.' Explaining he couldn't find anyone in London to lend him the money, he went on: 'And I will ask you if you could advance me £50 to enable me to remain in Paris and see the fight through. It is absolutely necessary for me to be on the spot. Mme Jourdain, President of the Academic Salon, has promised to

support the monument ...' Quinn, his suspicions of anyone who couldn't speak English doubtless confirmed by the affair, duly sent the money, while Epstein was busy enlisting the help of others. He had written to Henri Pierre Roché, a dealer and an adviser of Quinn's, on 19 September, who had soon put him on to a number of influential people. Back in Paris to take up these connections, he discovered that the masons working on the plinth were utterly demoralized by the trouble and that the tomb had indeed been defaced — a vast splodge of plaster, set hard, had obliterated all sight of the genitals.

Here was the story of the Strand scandal once more, only this time it was French officialdom's moral wrath that had exploded. Epstein did, however, see the funny side of the latest development: he recounted his experiences to Gaudier-Brzeska who passed them on to Sophie Brzeska: 'When he arrived "les worki" were plastered over; then the Prefect of the Seine had the whole monument covered with straw as being altogether indecent. Epstein took off the straw and plaster, leaving Wilde with his "couilles de taureau" which hung down a good half metre ...' The genitals, recalling memories of the writer's downfall, were too much for the Conservateur to take — 'Let him go to the Luxembourg — the Museum as well as the Gardens — and his eye will soon be edified,' wrote Georges Bazile in the great literary and art magazine *Comoedia* on 9 October. 'The postures in certain of the statues will perhaps appear more indecent and ridiculous to him than that in the monument of Oscar Wilde.' The Conservateur, the one who had instructed the Préfecture to put the monument under arrest, was as shocked as Father Vaughan had been by Epstein's nudes in London, and had made as big a fool of himself; and just as Muirhead Bone, D. S. MacColl and others had fought on Epstein's side then, so the French intelligentsia came to his rescue in the row over the tomb.

Bazile led the protest — Rodin refused to help — and his piece in *Comoedia* was followed by a petition drawn up by the associates of *L'Action d'Art* and published in the same paper as part of a further lengthy article by Bazile: 'With the monument to Oscar Wilde it is the very principle of liberty for Art that is threatened,' the petition ran. 'The interdictions of the Préfecture are a danger for art, and an attack on the dignity of man of sound mind ...'

This was printed on 21 March of the following year. There were other protests, manifestos and articles, and there were letters from writers like Remy de Gourmont and Laurent Tailhade of a furious kind, all of

which were dedicated to the protection of both the dignity of the sculpture and the memory of Wilde. In the meantime, Epstein was no longer able to put off his South African trip, and, in October of 1912, wrote to Bazile to thank him for his support and to tell him of his latest commission: 'I *must* sail at once,' he said, adding, 'I leave it to Frenchmen like yourself to defend my work and the repose of the great soul who rests beneath it. You can do it better than I ever could. I find my expression in a different material . . .' This news must have surprised Bazile, but, as it turned out, he needn't have worried, or have written in *Comoedia*, 'It therefore devolves on us to rise up and protest again and again to make our voices heard in the cause of justice.' For the expedition to South Africa never took place. 'At the last moment,' Epstein told Quinn in his letter of 28 November 1912, 'no doubt frightened by the Row in Paris, the South Africans threw me out. This may not be a bad thing for me, but they had involved me in some expense and I had made a finished sketch model of a lion for them, and I had given considerable time to the thing and yet they refused to give me a penny of compensation for my work and trouble. Dirty swine – I am glad to be rid of them.'

This wasn't the only thing to depress him. On 17 November, Quinn had sent him a cutting of a gossipy article that had appeared in *World Magazine* and had been sparked off by the controversy over the tomb. In the same letter, he told him that the Wilbur Wright idea couldn't come off because Wright's brother was alive. However, a Society of American Painters and Sculptors had been founded, and Quinn hoped Epstein would contribute – a way, he said, to make 'his bow before the American public'. While urging him to get on with the carving, he said that if he didn't want to do it, he would take any other piece he cared to do. He was also going to suggest Epstein's name for two statues in connection with the New York building for the San Francisco Fair that was coming up. He certainly did his best for Epstein.

The sculptor's reaction to the magazine article was predictable: he was furious – evidently, he wrote back, 'concocted by a damned journalist in conjunction with a fool of a brother I have in New York.' It isn't at all clear which brother he was referring to, since the 'Herman' in the report didn't exist. It is more likely that the source was his father, according to his sister Susie. The illustrations would have originated from photographs he sent to Ordway who, presumably, passed them on to his family, a thought which doesn't seem to have occurred to him. He

didn't know, he told Quinn, that one of the pieces – possibly the *Sun-Worshippers* (called *Death* in the article) – existed, and that, had he known of its existence, he would never have allowed it to be published. He regarded it as rubbish, as something that should have been destroyed, and he would, he said, have given anything to prevent its publication. And so, even far away across the Atlantic, the notoriety of the Wilde tomb was being exploited for financial gain and personal publicity, a common enough side-effect of fame that can damage the greatness of the creator. At any rate, the magazine article added to his anxieties, already stoked up by numerous other things, not the least of them being the trouble he was having in extracting his fees from the trustees – he believed that they had either got cold feet about the sculpture, that they were, at this late stage, trying to block its erection, or, much more likely, didn't want to part with the money. He was, of course, quick to become suspicious, but certain subversive manoeuvres behind the scenes were not an impossibility – even Ross, it seems, had been persuaded that the work was indecent, since he had, searching for a compromise (as to be expected), asked Epstein to modify the offending bit. Not unreasonably, he was sickened by this interference from Ross: since there was no indecency in it, he refused to do anything that would prejudice its immunity from such a claim. Ross, however, ignored him and went ahead regardless, finding someone who was prepared to make a large plaque, cast in bronze, to be fitted to the figure as, Epstein remarked, 'a fig-leaf is applied'. With this latest development, depressing English prudery had seeped through at last; his work was now being attacked from both sides of the Channel, leaving Epstein isolated and enraged. Not only had his magnificent sculpture and strenuous efforts been rewarded with a squalid attempt by the trustees to avoid paying the last part of his fee once the work was completed, but one of them, weakly submitting to pressure from the others, had committed the final act of treachery by personally organizing the defacement of the monument. Not that the plaque lasted long: some poets and artists raided the cemetery and removed it, and one evening, during the war, that supremo of black magic, Aleister Crowley, approached Epstein in the Café Royal with it dangling round his neck, and presented it to him.

Epstein was by now exhausted by the troubles that had blown up over his work. The row at the cemetery had, he told Quinn, brought him to the edge of 'a nervous breakdown'; while he thanked him profusely for generously letting him have the £50 that had enabled him

'to see the work through' (by which he may have meant carrying out necessary touches when the gendarme's back was turned), the whole business had left him with huge debts and penniless. He wanted to escape: 'My one desire now is to get to some quiet spot and do some work and leave large commissions alone. I am mad to think of doing big things and especially for the swine that have the giving of them . . .' He said he wanted to do the carving for Quinn but had to have peace of mind – 'I cannot get at it until I am rid of all these worries,' he wrote. He told him he was appreciative of his extreme kindness and patience, and how grateful he was that he had, through Quinn's financial assistance, been given complete freedom to do as he pleased over the carving the American had commissioned. That made him want to achieve something specially good for him when at last he could get down to it – as good, for instance, as a work he had just completed – a third portrait of Euphemia Lamb: 'One of my best things.' It was a mask of her, a brilliant head, and he hoped perhaps Quinn might take this in place of the carved stone: in the meantime, the small bronze of a girl Quinn had bought had been given to the Chenil Galleries to send on to him – Epstein was always meticulous over confirming details of sales, however unworldly in other ways. But about the possible San Francisco commission he was full of doubts: after the trouble over the tomb, could he face such an undertaking? He didn't want to get into further difficulties – better to hide away in obscurity and think things out: he had no desire, he informed Quinn, to emulate a successful New York 'pusher' like Jo Davidson, whose work and methods filled him with contempt. Despite his recent ordeal – unhelpful clients, the shocked public suspicious of imagination, originality and of art itself – and the arguments over money, he was determined to trust his own beliefs and judgement. And there was this dealer, a Mrs Smith, who wanted to give him an exhibition; yet that had its own dangers – 'the things I should like to show such as the *Sun-God* are impossible in any exhibition for the public, and I won't be mad enough to think of it . . .'

With fees owed to him and bills to pay (the donor's responsibility, he claimed, not his), Epstein was thoroughly disillusioned by the end of the year. The tarpaulin still covered his sculpture, and it remained there until the outbreak of the 1914 war when, mysteriously, it was removed without comment: by that time, doubtless, no one could remember what the row over the tomb had been about, and the great writer, poet and scholar, winner of the Berkeley Gold Medal for Greek at twenty, of

Firsts in Classics and Literature, and of the Newdigate Prize for English verse at twenty-eight, who had been imprisoned in England and whose spirit had been condemned to darkness under a stone slab, was honoured at last. Now, of course, Wilde's tomb is a 'must' in the official tourist's culture trail. Yet, astonishingly, the vandalism continues: in this beautifully kept cemetery with its avenues of chestnuts, clipped hedges, mown lawns and banks, its tidy paths meandering among graves surrounded by unusually choice trees, the only tomb which is repeatedly defaced with graffiti is the monument to Wilde: tradition does indeed set hard.

5

Quinn

EPSTEIN made new friends in 1912; he was particularly fond of Gaudier-Brzeska and T. E. Hulme, and his feelings about both were enthusiastically reciprocated. While Sickert had his soirées, and John his drunken parties, Hulme had his Tuesday evenings in Frith Street where a cross-section of London's art and literary life met for intense discussions (and these could turn into quite violent arguments). Ford Madox Ford (whom Epstein remembered as a most 'pontifical' person), Edward Marsh, A. R. Orage, Wyndham Lewis, Ezra Pound, Richard Aldington, Ginner, Gore, Gilman, Brzeska, Bevan and Stanley Spencer provide a typical sample of those frequently present. No women – Hulme reserved women for love affairs in the suburbs, on the architectural character of which he was something of an expert. But Epstein had a very soft spot for the energetic Brzeska: he had a certain brilliance, great vitality, described Epstein as 'the foremost in the small number of good sculptors in Europe' (the others being Brancusi, Archipenko, Dunikowski, Modigliani and himself – 'WE the moderns', as he called the group), addressed him in letters as Cher Maître, and lived only a stone's throw away in Paultons Square. Epstein, who said Brzeska was a follower – such a quick follower that he followed 'overnight as it were' – and not an innovator, was interested in his work and was prepared to put up with the neurotic Sophie Brzeska (the mother-figure with whom Brzeska shared his life) on account of his great liking for this young, warm-hearted admirer.

Epstein had, however, also made a number of friends among the Montparnasse set – Brancusi, Modigliani, Picasso and others of whom

Gaudier thought so highly – during his ordeal over the tomb in the summer; and, only a few days after the letter of 28 November went off to Quinn, he left suddenly for Paris with his wife, setting himself up in rooms over a baker's shop at No. 5 Rue Compagne Première in Montparnasse, the centre that had become fashionable when Picasso moved his studio there, bringing the art quarter with him. The immediate cause of his sudden departure was the appalling outbreak of noisy building operations on the site next to his studio where Ashbee was extending his development with some tall houses of a 'Renaissance' style opposite Chelsea Old Church, and the racket sent him into the sort of frenzy which had overcome Whistler during earlier construction works: for a person seeking peace and quiet, this latest development was the last straw.

Unfortunately, in the rush to get away, problems had arisen over a forwarding address; as a result, a letter from Quinn of 10 December, urging him to contribute to the Armory Show organized by the Association of American Painters and Sculptors for anti-academic purposes, had been delayed, reaching Epstein in Paris at the beginning of January. This exhibition was, Quinn told him, to be a very important art event, that it was going to be held in a gigantic apartment in New York's Lexington Avenue, and then, after running from the middle of February for a month, would be transferred to Chicago and Boston between the end of March and May. As Epstein wanted his work known in his home country (Quinn reminded him) here was an excellent opportunity to realize that ambition. Quinn was quite right – the exhibition was exceedingly prestigious: as New York's introduction to Cubism, Futurism and Expressionism, and to Cézanne, Gauguin, Van Gogh, Picasso and their contemporaries and followers, it was larger than either of Fry's shows at the Grafton Gallery, the second of which had just closed. So clearly it was important for Epstein to contribute work. In the circumstances, however, he had to write back on 11 January to say the suggestion had come too late – February was cutting it too fine. 'Besides,' he said, 'I have not been asked. Why, I don't think that it's worth conjecturing . . . Perhaps only dealers were asked to show' – Epstein didn't yet have one – 'as that seems to be the rule nowadays; and there is no doubt but the European dealers have got hold of a lot of good pictures.' This may have been a reference to Berthe Weill, Daniel-Henry Kahnweiter and Gertrude Stein, all of whom either owned or represented the paintings of Picasso, Modigliani, Braque and Gris (although Gris, oddly enough,

wasn't invited); he would have been even more upset if he had heard about the show from Brancusi who had been approached a few days after Quinn wrote. He assumed it was another, familiar rejection, this time by his own country. No one over there knew he was now a naturalized Briton – in Quinn's next letter, Epstein was asked to sign an affidavit to confirm his US citizenship (to avoid customs duty for the bronze sent by the Chenil Galleries).

The tomb was, of course, a most likely cause of his sudden return to France; still covered with tarpaulin, it was much on his mind, and when there he could at least encourage others, like Bazile, to harass the authorities, which they did. Apart from that anxiety, there were his feelings of isolation in London, and of being at odds with the English and their conventional aesthetic taste. In his next letter to Quinn of 3 February he repeated his favourite diagnosis of their problem – that 'the bad air in London befogs' their brains: 'Certainly the great B. P. is entirely befogged over sculpture, painting and writing. To startle them out of their respectable sloth is a task for a Hercules.' Then the arrival of this *Second Post-Impressionist Exhibition* of the previous autumn (and which may have had a hand in prompting the Armory show) possibly unsettled him. Did that 'startle' the English 'out of their respectable sloth'? Hardly; as late as the 1920s, London's art students were still kept in ignorance of the Impressionist masters, of Cézanne and his revolutionary followers, examples of their work being deliberately withheld from them. But when Epstein saw this display, he must have had an uncontrollable urge to get back among its artists, many of whom he knew; back to the source of these extraordinary developments, to Picasso who had swept on, his disciples in hot pursuit, from late Cézanne and the gentle airstream of the Blue Period to the hurricane force of Cubism, geometry and collage. The magnetism of Paris remained irresistible, as this bombshell of an exhibition, like its predecessor, instantly reminded the enlightened few. For what, after all, was there in England to compare with such a panacea of inspiration, vision and pure invention? Vorticism? In the hands of Lewis, William Roberts and others (and, fleetingly, Gertler), this side-effect of Marinetti's Futurism was an immediate response to the onset of mechanization; it had plain associations with graphics (something the American, McKnight Kauffer, was quick to pounce on in his hugely successful Underground posters for Frank Pick of a few years later) and was traded by a pamphleteer who had so little sense of proportion that

he would promote or demolish (in his magazine *BLAST*, launched in 1914) trivia with the equal vehemence he would devote to things of importance. For Epstein, such fashions were completely beside the point: they had no more to do with art as he understood it than Fry's Omega Workshop had. What was happening in England was quite apart from what was happening in France. 'This,' he said, 'was a period of intense activity amongst the artists of Montparnasse.'

Unfortunately, however, he found it difficult to concentrate in Paris; that was most worrying since he was trying to make up for lost time and to forget anything outside work in hand – the 'personal enmities' and ugly innuendoes he had left behind in London, and which prevented, he told Quinn, his work selling as well as it should. He may have been thinking of Fry's attack on his *Maternity* which had been briefly exhibited the previous year, for he said that in England 'the most ridiculous ideas exist as to what is good sculpture and bad, and the critics, almost without exception, hate what I do; and for such opposite reasons that I see, clearly there is nothing either in the critics' opinions or in those whom they influence.' Again, he put down some of their ignorance to the weather – 'the heavy air in London depresses people, makes them heavy, unintelligent'; the weather was another reason for leaving – he dreaded the worst of the winters with their habitual and dirty 'pea-soupers' that closed in on the city. In Paris, the air was much better, 'fresher, cleaner', and he was back in the district where he had lived as a student. His favourite restaurant was in his street, a little place run by an Italian woman named Rosalie, and it was there, among others, that Modigliani sold his paintings and drawings for five francs or less to customers (Nina Hamnett bought several), or gave them to Rosalie in return for a bifstek. Epstein's end of the Rue Compagne Première, a narrow eighteenth-century street packed with shops and tall apartment houses busy with activity, was nearest the Luxembourg Gardens which he loved: turn right into Boulevard Montparnasse, then first left, and there to greet him were (and still are, thankfully, a Seventies plan to build over them having been dropped) the long, rich and glowing pleached trees of the Avenue de l'Observatoire stretching back to his favourite haunt among the statues of the Queens of France in the Luxembourg. After that, the Place de l'Odéon and on downhill to the giant, spectacular St Sulpice with Delacroix's Christ throwing the money-lenders from the Temple, and the corner of the Rue des Canettes where he liked to buy his wide-brimmed black hats at a priests'

outfitters, just along the road from Charles Ratton, a friend of many years from whom he obtained much of his African and other non-European sculpture. And then on down to Boulevard Saint Germain and its atmospheric church, the little galleries round the Rue de Seine and the cafés where he met the artists in his circle – Aux Deux Magots and De Floré. 'There were more men of talent who came to the cafés then than at any subsequent period,' Epstein said, adding that their reputations soon brought the nightclubs, sightseers and tourists laden with cameras. When, however, his visits to Paris became a week-long Easter ritual after the First World War, he stayed in that quarter, near the Luxembourg Gardens and always at the Hôtel Odéon: in a sense, his roots were there.

Although he found it difficult, if not impossible, to get down to any constructive work, the move had its usefulness. The four months he was over there served as a necessary break for air after the turmoil of the Wilde experience had brought him close to an emotional collapse; and it gave him a chance to shape his ideas, and above all to rest, an ordeal forced on him, as it turned out, by his landlord, the baker, who slept during the day and infuriated Epstein by refusing to allow any carving because the hammering woke him – it was a painter's studio, he was told, not a sculptor's. This was the first serious hitch in his plans; and so, when he wrote in February to Quinn, offering the *Euphemia Lamb* bronze for £200 (he could deduct the £110 already paid for the stone head so that they 'would then be all square') and reminding him that, should he ever do the head, he 'could see it and take it or not' as he wished, he explained he was 'looking forward to getting a studio' where he could work freely. In fact, he was searching for somewhere with Modigliani – 'a shed', Epstein called it – where they could do their sculpture together in the open air around the Butte de Montmartre: Modigliani, debonair, witty and beautiful, whom he saw every day (they must have made a handsome pair), was doing no painting at this period – he was drawing or making the long carved heads that Epstein believed were suggested by African masks. They never found the 'shed', yet, despite the problem of concentrating and working that made his time in Paris so 'arid', he was enjoying being there. He was stimulated by the creative atmosphere of the Montparnasse group 'for whom', as Cocteau described it, 'commercial values and the problems of the general public simply did not exist'; and he liked its critical spirit. There were fewer people around who were, he told Quinn, 'bluffed by fake artists than

elsewhere', although, of course, there were the usual 'cliques patting each other on the back, but since I stand outside them I am in no danger of getting pats on the back for nothing.'

He did stand outside them, remaining, as he did throughout his life, curiously detached from the groups he moved among. This, one of his strengths, had the practical advantage of protecting him from unsettling distractions, and there were plenty of those in Paris anyway. While Mrs Epstein became increasingly worried he might get mixed up with narcotics in the company of Modigliani, Cocteau and others, he found more innocent sideshows a trap. He told Quinn: 'Cafés are a great temptation' – kept him up late drinking – 'and the talk! Enough art talk to talk one's head away.' He had avoided them in his youth and admired Brancusi for never going near them – like Epstein when a broke student, he drank only milk (and later water) and worked ceaselessly; whenever Epstein visited Brancusi's studio, he always found him working (unlike Modigliani, deep into alcohol and restless with drug addiction). He envied Brancusi, because, from the point of view of work, he remembered the period as his worst for 'fruitless attempts to settle down' and carry out ideas for sculpture. He had, of course, another interest which preoccupied him: African art. As he said, he started buying it in a small way when in Paris in the 1900s, at a time when other acquisitive artists were doing the same. They perceived it as a new source of inspiration, he said, believing that the quite extraordinary interest shown in negro art by those who followed the Impressionists could be explained very simply: it was a 'means of escape' from the impasse which their predecessors had reached at the turn of the century, its originality of ideas providing a new way of looking at life, although he himself thought that only Modigliani had used the influence to greatest advantage. As far as he was concerned, of course, his interest in it was for different reasons, this fantastic find being an extension, through art, of early experiences. While such a passion for it in one so young may seem inexplicable to those unaware of his Hester Street background, it would not have seemed so to him: here was an example of continuity, of the unbroken line of development that could be compared to an understanding of tradition. He had African friends when in New York as a boy, and it was quite natural for him to hire an African or Indian model during his time as a student: he wasn't flouting convention then, any more than when picking up a piece of Fang art for a few francs: the African brushed off on the sculpture, and vice versa –

the one explained the other. And though he insisted that his all-important influence lay with the guiding principles of classical works set down in the Louvre and the British Museum, the fascination of the amazing inventiveness of African art returned when he was back in Paris and met Paul Guillaume.

Guillaume was the dealer who, in Epstein's view, started the vogue for this form of art after it had been first spotted by the artists. Another possible source may have been Ernest Ascher who had a gallery near the Dôme, Epstein's favourite haunt close by in the Boulevard Montparnasse, from whom he bought work up until the Second World War. And at Joseph Brummer's shop he saw the famous Pahouin head that came to be called the 'Brummer Head' (when he tried to buy it, the dealer immediately withdrew it). By now, however, prices were beginning to rise, and everyone, he told Quinn, was on the look out for examples – he had heard of a head selling for 2,000 francs. On the other hand, he had had a bit of luck, by chance coming across four 'wonderful' pieces for only 100 francs each: three figures and the kind of mask used in dances – 'genuine old works without a touch of European influences'. He was so excited by the art that he wanted to pass on everything he felt about it to the American. Here was a factor of key importance: Western influences were so widespread that even Gauguin had had to search Tahiti for a culture that was uncontaminated by them. He said: 'The effect can't be conveyed in words – to feel it, they must be seen. The beauty of the lines, of the carving, the perfect realization of forms; nothing misunderstood, vague or primitive, in the sense of the work being without accomplishment. They are unlike other African things made, doubtless, in decadent periods.'

Quinn, of course, was immediately interested in the news of Epstein's African finds, particularly since they were so cheap. Was this, one can imagine him thinking, a source of investment worth investigating? First, however, he had some good news: he had managed to get the Euphemia Lamb into the Armory (he was a member of the organizing committee) despite attempts by an American woman 'to pass him over'; Epstein had once made a bust of her that she didn't find flattering and she took a deep dislike to Epstein's wife, as a result of which she became his 'sworn enemy'. ('It's good to make friends,' was his comment on this, 'but one cannot help making enemies.') Quinn was arranging prices for replicas, the exhibition was a great success and everyone, he said, wanted to see the work of the sculptor of the Oscar Wilde Tomb. Then

A. Davis, Photo Studio, 260 BOWERY, NEW YORK

1. 'This belongs to Honey Solomon': these words are written on the back of this photograph of Epstein at thirteen. Honey was his mother's sister. Even at this early age, the determination which carried Epstein through life is already showing.

2. *Above:* Epstein with his head of Bernard van Dieren, 1916, the inspiration for his *Risen Christ*, 1920.

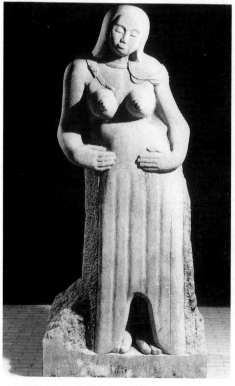

3. *Maternity*, 1910.

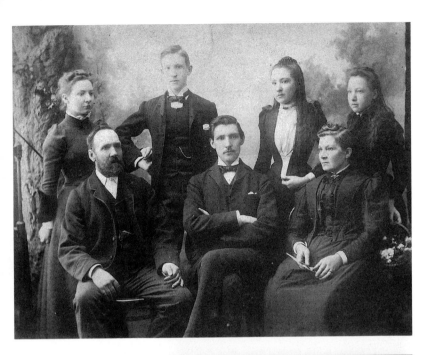

4. *Above:* Margaret Dunlop in a family group *c.* 1900 before she met Epstein: Margaret left, standing, her father left, sitting, her mother right, sitting, her husband centre, sitting.

5. Margaret Dunlop *c.* 1905, about the time Epstein arrived in London.

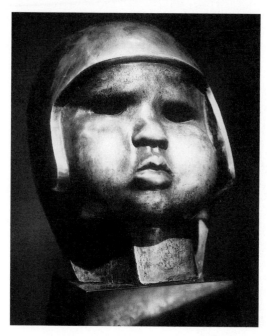

6. *Romilly John*, 1910, the head hailed by T. E. Hulme as the finest piece of sculpture since the Renaissance. The shining hair, which Epstein told Quinn must be kept polished, is of great significance to the work.

7. *Below:* British Medical Association Building (now Zimbabwe House) with the frieze of figures, Agar Street façade: unveiled in 1908 amid a storm of abuse, the sculpture was later mutilated in 1937 after the building was bought by the then Rhodesian government.

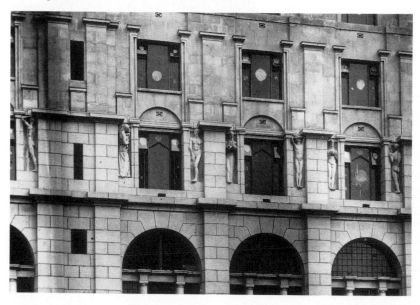

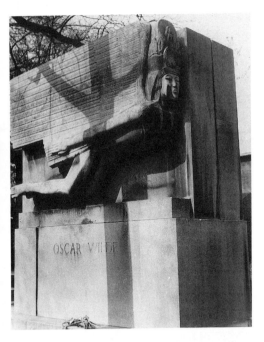

8. *Left: Oscar Wilde Tomb* at Père Lachaise cemetery, Paris, unveiled 1914. In this massive monument to the freedom of the individual, the horizontal lines of the wings capture the formality of Wilde's style, while at the same time retaining the rectilinear frame of the twenty-ton Hoptonwood block of stone from which the work was carved.

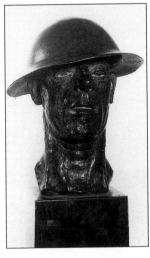

9. *Above: Tin Hat*, 1916. The horror of war is immortalized in this study of the British tommy's resignation, courage and obedience.

10. *Left:* On leave from the army in February, 1918, at Guilford Street; on the mantelpiece behind Epstein, a South Indian, fifteenth-century AD female figure from his collection.

11. Meum Lindsell-Stewart *c.* 1920.

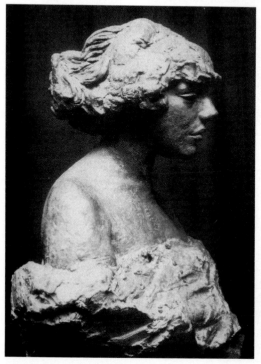

12. The first bust of *Meum Lindsell-Stewart*, the summer, 1916, when she was aged nineteen. In this beautiful creation hair and drapery float like clouds.

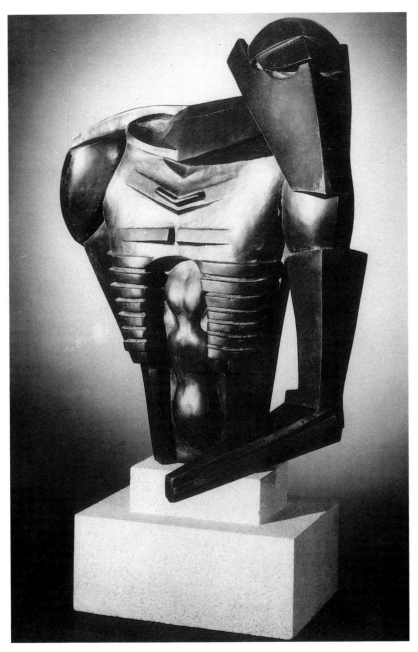

13. *Rock-Drill* in the modified form exhibited at the London Group in 1916; with the reduction in size, there was immense gain in power.

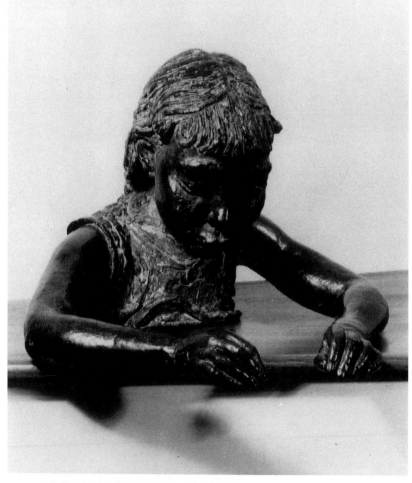

14. *The Sick Child*, 1928: Peggy-Jean when she was recuperating from an eye operation and one of Epstein's most compassionate studies.

he wanted information about the African sculpture. Would he part with any of his pieces? What was the material used? Could he get some for him? Could he send photographs of examples? Epstein, somewhat significantly, never replied directly to these questions (after all, these discoveries were his, and part of his *own* private collection), merely remarking that he wasn't so keen as it might appear to sell for money, glad as he was to have the balance on the Lamb – he had the trustees' outstanding debts on the Tomb hanging over him, and had to meet them to enable his wife 'to maintain a home without continual threats from the bailiffs.'

Anxieties were building up. He remained haunted by the problems over the Tomb, still covered, still waiting to be officially unveiled. He had become exasperated by the Paris life. He had achieved nothing of his own, and found the distractions increasingly irritating. He did tell Quinn in passing that there was a big show of African sculpture being held in the spring and offered to buy pieces for him if he agreed, reminding him that the choice was entirely a matter of judgement – no records of artists' names existed – but that good pieces would be as valuable as Egyptian and Chinese in a few years. However, Epstein was more taken up with a story he had come across in the English *Daily Mail* – a project had been suggested by Jack London, the American writer, for a huge sculptural work in a city, and Epstein, with a predictable burst of optimism, at once saw himself at the centre of the epic. Not only that; he was already planning how to get the idea off the ground. He would know where to go to get the sculptors for it; this was a project for a team. 'No one would get jobs, however renowned, and young men of talent and ardour would be given an opportunity,' he explained. 'A large body of able craftsmen could be trained, as in the great periods of sculpture, in India, Egypt, the Middle Ages, or in Mexico. Much could be done and a great work started . . . something may come of it.' The dreams Epstein had were like those of an inspired child, simple and clear to him, yet utterly improbable; here was one of idyllic proportions, and, like the dream of the Wilbur Wright monument, it vanished with reality.

With this letter came the announcement of a complete change of plans: as suddenly as he had left London four months before, he was leaving Paris – back to England for the summer; he had rented a cottage close to the sea – 'Bay Point', at Pett Level, near Rye in Sussex. 'I am leaving more or less immediately, my wife the following day . . .'

Was this abrupt decision prompted by the shock of another kind of dream, a telepathic dream he had that month? 'One night,' he wrote, 'in March, 1913, in Paris, I dreamed of my mother, and immediately received news of her early death.'

He left at once; the need to find a solitary place to concentrate had become desperate after this disturbing and wasteful period in Paris and he couldn't wait to get to the perfect surroundings in Sussex where he could at last start work: it was a tiny house with sheds in the garden for use as studios.

Nothing much has changed since he was there: 'Bay Point' overlooks the Military Canal (built as a defence against Napoleon), a straight channel of water that comes to a halt at a high, blunt and bushy headland above the sandbanks, a mysterious building hidden by trees and the huge edge of the cliff. His 'sheds' have gone, there have been the addition of a few more cottages, no larger than chalets, and some caravans have settled like litter by the shore. This is Pett Level, remote, somehow rather eerie, no more than a dot in an empty landscape. Yet it was here that his first major phase of work occurred. Like his move to Paris, it was again a decision that had considerable significance if only as an escape to work away without, as he told Quinn, 'bothering a soul', and with no one to bother him, either.

A note hastily sent several days after leaving France confirmed his arrival there, gave Quinn his address and the latest news of the Oscar Wilde controversy; now that he was in England, the Tomb was back in the forefront of his mind. The cause, he said, had been vigorously taken up in Paris, but on moral grounds [grounds which Epstein didn't like because they had nothing to do with art]: he was referring to the 'Petition by artists for the liberty of art' that had appeared in the periodical *L'Action d'Art* organized by Bazile on 21 March, two copies of which he sent to Quinn. Despite the hectic move, he had already got down to work: 'I have three pieces of stone and won't leave this place until they're carved into something.'

Epstein had indeed moved swiftly: a letter from Quinn was on its way across the Atlantic on 30 March to tell him that no replicas of Mrs Lamb had been sold, although much admired, and asking again about his African figures – could he give him first refusal if he did consider selling them? And could he go to the African exhibition and buy works for his collection? He wrote again a month later, assuring Epstein that it

was absurd that any official should want the Tomb removed or altered. 'Time will settle the matter – do nothing and all will be well in the end,' he said. He was very glad he was at the cottage and didn't wish to disturb him by getting him to go to Paris about the African show – he was not to go if it broke up his work. All the same, he was hoping he would. The correspondence remained as steady as ever, based on each person's need of the other: Quinn, the lawyer, intent on extending his range of investment, Epstein, the adviser and artist, intent on keeping his patron on a tight lead. So far as the three pieces of stone are concerned, it is difficult to identify the particular works he dug out of them in a three-year prolific period of activity that produced, besides *Rock-Drill* and *Cursed Be The Day I Was Born*, *Birth*, three versions of *Doves* and two of *Venus* in marble, not to mention ten or eleven portrait heads and busts, all of which were done either at Pett Level or in London during 1915. There were, in addition, the drawings which led up to his works of the imagination – in particular *Birth* and *Rock-Drill*. It was there, too, that he discovered a local material which he christened Flenite. He wrote on 10 May to tell Quinn that the 'African show hadn't come off yet'. He said he loved 'Bay Point' and would be content to stay for a long time – 'I am at peace here and I can work on a beautiful stone called flint which is as hard as granite, and needs lots of patience for me to make any impression on it'. From the conquest of this flint of beautiful greenish-grey came the remarkable works in Flenite: the two-sided study of birth and sexual love, and two extraordinary figures that evoke the spirit of early Egyptian owls which so interested him. The time taken must have been immense, but in this little place on the Sussex coast he had the time, at last, just to work. The only people they saw were fishermen and coastguards, and so he was left undisturbed. He said he had had enough of cafés for a very long time. 'I don't think I'll vegetate here,' he assured Quinn. He could always pop up to London to get materials, tools and other things – or have friends down. His wife was intensely occupied with her garden; it was she, possibly, who planted the hedge at the front for privacy and for protection against the south winds from the sea, and which has now grown to an enormous height and thickness. 'I seem to be in calm after troubled waters,' he wrote.

In fact, he had so fallen in love with his cottage that he wanted to buy it – he had everything he needed there, sheds to work in, it was freehold and suited him perfectly: the landlord was willing to sell it for £450, and could perhaps be persuaded to sell it for less, if he gave him the

money in cash. Or he could obtain a Building Society loan of £250, leaving him to raise the balance. For cash, there was the possibility of him getting it for between £350 and £400 – all details of the possible transaction looming up in Epstein's optimistic thoughts were relayed to Quinn. Could he stand in for the mortgage and Epstein repay him at a rate of £40 a year, with interest? – not an unreasonable offer when one thinks, say, of George Cadbury's benevolence that cost the purchasers of his Bournville houses a total of a mere £23 in interest for twelve years at around that time. Quinn could have his eleven pieces of African sculpture for security – carvings in wood and ivory – some Fang, but every one a 'super' example and 'in safe keeping' at the Tate Gallery. He wanted to make the house over to his wife to avoid pressure to pay the still outstanding debts on the Wilde monument, owed by the 'donor'. The house had become his latest obsession: he had to have it – there were fields and fresh air, it was convenient and his health, which he described in an earlier letter as 'indifferent', had improved: above all, perhaps, as a symbol of independence, it represented solid security, something he had never experienced. He didn't mind putting on the pressure: 'If I do not buy the place it will be very likely sold. I might have to move in December as the landlord is unwilling to let it for long.' Everything could be tied up with his lawyer, Mr E. E. Baines – everything, in these rushes of excitement, seemed simple to Epstein because he saw any project that absorbed him entirely from his own point of view. But perhaps the landlord was taking advantage of him? Could Quinn advise him?

Unfortunately, he had read more into his relationship with Quinn than in fact existed – he saw it as a real source of support in times of stress. Quinn simply saw Epstein as a means of investing money for him, a patron and artist arrangement. Poor Epstein: he was given short shrift by Quinn – to lend him £200 was out of the question. Why, he had just bought two large Puvis panels (oil paintings Puvis de Chavannes made in 1866 in preparation for his frescoes in the Picardy Museum in Amiens) for $28,000, a bit of news which might well have infuriated Epstein, already disappointed by Quinn's meanness: buying work of a sentimental kind for such a cost could have made him want to put up his prices. He didn't believe in lending 'friends' money, was justification for his refusal to let him have, in his terms, such a small amount: some friend. However, the mention of Epstein's African collection was too much for Quinn to resist – if he was willing to sell them, he might

be able 'to squeeze £100'; hardly a generous offer when Quinn was desperate to get hold of this kind of work, coming back to the subject of the African show in Paris at the end of his letter.

This turn of events occurred in June and relations between them became strained, often the case, unfortunately, where loans are concerned, particularly when the person in need is known to be habitually short of money as Epstein, of course, was. And Quinn's attempt to use Epstein's precious and meagre collection as a bargaining counter increased tension, a devious move from which Epstein would have taken time to recover. He did recover, however: Epstein dropped the matter of the house, and the correspondence − there wasn't another letter from him for five months. He was far too busy with his Flenite works and with the first and second versions of the *Doves* to become embroiled in a petty, pointless argument. He was also involved in a mass of exhibitions. For the twentieth-century Jewish section of *Modern Movements* at the Whitechapel Gallery (to be held in the summer of 1914, and to which he was contributing), he went, at the gallery director's request, to Paris with David Bomberg to check the latest developments in French art; this visit, made shortly after writing to Quinn on 22 May, meant he could catch up with the work of friends like Modigliani, Jules Pascin, Picasso and Brancusi, and attend the sale of African art at the same time. Then there was the Post-Impressionist and Futurist show in October at the Doré Gallery in Bond Street where his Flenite figures, drawings for *Rock-Drill* and one version of the *Doves* were exhibited − if Quinn wanted to buy the *Doves*, Epstein told him when he did at last write to him again on 21 October, he could cable the gallery. With Wyndham Lewis and Gaudier-Brzeska, he contributed to the Brighton exhibition and Camden Town and others in December; and, that month, he was having his first one-man show at Mrs Smith's Twenty-One Gallery at the Adelphi in London − ten pieces of sculpture, with drawings, mostly of the Pett Level period − the first version of the *Doves* and Flenite figures among them. Then, he was to show his work at the Goupil Gallery in March. It is curious to think of this man, working alone in sheds in a windswept and isolated place, far from friends, absolutely self-sufficient, kept going by an art-support system that generated its own extraordinary power − and quite suddenly and unexpectedly besieged by galleries wanting to show his work. Here he was, carving difficult blocks of flint, or shaving away the last, minute, superfluous irregularity in his marble *Venus*, crating pieces, taking

them to London, collecting materials to bring back to Pett Level to continue working on other things: he presents a picture of utter determination, of mental and physical strength, of resilience in adversity. Despite disappointments, tenuous communications, desperate money worries, the aggression of enemies, he refused to be diverted from his purpose.

However, he must have passed on the news of his successes to Quinn with a certain relish, although he mentioned only the Doré and his one-man show: he retained, at all times, a rare dignity characteristic of his fastidious nature. He did let Quinn know he had been working hard (a response to Quinn's complaints about having to do the job of his incompetent staff), adding:

> I feel my things are better than ever; which is some consolation, for the hard knocks dealt to one by the critics might otherwise discourage me. I look upon the art critics as all bought by the dealers and since I let no dealer corner me I can understand their rage. In the *International* for October there is an article on the Wilde monument which starts off by assuming that I altered it. I did nothing of the sort and the deadlock is still on.

It certainly was: in November came a report that the monument had been unveiled by Aleister Crowley, in defiance of the Préfecture's authority. A news item in *The Times* of the 6th read:

> This monument has remained hidden from the public gaze since its erection by order of the Prefect of the Seine on account of certain features which were considered to be objectionable. Mr Crowley was supported in his action, taken, as he explained, in the interests of the 'freedom of art', by some twenty enthusiasts from the Latin Quarter. The authorities were taken unawares and knew nothing of the invitations distributed last night ... to assemble at Père Lachaise. The Keeper of the cemetery explains that there is now no objection to the monument in itself, but that the authorities, for their own protection, demand that a certain portion of the monument shall be more securely fixed than is at present the case. The monument will be covered up again this evening and will remain veiled and under special watch until this is done.

Epstein wrote to the editor immediately:

I have read with some surprise in your issue of November 6th a
discussion of an unveiling of my monument by Mr Aleister Crowley.
In order that there may be no misunderstanding on the subject of my
own views, I should be obliged if you would give me the opportunity
of stating in your columns that I should have much preferred the
monument to remain veiled until such time as the alleged
improvements made against my desires have been removed. I do not
consider any unofficial unveiling a compliment to me, though no
doubt a jolly occasion for Mr Crowley and his companions.

This headed *The Times* letter columns of 8 November, giving an idea of
the exceptional influence Epstein's name had: it put his address as 35
Devonshire Street, W.C., which had its amusing side – a tiny attic
above Harold Munro's Poetry Bookshop that Epstein had rented,
together with a nearby garage for a studio in Devonshire Mews, when
rushing to London to get ahead with a big work while his two exhibitions
were on. As it happened, his relationship with Mrs Smith at the Twenty-
One Gallery was not a success, since she irritated him as much as he
claimed she irritated possible clients. It didn't help, of course, that his
dislike of dealers equalled his dislike of critics, both of whom he
regarded as deeply destructive to standards of art: dealers gave works to
critics in exchange for good reviews, so conspiring with them to mislead
an already ignorant public in the interests of sales. He disliked their
bossy form of materialism and wished he could avoid that world, but he
had to live; and it was not until he met Oliver Brown of the Leicester
Galleries that he found a dealer with whom he could hit it off. And, like
something pre-ordained, he did meet Brown at just about this time in
the backroom of Dan Rider's bookshop in St Martin's Court. It was a
chance meeting, but one which Brown remembered vividly, ending with
Epstein saying he would bring him a bronze of a 'baby's head' which he
was certain would appeal to the sentimental English public.

After his exhibition at the Twenty-One Gallery, his anger boiled over
once again when he heard that Mrs Smith had written to Quinn about
the sale of one of the exhibits, the Romilly John head. 'She has done
this entirely without my consent and against my express wish,' he wrote
to Quinn, who, for his part, hadn't approached her at all. He had
approached John for his advice on what works of Epstein's he should
buy (a rather curious way of going about things, perhaps, but he felt
safer when advised by outsiders), and he had recommended the head of
his son, for which he suggested a price of £100. So he asked Epstein to

reserve this on condition that it would be the first of two replicas (otherwise, he claimed, he had to pay 15 per cent duty), and that it was certified as such. The bronze he really wanted, of course, was the original owned by John, had he been prepared to sell it; since there is no difference between the first half-dozen or so replicas cast, this obsession with originals, which cropped up over and over again during Epstein's lifetime, and even after he was dead, can generally be accounted for in terms of value. However, in Quinn's case this was not entirely true: one of his great triumphs was getting legislation through the Senate in October 1913 that prohibited tax on original works of art; with paintings, this meant that copies could be identified; with sculpture, no more than the original and only two replicas would be allowed into the country without tax. It would bring purity to American art collections and, Quinn told John, 'tend to do away with fake Corots and so on.' It was a curious law but Quinn took advantage of it at once.

Epstein had written off to Quinn on hearing what Mrs Smith had done. He had no further dealings with her now that the show was over and regretted ever having it at her place; she refused to put up some of his drawings, had 'spoilt' his sales and, on what had been sold, took 25 per cent commission, which was 'bad enough'; but, on top of that, he had to pay all the expenses of the exhibition: no wonder he was furious – he can have made little out of it. Quinn, however, was amazed by Epstein's news, said he had never had a letter from Mrs Smith, had never told her he had bought the head, had never, as a matter of fact, had anything to do with her, and so couldn't see why she should think she was entitled to 25 per cent of a work ordered from Epstein via John. But he repeated his earlier condition with one alteration: he had to declare the work 'as an original piece of sculpture, or the first or second replica in order to be duty free.' Epstein must have thought this an extraordinarily pedantic condition and that Quinn wanted the certification for record purposes, should he wish to sell it. After all, £15 wasn't much to pay in duty; and, anyway, who would know if it was a third or fourth replica?

Whatever Epstein secretly thought, he agreed to send the head – 'Your copy is the *original one*.' (Original one? Surely not – John would scarcely have parted with his, and it was Epstein who needed the money, not him.) The underlining of the words indicated his extreme irritation over such a petty point. He wouldn't be long about sending it

– he was only waiting to get a new base for it in 'a very fine stone'. To keep his interest going, he had sent Quinn a reproduction of the *Doves* (which had just been sold) that had appeared somewhere, with the accompanying observation that, in future, he would prefer to deal with Quinn direct – he wanted to have nothing more to do with the 'nasty' Mrs Smith who took so much ('much too much') and had made him pay the expenses of his exhibition and had refused to put up some of his drawings. Although constantly dogged by such problems, mostly emanating from a mixture of unworldliness and dynamic determination, attention to his work in hand was never diverted by them (a good deal of his fury was disposed of in his letters). He had now taken a 'workshop' in Lamb's Conduit Street and was in the middle of some large pieces which he intended showing at an Anglo-American exhibition that was coming off in the summer at Shepherd's Bush in London. He hoped, moreover, to send some of his smaller bronzes to the Panama Canal exhibition planned for San Francisco: he seldom let up, and always had an eye to some place where he could expose what he was doing to the public where he 'might make some sales'. Money was constantly on his mind: he was still worrying, for instance, about Mrs Smith laying her hands on some part of his fee for *Romilly* which *was*, he assured Quinn again, the original – so worried that he added a PS to a letter of 14 February: 'On receipt of the Romilly head, will you send the cheque direct to me at the above address' (Devonshire Street).

The bronze went off on ss *Olympic* four days later, and a letter confirming this, and the fact that it was the original (the mystery of John's part in the story remains an unexplained episode in their friendly relationship at that time) in an edition of six, left the day before: 'I have made out the invoice papers and have declared that your work is the "original copy",' he said: John had the second replica, he had the first. At the same time, detailed instructions were sent: the head was precisely placed on the base to face one corner – this was intentional; and the hair was burnished like a helmet, while the face had a 'patina'. 'Should the helmet tarnish, you can rub it up with any metal polish.' But on no account was the face to be polished – the contrast of polished metal and the 'dark face' was 'essential'. And so the letters continued, back and forth across the Atlantic again: Quinn, now very warm towards his artist once more, was covering him with fulsome praise. He liked the 'ducks' (the *Doves*), despite the poor quality of the reproduction sent (for which Epstein apologized), and friends of his, the Hunekers, were, he said,

'tremendously enthusiastic over your works' — they had seen his three pieces at the London Group, the *Doves*, *A Bird Pluming Itself* and the second *Flenite Figure*. And James Huneker knew more 'of modern art than any other man living . . . No use for the old English pictures at all . . . calls them "painted dolls". No use for English artists' — he didn't mean living ones, Quinn added hastily — 'except Hogarth, whom he calls a mighty man; Turner, an early Monet. He says that the three biggest talents he has seen are Augustus John, yourself and Matisse.' One wonders what Epstein made of all this: he responded merely with a cable — 'Has the bronze arrived? Epstein' — which fortunately crossed with a cheque for £105 and a letter from Quinn. He was delighted with it — but was there any news of the African sculpture? The banter between collector and artist had resumed, too.

Epstein, who had been too busy to go to Paris again, told him that nothing new had come on to the market on the African front, but that he was meeting a collector soon and would buy things for him if he thought they were not too expensive. He had been very busy. He was sending a bronze to the National Portrait Society of which John had just been made president (and since the Epsteins were still very friendly with him, he had high expectations of the outcome), he had moved into a new studio where he was getting on with 'all sorts of things', and was hoping to get back to the country for the summer. In particular, he wrote in March to say he had just completed a large figure which 'I think is likely to cause some stir when I show it.' He did see the collector and quoted £800 for one of his African pieces, a price which Quinn regarded as 'outrageous'. But had Epstein exaggerated? His letters suggest that he wasn't enthusiastic about this rich and art-investment-conscious American breaking into his own precious and private domain; besides, if Quinn were to get involved with African sculpture, it might divert his attention from his, the last thing to be encouraged. And Quinn had plenty of questions about that. Could he have more photographs of Romilly? Huneker wanted them for an article he was writing (Epstein must have wondered why Huneker didn't have some taken himself). Then there was the marble figure he'd mentioned, three foot long by eighteen inches high — was this available? And the birds? Had they been sold? Could he make a replica? 'I read in the New Age about some things of yours,' he wrote, 'showing sex or balls. Have you got photographs of them? If they are not too absolutely outrageous, I might be interested in them in stone, if the figure wasn't too long and if it could, without shocking friends, be placed in my apartment . . .'

Epstein must have found these vulgar asides about his work deeply distasteful; his reply, however, was urbane enough – after all, the American wanted to buy the works, something which meant a good deal to him because he was desperately in need of money. None of the figures in the exhibition, to which the *New Age* had referred, he explained, were really 'outrageous' – 'you could show them in the house without blushing.' But while one had been sold (to Hulme), the other had gone to Berlin to be exhibited. There were the *Flenite Figures*, both of which were duly and viciously attacked by the critics. Sculpture? Good God, this wasn't *sculpture*! They were 'deliberate imitations of Easter Island carvings', according to one, and to another, 'rude savagery, flouting respectable tradition – vague memories of dark ages as distant from modern feeling as the loves of the Martians.' 'Modern feeling be damned!' wrote T. E. Hulme in the 25 December number of the *New Age*, rushing to the defence of Epstein's work.

As if it were not the business of every honest man at the present moment to clean the world of these sloppy dregs of the Renaissance. This carving, by an extreme abstraction, by the selection of certain lines, gives the effect of tragic greatness. The important point about this is that the tragedy is of an order more intense than any conception of tragedy which could fit easily into the modern progressive conception of modern life. This, I think, is the real root of the objection to these statues, that they express emotions which are, as a matter of fact, entirely alien and unnatural to the critic.

Nevertheless, despite the familiar and renewed battering his work received from the press, the exhibition had not been the failure the critics had hoped for: with regard to the birds, this group had been sold, too. Epstein, however, told Quinn that he would be delighted to make a replica in marble for him – 'I should be very glad especially to know that a carving of mine was in your possession.' At the back of his mind, no doubt, was the promise of the head for him he had never kept. And there was a baby's head in bronze that was available, if he would like that for 30 guineas? Epstein had been back at Pett Level since the end of April and working so hard that he hoped to have various 'things' finished by the end of the summer ready for another small show. He was very happy indeed to have escaped from London which, he told Quinn, 'is more full of intrigue than egg of meat. I can see that the only thing to do is to get out, work and pass by the howling and bawling

theorists and cliques. I feel thoroughly sick of them all.' He went on to tell Quinn about the figure he had finished in London, which was, of course, *Rock-Drill*. As he explained in a letter of 1 May, it wouldn't do for exhibiting in a house – it was too large. 'It is one of those things one is tempted to do occasionally and which for the artist is an indulgence as he has small chance of ever selling it.' For someone often described as boastful, then as now, the modesty with which he referred to his monuments and revolutionary works of the imagination seems singularly touching. Fleetingly taken with machinery in 1913, he had bought a rock-drill second-hand; he saw this powerful-looking object on its tripod as an interesting piece of sculpture, functional and unadorned, in its own right, and not for any sexual symbolism that is sometimes attributed to his interest in it, and then he built a robot above it. The preliminary drawings for this, carried out at Pett Level, and among others shown at his exhibition (or not shown, according to the whim of Mrs Smith), demonstrate experiments with ideas that had preoccupied him for some years. From the pencil and wash drawing of the Totem, derived from a construction of figures in angular arms and legs one above another like circus performers, it is possible to see connections with Egyptian or Aztec hieroglyphics; the finding of the powerful drill (used for blasting through rock down the coal mines), introduced the violent message of the work. This series provides a fascinating picture of the kind of threads an artist follows to finally pin an idea down to a practical form. When he had hit on this, he hurried off to London to make it.

And it was tall: the robot, itself nearly seven feet high, stood on the drill's tripod of stilts, bringing the whole work to more than nine feet. It had been done in a tremendous rush: David Bomberg recalled visiting a studio in Lamb's Conduit Street in 1913, to which Epstein had moved from the garage, and seeing the figure there. Epstein went on to describe it in detail to Quinn: 'It is a figure of a man working a rock-drill, and I think in some ways successful, as I've rendered the subject in a manner that gives the utmost driving force of hard, relentless, steel-like power; the work is metallic and is for metal.' In his autobiography, he elaborated: 'Here is the armed, sinister figure of today and tomorrow. No humanity, only the terrible Frankenstein's monster we have made ourselves into.' The machine's fascination for him was that of a repugnant, horrifying anti-body; little else. When, in 1915, he lost all interest in machinery, he discarded the drill and had only the figure's torso cast. Back then, however, off to the country again in the spring of 1914, he left it in his

London workshop with the intention of sending it to a show in the autumn, and promising Quinn photographs. Unfortunately, the casting of such a huge piece in metal was far too expensive for him, and he had to be content with plaster, the whiteness of which was effective in its contrast with the black-painted drill and tripod. Another idea, to attach a generator to the drill to make it hammer away when on view, was impractical, too; and he had to wait for the London Group show of the following March before he could exhibit it.

The work, both tall and complex, had been carried out possibly in less than three months. Gaudier-Brzeska had been to see it in his studio and was enormously excited by it – so excited that, when Ezra Pound, whom he'd brought with him, launched into an analysis of it, he turned on him, infuriated, saying: 'Shut up, you understand nothing.' Perhaps Pound had labelled the work 'Vorticist', something that Epstein, for one, would have vehemently denied. Hulme, who had also seen the clay at Lamb's Conduit Street, said in his *New Age* article: 'People will admire the "Rock-Drill" because they have no preconceived notion as to how the thing expressed by it should be expressed,' an observation which may still hold good, since this could explain why it remains for many Epstein's single reconnoitre of the then current Vorticist fashion. While the work's evocation of the machine's threat to man does give the view some substance, if only because Vorticism was primarily a machine-inspired aesthetic, the nature of the drawings, some for *Venus*, others for *Rock-Drill* and *Totem*, suggest more the influence of Futurists like Giacomo Balla. So far as Vorticism went, a passing interest in this might have been sparked off when he met Wyndham Lewis on the Strindberg decorations and saw him in action on the poster for the club, the murals, the cover design and illustrations for its brochure. These and other extraordinary creations were, of course, pure graphics (unlike his later portrait of Eliot, which was exceptional); nevertheless, this artist, dandified in his wide black hat, an actor who played his parts – as the silent and sinister host, the quizzical onlooker, the polemical writer and editor, the rebel poised to blast entrenched traditions to smithereens – with immense effect and skill, was consumed with a ferocious drive and enthusiasm, a vigour and ruthlessness, that would have interested Epstein. In the context, moreover, of the rest of the assembled company (Spencer Gore, Ginner and Gill, who were hardly inventive artists), Lewis must have appeared as a striking original with whom Epstein would have felt, if only briefly, a certain affinity.

Epstein wasn't an artist who was blown off course by the ideas of others – in fact, no idea of another could ever have fitted his line of thought; yet he always retained the curiosity of a student, this leading him to inquire into any material related to his work that might be transformed into a conception of his own. Take African sculpture: he told Haskell that he had been influenced by it in the same way that all work unaffected by Western art must influence the artist. 'African work,' he said, 'has certain important lessons to teach that go to the root of all sculpture.' He had, he said, tried to absorb the meaning of these lessons without being influenced by the African idiom; he was interested in the negro type of beauty, but his results were traditional and European in technique; his *Israfel* was, for example, taken from an Indian model but remained, in his belief, 'purely Greek in feeling'. He went on:

It would indeed be absurd for a European artist in these days to produce African idols, and like all imitation it would be insincere, but the African has lessons that would benefit the most sophisticated of present-day sculptors, just as the primitive caveman artist stumbled, centuries ago, upon the problems of draughtsmanship, shared by the French classicist Ingres, and the sophisticated Pablo Picasso. There are no sharp dividing lines in art, and artists, separated by centuries and continents, will enjoy the same experiences, and hit upon the same truths, in some cases by intuition, in others by a complicated process of reasoning. When a certain movement is in the air, it will be assimilated in a hundred different manners . . . It is not at all an easy matter to name the various artists who at one time have influenced one another, and I could not possibly say exactly how or by whom I personally have been influenced. Of course I have been influenced. No artist evolves altogether spontaneously out of nothing . . . The word 'influence', however, needs very careful explanation, as it is very loosely used by critics to mean anything from mechanical copying . . . All our academic sculptors are not 'influenced' by Greek art in the sense I understand the term, they are merely copyists of a period of Greek art that had already worn bare to a certain formula. The word 'influence', as I understand it, means more than a mere surface study, it means a full comprehension of both mind and technique, that go to the comprehension of a work, and a translation of that, according to the personality of the artist. A complete re-creation in fact through a new mind. In the sense that the word should be used, it is perfectly correct to say that Van Gogh is influenced by Rembrandt, and Degas

by Ingres. These influences are very real, they are obvious to the students of the particular artists, but in neither case is there a trace of copying. Every artist without exception is influenced in this manner, often quite unconsciously . . .

Epstein, to my mind, was influenced by African art in just this manner, and in one particular way: by the order suggested in the columnar form derived directly from the carving of the tree trunk, in itself the origin of the column in ancient classical architecture. From both came the frame that defined *Rom*, *Maternity*, *Ecce Homo*, *Lazarus* and other works through to the TUC War Memorial of 1958. Here, in the column, was a universal form. Yet whatever the influences on *Rock-Drill* were, and, as with any important innovation, many may be discerned, the personality created was an Epstein. The 'thing' to which Hulme referred was a portent, a shattering premonition of a fearful, awesome and alien condition that was to threaten mankind. Although eventually exhibited, appropriately, when the World War had engulfed Europe and the German army had swamped Belgium and burst into France, it had been conceived and completed when few could have forecast this dreadful calamity – the British, absorbed with Ireland, being caught unawares. 'An Englishman who was in Berlin during the week beginning July 18th,' my grandfather, A. G. Gardiner, wrote in *The War Lords*, 'has told me how puzzled he was, in that electrical atmosphere, to notice the unconsciousness that the English press exhibited of the significance of events on the continent.' If *Rock-Drill* was indeed a manifestation of a horror central to that war, it was of Man as a robot where humanity had withered to a foetus in the cage of ribs; or worse, of Man *regarded* as a robot – a terrifying, metal object, mindless as the machine that drills, achieving nothing, clad in the armour of a warrior or battle tank – a menacing, hollow, visually blind thing peering down from its remote position unseeingly through a 'visor' for eye-sockets. Yet its message gained more force when the figure lost its drill, tripod, legs, right forearm and left hand, and was exhibited in this form, cast in bronze, at the London Group in 1916. When the robot's head and stance could be closely examined (difficult to do at a great height), its character surfaced for the first time through the armour with an expression displaying the pathos of sheer impotence. With a head like a memory of an African mask, or the metal helmet worn by horses in ancient Egypt, the warrior had suddenly undergone an extraordinary metamorphosis:

here was an entirely new presence, a frighteningly sad and abject creature, a vision of humanity not merely in its time then, but, as Epstein claimed, in the future. This is a reason why *Rock-Drill*, as much as for any other, is so important.

In May 1914, a phase of extreme restlessness was over: after all the rapid moves – to London, to different studios – forced on him by the compelling urgency to make *Rock-Drill* (the sheds at Pett Level were useless for the enterprise), he was back in the security of the country again; no intrigues there to bother him, and the sight and sounds of the sea, gulls and terns to calm the mind. There were a few visitors – friends and acquaintances (who wanted to find out what the controversial sculptor was up to), and the models he needed for work – who called, but little else to interrupt the routine. One artist who appeared that summer was scandalized by what he found at 'Bay Point' – Mark Gertler, then about twenty-three, and so shocked that he rushed off a letter to Dora Carrington: 'Epstein is the one fault in my holiday here. Somehow he puts me off working. So far I have done nothing, but I've learnt a *great deal*. Epstein has a filthy mind and he always has some girl living with him, *including* his wife. Now he has a horrible black girl. She tells me she's sat at the Slade.' This news horrified him; he was at the art school then. 'She's like a Gauguin. I hate her more every day.'

Life in the tiny cottage must have been quite a squash, certainly, but Epstein's circumstances were such that, as an artist, he and his wife had to put up with petty inconveniences. He had to get away from the hassle of the art network in order to devote his energy to sculpture, and Pett Level was ideal for the purpose. At the same time, he had to have models, and, like the 'black girl', they probably came from London. Having found the right model, an exceedingly exacting task in any case, he had somehow to attract her to this desolate place by the shore, six miles from the nearest town, Rye. The obvious answer was to have her in the house, particularly since he had barely enough money to cover other expenses; that was practical – there were no trimmings in Epstein's life. Wherever he happened to be, in the country or not, his house was regarded as a shelter for relaxation, meals and sleep after a hard day in the studio. Models, like his tools, were part of the equipment; Mrs Epstein, moreover, saw herself as another part of it, as a necessary adjunct to a person whom she believed to be the greatest living artist. It may well have been the difficult experience of managing at Pett Level

that prompted her to indulge in the curious custom of encouraging models to stay in their various homes – on the spot, they were available when he might suddenly need one for some crucial study he was engaged on; at other times, they could do what they wished, or help around the house. This custom, for which they became renowned, was, of course, open to other interpretations, like Gertler's, and to ill-founded rumours circulating in the art world that did Epstein's reputation considerable harm. Such rumours were singularly misplaced: when he had no further use for a model, she left. 'The black girl, thank God, has gone,' Gertler wrote in a letter to Dora Carrington a few days later.

While Gertler was preoccupied with Epstein's morals, and complaining about how he put him off his painting (the presence of such an active creator would have been sufficient to accomplish this), Quinn was worrying away in New York about how he could get a sight of the latest work Epstein had mentioned in his letter of 1 May. These 'birds' greatly intrigued him – in a letter sent by return of post (13 May), he asked for a photograph; and also one of the baby's head he'd made in his student days – provided it wasn't too like *Romilly*. When he was told that both versions of the *Doves* were sold, he wrote wanting photographs of each so that he could choose which he liked best and perhaps authorize him 'to make another which, with differences, would make it an original piece of sculpture.' Epstein, who had already told him he would do this, that he was now working on a figure in Greek marble about three feet tall, and that he should come to Pett Level when next over to see what he was doing ('I am an easy run from London by car,' he wrote), was unable to reassure him that he wasn't in the business of making copies. Quinn replied that he didn't want a replica: he remained as suspicious as ever.

The *Doves* appeared as an idea for the base of his first *Venus*: as birds of peace and love, they made beautiful companions for the Goddess of Love. It was, as an assembly of elements, an extraordinary work where every part – head, breasts, hands and the doves' beaks – rhymed or half-rhymed. Like much of the output of this period, the crayon and pencil drawings that led to *Birth*, the female Flenite figures, the studies of pregnancy, *Mother and Child*, and the Flenite reliefs of sex and birth, all of which were carried out at Pett Level, *Venus* was a unique conception; predictably, of course, stunned critics responded to it with the same sort of platitudes – 'pure savagery' and 'flouting respectable tradition' – that greeted the Flenite figures. Epstein was indeed lucky to

have Hulme's first-rate mind, first drawn to his work by the Wilde tomb, to defend his sculpture; *Venus* horrified the English – it was a travesty of what Hulme had called 'the sloppy dregs' of classical art, and which had been reproduced a thousand times in sentimental poses with discreet drapery. They had never seen anything like it before: yet here, in fact, was a unique view of the essentials of classical order where the centreline – running from the head down to the beaks of the birds (rocking forward in the act of mating on a boulder of roughly chiselled marble) – accepted complete freedom of form within the range of the subject. And the birds gave birth to the series of *Doves*.

They had, some time before, made their entrance in the drawings that led up to *Rock-Drill*: on a sheet covered with ideas for sculpture jotted down like footnotes, there were sketches in pencil and grey wash of one pair of doves on a perch, another pair preparing to mate, with a further experimental bird at the bottom of the page. His drawings for sculpture were always exploratory, and thus tentative; seen as working studies, never as things for framing and sale, as many of the more pretentious artists regard their merest doodle. And so the *Doves* were as much a part of *Venus* as they were of *Totem*, and as *Totem* was of *Rock-Drill* or *Birth*, or of the female figures in Flenite, which, in turn, relate to *Venus*. These works have to be considered together, in sequence, like variations in movements of a piece of music, each unique in form, yet each inseparable themes of the total composition. This was the phase in which Epstein's sculpture of the imagination was itself born: the massive research and self-training that had their beginnings in New York, and that had carried on through the Paris years to the British Museum and the commissions for the BMA and Wilde, had found fulfilment in Pett Level, at last.

This side of his life, embattled with the problems of creation, passed Quinn by – he was interested in results, photographs, prices, progress reports; feeling isolated faraway across the Atlantic made him frantic for information – perhaps it was to hurry some news along that he sent a copy of Huneker's flattering *New York Times* article about his work; but the only reply he received from Pett Level concerned a new ten-ton block of marble that Epstein had been busy roughly shaping during a spell of fine weather, and which may have been the material for the second *Venus*. Thoughts of an exhibition in New York had crossed his mind, though working in hard stone was so slow he was put off the idea – a single piece took three to four months to complete. Dreams of great

commissions of 'heroic dimensions' still lingered on, despite the Wilde fiasco, while Quinn still pestered him for a third version of the *Doves*: writing to Epstein on 27 July, he was now saying he wanted a 'replica' – James Gibbons Huneker much admired both groups, he said. Epstein, of course, wanted to develop the possibilities of the subject. Birds were part of life at Pett Level, and it's likely that Mrs Epstein had procured the doves in the first place (providing a dovecote for them), so that he could work from a close examination of their habits, features and form. Mating, in particular, had a special relevance to themes preoccupying him at this time. In the first version, for instance, he had the male standing on the female in a way that there is again the hint of Egyptian or Aztec hieroglyphics in the overall shape: the problem of putting one bird on the back of the other was brilliantly solved by the use of the male's legs, these reducing the pair to a diagrammatic object. In the second version, the birds, more simplified, are brought together as a single form where the male sits comfortably on the female. In both versions, however, the life of the sculpture resides with the expressions in the birds' eyes: by delicately altering the form and shape of these, the artist suggested circumspection and apprehension in those of male and female in the first, and triumph and satisfaction in those of the second. With the two, he conveyed a picture of life.

Quinn's interest, on the other side of the world, remained consumed with business matters. He wanted to know the date of his next London show; to be warned of this 'in advance' so that he could order work 'in advance', thus getting first choice and bypassing the dealer's commission. If he wanted a New York exhibition, Mr Bunham (who had shown Epstein's work in Berlin) could arrange it – 'he's such a good salesman'. And what had happened to the Oscar Wilde? Was it mutilated? Still covered? – or was the controversy over? Did he approve of Brancusi's things? – he had seen the *Madame Pogany* head and a mythological bird in the New York Museum.

Before Epstein could answer any of these questions, the first catastrophe of the twentieth century had occurred: war had been declared on Germany.

The mass killing could have dropped from the blue: Epstein, stunned by the news, wrote to Quinn on 12 August in something of a panic:

I must stick here if I am to do anything . . . but don't know how I'll

pull through the summer. All dealers here refuse to have anything for sale; they are in a state of mortal funk and things have come to an absolute standstill. I had been depending on selling some small bronzes, but until the war is over no one on this side of the Atlantic will give a thought to Art.

However, his business was to get on with work in hand and to take less for it than 'the price on former work'. He went on: 'Everybody here is war-mad. But my life has always been a war, and it is more difficult I believe for men here to stick to their jobs than to go out and fight, or at least get blind, patriotically drunk.' One of his personal wars, by pure coincidence, was over: he had just heard the unexpected news that the Wilde monument had at last been unveiled, but felt furious that the ceremony for a work upon which he had given months of his life in 'hard labour' – and after it had been hidden for so long, 'mutilated and made a scandal of' – should be so 'sumptuously' done: that was just another example of the hypocrisy that had surrounded the affair. 'Pett Level is the place, here is quiet,' he concluded, while assuring Quinn that he considered, without reservations, that 'Brancusi is indeed a fine sculptor. I have the greatest admiration for his work. The good sculptors now in the world are few at the most – only three or four, I think.'

Times were indeed very bad, as he soon discovered: galleries refused to show his work on account of war scares about enemy aliens and spies – spies were thought to be everywhere. Epstein, unusual enough to be reported to the authorities by local people, was in the unfortunate position of having a German sounding name. He told Quinn in a letter of 4 September: 'Dealers here don't know that my origin is Polish and in this time of primitive passions, the most trivial of reasons sway people.' Anyone in the least unusual was suspect: Mackintosh, the great Scottish architect, holed out in Walberswick en route for the Continent on the outbreak of war, was, for example, under surveillance (probably because he was spotted painting the coast). Worried about money, he asked him if he could advance the sixty guineas he wanted for the group of birds he was working on – and to cable it direct to Bay Point. It wasn't that he was unpatriotic, he said, it was simply that his wife would starve on a soldier's pay if he volunteered (and what would happen, he could have added, to his collections of sculpture in various studios in London if he couldn't meet the rents?). He felt thoroughly down: the outlook for a sculptor like himself was bleak in England – 'My chances for Govern-

ment recognition as an artist,' he wrote, 'are nil; ... I am among the best hated ones here, or the most ignored.' He was also ignored by Quinn: no word came from him, no cable with money, despite his desperate plea for an advance – combined with his belief that every outlet for sales had been turned off by the surge of nationalism, Quinn's silence must have finally shattered his confidence and overwhelmed him with a sense of loneliness and despair.

Although lonely in Pett Level, he was at least cut off from the worst of the jingoism, women flourishing white feathers under young men's noses, posters going up emblazoned with patriotic slogans: 'GO! IT'S YOUR DUTY, LAD', 'WOMEN OF BRITAIN SAY – "GO!"', and the rest. Yet things weren't as bad as he had first imagined, despite the war fever, and when he had recovered from the shock of what war meant, his sights became once more firmly fixed on his job as an artist. With that decision and a resolution to devote a long period to sculpture, he brushed all thought of his American patron aside. He had other friends, and, in moments of crisis and adversity, they had a fortunate way of surfacing with offers of help. As a result of their efforts, he moved into a different gear and a new phase. He did a head of the Countess of Drogheda, a commission that led to an exhibition at the Droghedas' house in Wilton Crescent that included the second version of the *Doves*; and on, during the next two years, to a list of clients that presented an extraordinary cross-section of English society – Iris Tree (Sir Herbert Beerbohm Tree's daughter), Marie Beerbohm (Iris's cousin and Max's daughter), Elizabeth Scott-Ellis (Lord and Lady Howard de Walden's daughter). T. E. Hulme, Muirhead Bone, the Duchess of Hamilton (then the Duke's mistress), and, by arrangement with Francis Dodd, the Admiral Lord Fisher. There were others: from such a collection of names, anyone might think Epstein was an artist as fashionable as Orpen or even Frampton, rather than the wild genius from Pett Level who produced *Venus* in a shed, who was hammered by the art establishment, and continually desperate for sales to cover overheads and time (short, he believed) to get his multitude of ideas down. All his sitters, moreover, liked him, some, perhaps, were infatuated with him: Fisher was certainly bowled over by his portrait – he told Lady Hamilton (who had commissioned it) she must employ 'the genius – for God's sake, get him'; one thing led to another, and she was so struck by him that she gave him £150 to make a marble clock for her, although she must have known, of course, that such a commission was an impossibility.

With his work in the London Group exhibition in March 1915, he hadn't had time to argue with Quinn about his advance which, in view of the commissions, could wait, like Quinn. In due course, as to be expected, his silence again paid off: on 8 February, his patron surfaced with a long letter overflowing with profuse apologies – he had been ill, worried, had a pile of debts himself ('moratoriums in England and France had brought people swooping down' on him for bills for art) and so had been unable 'to comply with his request', his letter had become buried under a heap of personal papers; and so Quinn went on, describing the chaos in his office, a side-effect, apparently, of war in Europe.

Quinn was quickly back on his business tack. So what about the birds Huneker had seen? – 'Have you finished them?' A quibble over prices followed – although Epstein had said he'd let his work go for less, there had been no reduction on a bronze of a woman – fifty guineas – which, from the photograph, he didn't like. He could get up a New York exhibition for him if he paid for 'packing, steamship, insurance etc.' – Matisse had one on at the moment of paintings, drawings and sculpture (of course, he wasn't a sculptor, but did have interesting things in bronze and plaster . . .). The letter obviously irritated Epstein, and he didn't reply for eight weeks. Perhaps references to American artists who were 'dreadfully' hard up, that 'dear, personal friends wanted to borrow money', annoyed him, or perhaps he was just too busy with the Drogheda and other heads to give the pernickety Quinn a thought. When he did reply on 28 March, back at Pett Level after three months in London, he said he would 'get at the birds again and dispatch it' – it wasn't quite finished. He had had an extremely difficult time during the winter managing 'to pull through at all' and had sent four things to the London Group's show at the Goupil. 'The critics came down in wrath upon me,' he said. 'The scribblers have been emboldened by the war, and wish to take an unfair advantage of creative artists by declaring that now we are at war artists have no business to be anything but normal; that is: mediocre. Queer argument, that. In abnormal times be normal.'

He said nothing of the exhibition at Wilton Crescent, nor did he mention Lord Drogheda's reputed reaction to his wife's purchase of the *Doves* – that the 'fucking' thing should be thrown out of the window (later he forced her to sell it to Quinn). Instead, Epstein spoke of a head of Lillian Shelley he'd done, a girl whom, he believed, Quinn had once met. Not only had he met her, but had, as Epstein must have been told, romantic memories of her on a divan one drunken evening in Augustus

John's studio (the two of them planned to take her and Euphemia Lamb on their trip to France, but, much to Quinn's disappointment, the girls didn't go). The head might have tempted Quinn, if only for old time's sake. He considered the unlikely possibility of a New York show later in the year, and sent a photograph of the second Flenite figure Huneker had seen at the Twenty-One Gallery and Ezra Pound had praised at the London Group in 1914: 'The green Flenite woman expresses all the tragedy and enigma of the germinal universe,' his flowery comment ran, but he added, 'Mr Epstein . . . is, in the best sense, a realist.' Epstein asked £100 for it and enclosed reviews. 'With the exception of the *Manchester Guardian*,' he said, 'the critics have exhausted their vocabulary of abuse, singling me out for especial target. I can stand a lot, but this time they have really outdone themselves; and naturally sales have been affected . . . Of my three small saleable things, none were sold. My *Rock-Drill* was my great adventure and I did not expect to sell it . . .'

He was very, very upset this time; deeply hurt by the personally directed, vindictive assault from the press; but he could hardly have expected to sell the work after claims that *Rock-Drill* was, according to P. G. Konody of the *Observer*, 'Unutterably loathsome . . . leaving aside the nasty suggestiveness of the whole thing, there remains the irreconcilable contradiction between the crude realism of real machinery (of American make) combined with an abstractedly treated figure.' Only the *Guardian* reviewer had the sense to see the drill for what it was, devoid of sexual overtones, and was thus able to explain why the intricacies of the drill's construction 'fascinated' the artist, assuming 'the naked expression of a definite force'. Many an artist, faced with this latest disaster that left him practically penniless, might have given up; Epstein, however, immediately retreated to the country and buried himself in an eight-foot tall marble carving of *Venus*; it was his second attempt at the subject, and again had doves for a base, the male given a cockscomb on this occasion. In the meantime, Quinn, having received Epstein's letters and photographs, was full of enthusiasm, sending a cable on 15 April: 'Want birds that are stuck together, not pair one standing its legs. Writing.' He wrote the same day: he was interested in the Flenite, the Drogheda, the *Shelley* and *Rock-Drill*. He was insistent about which version of the *Doves* he wanted: he had had a letter from Ezra Pound who said, 'By the way, if you are still getting Jacob's "Birds", for God's sake get the two that are stuck together, not the pair

in which one is standing on its legs.' Quinn went on: 'I am sure you intend to send me the two that are stuck together because those are the ones that Huneker saw and liked.'

Quinn was obsessional about detail: once he had fastened on a point, he hung on, and even went to the trouble ('as a matter of abundant caution') of copying out the wording of his cable in case it had gone astray. He mentioned the group 'stuck together' six times in his letter, pursued his interest in *Venus* and followed that up with a list of instructions about the projected New York show (despite Epstein's doubts) – 'autumn best, should be at the Carroll Galleries, must provide at least fifteen pieces and photographs, no need to come over – a waste of money.' The war no more existed for him (some lines of business were doing very well supplying 'things' for armies) than Epstein's feelings, who was, not unreasonably, furious to have Pound's comments on his work passed on. The group of birds *were* the ones Huneker had seen, he wrote back on 28 April. 'Why Pound should implore you "for God's sake" not to get the other birds passes my understanding. I mean, his emphasis, unless I put it down to his usual futile over-emphasis. Let Ezra stick to his poetry and leave sculpture alone.'

He would have been angrier still had he known that John was advising Quinn as well, and that his remark about *Rock-Drill* – 'altogether the most hideous thing I've seen' – prevented its sale. As it was, he reserved his venom for Pound and the Vorticists, disliking Pound for his 'unseemly activities in connection with artists and their work.' By now really wound up on his favourite subject, he wrote: 'He is *not* an Art critic, scarcely in my opinion a *critic* of anything, poetry not excepted. But near contact with people like Wyndham Lewis has influenced him in directions for which he has no discernment, has given him, I think, ambitions so wide that he will only make himself ridiculous if he pursues them further.' Yet he was merely a symptom of a bad scene. Most things – written, painted or sculpted – were produced lightly, without effort, for great rewards – 'witness £10,000 offered for a Sargent portrait yesterday at Christie's if Sargent will be so kind as to paint another portrait'. And he wasn't the worst offender, Epstein said: while Marinetti should at least be honoured for his bravery in going to prison for his ideas, 'his wretched imitators who pretend they have started a movement in Art, the so-called Vorticists, haven't the courage even to go on imitating him, but have slunk back into their preciosities, after filching every idea they ever possessed from the Futurist propaganda'.

Epstein was fed up with the lot of them, but felt 'strong enough to stand alone and outside ephemeral "movements" of the "Vorticist" sort', despite the poverty that was getting on his nerves. He blamed this on the bad press – the art critics had even infiltrated the 'drawing room' to damn him; and after *The Times* reviewer had headed his article on the Goupil show 'Yankee Art', he felt utterly alienated in England – as an American and a Jew. It is difficult to see why he should have had any patriotic feelings towards the country.

He blamed the war, too: this increased tension in every way, from the difficulty of getting the materials and tools he needed to the threat of conscription. Would there be conscription? The war couldn't be won without that, could it? – in the American Civil War, he reminded himself, the North only defeated the South when conscription was introduced. So would he be called up? These were the thoughts that haunted him. He had friends at the Front. He had seen Gaudier-Brzeska off to France to enlist the previous year; and although these departures became progressively more horrific as the war ground on, the platforms milling with reeling, blind-drunk soldiers – the only way they could face the nightmare of the trenches, poison gas, lice and filth – surrounded by tear-stained relatives, it was bad enough at Charing Cross station when Gaudier went. 'The turmoil was terrible,' Epstein wrote. 'Troops were departing and Sophie was in a state of hysterics and collapse. Gaudier's friends, including Hulme, Richard Aldington, Tancred and Ethel Kibblewhite were there . . . and Gaudier, himself terribly pale and shaken by Sophie's loud sobs, said goodbye to us.' It was the final goodbye: when Epstein heard that Brzeska had been killed, aged twenty-four, on 5 June 1915, at Neuville St Vaast, the news devastated him. He had lost a real friend, the only true ally in art he had in England, an enthusiast for the adventure of modern sculpture, and a person he trusted. He made only a handful of close friendships during his life, and one of the first had suddenly been blown to pieces. The utter waste of a gifted artist too young to fulfil himself – who 'had not yet achieved great things but would have done', he told Quinn (at once requiring a spot assessment of his quality) – appalled him. But he had had another shock, his letter went on: Hulme, who had also joined up, had come back with a shattered arm – 'a splendid fellow who wrote for the *New Age*'; and now he was wondering about his friends among the artists in Paris – were they still working, still alive? The war had become a personal horror, and chillingly near.

About the time Brzeska was killed, Epstein was spending longer and longer periods in London on portrait commissions at a new address (67 Frith Street, Soho), and listening out for zeppelins coming over on bombing raids at night. He had to carry on: there was no question of giving a thought to a New York exhibition because he had to sell his work as he did it so that he and his wife could live. The advance, for instance, had at last arrived for the *Doves* (wrung out of Quinn after informing him that 'a beautiful block of marble of Paros' for the piece had cost more than £15) which were down in the country and nearly finished. At the back of his mind, though, there was the possibility of showing his work at the Leicester Galleries – Oliver Brown, with whom he had left the baby's head, now made a habit of calling in at the Café Royal after work, and the two were beginning to see a good deal of each other: 'It was not difficult to persuade him to consider the idea of an exhibition in our Galleries,' Brown commented. Epstein, however, had also met Bernard van Dieren, the Dutch composer, and he was so taken with him that he made a portrait of him the following day. This was the beginning of another close friendship; and, at the end of that year, a painter entered his life – Matthew Smith. With Hulme completing the group, an intellectual force with a constructive influence might have emanated from this nucleus, had the Fates permitted.

So there were a number of attractions, besides those of commissions, to remaining in London, despite the air-raids. And there were some other people he had come across at the Café Royal who caught his attention. There was Cecil Gray, an aspiring composer, and inseparable from his friend and hero, Philip Heseltine (otherwise, Peter Warlock, the fine, turn-of-the-century song writer), both of whom Epstein introduced to van Dieren (another of Gray's heroes); then there were two girls he used as models – a redhead named Billie Gordon and a waitress he described as a 'French apache girl', Marcelle. They were sources of inspiration for remarkable works, of which the mask of Billie Gordon is possibly the most astonishing. Unlike any sculpture that comes to mind, it has the immediacy of the moment, making it a spontaneous gesture that competes with *Romilly* for absolute mastery of touch and eye, and captures the idea of a person with the freshness of a painting or drawing – like Samuel Palmer's self-portrait in black and white chalk, for instance. He himself believed that this and the head of Marcelle, which caught the quizzical delicacy of expression unique to the French, were,

together with the studies of Meum Lindsell-Stewart which soon followed, the most important pieces of their kind he carried out during the war period.

He was back at Pett Level to finish the *Doves* at the end of July, only to return to London in October to a new address – 20 Great James Street – to continue work there. The group was ready to go to America but now transport was the problem; he was very worried about the sea journey because of U-boats, and, to make things more difficult, the Government had requisitioned the railways, causing endless delays in bringing it from the country. Eventually, he was forced to hire a taxi to London, packed it up in November, and sent it, with the Shelley head, in December. In Epstein's view, this third version was the best of the series, accomplishing the purity of the oval form he had attempted in its predecessor. And so he was very surprised indeed to learn that Quinn was dissatisfied with it: he was disturbed by a slight difference in the tips of the wings, and wondered whether the work had been damaged by faulty packaging. He questioned him, too, about numbers of castings again, this time with reference to the Shelley. Epstein usually limited his bronzes to an edition of six, so that, he explained in reply, they 'will not be multiplied indefinitely as is the case with Rodin bronzes.' He promised to make no more than four copies of Shelley and also undertook 'not to sell any copy besides yours in America; the others to be sold here . . .' This assurance may have calmed Quinn down on this particular subject, but he was still fussing away about the wing tip of the bird in a further letter of 25 January 1916. Epstein did his best to reassure him about that, too – 'having the group with me all summer, the dissimilarity of the tips of the wings did not disturb me.' He insisted the packing had been perfectly done, and said he was prepared to alter the wings when he was next in New York and 'make the tips exactly alike'. One feels sure he had no intention of doing so, and banked on Quinn forgetting about the issue in the meantime (which was bound to be a long time). Nevertheless, he added a condition that he underlined: 'I do not like the idea of anyone else doing it.' Epstein knew his man from long experience; a more impulsive reaction might have led to: *On no account let anyone touch it* – and losing a patron.

Against the havoc caused by the zeppelins, Quinn's fixation with minutiae appears more extraordinary than it would in normal times, and perhaps for this reason Epstein made sure he understood what the Londoners were having to endure:

The zeppelins pass over where I live and the shock of the explosions on either side smashed my windows. Believe me, the military damage done by these slugs in the air is everywhere apparent. Bombs of incendiary or explosive kind are dropped indiscriminately in dwelling house districts, women and children are killed and mutilated; a dirty business and one to rouse every decent person in the world to hate the 'Kultur' that produces it. I have seen the zeppelin and seen the results of its damnable work, the fires in the tenement houses, the blood on the pavement. The effect on London is to bring home the reality of the war, and is the greatest aid to recruiting.

His vivid account included the news that his wife's brother had been wounded at the Front and full details of the 'pitiable' victims of poison gas. He had met an American at the Café Royal whose lungs had been 'done for': he made the horror of war very real indeed for Quinn. And there was the harassment he'd suffered on account of his name – letters delayed, opened by the censor, or stolen and never received: in Pett Level, a sculptor living on the coast 'was beyond the understanding of the military authorities'. He had been besieged by inspectors who were puzzled why he should choose to live there and occupy himself 'with something they could not quite make out'. As though appearing through a sea mist, a picture emerges of shadowy figures nosing about round his *Venus*, staring at the crowd of plaster heads and the marble *Doves*, mystified. 'As one official put it suspiciously when questioning me, "You are the alleged sculptor, are you not?"' He was convinced they thought he was a German spy: here was the proverbial, bungling security officer's fantasy – the mysterious, rough stranger with a curious accent, the isolated cottage, the cover of 'sculpture' – of *course*, an enemy agent signalling to zeppelins at night! Beside this ugly source of anxiety alone, Quinn's trivialities about wing tips and castings must have been singularly exasperating.

Yet none of these experiences affected his concentration. 'Epstein was indomitable,' Oliver Brown said. 'In fact he could work harder and for longer hours than would seem possible.' He brushed them aside and, if anything, the hardships and difficult conditions, the threat of conscription and the hammering the country was getting from bombing raids, made him work with even greater vigour. Time could be short and he knew what he was doing was very important. 'It may not be reckoned so now,' he wrote to Quinn on 29 December, 'but I have no doubt that the future will think it important. Here I am clearing a path for future sculptors, should there be any . . .'

By the beginning of 1916, when the dreaded conscription had been introduced, he was in the middle of a period packed with activity and incident. He had changed his studio yet again, this time to 42 Emerald Street off Theobald's Road in Holborn; he had finished his *Iris Tree*, done a wonderfully compassionate head of the American soldier he met in the Café Royal, and had followed this up with a most unusual likeness of Hulme after his return from Ypres. The *Tree* went on show with several of his works at the Grosvenor Gallery in Bond Street, while Hulme, recovering from his wound, had collected enough photographs to start preparing a monograph on Epstein who had just launched into the carving of a five-foot-high mother and child in granite. All such information was passed on to Quinn; however, he'd had second thoughts about offering to change the wing tips of the *Doves*, cabling, '. . . left intentionally otherwise reduction scale main lines unavoidable.' Perhaps it was the surprisingly good reception to his sculpture at the Grosvenor which decided him to speak out over this; or possibly meeting Matthew Smith for the first time had something to do with it. He went overboard for Smith: here was a real English painter, at last, who had, at the outbreak of war, returned from France where he had worked for some years, who had nothing to do with the London art scene (which left him cold), and who was in love with colour, light and form. His *Lilies*, painted in 1913, was filled with sunshine, and Epstein, entranced by it, urged him to send it to the London Group in the spring. When someone bought the painting at the show, Epstein, who had wanted it himself, managed to make the man hand it over to him at his house. And that was the beginning of Epstein's Smith collection; and of his closest friendship, lasting until the end of his life.

The cable persuaded Quinn to drop the subject of the bird's wing, and, since Epstein didn't return to the States until after Quinn's death, it was never altered. In the meantime, the American had become more keen than ever to buy his work. How much would the *Sun God* cost? The Flenite figure? *Venus*? *Iris Tree*? *Italian Woman with Shawl*? The marble relief of *Mother and Child*? Epstein, responding with enthusiasm, reeled off prices ranging from £80 to £500. And he asked Quinn for a favour – would he send photographs of the *Doves* for Hulme's monograph? 'This,' he told him, 'will be the first critical estimate of my things in book form and I'd rather Hulme did it than anyone else, as he is sane and whatever he writes will be free from journalism and sentimentality.' He was very pleased about the 'great

success' of his works on show at the Grosvenor Galleries – not only had the critics 'turned somersaults with remarkable agility' but 'some even hark back to *Rock-Drill*' – and cabled Quinn on 1 March with the news that the gallery had offered £150 for the original bronze of the *Tree* and asked for his comments before accepting. While he was quick to see an opportunity, Quinn was equally quick to appreciate the distinction of having Hulme assess the scale of his achievements to date: the offer prompted another in a cable by return – £300 for three sculptures – the *Italian Woman*, the Flenite and *Iris Tree*: 'Among my best,' was Epstein's judgement to Quinn when confirming they were on their way. He may have been sorry that *Mother and Child*, the relief dating from 1905, remained unsold: he seemed to be set on clearing the decks of his earliest work like *Italian Woman* (model for the BMA's *New-Born*) of 1907. However, despite the unexpected praise, he was most critical of the reviews: 'Attempting even to put into language what is believed about a work like *Rock-Drill* and *Cursed be the Day*, they fail dismally.' He enclosed a cutting from the *Evening News* for Quinn as an example. 'The aesthetic side of the works they entirely ignore or miss. The determination and research of planes, the opposition of lines and planes, the spring of lines, the whole plastic side of a work exists not at all for these gentlemen who have jobs on newspapers . . .' He wasn't easily satisfied; his impatience with ignorance was quick to show.

They were points which, as Epstein realized well enough, would have passed Quinn by, too. He had decided he also wanted to buy *Mary Rankin*, another early work, and *Venus*, which, being in Pett Level, presented Epstein with a transport problem: he had to fetch it. However, as things turned out, there was no hurry for the photographs of the *Doves* after all (Hulme was finishing his monograph while back in the army, training), despite his wanting all material to be available for the book. And although he couldn't help being pleased about the latest reviews and sales, he was still as short of money as ever – so short, in fact, that he couldn't bring *Venus* from Pett Level, and had immediately to ask for an advance on the Flenite and *Iris Tree*; only at the end of May, four weeks later, did he receive the money, delayed by the censor who opened all his letters. This increased his agitation at a time when he was trying to finish the granite figure 'before further calls on the men of the country make work impossible.' With Epstein, everything always seemed to be happening at once anyway, and the war only accelerated the process, leaving him pent-up with anxiety. Then, having

sent Quinn photographs of *Marcelle* and *Rock-Drill* (now in torso form, cast in metal and priced at £200 if sold outside the gallery) on show at the London Group, he discovered that the American was frantic to make a clean sweep of the best of Gaudier-Brzeska's work as well. Unfortunately, in attempting a satisfactory deal on his sculpture (having already got hold of his drawings), he had run into problems with his 'widow' and was asking Epstein to intervene: 'I should be glad if you would tell her I am not a dealer . . . not a liar, nor a thief, nor a crook . . .'

This was a lot to ask of someone who had so much else on his mind. When Gaudier had been killed, Quinn wasted not a moment instructing Ezra Pound to buy anything of the sculptor's he could lay his hands on. Since Pound didn't like this job, Quinn now went to Epstein for help, an assignment he didn't care for, either, particularly since he was irritated with Pound for telling Quinn that Gaudier had been influenced by *Rock-Drill* and the Wilde tomb – he liked them, but that was all; he had never been influenced by his work. Nevertheless, he went to see Sophie and suggested she wrote to tell Quinn what she had, giving prices. No sooner had he made the effort on his patron's behalf than he had a rough rejection of one of his works: 'I don't care for the Mrs McEvoy thing at all. I don't like that type of Englishwoman . . . She is too damned typical, dry and uninteresting for me. I like them juicier than that.' This was followed by a complaint that *Romilly* had lost its shine; after that, Epstein could barely conceal his impatience, having discussed it before, and wrote back: 'Any common brass or metal polish would polish that helmet up in five minutes. And then if it was given a coat of liquid gold lacquer it would keep from tarnishing.' Practical advice to an unpractical person who was unlikely to have been near a tin of polish in his life. But then Quinn expected the objects of his patronage – Epstein, John, Pound – to return his 'generosity' by resolving any artistic problems at the drop of a hat. Unfortunately, though, Epstein and John were particularly in need of his money, Epstein largely on account of heavy overheads that included renting studios and the huge cost of materials like marble, and of transport and casting; John mainly because of extravagance. In consequence both generally managed some gesture of assistance or cordiality: if they failed in that respect, they realized their obsessional and grandiloquent collector might turn suddenly and cut off this vital financial life-line forever.

*

When Quinn's four pieces, 'carefully packed and insured', went off on 14 June, Epstein was putting the finishing touches to his bust of Admiral Lord Fisher.

What a phenomenon this artist was. He cropped up everywhere, usually in the most unlikely places. To the fury of academicians, there he was, at only twenty-seven, unveiling sculpture on the BMA building to howls of abuse. At thirty-one, he was in his Cheyne Walk studio entertaining the press with a preview of his Wilde tomb. A few months later he is in Paris with Modigliani, Brancusi and Picasso, and buying African art; and then he reappears in a lonely cottage in a remote village on the south coast carving a revolutionary series on the theme of love. Open a newspaper in 1915 and there's his picture beside a vicious review of his startling vision of twentieth-century man as a robot in *Rock-Drill*. Epstein's presence, whether through sculpture or the ragings in the press (normally both), swamped the scene: the Framptons and Pibworths were banished to the oblivion of dusty academic shelves. Probably down to his last pound note, still pursued by the debts of others on the Wilde tomb, yet here he was, a month after revealing his latest version of *Rock-Drill*, standing outside the Duchess of Hamilton's apartment in St James's at the end of the first week in June, fully equipped to start a bust, commissioned by the Duchess, of the impatiently waiting Lord Fisher. It was 10 a.m.: two hours earlier, Francis Dodd had arrived at Epstein's home, told him someone wanted him to do an important portrait, and bundled him into a taxi. He met Fisher, heard the news, went straight to his studio for materials, and returned.

The 'bohemian' artist and top naval brass (creator of the epithet 'moderation in war is an imbecility') – apparently irreconcilable extremes – had a real rapport. Both were fighters, both exceedingly hard workers: Epstein's vitality went into the modelling of Fisher's head, Fisher's into conversation – he had an amazing repertoire of Old Testament scriptures, reeled off proverbs and, according to Epstein in an interview with the *Weekly Dispatch*, had 'an excellent knowledge of art'. He had, Epstein said, 'a wonderful head', telling a friend only a month before the unexpected news of the commission, 'Of all the living men I should like to do a bust of Lord Fisher.' Fisher had just been forced out of the Navy, and, showing a certain relish for Admiralty mistakes, he read out 'a message from Lord Nelson' about the Battle of Jutland that didn't spare 'the Jacks-in-Office who, he alleged, had al-

lowed the German Fleet to skedaddle back to harbour'. Most of all, however, Epstein was struck by his interest in the work in progress which he watched in a mirror as he sat, absolutely still and with few breaks, for ten-hour sessions between 9 a.m. and 7 p.m. – 'You've got me,' he exclaimed before the first day was out. But then he was never in any doubt that Epstein would 'get him' – after all, Epstein was of Polish origin, and Fisher's cleverest ideas-man at the Admiralty had been a Pole. When the bust was finished (he was such an exceptional sitter, it took less than a week), Fisher said he wanted a portrait painted of the Duchess as a return for her generosity, and that Lazlo had been suggested for this, an idea that horrified Epstein. 'You must get John,' he said at once: Lazlo being preferred to him was out of the question. As it happened, of course, Fisher was so dazzled by his bust that he insisted on Epstein doing it.

By this time, Epstein was expecting his call-up at any moment, yet in August there was still no news: friends had put in an appeal in an attempt to protect him from having to go and were awaiting a decision. Meanwhile, the bust of the Duchess had been completed, and this, together with the *Fisher*, was being exhibited in the next Grosvenor show. The *Venus* had at last been moved to his Emerald Street studio; he was in the middle of a head of his wife, and was worrying about the second payment for the *Iris Tree* and the Flenite figure, due the month before. He was most worried of all, though, about the call-up – the uncertainty meant, he told Quinn, that he couldn't concentrate on anything which 'required months of continued work'. Eventually, he received the first instalment on his work in September, when the third payment was due, and he let Quinn know this when sending photographs of *Venus*, for which he was asking £500. Caution was making his patron unreliable over meeting commitments, and with still no news of the call-up he decided to go to Paris for a spell: London was very depressing, he told Quinn to explain this surprising news – 'Here there are no artists, only successful hacks. The museums are shut, a scandal since the saving in money is ridiculous.'

The proposed trip sounds like a fantasy prompted by his state of mind: although John went across in the winter of 1914 in search of Gwen, tight security would have made such an expedition highly danger-ous two years later. At any rate, he had found a new address by November – 23 Guilford Street, just north of his Emerald Street studio which he was keeping on: 'I have got so many things it became

impossible to move about', and so had to find 'larger quarters', he said in his letter to Quinn of the 10th of that month. The £500 owed had never arrived – letters, he explained, were delayed for weeks by the censor; in future, to bypass the authorities, all cheques must be sent direct to his wife. In fact, he was now desperate, following the letter up with a cable about debts over the Wilde tomb – 'Judgement out against me Could you cable £200'; and with another – 'Do cable money now Overdue Desperate'; and a day later, in a letter on 17 December, he said he was depending on this money, and had involved himself in expense which he wouldn't have incurred had he 'not looked forward to the certainty of this payment coming'.

He had, however, had news of the call-up – he had managed to get exemption for three months with leave to appeal again, which was, he said, 'as good as I could expect'. At least it gave him time to finish works in progress, to bring everything back from Bay Point (which the Epsteins still retained) to store in one place in the event of his joining the army, and to prepare for his exhibition at the Leicester Galleries the following February: now that he had a fairly comfortable studio, Oliver Brown said, he was 'working like a Titan' with the show in view. But then nothing – debts, setbacks, the call-up – was allowed to get in the way of his work. He wanted this exhibition to be a success – perhaps then, with his *Fisher*, *American Soldier* and *Tin Hat* (the brilliant encapsulation of the British private he had just carried out) to complement other pieces, he might have the chance of the official recognition needed to lead to a job as a war artist. His friends Muirhead Bone and Francis Dodd had already been appointed – Bone in June 1916, Dodd in December – and he realized that his qualifications were far better than theirs. Here was something he could do, a way in which he could make a constructive contribution to the war effort – and Bone was as keen as he that he should – and not waste his time training to do something at which he would be useless, like the art of killing with a bayonet; as an artist he could be an asset, as a soldier he would be an encumbrance.

Although he felt an outsider in England, he had never been tempted to go back to America. He had had offers of exhibitions there: only that November, a Mr Birnbaum had approached him about a show – 'He seemed to me to be opinionated,' was Epstein's curt verdict for Quinn, who had probably put the dealer up to it. 'A loud sort, and in a gallery keeper this is somewhat objectionable to an artist.' The year before,

Mme Strindberg had tried to lure him to New York to help decorate a theatre she was running – he was very suspicious of her, he wasn't risking his future on 'her vague and fulsome promises'. And there was Quinn, dropping names and ever ready with important contacts and recommendations. But there was nothing in America for him; despite the war and its dire problems, his future as an artist was in England, a strip of water away from the artistic civilization which had first brought him to Europe, and which, hardly surprisingly, kept him there.

Tying him down at that precise moment was, of course, the work for his forthcoming exhibition at Oliver Brown's internationally famous gallery. Yet, quite apart from this, there was another factor which had an effect on any immediate decisions he might have made. A few months before, he had met Meum Lindsell-Stewart at the Café Royal, and she was very much on his mind: she had been dumped by her army officer husband and had retreated to her aunt and uncle's house in Wimbledon to escape from strait-laced parents who, shocked by the failure of her marriage, made her vow she would never get a divorce. When she and Epstein fell in love, she moved into Guilford Street.

6
Birth

===

'THE ELUSIVE MISS M ...' Ashley Gibson, Epstein's journalist friend and one of Meum's many admirers from afar, called her this when, on leave from the Front, and enchanted by the tantalizing girl, he longed to take her out in a precious week off from bombardment and killing. The young soldier, doubtless a romantic fellow, was clearly very much in love with her; after the filth and violence of the trenches, she must have seemed as pure, soft and fragile as a moth. When, however, he did manage to catch Meum and be dazzled by her company, it was only for brief moments: on his last evening, there she was, 'cloaked and withdrawn in her corner' of the taxi as Gibson climbed out 'to get back to hell' the following day.

From what he said, she had a mystery and independence which, combined with intelligence, gaiety and undoubted sensuality, made her irresistible. Accounts of her are scarce, but those there are at least give a very different picture to one that has been spread around – that she was just a 'pretty blonde typist'; this choice of words is curious in view of Epstein's interest in her, and the masterpieces of sculpture she inspired. It was intended, one suspects, to put her down in importance, so diminishing, in someone's memory, the sheer loveliness of her presence. The poet Roy Campbell called her 'the beautiful actress' when he met her in the Twenties, while the essayist E. V. Lucas, who knew her ten years later, described her as 'the graceful and poetic Meum Stewart'. James Agate, the theatre critic, who also saw a lot of Meum and often dined with her, wrote in a postscript to a letter to Alan Dent: 'Met Meum Stewart, as enchanting as ever. She was wearing a wonderful

Réjanesque hat. It can have been given to few women to look at their first flush like an Epstein and at their meridian like a Gainsborough.'

With Agate's impression of her, she springs off the page: the hat, the Epstein with the fan, the stance in a Gainsborough; she loved hats, style, had a flair for fashion, designing her own clothes and cutting out the material for others by eye: 'The sight of valuable material being slashed up so dashingly must have been agonizing for the owners,' Maria Oliver recorded in notes about her: she was Meum's niece and remembered her well from the time when her aunt was dancing in C. B. Cochrane's shows at the London Pavilion in the Twenties. Meum, one of four children, had always regarded herself as the ugly sister of the family – until, that is, she was fifteen; constantly ill, she had an operation for pleurisy then that completely changed her; until then, she said, she was 'a *hideous* child'. Afterwards, she became healthy and beautiful, Maria's notes ran on. 'Her hair was fine and of the palest gold, her eyes dark blue with very long eyelashes . . .' She was a 'natural' – naturally beautiful and musical (her parents, the Lewises, were musical as well as literary), a natural designer and dancer, small and naturally elegant: a bewitching source of envy. Her real name was Dorothy – it was her husband, Tony, who christened her 'Meum'; he was a professional dancer, too, and when he vanished after joining up, she learnt to type in order to survive. 'She was a slip of a thing,' Meum's daughter, Peggy-Jean, said. 'She made me feel huge and clumsy, and I'm hardly big.' But Ashley Gibson's recollection of her conveys her magnetism and atmosphere better than most who knew her. He had met her before, of course, but on this occasion he saw her when he returned on leave after recuperating from wounds in a French hospital in July 1916; and since Epstein was already in the middle of his first bust of her, it's likely they had themselves just met. However, besides seeing her on his last day, Gibson also saw her on his second, the Sunday after his arrival; snatched moments of happiness between calling on relations, and a touching indication of the intensity of his feelings for her.

The point was, would Miss M., who wasn't a bit like De la Mare's, come to lunch? 'My niece is asleep,' her aunt told me. 'She went to a party. But if you don't mind waiting?'

In about an hour Miss M., her vague, fluttering, delightful self, floated down, welcoming but elusive in green velvet and a Russian hat.

Lunch would be divine, she said. But it would be a subsequent engagement. There was Epstein, keeping vigil even now, the half of a still uncompassed assignation, in the Chinese restaurant. He was doing a bust of her, a divine bust.

'You look so well,' she said. 'But you were disappointed when you saw me. You tried not to show it, but I can always tell. It's because I didn't have time to do my face properly.'

So we taxied to Glasshouse Street, and pacified Epstein, who seemed to have been waiting some time for his lunch, and was a little moody, with Louis Roederer 1906.

Gibson, an ardent admirer of Epstein's since seeing the Wilde tomb in his Cheyne Walk studio, must have been delighted by the surprise of meeting the artist again, and the opportunity of watching him at work, despite the setback of not having Meum to himself.

Almond-eyed attendants pattered up with noodles and other queer little messes, ordered rather carelessly and not, I am afraid, done justice to. Even without them there wasn't much room on the table for elbows, cigars, the ash, and my other bottle of Louis Roederer.

Then, in another taxi, to Great James Street, and while Mrs Epstein gravely sat and stitched, the sweet silhouette of Miss M., enthroned where the light made cunning play with the folds of her green velvet, wavered nebulously. Epstein was quietly busy with his clay. His movements had the stealthy, quick precision of a tiger's.

Miss M. slid out a long white snake of an arm.

'Talk to me,' she said sleepily.

The infatuated young man's remark about the 'long white snake of an arm' was to the point, and he may have fastened on something which could have inspired Epstein's *Meum with a Fan*, the fourth and last of his studies of her modelled two years later. All his works from Meum were different, and, equally important, each was unlike anything else he was doing at the time – the series of his wife, for example. With Meum, the works are evidence of his love for her: these are facts; everything he felt went into his art. As he said, it spoke for him. The soft pencil drawings of her on sugar paper are specially sensuous, and among the best he did. Indeed, those who claim he couldn't draw should look at them, and remember that drawing an idea for sculpture, itself a remarkable gift, cannot be judged by the same standards applied to one made from a subject. Those of Meum display – in the tenderness of the line

and touch defining an ear, the expression in the eyes, the hair, shape of nostrils, lashes, chin – a passion both for life and the exquisite delicacy of the sitter. It is, however, in the differing experiments in sculpture that some greater close-up of their relationship is clarified. She was living in the house much of the time, and Mrs Epstein was acting out the part of a mother-figure, an arrangement which left Epstein free to work from his subject with the detachment of one who was, although in love with her, not possessed by her; and this led to a sequence of ideas which sets this series of studies apart from any other he made.

Epstein's point of departure lay with certain conclusions he accepted in art – the works of antiquity, perceptions of nature, the sculpture of Michelangelo, Donatello and Rodin – and for this reason his sculpture embodies an existence outside his time, establishing for it a place in the continuum. Thus it would not seem surprising to encounter his work in the British Museum among the relics of the Acropolis, such as the Elgin Marbles. In an Epstein, continuity is a product of a maze of connections: while the first studies of Meum, the bust modelled in the few months left of 1916, the head in 1917, may be absolutely faithful likenesses of the sitter as he saw her (and captured with the same freshness the superb *Billie Gordon* possesses), they are, nevertheless, Grecian in spirit. In their interpretations of beauty, they present a picture of classical precision, repose and stillness; so much so that they could have been conceived in stone. Much the same could be said of the next study of her, the mask modelled in 1918. Here is a further illustration of connections: the mask form, an innovation he first employed with *Billie Gordon* (and repeated in his studies of Mrs Epstein and Van Dieren of that year), may well have been suggested by African art: the work itself, however, is strongly reminiscent of Egyptian sculpture – a sleeping princess or a 'Nefertiti' – in the simplicity of line, slanting eyes and mysterious inner peace. From profile or front views, the totality of the conception, derived from the line of the nose running into the form of the forehead, and following through to the mass of the hair shaped to a point like a crown, seems to metamorphose as the headgear that was the hallmark of Egyptian decorations, and which was repeated constantly in reliefs and statues. The same influence shows in his portrait of Gladys Deacon (later the Duchess of Marlborough), again of that year. This piece, exceptional as it is, was still a commission, and hadn't the freedom of the Meum mask; with Meum, he was released from any limitations on imagination and ideas that commissions impose, experimenting as he

wished with the image beauty suggested. He was experimenting again with *Meum with a Fan*, started in 1916 and completed in 1918. Once more, the work was a faithful likeness, but on this occasion, as she was a professional dancer, he introduced the element of movement, a theme, as expressed in the Wilde tomb and in *Pan*, his last work, that constantly preoccupied him. With Meum, this idea led into his interest in the extreme complexity of Indian sculpture where the rhythms and movement of nature and animals – plant-life, limbs, figures and creatures of all kinds – are interwoven as inseparable parts of eastern artists' vision of existence. In *Meum with a Fan* this art is reduced to the simplest of terms in the position of the arms – those long, slender, snake-like arms which, seen in the context of nature, remind one of branches of a tree. Meum was a magical discovery as remarkable as his immortalization of her: a focus for his love, she was a source of great inspiration, seemingly pin-pointing for him three massive forces of creation that had the most profound influence on his work then – Greek, Egyptian and Indian.

Meum arrived in his life at the beginning of his battle to join his friends Bone and Dodd as an official war artist. In a job like this, he could use his gifts: make drawings for war memorials, model the heads of great service chiefs like Fisher or politicians like Lloyd George and Churchill: when the idea of art as a means of propaganda suddenly surfaced in the summer of 1916, Epstein, with his usual logic, saw what could be done with such an important activity. Unfortunately for him, the War Office mind was not so logical, and the outcome of his attempt to contribute something of value was finally frustrated by a spiteful outburst inspired by extreme professional jealousy. The person who perpetrated this vicious act was an academician with those 'pedigree' connections typical of the English establishment and where merit has never counted for much – indeed, in those circles, it even could be regarded as something of a drawback.

It was a suspicion of artistic creativity, however, which led the War Office to lag behind its German counterpart in fastening on to the propaganda advantage that could be made of art. From the beginning, the Germans had realized the importance of waging an intensive campaign, using artists, to woo neutral countries on to their side. Most important among those was, of course, the United States, a country sufficiently undecided about where its interests lay that it might have gone over to them. Not only was there the large German population to

exacerbate matters; there was, on the Allied side, Russia, from where the hundreds of thousands of Jews had fled to New York right up to 1914. There was also the Irish factor, the Dublin rising of Easter 1916, and widespread American support for Ireland's cause that followed brutal British retribution. The obvious dangers of these complications finally forced the War Office, sceptical as it was about the role art could have and, remaining slow to react when the Battle of the Somme was under way, to consider the use of war artists for propaganda purposes. Epstein was an obvious candidate, and a great deal could have been made of his selection. Unfortunately, such a vision in amateur diplomacy was beyond the stuffed shirts at the War Office who would have merely regarded him as an American and a Jew – hardly a combination to commend him; at the same time, others with influence from the art world – Alfred Yockney, for instance – would have thought of him as an artist, and as no more than that.

Epstein had, nevertheless, some cause for optimism. His ever-protective friend, Muirhead Bone, the first war artist to be appointed, wanted to get Epstein a similar post. His qualifications were good: the study of Fisher had been a great success, as his portraits of the American soldier (such a very perfect picture of American physiognomy) and the British 'tommy' (so very British) had been. He was not, moreover, without connections. There were Bone and Fisher, and the future husband of Gladys Deacon was a relative of Churchill's. And connections were essential: getting a job as a war artist was largely a matter of knowing the right people. The key contact was Charles Masterman: former literary editor of the *Daily News* in 1903, this brilliant man was a member of the Cabinet in 1914, taking charge of the propaganda department at Wellington House. A. P. Watt, a leading literary agent, was on Masterman's staff, and, as an acquaintance of Bone's, performed the necessary introductions when the department started sponsoring war art; then the appointment of Dodd was on the recommendation of Bone, Dodd's brother-in-law. Orpen and Lavery, via the good offices of rich women clients, had feelers out in high places occupied by Sir Douglas Haig and Sir John Cowans; Orpen's job as a war artist was due to the intervention of Haig; Paul Nash had the weight of the art establishment to back up his claim to a job, and so on; Gill, not a war artist, managed to 'wangle' (his word) a quiet number as a draughtsman at the Admiralty. The reality was that the 'old boy network' counted for a great deal, yet Epstein believed, naïvely perhaps, that merit mattered

too, a reason why he laid such importance on the success of his forth-
coming exhibition at the Leicester Galleries.

He was lucky to have people around him who were more worldly than
he, for if left to his own idealistic devices he would have been in the
infantry on 5 July 1916. With conscription only six months old, the
dreadful news of his impending call-up came, and that he had to apply
by 24 June if he wanted to try to get exemption. Despite the panic,
Epstein, who had just finished his Fisher bust and was working on the
Duchess of Hamilton's, was quite unable to concentrate on anything
else, however vital to his future, and it was his wife who, with the help
of Muirhead Bone, J. B. Manson and A. R. Orage, filled in the appeal
form and saw that it was delivered on time. Then Bone arranged for his
friend and K.C., Frank Newbolt, to conduct Epstein's case at the
Military Tribunal – a smart move on Bone's part, since Newbolt's
brother, Henry, was a member of Masterman's staff at Wellington
House. Bone understood how the world worked: he may not have been
an artist of much significance himself, but he did know that Epstein was
an artist who must, if possible, be saved, and he used any connection he
had to do this. While Asquith's secretary, Edward Marsh, was another
friend, Bone got at Fisher through E. P. Scott, the *Manchester Guard-
ian*'s great editor, and Fisher, delighted with the bust that had just been
completed, promised to write at once to the chairman of the tribunal.
Yet another of Bone's friends, J. D. Macoll, Director of the Wallace
Collection, agreed to be called as a witness by Newbolt, and with Orage
reading out a petition signed by the directors of every art gallery in
London, Bone and Newbolt had, between them, managed the plan
excellently. But that was not all: in the meantime, Mrs Epstein, who had
sacrificed so much for her love of her husband and his art, and to whom
the idea of sending him to France and his probable death was as vile as
it was unthinkable, demonstrated her shrewd grasp of the significance
of the American connection – or was she acting on orders from Bone
and Newbolt? – by cabling Quinn on 25 June:

> Epstein not to know about this till after. Can you cable director of
> recruiting War Office London. Also to Clerk to Exemption Tribunal
> 197 High Holborn. If Jacob Epstein is not granted exemption to
> finish his largest statues Sungod Venus Man Woman Maternity and
> the Rockdrill all of which I have asked him to finish I can emphatically
> state it will be an exceedingly grave financial hardship for him –
> Margaret Dunlop Epstein Frith Street Soho London.

The meaning of this desperate message was not lost on Quinn. He realized, moreover, the importance he might have as an Irish-American collector of international renown, knew exactly what to cable and, with typical efficiency, did so: he might have been infuriating when bargaining over prices, but was always helpful on matters outside money. He received Mrs Epstein's cable the day after it was sent, and dispatched his cables to the War Office and the Exemption Tribunal within hours, enclosing a copy for Mrs Epstein in his letter to her of 26 June:

> I respectfully urge that Jacob Epstein, the well-known sculptor of twenty Great James Street, Holborn, be granted an exemption to finish his sculptural works in hand. If he is not granted exemption to finish his most important statues, including his large Sun God, figure of Venus, his important figure called Maternity and his Rock-Drill, all of which I have commissioned him to finish, I respectfully and most urgently submit that it will be not only an exceedingly grave financial hardship for him and his family, but will be a great loss to the world. He is a great artist, one of the two or three greatest sculptors living. It would be an irreparable damage to British art and a loss to the world if he should be unable to finish works in hand. Am writing details.
>
> <div align="center">[signed] John Quinn
Counsellor at Law</div>

The details explained his interest in Epstein, his experience as a collector and gave the name of Captain Sir William Wiseman as a referee, an English army officer who was in the USA. He assured Mrs Epstein that he would leave it to her to inform Epstein of what he had done, and at the same time urged her to see Ezra Pound and ask him

> to have W. B. Yeats interest himself in Epstein's case. Yeats is in the way of meeting important Cabinet men like Asquith and Balfour and so on. I don't know how well Yeats knows Epstein or Epstein's work but Pound would doubtless be not only willing but glad to do what he could and would I am sure gladly urge Yeats to do what he could. That would be a very direct way and would I feel sure be productive of good results. I suggest you do this as soon as possible.

When Mrs Epstein received this letter on 10 July, she replied immediately to give him up-to-date details of the arrangements Bone had made. She told him that Robert Witt, the solicitor who was preparing Epstein's case for Newbolt, was also a person of influence, that he was

in the Treasury, was the secretary of the National Arts Collection Fund and could be, according to Bone, in line for Director of the National Gallery to replace Sir Charles Holroyd who had just resigned through ill-health. She told him, too, that Fisher had written to the recruiting director and to Lord Derby at the War Office – he was in charge of recruiting generally and, at the beginning of the following year, was instrumental in getting Lavery appointed as war artist. All sounded hopeful signs, although Mrs Epstein remained extremely worried that 'a tribunal of tradesmen' would hold Epstein's German name against him – why his father should have picked that particular surname she couldn't imagine. 'I wish to goodness he had thought of, say, MacDonald.'

Epstein, who had been expecting to be called up and who wanted exemption to finish certain of the works Quinn had mentioned, was kept in the dark about Bone's plans in case he raised some objection. Some members of the tribunal had been in favour of total exemption, some not, but the difference of opinion was close enough for Mrs Epstein to report back to Quinn on the 18th that Newbolt 'thinks the renewal of the exemption practically certain'. He told Epstein 'that he thought your letter did it'. Clearly Epstein knew nothing of his wife's correspondence with Quinn. In November he was writing to say that the three months exemption 'is as good as I could expect', and failing to mention, inexplicably, that Newbolt had read out his letter in court and believed its influence was decisive, omissions which understandably must have hurt Quinn – the least he could have expected was some thanks. He didn't get them, and that might have led to delays in payment for sculpture over which Epstein was, in turn, 'very hurt'. But the moment some distracting crisis was resolved, the memory of it passed from Epstein's mind as he went straight back into his work: that was all he could think about – that and unpaid bills: he hadn't time for conventional pleasantries. All the same he may have upset Quinn in another way: Epstein knew Bone wanted him to have a war artist's job like his own, and Quinn knew this too. Mrs Epstein had mentioned the fact – 'a dead secret' – when writing to him with the good news of his temporary exemption: 'Muirhead Bone, who is the only official war artist in France, is trying to get Jacob out there as an artist. That would do away with all appealing.' 'A dead secret' perhaps, yet with censorship a dangerous letter to write. However, when Epstein told Quinn in January he hoped to get his exemption extended for a further three months, and went on to say that artists were 'being sent out to make drawings and

paintings who haven't a tithe of my ability and who are wholly unable to grasp the thing at all', Quinn knew who he meant: the etcher, Muirhead Bone. What Epstein said was of course true, but his interests would have been rather better served if his wife had kept him informed of Bone's work behind the scenes. She realized he would have been angry – as indeed he was when he found out – if he knew she was prompting Quinn. 'I'll blot out my part in it. He would not like my asking for time. Muirhead Bone is the active agent.'

Other than predictable abuse from those whom Epstein called 'malicious enemies for whom my life outside the army is a living rebuke', his exhibition went very well indeed. 'As it may be my swan song, I am going to make the most of it,' Epstein said. All his favourites of the last two or three years were there – *Venus*, the metal torso of *Rock-Drill* ('my strongest piece in abstract work'), twenty bronzes that included *Lord Fisher*, the *American Soldier*, *Tin Hat*, *Billie Gordon*, the bust and head of *Meum*, and an extraordinary study of Augustus John he had just finished, as craggy and wild as a chunk of Pembroke's granite cliffs – together with the unfinished *Mother and Child* in granite he had been working on. He was very excited and told Quinn the things on show were as good as any he had done, taking the opportunity to correct an artistic judgement the American had made that praised the avant-garde:

> I think you are inclined to over-rate what you call advanced work; not all advanced work is good, some of it is damn bad. I say this because there is a tendency to slight work that has any resemblance to natural objects. My own essays into abstract art have always been natural and not forced. I make no formula, and only when I see something to be done in abstract forms that better conveys my meaning than natural forms do I use it. There is solidity in natural forms . . . that will always attract a sculptor, and a great work can be done on a natural basis.

Of course there were those who detested the exhibition, whether among reporters in the popular press or visitors. A letter to the Leicester Galleries suffices as a potent example:

> Gentlemen,
> I paid 1/- today at the Leicester Galleries to see what has been advertised as a 'Venus'.

I would be glad to have the 1/- returned as what I saw can only have been intended as a joke.

I consider it distinctly unfair to obtain money from an unsuspecting public for the privilege of viewing a repulsive monstrosity, which bears not the slightest resemblance to the subject it is advertised to represent.

Yours truly,
W. A. Bristow
Lieut. Commander

Epstein took up the point about realism again when referring to the various ferocious reactions to his exhibition. While abstract works were 'quite beyond most poeple', it seemed to 'amaze them' that

despite what they consider very eccentric and outrageous attempts to annoy them . . . I can still do work which appears normal but possessed of fine qualities: that is, in heads and busts. I am sending you some of the more serious reviews. I think I've been wise to show these studies of a naturalistic kind for at last I've forced from downright enemies like Sir Claude Phillips acknowledgements of my prowess, although I resent the attempts at patronising from these incompetent writers.

Sir Claude, barrister turned biographer, was art critic of the *Daily Telegraph.* The 'serious' reviews were ecstatic: 'GREAT BRITISH SCULP-TOR'S NEW IDEA OF "VENUS",' ran one headline; and, below a picture of her, the caption, 'The most outstanding piece of sculpture ever produced by a British artist.' *Mother and Child* had equal acclaim: 'Here the sculptor's genius has infused inanimate stone with the vague stirrings and stillnesses of beings of a world alien as its own.' The portraits were the most prized: 'A Master of portraiture,' announced *The Times*; and from the critic of another paper: 'They are so beautiful, so full of knowledge . . . that I rejoice the tiger has come into the pasture and is eating clover.' Praise was piled on them; there was no stopping it – *John* ('magnificent'), *Meum* ('wonderfully fugitive'), the *Tin Hat* ('a poignant representation of an English soldier'). And so it went on: 'fine, serene', 'beautifully modelled', 'wrought by a master', 'this exhibition . . . establishes Mr Epstein's position beyond question . . .' 'We were,' Oliver Brown remarked in his memoirs, 'immensely impressed, and perhaps surprised, by the great crowds that visited the exhibition and the earnest and serious attention it received from

strangers who came in.' They had no help from the catalogue because there was no introduction beyond the artist's brief but effective: 'I rest silent in my work.' It had to speak for itself: Epstein had brushed aside the critic's jargon. Best of all there was a very long piece by Bernard van Dieren in the *New Age* of 8 March which fastened on abstraction in realism as the key to great art. For most people, he argued, representation of facts is the only medium through which art can have a meaning for them when the only importance of the human race consists in its ability to create, to give actual form to abstract thought. This, he said, is what Epstein achieves: to be seen in his sculptures are abstract conceptions, and the fact that they also represent existing beings is of secondary importance. He believed, too, that the idea the sitter inspired in the sculptor might be the wrong standpoint from which to look at art; that the sitters 'constitute sculptural conceptions expressing certain human qualities which rested clearly defined in the artist's mind till in his search for them he comes across the individual who could serve as a medium of the particular expression conceived . . .' *Tin Hat* was cited as an example; he saw *Billie Gordon* as 'dualism', and in *Meum* 'a frightening intensity'. 'The more abstract his work becomes, the more he becomes entirely individual, and in his creations of pure imagination he appears a Titan who, with towering strength, staggers us in works of Old Testamentarian power.' An Epstein fused intellectual and imaginative energy; he was an artist whose 'prehistoric simplicity' tied up with the nervous sensibilities and refined intellectual qualities associated with the more modern mind. Thus *Venus* is, on the one hand, 'lovable, seductive, virginal, lascivious'; on the other, 'an abstract idea . . .'

In a world where merit mattered, it would have been reasonable to predict that such excellent reviews were bound to have positive results: a sell-out perhaps as far as the exhibition was concerned, and Epstein would have been the obvious first choice as a candidate for the job of war artist with the Imperial War Museum, founded at the time of the exhibition (and with the War Trophies Section to obtain exhibits for the IWM established a couple of months later). Reviews apart, the studies of Fisher and of the American and English soldiers were memorable by anyone's standards – as examples of modelling as marvellous as Rodin's, or, on a completely different level, of a penetratingly observant grasp of national characteristics conveyed with total naturalness. Surely these qualified him for a job at the WTS. Equally, *Meum, Marcelle, Billie Gordon* and *John* (as he believed, and relayed to Quinn, the 'most

interesting' of the heads) were so immediate as presences that a dealer would have expected castings to sell like hot cakes. Astonishingly, however, the exhibition was only moderately successful; Epstein was particularly disappointed that no English buyer came forward for *Venus*. At the close of the exhibition, Quinn bought it, together with *Mother and Child*, but only after beating Epstein down over the prices – from £500 each to £400 for *Venus* and £300 for the others; at the same time, he offered £150 for the *John* (Epstein was asking £200 for it), provided castings were limited to three copies only. All these arrangements, Quinn said, could be managed later to avoid the dealer's commission, a suggestion Epstein rejected. But, as usual, Quinn had numbers on the brain – he had got hold of a catalogue from the gallery, and this stated the number of castings which, in the case of *Iris Tree*, *Euphemia Lamb* and *Lillian Shelley*, all of which he owned, exceeded the agreed figure: with each, six had been made. Quinn took Epstein to task for this: he didn't want to be 'churlish' but didn't think there should be more than three or four copies made – if Epstein was going to make six every time, he wouldn't be wanting any more of his bronzes: agreements were agreements and he should stand by them.

Epstein received this letter at the end of March in the middle of the worry of going before the tribunal to get a further three months' exemption. He was of course used to Quinn's obsession with numbers of copies, and fully realized that the scarcity value of the work – and thus financial interests – lay behind it. Nevertheless, this letter was nasty and threatening, even though it did end with a sweetener about wanting to buy the *Fisher*. Epstein must have been exasperated at times: if Quinn wasn't writing about money, he was complaining about incompetence in his office – one recent letter, closely typed in single spacing, continued for nine pages with criticisms of his assistants. Now he was back on the subject of numbers: after all, while Quinn, a rich lawyer, three-and-a-half thousand miles away across the Atlantic and safely out of range of the most hideous war in history was trying his best to do a deal with an artist to obtain the maximum investment for his money, the artist and his wife were trying to live. Epstein was concerned for her well-being: should he be called up and unable to do further commissions, at least he would know that the copies made of his works would keep his wife while he was gone. The possibility of his call-up was growing closer, like a huge black cloud on the bleak horizon. He wrote to Quinn: 'The Germans seem bent on goading the USA into the war and that

meantime the Great Push seems to have begun . . . Perhaps I'll be in it after all . . . '

On 5 April, he cabled Quinn about the numbers of castings: 'Gallery catalogue wrong. Adhering strictly to agreement. Sorry wrong impression given by general statement in catalogue. Cannot accept offer for John portrait.'

Quinn, in the meantime, had written a week before, on 28 March, congratulating Epstein on his 'fine exhibition' and putting forward offers based on six copies for *John*, *Tin Hat* and the two studies of *Meum* – a compromise, but Epstein expected that. He had won the main argument, and away went a cable on 28 April to confirm acceptance. Quinn's last letter to him for five months ended with the words: 'America is going into the war, totally unprepared but has the resources . . .'

The furore over Epstein's exemption occurred in June after the cover of anonymous proceedings in a quiet courtroom had been blown and the story got into the newspapers. Things started to go badly wrong at the beginning of May when his third appeal at the local tribunal was dismissed with the comment that the sculptor might win 'fresh laurels in the trenches' and he was told that he would be called up in three days. His solicitor, however, gave notice of appeal to a higher court which postponed a decision on the call-up until after a hearing of the case a month later. On the 20th, Mrs Epstein wrote to Quinn in a great state to say that 'it's impossible to hope for much because the rage against men being sheltered is very strong. It's the offices sheltering replaceable men that causes this anger and makes the exemption of a real irreplaceable like Mr Epstein very difficult . . . ' But did Quinn 'think that as a New Yorker born and bred', and with the Americans having declared war on 6 April 'he might get the job of artist with them?' 'Perhaps,' she added, 'he will get a month or two from the new court. I will let you know. He is working but this tribunal business keeps him from going to the country and working on big things . . .'

He *was* working – on various heads including the mask of *Meum*; difficult to imagine how with these crushing uncertainties on his mind. The distraction of hearing after hearing would have been enough to paralyse the imagination of almost any artist except Epstein. And on 6 June he went before the Law Society Appeal Tribunal and again applied for exemption; as before, he was represented by Newbolt who reminded the court of the sculptor's unique standing in the art world and that it

would be a great loss if this genius was sent into the army. The appeal was allowed on the grounds of 'national interests' and he was granted exemption for another three months with leave to appeal again. He was, however, ordered to join the Volunteer Training Corps. This order was, of course, a blow, but there was much worse to come.

Unfortunately for Epstein, a well-known practical joker named Horace de Vere Cole got wind of the Tribunal and had gone round whipping up agitation among artists and representatives of the military before the hearing. Epstein wrote to Cecil Gray and told him this when declining an invitation to stay with him at his house in Cornwall. As Gray, Muirhead Bone, Holden and others agreed, Epstein was, largely because of his experiences, suspicious to a point of persecution mania; nevertheless, Gray had no doubt that Epstein was correct in his assertion that Cole was responsible for the vicious press campaign that followed the Tribunal since he had first-hand evidence of his hatred for Epstein, and for anyone remotely connected with him. 'On one occasion,' Gray recalled, 'when I was sitting quietly in the Café Royal, having a drink with some friends, Horace Cole sat down at our table, uninvited and more than unwelcome, and then proceeded to pour forth a tirade of the wildest abuse directed against Epstein and myself, with the most outrageous implications.' This encounter led to a fight and two black eyes for Cole, and subsequently, to an attack on Gray's house, also repulsed, by hired thugs. Gray dismissed him as a lunatic: he could think of no other explanation for his fixation about Epstein, such a seemingly personal hatred from a practical joker who did at least have the humour to dig up Piccadilly Circus disguised as a navvy. Gray put it well:

Epstein . . . has had to fight on several fronts simultaneously; an unholy alliance between cretins and intelligentsia, between the man in the street and the Bloomsbury chorus of male sopranos and lady tenors, between the mandarin ducks of the Royal Academy and the guttersnipes of Fleet Street . . . and he has beaten them all (worn them down, it might perhaps be more accurate to say) singly, and in combination, by the sheer force of his genius and personality.

Perhaps Cole was mad: this wealthy dilettante who, John said, 'presented to the world the interesting spectacle of a pseudo Anglo-Irish aristocrat impersonating the God of Mischief' hardly sounds very sane. It's probable, too, that the sculptor, who attracted so much attention through his imagination and sheer hard work, inspired uncontrollable jealousy in

Cole; couple these with his extraordinary energy, and it's likely that Epstein brought the anti-semitism out in him as well. It was some such combination which united reactionary attitudes to art in English society, whether among Epstein's rivals, the popular press and Church. His brand of honesty, and his blunt expression of it, had the peculiar power, it seems, to transform even the followers of the modern movement in Paris like Fry, Grant and Bell of the Bloomsbury set (and who were, during the war, at the Omega Workshop) into a narrow-minded band of philistines. When word got round to artists and others of Epstein's exemption, their petty jealousies were suddenly released in a wholly jingoistic and (to their way of thinking) justifiable patriotic cause.

Epstein, right about Cole's antics, was wrong about what he believed to be John's part in them. John knew Cole, whom he regarded with a certain amused tolerance, but it was not in his nature to become involved in a vindictive campaign; his pleasures lay altogether elsewhere, in the social life, in his studio parties in Mallord Street, good dinners at the Restaurant de la Tour Eiffel in Percy Street presided over by the delightful and generous Rudolph Stulik; he would certainly not have become involved in one against a person who was on his side in the battle for art – in fact, he had seen Epstein when he was anxiously awaiting the result of his first tribunal, and had written to Quinn on 18 August 1916, 'I sincerely hope they'll let him off', a remark which Quinn quoted in his letter of 8 September to Epstein. The result of Cole's devilry was, however, devastating. On 7 June 1917, the day following the tribunal, various papers reported the hearing. But, in the *Evening Standard*, there was an interview with Sir Philip Burne-Jones, the painter whom (according to a note of Mrs Epstein's in the margin of a newspaper cutting sent to Quinn) Cole first saw in his quest to stir up trouble ('he is a commonplace artist who loathes the more advanced artists', Mrs Epstein wrote). Predictable clichés poured out of him: 'a good many well-known artists have been rather surprised at the tribunal's decision'; 'some of our most gifted native artists have, without protest, or the publicity of two contintents, gone quietly and ungrudgingly out to the Front to make the supreme sacrifice'; 'it should not be a hole-in-the-wall affair, and many distinguished artists – not a few of whom have expressed themselves to me strongly on this point – question the propriety of British Museum officials, or of the Art Collections Fund subscribers, arrogating to themselves the task of placing this or that artist upon the pinnacle of fame'; 'what of the artists who, though

pre-eminently talented and possibly among the world's immortals, do not happen to be the vogue of the moment, with a fashionable clièntele.' Jealousy leaked through every line of what was obviously a carefully prepared statement written with the knowledge of advance information. Far worse, it opened the door for others to rush into print: letters in condemnation of Epstein's exemption appeared everywhere. There was the follow-up of Burne-Jones's article in the *Evening Standard* from an anonymous source signed 'Artist, Now Lieutenant' on 11 June: 'I think it is deplorable that a few alleged admirers of the "genius" of Epstein should endeavour to seek exemption from military service of this sculptor who has brought himself fame by the production of a grossly hideous figure which he chose to entitle "Venus", and which was much advertised to rope in the shillings.' Here was jealousy fully expressed. 'It is splendid to think that members of the art world in all its branches have come forward to do their bit in the great campaign: why should one who poses as a genius be exempted from military service? He should have come forward long ago, like many more of us who sacrificed our art to our country,' he ended. Mrs Epstein wrote in the margin of the cutting she sent to Quinn: 'This is a sculptor friend of Cole's, Lieut. Derwent Wood, in the medical service in London.' So much for his sacrifice for his country, her note implied. She was right. But this wasn't altogether fair: to be exact Wood was doing the horrific job of making masks for the faces of soldiers utterly disfigured by mustard gas, an experience so shattering that it might have helped to prompt the writing of the letter. Still, the letter was deceitful: in remaining anonymous, and by appearing a hero on a battlefield, he was misleading the reader with an appeal to nationalism, the sickly theme that filled correspondence columns over the next few days. Artists couldn't wait to pronounce on the subject of Epstein and patriotism. Burne-Jones weighed in again with a pompous letter to the *Sunday Herald* about Epstein's so-called 'genius': ' . . . it is essential that such high distinction should be reserved only for one or two of the noblest in the land, and should not be squandered upon the popular exponent of a passing fashion or the favourite of a clique.' Again, the object of the attack is a person, not a principle. G. K. Chesterton, like his cousin, A.K., an outspoken anti-Semitist, also missed the point: 'It seems to me a dangerous principle to say that because a man is a great artist he should not share the ordinary responsibilities of citizenship.' But Epstein was not attempting to avoid his responsibilities: what he wanted was to have his

particular gifts used in a constructive manner – that was all. Unfortunately, however, these were not grounds from which it was easy to argue a case, and the very suggestion that Epstein might possess such gifts merely prompted furious cries of 'not fair' and 'traitor'. Walter Winans' brief paragraph from Claridge's Hotel, Brook Street, to the *Evening Standard* (12 June) presented the popular view:

> 'Artist, Now Lieutenant' is quite right. Artists do not try to hide behind Art: they go and give their lives for their country. If the Futurists, Cubists and Vorticists, who want to hide behind their 'Creations', would only go into the trenches with their 'artistic' productions and pop them up into the faces of the enemy, the latter would fall down, thinking they had overdone things and got an attack of 'D.T.'

This crude stuff from 'a very bad sculptor of horses' (Mrs Epstein) reveals one of the more depressing sides of a deep suspicion and jealousy of imagination which, bottled up in the system and uncorked by the war, led to the savage witch-hunt Epstein suffered from artists whose names were unknown in the world of art, and certainly have never been heard of again. Not a single letter supported him: hardly one had a good thing to say for his work, despite his highly acclaimed recent exhibition. He had become, it seems, an object for contempt in an anti-Semitic crusade which regarded Jews as cowards, Mrs Epstein reported to Quinn; the Jewish sculptor was a 'cheat'. He had been 'found out'; he must go to the trenches: that was his punishment.

Even newspaper accounts of the tribunal got the facts wrong, forcing Epstein, a stickler for accuracy, to contribute to the controversy with a correction in the *Daily Telegraph* of 12 June:

> It has been reported in some papers that the application for my exemption from military service in my adopted country was supported by the authorities at the British Museum, Wallace Collection, and National Art Collection Fund; but this was not so, and was not so stated at the hearing. The mistake may easily be accounted for by the fact that a petition in support of the application had been sent to the Recruiting Committee, and this was referred to, and was signed by individuals who were connected with, amongst others, the great institutions mentioned.

Here was the only letter in a hysterical correspondence that presented factual information sanely, clearly and economically. But it was too late for common sense, whatever the subject. The story was out, the public was informed, the gossip-mongers spread the smears, the hunt was in full cry and the hounds had their quarry pinned in a corner. Then, immediately following the artists' campaign, a question about Epstein's exemption was asked in the House of Commons which led to a further disastrous development and a desperate cable from Mrs Epstein to Quinn on 16 June: 'Military counter appeal to reconsider exemption because of artists' anger. Cable what you think Director Central Tribunal Local Government Board Whitehall.' Horace de Vere Cole must have been well satisfied with his work.

Mrs Epstein's cable was one of half-a-dozen that went off in rapid succession to Quinn at that time, unknown to Epstein who had sent a postcard to van Dieren from Pett Level where he was taking a few days off to, as he put it, 'make peace with Mrs Epstein.' He never gave a reason. 'As you may have seen,' he wrote, 'the "artists" have got the military to reconsider their decision and they are appealing against exemption. I shall get what holiday I can and be up in London before long.' When he heard from van Dieren, he wrote back at once: 'I have had your wire, and from the look of things I doubt whether anything can be done. I thought that at first something might be managed but now I know that as far as publicity goes no one will write. Everyone is afraid of his skin.' A friend had come to him with what he imagined 'a heroic and witty response but carefully asked me to get someone else to sign it! Hulme, of course, is indignant and says he will write but he is in a busy part of Flanders and I know how dilatory he is in any case. I think the only thing is to go on and in the meantime get as much done as I can.' As usual, his mind was on his work, grim as his prospects were, and, at this particular time, on the *Risen Christ* he had started. 'I have put up the Torso of the figure with the hands in position but cannot get much further without a model. If you come to town I'll be awfully obliged to you if you could pose once or twice for me. Stop with me as you did before.' He was referring to the time when he did his first portrait of van Dieren. He didn't see himself going to Pett Level again, 'There is too much to get done.' He had discovered, he went on, 'with some amazement that some of "my friends" look with at best the greatest complacency at my joining up or refuse to see that any "plot" forced the tribunal's decision. Some foresee great gain to me in "experi-

ence" and talk other buncombe of that sort.' Lady Tredegar had called on him, he said, to complain 'at length of her difficulties in getting her own dear son from being sent to France; but God only knew what beatitudes lay in store for me. In all of which I see the foul mouth of John who is in the process of painting her: lick spitting work I imagine.' John, of course, had broken a knee in a fall which refused to mend, and he was thus unfit for the army, a story Epstein didn't believe and which only increased his suspicions of the painter. 'I'm sick of the whole business,' his letter to van Dieren ended, 'and shall dismiss it from my mind . . .'

He was not allowed to dismiss it for long. In July came the news he had dreaded. The military had won: exemption was refused, a further appeal was impossible and he would be called up on 6 September – this was the message Mrs Epstein cabled to Quinn on 20 July. Epstein wrote to him the same day: 'My enemies have at last succeeded in forcing me into the army. I have not been averse to joining, but, ever since I've seen how eager my professional brothers were to get me in, I've taken a different view of that matter, and find that I really am too important to waste my days in thinking of matters military.' He described the 'deliberate conspiracy' that had been organized in the press against his exemption – 'bad painters and bad sculptors wrote and howled, like Brangwyn. One Sir Philip Burne-Jones, a son of the old B.J., a social nincompoop, and sculptors you've never heard of' – and maintained that Cole was a 'sycophant of John's'; in fact, that John's complicity in the plot was total – that he had instigated it and 'been behind the whole nasty business ever since the war started.' He had only found this out when John had him caricatured on the stage in a charity show at the Chelsea Palace to raise money in aid of concerts at the Front. 'This so-called Charity performance,' Epstein hammered on, 'was the work of our "artists" mostly hailing from Chelsea, and I was the chief butt, partly on account, as I take it, of the great public success of my exhibition at the Leicester Galls.' The performance had been staged on 20 March, when the exhibition had just closed, and was in honour of John, the popular artist's artist. One can see why Epstein – very sensitive, easily hurt, damaged by much offensive publicity and fearful his call-up might come through at any moment – was so paranoid about John who had, after all, managed to bypass conscription with something the painter jokingly called 'housemaid's knee': when everything came easily to the flippant John, the serious Epstein encountered only difficulties. Still, he

prevented any further performances of the caricature – the owner of the theatre, the actress Doris Keane, was a friend of Epstein's and she, he said, 'had the thing cut out, and forbade the theatre to be used for any purpose of that sort.' He added: 'To be attacked in the press is now my almost daily portion. I loom too large for our feeble small folk of the brush and chisel. Even my existence is a nuisance to them. They shall have their reward . . .'

He was probably right: he did loom too large, his existence *was* a nuisance and 'the feeble small folk' were quick to seize the chance to (they must have hoped) put him away for good: if he was killed at the Front the bullies would have been delighted – no more trouble from that quarter. Yet, despite the witch-hunt, Epstein continued to work with his usual vigour until called-up. He had started his *Christ* and, if unfinished, at least the intention, he believed, would show. He was, however, deeply depressed and disillusioned. He considered his life in England as a sculptor had been a failure; when he stopped to think what he could have done, and what he was capable of doing, he regretted even attempting to work there. His intention had always been to do great works, yet, as he put it, 'having trained myself in efficiency, lived simply, kept myself in good health, no use is found for my talents.' Instead, he was 'to be swept into the oblivion of military training for which I am altogether unfitted.' All the same, he didn't blame the military for the repeal of his exemption – up to the time of the publication of those scandalous letters, he had felt sure they were in his favour at the court hearings; the officials, he insisted, were in no way responsible, only the artists who had always hated his work, and his presence in England. And the consequence of these people who hounded him was the waste of an invaluable asset, his unique gifts – a fact which enraged him: it was an anathema. But perhaps being called a coward by these self-styled artists depressed him even more. He was hardly that. He preferred to stay where he was and finish what he set out to do: to brazen it out with the insular English, their hang-ups about race, foreigners, class, sex and all. He remained the innocent observer throughout, and, as far as his art and life went, totally ruthless.

In the end, of course, when all hope of his being used as he would have liked ran out, he did approach the United States Consulate to ask whether some important American commission was available for him to execute that would require his release. This was in the third week of August. Mrs Epstein had already approached Quinn with the proposal

that he could perhaps be seconded to the American army as an artist and at about the time Epstein wrote off to him, she must have received his letter dated 6 August. He said that it would, naturally, be 'criminal waste to put a man like him on the firing line', but there was an obvious insurmountable difficulty to his joining the American army in this capacity. 'The objection that Epstein had become a naturalized British subject seemed to be final,' he wrote.

There was nothing to be done; and 'no important commission'. He was working up to the last minute, and arranged for the bronzes, the marble *Venus* and the granite *Mother and Child* Quinn had bought to be packed up and sent off – there had been delays owing to shortages of labour for packing. But the continuing attacks in the press from art critics and artists alike were much on his mind. 'What scum!' he wrote. 'I have been invented as a monstrous figure, an example of vileness unspeakable, and bad enough as I may be, the representation is altogether unrecognizable. This is how legends are created. What a time this is. Will we ever get into a state where people will mind their own business, and let others live?'

Epstein understood instinctively how the art world worked, its connections, linked lives and often unbreakable circles of self-interest. Yet, as with most stories, there was another side to his. First, as he explained, the military representatives were not to blame for the decision that sent him into the army to learn the craft of hand-to-hand fighting with bayonets, and had not the topic of his exemption been dragged before the public by the most reactionary elements in the art world his future as an artist would probably have been secure. As with war, bad produces good: it is a measure of Epstein's supreme importance, both as the artist who created the Wilde tomb, the heads of *Romilly*, *Meum* and many more, and as a symbol of artistic freedom, that he was defended with a vigour equalling the venom with which he was attacked; and that once what was evil in man had done its worst, the civilized forces attempted, behind the scenes, to reverse the damage and to rescue him from the dreaded trenches by having him appointed as a war artist. It turned out to be a long and treacherous route to a simple objective, but at least the attempt was made.

For a start, Quinn was an unquestionable assistance as an Irish-American collector of repute. Battered by letters and cables from Mrs Epstein, he responded by cabling Lord Derby at the War Office and

John Buchan (head of the DoI) with pleas for Epstein's transfer from an active unit to the job of artist or draughtsman. He managed even to speak to Lord Northcliffe (owner of *The Times* and a powerful backroom influence on behalf of artists at the War Office) when he was in New York during the summer of 1917 trying to stir up Englishmen in the States to enlist. In addition, he had written a long article, densely illustrated and entirely devoted to Epstein's greatness as a sculptor for the October number of the *Vanity Fair* magazine – he would, he told Mrs Epstein in a letter to her of 4 September, be getting page proofs that he would send on to Northcliffe's office: since the piece focused on the outrageous waste of this American-born artist in the army, Northcliffe might, on reading it, take up such an important cause for himself. His efforts (for which he received little thanks because Mrs Epstein was in a state of panic about her husband), seen together or separately, without doubt impressed various heads of departments. Then there was the support of Muirhead Bone, an active influence in many circles including the British War Memorials Committee, the formation of which was largely the achievement of Robert Ross who had spent the war years working to secure an official status for the artist. He was of course an adviser to the Committee, and he was a friend and backer of Epstein's from long before. On the face of it, therefore, there should have been little difficulty in arranging Epstein's transfer to one of the ministries employing artists to record the history of the war. Then there was Hulme (three articles on Epstein by him were published in the *Pall Mall*, the *New Age* and elsewhere) and Orage – he promised to print anything that would help; and of course there were other supporters – the Duke of Marlborough approached Buchan, and Churchill was sympathetic to the cause. Even Epstein's commander of the Jewish regiment he joined on 6 September turned out to be a great admirer of his work.

It so happened that the formation of the regiment was not complete and Epstein was allowed home for two weeks, during which, with four cables, he confirmed the dispatch of the bronzes to Quinn, the marble and the granite, his acceptance of offers for *Lady Drogheda* and the *Duchess of Hamilton*, and asked for all payments to be made through his wife's account. He might have been on the verge of being in the army, perhaps sent away to be killed, but his mind never wavered from his work: he was thinking about that, and about being paid for his sales – nothing else. And when finally he joined his regiment at Crownhill

Barracks near Plymouth at the end of September he was still thinking of it: the separation from it, and from Mrs Epstein and Meum, had not yet, perhaps, sunk in. On 1 October, for instance, he wrote to Quinn giving his new address. But he was furious – he had just received a letter from Quinn (dated 12 September) claiming that Pound had told him that Wyndham Lewis was out of hospital after being wounded and was 'back in the thick of it'; and going on to say that Epstein would enjoy the army provided he avoided 'the trenches' – that 'change' would do him 'good', and so too would 'relaxation and exercise' – that he was ' young enough not to feel too badly about losing eight or ten months of a year when other people are losing their lives and limbs, and health and fortunes . . . ' This patronizing letter seemed to have been designed to annoy: Epstein said he was 'astonished' by its tone, angry to hear from his wife that she had been meddling in his affairs by cabling Quinn, and insisted he wanted no further intervention from him about the army. He had never shirked his duty; it was infuriating that his wife should have been corresponding with Quinn behind his back.

Mrs Epstein confirmed his anger in a cable to Quinn – 'my last communication', it said, and, 'Epstein extremely annoyed with your letter twelfth September especially as Pound's report from Lewis more brag than truth as we here know. Epstein's greatest friend Hulme out since 1914 just killed. Epstein writing you.' Quinn was disgusted: he regarded Epstein as thoroughly ungrateful; he told a friend, 'I have never had such a case as Jacob Epstein.'

This was all very well, but Epstein had never asked Quinn to help him, nor was he ever consulted on the possibility of his being able or ready to do so: the fact that his wife had secretly approached him, and that Quinn had tacitly agreed to this move, angered him; he had been deceived, and deceptions led to complications, and, in any case, all dealings which concerned him and his wife had to be in the open. On the other hand, as she had made clear in a letter to Quinn, he didn't mind if people did things for him on their own initiative as Muirhead Bone had done – that was fine, that was their business. But this was no reason for him to be grateful, to feel the gratitude which Rothenstein longed for, a response to convention which had prompted Holden to remark that there wasn't 'a spot of gratitude in his make-up': in Epstein's view, there was no cause to be gratuitously grateful for something someone wanted to do for him. In this context, gratitude would be an unnecessary extra, an emotional tautology: waste, which

Epstein would have regarded as extravagance, was an anathema to an artist for whom economy was essential to art.

These revelations must have been a nasty shock. Quinn's letter, however, infuriated him further. In particular, there was the comparison with Lewis – rather than getting 'back in the thick of it', Lewis was busy arranging a job for himself as a war artist (he got it a month later) – whom Epstein regarded, with Pound, as a 'charlatan'. And he hadn't liked hearing Quinn speak of Lewis 'in the same breath as Picasso' – that, Epstein wrote back on 1 October, 'is sacrilege'. He had given Quinn's ideas on art matters short shrift before, when he was referring to artists like Lewis. 'At three thousand miles away Lewis may appear to be a hero, but here he is nothing of the sort', he said, adding he was 'afraid and a braggart to boot'. Epstein seemed to have regarded Quinn, from reading between the lines of many of his observations in letters, as a provincial lawyer cut off from reality in his New York office, entangled in the minutiae of contractual affairs that Epstein found plainly exasperating: why hadn't the five bronzes been insured, where was the affidavit confirming the authenticity of the works? Quinn might have been able to imagine some of the horrors of trench warfare, but his comprehension of art (derived in any case from the views of advisers in New York, London and Paris) was as superficial as his understanding of the fears felt by almost everyone on the other side of the Atlantic. Did the death of Hulme mean anything to Quinn? Probably not. But it meant much to Epstein: 'He had, I believe, the best brains in England', he informed Quinn, 'and his nature was of the most generous. He was a great friend of Gaudier's, as well as mine, and his passionate interest in art had nothing to do with boosting himself. What a rare soul!'

During the next three months, while marching round the parade ground, he continued to keep in touch with Quinn by cable (four were sent) about prices of works, about payments overdue, about wanting confirmation of the safe arrival of *Venus*, and so on, almost as if still in London: the hard labour of army life was brushed aside, his concern for his sculpture and business undertakings never wavered. Yet there was also Meum; he was worrying about her, missing her dreadfully and writing to her daily (love letters which were subsequently lost). She was at Guilford Street and, in accordance with the curious arrangement that existed there, he wrote to his wife to say that he wanted her to look after Meum and 'to protect her from the evil men who would take advantage of her'. This may have been a reference to her interest in the stage and

theatrical people; or it may have been an indication of his fear of losing her – an impossibility since he was, her niece said, 'the love of her life'. More probably, he longed for her; longed to be back in Guilford Street with her. And there were attempts being made to this end, in the sense that there was a further drive to get him transferred to a department where he could do the work he wanted to do. A letter from Oliver Brown's partner at the Leicester Galleries, Cecil Phillips, may have started something off: on 9 October, he wrote to the Rt. Hon. Sir Alfred Mond MP, chairman of the Imperial War Museum, to say that he thought Epstein's *Tin Hat* was 'a brilliant portrayal' of the English soldier, expressing his 'rugged strength, the slightly contemptuous look, but not without a sense of humour'; suggesting it should be bought for the entrance to the Museum, he ended, 'I feel sure that it will be difficult to find any work of art that will so well typify for the future the British "Tommy" in the Great War ... ' This perceptive letter might have been the work of a dealer wanting to promote the rare gifts of his artist. Or it might not have been just this: it might have been the first move in an English plot planned by a circle of friends and admirers. Mond's Director-General at the IWM was Sir Martin Conway, the ex-Slade Professor of Art, who had written in support of Epstein's BMA figures nine years before, and had, as a great friend of Robert Ross, been in the Chair at the dinner when Epstein's name as a sculptor for the Wilde tomb was announced. Then there was Ross himself who, as advisor to the British War Memorials Committee, had recently had his idea for a Hall of Remembrance building adopted: sculptors as well as painters were needed to provide the works for this, and Ross, who commissioned Epstein's Wilde, had a poor view of most English sculptors – so far he had had to put up with second-raters like Gilbert Ledward, Derwent Wood and John Tweed. Then the architect for the Hall of Remembrance was Holden of the BMA building, and the man who recommended him for this job was none other than Muirhead Bone, Epstein's loyal supporter. He was, moreover, adviser to John Buchan who had already been approached by Quinn about Epstein's plight earlier. This kind of plot involves, of course, raking over the ground, carefully and well, and putting a word into an influential ear. The wheels of the army machine turned slowly, but, on 13 December, Conway suddenly wrote to Sir William Robertson at the War Office, reminding him that he, Sir William, had said that if the Museum needed anything he had only to let him know.

It was an extraordinary letter that had the unmistakable, collective imprint of Epstein's supporters; besides Conway, certainly Bone's and Ross's handiwork was behind it. But Conway needed Epstein's expertise: drawing attention to the 'perilous' situation he was in, Conway said that he was 'now a private in the Jewish Battalion. It is the desire of a very large body of artists and the public that his particular abilities should not be wasted and that he should be sent out to France and attached to Major-General Donald's Establishment.' Significantly, he stressed that the work for which Epstein was specially suited was demonstrated by the *Tin Hat* – 'a masterly piece of modern sculpture'. He added that they wanted 'to employ Epstein to make a series of typical heads of private soldiers ... Mr Tweed is already being employed and he represents one school of modern sculpture. Mr Epstein represents another school ... His ability is unquestioned and his suitability for the type of work above ... would be universally admitted ...'

Robertson passed this letter on to Lieutenant-General Sir C. F. N. Macready who replied that he had taken the matter up with Major-General Donald. Epstein did of course know something of these behind-the-scenes manoeuvres by the time he had written to Shaw a week earlier on 5 December to say that, while some effort had been made to prevent the entire waste of his time,

> Sir Martin Conway and Sir Alfred Mond have, I understand, the formation of a Historical Museum, a sort of record of the war, in hand. If I could be commissioned to go out and make records for them such as my 'Tin Hat', my head of a soldier now on view at the Leicester Galleries, or a bust of Sir Douglas Haig, or drawings of them, I would be doing better for England, the world and myself than by forming fours and marching round the square. Do you know either of them and could you speak to them on my behalf?

This letter should have worked out well – of course Shaw knew Conway; he knew most people with influence and had himself been to the Front assisting on a research trip in connection with a history of the war. Epstein probably never gave the fact he didn't get a reply a thought: the outlook wasn't too bad; Conway had written to Macready on 17 December to explain that the IWM was 'allowed to attach two artists to Major-General Donald's Establishment' and confirming that 'one of them should be Mr Jacob Epstein'. There was no objection to this at all – Donald was quite positive; the only point of disagreement was location:

Donald thought he should work in England – he could hardly work in the front lines on sculpture: he could be given a commission like Adrian Hill and work on the wounded at home. Conway, unfortunately, was adamant – writing to Donald on 3 January 1918, he said Epstein could only accomplish what the IWM wanted by going to France. In the meantime, Field-Marshal Sir Douglas Haig's letter to the War Office of 31 December, confirming Donald's wish to transfer Epstein, was forwarded on to Conway on 4 January, who replied saying he still wanted Epstein sent to France.

One way or another, Epstein would be working as a war artist; in France or in England – it didn't much matter. Conway's last letter went to the War Office on 5 January. On 8 January, Donald wrote to Charles ffoulkes to say that Epstein was expected to join his unit. The fact was he was so short of cars that an extra officer wouldn't be able to get about – his real reason, probably, for wanting Epstein to stay in England. 'There is no getting about at all at present,' he wrote, 'the roads are in such a bad condition ... ' However, he needn't have worried: after a letter from Sir George Frampton on 12 January, Haig wrote to the IWM on 21 January abruptly cancelling his transfer. No reason was given, but since the way was clear for this one day and then completely blocked just over a week later, it is obvious Frampton had said in his letter something lethal about Epstein that changed Haig's mind in an instant, and from then on it remained shut to any further argument or approaches; so lethal, moreover, that ffoulkes removed the IWM's copy of the letter from the files on 17 April the following year (the day before, interestingly, the IWM agreed Frampton's fee of £150 for a marble bust of Nurse Cavell) and, presumably, destroyed it. When thorough searches were made in the Museum's archives a few years ago, no trace of it was found.

Haig's cancellation meant the end of the matter. Ffoulkes wrote to Donald on 23 January 1918: 'You may be relieved to hear (privately) that the question of Epstein has been definitely dropped. I think this will be a great relief to all the people who really count.' And two days later Donald replied: 'Much relieved about Epstein!'

'The people who really count'? And who were they – service people, 'true blue' English who had the right background and had been to the right school? Epstein had no such qualifications. More to the point, what prompted Frampton to write such a scurrilous letter, and what did it say that had such an astonishing effect? The answer to the first

question must be jealousy – and not merely professional jealousy: sexual jealousy as well – as one woman admirer of his work put it, 'His sculpture had such energy that this in itself of course made him fascinating to women, and nothing makes men more jealous than that.' She was right. But this could be it – the letter amounted to an explosion of jealousy that had lain dormant since Epstein had arrived from France and seized the limelight with the sensational BMA commission; jealousy boiling up into such hate that the contents of the letter were aimed at sending the artist to the trenches and probable death. As to what Frampton actually said, we can again only guess. Since criticisms of his sculpture would have been brushed aside as competitive, the likelihood is that the letter exposed details of Epstein's love life, for there was rich material in it to provoke the army chiefs' disgust. After all, and as Mrs Epstein well knew, divorce was enough to ruin lives in those days, and the mere mention of the word 'model' made English hair stand on end; but here was a *ménage à trois*, a wife who was twice the age of the beautiful mistress, Meum, a girl who had in turn left her brave young army officer husband, Lindsell-Stewart, to run off with the notorious sculptor (in fact, of course, the opposite was the case). A brief paragraph would have sufficed to start the imagination working – the artist's model, passionate sex on the studio floor (or divan), the permissive Mrs Epstein looking on – the possibilities let loose in the army mind on hearing the bare essentials of this bohemian set-piece, stereotyped by John and his circle, could have been spectacular.

And so was it Frampton who was really behind Horace de Vere Cole's campaign to get Epstein into the firing-line? These self-important trouble-makers – Philip Burne-Jones, Walter Winans, Frank Brangwyn, Derwent Wood – were just the kind of club bores with whom Frampton (but not John) was likely to associate. At least this could account for his sudden intervention with the letter: the original plan, whoever had devised it, had succeeded, but when the object of the exercise seemed about to slip from under their noses, it was Frampton who moved in fast for the kill. The effect was devastating.

At about the time these decisions were taken, Epstein was busy sending cables to Quinn about unpaid bills for three bronzes. He had no idea of the War Office's change of heart, and none of Frampton's part in the affair: knowledge of the letter remained confidential, never getting

further than those at the War Office and ffoulkes. Since Epstein had nothing to do with him, the possibility of his complicity wouldn't have crossed his mind – as far as Epstein was concerned, Frampton was the man who was remembered for having done the Nurse Cavell memorial bust and little else. He referred to him somewhat contemptuously as such, always insisting on calling him Sir 'Reginald' Frampton, likening him to Sir Reginald Blomfield, the architect, Royal Academician, friend and accomplice of Frampton's, and another enemy of Epstein's. Perhaps he thought the name suited him better than the more robust 'George'.

A rumour that the IWM proposal had been blocked filtered through to Epstein via friends in London. He was now at a training camp at Tregantle in Cornwall which, he said in a letter to van Dieren of around the middle of February, was a beautiful and isolated place; living in tents was 'freer' and infinitely preferable to the 'prison-like air' of the barracks in Plymouth, and 'we have had wild stormy weather and I love to see something of Nature at any rate in wild freedom – no sergeant can howl the wind into silence or form fours with the rain . . . ' He hadn't heard from Shaw and others he'd approached, wasn't going to pester them further and took the disappointing news about hopes of a transfer philosophically:

> I've been told that there is a very special opposition to me at the War
> Office; this is a compliment. What has annoyed me most when I
> spoke to men who hold responsible positions as keepers of collections
> and one very influential, was this complacence at my position. They
> smiled very blandly and did not seem concerned that I was no longer
> creative. I am filled with rage when I think of the work I might have
> done in the last four months, and the wealth squandered and wasted.

It is difficult to imagine this artist marching backwards and forwards, presenting arms, saluting, and the rest of it, when what he longed for was to be back in his studio with the unique companionship of his works; and back with the love of Meum. But, in his letter, an inner reserve allowed him to say no more than that he hated the pointlessness of it all, and its absurdity in the only context he understood: art.

But if the transfer had come to nothing, at least he felt sure he wouldn't remain in the ranks. He was so convinced about this that he wrote: 'Before I go into the OTC I'll have to pass through the entire course for a private and that means a two-week course in living on the ranges and I've come away with about 180 men here for the first week

of the course ... I see another month at least in the ranks before me. I must try to bear it as best I can. It is a life of sweated rot, and for me ... of exasperation.' This letter must have upset van Dieren, for he knew how hard it would be for this hyper-sensitive, hyper-energetic artist to endure the illiteracy around him. 'He had quite remarkable vitality,' the pianist, Maria Donska, said. 'I have never encountered such vitality. It was in his eyes, of course. He was like a product of Nature. It was extraordinary.' Van Dieren may also have been worried that Epstein's optimism about being given a commission might be misplaced and that his friend would be in for another bad shock: was this extraordinary artist, van Dieren would have undoubtedly thought, really the conventional Englishman's immediate idea of 'officer material'? Hardly; it was much more likely, van Dieren would have thought, that he would, as soon as training was finished, be bundled off to the trenches in Flanders. Muirhead Bone must have been worrying about this prospect as well. At that time, however, another possibility of a transfer was surfacing. Lord Beaverbrook, who had for the past year been collecting art works for Canadian records of the war, was appointed Minister of Information. Now he wanted to make a similar record on behalf of the British, and with this Bone once more entered the picture: his enthusiasm and knowledge of the artistic scene impressed the ambitious Canadian millionaire who thrived on action and relied on him to explain whom to commission and get released from the army.

Unknown to Epstein, Quinn was suddenly taken seriously ill with an intestinal obstruction and was operated on in the middle of February; the first Epstein heard of this was when his wife was cabled money on 28 March by Quinn's secretary who stated that he would be away for some weeks. In the meantime, Epstein, his training completed, was on leave in the last week of February and at work in his studio on his fourth likeness of Meum, the figure with the fan. He met Beaverbrook then and was certain that this very powerful member of the Lloyd George Government (Beaverbrook was said to be the Prime Minister's personal preference for the job) would help him. Oblivious of Quinn's illness, he wrote to say that 'Lord Beaverbrook has asked me if I will do work for the Canadians, and if he can effect my transfer, as I've no doubt he will do, I will be given a commission to do sculpture.' Beaverbrook, he said, 'seems a decent sort and not lacking in courage.' Of course he couldn't wait to get away from the sheer boredom of the firing ranges, marking time and so on. Waste made him desperate – wasted hours, wasted

opportunities, wasted ability: all were constantly on his mind. Every day, he told Quinn, he was in the army as a private doing privates' work 'the nation is losing a valuable addition to its future wealth – I have shown by "Tin Hat" that I'm more capable than anyone to do propaganda work'; adding that he thought that Beaverbrook had seen Quinn's article about him in *Vanity Fair*. That would have pleased Quinn and was probably true: Bone was bound to have shown the Minister anything in the way of good reviews that would help his friend. As Epstein said, here was 'a glimmer of hope'. He was delighted to hear that Quinn liked the *Venus*: it was, he explained, the result of a series of experiments and carvings like those of the group of birds, yet, he said,

> it is for artistic expressions of the kind that sculptors like myself and Gaudier and Brancusi suffer the scorn of the badly educated and the mob. This includes, of course, art critics, connoisseurs, art patrons and, in my own particular case, even the army, for were it not for works like 'Venus' I would have by this time been included in the list of artists who are now doing propaganda work for the Government, instead of wasting every minute of my time and abilities in uselessness and futilities.

The army wasn't the only thing on his mind when he arrived back in London. Quinn had written to say (in nineteen pages of close type) on 20 January that he was delighted with *Venus* but didn't like the granite, omitting to tell him that both had remained in the basement of his apartment block because they were too heavy for the lift. Epstein, who offered to give him something else in exchange, was also told that his father had been in to see Quinn, that he was worried about his son, and that a letter wouldn't be out of place. This news left Epstein unmoved – his father only wanted to hear from him now because he was famous; he'd never bothered with him before, he replied, going on to offer him the heads of Bone and Hulme for £150. And that was another thing: Hulme's work – the manuscript of the book he had been writing for the past two years, and a large collection of photographs – had disappeared with his death.

> It was a very careful and original statement of my aims in sculpture and an estimate of my achievement, and it would have fulfilled for me what I have desired, a serious and non-journalistic account of my sculpture without deferring to the taste of editors or public . . . To

think that not only his body and brain was smashed up, but also the work of his brain, is appalling, for as well other manuscripts which I know he was writing also were lost. Mind you, these things were lost in his billet. Hulme was killed outside his gun-pit, and the disappearance of Hulme's effects has nothing to do with any shell-hit. Hulme wrote three separate articles to three separate journals in London on the subject of military service, which never reached England. Censored.

This extraordinary suggestion – that the manuscript and photographs had been stolen – was followed by a P.S. to say that all was not lost: the publisher, John Lane, had commissioned a fully illustrated book on his work from his composer friend, van Dieren. He must have felt when he sent the letter off that, despite the disaster of Hulme's death and the horrors of the army, there were hopes for the future: unfortunately, however, those concerning possible help from Beaverbrook quickly evaporated. This letter was dated 2 March. The following day, on returning to his unit at the end of his leave, the momentary optimism was shattered with the news that he was to be drafted for active service immediately. This produced a predictable reaction – a letter from Mrs Epstein to the IWM which said that Epstein wanted her to let the Museum know that he was due to sail for Mesopotamia from Southampton 'the day after tomorrow' (5 March), and that he was at the Crownhill Barracks at Plymouth with the 38th Royal Fusiliers. She said 'I give you these particulars because he thinks it may be a departmental error that he is ordered to sail while Lord Beaverbrook's application is being considered by the War Office. Sometimes War Office mistakes are put right.'

The surprise destination – the Near East rather than Flanders – was an irrelevance to Epstein: as far as he was concerned, Beaverbrook had applied for the release of numerous artists from the army for his project (sixteen, in fact) and had succeeded in every case except his own. He must have felt this latest turn of events was as decisive as it was baffling, and the pathetic tone of the letter is an indication of the hopelessness of the situation: 'he thinks it may be a departmental error' – in the face of the blank wall of ignorant officialdom, Epstein must have realized there was little to be done. That he was an artist of repute was, contrary to all expectations, seen as a failing by the War Office, and if there was something that could be done, there was no time to do it. The 'trouble-maker' was being removed from the scene as quickly as

possible. If this was the way Epstein construed his predicament, it was because, of course, he did not know of Frampton's letter. Then Shaw's failure to respond to his plea for assistance must have added to his despair. As far as this was concerned, three months elapsed before Shaw made a move; then he forwarded Epstein's letter to Conway at the I W M on 6 March with a covering note on a compliments slip which ran: 'I have just come across the enclosed among a heap of letters which I should have answered months ago. Epstein wants to make a bust of Haig. But he would make a bust of the devil to get back to his proper work. Don't bother to answer. G.B.S.' The condescension of this note was one thing; yet considering the nature of Epstein's letter, Shaw was outrageously irresponsible to forward it without the permission of its writer; and then to attribute motives to Epstein of Shaw's own making about so serious a matter was not so much mischievous as dangerous. Had Shaw written earlier, his frivolous interpretation of Epstein's intentions could have been highly damaging, weakening Conway's resolve to get him transferred. As it was, of course, his efforts had already proved abortive.

Beaverbrook's inability to obtain Epstein's release was, however, extraordinary, and goes to prove once again how potent Frampton's attack on him must have been: yet, as an expression of pent-up jealousy, such a letter was a measure of the force Epstein generated. And so the War Office merely ignored the Minister by making no attempt to intervene, and, by the time Shaw had managed to get around to writing to Conway, Epstein should have been crossing the Bay of Biscay. But he was not; fortunately in the circumstances, he was ill when he returned to barracks and instead went to hospital, missing the draft. This re-mission earned time for renewed attempts to have him transferred: once more tension mounted. There was, for example, a remarkable letter to Conway from Meum on 25 March, that was touching as well as intel-ligent; it was signed in her married name, Dorothy Lindsell-Stewart, and sent from her uncle's address of 'Kenmare', 37 Wimbledon Park:

Dear Sir,
 As I know that you have tried to get Mr Jacob Epstein from the War Office to do work in France for the British War Museum, I wanted to tell you – privately – that Lord Beaverbrook has been trying for the last two months to get Mr Epstein for the propaganda Department to do artist's work for the British and Canadians. Perhaps you could encourage or help Lord Beaverbrook.

Mr Epstein is at present in a military convalescent hospital recovering from internal inflammation (cystitis) and he is under orders to proceed to Palestine to join his regiment . . . when he gets out, which may be in a few days.

Let this urgency be my excuse for my letter to you whom I do not know personally. The loss of a great artist's time doing transport manual work in Palestine when he might be doing works for all the world which would live on for ever, will be, if it is allowed to happen, a disaster to the art history of England and a scandal to be spoken of in all that will be written about Epstein and his work after the war.

The English are too apt to throw stones at the man who thinks much or in a new way in art or science or war and will call it 'bad form'. They caricatured Rodin as being 'not a gentleman' and they have so far refused Epstein a commission in the Propaganda because they say he is 'untidy' and they order him overseas. Hoping you will be able to do something to prevent this ludicrous decision being carried out.

I am sincerely yours,
Dorothy Lindsell-Stewart.

'Untidy'! Meum had put her finger on an essential factor that stood between Epstein and his commission: English public school snobbery would have decreed 'he was not our class' and therefore not among 'the people who really count' for the likes of ffoulkes and company; Frampton's letter was of a kind that merely reinforced this view.

Others thought differently. The devoted Mrs Epstein refused to give up: she wrote to Major-General Donald about Beaverbrook's keen interest in her husband joining the MOI, of course unsuccessfully – he could not interfere, he wrote back on 3 April, in another's department (meaning the War Office's). But on 4 April, Lady Randolph Churchill telegrammed Lord Beaverbrook himself at his Hyde Park office in Knightsbridge with the dramatic: 'Epstein sails tomorrow Friday morning. Is at Crownhill Plymouth 38th Royal Fusiliers today. Could Winston help?'

Then, when Epstein's departure was postponed for a week, Mrs Epstein informed Beaverbrook of this on 8 April: 'Mr Scott,' she wrote, 'the Editor of the *Manchester Guardian*, is going to speak to Lloyd George the moment he gets back from France to see if anything can be done for Epstein's retention.'

As before, in the Strand scandal, the controversies over the Wilde Tomb, *Maternity* and *Rock-Drill*, and the campaign which hit headlines over his military exemption, the power of the die-hard Establishment was met with stiff resistance from those whose first priority was to protect art: people like Bone, Ross, Conway, Fisher, Beaverbrook, Scott, the Churchills and others. It was undoubtedly because of heavy, behind-the-scenes pressure from some of them, exercised separately or together, that Epstein's draft continued to be postponed. He was still in England on 20 April, cabling Quinn for £90 balance on bronzes and four instalments on carvings now due: '£100 received April 4,' he cabled on receipt of an advance.

Shortly after this – perhaps a week or two – the suspense and uncertainty finally overtook him; the inner reserves that had carried him through so much fell apart. He was absent when the remnants of the 38th regiment reported for embarkation and, after vanishing from his barracks, was found on Dartmoor having had a complete breakdown.

It is curious that about the time Epstein was undergoing this mental collapse, Henry Moore, whom he was to meet a little later and who was half his age, was training men for the Front in bayonet practice: Moore agreed he had a good war. Epstein, in contrast, had, during its last two years, a very bad one which culminated in desertion and being put under guard. He managed to pass on what he felt in a letter to van Dieren:

If anything can be done for me there is time enough to do it in . . . I believe that the opposition to my transfer came from this blessed Jewish regiment that I am in . . . I am at present imprisoned in the detention room, I hope not for long. I have passed through a mental crisis and you can imagine I am under the observation of the medical officer. My position in every way is horrible in the extreme. I have to submit myself to men who regard my attitude as a heinous crime. They know by this time how much I loathe the army and themselves and their ambitions, but they have me trapped and look upon me only as a schoolmaster regards a recalcitrant youth. As no one seems able to do anything for me I must submit to the future inevitable waste of days. How horrible that what amounts to my incarceration for an indefinite future should be looked upon as right, almost a fit punishment for my sins as an artist. I have got into a wretched state of nerves, so much so that I cannot sleep and feel an incessant desire

for movement. I walk about like a caged animal incapable of sitting down even for a few minutes . . .'

Of course there were those who have suggested Epstein feigned his breakdown. Yet what could be more natural? He was thirty-seven, detested violence and the coarseness of army life, was by nature highly sensitive, and had twenty years of dedicated work behind him; he had undergone immense emotional strain, had his wife, Meum, Guilford Street, Pett Level and studios to keep – how could he do this on the pittance a private received? And if he lost his houses and studios, he would lose his precious sculpture and art collection. No wonder he had a breakdown. This illness, however, marked the end of Epstein's threatened draft; he never joined his regiment in Palestine and was instead sent back to the military hospital in Plymouth, where he remained until his discharge on 25 July. While he was there he made ten drawings of wounded soldiers (including the remarkable pencil portrait of Sergeant-Major Mitchell). Alfred Yockney, Beaverbrook's secretary at the MOI, told the hospital Commandant, Lieutenant-Colonel Samuel, that he wanted to see them before Epstein sold them locally. Unfortunately, he had already sold them (to the Leicester Galleries for £70 in aid of the Red Cross, after first offering them to Quinn for £100). Samuel wrote back, 'I didn't think the drawings at all representative or interesting.' After Yockney's sharp reply saying he wanted Epstein at the MOI, Samuel explained in his letter of 27 July that Epstein 'could well be back at Guilford Street, a civilian again'; he should write there.

In July, Epstein had cabled Quinn from the hospital asking for £400 overdue on bronzes bought, but the moment he was home on the 26th, and had discovered how ill Quinn had been, he wrote to him:

> I have been discharged from the army as I had a complete breakdown and my condition became so serious that the last five months I've spent in hospital . . . I hope, Quinn, you are recovered from your operation which on reading through your letters I see you've undergone. I haven't been allowed to see letters and my state has been a bad one altogether. Everyone is suffering so one must not complain. Friends are killed on all sides . . .'

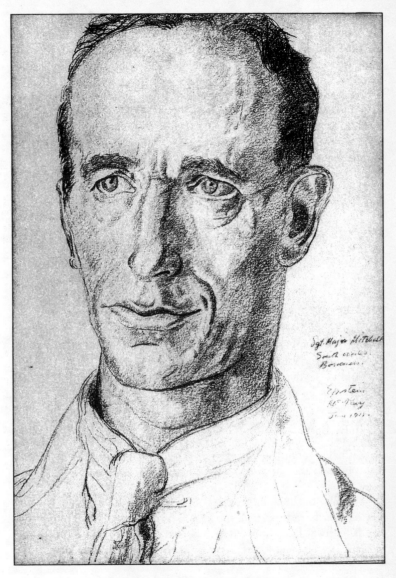

Sergeant-Major Mitchell, **June 1918.**

By the beginning of August Epstein was back at work, hoping for some big commission that would use all his powers – he wanted to make up the time that had been wasted over the year. He wished, too, he could work in some place where he wouldn't meet the intense opposition found in England. He wrote to Quinn about this a week later: 'Here all is pettiness and prejudice. If I produced babes' heads to the end of my days I would be thought wonderful, but anything large, grand and terrible, fit for our times, is timidly shrunk away from in the timid and tepid atmosphere of our art world here . . . Should any opportunity for a monument or memorial come to your notice, remember me.' If he didn't work in England, he said, he might find a chance in Paris – war, he claimed, had intensified the mean and parochial spirit of everybody and everything connected with art. 'The experimental artist is doomed. There is a shortage of everything now. The shortage is brains . . .'

Quinn was too exhausted by his illness to write back, but he cabled on 9 August to say he was sending £200 to meet their agreements, a sum which brought his total payments since January to £870. Epstein may have had some advance knowledge of a Ministry of Information plan for him to go to France, but the chance to do so came sooner than he might have expected. In picking up other strands of his life, he wrote to Conway, apologizing for not answering a letter from him dating back to April; he should have replied earlier, had been in hospital, and would like to work for the IWM on the lines suggested then. Conway naturally put him on to the MOI where Beaverbrook and Yockney had already decided that he should be sent to the Front, all expenses paid, as soon as possible with a commission to do six busts of war heroes for about £50 each. A letter setting out this proposal was sent to Epstein on 21 September. It was an offer too good to miss, and Epstein, hardly surprisingly, confirmed his agreement to it by return of post, adding the condition that he would want to supervise any castings that were made.

Suddenly, the dreadful traumas of the past year were forgotten – they might never have happened; the tension he had experienced in captivity had fallen away like a wire cut with absurd ease; a sky that had appeared so black one moment was replaced by an optimistic, flawless blue.

One imagines he couldn't wait to get to France; commissions apart, the trip was an opportunity to find friends in the Montparnasse group broken up by the war, and to see if any things of interest in the way of

African wood carvings might be available for his collection. When exactly he went is not recorded but he must have been in France when he wrote to Quinn on 28 October. There was no address given; it was very short – he wanted him to know, simply, how very sorry he was that Quinn had been so ill. He explained, too, that he hadn't been well himself; it would take time to recover fully from the breakdown – he couldn't, he wrote, work long hours without becoming exhausted and had changed his mind about doing large monuments. This was an 'obsession' that was better dropped: better to get on with work in hand, part of which had, of course, been commissioned by Beaverbrook and Yockney – 'size isn't everything,' he said.

Meum went with him to France, and in Paris, on 31 October, their baby, Peggy-Jean, was born. Mrs Epstein would have been there, too. She never failed to be present to supervise operations.

7

Van Dieren

WHETHER any work for the MOI came from the mission is uncertain: possibly the bust of Sergeant David Ferguson Hunter VC did, although it is likely this was carried out in 1919. By the end of October, the war was as good as over and the chance of making much further use of the sculptor's gifts was lost, thanks mainly to Frampton's interference. A contribution which could have been as telling as Paul Nash's memorable studies of shattered landscapes, C. R. W. Nevinson's evocation of death and loss, and Edward Wadsworth's remarkable exploitation of Vorticist graphics for the camouflage of ships had to remain, as far as the IWM's collection was concerned, with *Sergeant Hunter*, the *Tin Hat*, *American Soldier* and *Fisher*. When the Armistice was signed, Epstein was back in London working on a bust of Cecil Gray, a portrait which marked the beginning of his rush to make up for lost time in the months of inactivity which had preceded his very bad breakdown: this prolific phase carried him through to his second exhibition at the Leicester Galleries in February 1920.

Did he look back with bitterness to that wasted period, attending tribunals, fending off abuse from the press, training to kill and, lastly, recovering from the exhaustion which followed the breakdown? It would not have been unreasonable had he done so. He was thirty-eight – no longer a young man – and possessed with a sense of the shortage of time available to accomplish what he had to do, yet behind whom there was already a legendary output of sculpture which, shown in exhibitions and containing revolutionary works of great renown, had led to international recognition and the status of Britain's leading artist. In spite of this,

Epstein had been bundled into the army as a private as quickly as possible after his last appeal had failed, and might well have compared this treatment with that of a painter as facile as Orpen who had been provided with the rank of major and set up in considerable comfort with a car, chauffeur and batman. Here was an example of the class snobbery endemic in the English system, and of inestimable importance in that war, which Epstein would have regarded as so contemptible that the memories of his squalid experiences had to be swept aside without delay. For him, whose main concerns were quality and hard work, there would have been no looking back: he looked forward, driven on by his vision, creative ambitions, and by his exceptional energy and physical strength. The war had been interruption enough; nevertheless, its horrors were not forgotten in his work.

Considering how little time he had in 1918, and how embattled with problems he was, his output for the year was remarkable. If he had a moment, he worked: as he said, 'I cannot recall a period when I did not draw', a remark as true of his time in hospital as it was of his childhood – he drew, and his illness in no way affected the clarity of line and the sharpness of observation in his study of Sergeant Mitchell. And when on leave, back in his studio, he picked up from where he had left off as though nothing calamitous had occurred in the interval and there had been no break in the continuity of his thoughts: he set to work and made a composition as original and perfect as *Meum with a Fan*. Besides that and the bust of Cecil Gray (perhaps partly on account of recurring bouts of exhaustion, this took twenty sittings, twice his normal number, at the end of which he remarked, 'I am only beginning'), he finished three portraits of his wife.

The third of these, with the mantilla, and the fifth and last of the series, was, he thought, 'the most profound' of any he had made of her. His other favourites were his first in 1912 and his second, the mask of her, made in 1916, a year after the superb *Billie Gordon*. In the three that he liked so much the quality he conveyed, and which he seemed to particularly admire in her, was serenity. He said of the first:

Leaning upon her hand, she looks toward the future with serene confidence. In the composition itself, I attempted movement which, while very natural, I abandoned in later work, and severely restricted myself to the least possible movement. This I practised as a kind of discipline so that my construction would be more firm.

And of the second:

> In this mask, I immediately made what I think is one of my subtlest and most beautiful works. The serenity and inward calm is there, and from the point of view of style, the simplicity is that achieved by antique sculpture. I can recall that I worked at this mask without effort, achieving it happily.

This simplicity is also the characteristic of the masks of *Billie Gordon* and *Meum*. Of the last and fifth study of his wife, he said:

> it has that quiet thoughtfulness that I had unconsciously striven for in the other two; or most likely, as I matured in my work, I naturally brought into full play all my powers of observation and expression, and so made this one of my gravest, and I think one of my most beautiful busts. This work was unhurried and brooded over, and the drapery was worked with great care. The lines, all running downward like the rills of a fountain, are essential to the effect of the bust, and help to express its innermost meaning. I think of this bust as a crowning piece, and I place it with any work I have done.

And it was his last of her: she had already been afflicted by the dreadful ailment which lowers the metabolism and thickens the skin, and this changed her from the good-looking redhead to a person of gross appearance. She refused help from doctors, being something of a Christian Scientist, and that was unfortunate: even then there were treatments to arrest the disease.

Each of the three portraits of his wife was special – the first with its long and languid lines, the mask, a picture of stillness, while the third was unique because, as a study in depth, it intensified the tranquillity of the subject. Hence his observation that the downward lines helped 'to express its innermost meaning'; at the same time, his likenesses of her flashed a light into another corner – the shadowy character of Mrs Epstein and her importance in her husband's world. Her dedication to his work, plain to see in her lengthy correspondence with Quinn during the crisis of the call-up, ran parallel to her missionary zeal to protect her artist from any threat or enemy; yet this meant sacrifices, like accepting Meum into the household without fuss, models staying who had to be fed, and of going without herself, so short was money on occasions. Those close to her – Peggy-Jean and Cecil Gray, who was, with van

Dieren, one of Epstein's closest friends at this time – recognized in her exceptional qualities that brought calm and stability to her husband's life, whatever the difficulties. Gray was devoted to her; she was very kind to him, partly because, he thought, he was a Scot like her. When thinking of the wives of great artists he'd known (besides Epstein's, there were Sibelius's and Delius's), he wrote in *Musical Chairs* that 'I am never sure whether the latter [the husbands] are to be congratulated on account of their good fortune, or praised for their fine choice and judgement ... of all men I have ever known I have never known any so supremely blessed in this important conjunction as the greatest ...' Gray may have been an incurable romantic, but he wasn't a complete fool, and throughout the stress of emotional entanglements that accompanied much of the Epsteins' life together, one good reason their marriage didn't break up was her stubbornness in the face of a crisis.

He completed two further works as winter closed in with the end of 1918. There was first the bust of Clare Sheridan, the wealthy, well-connected, immensely popular cousin of Winston Churchill. She was unmarried, in her thirties, and had leapt into the gap of the lost generation left by the war when there were two million more women than men; and, immersing herself in new-found feminine liberalism, was already a highly successful society sculptor. Above all else, she longed to be taught by Epstein, the great artist, a celebrity, trained in Paris and friend of Picasso, Brancusi and Modigliani. When she discovered he didn't take students, she devised another plan – she asked an admirer to give her a Christmas present of an Epstein portrait of herself. In this way, she could surreptitiously learn from him by studying his methods. She wrote in her autobiography, *Nuda Veritas*:

Epstein at work was a being transformed. Not only his method was interesting and valuable to watch, but the man himself, his movement, his stooping and bending, his leaping back, poised, and then rushing forward, his trick of passing clay from one hand to the other over the top of his head while he scrutinized his work from all angles, was the equivalent of a dance ...

He wore a butcher-blue tunic and his black curly hair stood on end; he was beautiful when he worked. Then I learnt the thing which has counted supremely for me ever since ... He did not model with his fingers, he built up planes slowly by means of small pieces of clay applied with a flat, pliant wooden tool. He told me that he could

not understand how other sculptors could work with their fingers which with him merely left shiny fingerprints on the surfaces. This was what I had always suffered from, the shiny smooth result of my fingertouch. It had exasperated and perplexed me. It is his method of building up that gives Epstein's surfaces their vibrating and pulsating quality of flesh ... Without him ever suspecting it, I acquired from merely watching him, knowledge that revolutionized my work.

Her technique as a modeller, if little else: Epstein was only interested in her as a head. However, she didn't lose touch with him or any opportunity to ask his advice. For this purpose she invited him to large and fashionable lunch parties at her grand studio in St John's Wood Mews. It isn't at all easy to imagine him in this setting, at a dining table surrounded with pieces of sculpture in progress, with divans and personalities like the Attorney-General, Lord Birkenhead (a friend of Churchill's who, Epstein said, seemed to look, with a cigar sticking out of the corner of his mouth, 'duller than any man I had ever seen'), but doubtless Ambrose McEvoy, the painter whose wife's head Epstein had modelled in 1910, would have encouraged him to go. After all, in that rich, smart set there could be the chance of picking up a commission or a contact and Epstein needed as many as he could get of both. At the same time, he was constantly on the look-out for good material for groups and other possibilities he had in mind; Mrs Epstein would have urged him to go – she was always casting about for suitable models, and even went so far as to employ Peggy-Jean, when in her teens, to act as a scout on her father's behalf. The moment he arrived, and found H. G. Wells sitting for his portrait ('rolling a pellet of clay in his hands, a procedure which would have maddened me, had I been working from him'), Ms Sheridan asked him for comments. He pointed out an obvious omission – she had forgotten Wells's overhanging eyebrows, which gave him 'the Wellsian look'. It was at lunch that he noticed the Marchesa Casati.

Lady Michelham, a wealthy woman at the centre of an inheritance case called the Michelham millions, shouted over to him: 'And when am I going to sit for you, Mr Epstein?'

'Will tomorrow do?'

Unfortunately, 'tomorrow' wouldn't – 'tomorrow' she was sitting for Clare. The day after was no good either, and McEvoy had booked her for Friday – doubtless on account of her money and title, she was much in demand: another artist put up a hand to claim her.

With that, he gave up. But the Marchesa Casati, on the other hand, was delighted to accept his invitation to sit 'tomorrow': she arrived in a taxi punctually at two the following afternoon, leaving the driver to wait for her.

Out of this chance meeting came a mask, one of his finest pieces. He found her 'striking looking', 'weird', a 'timeless' sitter with a 'basilisk stare', a 'Medusa' with the strangest tastes – she adored snakes, wore a dress of white feathers on one occasion that 'left stray feathers floating behind her', and silk pyjamas at dinner on another; she lived in Capri and coveted the mask of Meum which she wanted cast in glass. Yet Epstein found her head so interesting that he continued working without a break until nightfall. As the room darkened and snow fell heavily outside, he encircled her with candles (there was no electricity in the house), built up the fire in the grate to get more light and invited the driver in to sit beside it and find a book to read from the shelves. It must have been a strange scene, like a set arranged to represent a mysterious ritual in a painting by some old Dutch Master: the Marchesa as the illuminated centrepiece; the sculptor absorbed with the clay form on his stand; the driver reading *The Brothers Karamazov* by the fire; Meum fluttering in like a soft, pale moth with her baby; and the whole group attended upon by Mrs Epstein, a huge shadowy pillar of motherliness, coming in with refreshments at appropriate moments.

The mask was finished at a rush the next day. Cast in bronze, some magical touch in its modelling retained the memory of candlelight glimmering in the eyes.

With 1918 over, a cable went off to Quinn on 3 January reminding him that payments on October, November and December instalments were now overdue, and it was only after three more cables (his letters were still being opened by the censor) that they were at last received by the end of June; money was badly needed. Two days later, he wrote to the MOI asking for the return of *Tin Hat* and some drawings that had been on exhibition there, because he'd had an offer for the bronze he wanted to take up. Yockney, however, told him that the works were on show in America, and that, since the MOI was closing down, he hoped the IWM would buy them. Through their correspondence, they struck up quite a friendship; on 15 March, Epstein offered a copy of *Fisher* to the IWM for £120, and, on the same day, Yockney promised him some commissions of 'VCs'.

Perhaps Epstein had neither the time nor inclination to do them; or perhaps Yockney's offer was countermanded by another, since, like a flashback to Epstein's experiences in the war, an inexplicable news item suddenly appeared in the *Morning Post* on 19 April (two days after ffoulkes removed Frampton's letter from the files) which completely contradicted it: 'It is officially stated that no commission has been given by the IWM to Mr Jacob Epstein to execute any sculptures respecting the Meurte or other incidents at the IWM.'

Epstein must indeed have been short of time. By the end of January, before returning to his *Christ*, and going on to do twelve busts at the rate of more than one a month, he completed the first of fifteen studies of Peggy-Jean. This was the longest series of one subject he did, and only ceased after the birth of his fifth child, Jackie, in 1934:

> I never tired of watching her, and to watch her was, for me, to work from her. To make studies in clay of all her moods; and when she tired and fell asleep, there was something new to do, charming and complete. To work from a child seemed to me to be the only work worth doing, and I was prepared to go on for the rest of my life looking at Peggy-Jean and making new studies of her . . .

She was so important to him as a source of inspiration that one is tempted to think that he saw her as the poetic conclusion to a phase of work dedicated to love, birth and life that was the exact reverse image of four gruesome and catastrophic years of hatred, destruction and death. It may be, too, that these years inspired the religious themes he pursued from then on, of which the first was *Christ*, begun before being called up and left until one day when he visited van Dieren ill in bed, soon after the war was over.

Van Dieren, often ill, was still at work on his Epstein book for Bodley Head, and they had a lot to discuss. Watching his head, spiritual and worn with suffering, Epstein suddenly realized he had to make a mask of him, and rushed home to get clay to start on it at once. He had immediately recognized 'the mask as the Christ head, with its short beard, its pitying accusing eyes, and the lofty and broad brow denoting great intellectual strength.' Epstein went on:

> 'You will say – an accident. That was no more an accident than the

The last page of a letter dated 11 January 1920 from Epstein to Bernard van Dieren in which he mentions some of his recurring anxieties.

event recorded in some short sketch by Turgenev, when he tells how, standing in the crowd somewhere, he instantly felt, in some man beside him, the presence of the Christ Himself and the awe that overcame him. So with the Disciples of Emmaus, as represented by Rembrandt in the unforgettable Louvre picture of that name. The Disciples have met a stranger at an inn who has sat down with them and broken bread. In a flash the divine head is lit up, and in awe and astonishment the Redeemer is revealed to them.

I saw the whole figure of my 'Christ' in the mask. With haste I began to add the torso and the arms and hand with the accusing finger. This I then cast and had, as a certainty, the beginning of my statue. So far the work was a bust. I then set up this bust with an armature for the body. I established the length of the whole figure down to the feet. The statue rose swathed in clothes. A pillar firmly set on the two naked feet – Christ risen supernatural, a portent for all time. I remember that I was interrupted in this work for a considerable period, a whole year in fact, and it stood in the centre of my studio in Guilford Street, unfinished. When I resumed work on it, it was only to finish the feet.

It was not that he was religious; it was that he saw in Christ a great and timeless subject. He had been carried away, as ever, by the inspiration of a sudden moment, unable to pause until the conception was formed, put down and fixed to the details. He finished the main figure at lightning speed, and stopped only when another passion overtook him – the heads and busts to do: Gabrielle Soanne (a former model of Modigliani's), three of Peggy-Jean, two of Betty May (nicknamed 'Tiger-Woman' from her gangland days in Paris), and his second of Lillian Shelley (like Betty May a dancer from the Café Royal). There were others, and by the time he returned to the *Christ*, van Dieren was back in Holland, ill again, and he had to ask his friend Jack Kramer, the Yorkshire artist, and Cecil Gray to pose for unfinished parts. Gray took van Dieren's place for the hands, neck and feet; he never forgot Epstein's inspection:

Epstein, quite abruptly, and for no explained reason, asked me to show him my feet, and I sheepishly removed my socks and shoes, and he looked at them closely and said: 'They will do' . . . But to this day I remember only too distinctly the agonies I endured in maintaining, for the Christ statue, for hours on end, the rigid position of the hands which are, in both senses of the word, the *crucial* element in the composition . . .

Throughout, Epstein said, his conception was clear; incredibly, however, the fact that living people had been the models, and had helped an artist in a work with a symbolical or religious meaning, was seen by some to be shocking. The remotest resemblance to a person they knew, Epstein said, was regarded as being sacrilegious – 'so with the "Christ"'. A woman, for instance, who knew and disapproved of van Dieren, and who had seen the work in his studio before it was cast, for some obscure reason declared in a horrified tone that he 'had committed something "evil"'; in her eyes, Christ wasn't a man but a spirit, to be mysteriously conjured from nothing. Epstein insisted, however, that his statue still stood for what he intended it to be. 'It stands and accuses the world for its grossness, inhumanity, cruelty and beastliness, for the world war . . .'; remarks which bear out van Dieren's own in his 1917 review that sitters 'constitute . . . certain human qualities' that have been in the artist's mind awaiting the moment when he comes across an individual who expresses them. Van Dieren, in this case, had acted as that individual.

In the meantime, on 26 May Epstein had been in touch with Quinn about the granite *Mother and Child* – if he didn't like it, he could have a carving of the *Mother* figure instead; it was at Pett Level, nearly six feet high and weighed a ton. He would wait for Quinn's instructions, explaining he hadn't done any carving lately and wouldn't be doing any for some time. The point over the carving came up because Quinn had told him that some photographs of bronzes Epstein had sent him had never arrived, adding: 'I do not think I would be interested in any more of your bronzes for some little time,' a remark which hurt Epstein. 'As you are not interested in bronzes,' he replied, 'it doesn't matter about the photographs going astray, but they were photographs of my latest work and, I think, my best. I am sorry to see that you think only good sculpture must be carving. Much bad sculpture is carving and the greatest works can be bronze.' He was plainly very angry when he wrote this, and must have regarded Quinn as having the arrogance of an illiterate fool. He went on: 'Indeed, the material is secondary, just as a painter can at will work in oils or watercolour or tempera, and what makes the work valuable is solely the genius of the artist.'

Quinn realized, of course, that the insensitivity of his remark had upset Epstein, yet there was no retraction. Instead, his precise legal mind was intent on having the record put straight – 'I did not say that "only good sculpture" must be carving' – as if some aesthetic

pronouncement had been made for posterity; and went on to repeat, sentence for sentence, what Epstein had said, expressing full agreement. He added that he didn't 'care too much for English art at all. It is too domestic, too heavy, and it lacks the brilliance and style and chic quality of the best French art.' He found Wyndham Lewis's work (on exhibition in New York) sentimental and was buying only Brancusis, Derains and Rouaults at the moment, all news which Epstein would have construed as an insult to himself. He was quick to retaliate:

> As you speak of an exhibition of English art in New York and express disapproval, I might say that what is done by English artists does not interest me in the least from the highest to the lowest. They are not merely 'domestic', they are thoroughly incompetent and pretentious. In cubism, they are only borrowers, and bad ones at that . . .

He was very much annoyed, and went on to remind Quinn that John Lane was bringing out a book on his work, and that the writer was van Dieren – if he had any good photographs of his pieces would he let him have them? As a matter of fact, he hadn't, but Quinn was clearly impressed by the news about the book and said he would be glad to have some taken – gloss prints for reproduction purposes, matt for Epstein's own collection; he was to tell him what he wanted. Epstein did. In a cable of 25 June, he said: 'Send photographs frontviews and sideviews Old Italian Woman/Irish Girl/Granite Maternity/Birds/Bronze Figure/Euphemia/Shelley/Flenite Figure.' Unfortunately, he then heard from Quinn that this was a most inopportune time, that he was still ill and was going on holiday. Epstein wrote back on 19 July to tell him not to worry about the photographs; there was plenty of time still, hoped the rest would improve his health and was very apologetic about his impatience. The fact was that he hoped this would stop Quinn from having them taken by a photographer of whom he didn't approve – Quinn had commissioned Charles Sheeler of Philadelphia. This impatience had been brought on by Epstein's own illness; he had been very bad – six weeks in bed with neuritis in his right hand and arm. Work had been out of the question; although this was obviously a side-effect of his mental collapse, he blamed the English weather, as usual. (Quinn wrote Mrs Epstein a four-page letter diagnosing his condition – change of diet, not change of climate, was the cure – and associating Epstein's complaint with his own; wrongly, of course.)

Epstein was convinced it was the weather; he was living – 'or rather dying' – in 'a great morass of mud and damp'; somehow he must extricate himself from this – have an exhibition in New York or find a studio in Paris. This was partly for reasons of health and his fear of the onset of winter; but partly because he despaired of the parochial attitude to art of the English; a spell in Paris was constantly at the back of his mind. He wanted to see what was happening there, and what he might find in the way of sculpture for his collection, not easy now that pieces were becoming expensive, even in London.

His illness, lasting several months in all, held up the completion of the *Christ*, *Lillian Shelley* and another study he was doing of Hélène Yellin, the wife of a musician. By October, when he was better, the *Christ* was finished, and his attention had now switched to the publisher's progress on the book. Mrs Epstein had already written to van Dieren in September, listing the photographs sent to Lane, and Epstein followed this up with a detailed discussion of the quality of the paper and illustrations: neither were any good.

> I have only yesterday received proofs of them [the illustrations] and they're so unsatisfactory that I have *rejected them all*. They [the printers] do not in the least understand what the things should look like and although I have insisted time after time that they should make the proof resemble the original photographs, they send me the wooliest sort of reproductions, also printed on such wretched paper that I have had to protest against it. Lane has now all the photos except 10 . . .

He had arranged an interview with the publisher's manager and printer 'to get,' he told van Dieren, 'some reasonable answer back as to the paper and quality of the reproductions.' When it came to anything connected with his work, he never let go; he was the all-round perfectionist, very business-like and practical, reserving for its presentation, as with the execution of it in drawing, modelling and carving, his undivided concentration. There was not a hint of sloppiness, ever, and the attention he gave to van Dieren's book is an example; he had decided to keep the ten photographs back until absolutely satisfied with the book's standard of workmanship. He reported to van Dieren: 'They are very tricky, the publishers, and once they get all the plates I believe them capable of bringing out the book, whether it pleases me or not.' He saw it to be, moreover, as much his book as van Dieren's, and the text, now

completed, could also be held back as a further precaution, he suggested. 'Perhaps you had better let me have it,' he said, 'or a copy of it, and I will give it to Lane only when I know he intends bringing out the book decently. I understand he has sent you some new proofs; you will judge from these what scandalous reproductions they are.' He was fully in charge and was not going to allow any detail to escape his hawk-like supervision.

Once he had recovered from his illness, activity in the studio was feverish again; he was working almost daily and finishing the bust of the girl, *Hélène*. The *Christ* was cast in bronze and in the 'shed' in Emerald Street. The *Shelley* had been badly cast and damage caused by the plaster moulders had had to be repaired by him before he could get photographs taken that he wanted to send to van Dieren. But his mind was still on the book. In another letter that went off on 5 November, he said he had seen Lane and had 'received a very sinister impression'; the more he went into 'the matter of the reproductions the worse things got'. Lane, it struck him, suspected van Dieren of not being the best person to write the book and Epstein, changing his mind, now urged his friend to get his manuscript in the post to the publisher as soon as possible; already Epstein was anticipating another crisis and a new attempt, imagined or not, to sabotage serious recognition of his work. Keeping the manuscript back would do no good, he decided – in fact, this could probably have the reverse effect: the publisher might exploit its absence. Lane had forty of Epstein's photographs and could, he believed, publish the book without the text, and that would be disastrous. All this he relayed to van Dieren. He had the distinct feeling that this was in Lane's mind; he was capable, using one excuse or another, of getting someone else to write it. 'I receive the impression,' Epstein said in his letter, 'of a very shifty man and I regret having anything to do with him.'

Memories of past experiences quickly worked him up into a state of extreme anxiety; an obsession with Lane's possible 'duplicity' was growing with every sentence he wrote:

Lane is filled with silly ideas of making the book 'popular' . . . His whole attitude . . . is wrong. He understands nothing of sculpture or any other art and only thinks of exploiting artists as cheaply as he can. Your text will bring to the book the right attitude and that is the opposite of this damned commercial publisher's idea.

He had become seriously worried that once again his work would fall into the hands of some writer who would exploit it for sensationalism in the cause of sales to suit himself. 'I can see that it would not do to give Lane the excuse of claiming that the manuscripts arrived *too late*.'

His anxiety spread to Quinn a couple of days later; again he was hammering home his view of the English and art, a favourite subject that recurred as often as his dislike of the English weather. He had been offered an exhibition at the Leicester Galleries but didn't look forward to this in the least. He was sick of England, convinced that it was no country for an artist; only vulgarity and slickness in painting and sculpture was wanted, and an artist who was a society 'pet'. He could, he remarked, come up to none of these 'ideals', thinking, doubtless, of smart luncheons like Clare Sheridan's and the people he had to put up with at them. Getting work wasn't a problem – he was given plenty of portraits to do; it was the sitters, who were rarely 'sympathetic' or 'understanding' and looking for flattery, not a work of art. Although he almost always managed to overcome this intrusion by becoming involved with the sitter as a sculptural object, what he needed was an interesting model who was either intrigued by the work as art, or who had no special interest in the result. Hence Betty May, like Lillian Shelley or the Marchesa Casati, was an ideal subject. So, of course, was his daughter – a reason why, despite the severe inflammation in his arm, he made four studies of her in one year. Dealers were another source of frustration – on the whole, he found them interfering nuisances, and he was particularly infuriated by the 'exploiting dealer' whose manner intimated that he knew more about the artist's works than the artist himself, and presented them to the public in a way that could only disgust him. In fact, he so despaired of the English scene that the possibility of a New York exhibition did occur to him more than once, and he put the idea to Quinn: perhaps he could look into this. If someone could advance him £500 – a hint to Quinn? – to cover expenses for crating and insurance, he could easily repay it: there were twenty bronzes available, none to be sold for less than £100, and one, a *Christ*, would be £1000.

Of course he went ahead with the Leicester Galleries' offer, a New Year resolution that was good news for Brown and Phillips: attractive as perhaps an official launch of his work in America might have seemed, the plan was too bulky to manage at short notice, and Epstein was not going to stray from England after all. In fact, he had suddenly cheered

up. The show, he told Quinn in a letter of 11 January, was opening in four weeks; and there was an excellent Matisse exhibition on in London with 'things far more vital than anything done by "our" great man' (he could never resist the chance to get a dig in at John these days); *and* Bodley Head was publishing van Dieren's book this 'winter'. By that, he meant February, to coincide with his exhibition, an unlikely possibility indeed. Epstein, perennially optimistic, saw the event merely from his point of view. Nevertheless, due to the enthusiasm and efficiency of the much maligned Lane, it didn't miss the date by much: priced £2-2s, with fifty illustrations, the beautifully produced edition was in the bookshops, amazingly, on 21 May, shortly after the show ended.

Lane had wanted van Dieren to meet the deadline; this was why he badgered Epstein about the material. Even so, getting it out when he did was quite a feat, as Epstein himself realized. Van Dieren's text only arrived at the beginning of January, and proofs were sent back to him in Holland the following month. Epstein, delighted with the text, had one criticism – he wanted a jibe about some work of Rodin's (van Dieren had compared it to 'candle chippings') deleted. Otherwise, it was perfect, a reaction that was hardly surprising, since it began:

> The world does not forgive talent. Consequently, those that possess it have to pass through a struggle which permits only the strongest minds to come through the ordeal with sufficient energy left to achieve their mission of enriching humanity, their most implacable antagonists included. This expense of energy is one of the causes of the rarity of good works.

After going on to say that 'The world does not forgive success either', and that 'Being itself responsible for its own bestowal, it is on that account the more vindictive', van Dieren compared Epstein's treatment with Rembrandt's three centuries earlier. He made the comparison because the two artists were alike, he said; and both had a force of individuality in their work which only a few others, Dürer and Michelangelo, for instance, could equal. Both produced a fantastic number of portraits; the productions of both were distinguished by a directness and sincerity that have often puzzled their admirers who could not reconcile this with the more fantastic execution of their purely imaginative works; and, moreover, both artists used the same models over and over, and not those pretty models which conform to

the public's idea of 'the artist's model'. Finally, he said that both artists achieved universal and timeless truths, and that they did this through the simplest of means that sometimes suggested, in both, the spirit of the Old Testament. Although van Dieren did rather go on, and although Epstein may have thought him at moments to be a bit of a windbag (the book was overwritten in a way quite contrary to the practical and simple nature of its subject), he could hardly have been displeased with this tract by van Dieren, T. E. Hulme's replacement as the leading authority on his work. To be placed in the context of his idol, Rembrandt, was profoundly moving.

The reference to the Old Testament was not a chance one; Epstein was fascinated by the imagination and mystery of its extraordinary stories – one of Peggy-Jean's earliest memories was of lying, like an effigy, in her cot along the end of her father's bed and listening to him reading aloud from the Old Testament every night; as a result, his extensive knowledge of it became an inspirational source for, in particular, the phase of his work in the Thirties. Otherwise, however, religion, *per se*, had no interest for him, a fact of which many who became angriest over his *Christ* at the Leicester Galleries that February and March were unaware. Then, Epstein's statue was condemned as a blasphemous departure from the Jewish faith; and the artist was, too, for trespassing on Christian territory. He said himself that the racial element could have been responsible for some of the attacks. 'The idea of a Jew and Christ,' he said, 'seems, illogically enough, totally unrelated to many people.' And there were other reasons for the furore that followed, the work sparking off violent reactions in a way that only an Epstein can. Even Quinn was appalled by it. On 4 February, Cecil Phillips, Oliver Brown's partner at the Leicester, wrote to Quinn, drawing his attention to the opening in two or three days, saying it was a finer exhibition than the 1917 collection, and enclosing a catalogue and two photographs, one of the *Christ*, the other, the Duchess of Marlborough's bust, called *Portrait of a Lady*. He wanted Quinn to make a special note of the *Christ* because he thought it 'a very remarkable work' that was 'sure to rank as one of Epstein's finest achievements', adding that the *Mask of Meum* was also extremely interesting. This letter would have arrived soon after the opening and possibly a little before advice on what to buy was sent to Quinn by his roving envoy, Ezra Pound. Quinn had been in contact with the Leicester Galleries after Gaudier-Brzeska's death in 1915, trying to get hold of his sculpture,

and at the memorial exhibition to him in May 1918, for which Pound wrote the introduction to the catalogue, he bought three major pieces for £600. But he didn't altogether trust Pound's judgement. He didn't, for instance, like any of the Vorticist things Pound had advised him to get (Epstein's condemnation of the 'fashion' may have influenced him here) except, that is, for Wyndham Lewis's which he was prepared to tolerate (although he thought them sentimental) out of loyalty to Pound, Lewis's friend.

At Epstein's exhibition, Pound was again in evidence, recommending busts of his wife, and also *Gabrielle Saonne*, the *American Soldier*, and the *Christ*: he called *Christ* 'magnificent, absolute wipe off of Rodin and Mestrovic'. Quinn, however, not impressed by Pound's enthusiasm, was so shocked by the picture of *Christ* that he sent off a four-page letter to the Galleries on 6 March with some surprising comments: 'I am not interested in mummies or any things that look like mummies, and the figure wrapped up in graveclothes had too much an appearance of a mummy lifted from a grave and braced up to interest me.' Then he revealed the real, obsessional source of his feeling of irritation: he loathed President Wilson!

> Secondly, its resemblance to Doctor Woodrow Wilson was altogether far-fetched, although I imagine some of his political enemies might wish that he was politically as inactive as a mummy, or that he had been mummified before he mussed into the European condition . . . He may be a great statesman but there is nothing Christ-like about him.

The media, he said, had tried to inflate his importance – streets were named after him etc. – but he would be forgotten in twenty years.

> Epstein's choice of Wilson's face, with more jaw than skull, for a figure of Christ, reminds one of Clemenceau's mot about him: 'Mr Wilson talks like Jesus Christ but he acts like Lloyd George'. Perhaps Epstein was thinking of Wilson's talk and not of his acts when he chose him as the model for his figure.

And so he continued, picking about among hypothetical psychological assumptions, describing Wilson's little fingers – so different from Epstein's Christ's strong hands – that lacked character (but giving a

good reason for this anomaly), always reading into the work things of monumental absurdity.

The directors of the Galleries were highly amused by his analysis of the *Christ*, writing back to tell him that no resemblance to the President was, they knew, intended; and if they showed Epstein his letter (it was headed 'confidential'), which they probably did, he would have been astonished at Quinn's ludicrous claim. Yet at least it was funny, and that was more than could be said of most press comment. 'CHAMBERS OF HORRORS BY EPSTEIN' ran the 8 February headline in the *Evening Standard*. '"Gabrielle Saonne" and a "Portrait of a Lady" are works which will leave the average person as cold as the bronze in which they are cast,' was a typically crude comment; another, that the head of the *American Soldier* resembled 'the type of person whom we know as a crook'; and again, 'studies of a babe, represented by four heads, is another repulsive exhibit'; and finally, 'clearly he loves the Asiatic type of face, as it dominated all his work'. This pointedly racist observation might have gone unnoticed had the theme not been taken up in the *Weekly Graphic* by Father Vaughan, the high-priest of the anti-Epstein campaign of the Strand scandal all those years ago: 'I feel ready to cry out with indignation that in this Christian England' – at last he had the perfect topic to work on – 'there should be exhibited the figure of a Christ which suggested to me some degraded Chaldean or African, which wore the appearance of an Asiatic-American or Hun-Jew, which reminded me of some emaciated Hindu or badly grown Egyptian.' Curiously enough, this abusive article, in which Vaughan called the statue 'gross and grotesque', betrays an anger expressed in Quinn's letter, and with a similar resort to fantasy; in Vaughan's case, using every so-called 'inferior' race which might be distasteful to the English. His remarks were, of course, warmly received by the general readership of the *Standard* and *Graphic*, and, as with the BMA figures, *Rock-drill*, *Venus*, and the call-up episode, every insult possible was employed: the work 'should be denounced from the housetops', it was 'too awful for words', 'this evil thing' with 'the head of a convict' should be thrown in the river, and so on. Cecil Gray wasn't far off the mark when he wrote: 'I question whether any great artist of our time or of any time has been so consistently maligned or vilified as Jacob Epstein.'

Vaughan had, it seemed, unveiled the barrage of devastating racist attacks that continued to batter Epstein in the Twenties and beyond. 'Deport him!' That, said the old military men who came to the gallery,

was the only thing to be done with Epstein. But there were those who were normally ready to help him. Shaw, partly perhaps to make up for being so unhelpful to Epstein in the war, saw the perfect opportunity to launch a blistering attack on Vaughan in *The Graphic* with a sample of vintage Shavian sarcasm:

Father Vaughan is an unlucky man. He has a genius for mistaking his profession. The war tore off his cassock and revealed the spurs, the cartridge belt, the khaki underneath. And now that he is demobilized, his wandering star leads him into the profession of art critic.

When I was last at Lourdes I saw a cinema representation of the Passion. I think that Christ would have pleased Father Vaughan. He looked like a very beautiful operatic tenor ... The Church knows its business at Lourdes. And the cinema actor knew his business, which was to study the most popular picture of Christ, and to reproduce their subject in his own person with the aid of his make-up box. He purchased the ambrosial curls and the eyebrows, and put them on with spirit gum. If his nose was not the right shape, he built it up with plastic material.

Vaughan was, he went on, in for some shocks by choosing art. At Bruges, Christ was made 'a plain, troubled, common man'; at Speldhurst Church near Tunbridge Wells in Kent, Burne-Jones made the figure on the cross 'a glorious Greek'; Michelangelo did similarly in his Last Judgement, and Holman Hunt had Him 'as an excessively respectable gentleman with a trim beard and a jewelled lantern, knocking at a door with the gesture of a thief in the night on one occasion, and as a Syrian on another – actually as a Syrian Jew instead of an Oxford graduate'. Raphael saw Him as a peasant, Rembrandt, as a Dutchman, and so on. 'We are only waiting for an advance in African civilization for a negro Christ, who may be quite as impressive as any of the Aryan ones. The shallowest of all Christs is the operatic Christ, just as the shallowest of the Virgins is the operatic Virgin.' If only Vaughan would 'read the Gospels instead of the dispatches of the war correspondents, he will find there is not a trace of "tenderness, calmness, and sweetness" in St Matthew's literary portrait of Christ, and that the operatic Christ was invented by St Luke.' Father Vaughan, Shaw concluded, 'will find his Christ in every Roman Catholic Church in the land, and in all the shops that furnish them. Let him choose the statue that is nearest his own heart; and I have no doubt that Mr Cecil Phillips will place it beside Mr

Epstein's and leave every man to judge for himself which of the two is the more memorable.'

But there were others who spoke up for him, too: the critic John Middleton Murry did so in the *Nation* on 14 February – he claimed that, to the contemporary mind, Epstein was Sculpture. Brzeska was dead before he could develop his gifts, and Gill, Murry said, was 'hardly more than a stone-carver of ... not unusual imaginative power.' Mestrovic was written off as unimportant. And so that left Epstein, Murry claimed, as master of the scene. 'That is a very good thing for the world, for Epstein is an artist through and through, and for the world to be impressed by an artist, no matter how, is a good thing.' It was the Christ at the exhibition that really fascinated him: 'Epstein's "Christ" is there to remind the world that it is always the artist who faces them.' He was 'a man, austere, ascetic, emaciated, having no form or comeliness ...' It was an impassioned piece which showed Murry was overwhelmed by some personal message the figure had communicated to him; equally, he was overwhelmed by the portraits – 'There has been,' he wrote, 'no such masterly realistic sculpture in England, in Europe even, for years ... The modelling is extraordinary. To sit to Epstein is to assure oneself of a physical immortality ...' For this praise, Epstein said Murry 'was severely taken to task by the *Nation*'s art critic' and told to keep off his beat. 'If the intelligentsia are to speak on art let them do so with one voice and not divide their allegiance and so create confusion.'

Perhaps that sparked off another of Bloomsbury's disciples, Charles Marriott, with a piece reflecting the condescension that was the hallmark of the writings of Fry and Clive Bell, the aesthete who introduced the catchphrase 'significant form' to the fashionable artistic language of the period. Juggling with words and carefully contrived inflexions of meaning were favourite pastimes of the Bloomsbury set: criticism should be oblique or deliberately precious, and in-jokes were all the better if made at the expense of a hyper-sensitive artist like Epstein from whom a furious reaction could be counted upon (if only because he disliked theorizing, believing it was a killer of intuition). The predictable controversy broke; one extreme produces another, ranks close in the face of attack; Marriott's dispiriting comments contrasted sharply with W. G. Constable's review of the day before in the *New Statesman*. Constable fastened on a comparison with Rodin's work at the currently running South Kensington Museum's exhibition for a measure of Epstein's stature as an artist – Epstein's sculpture demonstrated, he

said, that contemporary art can stand by the past without fear. 'The aim of the great sculptor, like that of the great painter, is the expression of a conception of essential structure and of reality; and this end he seeks to attain by the arrangement of a rhythmic succession of planes ...' Eulogies never failed to greet grand works, complicating the sense to a degree that Epstein must have found confusing. Still, Constable made some good points: 'Most modern sculpture, however, consists of frozen representations of a human form, rivalling an instantaneous photograph in accuracy, and with just as little power of aesthetic appeal ...' He said that Rodin and Epstein claimed correctly to represent the great tradition in sculpture. And while Rodin realized the surface perfectly,

> Epstein never forgets the underlying structure; and consequently his work has a monumental and typical quality which arouses feelings such as those experienced before the sculpture in the British Museum. Thus, not only in his aims and methods, but in the personal reaction aroused, Epstein establishes his claim to comparison with great masters of the past.

In fact, he rated Epstein very high indeed, preferring him to Rodin. The *Christ* revealed their differences, he said: 'Epstein thinks more consistently in three dimensions, and seems less concerned with outline than with the handling of internal masses.' Thus his work was less baroque, less consciously designed than Rodin's, and more vital, he thought: his *Christ* had 'to be judged by the extent to which the artist had created an independent reality.' Whether it was the public's idea of Christ was another matter; the fact was that Epstein realized a conception of his own, the true merit of any work of art.

The public's idea of Christ was of course very different; all the same, someone agreed with Constable – one day, before the exhibition closed in March, a young man walked into the gallery and bought it for the large sum of £2,100; this was Apsley Cherry-Garrard, a member of Scott's Antarctic expedition and already the owner of a Rodin, and he put the *Christ* in his garden, much to the amusement no doubt of his next-door-neighbour, Bernard Shaw. Epstein told a *Daily Graphic* reporter that he was sure that it would please the British public that it wouldn't leave the country – there had, after all, 'been several demands for the Statue from America where my work is well known, especially to Mr John Quinn, Director of the Metropolitan Museum of Fine Art, who

has upwards of twenty of my sculptures and paintings in his private collection.' He went on:

> Since the exhibition of the figure, I have received a large number of letters regarding it from all parts of the country. Some of them, of a remarkable character, came from mystics who professed to see in it prophetic visions. I do not know that I hold with these expressions, although I feel, in justice, bound to admit that they bear the impress of sincerity.

This kind of extra-sensory response to a work that was conventional by Epstein's standards might strike one as strange. As far as he was concerned, however, the experience was not that unusual. Far odder in his view was the general reaction to what he believed to be in no way a controversial piece; that the public should, at the sight of his *Christ*, express rage normally reserved for his more extreme creations like *Maternity* and *Venus*. For there were other letters as well – abusive ones, many illiterate, postcards and envelopes addressed to 'Christ, Leicester Square'. Besides Father Vaughan's diatribes, there were the stunned visitors, the horrified expressions and shocked remarks like 'I can never forgive Mr Epstein for his representation of our Lord – so un-*English*' to Oliver Brown from an old lady. No wonder Epstein was surprised; he could only imagine that something indefinable in his work touched off feelings of insecurity in a particular area of society – the upper middle-classes – where it disturbed 'profoundly rooted beliefs and shibboleths'; his total lack of inhibitions awoke inhibitions, fears and guilt in others. There was, for example, John Galsworthy, passing him as he went into the gallery with a friend one day, fists clenched and a furious face as he left the room where *Christ* was on show. Forever after, Epstein said, Galsworthy attacked his work whenever he had the chance; that might, from this novelist, come as something of a surprise, although J. M. Barrie's letter to the Duchess of Sutherland gives an inkling of the neurosis which, perhaps, lay beneath the surface: '. . . a queer fish . . . So sincerely weighed down by the out-of-jointness of things socially . . . but outwardly a man-about-town, so neat, so correct – he would go to the stake for his opinions . . .' Epstein didn't in the least mind the music-hall jokes about him, David Low's cartoons, caricatures (when they steered clear of Jewish noses), or what he called 'man-in-the-street jocularities' – he might have even thought these things

quite good fun; no, what he minded was the 'Galsworthy' type, the class of person who saw 'red' when confronted with something imaginative, inventive, experimental. As an illustration, there was the man at an exhibition of his drawings who said to the owner of the gallery: 'I should like to take Epstein out to a butcher's shop and have his hands chopped off.' What had prompted a remark as violent as that? But there was Father Vaughan and the regiment of mediocrities who had been attacking his work ever since his name became known with the Strand figures; Matthew Smith overheard a man saying to a woman in front of a Bond Street dealer's window displaying a flower painting of his: 'Those fellows Epstein and Smith ought to be in jail!' So what lay buried and smouldering in the mind that innocent works like flower paintings, still lifes, fruit, landscapes and portraits should ignite explosions of such hate? Epstein was utterly baffled: this form of anger, he said, could only be understood 'by relating it to something fundamental, going far deeper than the sculpture or painting involved . . .'

It is difficult to establish when Epstein left for a lengthy trip to the Continent. Cecil Gray, who dropped everything (including his girl-friend, Viva King) to go with him 'at his urgent request', couldn't remember whether it was in 1920 or the year after. The likelihood is that he went in the spring, when the exhibition ended and the gallery had paid him for the sales (and at a time when he liked to look in on Paris). He was certainly there that April, for Gertler was among a number of artists who saw him. And the show had done very well – besides the *Christ*, numerous bronzes had sold and gone to special collections: by this time, much to the delight of Oliver Brown, he had a large circle of admirers. Since it was his custom to make sudden decisions when struck by some compelling idea (decisions which often concerned changes of studios), this one was probably made when he had plenty of money. The visit in question did concern a studio – according to Gray, he wanted to find one near the white marble quarries of Carrara where Michelangelo had carved the stone for his works; Epstein, who used this material for *Venus* and *The Doves*, knew he could obtain the shapes and sizes here he needed for certain things he had in mind, and wanted to carry out on the spot. Unfortunately, however, the studios were all taken by commercial enterprises doing a good business as sculptors' subcontractors and they had to return, but only after having an enjoyable time in the Gulf of Genoa.

And then there was Paris on the way back and old friends and their work to see. One of them, that lovely artist Modigliani, had of course died in January, penniless in hospital, probably of pneumonia. Epstein had been in the Shaftesbury Avenue London Gallery of Zborowski (Modigliani's dealer in France who had set him up with a studio after Guillaume dropped him, and had commissioned him to paint nudes) when a telegram came through from Paris saying: 'Modigliani dying. Sell no more of his works. Hold them back.' After which news, his works soared in price, rising to the astonishing figures they fetch today. Rosalie, who had taken them in return for bifsteks, was one of those who rushed to sell her collection. Unfortunately, having thought nothing of them, she found that they had been eaten by rats in the cupboard where she had packed them away.

His death came as a shock; although they had only had the chance to meet once since before the war, they had been close friends, and now all Epstein had left of him was a drawing for a carytid in blue chalk. Still, there was always Brancusi in Montparnasse working away at his cool, white, abstract forms, and there were Guillaume, Ratton and other dealers in African art to look up. If he did less in 1920 as a result of the trip, he deserved some time off after the anxieties of the war, his illness, hard work and the usual problems with the critics over his exhibition: his last break, if an unfruitful stay in Paris could be called that, was in 1913.

His sudden departure may well have coincided with the end of his relationship with Meum: at any rate, his absence gave Mrs Epstein a clear run to resolve their domestic problems on her own. She had plenty of ammunition to use – the disgrace of the break-up of the girl's marriage, living in sin, and in a *ménage à trois*; all that was bad enough, but to have an illegitimate child was unforgivable! What would her parents think about *that*? So she encouraged Meum to pursue the stage career she hankered after, and to leave her to bring up Peggy-Jean, the baby she could never otherwise have had.

8

Green Mansions

$$\overline{}$$

KATHLEEN GARMAN met Epstein in August 1921, just as he was surfacing from campaigning to save antiquities in the British Museum from being vandalized by ignorant attempts at restoration. This cause must have surprised his critics since, as his friend Arnold Haskell said, 'Many people can only see him as the caricaturist Low has depicted him, as a figure with a paint-brush smearing the statues of Greece, like the vandals who have so treated his own work. Epstein,' he went on, 'was the first to protest against the shameful restoration of works in the British Museum, against the official theory that Demeter would be better with any old nose rather than no nose at all.'

On 2 May, Epstein had written a letter to *The Times*:

All those who care for antique sculpture will view with astonishment and dismay the present policy followed by the British Museum authorities in restoring the marbles — that is, working them up with new plaster noses etc. I have remarked with growing alarm marble after marble so treated during last year. I felt the futility of protesting, and so held my peace but now that the incredible crime of 'restoring' the head of the Demeter of Cnidus has at last been committed, the atrocity calls for immediate protest. No doubt the museum authorities do not like the Greek marbles in their possession, but why they should translate the masterpieces into something more nearly approaching the Albert Moore ideal of Greek passes my understanding. The Demeter is not only 'improved' with a new plaster nose, but to bring the rest of the head into consistency with this nose the whole face has been scraped and cleaned, thus destroying the mellow golden

patina of centuries. Other important pieces 'improved' are the marble boy extracting a thorn from his foot and the very fine priestess from Cnidus, so altered as to give an entirely different effect from what it originally had. How long are these vandals to have in their 'care' the golden treasury of sculpture which at least they might leave untouched?

The Museum's antiquities were, Epstein said, of enormous importance to a knowledge of art, and for this reason alone, their perfection apart, he believed passionately in their preservation as found. Here was material essential to the understanding of art – the 'amateur', he said, having cleared his mind of prejudice, reserved judgement, and gone through a period of thorough 'spring-cleaning', 'must learn to think of art as a continuous unbroken whole and forget all that he has picked up about ancient and modern art, British art and foreign art'. Ultimately, time and nationality were of no real significance: 'Great art,' he said, 'could speak to all peoples at all times.' That was the first vital lesson. Still more important was a comprehension of the meaning of tradition. No great work was ever produced by flouting tradition. *The whole integrity of art lies in its traditions,*' he insisted. Tradition didn't mean a surrender of originality: 'all great innovators' were in the great tradition. Of course, he said, 'sometimes tradition skips a generation or two, lost by the academicians, the so-called keepers of tradition, only to be found again by a Cézanne, who is jealously and blindly kept out of the salon of Bougereau. As a so-called rebel I was the only person to protest against the disfigurement of ancient sculptures by the museum authorities, whose sole function is to safeguard tradition.'

Within two years, the practice of 'improvement' ceased.

This was the dedicated artist whom Kathleen Garman first saw when she was having a meal with her sister, Mary, in a little restaurant at 50 Beak Street in Soho; it was called The Harlequin and had been started by an ex-waiter of the Café Royal. After a time, she became aware of two men on the other side of the room, one of whom was staring at her. The man was roughly dressed, but the stare of his dark blue eyes was so extraordinary, so concentrated and intense that she found herself unable to look away. Then a note suddenly came over via the waiter – would they join him and his friend? The sisters may not have found such attention that unusual – with their dusky brown hair, high cheek bones,

large slanting eyes and somewhat olive skins, they were a strikingly
physical pair; and young – Kathleen was twenty, Mary a year or two
older.

They found his interest highly amusing, as well as engaging, but left
without accepting the invitation. A few days later, however, Kathleen
was back in The Harlequin, this time alone, and there was the man
again. He was alone, too, and he sent another invitation. On this oc-
casion, once more finding his gaze irresistible, she joined him. He came
to the point immediately: Would she sit for him? That was that: this was
Epstein; they had met and fallen in love, passionately, instantly, totally;
the morning after their first night together, he modelled her head. So
began a relationship which lasted until the end of his life.

Kathleen Garman had six sisters and two brothers. Their mother was
Irish, the illegitimate child of Lord Grey (and half gypsy, some say),
their father, Dr Walter Chancellor Garman, was a wealthy doctor in
Wednesbury, near Birmingham; and their home a huge, gloomy,
rambling mansion of a place, Oakswell Hall. As a flashback to the
Victorian past, it suggests why the doctor's independent-minded and
adventurous children were determined to make a quick getaway; and
not merely from this – from the closed society of the provincial
Midlands, a hard business centre that must have seemed light-years
from their dreams of the civilized art and literary world up in London.
Kathleen was only nineteen when she left for the great city to join the
optimistic upsurge of idealism that followed the end of the ghastly war
to end all wars, but she did so against fierce opposition from her father,
he being an additional reason – perhaps the main reason – why the most
rebellious of his children departed so young. For him, strict rules of
etiquette still mattered: girls had to stay at home until ready to marry
into the professions adopted by boys of respectable families. Douglas,
Kathleen's brother, was reminded of this when he told his grandfather,
also a doctor, that he wanted to be a writer. He was given four possibili-
ties suitable for a 'gentleman' that brushed aside the enthusiastic
Douglas's 'new-fangled' ideas: 'the Church, the Army, Law and
Medicine'. And when Douglas ignored these instructions, he was cut out
of his grandfather's will. But their equally opinionated father was also a
tyrant: Kathleen once admitted that she thought this handsome and
highly successful doctor 'had madness in him'. Her sister, Helen, was
more forthright:

He was a cruel, bad-tempered, ferocious man who beat his children and locked them in cupboards. He beat them unmercifully – oh yes, the girls as well as the boys – for trifling offences, and chiefly, apparently, to rid himself of raging sexual desires that couldn't find fulfilment. Of course, they had to be strenuously repressed on account of his position. Otherwise, he would have been struck off and ruined in no time.

She added: 'He never touched Kathleen, mind. She was his favourite. That was because she played the piano so beautifully.'

The combination of private violence and public respectability had predictable consequences – while Douglas pursued poetry and communism, three of the girls broke accepted rules and chose men who were the antithesis of the suitable type. For Kathleen, there was Epstein; for Mary, the anti-semitic South African poet, Roy Campbell, who, after writing a dozen or so beautiful poems about Africa, went on to produce a good deal of doggerel; and for Helen, a big blond local fisherman in Martigues named Marius Polge. Lorna, the youngest, married someone acceptable, Edward Wishart, although he left the family business and founded *The Calendar of Modern Letters*, a literary monthly that was a forerunner of *Horizon*, publishing E. M. Forster, Robert Graves, Aldous Huxley and others, and edited by Edgell Rickword with the help of Douglas. Sylvia, the eldest, buried herself in a cottage in the tiny Dorset village of Moreton and was reputed to have been the only close woman friend T. E. Lawrence ever had.

They were an unusual lot, yet their singular love-lives can't wholly be explained by an old-fashioned upbringing. But old-fashioned it was – Kathleen's background was as strait-laced and religious as Mrs Epstein's or Meum's; her mother was a devout Christian ('I cannot recall her when she was not going to, or coming from, church,' her grandson Michael Wishart wrote in his autobiography, *High Diver*) and her father was a strict Anglican. Hardly surprisingly, he was horrified and furious on learning of his daughter's entanglement with Epstein. It had been bad enough her going to London at all, and, having punished the sisters by not giving them a penny, they only graduated from the odd-job business when he finally relented and gave them an allowance. And what had that led to? – this man, this bohemian. Didn't she have any notion of his reputation as a womanizer? The scandals connected with him? Obscene sculpture? That he was a married man? She must give

him up at once – so ran Helen's vivid account of the row that exploded when her sister admitted she was in love with the artist. If she went off with that man, she'd be cut off without a shilling like her brother, never to darken his doors again! Unfortunately, Epstein's overwhelming magnetism – sexual and mental – had captivated her and she refused to budge an inch: her father's frightful threats had no effect, and eventually he gave in – he may have found her, in his own way, as irresistible as Epstein did. Tall, self-possessed, remotely beautiful, she sailed through the storm, unscathed. She adored the gaiety of her magical life with her sculptor of international fame, she was excited by the Café Royal and its bohemian set, she enjoyed giving parties by gaslight and meeting friends like Kramer (of whom Epstein had just finished a fine head), van Dieren and Matthew Smith. For those close to her, she was human and perceptive, and the wittiest person on earth – 'Why use three languages when one would do?' she remarked once on hearing some sycophant attempting to impress Epstein with his arrangements to bring 'clients' to meet the 'maestro' in his 'atelier'. All the same, she was the embodiment of common sense, and more than a match for Mrs Epstein. She was romantic, infatuated by Epstein's brilliant mind and imagination, with his passionate intensity about all things that mattered, that dynamism which contrasted strangely with the uniqueness of his resonant, sensual and soft voice – all that, yet she never, although very young and inexperienced, allowed her considerable intelligence to desert her. When the two met, Kathleen and Mary were students – Kathleen was studying music, her sister, art – with a studio room at 13 Regent Square; there was never any question, however, of Kathleen following Meum's example and moving into the Epstein household in Guilford Street, a few minutes' walk away across the huge Mecklenburgh Square to the south. She remained where she was; in fact, for the whole period as Epstein's mistress, until Mrs Epstein died, she had a separate place. Despite her sheltered life in Wednesbury, she was not, as Meum sometimes appeared, naïve or vulnerable: she was already a highly cultured, independent and quite worldly person.

Physically, with her high cheek bones, she was an Epstein; imaginatively and intellectually, she was a source of inspiration. Day and night, he was haunted by her memory; couldn't bear to be separated from her, and, when he was, wrote to her, often and passionately, and with great simplicity:

I have your note and the news that you arrived home. I love to read
what you feel and that you know my happiness was so extreme that
were I to die then and there I would be an image of supreme happiness
in death. I still live in the night the three nights we were together. I
express myself readily enough with you but to write of it is impossible
for me. Your nearness, your glances and every touch of you fills me
with joy and that is what makes it so difficult for us to be together for
long. I will try and finish the head I am on; even unfinished I think it
will be beautiful perhaps owing most to the subject. Is this
illegitimate? The true artist should make anything wonderful. When I
look on you and am with you I see the most wonderful things and
they can't be but a memory with me. No more . . .

It may have been Kathleen's independence which generated the demoni-
acal jealousy Mrs Epstein felt. She hated Kathleen; Peggy-Jean said her
adopted mother never missed an opportunity to rub home that hatred,
calling her 'dangerous' and a 'witch'; Peggy-Jean's earliest memory was
of hiding behind Mrs Epstein's skirt as 'the witch of Mecklenburgh
Square was seen coming on the other side of the road in her billowing
black cloak'. She was, apparently, jealous in a way she had never
experienced before, to judge from her relationship with Meum. That
was different: this, one assumes, is because she was unable to exercise
the kind of power over her that she could have done if Kathleen had
moved into Guilford Street as other models had done. In the case of
Meum, it seems Mrs Epstein was in total control, dominating her utterly.
The moment this formidable woman suspected the girl's continued
presence in the house was interfering with her husband's work, she had
to leave. While she often came back to see her daughter, Peggy-Jean
(who didn't know Meum was her mother), she must have been extremely
upset by the experience: she may have made a great success of her stage
career as one of Sir Charles Cochrane's Young Ladies, but, as her niece
had insisted, Epstein was her only love. All the more reason, in Mrs
Epstein's view, for her having to go: 'Remember,' she told Peggy-Jean
when she was a teenager and in need of practical advice on the facts of
life with regard to husbands' habits, 'the wife is always in the strong
position.' Unfortunately, however, she was in a weak position in
Kathleen's case. In contrast to Meum's tender and sensual beauty, here
was a remarkably dramatic and striking presence; a very young, strong-
willed, mentally and physically energetic girl who was set, it appeared,

on stealing Epstein from her, and she was powerless to intervene. From the knowledge of her own uncontrollable feelings, love could be as ruthless as it was violent, and Mrs Epstein was, for possibly the first time in her marriage, absolutely terrified. There was no Meum to distract Epstein (indeed, gossip may have reassured Meum she was well out of it); a three-year relatively peaceful aftermath of war was suddenly over: in that tiny corner of London, emotional tension was building up as fast as thunder clouds.

Hence, perhaps, the fleeting significance of Viva King's appearance on the scene in 1921, or thereabouts: she was immediately aware of trouble looming above the horizon. As it happened, Viva King was herself in some sort of an emotional muddle, too; she was recovering from an impossible affair with the neurotic Philip Heseltine, while at the same time attempting to avoid the insistent approaches of the failed musician Cecil Gray, after he returned from his Italian trip with Epstein. He was so persistent that they became engaged for a time, only to break it off with recriminations on both sides. However, Gray introduced her to the Epsteins who took her up, invited her to concerts at the Wigmore Hall and were, perhaps not unnaturally, most sympathetic about her various romantic disasters. There is no record of her having moved into Guilford Street, although she was there on a daily basis for a considerable period; details of her experiences made an impression, and, writing in the Sixties, she described what she saw with customary vigour:

Peggy Epstein was a large, short woman and, with a veil over her head, looked very like a Russian doll – as broad as she was high and ready to roll back into place if knocked over. She had large, coarse features and limbs, and crimson-dyed hair, and she had a very strong Scottish accent ... They had with them a small child, who was the apple of their eyes, and I was of some service to Peggy by taking this child into the gardens opposite for walks. They thought then of changing their abode and I went round vetting houses I saw, and brought unfavourable reports. For this seemingly abortive effort Peggy gave me £5 which was as though someone today gave me £500 ...

There may have been rather more to this errand she was sent on, and the generous pay received, than perhaps she imagined. It was highly unlikely that Epstein would have proposed a move to the suburbs, an area she was told to investigate, since everything he could ask for –

apart from, somewhat ironically, the presence of Fry, Bell, the Stracheys and others in their group – was concentrated in this bit of Bloomsbury. It was central, near theatres, restaurants, Soho (the favourite artists' quarter) and cinemas (Epstein liked films, adored Charlie Chaplin); it was a delightful community of garden squares framed by the calm of eighteenth-century architecture. Queen Square, long, narrow with its passageways and pubs, south of Guilford Street, must have had a perfect human scale then; interiors were spacious; his beloved and major source of inspiration, the British Museum, was round the corner and near his two studios – one, in the delicious Lamb's Conduit Street, the other, in the next tiny road along, were just at the back of his house off the beautiful seventeenth-century Great Ormond Street. There was the vitality of street life – of bakeries, butchers, ironmongers and even a herbalist in Marchmont Street; there were corner dairies (unknown twenty years later) for a half-pint if you ran out, door-to-door muffin men, old coffee houses and antiquarian bookshops; there was his friend, the mystic Moysheh Oyved, who put Epstein's bronzes in the windows of his Cameo Corner in Museum Street to help promote him; there was George Rainbird's greengrocers in Tottenham Court Road from which he launched his art publishing business; a hospital (which proved convenient); and London University, which subsequently massacred the backwater with Senate House and aggressive concrete blocks off Russell Square. Is it in the least likely that Epstein wanted to go elsewhere? And more important to him than anything except his work and studios was Kathleen Garman: she was in Regent Square in a fine four-storey early nineteenth-century house: all he had to do to come home was turn left into Wakefield Street and cross Coram Fields and he was opposite the front door – the very reason, of course, why Mrs Epstein was desperate to leave, and as soon as possible.

The depressing condition of the Epsteins' house struck Viva King particularly: an air of dejection hung over it like a street blighted by the threat of demolition. She recalled:

The front ground-floor room was their sitting room and, as far as I can remember, the furniture consisted only of a table and some chairs – also innumerable saucers with dregs of tea in them or mountains of cigarette ends. Behind double-doors was their bedroom in which a large and often unmade bed could be seen. On one occasion the bedclothes were pulled back in place to conceal a laid breakfast tray

being kept warm for someone who was coming to breakfast. The first, or drawing-room, floor was Epstein's studio . . .

She witnessed the Epsteins' paranoia over Augustus John, which she found utterly baffling, as did John, still a fervent admirer of Epstein's head of his son, Rom: at the mention of his name, Mrs Epstein, white with anger, would go on to the attack with insults like 'that Welsh Fox'. So what had she walked into? Did Mrs Epstein remain convinced that John had betrayed her husband in the war? Was it through the intervention of John that Conrad had refused to sit for him in 1914? Or were they jealous of John's success? That was absurd – Epstein's position as a major artist was firmly established: four studies of Peggy-Jean, one of Kathleen, the excellent Kramer, and three commissions of that year had sold immediately. More likely, the feud was about a model – Betty May, possibly, who was also Kramer's. Models were, after all, prize possessions (remaining so until the abstract movement began to put them out of business), and as important to artists as artists were to models: a ropey lot, besides often being prostitutes or from slums, many were illiterate, and depended for their fame on the artist's name, while their *faciles moeurs*, Epstein said, could give the artist a lurid reputation if he wasn't very careful – among his models, Shelley, May and Dolores could do just that.

In fact, of course, the tension Viva King experienced on entering the house had nothing to do with the war, models or John, and everything to do with Kathleen. Campbell had considerably complicated things by moving into Regent Square with Mary Garman after he met her in October, and Epstein, egged on by malicious inventions on Mrs Epstein's part about Kathleen's 'promiscuity', had the idea Campbell was sleeping with both girls: intent on breaking up the love affair, all Mrs Epstein achieved was to work her husband up into a state of wild jealousy. Then, when Mary and Campbell took rooms over The Harlequin after their marriage early in the New Year, Mrs Epstein paid waiters to spy on them through the keyhole in the belief that her husband was using the place to carry on with Kathleen. But on 23 February she did something extraordinary. She wrote to Meum, saying: 'I was amused to hear that the effect of your glances in the Café Royal made Kathleen Garman, Epstein's latest, resolve to meet him elsewhere tonight. Look out! The two of you were in the Café Royal with Kathleen's sister Mary of the Zulu hair' – a reference, presumably, to Campbell's recently

published poem *The Zulu Girl* – 'and her husband, the extremely useful
Campbell, will twist your neck if they think you are a danger to the pre-
eminence of their sister over all Epstein's other mistresses. If you have
time at 2.45 I'm passing your door in a taxi to go to hospital. Come with
me.' She was suffering from a bad attack of phlebitis that affected her
legs.

Mrs Epstein's bizarre letter must have been intended to stir up more
trouble. While she was mad with jealousy over Kathleen, she was hinting
that Kathleen was furiously jealous of Meum: then the reference to 'all
Epstein's other mistresses' suggests that she was trying to awake jealousy
in Meum – a long shot, since Epstein was so in love with Kathleen, so
gripped by suspicions of Campbell's doings, and so involved with his
work that he would have had neither time nor energy left for others.
Was she trying to set them on each other, involve the lot in her crisis,
and so bring everybody's lives crashing to the ground? Meum, however,
did the common-sense thing – 'One day,' Campbell recalled, 'the beauti-
ful actress Meum Stuart (sic) came' and showed them the letter. In the
corner, he said, was a drawing of 'a dagger dripping with blood'. While
Meum wanted to know the meaning of this, Campbell was naturally
furious. Was she insane? She had paid waiters to inform on him and was
now suggesting he would strangle the beautiful Meum. Far from doing
that, the Campbells were greatly taken with her, and the three remained
friends for the rest of their lives. So what was going on? Had Epstein
put his wife up to it? Campbell must have believed something of the
sort because Mrs Epstein's devious manoeuvres led to her husband's
well-documented and abortive fight with Campbell above The Harlequin
during an evening when Epstein was dining there with Kathleen. Hence
Epstein's remark at the end of a letter to Kathleen: 'Write and tell me
how you are. The Harlequin has one use anyway; otherwise the place is
detestable to me.' She couldn't write to Guilford Street, so sent her
letters there.

Here at least is a glimpse into the kind of emotional explosion that
threw these people into a total turmoil, the surface tremors of which
were felt by an outsider like Viva King. She had heard rumours of Mrs
Epstein's kindness to models, probably largely started by the custom of
having them in the house, and made more exotic as, greatly exaggerated,
they went the rounds; but she could hardly have anticipated the recep-
tion she got. Soon after her arrival in this 'ménage', as she called the
household, 'Peggy became nervous and anxious for other than

persecutional reasons. She dropped dark hints, which I did not understand, and asked me to pose for Epstein – "as a great favour, perhaps in the nude?"'

She did sit for a head – interesting for her to watch his methods (utterly different from another sculptor who had modelled her) – but he seemed very faraway, 'absent-minded, his thoughts obviously on something else' and never finished the piece.

Then one day when I arrived, Peggy quite literally pushed me quite violently upstairs to the studio where she begged me to take the place of an 'absent model'. Well! anything to oblige, I thought, and with just a little embarrassment I lay 'à poil' on a rather uncomfortable sofa. 'Beautiful!' – which from Epstein might or might not be thought flattering – and he did some drawings.

She wasn't asked to repeat this favour and Epstein showed no further interest, at least providing some proof (for she was extremely pretty and shapely) that he wasn't the kind of bohemian artist who was unable to resist a naked girl. In time, however, the truth filtered through to her: poor Mrs Epstein was hoping he would be taken with her, so distracting him from the threatening presence of Kathleen Garman – if she had realized that at the time she would have been absolutely horrified; all she noticed was that Mrs Epstein, faced with this 'real and terrible menace to her life . . . became more and more unhappy and distraught until the crisis came with her aiming an antique pistol at her rival . . .'

These astonishing events – the crude attempt to employ Viva King as a sexual decoy, the mysterious goings-on at The Harlequin organized apparently by Mrs Epstein, the sinister letter to Meum which ended in the next best thing to a duel – occurred before and after Epstein's second and plainly sensuous head of Kathleen produced in January 1922. If the first head demonstrated the gaze of a girl awakened to herself, the second conveyed the heat of passion satisfied; in the first, the eyes were opened in a kind of amazement, in the second, eyes half-closed and lips slightly parted, the girl basks in the contemplation of desire and its fulfilment. Was it this piece that suddenly sparked the final scene in the melodrama? Not one of his works of Meum were studies of like emotions – in contrast, they were detached, almost objective in their preoccupation with classical beauty and the serenity of gentle femininity. Had Mrs Epstein been unaware of his love affair with

Kathleen, she would have regarded the latest head as merely a work of great art, which, of course, it was. But she was aware of it and she would have seen it in the studio where it was carried out – at Lamb's Conduit Street or Emerald Street. And while, as a woman of strong feelings, she would never have damaged any of her husband's works, however angry she felt, she might well have done her utmost to damage the subject of this portrait of what was plainly a profoundly pleasurable sexual relationship.

She wrote to Kathleen and invited her to Guilford Street to discuss the affair. Kathleen came – perhaps out of curiosity, hardly because Epstein would have wanted her to. Mrs Epstein asked her into a room, locked the door behind her and said, 'I'm going to kill you.' Whereupon, she produced a gun from inside her ankle-length skirt, went on talking and then fired, the bullet hitting Kathleen to the right of the left shoulder blade. She fell on to a couch, whereupon Mrs Epstein panicked and ran from the room; Kathleen, bleeding profusely, crawled along the floor to the front door and out into the street. There, by pure chance, the first person she saw was her incredulous brother, Douglas, who took her immediately to a nearby hospital where she was operated on.

The next day, the papers were full of it – 'ARTIST'S MODEL SHOT'. Nevertheless, no charges were brought: 'I must protect my wife,' Epstein told Kathleen when he came to the ward. That was a tough decision, but it was typical of him to take it, and the only one possible if yet another highly damaging scandal involving his family was to be avoided; and there was his work – a scandal would have distracted him, and that was impermissible. Kathleen's life had been saved, after all, and Epstein knew well enough what had driven his wife to such madness; besides which, her health wasn't at all good. Just the same, it says a great deal for Kathleen's devotion to Epstein that she went along with his wishes, particularly since the surgeon was unable to remove all the lead and her shoulder had always to be kept carefully covered to hide the permanent disfigurement.

With this incident, the crisis finally went off the boil: Mrs Epstein had to give in and accept, to a degree, Kathleen's presence in her life. From then on, their lives round Epstein followed a more orderly pattern – Mrs Epstein in Guilford Street, Kathleen in Regent Square: Epstein visited her every evening after work, and he spent every Wednesday and Saturday night with her. As if to give her acquiescence in the matter the official stamp, Mrs Epstein invited Kathleen to take a ride

round Hyde Park in an open taxi, so that, should anyone happen to observe this extraordinary exhibition of friendship on the part of the hitherto deadly enemies, it would be plain to see all had ended well between the wife and mistress of a very great man indeed.

This was another of Mrs Epstein's bizarre moves, yet equally astonishing, in view of the shooting, was the fact that Kathleen went along with it. Irrational as the meeting may sound, perhaps she felt Epstein wanted some show of forgiveness on both sides, thus enabling life to run on more smoothly and unemotionally in future. Whatever agreement was reached on their embarrassing tour of the park, this did not mark the end of Mrs Epstein's efforts to oust her rival; and nor, as Peggy-Jean remembered, did it deter her from calling Kathleen every kind of name, all of them bad.

After these troubles, things took a turn for the better: a calm descended with the more settled routine. First, there was a holiday in the Isle of Skye which Epstein never forgot; then, Dolores came to live in Guilford Street; thirdly, the death in August 1922 of W. H. Hudson, the naturalist, led to one of Epstein's finest carvings; Dolores was the model for *Rima*, the centrepiece of the composition.

Her move into the house was for Epstein's convenience. He had come across her long before, of course, when she, like Lillian Shelley and Betty May, sang and danced at Madame Strindberg's nightclub. However, he made his first of the six studies of her in 1921, and after that, in 1922, she was invited to live with the Epsteins: the series was completed in little more than a year.

Epstein thought her extremely beautiful, but that was as far as his interest in her went (doubtless to Mrs Epstein's disappointment if she nurtured hopes that Dolores might supplant Kathleen). She was certainly one of those models who capitalized on Epstein's fame, using it to the full and endangering his reputation by her own wild behaviour; Epstein himself was greatly affronted by the story of life in the Guilford Street household that she gave to the *American Weekly* published by the Hearst Press. This was in 1930, five or six years after she had left the Epsteins. He dismissed her claims with the comment that the story she told was 'packed-full of inventions conceived by the not very scrupulous brains of the scribblers who seized on her notoriety and exploited it': exposures of his feud with John (could Epstein have heard that he had advised Quinn not to buy *Rock-Drill*?), his generosity to

models, hatred of Lord Alfred Douglas, admiration for Wilde, Rodin and Joseph Conrad ('that touched the heights of adoration', she reported), much exaggerated and lifted out of context, were hardly intended for public consumption via Dolores. That kind of stunt was, however, typical of the use models could make of their position to benefit themselves, while severely compromising the reputations of others: Epstein, in particular, had had his reputation damaged enough without this account of experiences suitably enriched to attract a good fee. But Dolores proved difficult to give the slip – on one occasion, she used him to impress her friends: 'She married a coloured gentleman and sent out the invitations to the reception in my name.'

All the same, he wasn't angry with this flagrant exhibitionist who claimed to be half-French, the granddaughter of a General Count Fournier, and in her late twenties when she arrived at the Epsteins'. If anything, he was sorry for her – sorry that 'the beautiful and fantastic Dolores', in the studio, 'the devoted model', sitting rock steady, taking the job as seriously as a religious rite, allowing nothing to disturb her pose, should have become degraded by commercial publicity. And, of course, the story she gave to the weekly had its basis in truth. He said himself that his 'admiration for Conrad was immense, that he had a head that appealed to a sculptor, massive and fine at the same time . . .'; and she was right that he was 'incredibly generous' – he was in every way. While not exactly 'reckless in his extravagance', it was probably true that, on receiving a fee for, say, £1,000, he would, according to her, rush out and spend most of it on an item of African or some other country's art for his collection. By the mid-Twenties he had amassed nearly two hundred pieces: among the earliest bought (before, that is, the First World War) were the African works – the Fang figures, musical instruments in the form of figures from Zaïre and the ivory gong from Benin; perhaps even the Dan Mask, one of the finest objects in the collection, belonged to this period. His passion for sculpture untainted by Western influences rapidly led to other areas, for early, too, was his acquisition of Sumerian and Indian things. Altogether his expenditure on the collection must have been colossal by this time, even though prices, particularly in London, were still low; but there was also the further expense of renting sufficient space to house it. Dolores, for example, said he had seven studios which were, as she put it, 'filled with sculpture created by him, but not for sale', a remark which suggests she had mixed up his non-European art with his own. He had five possible

places – his house, Kathleen Garman's rooms, Pett Level, Lamb's
Conduit and Emerald Street – and may well have had a further two. It
is not difficult to see why he was constantly short of money – keeping
his collection was a far more expensive business than keeping a mistress,
if indeed he did that.

It was in 1922 that Mrs Epstein pursued her plan to find another
house, regardless of the cost: what Viva King had failed to find, Mrs
Epstein discovered on the edge of Epping Forest. To look there was her
idea, and she dragged Dolores out of bed one morning to take her off
house hunting. 'Put a cloak over your nightdress, tie a scarf around
your head and slip on your golden sandals', Mrs Epstein said. 'We
mustn't waste a moment.' For this dream-like sequence, sounding like
something out of *Alice*, we are relying on the memory of Dolores, never
particularly dependable; they interviewed several amazed house agents,
ultimately renting 'The shrine of the Simple Life'. With the champagne
celebration of the 'find' at the Café Royal, the general picture becomes
hazy: the Epsteins would never have indulged in such a vulgar affair,
and Dolores, given to exaggeration, had misled the American journalist
with her account of the story to the Hearst Press. Nevertheless, the
'find', at Baldwin's Hill near Loughton, was indeed a 'shrine of the
simple life' – a bare, tiny, bleak cottage off a lane on a ridge high above
London. To the south there is a remarkable view across the top of the
city towards the North Downs, and, in the other direction, the steep
slope vanishes into the mysterious glades, branches and tangled
undergrowth of the forest. Epstein would have liked the simplicity of
the cottage and its remote location, and would have been interested in
the contrast between the space and the suddenness of the enclosure.
Besides, in the cottage's long garden was a small summer house with a
verandah, the ideal shed for making sculpture: close to the house but
private. And so they took it, a decision that marked the end of Pett
Level: that had to be relinquished, and curiously enough, although
Epstein loved swimming, the freshness of the coast, and its birds, he
never went near the sea again, except for brief holidays in Skye and
Kent, and his visits to North Carolina. Baldwin's Hill must have struck
him as perfect: the air was good, well clear of London's soot and winter
fog, and Loughton was only twenty minutes or so from Bloomsbury by
train. The cottage was not, therefore, the escape from Kathleen Garman
Mrs Epstein could have hoped for: Guilford Street remained her
husband's HQ.

For her part, Dolores was emphatic that her relationship with Epstein was purely a business one; nothing more than that. Dolores saw the Epsteins' place in London as somewhere to put up for a period (she didn't much mind where she slept and ate so long as someone else paid), and they were, of course, extremely kind to her, taking her out to restaurants or away to Epping at weekends, and, she said, heaping gifts of jewellery on her. Although some of her claims were utterly nonsensical (like the one about the Wilde tomb being 'compromised by cutting the statue into a harmless torso'), Mrs Epstein probably did give her presents of rings, necklaces and other things to keep her happy and, very important, from straying. (She described herself as 'a happy prisoner in Guilford Street'). Mrs Epstein kept a collection of theatrical props which Epstein could call upon if he felt the particular nature of a study required some exotic touch of decoration, like the elaborate earrings she herself wore for her husband's second portrait, the mask (they were favourite pieces of equipment – according to Dolores, he said ears were the most important adjunct to the beauty of a woman); they were not things of value, though, having been picked up cheap by Mrs Epstein in job lots at auctions. Whether, as Dolores claimed, Epstein made her presents of a Rodin maquette of a horse, two heads of Peggy-Jean and a bronze casting of *The Weeping Woman* (for which she was the model) is open to doubt; yet if he did, such generosity wouldn't have been in the least out of character. The encouragement he gave to other artists (particularly those who were young and unknown) took, moreover, the constructive form of buying their work, as in the case of Matthew Smith, and of a sculptor who had recently left the Royal College of Art, Henry Moore, whom he had just come to know. And when Epstein bought a work it meant that the artist was given an official stamp of authenticity, so famous was he by then, and it was this which gave them immediate recognition in the art world. The same was true of models: Meum certainly owed much of her success on the stage (and to an extent as a social attraction) to the sensational likenesses Epstein had made of her – for who would have heard of her had it not been for him? But in the case of Dolores, her reputation for star quality was launched by Epstein with a good deal of help from her flair for exhibitionism, although he would have been anxious to reward her in some way for the inspiration she had given him.

In that sense at least they had a close relationship; and, in the space of two years or so, she became a household name in the art set – 'the

High Priestess of Beauty,' as Epstein described her, 'and this role she carried to ridiculous lengths'. 'My head', Dolores told the New York newspaper, 'would doubtless have been well and truly turned had not the spiritual spell of the sculptor acted as my shield against the world.' Of course, it had been turned: she too had joined an internationally famous sculptor's select band of models when he was, despite the turbulent private dramas, going through another extraordinary period of intense activity. The number of works completed by the beginning of 1923 was truly astonishing. Apart from the four heads of Dolores, the reclining figure and *Weeping Woman*, there were, among them, *Selina*, his Cockney cleaner; *Fedora Roselli*; a *Chu Chin Chow* singer; *Old Smith*, a preacher who haunted Piccadilly; *Old Pinager*, a match seller; *Eileen Proudfoot*, a South African art student who died shortly after the portrait was finished; the two heads of *Kathleen*; the colossal marble arms where a woman's hand rests on a man's (Kathleen's on Epstein's) that are nearly one metre long, *Ferosa Rastoumji*, the Parset pianist; *Madeleine Béchet* (after Epstein noticed her in Southampton Row and asked her back for sittings, it turned out that he was reading a book about her Senegalese father who married a slave he had bought – her mother); and there was *Dr Oko* (a lifelong friend from the Hester Street days), followed by three commissions for the Duke of Marlborough (all of which were modelled at Blenheim Palace), which included the remarkable, but unfinished, sketch of his wife, Gladys; and the head of R.B. Cunninghame Graham, the Scottish explorer and writer. Of these works, the fourth of Dolores (just the head, no neck) was the finest and most profoundly classical. It was as though he had found her, at last; in this, his love of her form, her high cheek bones and heavy lidded eyes take control of the sculpture – it has the agelessness of an Egyptian piece, and, eerily, likenesses to the fourth portrait of his wife (no neck, but with a scarf) and the second one, the mask: from the front, the *Dolores* could also suggest a mask. This head was the last before starting on his carving of *Rima*. In December 1922, he had been approached by his old friend, Muirhead Bone, about the commission to make a memorial to W. H. Hudson in a London park for the Royal Society for the Protection of Birds.

The commission must have come as a tremendous relief. He had many anxieties: he was hoping the Manchester Art Gallery would at last, after ten years of wavering about, buy one of his bronzes ('What can you

expect though', he wrote in a letter to Kathleen, 'from a committee with Todds and Dodds on it?'); and there had been disturbing rumours circulating that Quinn was trying to arrange a London sale through the dealer, Moore Turner, of his English collection – he had written to his adviser Pierre Roché on 20 May 1922, that he had bought so many Epsteins, 'about ten times too many; so many things by Wyndham Lewis, twenty times too many; so many things by John, forty times too many.' Word had probably got around that Quinn was only interested in the Impressionists now, and was furious with himself that he had wasted so much money on the outsiders of the movement. John, who had first helped Quinn to select really good paintings, was singled out for special attack, but general fears of losing this great source of revenue would have deeply depressed all recipients of his patronage. Thus the news of the commission to execute the Hudson memorial must have been exhilarating indeed. Epstein had been anyway most interested in Hudson's writings for many years, and in *The Green Mansions* in particular, the book which, when published in the United States, was a bestseller, bringing him instant recognition after a lifetime's struggle. In addition, the memorial was his first public commission since the Oscar Wilde tomb of long before the war; and it was to be a carving, the art form he had perfected but too seldom had the opportunity to explore, so much of his time being consumed in portraiture to earn a living.

Like the Wilde tomb, if for different reasons, the memorial was not begun for some time. Money to finance it was one problem: nearly £2,000 had to be raised from private donations, an appeal fund set up, and a committee formed to organize and advertise the venture. The chairman of this was Hudson's friend from the Argentine days, Cunninghame Graham (who commissioned the portrait of himself from Epstein following his appointment), and among its members were Bone, now a Trustee of the National Gallery and Epstein's most faithful, lifelong admirer, Edward Garnett, another close friend of Hudson's; H. J. Massingham, the influential arts patron from wartime; J. M. Dent and Gerald Duckworth, both publishers; and the Lords Buxton (Treasurer of the Royal Society for the Protection of Birds) and Grey: a line-up of formidable names for a formidable task. The committee met first on 28 November 1922 to consider the proposal to commemorate Hudson and to arrange for donations to be sent to Dent: these began coming in only two days later, and they included William Rothenstein's

gift of his portrait of Hudson. The nature lover, who died embittered by lack of recognition when young enough to enjoy it, never would have guessed that so many ardent admirers of his work could have rushed forward to help pay for such a singular proposal as the making of a monument to his memory: it was a passionate, spontaneous gesture of affection on the part of a devoted group. But with the fund launched successfully, and astonishingly quickly, Muirhead Bone was asked to report on the outcome of his approach to Epstein (suggesting Bone had put up his name for the job) at a meeting on 6 December when it was decided to site the memorial in one of London's royal parks. And since Hudson's greatest love was birds (a letter to *The Times* of 21 March 1924 appealing for funds recalled 'his passionate admiration for birds ... his indignation at the neglect and cruelty from which they often suffer', and that 'the birds of London were closely studied by him'), it was decided, as a first plan, to incorporate a fountain, drinking and bathing place for birds, in the memorial. In this connection there was an important meeting on 28 December when the detail design of the pool was brought up and various factors connected with birds' requirements – like the question of the water's depth – were discussed. These were not, it should be noted, seen as things to be tackled then, however; they could be left until later, after the more contentious matter of the sculpture was resolved. For the time being, as an important letter from Bone to Cunninghame Graham of 2 February shows, there were no worries about the design of the pool: however, he found the OoW (Office of Works) requirement of an 'unclimbable fence' as part of the architect's arrangements to protect the site annoying. 'Still,' Bone wrote, 'this is good in a way as it will keep all possible dogs and boys from troubling our birds when they are enjoying their baths!' That exclamation mark could have been a portent.

The first model for the monument was produced at great speed, approved by Bone, and shown to the committee at the beginning of the New Year on 10 January: here was what the members had asked for – a portrait of Hudson, one where Cunninghame Graham's first idea for a bust in the National Portrait Gallery had been replaced with a more ambitious work for an out-of-doors situation. Having settled on a site in Hyde Park where Hudson was said to have spent the night on his arrival in London, the committee had not given Epstein long to think about the project, yet the model he supplied to half-full-size (for a fee of a hundred guineas), following the approval of sketches, demonstrated an

attempt to avoid the conventional portrait accompanied by the inevitable fountain. While he made a point of always trying to meet his brief, a straight portrait for this kind of commission imposed limitations on the imagination. For this reason, he explored a wider interpretation of portraiture, a study of the subject in his ideal surroundings of nature: Hudson was depicted propped up against a tree in a woodland scene of birds and flowers, his legs tangled together like roots. Unfortunately, however, a portrait of the man was a further source of delays. Bone had been warned there would be difficulties over this by a Mrs Mackenna, an interested party who proved keen to get Epstein off the job, and when he met Sir Lionel Earl, head of the OoW, he was told that no representation of Hudson, or of any living person, would be allowed in a Royal Park. Bone relayed this message to Cunninghame Graham in his letter of the 2nd, and he informed the committee's secretary, Mrs Frank Lemon, of this fact – no one of less importance than Prince Albert had that privilege. Absurd as this rule may be, it had one constructive advantage; namely, it let Epstein off the conventional hook, giving him the freedom an artist must have if great art is to be produced. On 14 February, then, it was proposed that 'Mr Epstein should model an imaginative figure of nature' instead of Hudson, a proposal welcomed by Sir Lionel and the OoW. And so Epstein started again with renewed energy: while he said that the work would take about a year and that his fee would be £500, Bone agreed to have a model made to obtain approval from the OoW. There was, however, a further obstacle which threatened the progress of the venture: it so happened that John Galsworthy was an interested party, and he insisted on having access to committee meetings, asking for dates in case he was free to attend. Remembering that it had been Galsworthy who had, red-faced and tight-fisted, rushed out of the Leicester Galleries after seeing the *Christ* only three years before, and who had, Epstein said, 'ever after, in season and out, attacked my sculpture', the discovery of him hanging around in the wings must have been an unpleasant shock. According to Epstein, both Galsworthy and Sir George Frampton opposed his conception, and the threat of a move to block it quickly surfaced with a warning from Galsworthy that the committee should not put itself in a position where it had to accept whatever Epstein cared to provide without being able to criticize. Bone moved in rapidly to prevent his intervention developing into a setback; the adroit committee man with the acceptable face of an ex-army officer had no difficulty in calming Galsworthy's fears, at least

for the moment: 'When I explained', he wrote to Mrs Lemon, 'that all that was proposed was that Epstein should be asked to make us a model and that if we did not like it we could pay him for his model and go to another sculptor, he quite withdrew his objections to our way of going about it . . .'

Bone had immense experience in the art of persuasion: he must have loved Epstein as well as his sculpture, for he had been defending him since the Strand figures, and had fought very hard indeed to get him into a safe job as an artist in the war. As a quiet, civilized and rather uninspired artist, he presented a picture of an old-fashioned traditional-ist, exactly the person Epstein needed as an agent in the Establishment (before the National Gallery, he had been a Trustee of the Tate), and a man who could cool trouble brewing before most people realized there was anything to worry about. When he wrote to Cunninghame Graham on 2 February, it was to forestall any doubts there might be in the Graham corner as well:

It is absolutely necessary to have something beautiful carved on the stone – otherwise there will be absolutely nothing to look at at all, which is absurd! So it comes to this – what shall be put on the stone? I confess I am as anxious as ever to get something really strikingly imaginative and beautiful from Epstein, and I want to know what you think of the idea of the relief on the stone representing the wonderful woman spirit in *Green Mansions*? This seems to me a very fine subject for the sculptor and ought to result in a beautiful thing.

He added that the stone would probably be a small one now (as the proposed area had become smaller) and thought that they could 'get the whole thing done and beautifully done for round about £1,000 and I am certain we can easily raise that.'

With the precise area for the work defined, Epstein could make a fresh start. He had read the book, of course, but read it again: this gave him the facts upon which he could hang his ideas. 'The particular passage that appealed to me', he told Arnold Haskell later, 'was the description of how Rima met her death: "What a distance to fall, through burning leaves and smoke, like a white bird shot dead with a poisoned arrow, swift and straight into that sea of flame below".' He went on:

Although I read it and was moved by what I read, it is obviously

impossible to give an illustration of the book in sculpture that would be generally pleasing to all its readers and at the same time good as sculpture. A similar problem arose years before in my Oscar Wilde monument. Even if it had been possible to know how Hudson thought of Rima, I could only create her sincerely as I myself conceived her in my particular medium in the particular space put at my disposal . . . You have to conceive the idea poetically of course, only the medium is plastic. You have to think of the balance of the parts, essential rhythms, subsidiary rhythms, light and shade – all purely sculptural considerations. I cannot remark too often that the artist is a very practical person, fully as much as he is a dreamer. The two must go together.

At a meeting on 15 March, it was agreed, at Epstein's suggestion, that the committee members should come to his studio in Guilford Street on 23 March at 4 p.m. for the purpose of approving his new design before submitting it to Sir Lionel at the OoW: and it was duly approved and submitted. Then there was the inevitable, seemingly interminable interval while Sir Lionel and his advisers deliberated; while these people turned over the pros and cons of the matter, Epstein got on with other things – his portrait of Cunninghame Graham, for example, a man he found enchanting:

Imagine Don Quixote walking about your studio and sitting for his portrait! This was R. B. Cunninghame Graham, and you could see him on horseback any day in Hyde Park on his small American mustang, seated in a high saddle, riding along Rotten Row in a bowler hat . . . I should have gone on with his head and made it into a bust and full figure and mounted it on a horse, and had it set up in Hyde Park, where his ghost still rides.

Epstein credited him with getting him the Hudson commission, adding: 'You imagined around his belt (he scorned braces) a Colt revolver, and with his air of Hidalgo of Spain, he carried also a whiff of the American Wild West into London studios and drawing rooms . . .' Altogether, of course, he had thirteen works to complete in 1923 in time for his third exhibition at the Leicester Galleries in January of the following year. In the meantime, Bone, who had gone to New York on a job for several months, sent an aerial perspective drawing of Epstein's model on 1 May to Mrs Lemon to give to the OoW. He sensed, presumably, that there

238 / JACOB EPSTEIN

were problems in the wind – and perhaps Galsworthy had made some trouble – for he wrote to Sir Lionel on 19 June to emphasize the importance of having a really fine work of art. He went so far as to list Epstein's qualifications and to suggest that he called in the Trustees of the Tate for their opinions, at the same time sending a copy of this letter to Mrs Lemon to circulate to the committee: he believed, he told her, that persistence and conciliation 'would win the day'. He was sure that Sir Lionel would be 'supportive', but nevertheless was clearly anxious – should a careful and detailed model of the monument and its setting be made with 'trees, benches, flagged path shown modelled and properly coloured'? He would foot the bill, he said. Bone would not relax until he had seen the venture through successfully: he was a person of extraordinary energy, ability and dedication.

The bad news arrived eventually with Sir Lionel's letter to Mrs Lemon, dated 26 June. His Committee

> could not recommend permission being given for the scheme as designed. They feel that the sculptured stone would evoke wide and even bitter controversy, and that even the setting leaves much to be desired. They fully recognize Mr Epstein's genius, but they do not consider that his present design is either worthy of his talent or of the site on which it is intended to place it ... It is for your Committee to decide whether they would decide to carry out the present design on some other site outside the Parks, or to replace and redesign the scheme so that it could be recommended for installation on the site in question ...

This carefully worded letter from a representative of the old school of the English Establishment could have been interpreted as betraying a hope that the chairman of the Hudson Committee would show Epstein the door. A letter from Mrs Mackenna of 10 July could back up the view that outside influences had had a hand in behind-the-scenes attempts to oust Epstein, and that possibly Galsworthy had been a party to them: at a Royal Society meeting to discuss Bone's idea (or was it really Epstein's?) to use *Green Mansions* for the sculpture's subject, Galsworthy rose to declare that, in his opinion, Epstein wasn't the right artist to do the monument – his bitterness could be explained by a rumour that he had proposed another sculptor, and this had been ignored. Mrs Mackenna had also suggested another name to the Committee in the early days, and she brought it up again in her letter – Edwin

Lutyens should be invited to design a setting which had a bird bath, an inscription to Hudson but no sculpture, and Epstein should be paid off because she claimed that 'no modification of the present design will be accepted . . .'

This statement suggests that, like Galsworthy, what she wanted was Epstein fired and the latest set-back was the opportunity needed to achieve this. Unfortunately for her, Galsworthy and the anti-Epstein camp they represented, the committee members backed the artist and ignored the opposition: he was invited instead to do a third design for the memorial, and was paid, at his request, a further £100 to cover his expenses for wasted work, materials and time. Cunninghame Graham and Epstein went to the OoW to explain their plan, and one likes to think that on this occasion the artist made his position clear: he could not be hurried or rushed into fastening on a final idea, and the pile of drawings carried out to this end indicates he did just that.

Epstein was certainly disappointed – that was mentioned in Bone's memorandum to the Commissioner of Works after the campaign to discredit his sculpture broke out in 1925 when it was unveiled. He had been disappointed enough by the delay caused by the first change of plan and something of his dejection shows in a letter of 16 February 1923, which he wrote to Kathleen at Oakswell Hall where she was staying when her father was very ill: 'If only I could cast all my things in bronze I could show them and make some money independently of commissions. I mean something to work on one thing entirely after my own heart and let all other things go to the devil.'

From what he said in his letter, it appears that he had begun something new after the first proposal for the memorial had been rejected, writing that he had 'finished a fairly elaborate sketch for the Hudson'. He went on:

Tomorrow I work on the weeping figure as on Friday it goes to the Tate Gallery to be received next week; I have also worked on my other sketch for a building but I expect to finish it by the middle of next week only. All these things are problematical. I look at my other studies done out of sheer interest in the things themselves and think that I haven't wasted my time. I have received a small advance for the building sketch . . .

And they were problematical: the study for the Hudson, to which Bone referred in his memorandum, was of course turned down; the weeping figure was not accepted by the Tate trustees as a later letter to Kathleen foretells: 'Naturally I've been annoyed at the postponement of the bronze for the Tate; I had been counting on it for a sale.' At the same time, he was missing Kathleen dreadfully, every moment he was away from her:

> It is now a week since I've seen you and I've so longed to see you that my whole day and night is conditioned by my great longing: you do well to write in your letters of kisses and embraces – that is what I think of and were we together it would only be to kiss and embrace you . . . last night I believe I spent almost the whole night thinking of you. Why do I when it gives me such pain. I am not with you my arms that wish to hold you haven't you, my hands that want to feel you miss you: yours are the kisses I want: I want to feel you sincerely loving me and yet were I to believe what I hear of you I would have to think of you as the same Kathleen of a year ago full of wiles and lies, going from me to others.

Mrs Epstein knew her husband's jealous nature well enough and she seems, from what he wrote to Kathleen, to have played on it, putting into his mind stories about her affairs with others. These were cruel tactics to employ, but not unfamiliar where someone's marriage may be in grave danger of being destroyed: jealousy was being used by jealousy in another attempt to oust the mistress – Mrs Epstein, who had struggled valiantly to help her husband, had sacrificed many things and interests for his life, was terrified that he had become so utterly enslaved by what she saw as, or imagined to be, Kathleen's sexual expertise that he would leave her, and she would try anything to stop him. It was not, moreover, difficult to make the suspicious and jealous Epstein believe the gossip she spread about Kathleen's supposed infidelity: he was obsessed and tormented by it – what a handkerchief was to Othello, the expected letter that didn't arrive was to Epstein, proof that Kathleen was with another. Yet the moment he heard from her, the fears vanished in a blink: 'Your letters are wonderful – why shouldn't I believe them . . .' All the same, he needed continual reassurance:

> To hold you again in my arms when will I? And with all these thoughts I hear some to say the least curious rumours of you. How

can I accuse you who have given me so much. If you can give others what you give me what a nature is yours. I know you to have given me what no one else has, what no one else could give me. This is no exaggeration . . . How I wish we were together you and I in your little place. How happy I would be, happy beyond words and all expression in words. You you always in my mind. Write me my darling girl.

She was a girl: she was twenty-two, he was almost exactly twenty years older, and Epstein must have been haunted by the possibility of her being captivated by some irresistible man of her own age. Then, of course, Mrs Epstein, around ten years older than her husband, had become heavy and ugly with her disease, and her jealousy of Kathleen was nothing if not understandable. Yet both Epstein and his wife were wrong: Kathleen, in love with Epstein, would never have left him; while Epstein was much too considerate, and much too dependent on his wife to leave her. When he passed on his worries to Kathleen in a letter written not long after that of 16 February, he apologized for something he'd written in a hurry; he was 'feeling somewhat wretched' the day before, and explained that this was 'naturally the result of hearing some gossip about you: then could hear nothing of what you said on that miserable Café Royal phone in the evening.' He was in a state of great stress, sorry for upsetting her, but incapable of keeping his misery over the rumours that had been circulating to himself; and the fact that she was so close – a few minutes walk away across Coram Fields – must have increased his agitation to be with her. Yet he had his work to do – that was as important to him as she was: hence the letters, one a day sometimes, and the phone calls. He longed for them to be together, all the time, but his marriage and Peggy-Jean, to whom he was devoted, made that impossible, a romantic dream. 'Why do we meet to part and yet it is necessary', he says at one point. 'Some day it may not be.' His anguish was that of someone in love, and hardly difficult to imagine. Yet in the next paragraph, as so often, he reverts to anxieties about his work, his annoyance at the postponement of the bronze for the Tate; tells her that a committee from the Leicester City Art Gallery is visiting him in a couple of weeks and hopes something will come of that. 'I have to think of these things as the accumulation of my debts quickly robs me of any money I may make. Later I hope to do some portraits which will pay me. I pray the sitters won't be too uninteresting.' And with an apparent reference to Hudson, 'I will be on the present work for at least a month more.' Then:

Write me: your letters console me and dissipate the things I hear and imagine to be true; what a lack of faith in myself. To be thrown from the heights to which you raise me and realize what a mockery our love is. My hell is about as intense as the heaven I've been in. When you say they are liars I believe you. I want your love and without it I would be the unhappiest man on earth.

One thing is absolutely certain: Kathleen did love him – had she not done, she would never have suffered the frightful slander put around about her which, when without him, must have made her life hell, too. To be suddenly transformed from an infatuated and sensitive young music student, fresh from the country, into the familiar hard, calculating, experienced mistress – nothing less than a harlot, in fact – must indeed have made her feel, at times, the unhappiest woman on earth. Who the various people responsible for the rumour-mongering were, and what precisely was said, has never been recorded, although the original source is clear enough – Mrs Epstein. It was, however, against this background of jealousy and lies, suspicion and passion, that the Hudson memorial was conceived; and against the further distraction of the magnificent busts he made of the Marlboroughs, Ferosa Rastoumji, Dolores, and Cunninghame Graham, all of whom were most interesting subjects for sculpture. Despite this heavy work and the tumultuous relationship being acted out in and around Guilford Street or at rendezvous like the Café Royal, Oddeninos and elsewhere, his dedication to the Hudson commission remained absolute. From June, when he agreed to produce a third scheme, until the end of the year, he made eighty-six drawings and watercolours of ideas before finally arriving at a sculptural solution to the problem which satisfied him. This gives a striking picture of the artist. He was able, apparently, to concentrate on a dozen things simultaneously, and so was capable of an immense output of work, great vision and unwavering concentration in conditions that must have caused him extreme anxiety. Anyone might imagine that he needed the stimulus of tension to strive against, driving him on. If this was true, there was more of the same on the way: by the end of that year, he knew Kathleen was pregnant.

This news doubtless inspired further efforts from him. For work he did: when he wasn't carving or modelling, he was drawing, and while producing sheets of ideas for the memorial, he had been preparing for his

exhibition at the Leicester Galleries. And when this opened in January 1924, it received predictable reviews – extremes of praise, condemnation and abuse from extreme ends of the press: cool congratulations from *The Times*, the artfully snide remarks of Roger Fry in the *New Statesman*, and violently anti-semitic attacks from the fascist weeklies the *Hidden Hand or Jewish Peril*, the *British Guardian* and, with the disappearance of Orage, the *New Age*. *The Times* critic had enjoyed himself: 'We are looking not at a bust of so-and-so, but at a work of art by Mr Epstein . . . At least one bust, the superb thing of the *Girl from Senegal*, asserts itself instantly as a great work of sculpture, a masterpiece of form exactly expressing an idea.' The big carving in marble of arms showed 'in its very smoothness of surface and lovely flow of line that Mr Epstein is not a mannerist, but a seeker after beauty who knows that beauty has many forms.' This was some contrast to what Fry had to say: all city sculpture, and *all* sculpture, in fact, 'including the great names, has always bored us – till now,' he told his readers. 'And now comes Mr Epstein.'

Mr Epstein, he argued, started with remarkable gifts –

saw sitters as what he felt to be a style corresponding to his or her character – we had the strangest mixture in the series of Chinese bronzes, early Greek marbles, Aztec and Rodin. Now at last he has found himself, has developed a method and a manner of seeing which look as though they were definitive . . . Now that he has found his style we can recognize certain definite mannerisms. It would be easy to parody an Epstein . . .

He goes on: 'Is he a master of sculpture? And, alas! I am bound to say to the best of my belief, No.' He appeals, Fry says, 'to the majority, the general populace' – since attacks on him came mainly from 'the general populace', this would have surprised Epstein – but had improved since the days of 'the stylistic, decorative arrangements with which Mr Epstein started'. The work 'is a triumphant expression of genuine feelings about people's character . . . and if it doesn't evince any particular or exhilarating sense of formal harmony, so much the worse for the few people who happen to have a passion of such an odd kind.'

Epstein was furious: here was an example of interested artistic parties he loathed and Modigliani called 'Snobs d'Art. We working artists suffer from "Les Snobs d'Art".' Epstein said Modigliani 'always hit the nail right on the head'. How he would have wished Hulme was still alive

– 'my very great friend', he called him in his foreword to *Speculations*, Hulme's brilliant collection of essays on art published that year, in one of which he dismissed Fry as 'a mere verbose sentimentalist'. As it was, he sent a copy of the review to van Dieren, recalling another which singled out Frank Dobson as the only sculptor 'doing sculpture' – the 'others are merely "using" sculpture', he said, 'a fine distinction. Using it for God knows what purposes unholy to Roger.' He reeled off Dobson's influences to van Dieren – Gaudier Brzeska, Wyndham Lewis, Brancusi, Aztec, Chinese, Modigliani among many others – left unsaid by Fry. Dobson and Fry had 'a "holy" mission – pure form, pure art, pure significance', he said before going into 'the rubbish about "Third dimensional" art, as if that were something entirely new and most difficult to understand – really something quite mysterious. Any wax figure in Derry & Toms windows has this third dimension . . .' Striking aesthetic attitudes about common sense common knowledge never failed to irritate him: unfortunately, 'the name R.F. is one to hypnotize most people into the belief that platitudes and downright nonsense are profound and original wisdom to boost a "pasticheur" as an "organizer of forms",' and that 'could only be done in London where there is a large ignorant public ready to swallow anything from the scholarly art niceties of the Fry type. Muse critics and pure humbugs following several years after the fashions of Paris, always up-to-date a bit late . . .'

Nicely put; he was referring, I suppose, to Fry's wishy-washy, decorative paintings after the manner of Cézanne and others, and to his exalted position, created by his time at the MET, as *the* authority on art. He saw him as one who wasn't interested in what the artist thought, only in what *he* thought. 'As they are today,' he said, 'very often, practising artists themselves, or well-to-do amateurs, there is an element of rivalry or jealousy to be reckoned with.' Hence Modigliani's remark. But if he was able, with difficulty, to put out of his mind the prissy pomposity of Fry and his band of Omega interior decorators, he must have thrown the *New Age* on the fire. Here, as he put it, 'Aryanism has run amok . . . The review, so venomous, so vile was signed with a pseudonym – Rusticus. Obviously a forerunner of Herr Streicher.' As Epstein remarked, writing his autobiography in the late Thirties, the

hatred of, and propaganda against the Jews in Art, is of no recent growth. I, for the life of me, cannot see why my bronzes in this exhibition were particularly Jewish, any more than the works of

Rembrandt, and he is certainly not condemned for his Jewish subject matter, except by the Nazis, of course. I remember that Modigliani was intensely proud of his Jewish origin, and would contend with absurd vehemence that Rembrandt was Jewish. He gave as his reason that Rembrandt must have been Jewish on account of his profound humanity . . .

Rusticus couldn't see any humanity in Epstein's work: 'Epstein was not of the Aryan race', 'Epstein's sculptures . . . are instinct with evil', 'The intensity of revulsion aroused by them cannot be explained merely on the ground of their semitic cast', 'The women appear to be of lower race', 'His women are like animals . . . the portrayal of savage types', 'He narrows us down to tribal conceptions – to animal women serving the lust of their patriarchal owners . . . where power is the motive force of man, and woman is but an instrument of sensuality' – these are a few random views from Rusticus. The *avant-garde New Age* had certainly changed its spots; but then unfortunately Orage, its radical editor, had long since left for France.

As Epstein remarked in his autobiography, this astonishing tirade might have been written in Nazi Germany. He may never have seen the attack on him in the *Hidden Hand*. After reminding readers that P. G. Konody, the *Observer*'s art critic and an admirer of Epstein's, was a Jew, the paper's February review said that the 'Jew Epstein' was making a 'deliberate attempt . . . to influence our English public into admiration of something very different from what it has . . . admired in the past and so degrading it'. The review went on to quote Konody on a bust of a negress 'as the nearest approach . . . to the ordinary man's notion of female comeliness', saying this was 'a sinister attack on English woman-hood' and that it hoped 'our women-folk will rise up in their wrath and put a stop to this deliberate degradation . . . and this man Konody . . . obtaining space for his objectionable remarks in any English publication.' A further attack on Epstein followed in April with a leader headed 'BOLSHEVIST ART AND JEW ART CONTROL'. In this, any expression of enlightenment and imagination, from Van Gogh (described in passing as 'a Dutchman') to Epstein, was condemned as 'decadent' and sandwiched between political diatribes and rampant anti-semitism in wicked efforts to stir up the persecution of intellectuals and artists alike:

The Jew-controlled Leicester Galleries and Goupil Galleries ... are among the sponsors of 'Modern Art' in London. The Jew sculptor, Epstein, has just exhibited at the Leicester Galleries. The public are being 'educated up to' appreciating the charms of ugliness inherent in the human form as he sees it, his conception of Christ ... being all that Braunstein Trotsky could wish for in the way of blasphemy...

Epstein would have hurled this paper on the fire too, but its odious hate campaigns, backed up by those of numerous notorious books, periodicals and pamphlets of the time distributed by the Britons Publishing Society from Great Ormond Street, had a part in the horrible attacks on both Epstein and his sculpture later, particularly in connection with *Rima*. The picture of bolshie rebels smashing everything in their way provided a neat parallel, to conventional eyes, for the modern artists' destruction of academic values, which even a great liberal newspaper like the *Daily News* seized upon; on top of that, right-wingers like the *Morning Post* hammered home the anti-semitic propaganda, and for this, as the embodiment of English modern art, Epstein was the perfect target. For those wanting a scapegoat, he was it.

Still, only attacks from the Fry front upset him; they did, deeply, as can be seen from his letter to van Dieren. Otherwise, the sideshows left him untroubled; his exhibition, in fact, was generally praised, and it was a success; his work sold at the gallery, in his studio, and commissions for portraits rolled in. Best of all, perhaps, was the news that, on 14 February, around the time the show closed, his proposal for the Hudson memorial had at last been accepted by the Ministry of Works.

The final sheet of eight rough drawings of ideas for the memorial catch the peculiar magic of the allegory, sketchy as they are: and these, judging from Bone's bird's-eye perspective of the panel in its setting, led to an exact representation of the proposal from which he worked.

He had attempted many interpretations of Hudson's unearthly story – some as a relief crowded with birds, one of Rima as an animal, another as a watchful figure stealthily parting the reeds as she moves through them, yet another with two birds, another as a single huge head of Rima; but now she and her birds came together as, one imagines, Hudson would have wanted. Nature was his wife; she is Rima; and when the narrator, symbolically named Abel, discovers the dense forest (his 'beloved green mansions'), mysteriously avoided by natives who have

superstitions about a girl there who retaliates if anyone should try to kill one of the forest's creatures, he is bewitched by the birdsong, strangely human in sound, which follows him – 'a voice purified and brightened to something almost angelic'; he adores it. 'The blood rushed to my heart as I listened! My nerves tingled with a strange new delight, the rapture produced by such music heightened by a sense of mystery.' As the voice seems to follow him round the forest he never sees the singer. In the end, of course, he falls in love with the voice as though with an idea, and when he finds her at last, lying on moss among ferns, playing with a small brown bird, he can hardly believe what he sees, this vision with the sunlight on her hair, its 'strange lustre', its 'iridescent colour', this 'wild, solitary girl'; cannot believe that such a girl 'could exist in this gross world', yet knows he cannot have magicked her there because his 'imagination was powerless to conjure up a form so exquisite'.

The Green Mansions, the name Rima gave to her beloved forest, is a fascinating evocation of the meaning of nature seen through the dream-like relationship of Abel and herself. It is a love affair of the spirit: Abel is utterly changed by Rima – he can never leave the natural life and return to the city, and she cannot survive in the confinement of normal human company because she needs the freedom and wildness of the forest. She is the soul of nature – her soul is in the musical language with which she conveys her thoughts in sounds; his, she tells Abel, is in his eyes. She loves him and fears her feelings; if he touches her, she shrinks away. As the embodiment of nature, she's very vulnerable, and the possibility of being destroyed by contact with man – as indeed she is when killed by the ignorant natives – embodies in itself a startling prediction of man's horrifying threat, through ignorance, to the life of our planet. This is the book's message; a parable, it made a marvellous subject for Epstein; the story was a statement of Hudson's loathing of the men and women who worship success and the business of the world, and, as his friend David Garnett wrote, are the cause of 'nature being despoiled and beautiful birds and animals exterminated'. Epstein had similar feelings about this view of commercial life, and although, as he told Arnold Haskell, it was impossible to describe its message in sculpture, what he did was to capture an extraordinary portrait of the girl among her bird friends in the forest. Rima in the book is almost ethereal – she is continually vanishing and reappearing, like a quick bird that flies off, silently, elusive as a shadow: she seems to float. In the sculpture Rima is floating upwards, as though for air from the

depths of a lake, and, as she breaks the surface, forms a meniscus with the birds of head, hair, tips of fingers and beaks; her arms are like wings, the lower half of her body seems to metamorphose as a tail, her form and movement mirror the eagle's on her right, and her abdomen the breast of the bird on her left. Feathers and hair, wings and arms follow the same direction, expressing her 'one-ness' with the birds, so intensely emphasized throughout Hudson's story. But the movement upwards paraphrases the spirituality of his theme – the energy of the natural world, Rima's holiness, Abel's growing affinity with nature acquired from his love for her. In the book, too, Rima embodies nature, she is close to truth and beauty, is uncorrupted by civilization, yet not a 'savage' – hers is a spiritual nature, not a bestial one; in the sculpture, her figure and limbs embody, moreover, other living things: the serpent that guarded her on her first encounter with Abel; snake forms; her abdomen has the outline of a fish with her navel for an eye; her fingers and the palms of her hands make the shapes of beaks. Throughout the work, to the feathers suggesting the heads and necks of other birds, there is a multiplicity of strands of human and forest forms that build the whole, bewildering construction of nature, catching it as though in a single glance. No wonder Epstein talked to Haskell of a work's 'essential rhythms, subsidiary rhythms, light and shade'; in one image, *Rima*, outstretched, a gleaming white form of Portland stone, becomes the branching tree of life; but look again – in another image, those arms are like the great wings of a swan beating their way to freedom from the dark shadows and dense undergrowth of the forest behind.

Epstein began work on this complex and mysterious carving some months after he came back from doing a bust of Joseph Conrad in March, a commission which had, once again, been arranged by Muirhead Bone. This suited Epstein for there had been more hold-ups since his proposal's acceptance: first, there was the vital matter of money now that the project had official acceptance – a new, wider appeal had to be launched, and in March it was advertised in several newspapers with a drawing (by Bone), and *Country Life* opened a special fund. Then the size of the stone selected by the committee was too big for his studio-shed at Baldwin's Hill (where, not unnaturally, he wanted to do the work in the inspiring forest setting), and he had been given an extra fifty pounds to enlarge it. And so he went off to do Conrad at his house near Canterbury, in a taxi (Epstein invariably took a taxi, whatever the cost or distance, or hired a car), taking all his materials and tools with him.

He was excited – he was an immense admirer of both Conrad's novels and his head, and had wanted to work from him ten years before; however, on that occasion, he had been prevented from doing so by the intervention of some painter 'friend', he said. Nevertheless, one has the feeling that the experience was something of an anticlimax, even a disappointment. The weather didn't help (it was snowing), the countryside was sodden, the inn where he put up was cold and gloomy, his work began badly, Conrad was crippled by rheumatism, crotchety, depressed – 'I am finished', he said, 'played out' – and, on the second day, Epstein wired his wife to send his five-year-old daughter, Peggy-Jean, down for company. After that, things went better: his sitter, though ill, was tough – on one occasion during the three weeks he was there making both a head and a bust, Conrad had a mild heart attack, but insisted on continuing after his manservant had brought him a stiff whisky. He was always punctilious, immaculately dressed and careful that his hair was in place and beard was perfectly trim. 'There was', Epstein said, 'nothing shaggy or Bohemian about him ... He was the sea captain, the officer, and in our talks he emphasized the word "respectability". Respectability weighed on him and weighed him down. He used the word again and again and one immediately thought of *Lord Jim* – the conscience suffering at the evasion of duty.' He gave Epstein a feeling of defeat, 'but defeat met with courage'. He was in the middle of a new novel but doubted if he would complete it; he claimed to know nothing of either the visual arts or music, and had few books; he dismissed Melville's *Moby Dick* as ridiculous ('he knew nothing of the sea'), and seemed to have no use for anyone much except Henry James, and for him he had immense respect – D. H. Lawrence was 'filth, nothing but obscenities'. About Epstein's bust, however, he was ecstatic: 'The bust of Ep', he wrote to his official biographer and literary executor, Richard Curle, 'has grown truly monumental. It is a marvellously effective piece of sculpture, with even something more than masterly interpretation in it ... It is wonderful to go down to posterity like that.' His modesty was proved by the pleasure the work gave him, touching from one whom Epstein so revered as a writer. Opening a newspaper five months later, he read of Conrad's death: and Muirhead Bone's offer of a gift of the bust to the National Portrait Gallery was refused.

The cast went to Bone's son, Stephen, at a time when Epstein was faced with heavy removal bills from the Leicester Galleries' February exhibition where earnings hadn't matched outgoings. When writing to

Bone, asking for his son's address, he told him of his latest financial problems: Could Bone find him another portrait to do? What about Holden's new building (for London Transport) – would he be wanting a sculptor? Or would the 'letter cutters' get the work (a reference to Gill)? He could have done with the job of Professor of Sculpture at the Royal College of Art when Derwent Wood left that year. Although Rothenstein, who had, interestingly, no feelings of animosity towards Epstein, recommended him, the Governing Board was horrified: 'Epstein's appointment to a Professorship of the Royal College of Art would be a very perilous experiment and might cause considerable embarrassment,' was its comment. So that great opportunity for the RCA students to learn from an artist of genius was lost; and it was a great loss for Epstein, too, not merely from the point of view of money – he enjoyed the company of students in the way he enjoyed children's, and would have brought a new spirit of informality to the teaching of them there.

According to Epstein, he began his *Rima* around September; a note of his activities is picked up in a letter to Kathleen during a hot spell, possibly in June. Helen brought him letters from her sister to a secret rendezvous in the Forest, and on 1 July she came to give him the news that Kathleen had had her baby that day, and that it was a boy. But there is no mention of this in the letter, although the birth sounds imminent: 'I am glad you are feeling well and if you are well enough we can meet at Oddenino's on Saturday at seven. If you don't feel well let me know and I'll come to your place. I have been working hard and am reduced to a jelly this afternoon. The shed is so hot.' But at this stage he was working on another subject: 'The Hudson people worry me weekly. I am keeping at my own thing only because there is no room in my shed for another stone and there is a hitch in getting up the new shed.' So this was still the cause of the delay in getting started – space to work. All the same, another cause must have been the many portraits he was commissioned to do; although thinking to the future when tapping Bone's sources for work, he carried out eight between February and September that year; indeed, despite his determination to interpret as he pleased, and his refusal to compromise, he was now a most sought after, fashionable portrait sculptor. There was also the possibility of a figure for Bush House in the offing. In his letter, however, he was talking of his new work: 'You write as if my figure were already finished. It is altogether in an embryonic stage and I can only just see it coming.

I must have time to work it out; time is the only thing I feel I will not have. Time and peace to work on it . . .' With all his commitments, that was unlikely. Then he longed to be with Kathleen:

> Outside is wonderful and I think of the wonderful walk we could have in the cool green of the forest . . . Sweetheart I long to be with you again. Wait for me and we will enter that heaven on earth which is ours when together . . . I write in my shed before what I hope will be an image of holiness and beauty. Whenever it is finished at whatever time you will see it. May it be worth your gaze.

Perhaps it was *The Visitation*, completed two years later.

When carving started on Rima, it continued without a break, 'working through the winter, solitary, surrounded by silent and often fog-laden forest': it was a cold job that tested his strength, perseverance and endurance, immense as they were, in that wooden hut on a hill, exposed to the east wind. Nevertheless, the forest, ghostly with drifting fog or snow, must have been an exhilarating companion to have for his subject. But real art operates on so many levels: *Rima* is a manifestation of a tree, her arms, branches; of a bird, wings beating, her nose and hands, beaks; of a Greek goddess; yet also, with arms raised, of a Buddha – in fact, this panel filled with the creatures of nature recalls, in another image, ancient Indian art of the kind which interested him in the British Museum where the scene, crammed to the edge with the life of the subcontinent, was dominated by the elephant. Epstein made his forms work hard; at the same time, as he stressed, an artist is as much a 'practical person' as 'a dreamer'. The fact that *Rima* had to stand in the open, was carved in Portland stone, a relatively soft material, and was to be viewed from a distance of thirty yards, imposed certain conditions on the sculptor's treatment. Niceties had to be omitted for fear they would, exposed to London's polluted atmosphere, quickly become formless: hence his decision to keep the carving large and weighty, a treatment which also suited the distant view: this called for bold carving for forms to be effective, even if this meant a rough finish. Muirhead Bone drew attention to Epstein's responsible approach when defending *Rima* from demands for its removal. 'The work would consequently be useless if detached from its position', he explained in his letter to Lord Peel, Commissioner of Works. 'As well expect that one of the large Apostles by Bernini from the top of the western façade of St Peter's would prove

a desirable ornament in the gallery.' Epstein had tried to cover every eventuality: 'While I was doing the work in Epping Forest', he told Haskell, 'my wife said: "They will never be able to make a fuss this time".' But 'they' did, and a worse fuss than had ever been made before. Epstein said he would never forget Mr Baldwin's expression when, in May 1925, he pulled the string and the work was unveiled: his expression must indeed have been one of total astonishment.

The Prime Minister's unveiling lit the blue touch paper, and the public, standing back, watched the fireworks that followed, on and off, for the next ten years: the monument was attacked by vandals in October 1935 when it was disfigured for a fourth time, on this occasion with a chemical in heavy rain: restorations took weeks under the cover of tarpaulin.

As usual with Epstein's work, for and against took distinctive sides: his art was so positive it was either loved or hated. Likewise, himself: he had a diverse effect on people, mainly because he said what he thought; his honesty was delightful to some, unbearable to others. For example, the actress Sybil Thorndyke adored Epstein – it so happened he was about to do a bust of her as St Joan when the furore over *Rima* blew up. She told an *Evening Standard* reporter that May:

I am looking forward to it with tremendous eagerness. He has been such a tremendous inspiration to my work ... To me his Hudson memorial tablet in Hyde Park is supremely beautiful. Have you ever held a bird in your hand and felt it striving to escape? I felt that there was that kind of thing in that stone as carved by him, just some bird-like thing which he had imprisoned in stone. Only a very great artist could have reproduced that.

She rushed ahead with even more lavish praise:

Epstein – and this is something which people often cannot understand – analyses the soul, the feelings, the inner self, brings out the strivings and that part of one which reaches forward towards better things. Sculpture is the only art which really does that in any degree of perfection. It is a hundred years ahead of Drama in that respect. We try, we of the stage, but the sculptor accomplishes. The people who are criticizing Epstein and his work are simply just a hundred years behind him.

Compare this with the views expressed in the extremist *British Guardian* a couple of weeks later on 12 June:

> The public will probably remember that the agitation against the hideous and disgusting monstrosity for which the Jew Epstein is responsible, and which is now exposed in Hyde Park, is not the first occasion on which objection has been raised to this Jew being commissioned to execute work for British public memorials.

The stories of the BMA figures, the Wilde tomb ('so obscene and disgusting that the French police authorities would not permit it to be unveiled') and the *Christ* ('for doing which he would certainly have him imprisoned for blasphemy had we public men not all been under the same Jewish control which is exploiting Epstein himself') were dragged up as ammunition for the onslaught on *Rima*: 'This is apparently the only "artist" who can be found to commemorate adequately the nature-loving Hudson. How much longer are we going to tolerate this bestiality, this attack upon the Christian culture which we have inherited?' After turning on the 'Jew named Konody' and Wilenski, 'a Jew ... from Poland', and claiming that an interview in a Sunday paper called 'An American view of Epstein' was American only because 'American is Jewish', the writer concluded that the Hudson memorial was part of a political Jewish plot and that the only thing to be done with the sculpture was to remove it: 'Fascism is inevitable, and the sooner we experience it the better.'

These revolting remarks reflected the rise of Fascism in England in the Twenties; nevertheless, they had their echoes in politer language elsewhere. After letters flooded the correspondence columns of *The Times* with views on the latest Epstein controversy, and reports of what the public thought, after devastating headlines in the *Daily Mail* like 'THE HYDE PARK ATROCITY – TAKE IT AWAY', there was the alarming news that the matter had been taken up in the House of Commons. The *Mail* claimed (25 May) that two MPs, Major the Hon. E. Cadogan and Lieutenant-Colonel Dalrymple White, were to ask the Home Office Minister whether he could have this disfigurement in Hyde Park removed? And these questions and others were put down in the House three times by several Members over two weeks in July and August. But they had no effect; they were blocked by the dead bat of Godfrey Locker-Lampson, the Under Secretary at the Home Office.

The trouble did not, however, die down. On 7 October, the *Daily News* reported that 'The Hon. John Collier, the eminent artist', had delivered a scathing attack on modern art the night before at the Authors' Club dinner in which he said of *Rima*, 'Here you have a female figure purporting to represent an exquisitely beautiful girl. What do we get? A monstrous perversion of the female form.' Having gone on to say that 'advanced art', which was 'extravagantly praised by the critics' but loathed by 'the plain man', was 'ugly and inhuman', he added that he had no hesitation in calling Epstein's *Rima* 'a bestial figure, horribly misshapen, with enormous claw-like hands and the head and face of a microcephalous idiot. If the critics met a woman like that in the street they would flee from her shrieking . . .' While the *Daily News* called on the American film star Betty Blythe for a sufficiently feminine and detached view ('Everything is wrong', she said, 'the hands are wrong, the arms are wrong, and the breasts – oh, dreadful!'), the *Star* asked Epstein to comment on Collier's after-dinner speech: 'People like the Hon. John wrote with chagrin that all their efforts at attacking my Rima memorial in Hyde Park have signally failed.' He said they were a disappointed group who were really attacking Cunninghame Graham, Bone, Shaw, Lavery and others, all of whom had approved the work. 'We talk in two different languages. I am concerned with sculpture and art, and he is very much concerned with nudes and things of that sort . . . I can only take it that the hon. gentleman has been moved by a good dinner to apparent ferocity which leaves me entirely cold.'

But things went from bad to worse. On 12 November the memorial was smeared with green paint and the words 'Oh! Epstein!' were scrawled along the top of the panel. This act of vandalism could have been inspired by a singularly unpleasant observation in the *Morning Post* on 7 October coinciding with Collier's vicious remarks: 'Mr Epstein's work in Kensington Gardens [sic] is so far from being the object of admiration that were not the English a tolerant people, it would long ago have been broken in pieces.' The paper seemed delighted when the vandalism occurred; two days later, it exclaimed: 'The *inevitable* has happened to Mr Epstein's *Rima*. She has been ingloriously daubed with green paint.' Then the paper invited a letter from a group of diehards of the academic establishment, prompted presumably by the defacement of the memorial, and printed it on the 18th; among the fifteen signatures were those of Sir Frank Dicksee, President of the Royal Academy; Alfred Munnings R.A.; Sir Philip Burne-Jones; Sir Johnston Foukes-Robertson; and the

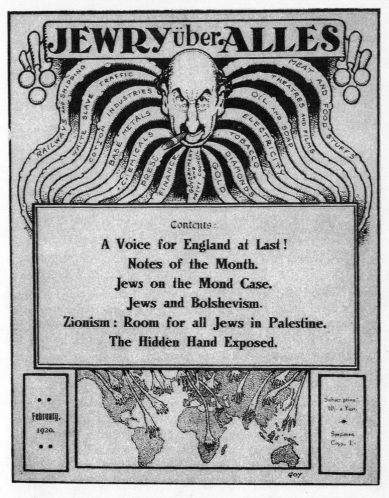

The cover of the monthly magazine which, originating in Germany,
spread anti-semitic filth in English for many years following the
First World War.

Hon. John Collier. They claimed that the memorial was, 'by universal consent, so inappropriate and even repellent in character that the most fitting course open to the authorities for so woeful a lapse of judgement would be to have it removed bodily from its present position with as little delay as possible.' As if this wasn't enough for a paper which, as Muirhead Bone pointed out in an interview in the *Observer*, had occasionally supported Epstein's work, there was a leading article headed 'Take it away'. This stated:

> The dignified and authoritative letter on the subject of the memorial to the late W. H. Hudson, which we publish this morning, puts the whole matter in its logical position . . . It is clear that there is some quality in the memorial in Hyde Park which revolts the public; and they have a perfect right to say so, and, further, to request the immediate removal of the offending object.

Taking up a point in the letter of protest that the memorial was 'a piece of artistic anarchy', and reminding readers that public 'disgust' had 'already found expression in the youthful, foolish, and rather hooligan dose of green paint', the leader writer urged the authorities 'to remove the excuse for further "outrages".' As the *Nation* commented on the 21st, taking Epstein's side, the signatories knew where to turn for relief from 'artistic anarchy', but 'these guardians of order say not a word about the anarchy of green paint.'

Muirhead Bone was, naturally, astonished: the suggestion of removing the panel was, he told the *Observer*, 'a most extraordinary proposal.' And on the 23rd, *The Times* printed a letter from him in defence of the memorial that was accompanied by fifty signatories opposing the removal of the work. On the following day, a second list of thirty-six signatories was printed, and this was followed by a third with a further thirty-four. On the same day, the paper reported receiving letters of protest against the panel's removal from 170 Royal College of Art students, eighty-five Slade students and from almost all students from the Royal Academy School. Yet despite this show of support from artists, writers, politicians and architects, more questions were asked in Parliament about the panel's removal, and, on 25 November, Mr Peto, the Member campaigning with the help of the *Morning Post*, told a reporter from the paper that Sir George Frampton, a so-called 'expert' who had been consulted by the Hudson committee on Epstein's

proposal, said 'that *Rima* did not look so grotesque on paper as when sculptured, yet, nevertheless, he remarked at the time that the designer obviously did not know the A.B.C. of sculpture, and that the figure was an insult to the intelligence of the country'. That, not unnaturally, was a predictable remark from one of Epstein's oldest and most envious enemies. So great, however, was the animosity, kept on the boil by arch-revivalists like Peto and Frampton, that Muirhead Bone, with yet one more gesture of respect for Epstein and his art, took it upon himself to write a lengthy résumé of the panel's history, covering everything from the cost of the work to the care with which Epstein had judged distances in his scale of carving, something which was seized upon as 'crude' and 'child-like' by critics like Patrick Abercrombie, the town planner.

The memorial was, of course, never moved: art apart, it was inconceivable for a British Government Ministry to have wasted a penny so gratuitously. Mr Locker-Lampson and others listened inscrutably to all the vicious attacks and ignored them; bored stiff by the tedium of the affair, they closed the file and locked it away.

So what was it about the relief that roused such fury? The *Nation*'s verdict was revealed in its comment of 28 November:

That the P.R.A. – his name is Sir Frank Dicksee, R.A. – and other titled painters should, immediately after the defacement of Mr Epstein's *Rima*, write to the papers urging its speedy removal, thereby tacitly endorsing that act of hooliganism, is typically a 'sign of the times'. The methods of intolerance, persecution, and violence which, since the war, have been so marked a feature of politics, particularly in Moscow and Rome, have also invaded art and literature. Elderly gentlemen, who have made themselves comfortable and respectable by 'literature', do not like the plays of young writers which are performed by private societies on Sunday evenings. They are not content with expressing their dislike, but immediately propose to forbid such performances, being determined that no one should see a play that does not meet with their approval. Others propose that the police should have the right to enter our houses, inspect our books, and seize any which they consider indecent, on the ground that no one should be allowed to read anything which does not meet with the approval of Sir William Joynson-Hicks and his Police Inspectors. So Sir Frank Dicksee considers that no one should be allowed to look at a piece of sculpture which does not meet with *his* approval. I daresay

he is right. He and his kind have made London so hideous and ridiculous with their statues and architecture that it is probably better that it should be all of a piece, and that future generations should be brought up to see that you cannot produce better art than the Albert Memorial, the cupola on the top of the Coliseum (which, I surmise, was designed by Sir Frank Dicksee, R.A.), the Nurse Cavell Memorial, and the stone figures which lean over the balustrades on the top of the new buildings in Regent Street.

This angry writer was taking a graphic look at England in the Twenties when the advance of fascism was invading society and the reactionaries were once again roused to hit out at the leader of modern art who threatened the status quo: no wonder the students, deprived of contact with European movements by their academic teachers, ran to support Epstein. There was, however, more to the public outcry over *Rima* than this: the grip of anti-semitic feeling, narrow nationalism and religious fervour was as tight as ever. Hence there was Joshua Brookes writing in the *Saturday Review* (quoted in the *Morning Post* on 28 November), 'It is necessary that nearly all the support for violence rather than beauty in art (i.e. for Assyrian and Egyptian ideals rather than Greek) should come from Socialists, foreigners, and Jews. Jacob Epstein's name proclaims his nationality . . .' And Epstein was, after all, both a Jew and a foreigner. But then, the overt sexuality and imagination of the work, so true to Hudson's theme and captured by Epstein in the purity of Portland stone, portrayed to the emotionally inhibited guardians of English good taste nothing less than pornographic filth. Dicksee's assertion that it was 'necessary in the interests of clean and healthy art to have *Rima* removed' was of a kind that filled the letters which swamped newspapers: 'The general public know that *Rima* is hideous, unnatural, un-English, and essentially unhealthy . . .' (to the *Morning Post*, 24 November 1925).

Really, Epstein's horrific experiences boil down to something very simple: in general, the English were against art and the Jews; anyone might assume they hated both.

Epstein was unmoved by aesthetic criticisms of his conception and its carving; he knew his material, and his judgement of the scale of the detail, seen from thirty yards, was exact; the sculpture's cool white simplicity, mysteriously ethereal and in no way damaged by weather

over time, still looks as fresh as if the relief had just been revealed. Some words in the *Spectator* (30 May) shortly after it was unveiled could serve as a suitable inscription: 'We shall be surprised if this work is not in future reckoned among the finest examples in British art of direct carving in stone and become known, as it is sure to be, all over the world.' To this would be added the sculptor's name, up to now omitted.

There is one last, strange twist to this remarkable story. On 13 June 1925, a letter from Mr Leonard Noble to one of the papers pointed to a fact 'that no one seems to have noticed in the voluminous correspondence' caused by the work. He didn't like it, but that wasn't the reason for writing.'Quite apart from the appalling horror of the Epstein plaque, the whole affair seems to miss the point from the birds' point of view.' For how, he asked, do birds reach water that is 6″ deep from a kerb 6″ above it? Right at the beginning, the design of the pool had been questioned; then, in the anxiety to get the sculpture accepted by the OoW, it had been left, to be taken up later. It was, however, never taken up, and apparently both architects and committee members never gave another thought to the birds' urgent needs and pleasures of washing and drinking. Since Hudson's first love was birds, their requirements were as important to the memorial as respect for Hudson and *Rima* were.

If Mr Noble's letter was noticed, no action was taken. The defect could easily have been rectified, yet it was not. Hudson would have found it difficult to forgive the committee for that. And, as though in an admission of failure, the ornamental pools (for this is all they were) now often lie derelict, without water, covered in leaves and backed up by one of the most extraordinary, as well as one of the most beautiful, pieces of sculpture in the country today.

9

New York City

On 28 July 1924, four weeks after the birth of Kathleen Garman's son, Theodore, news came of John Quinn's death. One person who was deeply upset to hear of this was Lady Gregory – for her, America *was* Quinn, and the country would be an empty place without him, she wrote in the twenty-eighth volume of her diary at Coole Park: 'the children will miss his Christmas apples . . .' The same could hardly be said of Epstein's feelings: although he had been a great patron, had built up his collection in little more than ten years, had been honoured by the French with the Légion d'honneur (he bought some fine examples of Picasso, Matisse, Derain and Seurat), and had supported Epstein in his troubles during the war, there had been little contact between them since some correspondence at the end of 1919 about the possibility of holding an exhibition in New York, and practically none at all since the rumours going the rounds, a couple of years later, about Quinn's intention to sell his English collection. Then, in November 1923, Epstein heard that Quinn didn't want the granite *Madonna and Child*: he had never cared for it and, more to the point, it was so heavy that, like the *Venus*, the effort of getting it up to his apartment proved an impossibility. And so Epstein asked his brother Louis to take it – he could throw it into the Hudson if he liked, Epstein told him. Following the transfer, however, there was an argument: Quinn gave Louis confusing information about the cost of carting round the work, and the moulder who brought it hadn't the means to position it and had to take it on to a warehouse; the whole transaction cost $40 instead of the $25 Quinn had estimated. This might seem a small thing, but it was enough to spark

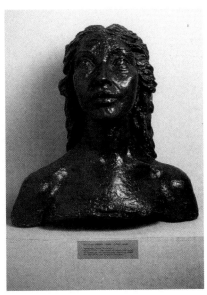

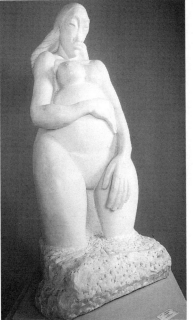

15. *Above left:* Kathleen Garman in 1921, aged twenty, when she met Epstein.

16. *Above right: Kathleen Garman,* 1921, the first of seven studies of his most famous model: 'The basis of the likeness lies in the shape of the skull and in the bony structure of the face' – Epstein in conversation with Arnold Haskell.

17. *Left: Genesis,* Serravezza marble, the subject of virulent attack from press and critics alike when shown at the Leicester Galleries, February 1931; now at Whitfield Gallery, Manchester: 'He has captured the feelings of a pregnant woman in a way that no person could ever have imagined' – Mrs Williams, a visitor to the exhibition.

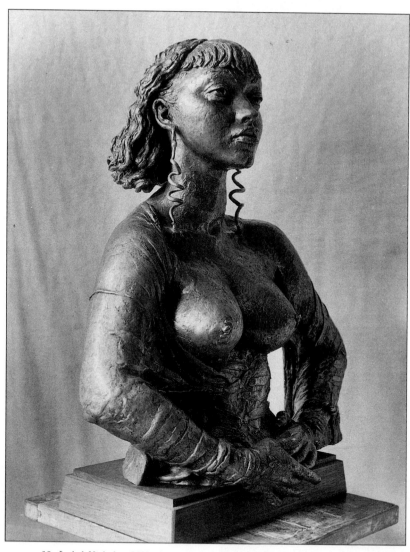

18. *Isabel Nicholas*, 1933, the second study Epstein made of this very gifted young artist, and among the greatest of his creations.

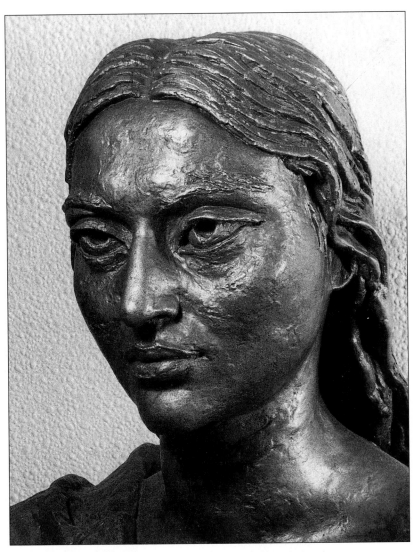

19. *Sunita*, 1927: the head of a model whom many described as the most beautiful woman they had ever seen. Together with the head of her son Enver, this work forms part of the Garman Ryan Collection, Walsall; the *Madonna and Child* group itself was bought by Sally Fortune Ryan from the Ferargil Gallery in 1927 and given to the new Riverside Church, Riverside Drive, completed 1930.

20. Entrance Hall, 18 Hyde Park Gate. Left of the staircase, the studio with *Ecce Homo* filling the doorway; on the sideboard, right, the bust of *Morna*, modelled in 1936 and daughter of Judge Sir Lewis Stuart.

21. Epstein carving *Adam*, early 1939.

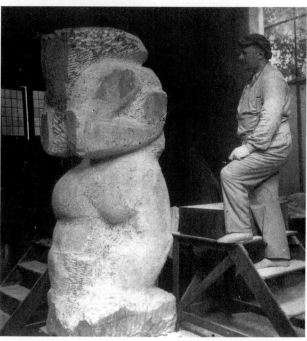

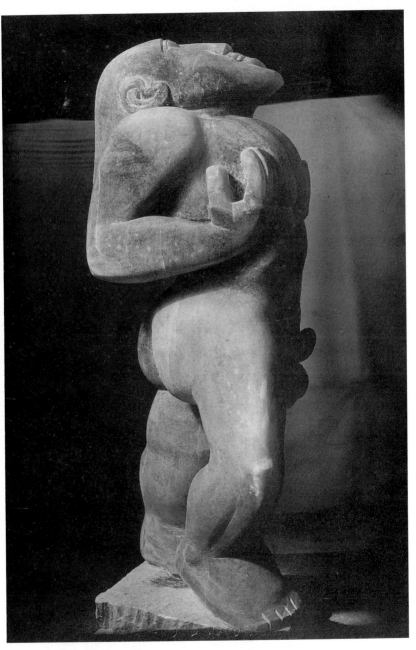

22. *Adam* was so powerful it appeared to silence the critics.
However, after being shown in Blackpool sideshows, exploited for
sheer sensationalism, and having toured America and elsewhere, it
was bought from Louis Tussauds by Lord Harewood in 1961.

23. The door handles Epstein made as a gift to the Convent of the Holy Child Jesus (now Theology College, University of London) in Cavendish Square. Clockwise from top left: Peter, Ian Hornstein, Isobel Hughes, Annabel Freud.

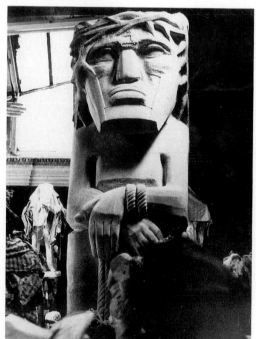

24. *Ecce Homo:* 'Squat, square, the totem of our crimes, he stands before us in a pitiless, blinding light' – Laurie Lee.

25. Epstein and Kathleen beside *Ecce Homo*, 1948.

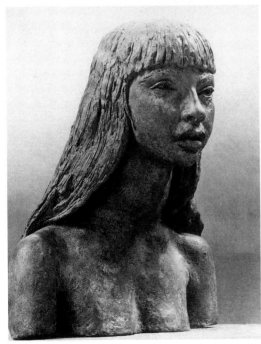

26. *Esther Garman*, 1944, aged fifteen. One of his finest works of which Epstein said, 'I could not have done it better.'

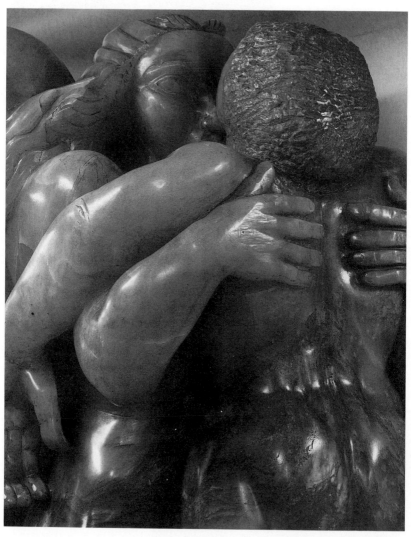

27. *Jacob and the Angel*, 1941, alabaster: detail.

off a row that ended with Quinn threatening Louis with a lawsuit. If Louis felt he had been cheated, the dispute would have angered Epstein – here was another example of Quinn's meanness: after all, the transport was his responsibility since it was he who wanted the sculpture removed.

Far more serious, though, was Quinn's decision to send twenty-three Epsteins, his entire collection, to the New York Scott & Fowler Gallery's exhibition in April 1924; they were for sale, and this, coming on top of the granite affair, would have profoundly upset Epstein. Since Quinn took decisions of this kind without even informing the artists (he admitted that Epstein, like John, Lewis and others, would be stunned by the news), the shock was bound to have caused considerable anger. As it happened, Quinn withdrew six pieces from the sale room (the bust of Meum was one), but the remainder were sold by the end of 1924, either in New York or through the Independent Gallery in London. Not unreasonably, perhaps, Epstein would have received news of Quinn's death with little interest. As for the granite sculpture, its whereabouts in America remains a mystery.

The following year, possibly in the middle of the furore over *Rima*, Epstein met Sunita, a young, tall Indian girl from Kashmir with a big, noble head and a taste for alcohol; her married name was Peerboy and she had left her husband and run away to England with her little son, Enver, and younger sister, Anita Patel (who had also left her husband); they had joined a troupe of magicians called the Maysculine Brothers, and Sunita's most remarkable act involved sitting in a glass tank completely immersed in water for five minutes or so, a trick performed with the aid of a translucent macaroni tube. Another sideline in survival was a stall for the sale of erotic objects which the sisters set up at the Wembley International Exhibition. It was here, according to one source, that Epstein came across Sunita, although it seems more likely that she was introduced to him by his great friend Matthew Smith, who had made a pencil drawing of her dated 1924, and whose girl-friend she is rumoured to have been. Epstein found her irresistible: she had the structure, the high cheek-bones, the contemplative, remote eastern dignity – and, yes, the maternal calm – which he was constantly seeking in models, and which never failed to captivate him. He claimed she was the most beautiful woman he had ever seen ('in the world' according to Dolores, though this may have been one of her many exaggerations), and, with another of his sudden decisions, he promptly invited the three

of them to live at Guilford Street. Dolores had left by then (she had found Mrs Epstein's generous presents and over-attentiveness, designed to make her stay in the house, too much of a good thing); Sunita and her sister needed a reliable roof over their heads, and Epstein couldn't wait to explore the sculptural opportunities of his latest find. Mrs Epstein was delighted, naturally: where Dolores had failed, here were two very attractive girls – if not as beautiful as her sister, Anita was certainly pretty – who might so distract her husband that they would sabotage his continuing, passionate love affair with Kathleen, and so put an end to the two or three nights a week he spent at Regent Square. But whatever kind of relationship he had with Sunita, it had no such effect, as his wife was shortly to discover.

And so began the Sunita phase, as obsessive as any he had with a model before – Nan, Meum, Kathleen or Dolores. There were four portraits of Sunita, one of Enver, and one of Anita; one of Sunita, lying down, three-quarters-length, and one of mother and son, his first *Madonna and Child*. He made scores of drawings of Sunita in pencil, watercolour and charcoal, many of Anita, nearly a hundred of Sunita and Enver, and as many of Sunita and her sister – all the work of six years up to 1931. While his second bust of Sunita was the most sublime piece of the phase (although the third runs this close), the best memorial to it is, probably, the *Madonna and Child*. Sunita was, Epstein said, that 'eternal Oriental type' which seemed to him right for a work of a religious nature. Sunita was most struck by the *Madonna*; perhaps she recognized something divine in it that lay outside herself, he thought, because she remarked that she couldn't 'look so good' as he had made her. For she was hardly a 'Madonna' by nature, being a heavy drinker, and often found inside pubs while her son hung about outside, as Epstein told Kathleen in a letter from America. The group was never quite finished because Enver preferred to be with Peggy-Jean – who had at last found a playmate – and was impossibly restless. But Epstein was satisfied: it had both the complexity and scale for the kind of cathedral setting he had intended it for, and this wish at least was fulfilled. Epstein recalled:

While the bronze was still at the foundry Lord Duveen asked me if I could see it and we motored to the workshop in Fulham. Looking at the work he turned to me and said: 'If you had in mind to do a Madonna and Child, why did you not choose a beautiful model?' I was

so astonished at this reception of the work that I turned away from him in disgust. This action as to what constituted beauty was typical of him. On one occasion I heard him say that had he not thought in his youth that Rembrandt's people were ugly, he would have made many more millions of money in his lifetime.

For one of the most influential collectors of his century, his remarks about Sunita and 'Rembrandt's people' were indeed extraordinary, suggesting that he was, in reality, visually blind. However, the story of the *Madonna and Child* did indeed end well: a copy was given to the Riverside Church on Manhattan's West Side by Sally Fortune Ryan, a New York sculptor who had come under the influence of Epstein's work. The connection with this enthusiastic admirer, going back a very long way to her millionaire father as Quinn's first and most important client when he set up as a lawyer at the beginning of the century, eventually led, after Epstein's death, to the creation of the unique Garman Ryan Collection which, in the Seventies, was given to the Borough of Walsall, a Victorian industrial centre on the edge of Birmingham and not far from Oakswell Hall where Kathleen Garman grew up.

James Feibleman remembered the Indian sisters and Sunita's little boy well. He was a philosophy student from New Orleans who was busy trying to write avant-garde poetry after the style of Pound and Eliot, and walked in and out of Epstein's life for a few years after 1926 when, like many Americans with wealthy parents, he was doing the grand tour of European culture: as Epstein explained with his usual simplicity, 'American artists made frequent trips to Paris and absorbed the very latest "ism" long before the English artists did, though they were much nearer.' Feibleman had other ideas, however. What was it that really drove artists abroad in the Twenties, and why the rush to seek in Europe the things that couldn't be found at home? – Feibleman asked these questions himself. He put the reason down to the alienation of the artist by the machine: that the combined effect of mass-production and its corollary in turning America into a highly successful trading nation promoted business, conformity and efficiency to such a degree that man's characteristics had to resemble 'the interchangeable parts of a product of the power tool' he said, adding that the 'first naïve impact of the technology of industrialization was to have its meaning applied, without proper intermediation, to everything'. Thus industrialist and

artist were set against each other, with the artists escaping to Europe to find a more sympathetic scale of values. Feibleman's view of uniformity would have endeared him to Epstein, however clumsily expressed when only twenty-one: as *Rock-Drill* demonstrated, Epstein's horror of mechanization was as great as his faith in truth to life.

Feibleman, who was slipping back and forth between various continental cites and London, and was accompanied by David Cohn, an employee in his father's department store, for a 'bodyguard', had the luck to be taken to meet Epstein at Guilford Street by the writer of a series on European artists for an American magazine. What Epstein made of Cohn isn't that difficult to guess, judging by the name he gave him for the amusement of Peggy-Jean – he called him 'the gangster', largely on account of the fat cigars he smoked (not a bad shot in the dark as it turned out, for, after later doing a head of him commissioned by the Feiblemans, 'the gangster' was fired for trying to get control of the family business). But Epstein liked the young philosopher: Epstein was, Feibleman said, friendly, hospitable and relaxed, gave them tea and took them on a trip round his studio. He was, of course, in the middle of another feverishly productive phase of which the massive studies of Sunita, Enver and Anita were only a part. Between 1925 and the end of 1926 he completed nearly twenty works. The first *Ramsay MacDonald* was one of these (the second, in 1934, was when he was Prime Minister). *Rabindranath Tagore* was another, a telling portrait that was more a 'beard' than a 'bust' of this hairy Bengali writer and poet awarded the Nobel in 1913; a person, with his following of millions, who was a bestseller and cult-figure of the Twenties, whom Epstein found distasteful for his conceit. As good as any of the period, however, was *The Visitation*, a lifesize figure of a woman with her hands raised, and which has, with the strongly modelled folds of a long dress, a distinct affinity with medieval cathedral sculpture – Gislebertus's, perhaps, at Autun. It was carried out in the hut at Baldwin's Hill and shown at another highly successful exhibition of his sculpture at the Leicester Galleries in June – 'it was a sell-out', Feibleman said. Epstein called this particular piece *A Study* to avoid controversy stirred up by any reference to a religious subject, a device which worked: there was no outcry and it was given to the Tate by another artist, Richard Wyndham, who bought it with the sales from an exhibition he himself was holding. George Barnard, Epstein's old teacher from the Arts League, passing through London, said he could arrange for it to be

taken by the MET, and wished Epstein (whose own preference for its siting was among the trees of Epping Forest, on a knoll in Monk Wood overlooking his favourite pond) would return to New York. It was a place of opportunity, he told him, he could assist him on a commission for a 'great Memorial Arch', a suggestion that was out of the question: they were, Epstein said, 'poles apart in conception and execution'. Yet that was not the only reason why the offer was an impossibility: a month after the exhibition closed in July, Kathleen Garman had their second baby, this time a girl – Kitty.

'He makes a significant first impression because of his quickness, the warmth and sympathy he exudes,' Feibleman recalled in his autobiography, 'and his sheer physical size' – a reference to his breadth, and to the strength of his arms and hands, for Epstein was not tall like Feibleman. He was particularly struck by the artist's singularly sharp, visual wit and his refreshing originality, the combination of which could penetrate some corner of life that normally passed unnoticed. He liked a remark made about the bust of Stephen Tennant just completed – that since it was to be put in a silver room, he had it cast in golden bronze; that this would look 'wonderful' in the setting. His eye for visual things was remarkable, like his wit, both arising from intelligence – 'Epstein', he said, 'had a genius for understanding abstract ideas.' Similarly with his conversation: 'He was a brilliant conversationalist.' His immense experience partly accounted for that, stretching from the Henry Street Settlement days to Paris and the artists, collectors and dealers he had known, but was also partly due to his extraordinary general knowledge, much of it picked up from continuous reading. 'He had a good friend who was a second-hand bookseller,' Feibleman said. 'Mrs Epstein would buy a pile of books from him and put them by his bed. He would read them indiscriminately, then send her out for more. His head was filled with bits of information. The books could be almost anything – novels by D. H. Lawrence, poems by De la Mare, textbooks on entomology, histories of the Chinese people ...' If the conversation turned on something he was unfamiliar with, he was silent and attentive; otherwise, it was clear he understood what he was talking about, however abstruse the subject. But he could be cutting: when Shaw had defended *Rima*, Epstein said he was in search of publicity and 'simply trying to get his name in the papers'.

Feibleman's picture of Epstein's haphazard reading-matter was drawn

from the memories of frequent visits to Guilford Street. He was indeed a voracious reader: in addition to Mrs Epstein's selection of books, there were several vast, leather-bound volumes of the Bible in different parts of the house which he studied whenever he had a moment – 'there's always something to be found in it that's new,' he would say; and Mrs Epstein sometimes read poetry to him ('reading him to sleep like a mother with a child', was Peggy-Jean's memory of these interludes), or Maupassant, Molière, Baudelaire, Zola and others in French, Epstein's daughter hazily hearing her, and their conversations, deep into the night from her cot in its unusual position at the foot of their bed. Cecil Gray, Feibleman and Arnold Haskell were among those who testified to Mrs Epstein being a knowledgeable and cultivated woman. All liked her: Feibleman found her interesting and very intelligent, and witnessed Epstein's care to see that she was never excluded in conversation – if guests did exclude her, they were never invited back. He was as protective towards her as she was towards him. Indeed, her maternal presence was, so long as she could remain detached from her jealousy of Kathleen, like a sedative for one so overwhelmed by stress. For instance, in September 1926, he had been treated to some very crude insults from Lord Wavertree, an ex-army colonel whose father, in the Walker family name, founded the Liverpool Art Gallery, when opening the autumn exhibition. Epstein had been invited to send examples of his work, and had responded generously with two pieces he considered good – a bust of his wife and another of Anita Patel. 'I have no doubt,' Wavertree told the assembled company, 'that Mr Epstein has done his best, but, after all, even the poorest artist could have done better if he had submitted his worst.' This gratuitous insult, from a man who bred racehorses and knew not a thing of art, was an example of English boorishness at its most adolescent: Epstein, infuriated, ordered the removal of his work, and only relented when persuaded to do so by a local alderman – he, 'greatly distressed', ignored Wavertree and claimed they were 'a valued feature' of the exhibition. Wavertree, of course, never apologized, inserting instead an advertisement in *The Times* thanking all those who had written to congratulate him on his honesty. As Epstein said, the damage was done: an attack from a 'noble lord' was bound to receive widespread coverage in 'the bullying newspapers', and once that happened, architects and public bodies would not give commissions if such publicity convinced them that the artist was 'unsafe or dangerous'. The combination of ignoramuses like Wavertree and the 'bullying' press could destroy an artist's livelihood by libelling him with impunity.

For many, that attack would be enough for one year. In the background, however, there was Kathleen and her babies – another family to support; and Kathleen was unwell, so unwell that her mother had taken Kitty to the country to look after her there. Yet Epstein showed no outward signs of anxiety at his Guilford Street house which was Feibleman's idea of the epicentre of English bohemia: 'It was a confusion of eccentrics, hero-worshippers, models, critics and buyers. And through this tempest Epstein always walked calmly, as though the madness was none of his making, the people none of his seeking, and himself the most conventional of men.' This was life in the four-storey Georgian house. Besides admirers like Bone and Matthew Smith, there were the models roaming round – Enver, the Indian girls, Oriel Ross (the clergyman's daughter of whom Epstein did three portraits during the months she was living there), Daisy Dunn from the all-black cast of the avant-garde musical hit on Broadway, *Blackbirds* (then the rage of London), Zeda, a Turkish girl, and Selina Pugh, the faithful Italian charlady who had sat for Epstein while looking after Peggy-Jean as a baby. Feibleman also met the model for the *Weeping Woman*, Dolores: the most talked about artist in the country had a full house.

With the responsibility of two families and his deepening passion for his increasingly costly art collection (he was buying pre-Columbian, Sumerian and Indian pieces in the late Twenties), anxiety over money was ever present, and he had written to Feibleman, who was in southern France, to find out when he was coming to London; and when he finally arrived, passing through on his way to catch a boat for the States, Epstein told him about another problem – the Polish Government, who had commissioned the portrait of Conrad (a fact that went unmentioned in Epstein's autobiography), had never paid the $2,500 fee due, and he could see no likelihood of its ever doing so. Feibleman seized his chance: Could he buy it? Surprisingly, Epstein agreed, and to halving the fee, provided he could have the money in cash. There was very little time – the bank would be closed in minutes and he had to catch an early train the next day to get the boat. 'I just made it to the bank,' Feibleman said, 'and drew out the cash. The head was mine.'

When Epstein returned to America in the autumn of 1927 to give an exhibition in New York, it wasn't a happy time for all concerned; it made Kathleen particularly unhappy; she was left behind with Theo, and was afraid he would never return – after all, it was his birthplace

and he had taken his wife and daughter with him. But it was unhappy for him, too, because he missed her, wrote continually and longed for her letters; and not an easy time for Mrs Epstein, either – she knew from his excessive restlessness that he wanted to be back with Kathleen, and she, of course, passed on her anxiety to Peggy-Jean, then nine years old. 'I was the only person she could confide in,' Peggy-Jean said. 'We must, my mother told me, do all we can to restrain him, and make him stay in New York.'

They arrived there on 1 October after a journey Epstein found thoroughly unpalatable. He wrote to Kathleen:

The whole idea of the ship was to make the passengers believe they were not on a great ocean one but in a magnificent hotel so that in the dining salon even the portholes at the sides of the vessel were disfigured with painted windows of papier-mâché and real curtains. Everywhere one heard only talk of dollars, a million dollars, and there was a great display of diamonds and ugly Paris jewellery . . .

Then, when the liner had barely docked, he was besieged with reporters – what was his attitude to Zionism, had he come to debunk sculpture? Not an auspicious start to his first exhibition in America. It was to be held at the Ferargil Gallery on West 47th Street: his latest, young and ardent admirer, Feibleman, had arranged it with the help of a friend, and by chance it coincided with another in England at the Ruskin Gallery in Birmingham. The exhibition was, however, wracked with problems from the start. Many English artists made a habit of going over there, but because this was his first visit (apart from the fleeting one after leaving Paris) for twenty-five years, it caused a commotion in the art world. Not only Kathleen thought he was off for good: 'So you are going to America,' Lord Duveen said. 'Do not let it be thought that you are leaving England because of dissatisfaction with the manner in which you are received here.' And James Bone, now London editor of the *Manchester Guardian*, wrote, 'England has been a bad stepmother to him.' That sounded final enough. Yet the truth was – and Epstein never ceased to be amazed by the fact – that anything concerning him had the greatest significance attached to it, whether it was an exhibition, a commission or the discovery of a model. His private affairs were matters for public discussion, and the rumour that he might be emigrating would have made headlines. Of course there was no truth in it: while

Mrs Epstein hoped their stay in New York would be long enough for him to break with Kathleen, his thoughts were fixed on his eventual return to her and England. He had the idea at one point of her joining him out there, but that was impossible, and she refused. At least he imagined he would be back by Christmas, though; as events turned out, however, he didn't leave until well into the New Year: on arrival he found that the opening had been postponed for a month.

The excitement and anticipation of an exhibition in his home town drained away at this news: 'I felt, that first night in New York, thoroughly downhearted.' Mrs Epstein might have welcomed the delay, but if she thought it would help her cause, she was mistaken: if anything, it strengthened Epstein's passion for Kathleen – he reacted by cabling her $15 three times in his first week; he wrote to her twice, gave her a post office address to use, had a letter from her, and then, on 13 October, cabled a further $25 towards buying the piano she very much wanted: having rented an expensive apartment (he had to take what he was offered) in West 59th Street near his old school, the Art Students League, and overlooking Central Park, these amounts were all he could afford, he said.

> I am only waiting Kitty for the day and the moment when I will see
> you again. I read and re-read your letters. I often feel that it would be
> better had I plunged into some sort of works to take my mind away
> from so much that I cannot help thinking of what passed between you
> and me. As I think of it now I know where only true happiness lies
> and when you write of us both lying in the morning with joy and fire
> still in our hearts I see all in all too well.

Then there was a further setback, the gallery and its owners: both horrified him, the gallery for being 'mid-Victorian', tawdry, and cluttered with curtains and chandeliers, the dealers for their utterly commercial attitude to art. Worse still, he was told his work had been allocated the badly-lit basement. This disaster made him turn to Kathleen; at least he could write to her and tell her what he felt; he spent his time thinking about her, 'going over the past, and every detail is beautiful.' In fact, there was little he could do except write, or wait to hear from her, for there was nowhere to work, and he had no wish to travel: 'I feel more than ever my life is with you,' he wrote on 14 October. 'I have had such bad hours that could I manage it I would

have taken a boat and come straight to 13 Regent Square and lived with you from then on. I had hardly known what I let myself in for when I planned the show and gave up my works to those damnable people.' Not only was his work to be shown in a basement – it was to be shown for a mere two weeks, and then with a one-third commission imposed. He was most annoyed: his art, the product of so much effort, was being treated as just another quick job in the annual turnover. And he was sure, too, that if the show was not a success, he would be left with all the bills for it, as a Spanish artist had been. After the tremendous expense of shipping over fifty bronzes, among which was the large *Madonna and Child*, the shock of this treatment left him appalled. But there were further difficulties that made him wish he had never come to waste time, effort and earnings on a venture packed with frustrations. The firm's head, who was like a bartender and fancied himself as an art critic, insisted that a preface to the exhibition was absolutely necessary; he wrote it himself, and it was so bad that Epstein rejected it out of hand, a further cause of tension between him and the dealers. Feeling worsened again when they told him that they expected the show to go on tour of a multitude of cities and towns round the States; he put his foot down about that, too, picturing what might become of his works – they might be stolen or damaged: an American artist had told him that her work had gone on tour years before and had vanished. Then a girl, hired at his expense for publicity purposes, had to be dispensed with by him; this, again, made him most unpopular with his dealers. Finally, there was another piece of news which shattered him: when he visited his family, he discovered that his collection of Hester Street drawings he had left with his mother had been destroyed by his father after she had died. He didn't mention this bombshell to Kathleen, a personal betrayal of the kind that can break the heart: one way or another, his sense of loss must have been as vast as the Atlantic is wide.

Things took a turn for the better after a little. Long before the opening, various cities wanted to exhibit any works that remained unsold, Chicago among them. Then, the Brooklyn Museum bought *Selina*, and eleven other pieces were snapped up. And he had been approached for portraits – if he accepted these commissions, he told Kathleen in his letter of 22 October,

> I'd be condemned for the rest of my life to do the faces of American professors and business men. Curiously enough, no women wanted

their busts, only men, and what I truly dislike most is the type of
academic professor here; they swarm in thousands and my entire time
could be taken up with these dull fellows if I let them: they want to
talk about art and its relation to everything under the sun . . .

However boring, these people had their uses; Epstein's obvious
importance as an international figure, and his pre-show successes,
impressed his commercially-minded dealers. And when he had offers to
move to other, better galleries, he and Feibleman (who had come up
from New Orleans with Cohn intending to see he had a fair deal)
managed, for the time being, to force new terms: the exhibition was now
to be in the upper, best room, it was to be extended for a further two
weeks in line with London practice (so giving his sculpture a chance to
sink in with a strange audience), and possibly a further four, and the
gallery's commission would be reduced to 25 per cent.

The haggles over money were most distasteful to Epstein – 'how I
wish I could get back into real life,' he wrote to Kathleen. 'I sometimes
imagine I'm in a sort of nightmare and nothing is genuine here' – but it
should have come as no surprise to him that he was as well-known in
New York as he was in London and was at once the centre of controversy:
his reputation had preceded him across the Atlantic years before this
visit. For instance, there was the Brancusi case when a tribunal at the
United States Customs Court was attempting to prove that the sculptor's
bronze 'Bird' was not the work of an artist but of a mechanic, in which
case, bought in Paris, its creator was subject to a huge export tax of 35
per cent of the value of the piece. It was not, however, an American
artist who was asked to adjudicate on the matter but Brancusi's old
friend, Epstein; and in attempting an explanation of the meaning of art,
he caused a sensation by producing a piece of stone which he said was
an Egyptian representation of a hawk dating from 3000 BC and offering
this as proof that Brancusi derived his ideas from ancient art. Unless he
had picked up the piece in New York, which is feasible, he must have
brought it with him from England. There is, of course, also the possi-
bility he had found a bit of stone that interested him (in Central Park
perhaps) and had claimed it was Egyptian: since he would have regarded
those who questioned Brancusi's art as completely ignorant, he would
have been quite capable of treating them as such. His point was that a
mechanic couldn't make a work of art, although if he did he wasn't a
mechanic but an artist. His logic was sufficiently impressive to assist

Brancusi in eventually winning the case, and his views were so widely reported that they contributed to the dealers' pre-publicity campaign surrounding his exhibition before the opening. He called this 'balderdash'; all the same, he was flattered by the long report of his evidence in the *New York Evening Post*, sending a cutting to Kathleen.

There seems little doubt that he didn't like much that he found in America. He had the gravest suspicions of his dealers and was already certain he would have to delay his return for two weeks after the show closed to 'wrest my earnings out of this confounded set of crooks I've got into,' he informed Kathleen. 'From what I've seen of the manager of the gallery, he is entirely untrustworthy, a confirmed boozer, and only looks at dealing in works of art as an easy method of earning a good living by exploiting artists. Not unusual in dealers but he seems to be the perfect type.' He could see he would have to use a lawyer – another expense – to force the partners to pay what they owed him, 'that is, if they have anything with which to pay out.' Then there was New York itself: that had changed utterly – the docks along the Lower East and West Sides, the wooden piers jutting into the Hudson, life in the Bowery; all this had been wiped out. The ancient warehouses were gone 'with their strange spicy smells, the ship chandler shops with their heaps of cordage and tackle. From the wooden piers, I used to be able to study every kind of ocean-going vessel, even great three-masters with their long bowsprits sticking out over the cobbled docks'. All were gone, much of the downtown area replaced with modern America. Among the high-rise canyons of streets, there was the crenellated crown of the neo-Gothic Woolworth skyscraper, and north of that the huge avenues of the city's grid were complete, most of the gaps between the nineteenth-century Dutch quarters were filled in, and Central Park, surrounded with mammoth apartment blocks, had become the reality of Olmstead's vision: a marvellously modelled landscape work in grass mounds, sudden dips and huge masses of foliage. This was Epstein's greatest source of pleasure. It was here, on lonely walks, or rowing on the lake when no one was about, that he read Kathleen's letters; and wrote back to her.

His anxiety was plain in the letters he wrote, in his repeated promises to return as soon as possible, in the explicit doubts and suspicions sparked off by a temporary separation in a passionate love affair. Her doubts brought his expressions of reassurance: 'There is much that is ugly here and it *isn't my idea to stay here*.' His first reactions to America, coloured by lovesickness, were frankly expressed, as if to

remind her that he didn't want to be there: 'There is a remarkable phenomenon now that almost every other man imagines he has "genius". I listen to terrible commonplaces, platitudes given out solemnly, and I feel like solitude. Oh to be with you in our small room together happy, always happy.' And there were suspicions of his own which he could never keep to himself: 'Your curious little note about the Gargoyle makes me wonder. Now you had to wait until I left London before you could be taken to see such interesting places and I wonder who took you back to your place despite the fact you didn't dance. I never danced with you at a club . . .' The Gargoyle, opened two years before by David Tennant, the brother of Stephen of whom he had made a portrait, was already a fashionable haunt in Soho for bohemians of the smart art set, and the mention of it must have stirred feelings of intense anxiety and of imagined threats to their relationship. His fears are revealed again when he wrote: 'Don't think darling there can be an American sweetheart for me; my girl my sweetheart is in London. Kitty I love you as you've always known dearly . . .' Then there was the nagging worry that his wife might discover the address where Kathleen's letters went, and take them, so he changed it to an American Express office on 5th Avenue: even thousands of miles away, a minefield of problems remained. Stress made him dislike every aspect of the trip: 'Everything is done with noise over here. My family were terrible and ready to tear each other to pieces over me'; the New York Paris set lived 'in a superior world of their own' akin to London's 'Bloomsbury Highbrows', and were followed around by the 'French bred' critics; the city monuments were as appalling as the English nonentities. Nevertheless, there were redeeming features – Epstein admitted this, and was quick to believe that his old friend Dr Oko, who was in town, would manage to get a group together to buy the *Madonna* for the Museum of Modern Art as he claimed he would. It might be a country where 'humbugs of all sorts abound', and everyone had to 'talk talk' (no matter what about) until he was talked 'to death', but there was enthusiasm outside the boring, smart art circles: 'I think I will find a generous acceptance here and not the niggardly and grudging patronage I've had in England.' He was delighted that work had sold privately before the opening (and celebrated by promptly cabling $55 to Kathleen), and pleased that there was to be an exhibition at an excellent gallery in Chicago (he promised her he wouldn't attend that). However, the disappointments and frustrations continued: things seldom matched his over-optimistic expectations. On 18 November he wrote:

I will say the exhibition looks well, although I haven't had one single happy hour over it. There was a disgraceful scene on Saturday night when I was placing the things and The Tipsy gallery man raised many a laugh with his assistants including two negros. I am getting to hate this country and all its crude ways . . .

Then both Feibleman and Oko let him down: Feibleman was simply too young to be a match for sophisticated dealers and went home having, Epstein told Kathleen, 'done nothing for the show'; in the end, he had to use a lawyer, but did not, after all, get his extension of time. Oko failed in his bid to sell the *Madonna and Child*, and he left New York, too.

Although there were other problems, the Sunday opening was sensational; or so he heard, since he didn't, as he put it, 'show up' for the private view – the idea of it was embarrassing. Afterwards, he realized his mistake. While he thought, naïvely, the works should speak for themselves, it was pointed out Americans want to see *you*. However, the next day, when he did go, he found a bunch of 'fresh red roses' Kathleen had sent to the gallery ('It must have cost you something to send them: the surprise of getting them was delightful'); this surprise was absolutely in character with Kathleen – her passion was flowers; loved arranging them, and giving them, but what Mrs Epstein thought about the astonishing present from London remains a mystery. Perhaps she didn't notice them for crowds: so great were these in the first week that many were unable to get through the entrance and were turned away. Hardly surprisingly, he was absolutely amazed that his reputation had carried across the Atlantic at all, and then on such a scale that it reached the mass of ordinary people. He was that singular thing – the universal artist who was either loved or hated. At first there were no reviews – notices were never admitted during the week. 'The newspapers here,' he wrote (18 November), 'only print news of murders, local politics, football games, prize results and finance during weekdays, and Sundays is left for art and literature.' He was convinced an anti-Epstein set existed – these were 'the decorative sculptors, stylists and abstractionists of all kinds.' He believed, too, that he detected a note of hostility in a weekly column headed 'Epstein has come home to roost' in the *New Yorker* during the show that was started off by his desertion of his country for Europe: however, this dig also suggested that his art was bad or too modern, that the English had rejected it (for the most part

they had), and that he had returned crushed, his tail between his legs. When the Sunday papers came, the hostility was plain enough: while he was most struck by the *New Yorker* column ('I had not realized I was as important as all that'), he was disgusted by the reviews: the enormity of the crowds had 'brought on the exhibition only the scorn of the "art critics"' who found the interest of students, returning again and again to study the works, really 'offensive'. There had, he said, been 'nothing but jeers'. This enraged him, particularly the charge of 'turbulence' being levelled at the works: he experienced only a feeling of calm in the rooms.

All the same, the reviews had no effect on the popularity of the show, despite the opening of 'pleasant art' two doors away to which, of course, the critics had a chance '"to turn with relief"'; nor did they affect his personal popularity – floods of printed cards invited him to lunches and dinners at which he was the guest of honour who would address the gathering, all of which he turned down. He had been asked to show fifteen pieces at the Arts Students League, there had been more commissions offered for portraits, one of which he agreed to do: this was of John Dewey, professor of philosophy at Columbia University, and it was because his students, who brought Dewey to Epstein's apartment, were paying the £500 fee that his interest was aroused.

And after a week, *Peggy-Jean Asleep*, both *Oriels*, the *Casati* and *Meum* masks had been bought, and the *Anita* and *Senegalese* heads had gone to the Buffalo Museum on approval. Nevertheless, he was infuriated by the way his work had been treated by the press and he wrote to Kathleen, 'I wish I had given you one or two pieces, particularly the Meum mask which I think you like.' Old friends like Barnard and Manship hadn't come, Duveen, whom he'd met in the street, was too rushed selling his old masters to look in, and his one real desire was to get back to London. 'To be with you again, darling,' he wrote (22 November), 'fire to make and see the light on the bronze together. With you alone I feel life really worth living and my desire is to work and be with you.' All was far from well, though: Kathleen, not unnaturally, was finding the separation unbearable and interminable; constant delays were now compounded by the Dewey portrait. Was he going to be waylaid by other lucrative commissions? Her anxieties were mirrored in his replies: 'I know you have the hardest and perhaps with justice the most terrible thoughts about me. If I said I want to work from you, you will laugh at me and yet that is what I want to do.' Kathleen, however,

was having to apply pressure to make him return – she knew how he could become totally involved in some enterprise he might be offered – and she wouldn't have missed a suspicious tone in his reaction to the news that their old friend, Jack Kramer, had been round to see her: 'But you didn't say whether you went out to dinner or not that evening; it was left in doubt in your letter.' He went on to say that he couldn't sleep for thinking about her, was taking pills, had headaches: it wasn't difficult to make him jealous, and to want her. She made sure that he realized that future dreams were no substitute for the confirmation of the date of a return ticket, for he said, 'I'll not write again of future hopes and desires as that irritates. You think I don't live practically, or even think practically, and certainly until I am really with you again I can only send out to you what perhaps seem vain compliments and longings.'

Epstein's expenses in transporting his work, himself and his family to America were enormous: in addition, he owed money to the plaster moulders and bronze foundry, and for once, possibly on account of his wife's foresight, anticipated the tax he would have to pay on his sales. No wonder he warned Kathleen, the moment he had sized up his dealers, of likely delays at the end of his stay – it was difficult to settle on a date of departure when he had to make sure that every dime owed by the Ferargil was paid. Since this was so, he reckoned he would have time on his hands that could be well used by carrying out the Dewey portrait, a commission that would help to cover his costs. But no wonder, too, that Kathleen was distraught: she was young and in love; a visit, which Epstein had found irresistible, had torn them apart, and no matter how many letters Epstein wrote, or cables he sent, expressing his longing for her, she was so desperate to have him back, so fearful she might lose him to another, that all the justifiable reasons he gave her for the delays built up in her mind as an intolerable language of excuses, barriers and even lies. These thoughts were conveyed to him at the beginning of January 1928, deeply hurting him: 'I have two letters from you,' he wrote back (8 January), 'one in which you fairly accuse me of living for nothing but money and thinking of nothing but this. My gains here are nothing to boast of.' And he went on: 'Our bitternesses I know come from too intense and unsatisfied love. I have only felt once before in my life as wretched and chained up as I have here and that was when I was in the army. As things are now I feel I am escaping from a life I don't want to lead to one I do.' In the meantime, while

writing, he had received another letter and three cables in which she said a date he had given for his return was the 'best news'.

It is possible, of course, that he took advantage of any opportunity to make some money in the States because he had no major commission in view, and was worried. He told Kathleen that he wanted to work from her – 'How I would love to work from you,' he insisted. 'You know sweetheart as well as I do that my things in important instances are suggested by you and were I really free to do them I would have worked from you. The figure at the Tate' – he was referring to *The Visitation* – 'was entirely suggested by you and there are many things in my mind that had I you for a model I know I would accomplish: fine things. Why do I write of this when you know it so well in your heart and I've never confessed to it. Do not think of me always in the manner in which you write bitterly and accusingly.' These assurances of her importance to him as an artist and source of inspiration suggest that she was tormented by feelings of being an outsider, brought on, not without reason, by both the separation and the fact he was with his wife and daughter. While she felt this, any slight hint of the presence of some other man made him violently jealous and determined to leave as soon as possible. For example, Kathleen made a point of informing him that her sister, Helen, wanted her to put up a Russian friend in her studio. Why should she ask you to do that? he asked.

> Does she imagine you would like to see him toasting his toes in front of your fire? In our place shall I say. I don't want to carry the picture further. The place is yours only and you will have whom you please. I am preparing to leave and haste the day of my leaving. There are so many things to say to you and so many things to do – together. I love you darling.

Kathleen's ploy was an old one, and it never failed to work.

Kathleen, however, wasn't easily reassured by what he said; she was too deeply unhappy to believe him; and a further complication which confused their relationship even more was the length of time it took for letters to arrive, at least ten days: news, points taken up by one to the other, was past history when letters were read. So the love expressed in his of the 9th would have passed hers replying to a letter of his of a couple of weeks before, a factor bound to intensify misunderstandings between them. His promises to return were a matter of doubt to her, as

a sentence, which she had crossed out, revealed. Once again, three days later, he reiterated his determination to leave America as soon as possible, explaining that a number of obstacles had to be overcome to fix a date, of which Mrs Epstein may have been one, since she used any subterfuge to postpone a decision: 'Don't think I am postponing my departure from here. I don't love living like this. I am without you without whom I cannot live,' he said in his letter of 12 January. His fear of what his wife might do was revealed in the addition of an ominous PS: 'Be sure you confirm any cables that may seem doubtful that purport to come from me. Have reasons.' Yes, he was afraid his wife, so intent on destroying their relationship, might even do that – send a damaging cable in his name.

Besides his anxieties about both his wife and Kathleen, his thoughts were on other troubles as well – the tax he had to pay on his earnings before he left, the commission the gallery collected, the expense of living there: he could see he would have little left to take home. Money was again much on his mind; all kinds of things exasperated him – for some reason, the Tate Gallery had become a particular obsession. He had met a Tate 'expert' who was on a mission to study American Museums – 'I can imagine,' he wrote to Kathleen, 'that enough was spent on his trip to put several masterpieces in the Tate'; then there was Duveen's purchase of a huge sculpture he was presenting 'to the Tate to open his new sculpture hall' ('by an American mediocrity called Sterne and a flatter and more stupid piece of sculpture I never saw in my life.')

The title of it was *Awakening*, the price £3,000, and there was a replica of it in the Brooklyn Museum. Epstein was sickened: 'When I thought of how he had talked of the *Madonna and Child* I felt furious, and from now on will have nothing to do with him or his committees. He has of course studiously avoided my exhibition of sculpture here . . .'

The trouble was that Epstein's thoughts were in two places at once – London and New York: this was the major source of his anxiety and stress. His inner self, the feelings to which he gave vent in his letters, was with Kathleen, in London, while his outer self, enjoyed by friends, acquaintances, admirers and sycophants, and surveying the world about him, was undoubtedly stimulated by meeting new people and seeing the magnificence of modern Manhattan. After his show closed and his work was transferred to the Arts Students League, one suspects that he

relaxed somewhat and explored his surroundings. He had his sailing date in his sights, a lawyer to look after his affairs at the gallery and the forthcoming exhibition in Chicago, and it was during this period, about six weeks in all, that he modelled his three portraits there – Dewey's; one of Professor Franz Boaz, a naturalist and scientist; and Paul Robeson's, the celebrated singer. Although, as he said, his stay was too short to leave him with any clear picture of American art, he did see in it the depressing spectacle of academicism (that reminded him of English official art) and a misunderstanding of the thinking taken from Paris and Munich.

> There was a curious harking back to pseudo-classical sculpture, a kind of early Greek stylism; or early Greek made into table ornaments or book-props, or Renaissance motives turned into garden statues, or for fountains, or Buddhist placidness on a small decorative scale, a sort of Sunday afternoon Buddhism, I thought, something that was the equivalent in sculpture of Christian Science. I found nothing in sculpture that was native, inspired by the soil, or even the vast commercial enterprises of America. At present, perhaps, the great works like the Boulder Dam or the Panama Canal or the skyscrapers come nearest to our impression of the American soul. Sculpture has to wait.

He mentioned these thoughts to Kathleen: 'I don't think I've missed any great men here. The painters are poor and their copying French work or working in an absurd naïve manner they think is American. The sculptors are either stylized or abstract or stupidly realistic but there is no one with real sensitiveness or power.' But he was very much struck by the architecture, saying that 'the amazing skyscrapers looked wonderful'. He preferred them from the outside than from the inside, and said that New York at night made a fascinating study: underneath his apartment windows, he wrote, 'I could watch the myriad skaters glancing to and fro over the frozen ponds with piercing shouts and gaiety.' His rent might have been expensive but he was lucky with his view – that wonderful view over the romantic Central Park framed by the shadowy presences of great surrounding structures, and which can be at its most spectacular in the snow when a red sun drops down behind on a winter evening.

If Kathleen had been able to accept his trip as part of his working life as an artist, and thus something which he had to do, he might have

been able to enjoy himself more; but she couldn't do this, felt she had been deserted and rejected; she was angry, accusing him, it seems, of merely 'playing' with her. He pleaded with her, 'How I want to be with you and more than "play" with you,' in his letter of 17 January. 'Then I can imagine you saying why don't you hurry and come back or why did you go away at all? . . . You know what I mean and when I ask you how our little girl is you will say "damn his impertinence" and that you no doubt think serves me right.' She had been for a week in the country to her mother who was still looking after their daughter, but hadn't mentioned it in her letter, and that upset him deeply. He had moments of pleasure, however, cramming a lot into his last four weeks. He had found a studio where he could work and had made friends of Dewey, Paul Robeson, who was playing *The Emperor Jones*, and Carl van Vechten – Orage, whom he ran into by chance, took him along to a cocktail party where he met van Vechten and Robeson. The Dewey portrait worked out well: the sitter was sympathetic and the student whose idea it was to present the work, Joseph Rattner, not only made coffee and discussed philosophical propositions with his professor, but took the entire affair in hand, managed the committee and made sure Epstein was paid on time. Dewey seemed pleased, saying he 'felt' like the bust; his family, on the other hand, were startled by it, and his son-in-law said Epstein had made him look like a horse-dealer from Vermont (Dewey's birthplace). Once finished, he had the plaster sent, in a double case to protect it from damage, to London for casting. He couldn't insure it, the rate was so expensive.

No sooner had he finished Dewey's head than he was invited, in the second week of January, to do the portrait of Professor Boaz. That, he said, would 'fill in the time' before sailing; an urbane way of stating his great interest in this man's face which had been dreadfully scarred in duels during student days in Heidelberg, and which led to an exceptional work of sculpture. In the meantime, he had become extremely friendly with Frank Crowninshield, editor of *Vanity Fair*, who had published Quinn's long and flattering account of Epstein's art ten years before. He took to Crowninshield, and accepted invitations from him to various gatherings. It was at these affairs, unfortunately, that Epstein, to his great embarrassment, found himself picked on to make a speech when, caught unawares, he had nothing to say. Americans may have liked the spotlight on the star of the occasion, but it was the last thing Epstein wanted. He did better with Robeson, going to Harlem to see the negro

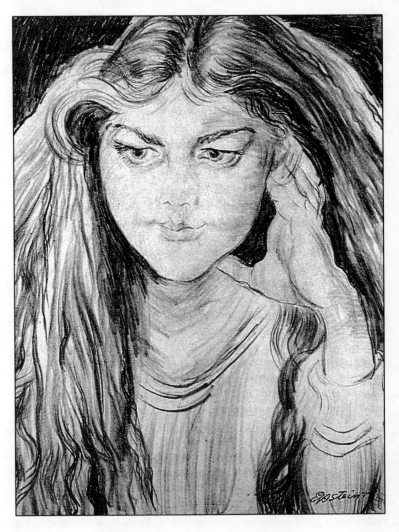

Kitty Garman, 1937, aged eleven; pencil.

dancers (he didn't think much of them) or to a club called Rita Romilly's where he met writers and artists, and where Robeson sang. Then Dewey, on 21 January, took him to Dr Albert Barnes, the famous collector in Philadelphia, where he saw his astonishing gallery of French art, a collaboration of his taste and money and Paul Guillaume's knowledge (Guillaume also advised him on the African sculpture he bought). The collection was not, at that time, internationally known, or understood nationally, for what it was. 'He has the largest collection of modern pictures in the world,' Epstein told Kathleen the day before he went. 'Good pictures – Renoirs, Cézannes.' He was excited by the prospect of meeting Barnes and promised Kathleen that he was going to tell the doctor about Matthew Smith whose show of work, on in London just then, he was sorry to miss. He asked Kathleen what she thought of it, and optimistically hoped he might be able to interest Barnes in his paintings. 'It seems to me madness not to buy paintings by Smith,' he wrote – that is, he added, if one had any money. He liked Barnes: generally regarded as boorish, he found him disarmingly courteous – he had done Epstein the honour of emptying the gallery of visitors so that he could enjoy the works in peace. He was very sensitive about his collection: if he heard facetious remarks being made (a dictaphone had been installed to record any), he had the perpetrators thrown out.

Epstein was naturally amazed by American art collections. Moments of depression – a despondent letter from Kathleen or another nasty review of his exhibition – often led him back to the MET to let a Cézanne or a Rembrandt calm him and restore his sense of well-being and balance. However, there was not much else to keep him in this museum. 'The Metropolitan is run by old fogies,' he told Kathleen. 'That seems well known. Its collection of modern sculpture is disgraceful. I've met no artists here who did not seem suspicious or businesslike. Concerning me, the most absurd reports were spread; that I came over with a press agent was one: this is because of the great attention my sculpture attracted.' Then, one Sunday, he was taken to see another collection – this time, one with Rembrandts, Titians and Rubens! – that belonged to an old man who had gone blind. The paintings were, as he said, wonderful, and some of the few pieces of sculpture – a Benvenuto Cellini, for instance – interested him, but he was shocked to hear this collector say, as though congratulating himself, that his taste stopped the year of Rembrandt's death. That taste and judgement could be limited to works of three or four hundred years of age, thus preventing

this wealthy man from buying anything later, infuriated Epstein. 'Conservatism I found as strongly entrenched in America as it is in England, or in official circles in France.' The experience at the collection of old masters prompted him to repeat the American's remark to Arnold Haskell when he was back in London. Reaching the point at which the old man said his taste had stopped, Mrs Epstein interjected, 'There was some excuse for him. He was more or less blind, wasn't he?'

'Yes, but only after 1669,' Epstein replied.

On 20 January he started his bust of Boaz, and intended to complete it four days later, he informed Kathleen (it would not, therefore, affect the date of his departure). He had just had a more cheerful letter from her in which she discussed future plans. Epstein gave up Guilford Street when he went to America and had been lent a house in St Paul's Crescent just north of the King's Cross station goods yard until he found a more permanent place to live. She had decided to move from Regent's Square, and to get a flat near him. He was thinking about finding a flat, too, and that would mean he would have his present studio in Lamb's Conduit Street to himself, and that she could come there; this seemed to be about the best solution to their unhappily inconclusive situation. 'Why didn't I meet you when I was a boy and as poor as could be,' he wrote, 'and we would have begun our life together and there would have been none of these complications that we have now and we would have been perfectly happy . . .' But this arrangement of her flat and his studio might mean the realization, he said, 'of being with you for lengths of time so that the swift happiness will have even more reality than it has now – not be so swiftly snatched away.'

He was still working on his bust of the naturalist, and had finished a 'hasty study' of Paul Robeson. Hasty it may have been, yet it was one of his best portraits. They got on extremely well together – Epstein, of course, had always admired the negro form and Robeson was greatly impressed by the artist.

I thought he was fine, just a fine human being. I'll never forget those eyes, and the way his face would break into a smile. I was pretty bad as a sitter but he, he was very kind, very patient, though he had to work in a great hurry. There was only a week to do the portrait. But he caught – more I think than I even put into the part of Emperor Jones – he caught the whole meaning and his feeling for my people. As in

everything else, he was way beyond the sitter, beyond just the personal
thing – so characteristic of him, and of his work . . .'

The trip was all but over. In his autobiography, he wrote: 'I had had my
exhibition of sculpture, I had made three portraits, and I had met
friends and enemies. It was a diversion – an interesting *démarche*.'

And to Kathleen, on 21 January: 'May this week and the following go
quickly. If I get in on the Friday night I'll be with you the following
day. Saturday night may it come with its joy.'

His final communication was sent on 23 January, four days before he
left, and it was a cable: 'Will count off each of the 18 days with joy . . .
Wait for me.'

**Kathleen's hand on
Epstein's drawn in
pencil on the back of
the Ferargil Gallery's
private-view card on
his return from New
York in February
1928.**

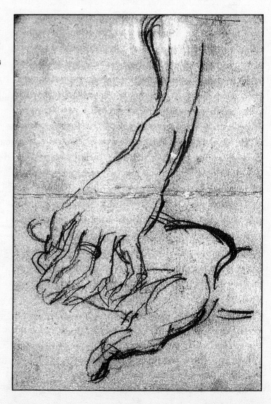

10

18 Hyde Park Gate

WHATEVER devious means Mrs Epstein employed, and there were probably many, in her persistent attempts to delay her husband's departure, a fragment of steel filing had finally put a stop to them. This blew into one of Peggy-Jean's eyes, temporarily blinding it, and they had to go back to England for her to have an operation and treatment. It was while she was recuperating that Epstein made his touchingly compassionate study of the debilitating effect of illness on one so young: he caught the limpness of children's illnesses, her arm supported by a table (a device that supported the sculpture), hands too weak to hold a pencil, in *The Sick Child*.

It was 1928; the year when Epstein's arch-adversary, Sir George Frampton, died, and when the disappearance of the last bit of John Nash's lovely Regent Street brought an end to the old Café Royal: this was demolished, and the era of the model partly went with it – at least as a central feature of artistic life when, as in the Epsteins' case, she was regarded as one of the family. The later takeover by abstract art could be said to have finished the job, but, for the time being, that loss – the loss of a unique meeting place for London's intelligentsia – made a hole in the social life that was impossible to fill: artists, writers, actors and others who had long frequented it, and who arrived en masse for special Friday evening sessions when various round tables were reserved for certain groups, had to go elsewhere. They scattered – to Fitzrovia, to their studios, to clubs and smart restaurants like the Gargoyle, the Tour Eiffel, the Ivy and Rules. Although reinstated when Regent Street's cumbersome reconstruction was completed by Frampton's friend, Sir

Reginald Blomfield, in 1930, the Café Royal was never quite the same atmospheric, disreputably delectable place again. The patina of past pleasures was no more possible to recover than the imprint of centuries after the cleaning of a building; it had become slightly respectable. For Epstein, however, 1928 was the start of a new chapter – in fact, of a series of chapters – in his life and work; it was the beginning of a rather more settled domestic phase, yet the works that followed were as bold, dramatic and experimental as any he had done before. First, on arriving back, the Epsteins stayed in Camden Town as arranged; but not for long – in the spring, they found 18 Hyde Park Gate, a house just south of Kensington Gardens, almost opposite No. 20 where Winston Churchill lived after 1945, and a few doors up from No. 22 where Sir Leslie Stephen had died in 1904, and his daughters, Vanessa (Bell) and Virginia (Woolf), grew up. It was exactly what Epstein wanted: it had five spacious floors and a very large, high studio at the back on to Queen's Gate Mews – there was plenty of room to store his work, and there was an entrance off the mews for moving heavy pieces of sculpture or stone in and out. He could give up the odd assortment of studios that were dotted around Bloomsbury and have his huge precious art collection in one spot where he could study the pieces as he liked constantly to do; and he could work in a big space at home *and* be absolutely separate, quiet and private when he wished. He could organize his life more simply, and concentrate his energies at last. The find must have been a tremendous relief.

It was a house, moreover, which had a presence of which he could be proud: unlike most mid-nineteenth-century streets in this Kensington area (Queen's Gate and Exhibition Road, for instance), many of the houses in Hyde Park Gate are curiously dissimilar. Apart from the occasional eyesore (the insensitive addition of two storeys that Leslie Stephen made to his stucco house, and some ugly flats built next to Epstein's house after he died), the road is a jumble of buildings of various heights and styles, as though each was some personal whim of its Victorian owner, and designed for that person. There may be something in this: it was true in the case of Epstein's, a house which is the odd one out among the rest. While the others have their eccentricities, they generally follow conventions of stucco, post-Regency classical taste; No. 18, in contrast, is gaunt, dark and bare; as dour as 'Scottish baronial', and with a severity which would have attracted Mrs Epstein. And it was probably she who found the house; she had found the

cottage in Baldwin's Hill, and while he had his work to do, she would have been rushing round searching for a permanent place where the family could settle down. He would have liked it, too – it was robust, a bit like a slice of one of E. R. Robson's fine Board Schools of the 1870s; functional, strong and original, without doubt the most distinctive as well as the finest building in the street; a rebel among its middle-class, wealthy-looking neighbours, it was surprisingly appropriate for the artist who inhabited it.

In fact, the flat, tall, grey-fronted house that finished at the top with the gable of a steep roof was designed in 1871 for Edward William Cooke, a painter, on part of the garden of his house next door. Apparently, Cooke, who had a smattering of architectural knowledge from working briefly for A. W. N. Pugin, had a hand in the design, sending on his ideas to Norman Shaw, who was in the middle of planning another house for him at Groombridge in Kent, for his comments. The outcome, to judge from the gable, the long and narrow first floor windows, and a touch of Dutch about the height and proportion of the building, suggests the form was determined finally by Shaw: Epstein, quite by accident, had stumbled across a house by a most remarkable architect who was responsible for a number of other houses in the neighbourhood. He had to have it but hadn't, of course, the money to buy it, and here, in contrast to his abortive efforts to get the Pett Level cottage, his apparently benevolent Irish collector and dealer in Dublin, Philip Sayers, cropped up with the amount required to cover a mortgage for the thirteen-year lease on offer. The Epsteins trusted him and his financial advice implicitly, and if there was a catch to his generosity it was that he could pick up the sculptor's work for a few pounds. This didn't bother Epstein: he had his house, perfect in every respect – it was near the park (not far from his *Rima*), near concerts at the Albert Hall, and near Green Line buses that went to Epping, dropping him and his family off at the end of Baldwin's Hill. Above all, there was plenty of space.

Below the studio there was a store for his sculpture – he had Hulme's collection of his flenite pieces among his scores of plaster casts there. A little boy named Roland Joffé, taken in many years later by Epstein when his parents vanished abroad, used to creep down very quietly for fear of surprising the *dramatis personae* from the artist's past – the eerie, dusty white heads of scientists, pianists, philosophers, children, politicians and beautiful models like Billie Gordon, Meum and Dolores

in their various poses, looking at each other or away – in case they were whispering among themselves about great days gone, the Café Royal, hours spent sitting for Epstein in the studio, visits to Paris at Easter, rows over his latest masterpieces in the press. Then, above the kitchen, overlooking the street through the bay window (not by Norman Shaw), was a large, airy room for all purposes – it was the centre of the Epsteins' family life, where they ate, had gatherings of friends and musical evenings, enjoyed their festive Christmases, and paintings of Matthew Smith's were hung, or a piece of Greek sculpture stood on the mantelpiece. Through the double glass doors, the room at the back had a formality which suggested that the influence the house had exerted had lightly touched the Epsteins' lives. Peggy-Jean's memory of Hyde Park Gate was very different to life at Guilford Street where 'there was a kind of music hall atmosphere – a music hall jamboree, the place filled with models coming and going'; rather as James Feibleman remembered it. Hyde Park Gate, on the other hand, was 'much more sedate, with classical music, famous musicians and artists coming to the house.' Her impressionistic picture of Guilford Street life may of course have been influenced by the antics of Sunita's younger sister, Anita, a dancer who, according to Feibleman's recollections of visiting there, 'rather incongruously was interested in jazz and would strike poses halfway between those of Siva and the Charleston.' When the Epsteins went to New York and gave up Guilford Street, the Indian girls had to find somewhere else. However, they were back in the Epstein household in July; Epstein's sister Susie, over in a visit that month, met them there.

She was certainly struck by what she saw of his life in London; his enjoyment at giving a big dinner for her at the Café Royal (Godfrey Phillips and his wife were among the guests); and, at Hyde Park Gate, by the immensity of his sculpture collection spread all over the house, the studio, the models (apart from Sunita and her sister, Betty Joel, the subject for Epstein's *La Belle Juive*), the cats Mrs Epstein had collected since moving in ('Margaret had cats galore,' she said), not to mention a curious Japanese 'butler'. And into this scene came well-known 'names' – Peggy-Jean was quite right: proof of that was in the Visitors' Book Mrs Epstein pushed in front of important callers. Under the influence of No. 18, she seemed to be making an effort to become somewhat conventional, despite the unconventional setting: the house book was filled with titled signatures: Sir Lewis Cohen, Sir Austen Chamberlain,

Sir Philip Sassoon, the Marquis of Reading, Lord Melchett and Viscount Rothermere are a few of the grandees who recorded their visits over the years. Rothermere had met Epstein on the boat back from America, commissioned a portrait which horrified his secretaries, and then, at a dinner he gave on board which included P. G. Wodehouse (who discussed stocks and shares throughout), made the classic remark to the sculptor, 'But Rembrandt isn't any good, is he?'

If surprised by the inhabitants of the house, these visitors to Hyde Park Gate would have been impressed by its interior – the spacious hall, the view through to the studio in the distance, and the wide, gently rising staircase to a huge half-landing, and then on to the floor above where the Epsteins slept at the back and, at the front, Mrs Epstein kept her props for Epstein's models: that was her private domain, stacked with trunks and, according to Peggy-Jean, like a lumber room. Above this floor were two more bedrooms (one was Peggy-Jean's, another was a spare), and above them, in the gable, a primitive flat with an old gas cooker and a sink: useful for models invited for a stay. While Mrs Epstein was in control of every part of the house excluding the studio and the ground floor, Epstein regarded the entire place as a shelter – for his family, for proceeding calmly with his work. Peace and privacy were essential: 'It is sometimes imagined,' he wrote, 'that I do my work in a storm of controversy' which he compared to the racket that accompanied a boxing match. 'The reality is that for long periods, thank God, I work quietly and give no heed to anything else. I do not know or care who is Prime Minister or what the London weather is like . . .' The work was everything – as long as he was working, and everything was going all right, he was perfectly happy, and he was very warm and genial in his home circle, as many would testify. The house, however, had another job to perform, as Susie had observed – it was a store for his vast art collection. Every spare corner was occupied by pieces of sculpture; his bedroom was crowded with figures and objects – Fang, Benin, Indian, Easter Island, pre-Columbian – on the floor, shelves, tables, mantelpiece, under the bed or packed away in cases: open a cupboard on a landing, and some priceless Greek, Roman or Assyrian sculpture might fall out. Yet these works were so valuable to Epstein's world that every room, case, trunk, or cupboard where they were kept was locked and personally guarded by his wife: she had a ring with at least fifty keys hooked to a belt under several layers of skirts, which jangled like a jailor's when she walked: and, for safety's sake, she had a duplicate set in a shabby

suitcase. She didn't, of course, have the keys to the studio: Epstein had these so that he could lock out intruders when he didn't want to be interrupted; Kathleen used the mews entrance when he wanted to see her, or work from her.

Visitors were astonished by the scene – how could he bear to wake in the morning and see that terrifying pair of figures, nearly six feet high, from Dutch New Guinea glaring down at him from a table by the bed: this wood carving of a man and a woman had been found by natives in the river running between the streets of a town where missionaries had thrown it. Feibleman said that the room was so crammed with pieces that all that was left in the way of a space was a path from the door to the bathroom, window and bed. He stayed at Hyde Park Gate for ten days in May 1928, while Epstein was doing a bust of him: as a reward for the New York exhibition, despite its shortcomings, he offered this for the much reduced price of $750. Feibleman was delighted, and bought a cast of the reclining study of Dolores, a mark of his pleasure at being singled out for a portrait by the world famous sculptor; and when it turned out so supremely well by Epstein's high standards he felt very flattered indeed. Years later, he spoke of it with immense pleasure – in his eighties, it was more like him than it was, he said with pride, when in his twenties: Epstein had captured his likeness through the permanence of the bone structure. Feibleman remembered the artist's intense interest in it over tea one day when arrangements for the sittings were being discussed: the accompanying clinical stare as he examined his head was something he had never seen before, and found quite alarming. Then the armature was set up, a perpendicular iron rod that was exactly aligned with the level and height of his head, and fixed in position with pellets of clay rolled to the size of matchsticks with his fingers: 'These pellets build up not to a head but to a skull. It is a little frightening to see one's own skull staring at one not four feet away. This skull is later filled out as though real flesh were being put on.' As the head evolved through this process, Epstein danced rapidly from one foot to the other as he worked in his efforts, it seemed to Feibleman, to observe sculpture and model within a single frame, simultaneously.

The sittings followed a rigid routine: Epstein was always punctilious; 10 a.m. to 1 p.m., when Mrs Epstein produced lunch; then 2 p.m. to 4 p.m., unless Epstein felt tired – if so, he knocked off at 3 p.m. For the whole of these agonizing hours sitting absolutely still, Epstein was so obsessed with his task that Feibleman felt reduced to a thing in limbo, a

three-dimensional form suspended in space. The moment the afternoon session was over, however, Epstein relaxed; back to the front room for tea with Mrs Epstein and Peggy-Jean, just in from school (tea was punctually at four every day), after which he might say he wanted to visit someone – his old friend, Matthew Smith, perhaps, or Henry Moore and his students down the road at the Royal College. 'Smith loved Epstein,' he said. 'If he admired a painting, he might easily give it to him.' Moore, another frequent visitor at the Epsteins' Saturday teas, was by contrast competitive: while interested in Epstein's astonishing collection of African art (possibly starting off Moore's giant written record of such works), he had made the extraordinary claim, three years before, that Epstein was 'only a modeller'. 'I am a carver,' he said, adding, 'I'm the best sculptor' – remarks that displayed the ignorance of someone with little experience. These teas, of course, were remembered with pleasure by Arnold Haskell who was thinking at the time of the excellent book Epstein could write about himself and the scandals over his work. Epstein, however, laughed at the thought: 'You are optimistic. But the fact remains that I am a sculptor, not a writer. I rarely even write letters now, and the idea of giving up any of my time in writing a book horrifies me. My work is there, that is enough . . .' So the proposal fell flat; but then one morning Mrs Epstein telephoned to say she was very much in favour of the plan and that he should call immediately. On this occasion Haskell suggested he could make a record of their conversations; that would produce a book in time, and save Epstein the trouble of writing it. This idea led to the epic study of Epstein's views in *The Sculptor Speaks*.

It brought Haskell to Hyde Park Gate two or three times a week over the months: the visits, he said,

were always of value because of the extraordinary mixture of people gathered round the table, beautiful exotic models, writers, painters, musicians and politicians. Epstein spoke well and with vigour on various subjects and never under any circumstances acted the celebrity. The room was always littered with interesting objects, casts of his latest works, sketches, paintings by Matthew Smith and others, or some fine example of African art that had been added to his large collections. Mrs Epstein was an admirable hostess, only roused when it was necessary to protect Epstein from some unwelcome intrusion.

He thought he suffered most 'from certain intellectuals who discussed his work in the art jargon of the period and dismissed his modelling because it was not carving . . .'

The portrait of David Cohn was modelled in 1929, the last year Feibleman saw Epstein. This had nothing to do with the head of Cohn which Feibleman described as 'vicious' – it was simply that his academic pursuits overtook his life. Still, he had his own remarkable bronze as a reminder of Epstein, a work which contained a multiplicity of viewpoints, yet had a Grecian honesty: Feibleman's characteristics, around six foot tall, gangling and slender, with a long neck running into a bony face, had been summoned up as a head that had the sharpness of sculpture cut from an oblong block of stone.

This unusual image – a frame of stone – suggests the idea of the work. Feibleman wanted it cast in silver, something his parents thought ridiculously extravagant. Understandably, their son loved the portrait, although he certainly didn't think it looked like him. 'No,' Epstein replied, 'but it will.'

Time would prove it: a head is as good as its skull; the structure of Feibleman's head would become more pronounced over the years, and it was, as always, the structure upon which Epstein had fastened.

Life in the Epstein household was back in its old routine: Sundays in Epping (back on Monday morning); a week in Paris at Easter; 8 a.m. starts in the studio; tea at 4 p.m.; and, after tea, a visit to Kathleen at her new address in Sydney Street, Chelsea (she had moved there to be nearer to him). On the two nights he stayed, they went first to dinner, occasionally at a little Italian restaurant they liked called Callettas in the King's Road, but usually at the Ivy.

However, early in 1928, when he was in the middle of producing scores of pencil drawings of three nude girls (one of whom was Sunita, one English, and one a negress), there was the chance of a public commission. On 11 January, Thomas Hardy had died, and relations and friends – Mrs Hardy, Miss Hardy, T. E. Lawrence, J. M. Barrie, H. Granville-Barker and Augustus John among them – hurriedly met to consider what form a memorial for the great writer and poet should take, and who should carry it out. Lawrence had written early on (29 August 1927) about a Hardy memorial to Sir Christopher Cockerell of Cambridge, saying: 'Statues are so difficult, unless someone quite first-rate does them. Epstein is the obvious choice.' This forthright recom-

mendation is a reminder of his close friendship with Sylvia Garman, but John also did his best to get Epstein the job: he had known the writer, painted his portrait, and, because he said that Hardy hadn't a sufficiently monumental build ('though a fine head'), felt that the subject of the monument should not be him but Tess of the D'Urbervilles. For this work John pressed for Epstein, a recommendation which must have shown the sculptor that he had grossly misjudged John: as an admirer of Hardy, Epstein was delighted to take on the commission, offering to make a maquette to submit for the committee's agreement. Although some of its members were sympathetic – and of course Lawrence, like John, heavily backed Epstein – the depressing memories of past controversies caught up with him: 'The name of Epstein,' John wrote, 'seemed to excite a general uneasiness, if not alarm.' John, for his part, had shown a good deal of imagination, both in suggesting Tess as subject and Epstein as sculptor – he knew the writer would inspire him much as Hudson had done, and Wilde before that. Unfortunately, however, the committee as a whole was clearly influenced by the press coverage of the rows which had broken out over these and other beautiful works – the BMA figures, *Rock-Drill*, *Venus* and *Christ*. Thus, to John's intense irritation, the idea got nowhere, and, as he said, with that news 'Tess was rejected in favour of the depressing object we now see at the top of the High Street, Dorchester.' Lawrence must have been infuriated by the committee's silliness. For how right John was: the lifelike yet lifeless likeness of the marvellous writer by Eric Kennington (whose effigy of T. E. Lawrence in the Saxon church at Wareham was far better), sitting in a chair, stares across a road at a brick wall, making us realize how very fine *Rima* also is, and how much was lost through prejudice.

And so Epstein returned to his drawings and to portraiture – after Rothermere and Feibleman, there was Mrs Godfrey Phillips, a work commissioned and shown at her husband's gallery towards the end of the year – and had started on a 'Pietà' composition, a carving for which he had the materials ready. As it happened, it was then, when Epstein was doing the portrait of his wife, that Phillips had the luck to see the extraordinary collection of drawings of nudes that Epstein was working on; as though continuing the obsessive effort which had gone into the preliminary studies of *Rima*, once he had started on the latest series he couldn't stop, and Phillips was so struck that he offered to show them with the head of his wife and three other busts. And then came another

break – Charles Holden, the architect who started him off with the BMA figures, and had assisted on the Wilde and Rima settings, reappeared with the huge building he was designing for London Underground. His latest client was Frank Pick, the patron and entrepreneur who had been connected with London Transport (as it subsequently became) since 1906, and, as managing director in 1928, brought a revolutionary new look and sparkle to the city's impoverished streets by employing young designers. He believed that something which *was* good should be *seen* to be good, and that something was public transport. Everything connected with it had to be the best – Tube trains, the Underground stations, buses – everything down to seating materials and graphics and colour: the scarlet bus was his, and that stamped an image on the memory which became famous throughout the world. Pick was a visual man with tremendous energy: he worked fast, called a meeting and appointed his architect the same afternoon; he was probably the earliest to give modern ideas a chance in the social sector. He wanted imagination to sell his services, knew that art could be a great communicator, and, in posters, Clive Gardiner, McKnight Kauffer, Paul Nash and Graham Sutherland are names which represent a golden age when strikingly original paintings – with overtones of the Cubists or Derain or Magritte – were suddenly splashed across the London scene with messages of escapist dreams about jaunts to romantic places, parks, famous stately homes and favourite beauty spots by train or Green Line bus. With architecture, the buildings and station designs, at first tinged with Art Deco, later moving into the more daring experimental sphere, are among the best things Holden ever did.

Unfortunately, London Transport HQ at 55 Broadway, St James's, wasn't one of them. Holden failed here: it was doubtless practical, but dull. Nevertheless, Holden enjoyed art (if for different reasons) as much as Pick, and wanted sculptors to decorate his building; and, like Bone, remained a faithful ally of Epstein's, difficult as he often said he was – he was determined that he should carry out works for two prime sites over the main entrances to station and building. However, despite Pick's enthusiasm to risk all for the best, there was a moment when Epstein's reputation for creating public controversy (ending with criminal damage in the case of the works in Paris and Hyde Park) once again looked set to deprive him of another commission. His prospects certainly appeared bleak when the subject of appointing artists came up: Pick was adamant – on no account was Holden to employ Epstein, an instruction which

took the architect aback. His admiration for the sculptor was so great that it never occurred to him there would be a problem over his appointment – in Holden's opinion, he was England's finest artist, the one who alone possessed 'the secret of making his work live'. Besides, the combination of Pick having been one of the dozens of signatories defending *Rima* and his reputation for being a patron of modern art had made such a choice beyond question: so confident was Holden that he had, in advance of official confirmation, gone ahead with discussions of ideas with Epstein who had made a maquette of 'Night' to illustrate his intentions.

Holden wasn't put off by Pick's hostility, and instead asked him to come over to Hyde Park Gate to see the maquette. This required conviction, if not courage; Pick was a tough, blunt northerner, and he was his client: 'I said we would not have Epstein,' he repeated, plainly irritated by his architect's obstinacy over the choice of this artist. Still, they had known each other too long to fall out over the disagreement – since 1915, in fact, when, of all extraordinary times, a European exhibition was held in London to demonstrate to British manufacturers what they were up against in the way of continental competition if they hoped to capture world trade (whether they took an interest and were anything but sceptical of the event is doubtful). It was this that brought the two together in a drive to get modern ideas through to the insular British, and to try to do this effectively they founded the Design and Industries Association (slogan: 'Fitness for Purpose'). So in the end Pick fell in with his plan. 'You needn't have the Epstein,' Holden told him. 'I only want you to come and see the model. You're under no obligation –'

Pick saw it, thought about it over the weekend, and on Monday Epstein was instructed to proceed.

'This is the sculptor.' Holden introduced Epstein to his Clerk of Works on site as though he was a representative of some trade like plumbing or carpentry. No name was mentioned: so great was the anxiety about the trouble that might be let loose if his identity was revealed, total anonymity was essential. His was of course a household name; and all the more so at this particular time, in October 1928, because of the mammoth publicity received by his recently opened Duke Street exhibition at the Phillips Gallery: a hundred drawings of nude girls, done, as the art critic of the *Evening Standard* was quick to point out, in only two

months. It had made headlines again. Nevertheless, Epstein found this introduction very strange. Doubtless Holden's introduction of Henry Moore (whom Epstein had recommended), Eric Gill, Sam Rabin and others working on a 'Winds' theme (and all, interestingly, influenced by the Wilde tomb) were made in the normal way. 'Mr Holden,' he recalled, 'explained that it would not do for me to be known as yet, at any rate not until I had actually set to work. "Dark forces might upset things" – ' Holden naturally had in mind right-wing elements in the press and people like Dicksee, Blomfield and other cronies of Frampton's. 'I had to be smuggled in. It was in this atmosphere of mystery that I began a six months' work, which took me through the entire bitter winter months of 1928, working out of doors.' While Epstein, now forty-eight, had to put up with the wind whistling on one side 'down the narrow canyon of the street', he said, Moore's sculpture, being high up, was carried out almost entirely in his studio.

Epstein was commissioned to do two pieces, and for subjects he chose the elemental figures of 'Night' and 'Day', the one contemplative, the other active, perhaps in deference to Michelangelo's works for the Medicis, but obviously justified on account of the morning and evening life of London Transport's trains and buses carrying people to and from their offices: he had, he said in an interview, first considered some form of expressing the traffic and crowds moving in and out of the stations but found he couldn't get a plastic idea for this that would frame the thought. The size – nine feet tall – and sites for the groups over the entrances to the offices were settled by the architects, *Night* on the north side in Petty France, *Day* on the south in Broadway. Unlike the BMA figures, close to a collective decoration on account of their position and number, these works were sculpture in their own right, and, again, unlike the Wilde tomb and *Rima*, they were not objects in space. Yet 'Night' and 'Day' were as concerned with their surroundings as were the BMA figures (evocative of a frieze of caryatids), or the tomb (in a cemetery, this was, like a gravestone, boiled down to the essentials of a plaque), or *Rima* (about nature and in a bower, it was a portrait of subject and place). He attached great importance to the context, in this case a building: 'In Egypt can be found the perfect example of the alliance between sculpture and architecture,' he said. To have 'stuck' any group, however good, against Holden's building, regardless of its design, would have produced 'a very restless effect'. Milan Cathedral was a case in point – figures 'stuck' to the surface made 'this most

popular building extremely disturbing.' In fact, he was as specific when discussing objectives as he was concerned about the context – he was, he said, bound by the architectural form, a condition which made his work on this occasion less personal than it would have been if conceived for a museum or an open space. There were, for one thing, clear associations with the massing of the building – the combination of the low street frontage (where the Epsteins were situated) and the main body of the structure (high, standing back and tapering towards the top) could be glimpsed reflected in the horizontal and vertical elements of *Night* and *Day*. 'The group,' Epstein said of *Night* when pestered by reporters after the inevitable storm over it broke, 'must be regarded as part of the whole building which it decorates.' As to meaning, he explained that his

idea was to impart a vast, elemental, or primitive feeling to the group. The large figure of the woman symbolizes Night – not the night of the night clubs, but of repose and rest. The recumbent male figure symbolizes Man – Man reposing. There is a special symbolical feeling in the protective gesture of the woman's arm above the recumbent man, and in the gesture of her other hand supporting his head.

As with all art, of course, both groups suggest a multitude of images and associations that only emerge over time, the most important being a startling flashback over the millennia to the first known architectural form devised to give aesthetic sculptural expression to a structural principle – the thirteenth-century BC Lion's Gate in Mycenae. In that work two lions face a central column, three elements which frame the area of masonry supported by the lintel spanning the opening. In this way, they reproduce the shape of the triangular spread of the load, so describing the diagrams of forces. In *Night* most subtly, and in a more overt manner in *Day*, Epstein conceived the groups as integral parts of the entrance and their columns below; as if seizing a chance for a giant dramatization of the Mycenaean idea, the groups and entrances then metamorphose as sculptural 'loads' supported on post and beam construction. Here then is a second architectural association. Yet there is a third, too – *Night* is in itself an encapsulation of this ancient conception, the mother-figure spreading in a triangular fashion down to the legs, which act, much like the stone gate-posts in Mycenaean structure, as supports for the man-child stretched across the knees in a

form resembling the lintel of the Lion's Gate. The structure of the building and the figures expressed in the entrances and the sculpture, coalesce as single compositions; and the theme, mysteriously in harmony with ancient and modern material, is handed down from the architectural form to the entrances and their sculpture and from there to the sculpture alone. If we remember that the statues could be regarded as a manifestation of the 'Pietà' Epstein had contemplated doing, and that thus they have a compositional as well as a religious source, we can see that this interpretation of the continuity of idea helps to explain the enduring impact of Epstein's work.

The sculpture was carried out as the building progressed. That had its dangers: 'I had to be oblivious to the fact that for some time tons of stone were being hauled up above my head, on a chain, and if this chain broke . . .' Then the extreme cold gave him terrible stomach-aches, he suffered from loss of weight, and there were times when he could only work alternate weeks.

Eventually, however, his conditions were improved: a rough lean-to shed was built round his platform in the scaffolding to protect him from the weather. Then, of course, a further problem arose: word had got into a newspaper about his identity and immediately reporters descended on the scene, hoping to catch a glimpse of what the notorious sculptor was up to this time. By February, at least a dozen papers were following the story: three were American – the Parisian issue of the *Chicago Tribune*, the *New York Tribune* and *American Art News* – and among the British were the *Daily Express*, *Observer*, *Manchester Guardian* and the *Daily News*. Even his clothes attracted attention: 'Mr Epstein carries Bohemianism in dress to a degree that only a great artist may. In his wooden eyrie up above he appears at intervals in his astonishing red jersey and below gather absorbed and fascinated little groups of people,' reported the *Daily Mirror* on 21 March. No one was allowed to enter the shed and he kept the only key; constantly badgered by newspaper men, he told a *Daily Express* reporter: 'I wish to be left in peace to proceed . . . I cannot permit anyone to enter my studio . . .' He was pestered: one man peered between the wood slats surrounding the shed from a window above, but all he saw was a moving arm holding a sculptor's mallet and part of 'a vivid lilac linen shirt and a dark, absorbed, critical face'. Exasperated, he climbed out of the window to get close to the slats, but suddenly, he reported in his newspaper,

something alarming happened. Mr Epstein had been hopping cheer-
fully on and off a short ladder to see how the work was progressing.
During one of his critical surveys . . . he suddenly stood quite still,
and stared at the window through which I was peeping, with his head
thrust forward suspiciously. *Had* he seen me? I did not stop long to
wonder . . .

A reporter from the *Sunday Dispatch* had better luck when he tried to
see *Day* after *Night* was finished. This was in June. Of course, the
contractor's foreman told him there wasn't a chance – 'We're not going
to let Mr Epstein be disturbed by reporters, so run,' he said. However,
he managed to disguise himself as an architect by putting on glasses,
carrying a book and a ruler and 'wearing a dreamy air'. The imperson-
ation worked and he got past the foreman, went up two or three ladders
and there, in front of him, was the shed, Epstein and *Day*. So surprised
was he by all this, he tripped and fell flat on his face. But Epstein,
engrossed in what he was doing, didn't notice him: he seemed to be in a
dream, the reporter said, and went on working. For ten minutes he
stood watching him cutting out the gigantic figure of the man (completed
to his eyes) and the child, itself over six feet, transfixed by what
confronted him – 'a massiveness, a sense of awful strength, rhythm and
wild beauty', was how he put it. Then suddenly Epstein saw him. 'How
the devil did you get in here?' he said. 'The foreman –' He was on the
way down his ladder. But to the reporter's amazement Epstein didn't
tell him to go; instead, he talked and was charming. He had his chisel in
his hand, was wearing a blue shirt, and proceeded to explain the meaning
of *Day*. He spoke, the reporter went on incredulously, of art, but then
made him promise not to repeat a word of what he'd told him.
'Newspapers exaggerate . . .' All he could say was that Epstein was not
sure when the work would be uncovered . . .

In fact, the sculpture was uncovered a couple of weeks later on 1
July, little more than five weeks after the unveiling of *Night* on 24 May.
The short time taken over it is simply explained: he started on *Day*
first, and when nearly complete moved on to *Night*; then, having
finished this, went back to *Day*. Meanwhile, Pick had prepared himself
for a barrage of criticism. Throughout the work in progress, he remained
cautious, constantly reassuring himself by saying, 'Wait till it is
finished.' He didn't have to wait for the reactions of the press, which
were immediate: *Night* was used for the cover of the *Art Digest* in New

York and the verdict of the *Daily Telegraph* on it as 'a great coarse object in debased Indo-Chinese style, representing a creature half-Buddha, half-mummy, bearing on its knees a corpse-like child of enormous proportions' was quoted the day after, on 25 May, in newspapers as far away as Melbourne in Australia and Christchurch in New Zealand: the *Rima* sensation, journalists were agreed, was 'likely to be eclipsed', and certainly the *Telegraph*'s crude observations were confirmation of that. And with the unveiling of *Day*, the crowds moved in to get a look with the same enthusiasm they had shown more than twenty years before for the BMA figures, the controversy even penetrating the dormitories and quadrangles of nearby Westminster School. On their way to and from school, the boys were constantly confronted by gaping faces staring up at the works at St James's Park station, and, according to Lawrence Campbell, there at the time, the boys 'spouted nonsense about the Greek tradition when they read the newspaper accounts', probably repeating views aired by parents. Nevertheless, reactions were mixed, the extremes of abuse and praise following the familiar pattern. G. K. Chesterton was among the chief critics – 'Sculpture is normally a public and monumental art', he said, and Epstein, in taking a commission to execute a work to be viewed from the street, 'was in duty bound to please the crowd'; 'weird', 'grotesque' and 'uncouthly hideous' were typical comments from his camp: 'Most who saw it [*Night*] shuddered', and so on. Yet from the other side, the *London Mercury*, for example, came the admiration of a serious reviewer: it was reassuring, Howard Hannay wrote, that Holden, undeterred by the outcry over *Rima*, should have again employed Epstein for the principal sculptures. 'And again Mr Epstein has produced work which, to say the least of it, will be a fine education for the English people.' He wasn't enthusiastic about the other sculptures. 'I am prepared to join with the philistines against the frog-like figure by Mr Moore to the left of Mr Epstein's *Night* . . . Mr Moore represents formalism empty of meaning, while Mr Epstein has employed a very profound acquaintance with the Eastern Sculpture admired by the modern formalists and also an understanding of the modern aesthetic principles to express a meaning . . .'

Frank Pick was, of course, well-known for his own strong views on art. For instance, he kept Gardiner's famous 1926 Palm House at Kew poster pinned up in his office for a month before deciding that its Cubist imagery could be made comprehensible to the public by the addition of the sub-heading 'But see it for yourself'. To Epstein's *Day*,

of which he had merely seen a photograph, his immediate reaction was that it looked 'awful', but that he was nevertheless sure, when judged in relation to the whole building, 'people will not find fault with it'. His final pronouncement was: 'It is easy to decry Epstein's work. It could be called crude, rough and uncouth, but that does not detract from its merit.' The sculptures' quality had sunk in and Pick must have been gratified, whatever anyone thought of them, that these controversial groups confirmed his reputation as the most avant-garde public patron of his time. Not only had he a formidable list of experimental artists to his credit; the work of one of them had swamped newspapers all over the world – from America to New Zealand, and from Canada to Egypt, Ceylon, India and South Africa – with hundreds of letters, reports and reviews gobbling up thousands of column inches. This sort of coverage was normal for an Epstein; whatever Pick privately thought, he was not averse to publicity and controversy, and may well even have been exhilarated by the international battering the works commissioned for his headquarters had received.

This reception, if more far-reaching than usual, was commonplace as far as Epstein was concerned, and although the often expressed ignorance never failed to irritate, it did not deter him, either. There were those who supported him – for example, Osbert Sitwell in a BBC programme, R. H. Wilenski in the *Evening Standard* and James Bone in the *Manchester Guardian* and a number of enlightened letter writers to that paper – to whom he was grateful. In particular, he would have been grateful to Wilenski: '*Day* and *Night* are the grandest stone carvings in London. To say this is grossly to under-praise them.' And of *Day*:

> It can be apprehended by every man and woman who can grasp the ideas of the words Time and Form in the abstract. Because the spirit that created these grand carvings is a spirit of all time, and the brain that carved them is a brain that can invent symbolic form. Such spirits and such brains are rare. They are the brains and spirits of the great artists. *Night* and *Day* are certainly the best things that Epstein has yet done.

This captures the power of the works, and explains why they were the targets for the missiles fired in anger, and why those by Moore and the others were largely left alone: these were decorations where Epstein's were sculptures, carvings with a life beyond that of the building's

design. *Night* and *Day* were unlike anything Epstein had attempted before, and are so positive and dramatic, and communicate such a concentrated, ageless and personal message, that their magnetism is irresistible: all else, including the building, is blotted out in the presence of this intensely real and passionately vivid art. No wonder, then, that the critics singled them out for attack and that the mass of the letter-writing public, in doing likewise, forced the arch-traditionalist Sir Reginald Blomfield, to join the correspondence with a lengthy epistle headed 'Epstein and the Cult of Ugliness' to the *Manchester Guardian*. He was a good one to talk on such a matter, having just swept away the last remnants of Nash's Regent Street, and replaced his precious façades with sub-classical styles in a heavy, depressingly dull design. In fact, Blomfield's verbose and rambling letter said little beyond remarking that modern sculptors 'repudiated sculpture from Pheidias down to the present day', that the 'promise of those halcyon days' of the BMA figures 'seems to have faded away', and that 'bestiality still lurks below the surface' of Epstein's sculptures on the Underground building.

Epstein replied to the newspaper on 3 August, setting out his ideas with accustomed simplicity. He was reasonable, logical, practical; he scrupulously avoided any fanciful red herrings, sticking only to the facts that he understood; he was exact, patient and clear, and those who read the report of the interview with him in his house at Hyde Park Gate would have learnt something about art, as the journalist from the *Sunday Dispatch* did. With *Night*, his intention was to convey 'sleep and rest descending on tired mankind,' he said. Where *Night* faced north and had to be deeply cut for want of shadow, *Day* was on the south side, a figure of the father in nature where the man-child, facing the light, still holds on to the father and the whole is activated by the movement of the sun as the forms are revealed. He had not thought of the father, as had been suggested, as the sun, and although *Night* was pyramidal in form, and *Day* rectilinear, he had not thought of them as symbolic of keystones: they developed naturally in this way. He said he had been delighted by the support of many notable people in the *Manchester Guardian*, but was most surprised by Blomfield's assertion that the promise of him in the halcyon days of the Strand figures seemed to have faded away, since he had no memory of Blomfield's name among those who defended these works when the same sort of attack was made upon them as on *Night* and *Day*. 'Perhaps in twenty years from now, if I live to do statues then, we shall hear about

the unfulfilled promise of the halcyon days of my Underground Railway period.' He was very surprised that Blomfield committed himself to the statement that the Underground sculptors were 'trying to convey more than can be conveyed with any hope of success by the art in which they are working' – it took a good deal to lay down the limits of art; and was surprised, too, by his remarks about Pheidias – 'Even Greek sculpture did not begin with Pheidias, and to many of us nowadays it was only beginning to decline with him.' And so far as his references to 'bestiality' went, Epstein said he never expected that this would be dragged up again. 'Did not Ruskin find something of the kind in Rembrandt's subjects and treatment?' But, really, he thought it was about time to give this talk about 'the cult of ugliness' a rest. 'Nobody,' he said, 'seeks for ugliness. I am not sure that anyone seeks for beauty. The artist seeks to express himself, and if he is sufficiently an artist he finds beauty in his way of expressing himself. But he does not set out "to seek for beauty". That is not how beauty is found.'

As far as letters to the *Manchester Guardian* were concerned, Epstein would have been most heartened by R. E. Walker's, the assistant editor of the *Print Collectors' Quarterly*, in which he said (6 August) that the sculptor was

> quite right in ridiculing the 'cult of ugliness' cry, which is just as silly as the cult of beauty pose of the 'Greenery-yallery Grosvenor Gallery' school of the Eighties. Beauty and ugliness are vague, meaningless terms, like truth and goodness. What is truth? What is beauty? Rembrandt saw beauty in the squalid slum quarters of Amsterdam Jewry . . . Beauty is not the monopoly of 'beauty spots' by mountain, lake and river, or in the features of Greek youth . . .

Epstein was as used to the abuse of Blomfield's kind as many nineteenth-century artists had been to that of their critics; and not merely the Impressionists – Millais, on seeing work of his at the British exhibition at the London City Guildhall in 1892 that he had not seen for forty years, used words which resembled Epstein's: 'All my early pictures were universally abused, and now critics say I have not fulfilled their promise.' Blomfield's abuse, however, was nothing to finding his Hyde Park Gate house covered with swastikas and scrawled messages like 'Jew go home' first thing in the morning. And nothing, perhaps, to the news a couple of months later, on 9 October 1929, that *Rima* had once more been vandalized, blackened with tar and covered with brown

and white feathers; and to hearing, the following week, that two glass 'bombs' filled with tar and feathers were flung at *Night*. In this case, fortunately, no damage was done.

Luckily, a policeman saved *Night* – on his beat at 2 a.m., he disturbed the extremists: four men (two, he noticed, wearing plus-fours) dashed from the entrance, jumped into a waiting car and drove away at high speed towards Victoria Street as the constable blew his whistle. *Rima* was not so lucky; streaming with tar, it took as long to clean – weeks – as when splashed with paint before. None of the attackers in either incident was caught, and that day the evening paper, the *Star*, received a typewritten letter postmarked 'Norwood, 9.30 a.m.', or before news of the assault on *Night* broke. It said:

> Sir,
> In order to demonstrate our rigid dislike of Epstein's works we intend, this evening, to decorate his ghastly effigies in a similar manner to *Rima*.
> We should like to point out that this is not being done in any vandalistic spirit, but merely as a demonstration which, we are sure, all right-minded and right-seeing people will appreciate.
> We should appreciate your support.
> Tar & Feathers

On the back of the envelope was written: 'Attack failed. 2 Bombs thrown. 2.11.'

And so once more Epstein's work hit the headlines across the world with 'EPSTEIN SENSATION', 'TAR AND FEATHERS', 'NEW CRISIS' and so on; once more sheer excellence had upset the philistines and had started another battle in the newspapers about what art was and wasn't; a letter to the *Manchester Guardian* on 18 October put the position well:

> Epstein's work has a singular power of moving strong feelings in the beholder. Those who admire it and those who dislike it are equally emphatic. Whichever side one takes one can at least understand why work so strongly individualistic should cause controversy. But it is quite impossible to understand the savage resentment which can only express itself in the defilement of the artist's work. Last week a second outrage upon the Rima Sculpture had to be recorded, and now

it appears an attempt has been made to tar the figure of *Night* upon the new Underground Building. It is unbelievable that such outrages really spring from any feeling about what is art and what is not art. It is much easier to attribute them to insanity. But then why do they always descend upon the work of Epstein?

The sculptor himself, apart from concern over the possible damage to *Rima*, was unruffled. Interviewed by the *Jewish Chronicle*, he said that, for one thing, he had four pieces of sculpture on show at the twenty-seventh exhibition of the London Group opening that week at the New Burlington Galleries to think about; for another, he was wholly indifferent to these latest outrages.

The people who do this sort of thing make a great mistake if they think I am angry. I am not even disgusted. An artist's feeling is confined entirely to his work, and I have no sentiment one way or the other about acts of this kind. It looks as if I am in the historical tradition. Michelangelo's *David*, at Florence, had bars put round it during the night to protect it from attack after it had been stoned by the populace. So I am in good company.

As his dealer, Oliver Brown, had remarked so admiringly, he simply brushed these abuses aside as utterly irrelevant. He believed in himself as he had always done, had absolute faith in what he was doing and wanted to do next; once a work was finished, his ideas had already formed about what was to follow. Yet he had his supporters. As before, they did not let him down – they were writing or speaking in his defence with a fearlessness comparable to his own. The novelist Frank Swinnerton wrote to the *Manchester Guardian*, for instance: 'It is difficult to judge Mr Epstein's sculptured figures from photographs, but even in the photographs they are extremely interesting. Taking the photographs in conjunction with *the names and expressed views of those who condemn Mr Epstein's work*, I should suppose the figures to be masterpieces.'

The newspaper clippings about *Night* and *Day* filled three trunks at Hyde Park Gate by the time the outcry eventually died down, and that showed, Haskell said,

something of the difficulties under which a creative artist has constantly to work. Today, everyone is aroused in a superior way by

similar cuttings about the Impressionists or Rodin, to take only two examples, yet Albert Wolff, the *Figaro*'s leading critic, could say in a laboured attempt at wit, similar in manner to the tone adopted by Epstein's detractors, 'To-day a man rushed into the street and bit a passer-by; evidently he had just been to visit The Impressionist Exhibition'.

Haskell was referring to the 1876 exhibition in Paris, and added, 'This about the work that is honoured in the Louvre to-day, and which is collected by every millionaire who seeks a name as a patron of the arts.' Rodin had been attacked for being either too lifelike or too far removed from life, and Whistler for charging 'two hundred guineas for flinging a pot of paint in the public's face'.

Epstein had, of course, counter-attacked vigorously whenever possible. For instance, after Archbishop Downey had entered the controversy by saying that, although the new Roman Catholic Cathedral in Liverpool should express the twentieth century, it would be 'calamitous if this meant something Epsteinish', Epstein retaliated in an interview with the *Daily Dispatch* on behalf of the school of young sculptors he represented; by this he probably meant sculptors like Moore and Rabin, and possibly some students. Irritating as he found constant demands for explanations, he said: 'Apart from this school, what new progress is there in sculpture – what attempt really to express 20th century ideas?' He went on: 'I would call myself a religious sculptor. I mean religious in the widest sense. Every imaginative work is religious, and art is one of the most sacred things in existence. You cannot draw hard and fast lines between sacred and profane ... Does Sir Edwin Lutyens' – the proposed architect for the building – 'mean to turn to the traditional ecclesiastical sculptor who has filled our churches with dull, expressionless works which don't evoke the faintest response or flicker of feeling in the spectator?'

In fact, as Haskell says, it was 'a case of a postman, a policeman [quoted in the *Evening Standard*], Sir Reginald Blomfield, Sir Reginald [sic] Frampton [the sculptor of Nurse Cavell], and the late Sir Frank Dicksee on the one side against H. G. Wells, Bernard Shaw ... Orpen, John, McEvoy, James Bone, Wilenski, Rutter, Aitken, Marriot and many more on the other.' And Epstein took up the point when writing to the *Daily Telegraph* at the beginning of January 1930, in response to its art critic's claim that 'the most experienced art critics ... were agreed that

the sculptures are thoroughly bad as works of art'. To counter this, Epstein quoted from those generally regarded as the most eminent of the day, James Bone and Wilenski. 'Perhaps,' Epstein concluded in his letter, 'your Art Critic only reads his own opinions.'

The extremes in reactions to his works went on. For example, when he heard on 28 January that *Rima* had been vandalized yet again, this time with red, black and green paint, he must at least have been thankful to read over comments on *Night* and *Day* by some of his supporters, of which those of the thriller writer, Edgar Wallace, were undoubtedly the most telling: 'If these works were dug up by some archaeologist they would immediately be hailed as masterpieces.'

Epstein told reporters that, on average, he was given one public commission every seven years; not much in the way of a reward for merit. And after the Underground job there wasn't another for two decades: the 1929 financial crash followed by the Depression, the unemployment of the Thirties and the Second World War are an explanation for this, but equally responsible was the fear of an 'embarrassing' outcry the work of this 'rebel' was bound to cause. And not just in England; in Paris and in New York – 'NEW EPSTEIN SURPRISE: DRAWINGS BANNED IN AMERICA' ran a newspaper headline on 2 July 1929: a copy of his collection of nudes, published as *Seventy-Five Drawings* after the sensational Duke Street exhibition, had been shown to a publisher over there, immediately seized, taken to Washington and pronounced 'unfit for circulation in America'. Epstein was amazed: 'I don't know what to make of it,' he said when told of the ban by a reporter. 'I would have thought that anything good enough for this country was fit for any other part of the world.'

An eventful year, 1929 had started quietly with Mrs Epstein negotiating the purchase of a flowerpiece to add to their collection of Matthew Smiths. 'Will you sell to me the picture you have at the London Group for 250 guineas,' she said in her letter to the artist of 9 January. 'I will pay you 250 guineas on the word of a Scots woman.' (Mrs Epstein dealt with all her husband's financial matters, including paying for taxis and bus fares. At home, with friends, she remained a background presence, expressing anger only when his guests betrayed his hospitality by gossiping to the press about life at Hyde Park Gate. 'A woman author,' Haskell said, 'in particular aroused the usually gentle Mrs Epstein's wrath by writing about dirty teacups, a picturesque detail that happened

to be untrue.') 'I will send you now 50 guineas and the balance in instalments of 50 guineas over an agreed period,' her letter to Smith continued. 'You know the picture I mean. It has red smouldering flowers in front of a darker background and pears yellow in front and greener at the back. It was mentioned at dinner last night . . .' With this message, confused as it sounds, the picture, one of four Smiths shown at the London Group that year, springs from the past with the suddenness of the painter's colour. The conversation over dinner seems almost audible as well – the discussion about one of the many paintings Epstein had wanted by this man of whom he was so fond.

Matthew Smith was reticent and thoughtful, reserved and outwardly imperturbable. When, for instance, the landlord of his studio at Cézanne's Château Noir in Provence became worried that he hadn't seen the painter for three days, and was forced to break the locked door down when there was no answer to his knocks, Smith looked up from his painting and merely said, 'What do you want?' Engrossed with his work, he was averse to any form of publicity – he needed someone else to do the pushing. 'That person was Epstein. The sculptor filled his home with the painter's work long before he was generally recognized,' Kathleen Garman said. She knew him, too, and became as devoted to Smith as Smith was to Epstein; he called him 'Matt'; Smith called Epstein 'Jake', a rare break from the usual 'Epstein'. Their friendship lasted over forty years and was close: their differences in temperament – Epstein, ebullient and self-confident; Smith, as diffident and hesitant in manner as his features were delicate – seemed to endear each to the other. Yet they had many things in common: while Smith remained passionately English at heart (he volunteered in 1916, possibly partly because his wife had generations of army in her family, as far back as Wellington), as a painter he was influenced only by the French School: like Epstein, his early training was in France, he had studied in the Parisian ateliers where Matisse taught, his paintings reflect the mood and imagination of Rouault and Bonnard, and the artists he appears to have talked about most frequently (Kathleen remembered) were Cézanne and Ingres; and he owned an early Van Gogh of the Nuenen period. Here were particular pleasures Epstein and Smith shared like happy memories. There were others: both were most fastidious, Smith in everything he said, and while their appreciation of each other's work was as enthusiastic and constant as the affection between them was strong, there was little familiarity. Perhaps the curious humour which

lightened their conversation conveyed what they felt best – Smith's 'dry humour', Kathleen said, 'was like the exquisitely dry champagne he always served when he invited one to "tea".' And it was his reticence which invariably surprised people: to judge him by first impressions was to know nothing of the man beneath them, and so to be startled by the contrast with his passionate, voluptuous paintings. It was here, in their work, that the personalities of the sculptor and painter coincided – in the thorough and exacting enjoyment of the best the senses have to give.

Many of Haskell's memories of Hyde Park Gate when amassing material for his book *The Sculptor Speaks* were dominated by Matthew Smith's pictures – 'a vigorous series of paintings, flower pieces and nudes.' They were 'rich and glowing in colour, paintings of a quality rare' in what Epstein called 'this anaemic age'. He said there were also some Epsteins, a head of his wife, some baby heads of Peggy-Jean and the mask of Meum. Sculpture covered the piano (even the most distinguished pianists were never able to lift the lid) and in the back room, through the glass doors, he could see two large Marquesan idols from the Epstein sculpture collection. One of his two Rouaults was there as well.

Ethel Mannin mentioned these idols when she visited the house in 1929, and it might have been the remarks of this left-wing friend of Bertrand Russell, appearing a year later in her book *Confessions and Impressions*, which infuriated Mrs Epstein. The romantic novelist was a great admirer of the sculptor, both for his work and the stance he took with the puritan British public, and had been asked along by Mrs Godfrey Phillips to one of the Epsteins' 'at homes'. She was a sharp observer, missing nothing – the big, shabby, neglected house, the little girl with flaxen hair who answered the door bell and had the uncanny knack of sizing up the right people to admit, the 'big shabby room with a garish light like that from an incandescent gas-burner, and the dust of ages black upon the picture rail'; and, by the table in the centre, the massive figure of Mrs Epstein presiding 'over the cheapest kind of tea-things'. There was, she said, something 'terrific' about her – 'something which compels respect, and sets one thinking about what is going on behind all that sphinx-like placidity'. From these observations (which would have been enough to prevent her return to the house after the book was published) she moves on to 'Epstein's gentle dark eyes, kindly

and yet penetrating and shrewd'. For him, there was this spot analysis: 'He sees right through the outward trappings of civilization to the flesh and blood. He does not see women as they see themselves in their mirrors, with their lipstick, powder, rouge, their furs and smart clothes; he sees them more nakedly than they ever see themselves.' She found him 'shy, retiring, diffident', in appearance like a plumber 'come to see about a burst pipe', or one who could still be 'a struggling artist'. He was far from that, surrounded by admirers on the window seat, listening fascinated to him talking about art, Mark Gertler among them. Other than her obvious respect for him, and noticing a Henry Moore drawing, the Matthew Smiths and Epstein bronzes, the picture conveyed is depressing – the 'shabby manservant' who brushed 'a few crumbs off the grubby green tablecloth', the 'gas-lit dreariness' and 'gloomy staircase': it was a picture that described an artist's poverty.

She did not, it seems, notice Arnold Haskell, quietly taking notes of what Epstein was saying as he embarked on his giant undertaking to record the views of, in his opinion, a giant of art. Saying that Epstein, 'almost alone in the world today, holds the secret of true beauty', he was as much an admirer of the sculptor as T. E. Hulme had been, who had insisted Epstein was 'in a class by himself' and 'certainly the greatest sculptor of this generation', adding, 'I have seen no work in Paris or Berlin which I can so unreservedly admire.' Although Haskell arranged his material with such skill that the book reads as spontaneous conversations, it was a task that involved very hard work. This quiet man, who took part with others in discussions over tea (usually), and, apparently, committed Epstein's remarks to memory (although it is said he had a shorthand of his own), wrote down everything heard and remembered when at home, and then returned to Hyde Park Gate for consultations, corrections, amplification or omissions. It was an exhaustive process which Epstein took so seriously – as seriously as anything else he was engaged upon – that the work turned into a major statement on art. The range was enormous – historical, European and non-European influences, figures of outstanding importance, criticism, personal reflections, carving and modelling, interpretations of beauty – and the material precisely and economically used to express his views; from a comprehension of one aspect of art comes an understanding of others. Epstein, a mouthpiece for common sense, spoke simply, modestly and logically whatever the topic. When Haskell, referring to the latest revival of what had come to be called 'Rimaphobia', had another try at getting him to do a book or series of essays to explain his aims, he replied:

I am quite used to 'Rimaphobia' by now, but I never let it worry me in the slightest. It is no good paying any attention to the opinions of the man in the street. A man who knows nothing about surgery would not be allowed to criticize a surgical operation. A man who knows nothing about sculpture should not criticize sculpture ... My sculpture is a sufficient explanation in itself, and my only aim in life. You write a book on me, you understand and feel my work, you will make less of a mess of it than most people. But don't make the mistake of thinking that a work of art can be explained.

He added that an art critic can only throw out hints, that something can be said about the medium, the circumstances under which a work was created, and that there was a place for, of course, the historian; that outside these valuable limits, 'he becomes misleading'. 'Whistler has dealt magnificently with "the professors" in his delightful *Gentle Art of Making Enemies*. There is no one with the spirit of Whistler today. They all kow-tow to publicity and run after the press.' Haskell had tried again, nevertheless: one of Van Gogh's greatest patrons, who understood his work before it became fashionable, was a proprietor of a 'bistro' who took canvases in exchange for drinks, thereby showing his art to the public. Couldn't Epstein, by writing, achieve a similar objective? No, he could not. What he, Haskell, could do was make a record of their conversations; he could do that, provided it was accurate and fair, and that he wasn't asked riddles like: 'What is my definition of beauty?' 'One man from an inferior paper made up a long imaginary interview with me, when actually I had turned him out of the house, in which he said to me with great courage, "Epstein, I don't like your *Madonna* at all". It is rather unnecessary, it takes time, and I am tired after my day's work.' At which point, Haskell wrote, Peggy-Jean came in, and Epstein became entirely a father.

And so Haskell's book was launched. At the same time, Epstein was increasing his collection of sculpture from all parts of the world: there are few records of where he bought the works (it is believed, for the sake of privacy, he bid for some of them through others, or under the alias of 'Martineau') other than Paris, London and Brussels; some came from specific people like Derain, Ratton, Guillaume and Brummer, but largely the sources of over a thousand pieces collected between the wars remains a mystery. Henry Moore, when he came to know Epstein quite well in 1924, wrote that he had never forgotten being shown his collection of 'primitive' carvings in his bedroom: 'It was so overflowing with

negro sculptures etc., that I wondered how he got into bed without knocking something over.' His energy in this direction, as with his art, was tireless. Yet this was the same attention which he gave Haskell, or a model like May Goldie, an African girl with Jewish blood whom some would have thought ugly, Haskell found beautiful and Mrs Epstein described as 'a bird of Paradise'. Epstein regarded her as one of 'great beauty': 'Particularly her thin neck, supporting the large curly head, like some flower ...' When Epstein fell in love with this image, it didn't mean that he had fallen in love with May; the artist, he said, could fall in love with a line, a curve or a colour – Brancusi, he felt sure, was in love with the oval. Epstein told Haskell,

> Renoir expressed the whole thing admirably when he asked his wife to choose cooks whose skin retained the light. He was never in love with his models, but in another sense he may have been and certainly was attracted purely as an artist with a certain type of flesh. Renoir as you know always used his cooks as models. Rodin once said: 'It is extraordinary how I can always get better onion soup at Renoir's than at home, though my own cook is a real one and Renoir's is a model.' Sculpture is definitely a sensual art, and the sensual feeling cannot and should not be dissociated from its appreciation ...

But that did not mean the artist had fallen in love: Epstein used girls who worked about the house as models – Selina was one, Louise another – but there the relationship ended. He had his own real love: Kathleen. And in April of that year, at the onset of the uproar over *Night* and *Day*, their third child was born – Esther.

In 1930 a decade of work began, much of it carried out at Baldwin's Hill, which transcended even the Pett Level period for 'the peculiar energy which,' to quote T. E. Hulme again, 'distinguishes the creative from the merely intelligent artist'. During these ten years, Epstein demonstrated the entire range of his extraordinary gifts, the carver, modeller, painter, draughtsman and illustrator going into action to exploit every possible aspect of his amazing and strange imagination. His work continued to follow a highly individual course that was concerned solely with positive and powerful ideas. 'Better,' he said, 'far better to praise a Meissonier at the expense of a Cézanne, let us say, than to lump them both together, with many others, as "agreeable painters".' He was contemptuous of the desire to be *dans le mouve-*

ment', of the tastefulness, the sitter on the fence which resulted in 'feeble generalization and a dread of uttering any definite opinion for fear of future developments'. He could have been thinking of Fry and Bell. And so in this decade he was as fearless and energetic as ever: in the first year he completed *Genesis*, a work for which he had found, in Paris, a block of Serravessa marble as early as 1927 (when first considering the possibilities of the subject), and started after the Underground commission was over; an interval of this kind was not uncommon with him, since he had, as he often remarked, to understand the properties of the stone before he could begin. He was the major representative of British sculpture at the Venice Biennale, contributing nine works, and, in this year, too, completed eleven for bronze. Then, at a Sotheby's sale in April, he bought eighteen pieces for his collection that included two masks from New Guinea, a ferocious War Mask from the Ivory Coast, and two heads – one of a woman on a lion's fang, the other of a bearded man – from the Belgian Congo, the whole for £300. By the end of the decade, moreover, he had made well over 100 portraits, had carved some of his finest works of the imagination – *Chimera*, *Elemental*, *Woman Possessed*, *Ecce Homo*, *Consummatum Est* and *Adam* – to satisfy his unending determination to research universal themes (none was commissioned), and he had completed a revolutionary series of illustrations which attempted to unravel some of the stories central to the Old Testament; in addition, he had carried out scores of watercolours of, first, Epping Forest, then of flowers, to fill four exhibitions, ventures into nature that took time off from stress. He had been condemned and praised for *Genesis* as the forces of the Establishment and of the enlightenment dug into their accustomed, immovable positions, and had suffered terrible attacks on his illustrations for Baudelaire's *Les Fleurs du Mal*. This followed his campaign to save his Strand figures when renewed controversy blew up after the BMA sold the building to the then Rhodesian Government. His new-found enjoyment in painting and drawing continued with his design for the curtain for the Markova-Dolin ballet company, and with an astonishing collection of drawings of his fifth child, Jackie made in 1938; and, as if as an afterthought, his earlier, determined resistance to the idea having apparently passed from his mind, he had written his autobiography for Michael Joseph, a detached summing up of his battles with the rule of mediocrity. It was one of his most prolific periods.

Modelling in his Hyde Park Gate studio, carving in the summer

house at Baldwin's Hill and painting in the Forest, left him little time for anything outside his customary break in Paris at Easter; as he said, 'I am tired after my day's work.' And there was Kathleen, the baby, Esther, and their son, Theo – Kitty, a delicate child, was living happily in Herefordshire where her grandmother had moved after Dr Garman died in 1924. With Kathleen, he could escape, if still fleetingly, to the comparative calm of another kind of life. There were problems, of course: she had changed addresses again, this time to 272 King's Road, a rickety, eighteenth-century house, a move that might have been precipitated by constant harassment from Mrs Epstein. One example of this, passed on by Helen Garman and possibly subject to some exaggeration in the telling (she was an exceptionally imaginative raconteuse), was terrifying: that there had been a fire in the Sydney Street house where Kathleen was living – as she put it, this was another bungled murder attempt organized by Mrs Epstein: 'The red-haired lady,' Helen insisted, 'was driven insane with jealousy over the love affair. But then my sister was, you know, a *femme fatale.*' That wasn't all: a private detective was hired to tail Kathleen in the hope that evidence of her infidelity could be presented to Epstein, for she firmly believed that the malicious stories she invented in her efforts to break up the relationship were mysteriously based on fact; the claim, for instance, that one of Kathleen's children was not Epstein's was a fabrication, possibly prompted by her sadness at having none of her own by him. But the detective was a waste of money: the only man visiting her regularly, always at the same time, after work, and always armed with a big bunch of flowers and a bag of exotic fruit (whatever the season), was Epstein.

Epstein's life with Kathleen was an escape – to the relief of normality from moments of acute unhappiness and constant anxiety. Yet there was no way out of his domestic problems. While his wife was not insane, she was very ill, her creeping disease gradually reducing her mobility, something which of course filled him with despair. All the same, he had his art: that was his life; as a magnificent phenomenon, it transcended everything else; beside it, family matters seemed to have contracted to details – any minor (to him) difficulty was, more often than not, 'petty'. Inside his house, he had his studio, his work, his hard labour as a sculptor, his collection; he had his wife doing her best to manage his everyday affairs in complex circumstances – if it hadn't been for her, friends said, he would have had no cook or handyman to look after things, and bailiffs and income tax inspectors would have been

hammering on the door. As far as paying bills went, Haskell said that he wouldn't have known how to sign a cheque if asked to do so. Outside his house, he had his devoted Kathleen. He had his relaxations too – evenings at the films, the music hall, a favourite Chinese restaurant in Wardour Street (where he saw the hardworking waitress, Lydia, in 1930, and made two remarkable busts of her), and close friends calling, like the actor Franklyn Dyall, and his wife, or Matthew Smith: Duke Ellington, a great admirer of his work, sent him tickets for his concerts when he was in London. Yet for his wife, her dreadful ailment, heightened in the context of Epstein's passion for exotic beauty, was of course a source of extreme unhappiness; and so, while he was buried in his art, she pursued her own passions – mainly, collecting things, rummaging around in auction rooms to add to her singular pile of oddments which, unknown to her husband, were kept locked up in the first floor room, next to their bedroom. Calling this her 'secret' and her 'treasure chest', it was crammed with trunks packed with odd lots picked up at sales: Indian saris, Spanish shawls, headdresses, theatrical jewellery, art materials, silver combs, oriental costumes – anything like that; and masses of furs – minks, jaguar coats, black lambs, fox. There was little she could resist on her outings two or three times a week, always by taxi and often with Peggy-Jean.

The house, fast becoming a warehouse for collections of very different kinds, was far too big for a cook and a handyman to manage, and with Mrs Epstein unable to assist on account of her immobility (Peggy-Jean had to bath her – an ordeal for one so young – on the nights Epstein was with Kathleen), a string of helpers were constantly passing through: they were a strange assortment – after the Japanese proved a disaster (he presented them with a special delicacy as an offer of friendship, a soup with fishes' eyes floating in it, and was mortified by Epstein's horrified reaction: 'Take it away!'), there was an Austrian girl (Adele), an Irish waif and a Hungarian. Most curious of all, perhaps, was the shambling butler, Jones, who was suddenly employed, and mentioned by Ethel Mannin. He came after the Hungarian, in 1929, and, surprisingly, appeared oblivious of the unusual features of the household, the muddle, the far from conventional routine, the models roaming about, the startling African figures peering over the Epsteins' bed, remaining as aloof as any 'Jeeves'. His manner was impeccable, face straight, as he served meals with dignity, and his imperturbable presence silenced all those round the table as he floated about with plates and wine. No little

job was a bother – sweeping up, laying fires, starting the boiler in the studio; or bringing up breakfast for the three of them in bed on a Sunday morning; after this, they got ready to go to Epping, where someone else – Betty May at times, before she ran off with Edgell Rickword – was doing the cooking.

While Jones amused Epstein, his presence must have mystified friends like Smith and Bone: although hardly consistent with the picture of P. G. Wodehouse's creation (then very much the rage), Epstein always referred to him as 'Jeeves' and liked him around the house. He lasted for about a year, eventually leaving for a curious reason. Mrs Epstein's bunch of keys, for everything from the trunks under the bed to the coal bunkers in the basement, went missing. Her husband was out and she knew he would be furious when he went straight to his bedroom and couldn't get in. She had good reason to think this: his precious African work was there, and this included the noble Kongo head, the rare and powerful Tabwa figure, the funerary works from Madagascar, the double bell and the ivory bracelets from Benin, and the intensely dramatic Dan Mask, among many other beautiful pieces. She couldn't use the spare bunch because it was locked in the suitcase with a key from the missing ring, and while hovering at the bedroom door wishing she could think what to do, Jones passed. 'Jones,' she said, 'have you seen my bunch of keys?' He hadn't and, observing her predicament, said, 'If you'll excuse me, madame –' At which point he removed a hairpin from her hennaed hair and, bending down, proceeded to pick the lock with the skill of an old hand. Pushing the door open, he waved her in: 'Madame, your bedroom –'

Mrs Epstein, delighted and amazed, was also practical: she fired him. 'It's not safe to have him in the house,' she told Peggy-Jean afterwards, upset at the news. 'Think of all the valuables . . .'

After that experience, Mrs Epstein never felt really safe again. All the same, she wished the departing Jones well. 'Always wish them well and wish them further,' she added, a favourite phrase among the many she was fond of drumming into Peggy-Jean's head. She gave the butler an excellent reference.

Epstein was sitting beside the partly carved *Genesis* in his garden shed at his tiny cottage on Baldwin's Hill when he wrote to Kathleen about a remarkable series of illustrations of the Old Testament he had in mind: 'It is raining all the time. I have nothing to read except an old Bible. I

keep reading Genesis and have made some drawings.' The scores of drawings which led to the publication of the book of them (*Seventy-five Drawings*), and selected from his Duke Street exhibition of 1928, may have started off a phase devoted to an area of art that had always fascinated him, whether in line or watercolour, his return to the medium seen first with the *Rima* studies and then with his breathtaking exhibition of his drawings for the Old Testament at the Redfern Gallery in 1932. The Song of Solomon in itself would have interested him since – visionary, rich, exotic, spicy even – it expresses his own work well. He was brought up in the Jewish faith by a strict father who spoke Hebrew, and would have been drawn to the Old Testament because it was the Hebrew original: the search for the Messiah is, it could be said, more in tune with the spirit of his art than the Messiah found.

Genesis itself was completed in Hyde Park Gate in time for his February show at the Leicester Galleries in 1931, where it was surrounded by bronzes like *Paul Robeson*, *May Goldie*, *The Sick Child*, and *Israfel*, a new bust of Sunita. Of this he said, 'The fact that I had a Russian or Indian model would not mean that I was influenced by Russian or Indian art. The *Israfel* is taken from an Indian model, but it is purely Greek in feeling . . .' About *Genesis* he was unusually frank over his intentions. He had conceived it long before, in 1926, after his study for the *Visitation*, another facet of the same idea: 'I felt the necessity for giving expression to the profoundly elemental in motherhood, the deep down instinctive female, without the trappings and charm of what is known as feminine; *my* feminine would be the eternal primeval feminine, the mother of the race.' It was the continuation of a theme with which he had been preoccupied all his life – the *Maternity* of the 1908 Strand figures, of the Hoptonwood *Maternity* of 1910, and *Birth* of 1913. He said: 'The figure from the base upward, beginning just under the knees, seems to rise from the earth itself.' Again, there are connections with *Maternity* of 1910:

From that, the broad thighs and buttocks ascend, the base solid and permanent for her who is the bearer of man. She feels within herself the child moving, her hand instinctively and soothingly placed where it can feel this enclosed new life so closely bound with herself. The expression of the head is one of calm, mindless wonder. This boulder, massive yet delicate, with transparent shadows of the light marble goes deep, deep down in human half-animal consciousness . . . She is

serene and majestic, an elemental force of nature. How a figure like this contrasts with our coquetries and fanciful erotic nudes of modern sculpture. At one blow, whole generations of sculptors and sculpture are shattered and sent flying into the limbo of triviality, and my *Genesis*, with her fruitful womb, confronts our enfeebled generation . . .

A visitor to the exhibition, unknown to Epstein and a great admirer of his work, was so struck by what she saw that she told her young son, Bernard Williams, some years later, 'He has captured the feelings of a pregnant woman in a way that no person could ever have imagined.'

Yet before the exhibition had even opened, it was suggested that the gallery director should withdraw this brilliant piece – 'It seemed a strange squeamishness that would question the right of a modern artist to deal with the subject of pregnancy,' Oliver Brown said. And when it did open, the work was duly met with cries of horror: in fact, it outdid *Night* and *Day* for coverage. That surprised him: 'I worked on this figure with no hesitation, and with no preliminary studies, and knew very clearly what I wished to achieve. I attacked the stone with my aim very clearly defined in my mind, and with a sympathetic material.' In fact, he was astonished by the work's reception. This was vehement.

Our emasculated period was shocked by a figure without 'sex-appeal', without indecencies, and without charm. It was not the eternal feminine of eroticism, and perhaps for that reason raised the ire in woman. Women complained I had insulted their sex; there is something in this complaint. Missing in this statue all the usual appealing, so-called 'feminine' graces, they would see in it an attempt to undermine their attractiveness, their desire to please and seduce. This is where 'the insult' to womanhood came in. They were more alarmed at the fundamental truth of this statue than at the many cruel caricatures perpetrated by a Daumier, a Toulouse-Lautrec, or a Grosz, whereas my work is a hymn of praise and rejoicing. The misunderstanding of my motives and the perverse construction placed upon my aims always astonishes me.

With Epstein, loss of temper was rare ('I have put all my violent energy into the work,' he said, 'there is none left for this stupid thing'), but impatience with an obtuse public shows through with these words. Press and private view days were never a pleasure to Epstein; the sooner

he could get away to the quiet of his studio the better. He could not, however, escape the repercussions: apparently timed for the opening of the exhibition, Londoners were alarmed to learn that shots had been fired at *Day* on Broadway, hitting the figure of 'father' in the right forearm and the chest of the 'man-child'. Thus his works at the Underground building (patrolled by police since the earlier 'bomb' incident) and his *Rima* in Hyde Park had been the objects of altogether four fanatical hate attacks in just under eighteen months. A shooting, however, displayed a horrific escalation of the vandalism of his sculpture, and, compared to this, the vociferous verbiage poured out over *Genesis* seemed relatively mild: 'Mongolian Moron That is Obscene' (*Daily Express*); 'Mr Epstein's Latest – And His Worst' (*Daily Mail*); 'A Statue Unfit To Show' (*Daily Telegraph*). A cool notice from James Bone in the *Manchester Guardian* was as unhelpful to his cause as the cruder ones. Nevertheless, vicious as the reviews were, the statue was sold; Alfred Bossom MP, an architect, bought it and then offered it on loan to the Tate, where the Trustees refused it on the grounds that it had caused a 'sensation' – it was, Epstein said, thought to be 'unsuitable for the solemn walls of the Gallery'. This annoyed Mr Bossom as much as Epstein – the MP immediately sending it on tour to collect money for charities: in Manchester, over 40,000 paid to see it, and in Liverpool, it realized £1,200 for the Bluecoat School's new building fund.

But Epstein didn't always mind criticism; he found it often amusing: 'You mustn't,' he said to Haskell, 'put your indignation into my mouth in this book or you will be misrepresenting me entirely. I have already had to cut out a good many paragraphs from some early chapters,' he added pointedly. If there was no criticism, he said, he would be quite certain that something was wrong with his work. He enjoyed the typical banter heard at the exhibition: 'There is a remarkably religious atmosphere about *Genesis*.' 'Yes' – with a sneer – 'a religion from the East.' 'Do you know a religion that doesn't come from the East?' The second voice moved off. First voice: 'It shows what power the sculptor must have put into his work to make an otherwise harmless idiot so offensive.' However, Paul Nash's comments in the *Weekend Review* a couple of months later, on 18 April, were sufficiently untrue to stir Epstein to action and to write a reply. Nash, attempting a put-down, was relegating him to the level of the 'man-in-the-street' who enjoys cheap entertainment, a ploy which others used even after Epstein's death. Nash, of course, had a way of looking down his nose at those

around him – he was quite different in character from his brother, John – and began with a slight air of plummy pomposity, 'Now that the shouting has died down and no one writes any more letters to the papers about Mr Epstein's *Genesis*, an unprejudiced inquiry as to what all the fuss was about might not be out of place . . .' He went on to say that the world was full of humourless people and that 'dolts' were not rare. Epstein, however, *was* rare – as a critic at Epstein's exhibition had remarked, he was the only artist around with the power to shock. Nash went on:

> More to the point is that Epstein is the only artist among us who *wants* to shock. His work is definitely *épatant*. The principal subjects of his exhibitions are invariably controversial. But it is seldom aesthetic controversy which they excite. Faced with such a creation as *Genesis*, critics and purists are apt to stand a little to one side, if they are not to be positively elbowed out of the way or trodden under foot.

But it was journalists rather than critics who wrote about 'important' sculpture by Epstein because there was much for a journalist to write about: the naming of the work stamped it with the expression of 'a great idea; this philosophical idea has to have a name – *Genesis*.' It was 'the expression of a thought hardly realized within the limits of art, but seeming in some ways to have other ambitions' besides that of pure form. He didn't know what these were other than 'to shock, to challenge, even to hurt the minds of men'. Epstein was the perfect example of the artist seen as a public figure – he was the average man's ideal of what an artist should be: Epstein could be relied upon to put on 'a great show'.

Nash wouldn't allow Epstein to republish this review, to which he replied:

> I suppose I ought to be extremely flattered at the length of Mr Nash's so-called 'post-mortem' on *Genesis* and myself, but apart from the many amusing quips and divagations, I am struck by the ready accusation, for it amounts to that in my mind, that I am 'out to shock', and further on this is varied, as follows: 'to shock, to challenge, even to hurt the minds of men'. I might assert with as much authority that Mr Nash paints anaemic pictures in order not to hurt people's feelings. Mr Nash by his accusation of my intention to shock, allies himself with that large body of journalists and critics who declare that I work with my tongue in my cheek.

Taking up Nash's point that his concern was not only with 'pure form' ('whatever that may mean'), Epstein said that proved

> that Mr Nash is not above borrowing an idea from that school of aesthetics and critics commonly supposed to reside in the neighbourhood of Gordon Square: the 'through the teeth' school.
>
> Mr Nash deplores the fact that when a work of mine is in question the critics and purists are shoved aside if not positively trampled on. Actually the critics in the case of *Genesis* came out in force and had their say in full and all agreed with the gossip writers, comic men and indignant letter-writers that *Genesis* was 'shocking' . . .

It was left to Wilenski in the *Observer* and the Belgian critic Sander Pierron in *Neptune* to pick up the pieces. Wilenski wrote: 'No other sculptor in England to-day could have produced this *Genesis*, because no other is mentally so removed from everyday life as to be able to arrive at this primeval conception, and to rest upon it as sufficient . . .' And Pierron: Epstein had, he said,

> the fierce and inflexible will of those men of primitive times to whom his *Genesis* takes us back. Is it not true that he is related, across the milleniums, to those sculptors in ivory who chiselled that famous and astonishing figure of fecundity, called the Venus of Brassempuy, whose body, so small in size yet grandiose aesthetically, displays the same 'fatal' deformities as the lofty marble figure by Jacob Epstein? This primitive artist has been guided solely by instinct. The sculptor of *Genesis* is guided uniquely by reason . . .

Two or three days before Nash's patronizing notice appeared, Epstein's generous foreword to Moore's first exhibition at the Leicester Galleries in mid-April was being widely quoted in the press: 'Before these works I ponder in silence. The imagination stretches itself in vast disproportions . . . Henry Moore by his integrity to the central idea of sculpture calls all sculptors to his side . . .' He went on to praise him further, and Oliver Brown was in particular (and not unnaturally) struck by this act of generosity (it was most unusual to find sculptors in such a competitive activity being nice about each other's work); and Moore, he said, 'never forgot it'. Certainly Moore did not respond in a similar fashion over Epstein's work, and, in view of his failure to assist when threats to the Strand figures recurred four years later, Epstein could hardly have agreed that his kindness had been remembered. Nor would he have

written so glowingly again: although he meant what he said then, speaking just as highly of his work to Haskell ('for the future of sculpture in England he is vitally important'), in retrospect he saw Moore (as perhaps he had seen Gill) as a promising student who hadn't fulfilled his promise, too many enemies of it – ambition, politics, worldly success, assistants and the rest of the paraphernalia of fame – blocking the development of his natural gifts. Anyway, there can't be much doubt that Epstein's foreword was largely responsible for the exhibition immediately putting Moore on the map: his praise did the trick – one section of the press went overboard for the show. The English find was hailed as a 'genius'; Moore was already heading for a place in the safety net of the new art establishment that was overtaking the traditionalists. Often referred to as the 'Hampstead Highbrows' by the so-called 'Chelsea bohemians' some miles to the south, its nucleus lay with the up-and-coming modern movement of painters, sculptors, architects, critics and patrons: a founder member belonged to a slightly earlier generation – Paul Nash.

Epstein had no particular interest in this group. Well out of range in the quiet of his studio or his cottage in the Forest, and glad to have escaped from the nightmarish ordeal of his own recent exhibition, he was thinking out ideas for illustrating the Old Testament: 'Moses descends from Sinai' (Exodus, Chapter XXXII, verse 15); I Kings, Chapter II, verse 12; The Song of Solomon, Chapter VI, verse 10; and 'The Hand of God' were some of those which he transformed into sixty watercolours for a Redfern Gallery exhibition in 1932; the drawings which he had begun the year before at Baldwin's Hill had gripped him: 'I became so absorbed in the text and in the countless images evoked by my readings, a whole new world passed in vision before me. I lost no time in putting this upon paper.' It was a good year. Haskell's book, *The Sculptor Speaks*, was published, had excellent reviews and was a considerable success. And alongside this came a stream of commissions and studies from models: the third bust of Kathleen, the last work from Sunita (reclining) before she went back to India and mysteriously died, the second portrait of Lydia, the third head of the clergyman's daughter Oriel Ross, one of the actress Joan Greenwood, and the completion of the *Sun God*, begun years before, with the addition of a relief of *Birth* carved on the reverse side of the Hoptonwood slab. Like a painter who turns over his canvas board without a thought for sales to attempt another version of a theme, Epstein used the bare back of the

stone for one more idea in his series on creation. Then one morning, in late October, a letter from a Miss Cooke came asking the price of a portrait she wanted to commission of Emlyn Williams, a young actor who had just made a hit in the latest Edgar Wallace play, *The Case of the Frightened Lady.* Epstein wrote back: 'Dear Madam, I acknowledge your kind letter. My fee for one cast of a bust is Two Hundred Pounds (£200). I await hearing from the young gentleman concerned.' Even for Epstein, £200 was modest, and possibly so because the sitter interested him. A year later, when Arthur Tooth asked him for his prices, he gave a figure of rather more than that. Hardly surprisingly, a telephone call came the next day: 'Could you put me through to Mr Epstein, please?' 'This is Jacob Epstein.' Williams was struck by his shy, gruff voice. 'Mr Williams, is it? May I suggest about ten morning sittings, starting 10 a.m., Friday, collar and tie?'

When he arrived at 18 Hyde Park Gate, which he was interested to find was a large respectable house, the door was opened 'by a coatless caretaker with sleeves rolled up who seemed to be engaged on some job in the shabby hall'. This was Epstein: had he looked closely at his shirt, he would have noticed that safety pins held it together where buttons were missing; his cuffs were always held together with safety pins. 'He smiled and bowed. "Please come in." He then took me gently by the elbow as if I were a breakable object.' His manner, the actor said, was as diffident as his voice; he went down a couple of steps to the studio and was led to a gnawed high stool in the middle of the floor where Epstein asked him about Miss Cooke. 'She sounds a fine woman, how kind of her to write to me. Excuse me while I walk round you.' Many sitters have commented on the metamorphosis that occurred when work began; that his gaze changed suddenly, sharp as a pencil point as he walked round the sitter with cool detachment and narrowed eyes. While Emlyn Williams studied the armature on a stand, two pieces of wood roughly knocked together like Christ's Cross and covered with a grey mass of clay, he felt he was under examination by a surgeon about to perform the most delicate of operations. And as he became aware that he was being studied from every angle, he realized that his face was becoming increasingly transparent, as though there was nothing left inside it that could be concealed from him. Then, after rolling the clay into a mass of things the size of chipolatas and slapping them on to the 'mess' of the armature, he set to work with 'lightning dexterity'. 'Relax, please,' he said as he studied his head 'with the cold absent stare of an adversary'.

All Williams heard from that moment through nine mornings was his rapid breathing 'alternating with the sharp unconscious grunts of creation'. Williams felt relaxed and calm throughout: every day, he said, the shy, courteous host was transformed into the absorbed, implacable creator the moment he entered the studio. Occasionally he made some vague remark which Williams found so absent-minded 'as to convey an idea of ventriloquism': 'What a prolific writer Wallace is!' 'Warm for November, would you say?' And then, as though discussing the work with some other professional: 'Strange. I have always found that the face of every male sitter has one profile masculine and the other feminine. I've rarely seen it so marked as in this one.'

With the completion of the bust near, the part of the sitter, watching his re-creation in clay, took possession of the actor, so that he seemed to become in some way inseparable from the creator:

> As the end approached, the hammer-gossamer hands took to hovering stealthily above the work, as if about to pounce and destroy it, while the eyes bored into my face and then into the clay, darting with increasing speed from one to the other. Then two fingers would slowly descend, stubby yet feather-light, and flick the clay with the last vital touches. They would press it a thousandth of a millimetre to left or right: a stroking which, if it had not been professional, would have been a caress.
>
> The rhythm of his movements – of the fanatical jerks of the head as he stared from me to the clay and back, of the airy touches – began to accelerate, the grunts grew sharper, the breathing more frantic, as if this were a sex ritual and an act of consummation was taking place.
>
> And that seemed splendidly right, for what is more physical than the phenomenon, as simple and mysterious as birth, of a pair of human hands, over hours, moulding dead clay into the eternal semblance of a mortal man?
>
> After the very last brush of a finger-tip coaxing a last edge of clay-flesh one hair's breadth into perfection, the hands rose slowly together from the work and turned back into the peasant hammers. Then came the long expulsion of breath, as final as the end of life.

Epstein opened a packet of Craven A cigarettes and draped a frayed dish-cloth with a cigarette burn in it over the head.

'I think that's all,' he said, striking a match with a hesitant smile that showed broken teeth. 'You have been very patient – children are the most difficult sitters, of course.' One of his finest heads was done.

*

Isabel Nicholas must also have wondered about the burly man who answered the front door around this time. Isabel, young and juicy, brought up in Liverpool with a sea captain for a father, ran away to art, joining the Royal Academy Schools in London. She was penniless, and a sculptor there suggested that Epstein might employ her as a model. Try him, he said – he was always on the lookout for suitable subjects. She explained she wanted work and, although a model named Ahmed, an Arab girl, was already living there, he was most welcoming. She was amazed. 'You can come here,' he said. 'You can sit for your portrait, help in the studio, go to school, do your own painting –' If she wanted, as she said she did, to draw at the London Zoo, that, too, was fine by him. He was never indecisive: he had taken to her; liked her looks, manner, bone structure – quite enough for him to invite her to stay.

She couldn't believe her luck: here she was, eighteen, moving in with the great artist, and, for a girl who didn't know where she would spend her next night, the house was as comfortable as a hotel. She was adopted as one of the family, taken to Baldwin's Hill at weekends, out to restaurants and, at Eastertime, to Paris. It was an extraordinary introduction to art – there, she went to Rodin's museum, the Louvre and cafés where she met artists like Picasso and Derain; but then, Epstein only went to Paris to see artists and dealers – he didn't like the French bourgeoisie whom he regarded as narrow-minded. And there was Le Dôme where a seat was named after him and admirers came to shake his hand. Yet it was an arrangement that suited both sides. For Peggy-Jean (now a boarder at Dartington Hall), Isabel was like an older sister (with the single exception of Sunita's son, Enver, this was the first time she had had the constant companionship of someone at home who was near her own age); for Mrs Epstein, she was like another daughter, and intelligent and attractive enough to divert her husband's attention from the 'witch', Kathleen; and for Epstein, she was an excellent model. In 1932, he made his first bust of her, an experience from which Isabel learnt about the methods of a real, hardworking artist; that everything was done with great care, and that since each move was calculated beforehand he knew in advance exactly what to do – nothing was left to chance. If she found him rather silent on the subject of art when she sat for him (he preferred lighthearted conversation), one thing came over clearly: his views on it were decided and unattached to those of others.

Mrs Epstein, despite her vast size (always on strict diets, she refused to go to doctors), was quite active – she was the matriarch, looked after

everything, acted as both mother and secretary to Epstein – in her eyes, Isabel discovered, he was the greatest genius ever: hence the reason her life was entirely given up to him. Yet her faith in his genius didn't prevent her from being, or so it seemed to Isabel, extremely jealous of other artists' successes, notably John's: 'Don't ever go anywhere near Augustus John, *will you*?' In his case, this order suggested that something more than jealousy was in her mind; that she was afraid of Isabel straying – John was, after all, a confirmed womanizer who wouldn't be able to resist the charms of the lovely Isabel with her precocious sexuality. The last thing Mrs Epstein would have wanted was that, now that her husband was so interested in her.

Isabel was at this time unaware of his interest. Go to bed with his models? – the idea was absurd; if anything, he was rather a puritan about that kind of thing; that was her feeling. She was of course aware of Kathleen's existence, but this didn't mean much to her – Kathleen was no more than a name, a vague, outside presence. Isabel, on the other hand, an insider, was a witness to the sculptor's endless activities. For instance, shortly after she arrived, a new row blew up over *Genesis*: having toured Manchester, Liverpool, Leeds and elsewhere, it had ended up, he believed, in a sideshow in West Bromwich. Off went a letter to the *Manchester Guardian* on 13 December 1931: under the headline 'EPSTEIN ANGRY', he said that he wished to dissociate himself from this indignity, and that the manner in which it was being shown was 'disgraceful'. The local council and Bossom appeared equally annoyed (the work had been borrowed for a trade fair at the Town Hall), also dissociating themselves from the affair. Matters had been made worse by a letter to the paper from Mrs Bossom which defended the exhibition of the work for charity purposes because of the many thousands of pounds that had been collected in this way. On hearing this, Epstein told a reporter that the work had been shown in a most unsuitable manner, and that it was, in effect, part of a trade show, and that this was not the environment in which a statue should be seen. He was, however, particularly incensed to learn that Mrs Bossom intended to take *Genesis* to America. 'I should like to ask if she intends to show it at Coney Island for charity or for any other purpose,' Epstein said. 'It is with real sadness that I see that Mrs Bossom has failed to call for any modification in the showing of my work.' This controversy, attracting maximum publicity, may have put an idea into some others' minds for which Epstein suffered later.

But there the matter ended. He had his work to do: he was in the middle of another upsurge of activity. In 1932, there were a dozen portraits, including the fourth *Kathleen* (laughing, as she so often was), the fourteenth *Peggy-Jean* and the excellent *Isabel*; and there were the alabaster carvings of *Chimera* and *Elemental*, and the Hoptonwood *Woman Possessed*. But first, in February, came the opening of his exhibition of Old Testament illustrations at Rex Nan Kivell's Redfern Gallery in Cork Street. This display of sixty astonishing watercolour drawings, some coloured, some not, carried out entirely by brush, caused the predictable uproar, for the works, an attempt to interpret in imaginative terms complex characters like David, Saul, Moses, Jehovah and others, peeled away a several-centuries-thick coating of cover-ups that had rendered the truth of their emotional exploits palatable to the respectability of English taste. 'When I exhibited them,' Epstein recalled later, 'it seemed that I had again committed some kind of blasphemy, and countless jibes were forthcoming. There is an element in all countries which would suppress the fine artist, kill original thoughts, and bind the minds of men in chains . . .' Nevertheless, the drawings prompted a remarkable notice in the March number of the *Architectural Review* by Cyril Connolly, then in his late twenties. He called the exhibition 'a magnificent attempt' to penetrate the emotional mysteries surrounding these ancient aboriginals. He wrote:

Who were they? What did they look like? These Kings of a small negligible country; these prophets whose austere message was revealed in visions of inconceivable vulgarity; wheels, flying rolls, whores and many-headed monsters; this Deity who, despite his claim to unity and omnipotence, seems more parochial and earthy than the least divinity on Olympus – 'Old Nobodaddy up aloft' whom the translators of James's reign elevated into an English headmaster, a beast, but a just beast, and wearing his old boy's tie. The English genius has absorbed Judah as it has absorbed Greece. But so far it has not absorbed Mr Epstein, for it can only swallow its prey dead. In fact, the importance of Mr Epstein is that in a world of art where the masterpieces of Greece and Rome have unconsciously influenced everyone, as much as those who reject as those who accept them, he alone has been able to stand absolutely outside . . . For this reason, no one is better equipped to rescue the Old Testament from the Anglican Church, to scrape off the accretions of Anglo-Hellenic good taste that generations of Etonian bishops have allowed to accumulate on the subjects of

their exegesis. At last we see them as Blake would have drawn them had Blake been a Jew. Mr Epstein has taken his subjects from the Hebrew original. He prefers 'dissipabitur capparis' – the caper berry will cease to be an aphrodisiac – to 'desire shall fail'; he finds that David did not play the harp to Saul, but played with his hands, and paints them doing so. His heroes, I think, are Moses and Absalom; Moses he draws as a huge man of extraordinary physique seen splendidly beside his altars or, in one of those strange conjunctions observed by our own teachers, with his Ethiopian wife. Absalom is perhaps Mr Epstein's favourite. He seems an inscrutable youth impelled by pride, a kind of driving power of evil, to rebel against his father. Notice the extraordinary expression, remorse fighting with self-justification, in the reproduction which shows him with David's concubines. The keynote to all his pictures is the flaming yellow hair prophetic of his ruin. Other pictures of this passionate and tortuous race show David dancing, farouche effeminate, royal; David in bed with Abishag, the brown girl reverently nestling like a squirrel, on the great cold bosom; Absalom the Pretender seated on the Throne with the same fixed stare of emotional conflict; Joash the boy king, awkward and lonely, on the primitive Throne; the messenger for the Creation; the spirit on the face of the waters; Abraham, Isaac, Noah; obscure echoes of scripture examinations, Billah, Benaiah.

The drawings themselves are amazing in that sureness and simplicity, the power of the line, the extraordinary sense of drama the artist brings out in them, in the half-divine heroes of these barbaric tragedies. Epstein himself enjoys doing them very much; he finds them a relaxation from sculpture, from hard work in three dimensions. He enjoys painting rainbows, fiery furnaces, writing on the wall, subjects that elude the chisel. The pictures here shown are only a selection of his biblical drawings. He works fast and starts again on a copy if he is unsatisfied. He is beginning on the visions of the prophets. No one should miss this fine exhibition of beauty, of alien splendour – this story told by these fierce watercolours of the chequered dynasty of Jesse, till Solomon, in a drawing of exquisite grace and lightness, succeeds to the throne and sits before the pentacle, which is painted – as if to emphasize the similarity between the royal youths – the yellow of Absalom's hair.

The refreshing brilliance of Connolly's appreciation, objective yet impassioned, whistles like a cool breeze through the heaviness of much of the contemporary criticism surrounding Epstein's art, whether outraged

or not; no boring hang-ups – a young writer's imagination had responded to the great sculptor's, a rare happening, then or later.

Connolly's analysis opened up a vision of Epstein's entire world of ideas and inspiration in the setting of English middlebrow taste. He had been drawing throughout his life, either from the model or for sculpture, almost always with crayon, pencil or black, blue or red chalk in a multitude of studies of the Lower East Side, the Strand figures, *Rock-Drill*, people in the war, Sunita and others, and only occasionally, as in the preparatory sketches for *Rima*, using watercolour. This, however, was a new departure. After returning from Paris, where he had bought some Fang pieces following the dispersal of the de Miré collection at the Hotel Drovot, and coinciding with renting Deerhurst, he became deeply interested in this very subtle and difficult medium. Deerhurst, a pleasant and spacious house, just across the lane from the cottage where he continued with his sculpture, was faced with a close-up of the beech forest, as dense as a hedge, down the slope at the end of the garden. The scene is as unexpected as Epping Forest is unexpected. After Walthamstow, following the Green Line route he used, suburban London breaks off, crumbling away into village fragments, ponds and collections of cows grazing: ribbon developments vanish up the sleeves of glades and mysterious tracks disappear in the undergrowth. The view from Deerhurst catches the suddenness of that remarkable metamorphosis: like Pett Level, Baldwin's Hill was, despite its close proximity to London, extremely remote – in the Epsteins' day, only a few cottages (from which, to their exasperation, neighbours peered from behind curtains to watch the famous artist's unusual entourage) and an inn existed: a quiet, rural scene. While Mrs Epstein pursued a botanist's pleasures at Deerhurst (until so incapacitated that a gardener was employed full-time), planting rhododendrons and lilies, he could enjoy breaks from sculpture in the intense atmosphere of the ancient forest. He heard voices there; and the luxuriance of it, explored on walks with Peggy-Jean down by his favourite pool (good for swims) and on to the Owl pub (then white-boarded with a beautifully panelled dark interior) for tea a couple of miles off at High Beach, filled his mind with curious visions and imaginary tales inspired by nature, its trees, its creatures, its foxes, deer, hares, badgers, and birds; and by legends – that once upon a time, for instance, priests had trained branches in Great Monk Wood to follow the shape of an elephant and other animals. Imaginative experiences of nature over ten years, and which included *Rima*, transformed his latest phase.

Two of his strangest works, *Chimera* and *Elemental*, possess the imprint of the Forest. *Chimera* is, in particular, frightening: like some gigantic blow-up of sperm or a mindless apparition, well-suited to the 'nightmare' of the German usage, its eeriness is magnified both by its tiny dimensions (4″ high × 9″ long) and by the translucence of the alabaster from which it is carved. The meaning of the name he gave it seems to be a clue – an 'organism', 'a fire-breathing monster with a lion's head', 'a grotesque product of the imagination', 'a fabulous beast made up of parts taken from various animals' with 'a tail of a serpent'. Epstein's head and tail appear as a manifestation of some alien, unseen force emanating from the depths of nature, and, because of it, as a threat to nature: inexplicable, momentary, yet none the less capable, like some experience of the supernatural, of inspiring panic, even terror: a giant, translucent tadpole floating from murky shadows. That image suggests a peculiar connection with *Elemental* which, two feet tall and, like *Chimera*, carved from alabaster, but this time with a rough finish, seemed to contain a terrific inner force in its compact form – at any second it may spring, startling us like a frog. This mysterious, crouching object again hints at some alien predatory power that lurks in nature, its blind eyes and flattened head generating a fear of something somewhere unknown, unseen.

Epstein had never before touched on the supernatural; it had always interested him, having had unexplained experiences which he put down to some kind of human radar – there was the haunting dream he had prior to news of the death of his mother and there were the voices he heard on his walks. Was he attempting an interpretation of nature through this medium? Both *Chimera* and *Elemental* were carved in his shed across the lane, yet close to the atmosphere of the Forest. And then there was *Woman Possessed*, in this instance chiselled out of his favourite Hoptonwood stone, another strange work with an obscure source of inspiration. By what was the woman possessed, lying on her arched back, hands clenched, eyes shut, body tense? With three women in his life, was it a comment of a personal kind? Or was it an expression of Woman's predicament? Cast in a submissive role by society, she wants to achieve the upright position occupied by Man. Was this the explanation of the display of frustration and desire the work suggests?

Although so different in idea to the other carvings of that year, this work is sufficiently mysterious and sensual to indicate an influence of nature. And though it was exhibited, together with *Chimera*, at the

Leicester Galleries in May, surprisingly, *Elemental* was not, for some reason, shown until after Epstein's death. Then, following this exhibition, he came down to earth with his second portrait of Isabel. This one was magnificent – the upright, three-quarter-length work which generated the tremendous self-confidence of a remarkably beautiful girl, an aspect of youth not seen before in his studies of women; with the breath of a secretive smile, the jutting superb breasts and – a brilliant touch – the Hasidic earrings (doubtless an offering from Mrs Epstein's treasure chest) spiralling down to the shoulder to transform the ears themselves into sculptural elements of a unique kind, the portrait captured an oriental eroticism which always fascinated him. The predatory sensuality that emanates from the work suggests that, by then, there was more than a passing attraction between artist and model.

At the same period there came, too, a sudden, startling new departure: landscape painting. With Kathleen having gone to Martigues for two months to see her sister, Helen, who had recently married Roy Campbell's blond fisherman friend, Grandpère, and now had a baby, Cathy, Epstein went to Deerhurst with his family and Isabel. As he explained later to a reporter interested in how he took to painting, he had a little cottage on the edge of Epping Forest.

> It's a lovely spot in the summer and the colours of the trees are gorgeous. I was down there in August when it was very hot, you remember, and I thought how nice it would be to sit in the shade of the trees. But as I could not do any work there, and as I hate doing nothing, I had a notion to try to paint. So the beginning, you see, was more or less accidental.

Isabel, a gifted painter herself, often with him and Peggy-Jean in the Forest, thought she might have started him off with the idea by painting the woods herself. While his watercolours were a development of work begun earlier, she may well have been right that her initiative had something to do with his latest, extraordinary adventure, but he had, of course, been moving in the direction of watercolours for some time. First, the *Rima* drawings, then those for the Old Testament; and that year, 1933, his illustrations for Moysheh Oyved's long prose poem (in which the mystic saw himself as the prophet of God) were published as a book by Heinemann. Perhaps he had done these as a favour, Oyved having been helpful to him in the early days, but he was enjoying the

medium. And now, on these walks together, the three of them didn't have to go far before they saw something of interest worth painting: 'As usual with me,' he said, 'what I started as a mere diversion became in the end a passion, and I could think of nothing else except painting. I chose to paint, and painted until sundown . . .' When sundown came, a painting was finished; there was no going back the next day because then the conditions – the light, weather, the entire look of the scene – would be different. Towards the end of August he wrote to Kathleen in Martigues, telling her what he had been doing, but clearly in a state of some distress. He was missing her very much and blamed himself for difficulties that had arisen between them: 'How long seems our separation.' Although he had his work, two months without her was far too much, increasing his longing for her. Why was she coming back on Saturday and not Wednesday?

> Separated from you I am really unhappy and try as I do to absorb myself in painting the days and nights drag. If you will answer this when you get it I can then go through this forest to Epping Town and that will help pass the time . . . In this forest which I visit we could live quite happily and nature might seem just as wonderful to exist in as in the South of France . . . I have over 30 paintings. Nothing in that . . .

Thirty paintings was a considerable understatement: the gallery owner Dudley Tooth saw a selection of around forty paintings of Epping Forest when he came to Hyde Park Gate in September; another sixty or so remained at Deerhurst.

Tooth had been in touch with Epstein since 1930, writing to him when a Mr Keene wanted to buy a cast of the twelfth portrait of Peggy-Jean, *The Sick Child*. The price was eighty guineas and over the next two or three years several bronzes were sold through this gallery; in addition, Epstein had bought a Matthew Smith there, and had two other paintings by Smith framed by it. However, when Tooth saw the watercolours he was so struck that he immediately wrote to Epstein offering him an exhibition and making an appointment for him to come to his gallery on 3 October to see if he approved of his framing of one that he had taken away with him. It so happened that Epstein had been working on a head of John Gielgud in mid-September, 'commissioned', Gielgud said, 'by an anonymous fan of mine'. The bust subsequently vanished, reappearing eventually in America: 'Epstein didn't greatly

care for it,' the actor said, 'the back of the head and neck being most like me! Epstein began very well, but got a commission to do Einstein, and he got bored with me in the end!' Perhaps this was understandable since the circumstances surrounding the Einstein commission were so very curious. He had had a letter from a Commander Locker-Lampson about the great physicist which must have been extremely intriguing: Locker-Lampson, it transpired, had smuggled him to England after he had first gone to ground in Belgium. In this bad time when Hitler was master of Germany, the British Union of Fascists was established in London, and there were rumours of a plot to assassinate Einstein, secrecy was vital. Someone wanted a portrait of him by Epstein during the short time he was in England before going on to America and it was essential that this was carried out at the professor's hideout near Cromer. A week of sittings, mornings only, had been set aside, a room booked for the sculptor, all expenses paid, at the Royal Cromer Hotel, the work to take place in a hut at a secluded spot near the sea. Epstein, driven out there, described the scene: 'Einstein appeared dressed very comfortably in a pullover, with his wild hair floating in the wind. His glance contained a mixture of the humane, the humorous and the profound. This was a combination which delighted me. He resembled the ageing Rembrandt.' The last remark left an impression in some minds that the work must be 'Rembrandtesque'. That is not so: Epstein, despite unusual and very difficult conditions, created a remarkable 'Epstein'.

Conditions were difficult: on the first day, Einstein smoked a pipe so hard he could barely be seen for the haze; then the hut, largely occupied, most surprisingly, by a grand piano, was so small that he had to have the door taken off to allow sufficient room for manoeuvre; and the sittings were only two hours long, after which the pipe-smoking physicist would settle down at the piano and play. Yet Epstein was charmed by him – he was full of bonhomie, joked about Nazi professors, a hundred of whom had condemned his theory of relativity in a book. 'Were I wrong,' he said, 'one professor would have been quite enough.' 'Einstein,' Epstein said, 'watched my work with a kind of naïve wonder, and seemed to sense I was doing something good of him.' He was doing something very good indeed. Once more, as with *May Goldie*, he returned to the image of a flower. In fact, *Einstein* was like a flashback to *Sunflower*, that early subject where the image was the sun, but in the being of some ancient god; *Einstein*, in contrast, was a reverse image – a vision of a god-like creature as a sunflower. Models often seemed to

have put such poetic images into Epstein's mind. *Augustus John* cuts to the cragginess of a Welsh coast of the painter's ancestors, while some later works of the Fifties suggest birds – there is an eagle in *Alic Smith*, the poise of a swan in *Anne Tree*, in *Maria Donska*, a blackbird. And so with nature fully in command in *Einstein*, this could be seen as in some way a continuation of his feverish work in the forest of a few weeks before: the demonstration of freedom, which Cyril Connolly had observed in his watercolours of the Old Testament, is just as evident in his extraordinary head – in the spontaneity of the idea, the halo of hair, the movement and modelling – as it is in his landscapes of trees.

Epstein had to stop work at the beginning of October and felt the bust was not completely finished (he had only twelve hours' work on it), but Einstein had to rush off to address an audience at the Albert Hall, his last public appearance in Europe before leaving immediately afterwards for America. Epstein must have been very excited, all the same. Not only was the Einstein a great head; he had received the letter from Dudley Tooth on 26 September to tell him he had been shown the Epping Forest watercolours by Mrs Epstein: 'I like them very much indeed and think they would make an attractive exhibition ... I can confirm January 18th–February 10th as dates for the Exhibition ... If by any chance Skeaping [the sculptor] is not ready for his Exhibition from Nov 29th to December 23rd, I will keep that date free for you instead.'

Skeaping wasn't ready and Epstein's paintings replaced his sculpture. He sent in a casting of *Einstein* as well, and this must have looked most beautiful surrounded by the brilliance of his astonishing summer achievements; a glorious, blazing, sunny ending to the year.

The exhibition was a sell-out; rave reviews of the notorious sculptor's latest departure pulled in the crowds; when a *Daily Mail* reporter arrived at the gallery with a prospective buyer on 12 December he was confronted with a notice on the door which read: HOUSE FULL.

There were a number of interesting developments after the opening. When Frank Pick bought a painting and an official from his department at London Transport followed suit, in this case to use it as an Underground poster, Epstein wrote to the gallery on 11 December about copyright: 'If a watercolour is to be used as a poster the company should pay a fee. I don't quite know what that should be: McKnight Kauffer works on these lines and he perhaps might let you know what is

the usual charge.' Then, with all the paintings snapped up, the gallery sent off a circular on 13 December to a list of special clients who had been unable to buy one, informing them that twelve additional studies were being brought to London from Epping Forest and would be on sale the next day from 9.30 a.m.: 'These drawings are equal in quality to those in the Exhibition and were only previously excluded owing to lack of wall-space.' At the same time, three casts of *Einstein* were sold, completing a set of six in the space of two months. And with London Transport promising, after Christmas, to pay a further £52 on top of the gallery's price, the exhibition turned out to be such a remarkable success that a permanent arrangement was established between Epstein and Tooth, other shows of paintings being held and bronzes sold. Nevertheless, Oliver Brown remained his sole dealer so far as exhibitions of sculpture went. 'Painting is wonderful,' he said, 'but sculpture, oh! That's my life.'

There was a further development: the watercolours transformed the rebel outsider into a fashionable figure: for a month, Tooth's gallery became the smart place to be. The *Daily Sketch* gossip columnist reported:

I found Lady Dashwood lingering over the Epsteins, one of the best of which was bought by Isabel Jeans, who already has an Ethel Walker in her choice little collection. Lady Dashwood is said to be highbrow. I can vouch that she thoughtfully studied these thrilling and beautiful watercolours for one hour without a companion for chatter or other diversions: Mrs Tweedie, in one of her Edwardian hats, and Mrs Alec Roberts in the most recent halo; also Cunninghame-Graham, who thought Epstein's head of Einstein was one of his finest . . .

Of course there were questions: it was a source of annoyance that he had done so many paintings – to a critic, Epstein said, this was really a sign of bad taste. Why not paint only two or three a year? 'To the sterile and unproductive person a hundred paintings all done in a couple of months is disgusting, a kind of littering.' It was no good being lazy, Epstein told a reporter, when you want to get things done. 'If you know what you want to do, and how to set about it – then there's nothing in the world to stop you going ahead and getting it done quickly. Do make no mistake. This painting is not a hobby . . .' But surely no one should paint as well as he did without years of practice? It was his first attempt – it made it all seem too easy.

The subject matter was at my door. They are straightforward landscapes. I painted them because I wanted to. Painting may be just as much my occupation as sculpture. I did not do the paintings as a relaxation. It takes a lot more than relaxation to paint. You can't make a painting as you drink a cocktail. If I feel like this I may do many more . . .

He did do many more; he had a further exhibition of paintings at the Redfern a few months later, and continued to paint, on and off, for the rest of his life. Yet he conceded that sculpture did really come first and, in the spring, A. R. Orage arranged for a portrait bust of Bernard Shaw to be commissioned; he did a further study of him as well, a head. Shaw didn't like either, and his wife thought them horrifying. Shaw said in a letter to Mrs Epstein three years later:

Jacob, as you know, is a savage, always seeking to discover and expose the savage in his sitters . . . When he said to me 'I will show you what you really are' I knew quite well that he would do his utmost to represent me as an Australian Bushman. The result was a very remarkable bust; but as I am neither an Australian nor a bushman, my wife, when she saw a photograph of it in the papers, absolutely refused to see it or to have it in her house on any terms. And she expressed her feelings very emphatically to Orage, and indeed to everyone who mentioned the bust to her.

Epstein, who was unaware of this correspondence (his wife didn't want to worry him when in the midst of a carving), had made up his mind about Shaw's understanding of visual art during the sittings. 'In matters of Art,' Epstein said, 'he aired definite opinions, mostly wrong, and I often had to believe that he wished to say smart, clever things to amuse me.' Shaw seemed puzzled by the bust which he looked at constantly, apparently mystified. Then he asked about a six-ton block of stone in the studio – what did Epstein intend to do with that? When told he had a plan, Shaw exclaimed: 'What, you have a plan! You shouldn't have a plan. I never work according to a plan. Each day I begin with new ideas totally different from the day before.' As if, Epstein said, a sculptor could alter his ideas daily when carving a huge block like that! The exhibition of watercolours of Epping Forest seemed quite beyond his comprehension, too, for he asked: Had he done the paintings with brushes? Shaw had a gift for perversity.

*

The year 1934 was full of incident. After Easter in Paris, on 10 April, he bought eleven pieces for his collection at a Sotheby's auction, among them a rare stone sculptured *Figure of Man* from Sierra Leone and extraordinary wood carvings from Makalanga: at this time he was buying avidly, which landed him in many problems and debts. Then, Isabel spent some time in the country, changed her name to Epstein by deed poll, had an exhibition at Arnold Haskell's Valenza gallery in Conduit Street that was another sell-out, and left for France; Mrs Epstein, now in her sixties, strapped a cushion under her skirt to appear pregnant (and so, as she would have thought, protect Epstein from the scandal of another illegitimate child) when reporters came to the door; Roger Fry died and Dolores, aged forty, was found dead in a basement room in Paddington; and Epstein's boy, Jackie, was born.

Mrs Epstein, writing a curious note to Matthew Smith the following year to explain a change of plan over an invitation to stay at Deerhurst, said her husband was thinking 'of the baby son I had in Sept 1934 . . .'

11
The Forest

KING'S PARADE no longer exists. In the Thirties it was a dozen or so houses on the north side of the King's Road, set a few yards back behind railings and overgrown gardens between Manresa Road and Dovehouse Street, a lane running beside a burial ground with enormous planes. This terrace had turned a quiet pink with age, looking as soft and fragile as faded blotting paper; thirty years later it vanished without a trace under a new fire station.

The Parade was in Chelsea Central, a strip of High Street made legendary by the artists who congregated there, and packed with the activity and colour of red buses, greengrocers and junk shops – people tripped over the furniture that tumbled on to the pavement, there was so much – and with cheap cafés, art stores and students. Kathleen's house was towards the burial ground (on the way to the Chelsea Palace, the famous music hall of the George Robey and Max Miller days), and its frail interior, four floors high, with beautiful fireplaces and rich with Epsteins, paintings, Fang and Benin sculpture, was simply arranged by a delicately feminine touch. Her upright piano was in the first floor front room where the tall windows and shutters folded back from balconies opposite Argyle House; and, on the other side, the rooms looked over the glass roofs of a network of studios (all gone now) off Manresa Road and just across from the Chelsea Art School which had moved from Flood Street to the top storey of a block of chemistry laboratories next to the Public Library. Her garden ended with a blacksmith's; this man had become something of a friend to her son, Theo, who was attracted by the mysteries of his workshop, its strange tools and benches, and was

always running in and out of it. One day in January 1935, she took the blacksmith up to meet Epstein in his studio (using the back way off the mews, of course) and found him working on the huge stone figure of *Ecce Homo* now clearly forming. Epstein explained it was a hard material to work, offering him a mallet and chisel to have a go. The tough blacksmith hit the stone with all his force and couldn't make a mark.

That wouldn't have surprised Epstein:

> This Subiaco block of marble was the toughest, most difficult piece of stone I had ever tackled. All the tools I had broke on it, and it was only after trying out endless 'points', as they are called, with different tool-makers that I finally hit upon a 'point' that resisted, and began to make an impression on the stone. [He wished] to make an 'Ecce Homo', a symbol of man, bound, crowned with thorns and facing with a relentless and over-mastering gaze of pity and prescience our unhappy world. Because of the hardness of the material I treated the work in a large way, with a juxtaposition of flat planes, always with a view to retaining the impression of the original block. Matthew Smith on seeing the statue in my studio said: 'You have made a heavy stone seem heavier' – a profound comment. The plastic aim was always of paramount importance and the 'preaching' side secondary, or rather the idea, the subject, was so clear and simple to me, that, once having decided on it, I gave myself up wholly to a realization of lines and planes, what our critics are fond of calling 'the formal relations'. I have not attempted to describe this statue as I think it describes itself. I will let the beholder do that. I look at the work and feel that it confronts time and eternity.

It was exhibited, not quite finished, at the Leicester Galleries: at eleven feet high, surrounded by portraits of Shaw, Lord Beaverbrook, Hugh Walpole and many heads of women, it must have looked astonishing, yet it was not a work which owed anything to the Easter Island sculpture it is often supposed to; its idea was determined instead by the marble block, the outline of which, as he said, he wanted for the frame for the work, and by the massive head, its mind: if there is a likeness with the sculpture of that Pacific island, it's an accidental one – literal influences formed no part of Epstein's art. The moment the show opened, this work, called *Behold the Man*, was attacked, G. K. Chesterton leading the way in the *Daily Mirror*: 'It is an outrage, and I admire the *Daily Mirror* for refusing to publish a picture of the statue. It is one of the

greatest insults to religion I have ever seen, and will offend the religious feelings of the whole community.' Why? What was offensive about a symbol of man in the being of Christ, and carved on a magnificent scale because, intellectually and spiritually, Christ was magnificent? As Laurie Lee wrote of it so beautifully: 'Squat, square, the totem of our crimes, he stands before us in a pitiless, blinding light. No chisel was ever less compromising than Epstein's in this work. Ten thousand churchfuls of sentimentalized Christs are denied for ever by this raw and savage figure.' Presumably Chesterton, like the public in general, preferred the standard, academic, sentimentalized version, regarding originality, when applied to a religious subject, as a horrific sin: Epstein had suffered the same outcry when his *Risen Christ* was shown, fifteen years before. Lady Snowdon backed up the writer's view: 'I congratulate you. To publish such an atrocity would have offended thousands . . .' The art critic of the *Catholic Times* introduced the familiar note of racism: 'We see only a distorted reminiscence of a man: the debased, sensuous, flat features of an Asiatic monstrosity . . . As an art-lover, I deeply appreciate beauty, but *Behold the Man* is not beautiful: it is ugly and vile.'

These attacks brought in the supporters: sculpture, T. W. Earp wrote in the *Daily Telegraph*, was 'an exhausted art' when Epstein arrived on the scene, 'devoted to academic exercise'. He had given 'the art a new lease of life', bringing 'to it an enthusiasm and an impetuous imagination which broke the rigid mould. He enlarged its scope and originated a spirit of experiment . . .' He went on: 'With astonishing virtuosity, and frequently with something more, he still keeps abreast of his disciples. He has put sculpture back into the news and aroused a public interest in his work that may occasionally be embarrassing. At his exhibition at the Leicester Galleries controversy rages as usual . . .' And so it did, from a very long and very silly diatribe by the *Sunday Pictorial*'s editor to the balanced understatements of James Bone in the *Manchester Guardian*. And a review in the *Spectator* of 15 March from Anthony Blunt, one of the younger members of a rarefied circle of aesthetes, had also more than a passing interest. In times when a religious following was thin, he argued, there were nevertheless artists like Masaccio and Blake who painted religious subjects with unrivalled intensity, but in the nineteenth century, when traditional methods of expression were dead or had dried up, revivalists attempted to revive tradition by going back to Gothic for imagined sources of the religious style. Now, with religion once again a minority subject, Blunt used his thesis to remind

his readers of Epstein's love for non-European art in, according to Blunt, his attempt to discover his own method of expressing religious themes. To remind them of, as he put it, his 'interest in the arts of the savage races'; that this 'interest in savage art' had offered the sculptor 'a new way of making statements about the supernatural'; he had 'vivified European religious art by an infusion of dark blood, itself not pure but drawn from African, the Aztec and many other races . . .'. These observations could, of course, be interpreted as a subtle and sinister form of abuse, for he was equating Epstein's art with the art of the savage (as he, among many fashionable art historians and the like, regarded African sculpture then), not with the accepted greatness of a Masaccio or a Blake. Blunt was clearly forcing a well-worn racist card, for it's difficult to see how, for example, any traces of the African influences can be detected in *Ecce Homo*.

'Savage' was a word commonly dragged into the attacks on Epstein's work; even Shaw used it over his portrait – it was shorthand for 'backward', 'uncivilized', 'tribal', 'bestial', anything that echoed the contempt with which tough repressive European rulers viewed the ruled in Africa: hence 'dark blood'. That was very different from Epstein's interest in African art – he saw in it an innocence that was directly connected with feeling; so great was this belief in the art of the country that he sincerely believed that civilization would be saved by it. However, Blunt's use of 'supernatural' contains a similar slight, suggesting 'witchcraft' and 'witch doctors', and recalling middlebrow charges of blasphemy. Once the association with natives could be identified and established through Epstein's African collection, his art could be dismissed as being on a par with that of the 'savages'; a useful ploy at a time when the Africans' emerging struggle was causing consternation. Epstein missed none of these subtly devised innuendoes: yet what he found so painful was people's apparent determination to be 'affronted or insulted' – there was no need for this masochism, no reason, he pointed out, to feel compelled to enter a private gallery where an admission had to be paid to see *Ecce Homo*.

I have carefully refrained from advocating religious or idealistic propaganda of any sort, and have always put out my sculpture as sculpture . . . I do not see myself as a martyr, but what has always astonished me was the bitterness of the attacks on my statues. Their cause I am unable to fathom. In some cases, like those of art critics,

I can very well understand the motives, the long cherished hatred of a powerful rival to artists of their own set, the desire to monopolize and cut out one who threatens their supremacy by his merely existing, working and exhibiting. It is the almost insane hatred of the average man and woman that is baffling.

A fortnight later, at the beginning of April, Epstein's painting of Epping Forest was shown in an exhibition of travel posters among the best of the day – McKnight Kauffer's *By Great Western to Cornwall* and Clive Gardiner's *Tower of London*. Then he had an extraordinary slice of luck: in Paris at Easter, poking about in a dealer's basement, he opened a cupboard and saw the piece he had been searching for since first seeing it in Joseph Brummer's shop in 1913: the *Brummer Head*, which all Paris was seeking, had qualities, he said, which transcended 'the most mysterious Egyptian work'. He bought it. Yet that wonderful find was followed by the worst possible news. Almost immediately afterwards, at the end of April, came a sudden bombshell: the Southern Rhodesian Government took over the BMA building and announced that the statues were to be removed. The new occupants felt they were 'undesirable'. The penultimate phase in Epstein's 'thirty years war' had begun.

The announcement was made in the press, and was so insulting that Epstein sent off a letter to the *Observer* on 5 May to protest:

In your issue of April 28th, your 'Observator', in alluding to my statues at the corner of the Strand and Agar Street, refers to them as 'topical' and thereby laying themselves open to a charge of unsuitability to the new and present owners of the building, the Government of Southern Rhodesia. Might I point out that they were never intended to be 'topical' and perhaps that is the most far-fetched charge that could be brought against them. The figures were intended to have a universal appeal, even perhaps understood in South Rhodesia. The High Commission has taken no trouble, so far as I know, to consult Mr Charles Holden, the eminent architect, or myself. The statues are an integral part of the building, and are actually built into the fabric (actually carved in situ), and to remove them would be risking damage to the statues.

The vandalism consists in removing and putting a price upon a decoration, the battle for which was fought out twenty-seven years

ago, but the spirit of Philistinism dies not, and united to ownership dictates what shall and shall not be done to a decoration on a London building. We think dynasties that destroyed and mutilated the works of previous generations vandals. How is this different in spirit and intention? Ownership does not give the right to remove and destroy, or even the right to sell.

Of course an acrimonious row broke out, the Rhodesian High Commission declaring that they could do what they liked with the statues – these belonged to them, not to Epstein who had been paid off in 1908: the statues came with the building which they had bought. This aggressive stance led the *Manchester Guardian* to ask Epstein to report on the statues, which he did through James Bone. Epstein also gave an interview to the *Daily Telegraph* in which he said that this was another attempt to dictate London taste in sculpture: 'Today we have a victory of the Philistines from the outposts of Empire.' With Rhodesian owners showing no signs of reversing their decision, others associated with the arts were, as before in 1908, asked to support this latest attack on the sculptor's work which involved, like *Rima*, its removal. Some were quick to do so: Sickert wrote at once to the *Daily Telegraph* as a former supporter in the first controversy. The Director of the Victoria and Albert Museum, Sir Eric Maclagan, had no trouble in persuading a list of interested and well-known people – Kenneth Clark, W. G. Constable, Lord Crawford, W. Reid-Dick, H. S. Goodhart-Rendel, G. F. Hill and J. B. Manson – to sign his letter to *The Times* on 16 May urging the new occupants to preserve the building intact; that to do otherwise would be an act 'of grave vandalism'. All were asked to sign in their personal capacity, but one who refused was Sir William Llewellyn, President of the Royal Academy, giving his reason that he 'felt unable to do so without seeming to commit the Academy as a whole to its support'. There had been no meeting of members to consider the matter and when his refusal was broadcast it brought a furious reaction. Holden wrote a letter to the *Manchester Guardian* and Sickert promptly resigned from the Academy: 'If the RA cannot throw its shield over a great sculptor,' his letter of resignation ran, 'what is the Royal Academy for?' Epstein, commenting on this latest development, recalled that Dicksee, a former President, had signed a petition for the removal of *Rima*; now another had refused to sign a petition calling for the preservation of his work. 'This is the spirit of the Royal Academy!' he said. And

344 / JACOB EPSTEIN

as one who had been put forward for election to it on three occasions between 1929 and 1932 without result, he wrote to the RA secretary on 17 May: 'As I understand that my name is still down as a candidate for the Royal Academy (by courtesy of Sir John Lavery) I wish to take this occasion for formally withdrawing it.' And four days later, Goodhart-Rendel, President of the Royal Institute of British Architects and Principal of the AA School of Architecture, sent off a furious letter to *The Times* pointing out that Llewellyn hadn't been asked to sign the letter on behalf of the Academy, but on his *own* account: did he really believe that Clark had been requested to sign on behalf of the National Gallery's Trustees or Lord Crawford on behalf of the House of Lords or Professor Constable on behalf of Cambridge University? Another who unexpectedly declined to support Epstein was Henry Moore. No explanation for this has been recorded, but perhaps Moore, having moved away from Epstein's circle at Hyde Park Gate and into that of the Herbert Read, Ben Nicholson and Nash set, felt it would be undiplomatic to do so, and thus contrary to his own interests; he was, by many accounts, a most ambitious man. For Epstein though, who had shown him a generosity rare between artists (buying his early work, praising him in the Leicester Gallery's catalogue and, more impressively, in Haskell's book, not to mention his recommendation for the Broadway commission), his failure to help was a blow that represented a far greater betrayal of both art and himself than Llewellyn's action had been. He expected that treatment from the Academy, but not from someone he had regarded as much a friend as the trustworthy Muirhead Bone or Matthew Smith. He was deeply hurt, reacting with a vigour that accorded with his nature: he shut Moore and his sculpture out of his house – he sold everything he had of his, immediately. After that, he returned to his own work.

So far as the Strand saga went, there was a lull: faced with a hammering from eminent men's further letters to *The Times*, the *Daily Telegraph* and the *Manchester Guardian*, the Rhodesians retreated. Epstein had appealed to the Royal Fine Art Commission for assistance and six weeks later, on 19 July, he had confirmation from the RFAC's Secretary that the second battle to defend his work had been won: 'In reply to your letter of June 6th, I am directed by the Royal Fine Art Commission to state that, from enquiries made from the Southern Rhodesian authorities, it appears to be certain that your sculpture will not be removed from Agar House.'

*

That unpleasant incident was not quite the end of his troubles for the year: some time between 10.30 and 11.40 on the morning of 8 October, *Rima* was again disfigured; according to a police report, a chemical in crystal form (permanganate of potash) had been placed along the top of the relief. There had then been a downpour and the chemical had run, staining the sculpture and polluting the water in the fountain. 'At the foot of the statue,' the report continued, 'a piece of cardboard was found on which "Cancer of Judah" had been painted in black ink . . .'

By stopping for a moment and thinking, it's just possible to imagine something of the anguish he must have felt. Yet he had learnt to be philosophical: it was just another insult, racist inspired, and *Rima* would again have to be cleaned; the hooligans had done their bit in celebrating the tenth anniversary of the unveiling of the work, and that would perhaps be that. 'Mr Epstein is busy on his theatre drop curtain for the ballet of David,' Mrs Epstein said in her letter to Dudley Tooth of 22 November. 'He asked me to write to you and to send you this morning two bronzes he had recently finished.' She had taken over the upbringing of Jackie in order, as with Peggy-Jean, to avoid scandal, and was looking for some suitable girl for a nanny; for the rest, while she was managing as well as she was able, Epstein's book-keeping, income tax, the house and dealing with sales, he was ceaselessly working. He completed thirteen portraits that year, including two of Jackie, his fifteenth and last of Peggy-Jean, his fifth of Kathleen, the two *Deborah*s and the *Shulmanit Woman* (an Arab girl), that had gone to Tooth's, and *Neander*, a cast of which was also sold through this gallery. And then he had started on the curtain for *David*, a commission for the Duke of York's theatre in St Martin's Lane which in substance was a continuation of both his studies of the Old Testament and his increasing passion for painting and colour. It was a perfect subject for him – a cross between the two. He testified to this with his familiar vigour in a forthright interview with the *Daily Telegraph* on 18 November: 'This is a new departure for me, and the first work of the kind I have done, although I executed some Biblical drawings three or four years ago. I am doing all the work myself, including the original designs of the curtain.' This was typical of him: whatever he was working on, he was in total control of the outcome: no assistants for him, whether carrying out such a vast undertaking as the Strand frieze in a very short time, or the mammoth task of designing and painting the *David* curtain in a mere two months: the ballet's first night was on 13 January. 'There are

ten episodes from the life of King David. In the middle of the curtain David sits on his throne. My original scheme included the famous Goliath encounter, but for various reasons this has now been discarded.' The plan of the decoration displayed Epstein at his direct best: the episodes framed the central space occupied by David with pictures of immense activity – figures dancing, holding huge candlesticks, making love, swimming, representing both the harem and processional rituals – that dramatically captured the story in the image of a proscenium opening reproduced as wings of scenery that framed a 'stage'; on this was the king, master of ceremonies, flanked by the Lions of Judah, his arms raised after the style of Indian art. Images doubled and tripled in Epstein's work, intensifying the electric excitement before the lights go down and the curtain goes up. 'The curtain is canvas and is 30 ft by 25 ft. I find the painting an extraordinarily interesting and stimulating experience. A feature of the work is the brilliance of the colouring.' He used a mixture of vivid blues, oranges, greens, reds and yellows: a large watercolour that acted as a working drawing for his complex work, and on view at the Redfern Gallery to coincide with the Markova-Dolin ballet opening, suggested the influence of ancient Egyptian pattern making. Epstein had a different view: 'The figures and general design are monumental in force and scale. Perhaps I can best describe the effect as being like a Russian icon', going on to say that he didn't anticipate his curtain providing a 'sensation', but did believe that it would produce 'a very definite reaction in the beholder.'

He was right: delighted, too, when his design was received so well by the critics. Arnold Haskell was to be depended upon for praise in his capacity as *Daily Telegraph* ballet critic: he considered Epstein's curtain as 'the most striking feature of the production'. There were many other reviews as good. 'The whole effect is one of shimmering movement, already partaking of the triumphant rhythm of the dance it preludes,' wrote the *Telegraph*'s art critic, T. W. Earp, on 14 January. 'Epstein has scored again.' Others were struck by Epstein's close collaboration with the scenery designer, Bernard Meninsky, whom Epstein had by chance come to know in the Jewish regiment during the last year of the war. 'The Epstein curtain sent hopes soaring high,' the critic of the *Dancing Times* commented. 'Not only was it a fine picture in itself, but its form was that of the title pages of books of a bygone age, in which, by means of engraved panels, the artist delineated the most exciting events that were to follow in the reading ...' 'It is one of the finest

pieces of decoration ever seen in a London playhouse,' declared the
Observer's George Bishop. The curtain had certainly gone up with a
bang on the New Year. While it helped to pull in the crowds to the
Markova-Dolin production, it may have led on to some interesting
developments for Epstein. There were five commissions, including Haile
Selassie's (the Emperor in exile after Mussolini's invasion of his
country), among the ten busts completed, all of which were done in
something of a rush: they had to be crammed into the space of a few
months, largely on account of a new passion which had overtaken him –
painting flowers. A very curious commission from the year before had
started this off: Ascher & Velker, a Dutch firm of dealers in old
masters, had asked him to paint a series of watercolours of flowers, put
in mind by the extraordinary success of his paintings of the Forest. He
had agreed to do twenty and in the end did sixty. As usual, this new
departure carried him away, and the following year, in the spring, he
had become immersed in another feverish phase of activity. 'Not content
with this,' he said of the commission, 'I went on painting, giving up
sculpture for the time being, and painted three hundred more. I lived
and painted flowers . . .' Like the Forest series, he couldn't stop, quoting
Blake by way of explanation: 'The Gateway of Excess leads to the
Palace of Wisdom.' At Deerhurst, he painted on the spot; from the
steps overlooking the flower beds his wife lovingly tended, or from
the greenhouse tacked on at the back; where the garden shed with its
view of space from the cottage opposite suited visions of sculpture, the
limited close-up from Deerhurst was perfect for the study of the
minutiae of blooming plants. Painting didn't end, however, at Baldwin's
Hill; the Epsteins brought back huge bunches of flowers to Hyde Park
Gate on Mondays, and, astonishingly, to add to this glorious display,
Ascher & Velker sent crates of flowers by air freight every week until the
outbreak of the Second World War, so excited were they by his paint-
ings. No wonder the house was overflowing with peonies, roses, poppies,
daffodils, marigolds, fritillaries, daisies and sunflowers. And when
Tooth's gallery announced he was painting flowers, and that an exhi-
bition was to be held in the gallery in December, at least five other flower
exhibitions were launched simultaneously. 'London,' Epstein said,
'became a veritable flower garden.'

Long before this exhibition opened, another development of an even
more peculiar kind suggests that the Dutch dealers' commission had
been picked up across the Atlantic. George Macy, President of the Macy

Limited Editions Club of Madison Avenue, New York City, had put out feelers to discuss whether Epstein would agree to his flower paintings being reproduced as prints, at the same time asking him if he would care to illustrate one of the publications he had in mind. Epstein saw this as a magnificent opportunity to suggest Baudelaire's *Les Fleurs du Mal*, poems which had greatly interested him ever since picking up a copy of the book when first in Paris in 1902. As for the reproduction of his paintings, it turned out that Macy had obtained a portfolio of ten watercolours of flowers, and Oliver Brown at once wrote, on 8 May, to ask to see these to establish their authenticity. Once this was done, Epstein sent him a letter (15 May) about contractual arrangements. Macy could have 'reproduction rights' of the ten paintings for £200, but the originals must be returned to him – he wanted to exhibit them at the Leicester Galleries. Macy, however, decided to reproduce only six watercolours first to 'feel out the market'; at the same time, he agreed to pay £300 for thirty to forty pencil drawings to illustrate *Les Fleurs du Mal* to be reproduced in a book printed by Oliver Simon of the Curwen Press, the originals to be again returned to Epstein. There was a further condition related to the watercolours: he would issue 300 portfolios, each containing six reproductions, each of which was to be signed.

It was an uneasy relationship from the beginning, differences of opinion developing into disagreements and downright bad feeling as time went on. For a start, the stipulations referring to the Baudelaire illustrations and watercolour reproductions didn't please Epstein, and a letter on 18 May, followed by a telegram a day later, went off to Macy. He thought thirty to forty drawings excessive – would agree to only fifteen or twenty for £300 – and reserved the right to make a decision about the medium. As far as the watercolours went, if Macy wanted six, Epstein would limit the arrangement to that number; any additional series would be subject to a new agreement. The idea, however, of signing the reproductions horrified him. He had better things to do: 'I simply could not sign 2,000 names. I will sign each portfolio. That is 300 and God help me!' The thought of that was dreadful, prompting the telegram: 'Would you care to call off the flower arrangement. I feel you are not keen about it and neither am I.'

Macy, disappointed and irritated about Epstein's objections to both projects, and by the telegram, agreed to scrap the idea of reproductions and to return the paintings. He hoped instead to clinch the Baudelaire

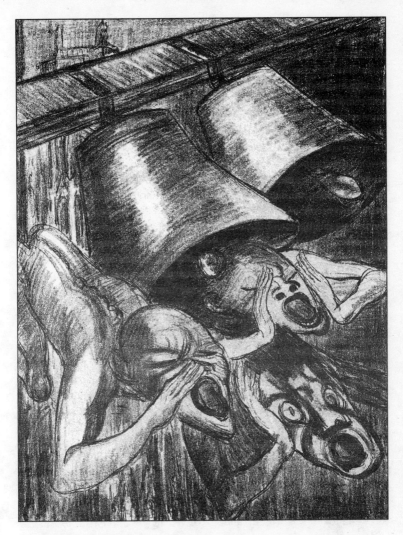

One of the drawings in the *Les Fleurs du Mal* series exhibited at
Arthur Tooth & Sons in 1938: cries of 'obscenity', 'morbidity' and
'lasciviousness' from most reviewers were rebutted by comparisons
with Gothic 'gargoyles' from J. B. Powell of the *Birmingham
Mail*.

deal when he came to London in the summer. By June, when he had sent on the contracts to sign and an English translation of *Les Fleurs du Mal* that had been published by Hamish Hamilton (and slated in the press) as a guide, Epstein was deep into painting scores of watercolours of flowers. As a result, the contracts disappeared for a time under a pile of other papers; Mrs Epstein, who would normally have seen to it that he signed them, unfortunately had serious anxieties of her own. She was, of course, worried about money: there were debts of £2,000, with another £600 owed to moneylenders; she was also worried about Peggy-Jean, her education and state of mind. Dartington Hall had proved a failure – the school had merely 'taught her to smoke and drink at 13, among other things,' she informed her American sister-in-law Susie (now calling herself 'Sylvia' after her marriage to Alexander Press), in a letter of 6 August. It wasn't Peggy-Jean's fault – she'd had 'an unusually stormy upbringing' – and when told by Mrs Epstein, after being taken away from Dartington the year before, that she was really Meum's child, it was hardly surprising that she became a complete emotional muddle. For this was an astonishing discovery: she was already most confused – didn't know whose children were whose in Kathleen's household, couldn't make out the procession of models at home, the artists bringing their mistresses (Mrs Epstein would introduce them, saying, 'This is so-and-so and his mistress'), or finding one of her father's socks in her bed after Isabel had moved into her room. She had a string of governesses after leaving school, but it was no good – she couldn't concentrate, and the latest had just walked out on them. Epstein was extremely worried: he blamed his double life for her going off the rails, to clubs at night and sleeping half the day. And there was Jackie, now nearly two, to consider: Mrs Epstein had found a German nanny, Gertrude, to look after him, another of her peculiar employees: she was thought to be a refugee – they had a number at various times. In fact, this reddish-blonde was a Nazi, 'hailed Hitler' while listening to his speeches on the wireless ('he can make you laugh, he can make you cry') when nobody but Peggy-Jean was around, and instructed Jackie in physical exercise.

And so it was decided to send Peggy-Jean to New York to stay with Sylvia for a spell: Epstein had just done a portrait of Rosemary Carver, an actress who was going over that month, and who would accompany his daughter on the boat. This plan gave Mrs Epstein a rest, time to concentrate on Jackie, to think ahead and dream of another visit to New York that she, Epstein and Jackie might make, so getting rid of his

'mix-up' over Kathleen forever: where it hadn't worked the first time, she wrote in her letter to Sylvia, 'the next time it would succeed, I think.' Perhaps Sylvia could make inquiries as to possibilities?

There was yet a further anxiety: she was troubled about their neighbours across the road. She was becoming convinced they kept a watch on the house, on the exotic models, on the anti-semitic graffiti appearing on their walls overnight: on one occasion, apparently, they sent the police round, having mistaken Mrs Epstein's cigarette lighter for a pistol, of which it was a fascimile. Had she known Gertrude was a Nazi, she would have been still more worried; with the black shadow of Hitler swelling up over Europe, most threatening of all were the kind of political figures who visited the house opposite. One frequent caller, for instance, was the German ambassador to Britain, von Ribbentrop.

George Macy was becoming exceedingly worried, too; he had heard nothing from Epstein for more than two months, and on 26 August wrote to say he wanted to see him and finalize the agreement; and when he had no reply to this either, he wrote again on 7 September to say he was on his way to London with a new proposal – an illustrated version of *The Merchant of Venice*. At this point, Mrs Epstein took up the correspondence, explaining that her husband was at Epping where the telephone had been cut off by storms, that he would be delighted to meet him at Hyde Park Gate, had signed the contract with its delivery date of 1 July 1937, but would prefer to illustrate *King Lear* to *The Merchant*. Macy gave Epstein his advance of £150, agreed to pay him £100 for six drawings for the *Lear* and had asked Oliver Simon of the Curwen Press to send a dummy of the Baudelaire which Epstein could use to start his sketches.

Epstein, of course, had taken on a great deal when he already had much to do and think about. His book was one thing; then he had been working through a mass of watercolours for his exhibition of flowers at the end of the year, and he had started on his third great religious work, *Consummatum Est*, from a block of alabaster which had been lying in the studio for a year.

While I work at other things I look at it from time to time. The block lies prone in its length, and I consider whether I should raise it, but decide to leave it where it is. I can conceive any number of works in it. I have been listening to Bach's *B Minor Mass*. In the section,

Crucifix, I have a feeling of tremendous quiet, of awe. The music comes from a great distance and in this mood I conceive my *Consummatum Est*. I see the figure complete as a whole. I see immediately the upturned hands, with the wounds in the feet, stark, crude, with the stigmata. I even imagine the setting for the finished figure, a dim crypt, with a subdued light on the semi-transparent alabaster.

He had a vision of an effigy, and used to say what a wonderful experience he thought it would be to have work like that exhibited to an accompaniment of music. He loved Beethoven's Mass in D minor. He saw in that the work of a wonderful sculptor in sound, and he compared Beethoven's later quartets to the later works of Rembrandt, and the last works of Donatello. Of *Consummatum Est*, he was specific: 'Instead of writing about it, and people standing about talking, arguing, disputing over the prone Son of Man, with protesting palms upturned, there should be music, the solemn Mass of Bach.'

This carving was of such importance to him that he described, in greater detail than any of his other works, how he approached it, and the emotional sensations he experienced in his explorations of the subject through the material. As with the watercolour phase, he became totally engrossed in his latest task, putting the illustrations for Baudelaire right out of his mind. These had to wait, at any rate until he had read the poems again and thoroughly understood their meaning; and since they were in French, and French in thought, this would take time. To read them in bed when his mind was so occupied with his sculpture would have been difficult. As he said,

Many imagine that the artist, having his working hours like any other craftsman, thinks only when in front of his work about the practical problems of shaping and chiselling, but this is not so. The work a sculptor is engaged on is continually in his mind. He sees it with his mind's eye, and quite clearly, so that at any moment of the day or night, or even in lying down to sleep, the vision of the work in progress is there for analysis, as an inescapable presence. I would say that on a work like this, one lives in it until it is finally finished and one has gone on to some other work which usurps its place in one's thoughts ... The sculptor with his vision, planning, working, laying loving hands upon the willing and love-returning stone, the creation of a work, the form embodying the idea, strange copulation of spirit and matter, the intellect dominating hammer and chisel – the concep-

tion that at last becomes a piece of sculpture . . . *Consummatum Est* –
It is finished.

When so possessed by a work in progress, there was no chance of the artist breaking off.

His daughter, having had a very good time in New York, returned reluctantly to London in late October, in time to hear that vandals had attacked *Day* again, covering it with blue paint. Then, in December, following an exhibition of Matthew Smith's, Epstein's watercolours opened at Tooth's, surrounding his portrait of Haile Selassie with the brilliance of a garden of flowers. An African centrepiece was exactly right: the boldness of his paintings, the dense coverage of a large sheet of paper, the sheer size of the blooms, the intense blues, purples and greens in his multicoloured spectrum combine to communicate a startling life and scale that recalls Africa, the continent that belongs to nature, and where all things to do with it are enormous – flowers, birds, lizards, giraffes and elephants. Epstein's paintings were big paintings: no wonder they received the acclaim that had previously been reserved for the Epping Forest series: 'By that strong, inexplicable miracle of genius they round the circle and one finds that they *are* composed, they *are* drawn,' ran the report in the *Jewish Chronicle*. On the utter sponteneity of the work, it picked out 'the burning sunflower', 'the turbulent peony', 'the shimmering sword of the gladiolus and the passion-ate, blood-stained rose . . .' The *Illustrated London News* reviewer called him 'one of the sincerest painters living . . . with a child-like unconcern for the onlooker. Mr Epstein continues to turn his inside out so that all may see exactly what is in his mind . . . He approaches, more so now perhaps than ever, what he does as if no one had done such a thing before. Modelling clay, watercolours and brushes seem in his hands something he had discovered for the first time . . . He seems here, therefore, not so much an artist, a sculptor, a watercolourist, as a man terrifically interested in poppies, daisies, sunflowers, Haile Selassie, rhododendrons, peonies . . . what he sees in the miracle of intense colour and irrepressible urge of life . . .' T. W. Earp had the last word in the *Daily Telegraph*: 'He has filled with explosive energy the most fatigued sector of contemporary art, the flower piece in watercolour.' Every painting sold.

It was no surprise for Epstein to receive a letter from Macy on 19 January of the New Year pressing him to get on with the drawings.

Epstein didn't reply: he was far too absorbed in his conception for *Consummatum Est*. He had started by drawing in with chiselled lines the position of the head, the lengthened arms, draperies and feet, jutting further out. He began the carving with the head ('tentatively, carefully'), having chosen the lighter part of the stone for that, and then worked downwards to shape the entire figure. 'I concentrate on the hands and give them definite form and expression.' There was no model: he relied on his experience and knowledge.

> I block out the containing masses, leaving the details until later; I always try to get the whole feeling and expression of the work, with regard to the material I am working in. This is important. There are sculptors who treat a figure in stone in exactly the same manner as they do a work in clay. With an isolated piece of stone they should regard the sculpture as primarily a block, and do no violence to it as stone. There must be no exact imitation of nature to make one believe that one is seeing a translation of nature into another material. Imitation is no aim of sculpture . . .

As he carved the figure in alabaster, he asked himself continually whether he was getting the feeling, the emotion from the work he intended. And where would it go? Was a cathedral or a basilica really imaginable?

> It came from me and returns to me in a world where it is not wanted. I imagine a waste world; argosies from the air have bombed the humans out of existence, and perished themselves, so that no human thing is left alive. The feet are weary from having trod the earth in vain, the hands with their wounds turned to the sky, the face calm with all the suffering drained away. Like the enigmatic stones of a far island that face the sea, my stone will face the sky and give no answer.

This frightening prognosis in poetic prose, evoking the horrors of the Abyssinian war and Franco's terrorist air bombardment of Guernica, is a reminder of how well Epstein could write. Michael Joseph, whose first five authors had recently been commissioned, would have seen Epstein's sensational story of struggle against reactionary forces as excellent material to add to his exciting list of forthcoming works. Joseph had been with the literary agent Spencer Curtis Brown before becoming a publisher, and with Curtis Brown as Epstein's agent, this commission was neatly tied up. In order to fit in so many undertakings, however,

Epstein had to break off from one thing to start another: this was only possible when the conception of *Consummatum Est* had been firmly established, and then the carving of the work had to be approached with precision and care: the slightest error of judgement with such a delicate material as alabaster could dislodge a piece of stone and ruin the sculpture. It was possible, too, because of his dedication and speed in getting a sculptural idea down – for him, this was the most exciting moment in the creation of art. After that stage was accomplished, he might leave a carving, set up a life-size figure in the morning, a portrait in the afternoon, and draw in the evening. His agreement to write his autobiography, something he insisted to Haskell he would never do, suggests he found this new venture irresistible after all, provided he was given sufficient time to do it, and an advance was paid. He may have started working on the book in late 1936; he was certainly hard at it early in 1937, he at one end of the long dining room table writing, Mrs Epstein at the other, and Peggy-Jean, a reformed character now that she had been asked to do something constructive for her father, in the middle, tapping away on a Remington typewriter. 'The words flowed out of him,' Peggy-Jean said; they flowed, in pencil, on to pad after pad of Lion Brand notepaper with scarcely a crossing-out, just as though he was writing one of his long letters to Ordway or Quinn or Kathleen; when he was through one pad, Mrs Epstein, relishing the job of organizing things, would produce another. It didn't matter if it was of a different size: he carried on where he had left off. He was, moreover, as methodical and practical as ever: common sense dictated the structure. He set out the chapters first and began: 'My earliest recollections are of the teeming East Side where I was born.' True to his nature, he put down only the essentials of his life and work, the carvings significantly taking precedence over his portraits. He included his struggle, anything which he regarded as important, interesting or strictly relevant, and had remained clear in his memory; with the rest omitted, his story still made a long book.

In this phase, he had time for his carving, various models (including Jackie and Sally Ryan) and the book, but he was still not ready to be diverted by the drawings for *Les Fleurs du Mal*. Then came a severe distraction: a disaster in the Strand brought his frieze suddenly back into the headlines. Edward VIII had abdicated and George VI's coronation took place on 12 May. When some decorations attached to the figures were removed, a small piece of stone from one of them

was dislodged and, so rumour went, fell to the pavement below, narrowly missing a passer-by. Immediately, scaffolding was erected, the sculpture condemned as dangerous and to be demolished, and Epstein was refused permission to see for himself what had gone wrong. And so this latest development in the agonizing story had to remain unsolved. All the same, he had two explanations for the failure of the Portland stone, a material he knew well (*Rima*, *Night* and *Day*, all of this stone, are in perfect condition, despite the chemicals and other substances thrown at them): while carving the figures, he had noticed blackish and greenish streaks dropping on them when it rained, and believed these came from drips off plates supporting a cornice above. He had pointed this out at the time and was told that the plates were lead; he disagreed – the nature of the discoloration suggested chemicals, and it is of course known that the combination of two alien metals, like zinc and copper, can set up a chemical reaction that will corrode structural materials. He was probably right that a constructional detail was to blame, a reason why Holden was quick to order the removal of parts of the figures after his inspection: who knows? – he might have been held responsible. In fact, Holden's design *was* to blame: the statues should have been sheltered by a projecting stone shelf, a detail that would have improved the appearance of the building by creating proper niches for them. Then the pollutant wouldn't have touched them and the form of the second-floor frieze would have been strengthened. Too late: the Rhodesians had found a way of getting rid of the offending nudes and this time the letters of Earp to the *Daily Telegraph* and of Bone to *The Times* in June were of no avail. Earp, in expressing his horror at the owners' decision, pointed to the impotence of the Royal Fine Art Commission in being unable to back its word with authority: 'We lose prestige along with beauty,' he rightly said. And Bone explained that decayed stone could be restored – the colleges of Oxford were tackling 'the same sort of thing, year in, year out' – he had never 'heard of them completely obliterating an admired series of sculptures on their buildings when faced with the restoration of a few ailing pieces'. There were, of course, scores of other letters, including one from Edwin Lutyens who advanced the foolish argument that the loss was not 'irreparable' since the artist was alive. There was nothing to be done: the demolition was executed with ruthless efficiency, and, among the bits left, not a single head survived. 'Anyone passing along the Strand,' Epstein wrote in his autobiography, 'can now

see as on some antique building, the few mutilated fragments of my decoration.' His thirty-year war was finally over.

On 5 July, the delivery date for the Baudelaire drawings overrun, George Macy was back in London, hoping to collect them and contacting possible editors for the text. In a letter to Epstein of that day, he said he wanted to take the Lear drawings as well. Neither had, of course, been begun, as Macy suspected: 'I am willing to believe that you left them for the last minute, and that the remarkable position taken by Southern Rhodesian people over those statues destroyed your ability to create drawings during the past few weeks.' No reply to this brought a stiffer note from him on 29 July, pointing out Epstein's obligations under the contract: 'I hope that you will now arrange your affairs in order to give yourself time for doing these drawings . . .'

He had a reply to that letter: it was short and to the point: 'I have come to Paris for a week or ten days and when I get back I will get at the drawings. It's no good saying I am sorry they are not ready but I have had a busy time with portraits I have had to do. Once I get at the drawings you won't have to wait long.'

No doubt he had other reasons for being in Paris besides having a break from his exertions, but the visit turned out to be a momentous one. While they were sitting in Le Dôme on their last day, a young New Yorker, strolling by, caught the eye of Peggy-Jean, now eighteen. He wandered back to have a better look and then introduced himself – his name was Norman Hornstein, he was studying medicine at Edinburgh, and wondered if he could take her out. 'Not possibly,' Mrs Epstein said, 'we're leaving tomorrow.' Epstein was, however, interested in him, particularly his hands, at which he stared hard. Back in London, Hornstein reappeared and did take her out, while Epstein, haunted by Macy, received two further letters from him; he was still in London and, in his second of 24 August, said he hoped to collect the Baudelaire and Lear drawings before returning to America soon. To this Epstein replied immediately: he was in Epping, and said, 'Although I have started the drawings, there is no question of my having them ready before you go to America, I am beginning to feel like a criminal about them; and that's bad. Do give me time and let me produce the drawings: that would be the happiest way: instead of my having to tell you that they are not ready . . .'

Macy was 'greatly disappointed'; July had 'seemed very far away'

when the agreement was made. However, he would be back in London on 1 January and hoped they would be ready then. Epstein promised they would in a letter of 13 September, and Macy, delighted, told him he was getting another illustrator for the Lear, imagining that this would come 'as a distinct relief' to him. The correspondence between them ended there for the moment, and, on 24 September, Peggy-Jean and Hornstein were suddenly married after a racy romance. Mrs Epstein, very pleased, relayed the news to all their friends: 'He is very good for her I think,' she wrote to Sylvia Press: the couple had gone to live in Edinburgh. Epstein, for his part, made a fine portrait of Hornstein: resembling a Roman warrior, he called the piece *The Young Communist*.

This was one of twenty bronzes shown at the Leicester Galleries in October; *Haile Selassie* was there; so, too, were *Rosemary Carver*, the brilliant *Rita Romilly* (a night-club owner) and *Consummatum Est*.

The attention of reviewers naturally focused on the great religious work, with the bitterest attacks coming from Roman Catholic journalists. All the same, Epstein felt that, on the whole, the majority of criticisms, veering between serious comment and rantings of the silliest kind, were in favour of it, rather than against. There were the usual shocked letters to newspapers from the interested visitor to the exhibition – 'A disgusting travesty, an outrage on Christian ideals' (Sir Charles Allom, an architect) – and imbecilic remarks: 'From the pictures it only looks to me like a child's first attempt in plasticine' (Roman Catholic *Universe*). But he had support from Bernard Shaw – 'It is an extremely imaginative figure,' the playwright told the *Star* (1 November) – and an impassioned defence from William McCance (*News Chronicle*, 28 October): 'Leave Epstein alone and your children will bless you in days to come. Strangle him by abuse and receive the immediate blessings of Dr Goebbels and his band of tenth-rate reporters in paint and plaster who are leading a nation to cultural suicide.'

And then, of course, there had to be the pretentious heavyweight 'highbrow' weighing in (anonymously) from *The Times*: 'As is usual when he shows his work both Mr Jacob Epstein the great artist and Mr Jacob Epstein the Great Artist are represented in his present exhibition ... All the necessary criticism of *Consummatum Est* is contained in the title. That is to say, Mr Epstein has used many hundredweights of alabaster to say a great deal less than is contained in two words, or, if

you prefer the English, "It is Finished", three ... In comparison with the artistic stupidity implied in its conception all other criticisms which are likely to be passed on the work ... are artistically irrelevant ... It is the wrong thing done very well indeed ...' About this, Epstein wrote, 'by the time the critic is through with you, no shred is left, you are stripped bare of all honour and are only a poor wight to be pitied ... Always a belittling, a whittling down to the trivial, to the impertinent.' Although Hornstein, as a newcomer to the scene, felt Epstein was weighed down by such remarks, he saw through their writers; Epstein remembered, for instance, reading a vilification of *Genesis* by the same critic who later described a clumsy piece of sculpture by a painter from his set as 'this beautiful bronze'. He was sure that dailies and weeklies were dominated by this kind of prejudiced critic, determined at all costs to look after himself and his cronies. 'Their distortions,' he wrote, 'are often so ludicrous as not to be worth answering, as where, in comparing the treatment of the hair in my busts and heads, it was pointed out that a certain French sculptor's treatment was in all cases sensitive and mine coarse.' The truth was the exact opposite; and why, anyway, did the comparison always have to be with him? Why not with artists of the past, with Donatello, Verrocchio? How happy he would have been if he could have seen *Consummatum Est* where it now resides in the Museum of Modern Art in Edinburgh, its authority eclipsing all else. That happiness was denied him: and far from ending in some crypt to the unearthly sounds of Bach, this great work eventually, five years later, fell into the hands of a Mr William Cartmell, acting for the Parkinson family, owners of the Louis Tussauds gallery in Blackpool.

The *Sunday Dispatch* reported that Epstein had said (24 October) that the work, then unsold, was on no account to go on tour, the damaging experience which had befallen *Genesis*. This had hurt him more deeply than he could ever explain, but he hoped that his widely published protests would see his wishes respected. So that was that; he had started out on a new series of drawings of children which included many of Jackie and one startlingly beautiful study of his daughter Kitty, aged eleven; this was a great work, so memorable that, once seen, its image returns constantly to mind. He had also, moreover, begun a new carving of colossal size almost immediately on finishing *Consummatum Est*: once he put down his tools, he picked them up again, unable to delay, it seems, for one moment his continuing development of a theme as ideas crowded in. Mrs Epstein referred to this work when

writing to Shaw on 14 December – she hadn't told her husband about the correspondence; when he was working on 'a stone' she tried to keep all other worries from him. Her letter was about a number of things – for a start, she was upset that Shaw didn't like the bust of him, or so Orage had told Epstein; and that since it was 'offensive' to his household, he had sent Shaw's cast to a Mrs Grant in America. Then she put to him the possibility of setting up an Epstein foundation to secure the guardianship of his 400 or so plasters; Orage had already broached the idea and she wondered if Shaw could use his influence to bring it to fruition.

'The Tate Gallery,' her letter went on, 'is no adequate sanctuary for Epstein's sculpture to carry into the future. To my knowledge, he has carved stone for 35 years and they have not a single carving in the Tate.' The *Genesis* had been offered on loan by its owner, Alfred Bossom MP, and, she said, one member of the Gallery's committee had been instrumental in its refusal – 'they could not have a sensation in the Tate Gallery', the committee had said. 'That was Sir W. Rothenstein,' Mrs Epstein explained. 'The Jews persecute their own prophets sometimes.' The Tate had become, she said, 'something of a dishonest prostitute under the influence of the overpowering magnificence of Duveen's bequests, and prejudices, and powers over the futures of officials.' She pointed to the Rodin experience – his prestige had suffered after his death 'from commercial hands getting hold of a few of his plasters and reproducing them ad lib, which always means fainter and therefore inferior copies'. Even the Musée Rodin, she went on, although a refuge for his plasters, was slightly tainted with commercialism by selling copies of them. Shaw's reply of 29 December could have been anticipated: the man who had been in 1906, Mrs Epstein said, 'a sort of magnificent Father Christmas to us', completely ignored her interesting proposal for a foundation to protect her husband's work, and instead launched into the attack on the bust. After saying again he was neither an Australian nor a bushman, he went on: 'What interests me at an exhibition of Jacob's work is always the work in which the truth breaks through the biological theory, which began as a phallic obsession and held him back for years . . . He is always picking out the women models on whom he can lavish exquisite modelling in detail but on the whole makes them lizards, not women.' He ended: 'If all this makes you angry, just think how you would feel if you ordered a statue of Jacob to remember him by, and you received instead a statue of Ishmael!'

Epstein would have gone through the roof if he had seen this letter:

of course he didn't – he was bogged down enough by the correspondence with his American publishers. Macy was back in London in January, hopeful as ever, and, though getting no reply to his inevitable inquiry about the drawings, went ahead with his efforts to find an editor to organize the book and, in particular, translations: eventually, he found James Laver whom he would have regarded, as head of the prints department of the Victoria and Albert museum, sufficiently prestigious for the job. Then, on 6 May, somewhat to his amazement no doubt, he received the letter he had been waiting for: 'I have the drawings for the *Fleurs du Mal* ready.' There were, however, conditions: the book was to come out after he had shown them at Tooth's in December, and 'only those who are to make the reproductions should handle them'. Epstein went on: 'About the residue of the payment, which is £150. I suppose a request for that will fall on stony ground. *Les Fleurs du Mal* cannot bring forth much except in drawings.' He was wrong there: Macy sent a cheque and had the drawings picked up by the Baynard Press on 30 June. Despite doubts resulting from delays, the book was clearly on its way, Epstein having supplied thirty-two drawings (many more than promised, but about half the number he had actually carried out) from which Macy could choose: 'I am looking forward to seeing the reproductions,' he wrote on 1 July, 'and expect masterpieces.'

Laver had been shown the drawings and thought them 'terrific', Macy said, after which he sent Epstein a sample reproduction, together with a present of *Salome* with illustrations by Derain; he had obtained a copy of the *Fleurs du Mal* with drawings by Rodin, suggesting the idea of a double volume, the French version with Rodin's, the English translation with Epstein's, 'the two great sculptors of modern times'. This brought an instant reaction: thanking him for *Salome*, he said he preferred Aubrey Beardsley's drawings to Derain's for this, and thought the typeface 'horrible'. Then there was the sample reproduction: 'Frankly, it seems to be so-so: it lacks what I could only define as the "quality" of the drawing: without the original in front of me of course I cannot speak more definitely than that.' And it had been reversed – 'surely modern methods could reproduce a drawing the right way round!' Asking to see more reproductions to get the total effect, he went on to the attack on another front: 'I never thought you were serious when you suggested an English translation of Baudelaire,' he said, referring to an early discussion of the project.

The English or American translations are an insult to Baudelaire and
I could never look on a book of my drawings with the English
translation as a *Baudelaire work*. I have every admiration for Rodin
but why not reproduce his drawings with the English text and mine
with the French? If you printed these wretched translations with my
drawings I'd not want to get the volume. I made the drawings for the
original text.

This infuriated Macy: first, the picture, reversed in the lithographic
process, would of course be printed the right way round when
reproduced in the book (he had in any case dropped the Baynard Press
and was having the work done by a firm in Paris), but, on the matter of
the translation, there was no possibility of the text being in French –
very few Americans could read French. He was sure that Epstein would
come to like the translations in the end, although Epstein, who now
wanted his drawings back by October for his exhibition, was equally
sure he wouldn't. He couldn't get Macy's decision over them out of his
mind. He wrote back on 1 September:

I wish you would reassure me about the text, and that there would be
a Baudelaire book worth having. You can't imagine how inadequate I
thought those translations you sent me were. I said nothing at the
time but if you saw the reception of that book here you would
understand what was thought of it by anyone who took the trouble to
read it.

Brian Reade, the Cambridge scholar and aesthete who rediscovered
Beardsley in the Sixties and had just joined Laver's Prints section at the
V & A and knew the book, supported Epstein's view: 'Laver had been
appointed editor for the Baudelaire and was casting round among people
in the department for candidates to fill the gaps in the collection –
would they care to translate some of the poems?' Reade, who thought
Laver went about this task of great importance in a somewhat casual
manner, refused. 'I told him that Baudelaire was untranslatable without
a complete knowledge of French culture, literature, history, society and
so forth; and without an understanding of the special flavour of
Baudelaire. Others, however, putting ambition before good sense, ac-
cepted. I saw some of the translations and thought them dreadful –
utterly superficial.'

He was very interested that Epstein thought the same. In fact, the

sculptor was deeply disturbed, and Mrs Epstein, greatly troubled by his anguish, took up the subject in a letter to Macy of 4 September in which she tried to explain what her husband felt at a time when 'he was too busy on a big stone to write'. She said:

> He made the drawings for the French text only, and could never have made any drawings for any English translation that he has seen. In fact, I had to hide all English translations while he was making the drawings because they put him out and off doing anything altogether. They were meaningless to him . . .

This didn't please Macy: Mrs Epstein was interfering in a matter which was nothing to do with her. However, to put the record straight, he replied to say that he found it extraordinary that her husband could have ever believed that their intention was to publish in French – his was an American firm that always published in English, and this had been made clear at the start.

> I have worked out this scheme to issue the Baudelaire in two volumes only as an afterthought; and this is, if I may be permitted to write frankly, because I think some of our subscribers will not find Mr Epstein's drawings palatable, and I hope to please even those people by giving them the two volumes, Epstein and Rodin together. I cannot understand, and I cannot sympathize with, Mr Epstein's objection to what seems to me to be a fine plan.

For the rest, the drawings had been delivered to the new printers, Mourlet Frères, in Paris and the lithographer there had been instructed to return them to Epstein before 1 November.

Epstein's life, packed with activity, often appears like a complex scene trapped in a telephoto lens – as a mass of incidents flattened within a single frame. At this time, he was hemmed in with anxieties and work: he ignored Macy's rebukes. There were worse things than the translations to worry about; worst of all, there was the menace of war, the headlines growing big and black with it during the months leading up to Munich and the annexation of the Sudetenland. So indeed, in all probability, was Philip Sayers worried, over in Dublin: he had suddenly demanded back the money loaned to Epstein to cover the mortgage on the house, and, from being a good adviser and friend, he had become 'that rascal Sayers' in the Epstein household. To make matters worse,

the end of the lease was looming up, money had to be found to renew that when the time came, and, as Mrs Epstein had informed Sylvia Press, they had huge debts all round. Epstein could see only one solution – to sell his collection of thirty Matthew Smiths and the two Rouaults. That was a dire decision to take – he loved the paintings and didn't want to hurt his friend, but paintings were, in this crisis, of secondary importance compared to his sculpture collection, a single item of which he could not bear to part with. And so he made the necessary arrangements with Oliver Brown; and with that cleared up, no angry letter went off to Macy – instead, he wrote to say he was delighted that the drawings had been returned in perfect condition, and that four proofs he had received were excellent. He assumed that the set of twenty-four illustrations sent had been accepted and looked forward to receiving the rest of the proofs.

Perhaps his mood was improved by a new, absorbing assignment – just before Tooth's exhibition opened, he was in the middle of a portrait of the Robesons' son, Paulie. He wrote at the end of November:

Dear Mrs Robeson,
 Don't forget: Paul is coming to pose. He left on Saturday without lunch. Said he had to get back early. If you could look in tomorrow for half-an-hour first so I could do his eyes I'd be awfully pleased: you see, he mostly looks down while he is playing with the clay (making abstract sculptures) and humming old tunes. If you talked to him for a little he would be looking up and then I could do his eyes. I think I've made a good start.

Epstein had wanted her to be there while he was working, but she refused and later he agreed she was right. 'Paulie and I got along fine,' he said. 'He has settled the Jewish question and' – laughing – 'I have settled the negro question.' The portrait was finished and cast by 5 December: 'It's at my place,' Epstein wrote, 'and if you come any time I'd love you to see it.'

As this letter was on its way, the reviews of the *Fleurs du Mal* exhibition had begun to roll off the presses. On this occasion, there was a totally different reaction – the acclamation given to the paintings of the woods and flowers might never have been: while Epstein, carried away by the project, had on show thirty-seven drawings (a selection from a total of sixty-one), to the art critics he was once more the 'Public Bogey Man No. 1'. Where *Les Fleurs du Mal* were now hailed as great

works, Epstein's illustrations merely resurrected the furious animosity
that had bedevilled his sculpture over thirty years (and had greeted his
drawings for the Old Testament), equalling the ferocity of the attacks
on the poems in 1857 which brought Baudelaire to court on a charge of
offending public morals. 'EPSTEIN HAS CREATED A NEW HORROR' ran
the *Daily Mail*'s headline. 'Horror and near-obscenity,' wrote the
paper's critic, Pierre Jeanneret,

> with no aesthetic value . . . Epstein has produced no beauty of form
> and composition analogous to Baudelaire's rhythmic language and
> ability to off-set the gruesomeness or indecency of the themes . . .
> The entire series – with misshapen females, sometimes decapitated,
> always repellent; lewd navvies fresh from or leaving for the
> torturer's rack; and disgusting embryos – is an insult to good taste
> – and to Baudelaire . . .

'Exercises in the Macabre' proclaimed *The Times*, and cries of 'Morbid-
ity' and 'Shameless lasciviousness' from other writers. Perhaps most
damning of all was the *New Statesman*: 'Mr Epstein's virtues have
always been vigour and expressiveness, and in his better works these
have gone far to compensate for the absence of distinction and sensibil-
ity.' But these were not only 'impertinent, they must be classed among
the emptiest works that he has ever exhibited' – and, after all, he said,
'Baudelaire is a great classical poet, at once marmoreal and exquisitely
fine . . . One does not need to be a Blimp in order to feel that ugliness is
not enough . . .' The highbrow critic, Epstein said, had the misfortune
to find himself 'bedfellow with the gutter journalist in questions of art.
The highbrow critic gets round this by asserting that his lowbrow twin
dislikes me for the "wrong reasons".' It was left to writers in newspapers
like the *Daily Post*, the *Jewish Chronicle* and, in particular, the
Birmingham Mail to support him: in the last, the writer was exceedingly
perceptive, calling upon the fantasy and invention of the Gothic gargoyle
for comparison with Epstein's 'adventures of the soul', not, he said,
'popular nowadays', and which were, in any case, 'likely too soon to be
confronted by the modern Inquisition of totalitarianism'. He mentions
Winchcombe Church in this connection but the vigorous series of
macabre gargoyles along the eaves at the Herefordshire church, Kilpeck
(believed to have been built by the Vikings), also have a fascinating
resemblance to Epstein's fertility of invention. He went on to compare
the profundity of the drawings with the mysticism of Da Vinci which

they irresistibly recalled. 'Les Fleurs du Mal is a theme felt acutely enough and of the artist's joy in creation there is no doubt,' he concluded.

Epstein himself was convinced that anti-semitism lay behind the attacks: anti-semitic prejudice arose constantly in what was said. Consummatum Est had been condemned because the critics said it was wrong for this recumbent figure of Christ in his final agony to be portrayed by a Jew: 'Those that took that line,' Epstein observed, 'forgot that Christ himself was a Jew.' And so far as the present exhibition went, he couldn't see where '"near-obscenity"', whatever that might be, came in. 'They are of spiritual character,' he insisted, 'extremely tender in their conception in many instances. That some of them are macabre is true. But that word was used by Baudelaire himself to describe the poems. Whether I have produced beauty in making these drawings is a matter of opinion. I cannot believe there is anything but prejudice behind some of the more violent attacks . . .'

He had made his aims clear in his brief foreword to his catalogue. He had bought a copy of the poems in 1902 when a student in Paris, and said:

For long I have been haunted by the images of revolt, anguish and despair – disgust with the world and self – expressed in Les Fleurs du Mal. To evoke upon paper this profoundly felt and pitiful drama was an aim that called for imaginative and courageous treatment. Here is an adventure wholly of the soul. Man caught in the snare of sinful existence to escape 'la conscience dans le MAL'. My technique, my plan of pencil drawings, with a result somewhat like lithography, is justified by the austere and measured form of the poems.

He made the further points that it was to satisfy 'a craving solely' of his own that he had undertaken the work, that 'this Bible of modern man' had long called to him; in remarking that earlier illustrations had unduly stressed the erotic and sensuous side of the poems, 'and that drawings of seductive mulattos, exotic negresses and nostalgic eldorados' did not altogether 'sum up Baudelaire', he didn't, however, mention the forthcoming book for Macy.

The news of the exhibition was picked up by the magazine Time in New York on 19 December: 'The massive, primitive and impassioned works of sculptor Jacob Epstein have shocked London for thirty years. Last week, Londoners were not so much shocked as surprised by Epstein's latest exhibition which consisted not of sculpture but of 37

pencil drawings . . .' Taking as examples *Danse Macabre* (a skeleton lying in front of a fountain) and *Fleurs du Mal*, the writer claimed that even conservative critics (who were, of course, shocked) had to concede that the drawings were true to both poet and poems. It would have been Epstein who was surprised this time: while he regarded them as amongst the best work he had done, they had been almost wholly dismissed as being as blasphemous as those for the Old Testament (when Connolly was the lone figure who understood them); and, Epstein said, 'the connoisseurs without exception found that I had no "understanding of the poet"' – they could have just as well have been illustrations for Bunyan's *Pilgrim's Progress*! What astounded him most, however, was the unbelievable discovery that Baudelaire was not the unknown poet he had imagined him to be in England, but that he was instead a household name! He found this sudden reverence for the poet most touching, but that was the only amusing side of the exhibition, which was a complete flop. The reaction of the die-hards was devastating: he sold little, and even the gallery directors seemed ashamed of the drawings. And so with customary decisiveness, this fearless artist withdrew his work and closed the exhibition down after a fortnight. His enemies had killed it.

Over in New York meantime, Macy, having digested the *Time* review, immediately wrote to Epstein deploring the omission of a mention of his firm of publishers, and wanting a copy of the catalogue sent so that he could check details, not unreasonably in the circumstances. Epstein didn't reply: with the monumental disappointment of the Baudelaire affair on his mind, he was too depressed to think about Macy's problems. He was depressed for another reason, too: although there was an exhibition of his sculpture and drawings opening at Zwemmer's in January, it was that very month when he had to part with most, if not all, of his precious Matthew Smiths, on show at the Leicester Galleries, an occasion he dreaded. All this came on top of the disaster that had overtaken his Strand figures, now hacked to pieces.

It was perhaps not so surprising then that, walking down Kensington High Street with Hornstein one day, he cried out suddenly: 'No-one knows how unhappy I am –'

Nothing more was said, Hornstein asked no questions and the remark remained unexplained. The blows had been too many too rapidly and too heavy – the Strand affair, the Baudelaire fiasco and the sale of the

paintings – that much is certain. Yet the Smith exhibition was a sensational display; it was also unique – no other person in the land (and what a shock it must have been for the 'highbrow' critics to discover that person was Epstein) possessed such a large and magnificent collection of the painter's work, and if Smith was equally sad that his friend had to sell them (which he was), he understood the reasons; and, as a remarkable retrospective, the show did at least print his great gifts indelibly on the art scene, thus enormously increasing the diffident artist's reputation. Perhaps Epstein had that in mind when he decided to sell the paintings rather than some things from his sculpture collection; yet seeing how truly marvellous they looked on the walls of the Leicester Galleries he must have been appalled by the enormity of his loss.

On 13 February, about the time these exhibitions were closing, Macy sent off another letter: the printers wanted the originals back to check certain points. Epstein had scarcely told him he couldn't help – 'the drawings have gone to the four corners of the globe' – than Macy turned up in London. He had been to Tooth's and wrote again, furious his firm got no credits, that one of the illustrations had been reproduced in the catalogue without his consent – he called that 'a gross discourtesy' – and threatening legal action. Epstein, astonished by this latest turn of events, wrote back that the drawing used had been rejected by him and returned, and he reminded Macy that he had not only suggested the idea of illustrating the *Fleurs du Mal* but had given him far more drawings than required in the contract for £300 (and thus for nearly half price); and that, as Macy well knew, he had made them not for money but 'con amore'. Macy, moreover, had never consulted him on the final selection: 'If there was any discourtesy it was not on my part . . . and to have it end this way is the depth of bathos.'

That was a further blow in the wretched story. However, his reply flattened Macy; he heard no more from him on the subject, and went on to become almost at once involved in a new correspondence in *The Times* over cleaning methods at the British Museum, this time about the Elgin Marbles. His anxiety, prompted by the dismissal of the Head Cleaner and others, led him to say, 'When will the British Museum authorities understand that they are only the custodians and never the creators of these masterpieces?' Three letters followed, one of 20 May from Sir George Hill, a former director, one of 22 May from Epstein, the last of 25 May from Hill, none of which convinced either writer.

With that, Epstein returned to the finishing touches of his alabaster carving on which he had been working at intervals for over a year. This giant work, seven feet tall, was his *Adam*, completed in June – six months after the *Fleurs du Mal*, a 'shocker' to make women rush for their smelling salts at the Leicester Galleries. Despite the invective hurled at the Tooth show, the artist couldn't be tamed; there was no compromise in art. And it was a particularly beautiful exhibition: besides the one enormous figure, there were several pieces – two of Jackie as a baby; one of him aged three; a lovely head of Ti-yi, a young opera singer (with lips and eyebrows painted); Robeson's son, Paulie; Dr Rabbi Stephen Wise; and Robert Flaherty, a film producer. The painting of Ti-yi came in for criticism of course, and Epstein was quick to point out that there was nothing new in this – sculptors had used colour from the Greeks up until Donatello's time. But the bronzes of *Jackie* were the most important of the small studies, since they formed the sculptural extension of a remarkable series of pencil drawings of children (all on the large 58cm × 44cm sheets he liked for works on paper), the majority of which were of him, aged four; exquisite drawings that caught the immediacy of the child in movement, and thus making a fascinating counterpoint for the bronzes. This series continued the selection of a subject which he then pursued relentlessly – those of Nan in 1909, the scores of studies of Sunita, the fifteen of Peggy-Jean, four of Dolores and five (to date) of Kathleen. With the drawings and paintings for *Rima* and the Old Testament, of Epping Forest and flowers, for the *Fleurs du Mal* and now of Jackie, the research into a single subject accelerated with a greater urgency: as Picasso had once written that sometimes he seemed to get full of green and had to paint and paint green until he got the green out of his system, so Epstein, moved by an impulse, drew and drew, or painted and painted a subject until its vast potential was exhausted: '. . . from the beginning I know what I want to render,' he wrote of his passion for drawing his son.

It is the life, free, careless, and apprehensive at the same time, of the little boy with his lively intelligence and quick ways, especially his eyes, and also his expressive hands in their infinite and unconscious gestures . . . My drawings of Jackie present a period of my life . . . To have captured the fugitive and endless expressions and changes of movement of a child has been a rare experience.

On this occasion, much to the surprise of Brown and Phillips, there was no abuse from the press; apart from a few deliberate personal insults from the so-called 'left-wing intelligentsia', *Adam* was praised. The gallery directors were surprised because, after seeing the figure in his studio, they wrote to say they couldn't show it; then, when Epstein refused to withdraw it, they came again, spent three hours cogitating over it alone, and finally agreed, although with considerable doubts as to the outcome; the disastrous reception of the *Fleurs du Mal* was much on their minds. *Adam*, in common with *Ecce Homo* and *Consummatum Est*, was a classical work, an organizational feat derived from a column of stone that had again, like *Consummatum Est*'s, stood in the studio for years. 'During that time,' Epstein told the *News Chronicle*, 'I thought out every detail. It is conceived as an elemental figure, the father of us all.' The freeing of the figure from the alabaster retained the outline of the column as the discipline for some enormously powerful eruptions of form in the huge legs, biceps and head, and in the dramatic invention of a double image at the epicentre of Man's sex with its subliminal likeness to a fig-leaf. It was this, of course, which had stunned the gallery directors; even frightened them. Yet they needn't have worried: besides the surprisingly good reviews, the gallery was crowded – throughout the duration of the exhibition, the attendance demonstrated once more that his work did at least bring the public to art, more than could be said of any other's. Elsewhere, galleries were empty after the private views were over. Even public galleries suffered in the same kind of way: when the Tate and National Galleries should, in Epstein's belief, have been full, they were usually empty – he could, for instance, never understand why sculptors and painters didn't visit the British Museum; that they should seem ashamed for some reason to be caught studying great works like a Raphael, or a Mantegna, or a Veronese in case they should be thought to be cribbing; something like that.

Adam could be regarded as the climax for the phase where nature was central to his source of inspiration. This giant was symbolic of reproduction, a creature of the forest – of Epstein's Epping Forest, that breeding ground of deer, badgers, hares, foxes and the rest of the wildlife which were his friends there. And as it had somehow been right to surround the African, Haile Selassie, with the brilliance of his enormous watercolours of flowers, so it was right that *Adam* should have around him a crowd of portraits of children. Huge, elemental, his

presence of course transfixed people; they were spellbound by 'the monster', as Epstein referred to him, and it made, as a sensation, the perfect *Picture Post* story for Edward Hulton to run: 'His output in sheer physical labour is terrific,' wrote William McCance, the *Post's* critic. 'He does not know what it is to compromise.' There were the remarks of mystified spectators for captions – 'Did you ever see a man like that?' and 'After all, you can't ignore Epstein'. 'Some go to be shocked,' the captions ran on. 'Some go to be fashionable. Some go to enjoy the sculpture.' But the accompanying piece by McCance was serious enough:

> Like so many significant works of the past, Epstein's sculpture is so powerful and stimulating that it is bound to lead to violent reactions. Before his work can be appreciated or understood, the mind of the spectator must be clean and free from prejudice. It is so easy to hate something we do not understand. It is so easy to abuse something we are afraid of. But when a thing is so powerful that we are even afraid of trying to understand it, our only hope is to persecute it out of existence.

He listed what were for him the qualities essential to sculpture – naturalism, realism, truth to materials, a life of its own: 'This *Adam* is a great work of art because it has all these properties.'

Epstein himself was disappointed that *Adam* had completely stolen the show; the bronzes and the drawings of children meant as much to him in their way as the statue. Still, a passing remark from a New Yorker, quoted by his latest admirer, L. B. Powell of the *Birmingham Mail*, would have pleased him. She said: 'To me *Adam* is as if it were not made by a man, but by mankind.' That was much like Epstein's own explanation of his creation: it was a religious work – 'I have portrayed him searching, seeking, questioning, yearning – the appetites, aspirations and evolution of mankind . . . Adam is not to be regarded as primitive man, but as man in general, something of the earth, the air, the sea, the sky.' Powell wrote (3 June 1939): 'I take the American visitor's words to mean what Epstein himself hoped and knew he would mean in this elemental depiction of man, earth-bound but reaching upwards because man knows no other destiny . . .' He added that there was bound to be the objection that it was impossible to see the features of the face without a ladder, taking up the same point of the later *Picture Post* caption (in itself, a version of the 'Let's see if we recognize

the woman' applied to *Genesis*): 'As if sculpture,' Powell said, 'when it is the image of thought, should be judged by its resemblance to people we meet in the street.'

An unsigned review in *The Times* managed to put a damper on proceedings, and was written in that arch style which suggested the identity of the writer might well have been Blunt or Nash or Bell. In carving *Adam*, the reviewer compared Epstein to the poet who turns from a 'free ode' to a 'sonnet' – there was 'apt to be a discrepancy between content and form.' He said he used the poetic form 'sonnet' advisedly because *Adam*, although 'of great size', did not look large, 'and would probably be more impressive in a two-foot-high statuette'. However, one of the writer's more spiteful remarks was reserved for the bronzes: 'He is always successful with children because . . . his genial appreciation of their forms is free from the crooner's emotion which he is prone to express in older persons – in the head of *Ti-yi*, for example.' Although, as Hornstein and others noted, this manner of sophisticated bullying from the 'highbrow' critic, carefully calculated to hurt, never failed to weigh on his mind, on this occasion he was worried about something else: to the astonishment of his dealers, *Adam* was bought for a rumoured £7,000 by an Australian who wanted to remain anonymous.

He didn't remain so for long: his name was Charles Stafford, the director of a goldmining business who evidently saw *Adam* as a gold mine. The news that Epstein had actually sold the sensational work hit the headlines – now that the sculptor had apparently made money out of it, newspapers displayed their hostility with leading articles. Horror was expressed by one paper that his art could fetch so high a price – a paper which, as Epstein pointed out, commonly reported business transactions of millions of pounds; eyebrows were raised 'in astonishment that I could "easily" earn seven thousand pounds,' he said.

Think of the manner in which millions of money are made on the Stock Exchange by looking at the ticker-in offices, with the help of managers, vast staffs, and with no surprising comment by leader critics; yet the fact that a sculptor, single-handed, could with all his out-of-pocket expenses, over-head charges for studio, sustenance for himself and his family, and the labour of about fifteen months, earn the magnificent sum of seven thousand pounds, passes their belief. Of this sum received, one quarter is deducted for the Gallery, another

quarter or more goes to Income Tax, and to sum up, and to make the whole thing more grotesque, the actual price of the work was not one-quarter of the published sum.

Stafford had bought the statue for a mere £750 (the figure spread by the newspapers was complete fiction), whereupon it transpired Stafford had done a deal with a Mr Lawrence Wright who had paid him several thousands for the rights of exhibiting the masterpiece in Blackpool for a shilling a visit. Stafford described himself as an admirer of Epstein – 'art has always been my hobby,' he said. Wright, who described himself, among other things, as a composer, and who reckoned to make £20,000 from the exhibition, claimed he had obtained the right to hire the work against intense competition from circuses and sideshow promoters. Epstein, who had not been consulted, was furious: 'I would have liked it to be shown at the Tate Gallery but you know it would have been rejected – the trustees of the Tate are lacking in both imagination and initiative'. Yet, although the Blackpool scheme disgusted him, there was nothing he could do except protest. He had no legal rights in the matter and it had to be remembered that 'art is for everybody or it is nothing', he said; here again, art was akin to religion with him.

He opened the exhibition; *Adam* was in an art gallery, and was not, after all, displayed as the 'vulgar sideshow' he had feared. Just the same, he was horrified by the setting of the work, but said nothing – what could he say that would do any good? He couldn't stop Stafford sending it off to the New York World's Fair for thousands more to gape at it; and that was what Stafford proposed to do. And there were other rumours: Wright, it was widely reported, had given Epstein £5,000 for a companion for *Adam* that he would exhibit the following year, *Eve*. The total agreed fee was £15,000 – 'Adam is lonely,' Mr Wright was reported to have said, having also offered a further £15,000 for fourteen bronzes, the report continued. All these stories, and many more, were, hardly surprisingly, utter nonsense, thought up presumably by Wright for publicity reasons. And six months later *Adam* was moved from the art gallery to a fun fair where Stafford was making, he claimed, £1,000 a week; in America, where it was to travel to sixteen cities, it would make a million, Stafford told Epstein, and he would get a cut of this. Of course, he never did.

Despite the treatment *Genesis* had, and his fears for *Consummatum Est*, Epstein was far too unworldly to appreciate the commercial implica-

tions of the scheme. But even so, it was not possible to stop the exploitation of his work, the legacy of which were recurring bouts of anxiety and very bad publicity. He had weathered the constant attacks on his work and himself in the past – the vandalism of the Wilde tomb and of *Rima* (so many times), the smashing up of his Strand figures, abuse from both gutter press and critics in the posh papers, the violence directed at *Night* and *Day*, the anti-semitism, his named dragged through Parliament, smears on his character and countless other horrific experiences – yet never before had one of his sculptures fallen into the cheap, squalid clutches of the basest commercial interests where merely materialistic returns mattered. This horrendous end for a work of great art could be blamed on none but those who saw an obscene opportunity to exploit it for low gains of their own: as such, the sale of *Adam*, a carving inspired by the highest possible ideals, was a terrifying portent.

At least, that is the inference which could be drawn from the story as presented by the newspapers. Yet the mysteries surrounding the sale still hang on: *Adam* ended up in the basement 'anatomical department' of the Louis Tussauds showroom owned by the Parkinson family, where it was to join *Consummatum Est*. William Cartmell, the front man for this buy, was also associated with the sale of *Adam*, but, according to the Parkinson archives, neither Stafford nor Wright was employed by the family. From these facts, therefore, it may be assumed that the decision to send *Adam* on a tour of first America and then England wasn't the Parkinson family's, and that many of the newspaper reports were, like such details as the commissioning of 'Eve' and the crazy accounts of fees paid to the artist, a complete fabrication.

The exhibition had one further devastating consequence. Beth Lipkin, a young Canadian pianist whom Kathleen had befriended, walked up the garden path of 272 King's Road one day, thinking perhaps about some duet the two of them might play. As she came through the front door, she saw Kathleen standing at the top of the stairs, her face white with anguish.

'Beth,' she whispered, 'I've just had some dreadful news. I've just read in the paper that the drawings of the boy are drawings of his boy, Jackie. He has had another child –'

She stood there, staring down, saying again:

'*He's had another child . . .*'

12

Mrs Epstein

CLEARLY, the news of another child was a devastating shock, and much the worse for coming the way it did, out-of-the-blue via a newspaper report of the accompanying drawings to the *Adam* exhibition which, hardly surprisingly, Kathleen had seen for herself. Did she know about Isabel? She must have known or suspected something, and the blurred outline of a very young, very lovely possible rival materializing on her horizon could have been bad enough. With this discovery, however, the fog suddenly lifted and the stark truth was a blow that would have dazed anyone; here she was, much in the position in which Mrs Epstein had been when she had arrived on the scene. After that, there were rumours – of a monumental showdown with Epstein, a break-up threatened, talk of an affair as an act of revenge, Epstein's jealousy over that, letters to Hyde Park Gate opened by Mrs Epstein and invisibly resealed – which, if true, were understandable in their different, conflicting ways. Nevertheless, to the disappointment of Mrs Epstein, watching from the wings, the relationship held: Kathleen, a supremely intelligent, balanced and courageous woman who was capable of great gaiety in even the most painful circumstances, managed to overcome the apparent betrayal: Isabel had, after all, long since vanished and, in any case, she loved Epstein too much to lose him. Did she dismiss the matter as a fleeting affair – as sex and nothing more? Did the incident seem somewhat trivial in the context of the imminent outbreak of a terrible war? Or was it more simply that Epstein and his art were so important that both had above all else – herself, her feelings – to be protected? About his art, she shared Mrs Epstein's dedication:

she, too, wanted to make an arrangement to protect his work after his death; in fact, both formidable women shared an altruistic love for him, each having made huge sacrifices involving family loyalties to be with him. If Mrs Epstein's devotion was derived partly from unfulfilled maternal instincts, and Kathleen's partly from his vision of her as a source of inspiration to him, both were faithful to a great cause: art. Otherwise, their viewpoints were entirely different: while Mrs Epstein hoped to be remembered (or so Norman Hornstein, for one, believed) for immortalizing her husband, Kathleen, who maintained her independence throughout all entanglements, may have justified her trust in him in a more objective way: 'Epstein,' she was known to say, 'is a child of nature.' She wasn't alone in thinking this: in his case, it was so obviously true that his manner of living and working could have originated the saying.

As it happened, a grandchild had just come his way: Peggy-Jean's daughter, Leda, was born on 23 August 1939. Commenting that 'the life of children has hardly been touched upon in sculpture', he went on to make four studies of her in eighteen months, the first two before the year was out. The day after this good news, he heard some more – that the production of *Fleurs du Mal* was under way: Macy, who was, mistakenly, not anticipating any further problems, had written to ask Epstein for a photograph of himself for publicity purposes, to which the sculptor replied, agreeing to send one, 'Perhaps a photograph of me will spoil everything.' Before the end of that year, too, he completed a brilliant portrait of Jackie, his fourth, which he nicknamed 'Ragamuffin'; brilliant, because it captured the utter naughtiness of a child in the midst of movement and hilarious laughter. This was one of those works, like *Romilly John*, *Billie Gordon*, the *Mask of Meum*, the fifth of Mrs Epstein, the *Marchesa Casati*, the first of Kathleen, the fourth of Dolores and many others, which was a breakthrough in art; the study *Kitty* in pencil was also such a one. So in a year in which he completed *Adam*, and which included painting, drawing and writing his book, an output of ten portraits was considerable. And once his exhibition at the Leicester Galleries, together with its frightful aftermath of sensationalism was behind him, he began considering another enormous carving in alabaster, his last of the series from *Genesis*, to be called *Jacob and the Angel*. As a struggle between good and evil, this too could again be seen, like *Consummatum Est*, as a comment on twentieth-century turmoil, the age of waste – wasted lives, opportunities and resources,

squandered in wars. Continuity of idea had to be maintained. Work, like life, had to go on.

And he had to get commissions. 'I must sometimes turn to and earn a living like other persons,' he wrote, 'and not indulge too much in strange and unrealizable longings and desires.' If he was sometimes criticized for agreeing to do dull sitters (for why should genius be wasted on such subjects?), he saw himself as a professional artist: while the sitter might be dull, such an artist was concerned with solving problems, a reason why he would constantly refer to books on anatomy, examining parts of a body's structure to make sure he knew exactly how they worked. Students, he said, must go to school to study, to draw – they would never otherwise develop their gifts. And an artist had to sell his work: he had to be practical. On 26 August he was writing to Mrs Robeson at her Highgate address with just that thought in mind, offering the head of her son for the knockdown price of £60: 'I'm so glad you saw the portrait of young Paul and liked it. If a mother likes it, it must be good – at any rate *like*. I'd like you to have it.' At present, it was at his latest exhibition at the Sheffield Art Gallery, but was due back soon. 'Some day, you, I and Paul ought to get together and look at my collection of African sculpture which is very remarkable, and if I should ever hold a show of them for some good African cause, Paul would be the man to head it. I speak of this because of what you wrote of my *Adam* which as you say is chock full of spirit.'

With war declared a week later, the grim memories and anxieties of the horrific confrontation of a quarter of a century before returned: 'This war is terrible,' he wrote to Mrs Robeson on 11 September, 'and will settle nothing. When millions have been killed and wounded the world will be as bad as ever, and we are going to be plunged back into a common barbarism in the meantime. You are wise to get off to America.' She had bought the head and had told him that a friend in New York wanted a cast as well: he was writing about this on 25 October when she was back there: 'If I could make this sale it would be more than welcome: things have got pretty bad here; in fact, for the artist, everything is dead, and if your friend could send me a cheque for the head it would help me to survive this terrible period.' When he heard that yet another friend, a lawyer, wanted it, too, he offered it for £100, as he had a cast on exhibition he could get for him: if Epstein cabled, and had an early reply, the head could be sent over quickly. 'The exchange just now is very favourable for dollars. Things are looking

mighty bad here and a sale would help enormously. I would be ever so grateful if you brought it off,' he told her, writing in November. Where his work was concerned, in whatever way, he was practical.

Times were very bad indeed. The appalling news – Poland overrun in a matter of weeks, the knowledge that defeat would make him a top Jewish target for the Nazis – might have been enough to bring his activities to a halt. It did no such thing: his routine remained the same – in the studio all day, tea, then off to get the evening paper, supper, a spell listening to music (Promenade concerts were his favourite programmes), bed at ten, taking a glass of Dimpel whisky (the only one of the day) with him. What he was short of, and desperately, was money. Despite sales of work and, among his heads of children and a second bust of Hornstein, two commissions – *Lisa Sainsbury* and *Melinda Pearson* (a wonderfully alive portrait of the wife of Charles Holden's partner) – late that year, he found he couldn't meet his overheads, including bronze castings, the plaster moulder, tools and materials. His difficulties over his expenses had been enormously increased by his heavy spending on African, Indonesian and other work during the mid-Thirties (Joseph Herman, the painter and collector who met Epstein a year later, said that by then his collection was largely complete at over a thousand pieces, more than four hundred of them from Africa). With the war, there were no public commissions, a source of income denied to him in the past ten years by architects and others who feared 'scandal', and the *Sainsbury* and *Pearson* portraits were the last for a long time. There was always the book, however: 'Peggy', he would say, 'get hold of Curtis Brown and see what you can do there –' He regarded the advances as 'niggardly.' 'But it's not your money,' his wife replied, 'it's the publisher's. And you haven't finished it yet.'

This reproof made him complete the book by the end of the year. But it had been a carefully considered work overall, given the time he could spare between other undertakings: first written, it was then typed, revised with suggestions from Mrs Epstein and Kathleen (Kathleen's were useful in the section on music, drawn from concerts they had been to together), and then re-typed. Otherwise, it was entirely his work. There were distractions, of course: the Epsteins took in an exceptionally lovely housekeeper cook named Deirdre at the beginning of the war, and there was Betty Peters, a black girl whom Epstein and Kathleen had noticed when leaving the Ivy one evening. After doing a bust of her (the light-green patina in the casting caught the tone of her skin

perfectly), she became the chief subject in a series of at least twenty small nude studies carried out during the war, and eventually exhibited at the Leicester Galleries in 1947.

There was, however, one singular incident before Christmas in the first year of the war so out of character that it is an indication of the stress of the times. Epstein asked his wife to buy a present for Kathleen: when she said, not unnaturally horrified by the suggestion, she would do no such thing, he smashed a set of glasses. Mrs Epstein was unmoved. 'Extraordinary,' she told Peggy-Jean later, 'to ask your wife to buy presents for your mistress . . .'

The fear of massive air attacks on London made members of his two families scatter. For a start, when the Hornsteins left Edinburgh (Norman having qualified), Epstein wanted, mainly on account of his baby granddaughter's safety, to send Peggy-Jean to relations in America. But there were difficulties over a visa; born in Paris in 1918, she had no birth certificate. Then there were problems over booking a passage – ships were filled with evacuees. So when Hornstein went to work in a hospital at Aylesbury, Peggy-Jean decided to rent a cottage in Whiteleaf village on the edge of the Chilterns. The Epsteins, meanwhile, remained in London during the week, however devastating the bombing, so that he could continue his work. They had their helpers: besides Deirdre, there was Chai-Pi (whom he used as a model) and her husband (who had lost his job at the Chinese embassy) – they also lived in. Otherwise, there was an exodus to Deerhurst: Jackie and a governess went, staying for most of the war. The handyman from Hyde Park Gate, Nichols, also went: he looked after the garden while David Roche, an Irishman, was put in charge of the house (these retainers give some idea of the expenses which had to be met on top of his many other responsibilities). Then it turned out that, far from being a safe place, Epping was a military target (there were airfields and troop movements in the area), and an Anderson shelter had to be ordered; this was built inside the house, filling the living room, the water table in the vegetable garden making that site an impossibility, and it couldn't go elsewhere because of the flowers Epstein was painting. He regarded the shelter as a complete waste of money and wouldn't use it, similarly refusing to go into the basement at Hyde Park Gate when the sirens went off, preferring to stay in bed, or in the studio, or wherever he happened to be. As buses were rare because of petrol rationing, the Epsteins were brought to Deerhurst on Sundays by a taxi driver they knew.

On Sundays, too, Kathleen went to Vine Cottage in Harting near Petersfield. Her mother had moved to this village from Herefordshire, and Esther joined Kitty there; Theodore, at school and developing into an exceedingly brilliant painter (he had just completed two beautiful crayon drawings, one of a dying miner he knew, the other of a lake at Walsall), lived in a nearby cottage. Meanwhile, Helen, back from Martigues with her daughter, Cathy, at the outbreak of war, was living with Kathleen in the King's Road, having failed to persuade her husband to come with them (amazingly, before the German invasion, she returned to France on a frantic trip to attempt to change his mind, but without success). Cathy was sent to Oakeswood Cottage in the Dorset village of Moreton to stay with the eldest Garman, Sylvia. She was the friend of T. E. Lawrence who had lived nearby at Clouds Hill; he was killed in 1935 and his funeral at Moreton's churchyard was attended by Churchill, among other dignitaries. To commemorate their friendship, she had a large painting of Lawrence by Augustus John hanging in her dining room. While this suggests something of the closeness of the relationship, an extraordinary experience of Helen's when she took Cathy to Oakeswood Cottage eerily recalled some long-past ritual they had enjoyed. Helen was sitting in the kitchen talking when she heard the click of the garden gate and someone walking up the gravel path:

> There was a knock on the back door and Sylvia started. Then she put a finger to her lips as she tiptoed past on the way to find out who was there. I heard the door opened and my sister whisper something like, 'Not now – come tonight, later.' When the door shut and I heard the gate click again, I twisted round to look through the window to see who it was. But would you believe it? – nobody was there, nobody, at all. A blank. Emptiness. Do you know, I felt sure that I'd had a supernatural experience – that the mysterious visitor had been Lawrence.

This strange story is more than a reminder of the Lawrence legend; it again brings into sharp focus his connection with Epstein via Sylvia and Kathleen. The admiration he had for his work, and the backing he gave him over the Hardy monument, undoubtedly arose from strong convictions of his own; yet they made sense in another way – through this relationship. And his keen interest in the sculptor and his work was recalled again, long after his death, when his brother, Professor A. W.

Lawrence, arranged for the acquisition of two of his statues to be funded by the *Seven Pillars of Wisdom Trust*.

After a time, Cathy joined Kitty and Esther at Harting: there, Helen, who was working for the Free French, was able to visit her, arriving on Sundays. Kathleen led the way with armfuls of presents; she brought the fun. In the meantime, over at Baldwin's Hill, Jackie had picked up where Peggy-Jean left off. On Sundays, he and his father, and very often Matthew Smith, who had been unwell, went for walks through the woods to the Robin Hood pub for tea; or he followed his father on painting expeditions, taking sandwiches, a chair, a stool, watercolours and brushes between them. Epstein never took an easel; he used the chair to rest his board with a sheet of paper pinned to it, and sat on the stool. Whereas Peggy-Jean stayed to paint with him (and was usually offered his painting as a present, only to have it retrieved to sell), Jackie went off to explore the Forest for the day, coming to regard it, much as his father had, as *his* Forest, inhabited solely by himself, the animals and birds. In fact, the moment he arrived there, and was told by Mrs Epstein not to talk to people in the village (those so interested in watching the famous sculptor, his family and beautiful models from behind curtains), he was on his own, quickly discovering a way of escape through the wire fence at the bottom of the garden and into the magic of the mysterious Forest. On the occasions when his father was painting, the work was always finished by the time he returned.

When the 'phoney war' came to an end with the spring of 1940, *Adam* was on show in New York with the Robesons' son *Paul*, at the Famous Galleries. This was in May, a month in which Frederick Brown, once a rebel, now a reactionary, chose to attack Epstein in a letter to the Royal Academician, Sir George Clowsen: 'We must be thankful that we have escaped the disaster of the election of that arch-humbug, Epstein, who is more responsible than anyone else for the ugliness and deformity of the human figure in sculpture and still worse in his drawings and paintings if they can be called such;' and he added, in a reference to the National Gallery: 'Why is Cézanne shown there even temporarily? He is much overrated . . .' These remarks, in the tradition of the British inability to enter the twentieth century, are in strange contrast to some words of Epstein's, then immersed in another burst of painting flowers between his third *Leda* and a head of a little African girl which he called *Piccaninny*:

I regret that I have not done more children, and I plan some day to do only children. I think I would be quite content with that, and not bother about grown-ups at all. I would love to fill my studio with studies of children. Children just born. Children grown up. Children nude. Children in fantastic costumes *en prince*, with pets of all kinds, and toys. Dark children, Piccaninnis, Chinese, Mongolian-eyed children.

However, as he said, he had to be practical, earn a living and forget his dreams; no commissions coming his way for twelve months may have enabled him to get ahead with *Jacob and the Angel*, but he had to find sources where he could sell past work. One of these turned out to be a Mr Samuels in Liverpool; an acquaintance became a patron who introduced him to others – Dr Henry Cohen, for instance, bought the third *Oriel Ross*. Samuels, nevertheless, was the main target: with letters from Epstein during 1940 and 1941 constantly referring to his dire financial straits, he bought *The Visitation* and three paintings early on ('sorry you made the cheque so little', Epstein remarked over the sale of the paintings); and, after a letter from Mrs Epstein listing their overheads down to the last bag of coke, he decided to take the *Shaw* (later, he bought three further busts). In the meantime, over in America, the war was creating immense difficulties for Macy. In July, with Hitler overrunning France, Macy was in a panic – it wasn't that the war across the Atlantic had much reality for him (it meant little more to him than the 1914 war had for Quinn); he simply couldn't understand what was the hold-up that prevented the delivery of the 1,500 Baudelaire copies, and so sent frantic cables to Mourlets in Paris asking what had happened to them; clearly, he thought they were stalling. Hardly surprisingly in the circumstances, there was no reply; communications, as he should have realized, were chaotic. Then a partner at the London end of the firm attempted to contact them, again without success. When he cabled Macy explaining the impossibility of locating the whereabouts of the books, Macy merely replied that he had to know one way or the other: he seemed absolutely sure now that they were being deliberately withheld – either they were produced or he would drop the entire project. With this ultimatum, the partner suggested he should contact his wife, still over there. Whether he did is unknown, but someone, presumably his wife, managed to get to England with a limited quantity, and on 21 August he cabled that he was preparing to ship them across.

In October, Epstein's exhibition at the Leicester Galleries, where he was showing several bronzes that included two of *Leda* and his *Piccaninny*, and a huge new collection of flower paintings, was a sell-out. And the following month, coinciding with the appearance of the restricted edition of *Les Fleurs du Mal* in New York, his autobiography, *Let There Be Sculpture*, was published. Here was another event. But did it relate the kind of story the public expected from so famous an artist dogged by newspaper scandals? Or the reviewers? Nothing personal was revealed, no secret loves, no cats were let out of the bag. Instead, for the most part, he presented, as though in a court of law, the evidence – the attacks of the prosecution countered by the claims of the defence, put forward largely without comment. He described his childhood, his family, his love of music and African art, his struggles involving media and public, New York and Paris, but, apart from an outline of his life and interests, he carefully sidestepped piles of complex controversial material in an objective attempt to put the record straight. As such, the work was a mirror-image of Epstein, of the practical, disciplined artist whose common sense and powerful intellect acted as a self-critical balance for his immense imagination: in this book, he was concerned to lay before the jury ('the Great BP', as he would have called it) just the essentials of the evidence. Since art is inexplicable – clues to it, as he reminded Haskell, could only be hinted at – and there for spectators to make what they like of it, he could think of nothing much he wanted to say on the subject beyond what he had already said in *The Sculptor Speaks*.

His reserve prompted Robert Lynd to write in the *News Chronicle* in November: '*Let There Be Sculpture* is the fascinating story of a fascinating and enigmatic man of genius.' The review, headed 'Book Of The Week – Epstein's Own Story', was not critical or condescending, more a summary of its main points. On the other hand, the *Daily Herald* book critic saw in it possibilities for the usual Epstein row: 'ART CHIEFS ATTACKED,' ran the headline: 'CRITICS AS "SPAWN"'. 'One of the most sensational and outspoken autobiographies of recent years is published today. It is by Jacob Epstein, the sculptor. It will, it seems, hurl him into the centre of yet another controversy.' True, it had, unlike John's rambling autobiography, a positive message, but this was surely something of an exaggeration? The critic was determined not to be disappointed by Epstein's objectivity: 'In it he flays people from almost every class with whom he has come into contact during his 30-odd years

in England. He alleges that there is a boycott of his work by certain architects. "Articles in newspapers, and critics, have instilled fear into them," he says. "I can give specific instances where an architect or an institution has been warned on no account to employ me."' Taken out of context, the quotation introduced a campaigning flavour the autobiography didn't have: the observation was a statement of fact in a well-balanced record of his unique difficulties.

Of course he was outspoken in the book: he had suffered so much from critics and the worst kind of irresponsible reporter that the omission of references to such experiences would have been thoroughly misleading. Since, moreover, the book was well-written and direct, anything he said had considerable impact. There is no doubt that Epstein could write – his letters alone, particularly those to newspapers, show he had a gift for organizing his thoughts economically and simply. And many read it: some, like C. R. W. Nevinson, whom he met one day in Charing Cross Road, congratulated him on it; others were infuriated by it, like Shaw, who wrote off to him immediately: 'I have just finished reading your book from which I have learnt a good deal, learning being one of the privileges of old age. To repay you I will tell you some of the things you don't know. Being a creator you have not had to learn them, but I being a critic had to.' After telling him that he had sat for Rodin, whom his wife had offered a very high fee, and that Rodin had worked with callipers, measuring every dimension, he went on: 'What were the visible facts that Rodin had to suggest in clay? I am a civilized Irishman with a thin skin and hair of exceptionally fine texture, always well brushed ... All this, Rodin conveyed perfectly.' Having listed three more sculptors whose portraits pleased him, including one by a Russian communist who made him look like a Russian nobleman, he used the letter to launch into another bitter attack on Epstein's bust of him – in fact, just that kind of wild attack of which Epstein complained in his book: 'I became a Brooklyn navvy in your hands. My skin thickened, my hair coarsened, I put on five stone in weight, my physical strength was trebled ...' Something in the book had set him off, rubbed him up the wrong way, reviving the kind of abuse he had unloaded on Mrs Epstein a few years earlier, and there is no difficulty in seeing what this was – 'He seemed deficient in all sense of the plastic', Epstein had written of him. He added: 'I would say that Shaw was not really interested in the plastic Arts ...' Shaw must have found that alone intensely irritating; the truth is irritating, but Epstein reported what he

thought without apology; it would never have occurred to him to make concessions to suit some end of his own or for the sake of good relations; only in this way, as he saw it, could truth be protected, a rule he followed whatever the medium used to convey it. Thus, however dispassionate the book may appear in retrospect, its effect at the time could well have been different, and it is probable that many who read it were indeed affronted by certain things he said. This must have helped with sales, and in America, where Epstein's name was enough to attract attention, publishers were soon competing for the rights. 'The publisher is not very intelligent,' Mrs Epstein informed Sylvia Press in a letter of December 1941, 'but we chose him because he offered more money than the others . . . The book will cause a lot of discussion' – it was due to be published the coming February or March – 'not very good-tempered discussion, I'm afraid –'

Early in 1941, the year his father died, Epstein made a fourth study of *Leda*: with still no commissions, he was continuing to carve *Jacob and the Angel*, working from models round him, painting and drawing, and experimenting with sculptural ideas like the *Study for Resurrection* and *Slave Hold* for big groups. His three busts of Deirdre were winners, particularly the first, and there was a new portrait of Kathleen, the sixth in a series that was curious for a number of reasons. Although she has come to be regarded as his most famous model, partly on account of the depth of their relationship, and partly because his works from her spanned a period of nearly thirty years (the final bust was made in 1948), only the first two conveyed the sheer scale of her beauty and, through this, her mind; one further, tiny head of her, which could be called the eighth of the series, and very remarkable, still didn't achieve that. She was a very beautiful woman indeed, the purity of her looks appearing as much the creation of her singular imagination and intelligence as of the shape of her features and the classical form of her bone structure. All the portraits were of course living likenesses – he captured fleeting expressions exactly, the flash of laughter, the glance, at one moment pensive or inquiring, the next mischievously amused, over the slanting line of her cheeks, the characteristically slightly parted lips which anticipated the offering of some original observation in her hesitant, husky voice; but not the mysterious spirit of the inner self which inspired them, that self which, in works from other subjects, he transformed into some strange, extraordinary and remote vision of his own. Those portraits – like *Romilly John*, or the masks of *Billie Gordon*,

Mrs Epstein and *Meum* – express something of the universal themes underlying monumental sculptures like the *Wilde* tomb, *Rima*, *Night* and *Day*, *Ecce Homo* and *Lazarus*: ancient themes which, again, persisted like memories of distant civilizations down the centuries.

So why was it that the majority in the series of *Kathleen* are of a different kind? It may be tempting to think that he was too emotionally close to her to be able to preserve the detachment that turned those other works into masterpieces. This is one possible explanation. A second could be that the perfection of her features and bone structure combined to produce their own masterpiece; that her head, having the calm of a stone carving and a beauty comparable to the mask of Nefertiti's, couldn't be improved upon. She had a likeness to the Nefertiti, a cast of which Epstein had obtained from an English collection just before the war; there was this exceptionally strong sculptural quality of her features, and when Epstein called Nefertiti the 'calm-faced Queen, with her cold, mysterious glance' he might have been describing Kathleen. Nefertiti fascinated him much as Kathleen did: he thought the mask one of the most beautiful things in the world – 'a real presence, a person out of the past, almost alive, with extraordinary beauty of modelling from the lower eyelid, along the cheek, to the mouth with the full, closed lips.' Here was an idyllic representation of perfection, an image to strive for, but one which, like Kathleen, was unattainable.

Meanwhile, Mrs Epstein was worrying. After telling Sylvia, in her December letter, to look out for her husband's ballet curtain for 'David' that was on its way to New York for a production there, she continued:

> Some little disputes will go on with the publisher – there must be
> such I suppose . . . However, we haven't seen the money yet, we had
> hoped to before Xmas but alas there is no sign of it yet. We found the
> war cut in and smashed all the contracts connected with Adam, which
> was so much advertised. So we are not at all well off at the moment,
> still something always seems to turn up in the nick of time, so I never
> worry.

She went on to say a word about Jackie, now seven:

> He is I suppose what Jacob was when he was little a terrible mixture
> of goodness and bad moods, highly strung, a temper like a volcano
> one moment, and sweet and good-hearted the next curiously enough

only interested in machinery and ships. Engines are his little Jackie's
heart's delight. He thinks of a submarine as a paradise . . .

Something did turn up in the nick of time. Early the following year, a
most important telephone call came through inviting Epstein to work as
an unofficial war artist, if for a meagre fee. Their cockney maid took the
call, and then shouted out: 'The Ministry of Inspiration –'

With 10 February came the exhibition at the Leicester Galleries when
Jacob and the Angel was shown with six bronzes that included a bust of
Ivan Maiski, the Russian ambassador, whom Epstein had modelled in
1938. 'EPSTEIN, INSPIRED BY BIBLE, ENDS YEAR'S TASK' was the
gigantic headline in the *Sunday Dispatch*. Inevitably, the sculptor was
interviewed: 'The carving,' he explained simply, 'is a group of two
figures depicting the Biblical narrative of Jacob struggling with the
Angel.' For the rest, the reviewer appeared so baffled by the
extraordinary group – even frightened, perhaps, that the Angel might
suddenly jump and attack him – that he could only relate the Biblical
story in some detail. T. W. Earp of the *Daily Telegraph* found it
equally incomprehensible: in this case, the headline claimed that the
sculpture was 'not his best work'. Saying he was presenting his most
ambitious group to date, he went on to add there was no 'hint of a
"message", and critics who usually find Epstein too exciting might well
complain that on this occasion he is not exciting enough. Herculean
effort has been spent on the huge block of alabaster, but the result in
art is not proportionate to the undoubted achievement in craftsman-
ship.'

This odd comment might well have earned the reviewer the name
'twerp' from Epstein. The sculptor didn't go in for 'messages': he was
making sculpture that was inspired by a graphic story and pursued a
theme that had, in a century of appalling violence, possessed him since
the First World War and *Rock-Drill*. In this work he expressed the
meaning and spirit of the story with the simplicity of a child's eye; a
simplicity that was common to all his work, and was in itself a reason,
no doubt, why he felt such an affinity with children and respected them
so highly. As sculpture, *Jacob and the Angel* was baroque in scale and
execution, a classical work; at seven feet high, and four feet square in
plan, its proportions and order were determined by the Renaissance
discipline of the Golden Section; in its extraordinary display of

movement in forms and elements, it recalls Bernini's *Four Rivers Fountain* in the Piazza Novona or his brass *Baldacchini* over the altar in St Peter's. As ever, the artist was faithful and true to his subject, in this case, the story as told in *Genesis*, chapter XXXIII, verses 22–32. Jacob, a difficult individual from birth, had tried to hold his twin brother, Esau, back by hanging on to his heel while he was being born ('Jacob', in Hebrew, means 'heel'), had cheated him of his birthright and (with his mother's help) of getting Isaac's blessing, later dumping both his daughters and most of his sheep on his father-in-law; in fact, he was a bad lot, a 'heel' in the slang sense. Eventually, however, he had to meet Esau, now rich and strong, and was very frightened. The night before the meeting, he sent his wives and all his company across the River Jabbok, remaining alone on the other side, 'and a man wrestled with him until the breaking of the day'. He knew then that he was wrestling with God, and he fought bravely. His mysterious antagonist, who had to leave before daylight, went outside the rules of wrestling and dislocated Jacob's thigh, preventing him from doing anything except holding on and not letting him go. So Jacob said, to retrieve something, as always, from the situation, 'I will not let thee go, except thou bless me,' and the blessing he received is a change of name: 'Thy name shall be called no more Jacob but Israel,' a name which means 'God strives or persists', and suggests that Jacob's nature has changed from a crafty deceiver of men to a man who has met God, struggled with him and been blessed by him. And so he called the place 'Peniel' ('the face of God') and became a hero of supernatural strength, able not only to outwit his enemies, but to stand up to God and win his favour: he has seen God and still lives, questioning God's Will but always acknowledging his guiding hand.

This powerful story is reproduced in the sculpture with an equivalent power: there are no sexual connotations (as has been suggested) – Jacob, face to face with the Angel and hanging on, has met a superior force, the force of God or whatever means the Good, and the force with which this 'force' is represented in the group is truly astonishing. But *Jacob and the Angel* is art, not literature: Epstein, inspired by the story, exploited it for purely sculptural ends; in a conception where the huge upright wings of alabaster support, like buttresses, the aesthetic weight of struggling bodies, the compositional counterpoint of strength and weakness, of victor and vanquished produces a tension of devastating effect. As in the *Wilde* and *Rima* monuments, he had resolved the

problems of the epic in the service of art absolutely: *Jacob and the Angel* lit up, as an image of a poet can light up some idea of landscape, a picture of life on earth of any time, in the history of Man.

The complaint that it was 'not exciting enough' is plainly amazing: the reviewers, tangled in the web of this mysterious story (of which an excerpt was printed in the catalogue), must have found the work too enormous to make an objective judgement, despite the photographs on sale at the Galleries to assist the baffled onlooker. For Epstein, his God, huge and overwhelming, was another high peak in the range towards which he had been striving since mentioning 'carving mountains' after first settling in London. It was his last in alabaster: otherwise, it was merely a pinnacle reached on the way to somewhere else: his work could never be finished – two years later, he had already started out on another long climb. But those two years gave him a break to think, to analyze ideas, to turn his attentions to working with models and making a living from a sudden and surprising influx of commissions. Here a pattern emerges: after the upsurge of energy had produced some great work of the imagination, and had been exhibited to the accompaniment of enormous publicity from enraged press reports, a kind of lull followed, a period of relative quiet during which he returned to continue his study of the human head, its structure and fascinating peculiarities, and to the mind that lay within. He returned to the fundamentals of his sculpture, the starting point from which the big landmarks in his life as an artist, happening at regular intervals, stepped off – people. With his portraits, the strong relationship established between himself and the sitter was partly responsible for the mysterious atmosphere and form of the work. Sybil Thorndike, who sat for him many years before, described this with marvellous candour:

I met him in about 1924, when we'd been playing *St Joan* in London, and oh I fell for him, straight away. The idea really was for a bust of St Joan. I went and sat for him every day for about three weeks. He said at the first one, 'Do you want to talk?' I said, 'No. I've work to be getting on with.' He said, 'Fine. Fine, I like quietness.' Well, talk about quietness! He walked about the studio making noises like a bull – 'Urrh, urrh, urrh, urrh, urrh.' What I was doing was learning the part of Hecuba: he didn't know I was but – do you know, the bust came out not so much like St Joan, but like Hecuba, wasn't that queer?

The publicity of exhibitions brought the commissions, of course, and it was only the shock of the war which broke up this pattern: that happened after *Adam*. Then, in 1942, there having been some sort of recovery from the sense of shock, they came pouring in again and he was able to continue his studies; he completed fifteen busts, an extraordinary achievement. Among them was a portrait of the Dean of Canterbury, 'a wonderful subject', he said, a head of Alexander Margulies and one of his daughter, Judith. Margulies, a collector, and a friend of Samuels, had bought a cast of *The Visitation* in June. But the success of the exhibition attracted dangerous interests, too: the month before, there had been an offer of £750 for *Consummatum Est* from William Cartmell – he wanted it for exhibiting purposes. This threat prompted Epstein to write off to Samuels who had, unsuccessfully, tried before to get a subscription together to buy it for Liverpool Cathedral. Could he try again? 'I hate to sell it for that purpose and to have the work dragged through the mud of a cheap show,' he said. 'At the same time, I need the money badly.' The Liverpool Art Gallery might like it – he would accept payment by instalments just to keep him going. Nothing came of that, either: Cartmell got it.

So Epstein brushed the matter aside and went on with his portraits. However boring a head might at first appear, he was soon involved with its problems – so long, that was, as he liked the sitter. An example was the unusual case of the Countess of Berkeley, a woman whose conventional looks he transformed, in his second version of her, into a passionate likeness of St Francis for her villa at Assisi. His third *Deirdre*, however, was pure sculptural pleasure, and so too was the head of his second grandchild, Ian Hornstein, born that year. Epstein said:

In the opinion of many, portraits are of a lower order of creation than imaginative works. I do not hold this opinion and if you reflect for a moment on the great portraits of the past such as Donatello's Gatamelatte, Verrocchio's Guiliano de Medici, Titian's Charles 5th and Rembrandt's succession of great portraits, you must realize what imagination is needed to achieve a portrait. Far from it being a dull record of facts, a portrait can lead the mind into depths of feeling and sympathy that correspond to the portraits of drama, such as Shakespeare's or Ibsen's. In my portrait of Shaw, I had the happy experience of reproducing a character of peculiar complexity, of an extraordinary combination of contradictions. It is not the Shaw

of other sculptors of whom he himself wrote to me in an amazing attempt to appraise what I made of him. For one thing, Shaw did not recognize my portrait as true of himself, but pretended to see in it a projection of my own personality. He wanted to know what went on in my mind and unhappily the portrait did not reveal this to him. But I can only be grateful to him for sitting to me with that unfailing kindness so characteristic of him, thus putting on record a present-ment that is not, I hope, either sentimental, philosophical, poetical or even 'gentlemanly'.

It was seemingly impossible for the two sensitive artists to rid themselves of the feelings of animosity the portrait stirred up, and he went on to say that a sculptor must keep his vision intact and not be influenced by the sitter's opinion of himself. Using two further examples, he added: 'I well recall a millionaire who posed for me asking me "to cheat nature", and a very venerable American lady, after days of devoted work, sighed: "And I expected you to make me young and beautiful." I pointed out to her that the bust *was* beautiful. Shades of Whistler's Mother!'

The year 1942, which included two busts for the Ministry of Information (Major-General Sir Alan Cunningham and Air Marshal Portal), and the strange *St Francis*, ended with an exhibition at the Leicester Galleries, which had become something of an Epstein ritual since his watercolours were first launched at Tooth's – flowers for Christmas. They were the perfect present in those grim, wartime winters with the night bombing at its height; to make the point, Epstein had a couplet from a Shakespeare sonnet quoted in the catalogue: 'How with this rage can Beauty hold a plea/Whose action is no stronger than a flower?' It so happened that this was peculiarly apposite, since a bomb dropped on Leicester Square, its blast blowing the gallery's windows in. No paintings were damaged and, despite the violence of the incident, Beauty held its plea; as usual with his paintings, there was a very large attendance and the whole exhibition sold out immediately.

More portraits followed: a good one of Yehudi Menuhin; *The Girl with Gardenias* (a development of the sixth *Kathleen*); the small nudes in the *Betty Peters* series (with occasional contributions from four other girls, Marie Tracy, Tanya Wickham, Juanica Forbes, a Mexican, and one known as Kay); and the very interesting *Dr Whittaker*, a commission modelled in the Onslow Court Hotel in South Kensington. Then comes a significant event: he had been reading *Paradise Lost*, the first book of

392 / JACOB EPSTEIN

which had started off thoughts about Lucifer, his fall from Paradise, from Heaven to Hell, about Satan and the eternal struggle between good and evil, and about the dramatic images describing such scenes; thoughts which crossed with others arising from his intimate knowledge of *Les Fleurs du Mal*, which he constantly studied, and from reading Isaiah, chapter XIV, verse 12, where there is a verse in an excellent poem which mockingly celebrates the overthrow of a tyrant (the King of Babylon): 'How art thou fallen from heaven, O Lucifer, son of the morning! How art thou cut down to the ground, which didst weaken the nations.' Imagination had 'exclaimed' that, Epstein said, quoting the first part when speaking of his sources of inspiration: he had the 'Lucifer' imagery clearly in his thoughts, in its best sense, as the bringer of Light, and as it is applied in the New Testament (Peter, chapter II) to Christ where he is called Phosphoros; and in the Revelations where he is called The Morning Star (in quoting Isaiah Epstein introduced the word 'Daystar', a note of optimism). His meditations on these matters took a long time and many 'inner probings' because of his predilection 'for the understanding of the awesome problems of evil and revolt' concerning Lucifer – 'He whom Shakespeare called "Proud Lucifer",' he said, 'a conception of high daring, an expression of the darkly beautiful beloved of great poets.' He had tried to express all such strands of meaning in his *Lucifer*. And so, from this maze of sources, springs a picture, if shadowy, of the imaginative workings of an artist's mind. From thoughts he'd had for decades – in war, in a depressed, unsettled and battered peace, and again in war – came the first tentative drawings; the drawings turned into maquettes, and, by 1944, the maquettes had metamorphosed as the conception for *Lucifer* as the tall sculpture of a rebel. Epstein, himself a rebel, had perhaps a further subject in mind: that enigmatic elusive rebel, the charismatic T. E. Lawrence.

His drawings of Lucifer were begun in 1943 – Lucifer as the person synonymous with Satan, the manner in which St Jerome and other church Fathers chose to use the verse from Isaiah, and described by Milton as 'a falling Star . . . headlong sent/With his industrious crew to build in Hell'. In one of the two preliminary ideas Epstein put down, Lucifer is dropping through the night sky surrounded by his 'crew' of grimacing and threatening angels; in the other he is standing at the Gates of Hell. Then came a maquette, about a foot high, of a group of three figures – *Satan, Beelzebub and Belial* – that was followed by *Fall*

of Lucifer, a highly complex relief twice the height of the maquette. In this, Lucifer presents the commanding centrepiece of a composition set in Hell, the 'tyrant' having been cast down there, the poet in Isaiah wrote, for aspiring to the throne of the universe. This belief, recalling something of the intricacy and action of his *David* curtain, and brilliantly organized with a necklace of good and bad angels around Lucifer, bore no likeness whatever to the final work. In this, the bringer of Light has just alighted with the spring of a bird; the 'Proud Lucifer' of whom Milton said, 'He above the rest/In shape and gesture proudly eminent/ Stood like a tower.' Epstein's *Lucifer* is the grounded Angel, the 'Son of the Morning': that rebel, imagination, brought down to Earth.

'He above the rest . . .' Lucifer is on his own. This sculpture, eleven feet high and cast in bronze with a golden patina, is an extraordinary conception. Two enormous wings and a tail wing frame the figure: the hands, spread out, suggest the lightness of the landing; unlike the winged 'messenger' of the *Wilde* tomb, where, with legs swept back, the figure floats, Lucifer's tail wing, like a heavy curtain, ties the sculpture to the ground. It is a colossal imaginative work, of a daring he ascribed to Shakespeare's tribute. Great names haunt it, a very rich history lies behind it, and an immense build-up of research led to it, yet it is, above all, a classical conception governed by a single idea of tremendous power; and, to conclude the statement, he chose as the model for the head *Israfel*, a portrait from the past of that marvellous subject, Sunita, whose aquiline nose is emphasized to pick up the vertical axis of balance in an asymmetrical composition. Not unnaturally, considering its scale and detail, *Lucifer* ran over two years in the making, and, by the time it was finished in 1944, he was tirelessly pursuing other subjects, the airraids were largely over and his children were back from the country. There had been some nasty moments: besides the incident in Leicester Square, Kathleen had a near escape when two houses at the end of King's Parade were demolished by a bomb; a flat used by Peggy-Jean in South Kensington was damaged by a 'doodle-bug' (the proto-missile), and then a warehouse south of the river was hit, damaging a number of Epstein's plaster casts stored there, including *Meum with a Fan* (afterwards only the head was cast). But now, with Hitler in retreat, a somewhat peaceful air had descended on London; Jackie was back in Hyde Park Gate, and with Theo, Kitty, Esther and Kathleen's niece, Cathy, at '272', Epstein had his first opportunity to work in clay from his two young daughters. That year, besides continuing his series on

Betty Peters, he completed, in a rush of other works, the beautiful *Girl from Baku* and his fifth *Leda*; yet it was his *Esther* which turned out so extraordinarily well – in his view, it was as good as anything he had ever done. He said: 'If I had to be judged by one work I should choose this. It has all the qualities I most value in sculpture. I could not have done it better.'

Esther was still a schoolgirl, and he had captured her magical looks at a magical moment. It has been said that he exaggerated the length of her neck and the pout of her lips. In both cases, that was unlikely: for him, to exaggerate was a betrayal of the truth, and, as others have testified, he was careful to check dimensions he measured by eye with his tape after the work was finished; his eye for proportion was so extraordinary that he startled one of his sitters by saying, 'You're not wearing the same collar as yesterday' – the collar was an eighth of an inch larger. Esther did have a very long neck and full lips. Whatever made this work so wonderful had nothing to do with things like exaggerations, and is of course beyond analysis; yet, as ever with Epstein's finest works, the spirit of some ancient ancestry (Egyptian?) lives within the living likeness, in this case of a young girl besieged with the puzzling mysteries of the curious life in which she finds herself. When he spoke of the contours of Nefertiti, he could have been thinking of this work too, since, from the enormous swathe of hair to the minutiae of the touches that suggest the merest subliminal expressions – some sad, some perplexed, all so serious – round the line of the lower eyelids, and along cheeks and mouth, *Esther* is a dispassionate and great study in faultless perfection and the very beautiful.

Esther, *Kitty*, *Leda* and the *Girl from Baku* were modelled in the early part of 1944 and, with the *Girl with Gardenias* and other works, were shown in his summer exhibition at the Leicester Galleries. At the end of the year, there was another glorious exhibition of flowers and landscapes. After that, in 1945 when work on *Lucifer* was still under way, came four more portraits, one of which was a study of Myra Hess (a familiar face at Hyde Park Gate) commissioned to commemorate her wartime piano recitals at the National Gallery (which Kathleen and Epstein frequently attended), and another a head of *Ernest Bevin* for the Ministry of Information. *Bevin* was such a success with the War Artists' Advisory Committee of the National Gallery, that the Secretary, E. C. Gregory, wrote to Epstein on 30 August to commission portraits of Sir John Anderson and Winston Churchill. Epstein, accepting, replied

to say that General Wavell would also be an excellent subject, and on 14 September Gregory wrote back confirming that his offer was accepted unanimously, and that 'as regards Churchill and Anderson, the Chairman, Kenneth Clark, is writing suggesting they give you sittings early in November.' At the same time, they wanted another of John Winant, the American ambassador, when he was available. These gave Epstein a good deal to do; Sir John Anderson's sittings were arranged without difficulty, but Churchill's had to wait until later. Moreover, with November came the moment to exhibit *Lucifer*. He had already had another show of his sculpture and watercolours in New York that June, yet this one was special: just *Lucifer* and *Yehudi Menuhin*, and the walls hung with paintings of the Forest. Of course, the great Biblical work dominated: in fact, it was so huge – the wing-span alone was seven feet – that it made a dramatic entry to the Leicester Galleries; their entire front had to be dismantled to enable the workmen with derricks, jibs, crowbars and rollers to get the one-ton apparition (the statue was covered with a shroud) inside; after which, it was reported in a newspaper, Epstein, all smiles, left for home. And it was well received by the press, a rare occurrence indeed. With the war at last over, so too perhaps was the war with the sculptor, at least for the moment. *Lucifer* had taken 'some years', Epstein told the evening paper, the *Star*: 'It was not easy. Often I would put it aside for six months at a time. Now it is finished, and I am satisfied with it.' When asked what had inspired the work, he quoted the passage from Isaiah ending with 'Son of the Morning'. '"Son of the Morning",' he repeated. 'It holds the key.' Seen then, after the terrible devastation of six years of relentless destruction, the figure might have appeared to possess some special significance – not, after all, an image of disaster at the Gates of Hell, the message normally attributed to it, but instead one of optimism: the 'Son of the Morning', heroic, serene, awesome, was herald of better days and brighter skies.

Epstein was 'seen at his best', T. W. Earp said in the *Daily Telegraph*. 'The actual modelling is superb.' All the same, the show was a disappointment: while in the meantime *Jacob and the Angel* had surprisingly been bought (most unfortunately, it transpired, by Cartmell acting for Tussauds), *Lucifer* remained unsold, and that was very worrying indeed for him; the work had not only taken a very long time to do, which had meant setting aside other things he was anxious to get on with; it had taken six months to cast, which alone was a vast expense that had somehow to be met. However, a stream of commissions had again come

his way; besides Churchill's and Wavell's, he was asked to undertake a portrait of Heathcote Amory, and these helped to cover the heavy overheads – of his *Churchill*, for instance, a work he wasn't pleased with, he sold many casts. It was a pity this didn't turn out better, but he was a difficult sitter. He had come to live opposite the Epsteins in 1945 after the Tories lost the election, a convenient happening for the portrait, though it transformed a quiet cul-de-sac into a street full of police, official cars and reporters. Work, however, began well enough: he arrived at the studio complete with cigar, secretary and a plainclothes man who, having taken up guard by the door and been offered a chair, was promptly dismissed. 'Lighting his cigar, with his secretary seated behind me ready for dictation, we were all set for a fair start.' This was Epstein's description of the scene.

> After an hour, this secretary was dismissed and a second appeared for further dictation to the accompaniment of a second cigar. After three somewhat restless sittings, Churchill decided to stay at Chartwell where he gave me further sittings. Unfortunately, it was winter and the light far from ideal and I felt that I had made no more than an interesting character study . . .

He did like Churchill, and was touched when he asked him over to his house to look at his paintings, an expedition he undertook with some trepidation, fearing the worst and having to give an honest opinion; however, he was received with great courtesy and, much to his surprise, he thought they were 'not bad', and was struck by his humility. But the *Churchill* was the last in the series of wartime portraits. He never did the John Winant head, a man with whom he had a curious experience. One evening when he was alone in the house the bell rang and on opening the door he saw a man he had never met but whom he instantly recognized. It was the then ambassador of the USA, John Winant, who asked him if he could spare him a few moments for a talk. He stayed for two or three hours, and as dusk fell these two, diplomat and sculptor, discussed the American scene as they remembered it in boyhood, and the trend of world thought today. The sculptor was deeply interested in the other's appearance which reminded him of Lincoln's, and the diplomat left thanking him earnestly for receiving him uninvited and unannounced, moved by an irresistible impulse to unburden himself to one he had long wanted to meet. No arrangements for sittings were

made and a day or two later he read of Winant's sudden and tragic death; he had killed himself.

That shock affected Epstein deeply. He was always anxious, and at this time was in any case very worried about his wife's health and about both his sons: Theodore was producing some very original and wonderfully luminous paintings, had hoped to go to university, but had suffered a severe breakdown; and about Jackie, because he couldn't stand his school in Highgate, running away at the first milk break to get back home (by bus and walking) where he had rigged up a survival kit in his second-floor bedroom (shades of his father as a boy) – an RAF rubber escape dinghy, a tent, a collection of antique swords and a system of pulleys at the window to enable the quick getaway to the street below; a bizarre assortment of equipment for emergencies. He was now eleven, fascinated by anything to do with motoring, subsequently carrying the chassis of an MG to his room with the help of Ginner, a powerful Italian maid, and then, taking the engine apart and dragging up the bits, he rebuilt the entire car in his bedroom. Hardly surprisingly, the Epsteins felt his education needed attention, and an advertisement was put in *The Times* for a secretary (the method Mrs Epstein normally used for finding 'handymen'), which produced a young, aspiring writer named John Finch. He was to take Jackie to school in Kensington, shop in Barkers, act as a tutor on the side, check housekeeping, write letters, take a bust to the foundry or to the Leicester Galleries – one of the models who occasionally stayed overnight helped him with Jackie. It was a curious job, a kind of handyman with special duties; but with him installed, Epstein could carry on without distractions with the continuing series of nudes, three commissions that included the beautiful Anna Frankel (wife of the composer whom Epstein referred to as the 'Aldgate spiv'), several imaginative pieces and a head of Pandit Nehru, in London for the Commonwealth Conference. Nehru ended up as a sitter purely by chance; he had never met Epstein, and wanted to see his studio while he was over; he was so keen to do so that he waited half-an-hour for the sculptor, out when he arrived. As they were talking together, Epstein became interested in his remarkable looks, and, realizing that a rare opportunity was being wasted, at once asked him to sit. In three days, with a session of one hour only starting at 9 a.m., the head was finished: Epstein called it a sketch, but it was a superb sketch, capturing exactly the Indian delicacy of the subject's bone structure.

*

Then, towards the end of 1946, he had some good news: Professor A. W. Lawrence bought *Lucifer* for £4,000 out of *The Seven Pillars of Wisdom Trust*. Lawrence, like his brother T. E., was a fervent admirer of Epstein's work. As Laurence Reader and, in 1944, Professor of Archeology at Cambridge, and as a scholar whose study of Hellenistic sculpture had led to his perceptive books, *Later Greek Sculpture* and *Classical Sculpture*, his admiration for *Lucifer* alone is a matter of very special importance, particularly in the context of subsequent events. Highly delighted with this new and great possession, he at once offered it as a gift to the Fitzwilliam Museum, sure that it would be snapped up by the Syndics there; unfortunately not — to his astonishment, the work was rejected for vague and unconvincing reasons. Lawrence was not put out — he was determined a public gallery should have it, and asked Epstein for advice. He suggested the V&A, but again it was rejected, this time on the grounds that the museum didn't exhibit works by living artists. At this, Lawrence decided to offer it to the Tate, and Epstein wrote on his behalf to the director, John Rothenstein, asking him to invite the Trustees to his studio to view *Lucifer*, 'several of whom', he told the *News Chronicle*, 'I know had never seen the work.' None came, and when an alliance among the Trustees that included Moore, Philip Hendy (the Director of the National Gallery), and Charles Wheeler, a maker of utterly dull and sentimental sculpture, achieved the Committee's unanimous rejection of the work, Epstein reported this to the newspaper — 'rejected unseen,' he said. It so happened, Rothenstein was in Rome at the time, and, as if by way of explanation, the Trustees' chairman, Sir Jasper Ridley, was reported as saying, 'We have nothing personal against Epstein. We do not like the work sufficiently to include it in the collection at the Gallery.' These curiously phrased remarks, so overtly patronizing, infuriated Epstein. 'I'm disgusted,' he said. 'These people are always willing to speak of their friendliness towards me and the interest they take in my work, but when it comes to a practical demonstration of this friendliness and interest they invariably move in the opposite direction. Lucifer is one of my most important pieces.' He made the further point, in an interview with the *Manchester Guardian* on 27 January, that to decline such a gift was a 'discouraging performance on the part of the Tate Gallery Trustees'. And Finch, using this latest controversy to express his admiration for his employer, wrote a piece in *Illustrated* (15 February 1947) in which he said, 'The British public, once abusively critical, now regards his work with a reasonable

standard of intelligence and appreciation, at times even showing more discernment than fellow artists.' The Tate's bleak rejection also insulted the Lawrence Trust which had already donated works to various collections, including the Ashmolean's and British Museum's; most of all, though, *Lucifer* was a sculpture of compelling imagination and nobility. No wonder Lawrence was astonished by the treatment his offer had received.

Rejection by the Tate had one advantage: it attracted immediate publicity: papers were full of the news, bringing instant inquiries from provincial galleries. As the *Manchester Guardian* was going to press on the 27th, requests for the work had already landed on the doormat at Hyde Park Gate, prompting David McFall, a sculptor friend and admirer of Epstein's at the time, to send off an urgent message to the Birmingham Art Gallery a couple of days later. 'I do not know,' he wrote, 'if you are aware that since the Tate Gallery turned down the offer of Epstein's *Lucifer*, the city art galleries of both Liverpool and Manchester have been after it.' Saying that Epstein preferred Birmingham's to these two and that the offer was still open, he went on: 'I was in your gallery recently and saw the fine circular room and thought it most suitable for showing large statuary. If you are interested to acquire *Lucifer* get in touch at once with Jacob Epstein, 18 Hyde Park Gate London SW, phone – WESTERN 5723 –'

The reply from the gallery's director, Trenchard Cox, came by return of post, saying that Birmingham would be honoured to have the sculpture, that it would look 'magnificent' in the Round Room, and that he was taking his chairman to see it at Epstein's studio. The day after this, Rothenstein, back from Rome, wrote to Epstein: 'I can do no more than acknowledge your letter except to express my regret that you should have suffered distress as a result of the offer of a gift the generosity of which was fully recognized by all the Trustees of the Gallery.' This contrasted interestingly with Cox's letter of 17 February to McFall, sent after his visit to see the work: 'I am sure you will be glad to hear that the Committee have accepted with gratitude the gift of Mr Epstein's *Lucifer*. We all feel greatly privileged to have this important work in Birmingham ... My Chairman and I were most courteously received by Mr Epstein last week, and we greatly enjoyed our visit to his studio ...'

Peggy-Jean and her children left for America just as her father's

February exhibition opened at the Leicester Galleries; she went on the *Queen Mary*, packed with 'War Brides', to join her husband who was working in New York. She was very much looking forward to this new adventure, yet even as she left she was anxious. Mrs Epstein had been in poor health that winter, one of the coldest on record, and her father was worried, too. On 8 January, he had written to Matthew Smith, also ill and in bed, to give him the latest news – that he had just finished his second study of 'the young lady', Kitty, that work prospects were bad, and that he was arranging a show of flower paintings at Connells Gallery in Glasgow which might 'turn out all right'. He was anyway depressed by the news from the Tate then, and went on to say, 'Peggy has been very unwell with bronchitis, quite laid up, and Jackie also developed a bad cough during Christmas so there is trouble all round . . .'

On Sunday 2 March, the Epsteins and Finch went to Baldwin's Hill by taxi, as usual. They came back in the evening, Epstein, Jackie and Finch going on into the house ahead while Mrs Epstein paid off the driver. Finch had gone to see the Irish cook, David Roche, about supper arrangements when he heard a cry; he went to the door and was horrified to see Mrs Epstein lying at the bottom of the steps, unconscious. He called out to Epstein and fetched the cook, and together they carried her into the house where she recovered consciousness. Epstein wanted to phone for a doctor but she insisted she was all right. And so they sat down for the meal, soup was brought in, and suddenly she fell forward. Mrs Epstein was dead.

13

Resurrection

MRS EPSTEIN'S death didn't go altogether unnoticed, as may be imagined. Reports of it were misleading, as any news concerning the Epsteins usually was: there were predictable headlines like 'MRS EPSTEIN'S MYSTERY FALL' and 'BEHIND A GENIUS' that were followed by gossipy details of their life together as inaccurate as the estimate of her age – she was described as sixty when she was in her mid-seventies. In the *Daily Telegraph* of 7 March, for instance, the claim that 'the recent bust of Lord Wavell owed much of its success to her ideas' was a wild distortion of the truth, if not wholly nonsensical: Epstein always ignored the suggestions of others, whoever they were, chiefly because no one knew what idea he had in mind, but also because he was exceedingly self-critical, and for this reason alone an outsider's comments were irrelevant and off the point. And there was no mystery about her death: she had been suffering from bronchitis (confirmed by the hospital) and had, at the top of the steps, clearly become dizzy and fallen backwards.

Naturally Epstein was deeply upset: the woman who had occupied over forty years of his life with a solid presence of utter devotion and self-denial had suddenly gone. Then came the discovery of her 'treasure chest' next to their bedroom of which he had known nothing, and this was profoundly distressing for him, too. Finch had brought back her clothes and bunch of keys from the hospital and had opened up the room. Its contents were a tremendous shock, and the smell of mothballs and decaying fur coats stuffed away in piles of sacks and trunks was appalling. On top of all this, a cat had got in and had had kittens there,

infesting the room with fleas. It was then that Epstein, overcome by the utter squalor of the scene, and perhaps suddenly glimpsing, in one raking glance, his wife's shockingly private miseries hoarded like unwanted, disintegrating garments, rushed out for air into the mews at the back and ran into a rag-and-bone man often in the area. He asked him to clear the room of everything in it, immediately, and left him to it. Peggy-Jean, who was the only person who knew of Mrs Epstein's 'secret' and the haul of 'baubies', as she sometimes so pathetically called the things she stored away, was horrified, too, when she heard from her father what had been found there. She had flown over for the funeral at Highgate Cemetery, having refused an offer from Sylvia Press to accompany her. Sylvia had the idea that a chaperone was needed if that dangerous and wicked mistress of Epstein's was around: her picture of Kathleen had been blackened by Mrs Epstein's lurid descriptions of a greedy, evil creature hellbent on breaking up marriages. So of course had Peggy-Jean's, and so she was amazed to find instead a gentle, quiet, cultivated and dignified woman.

Peggy-Jean was saddened by the story of the room for another reason; gone was a packet of World War One letters from her father to her mother, Meum, whom she hadn't seen since she was a child, and who was now quietly breeding dogs in Suffolk; there had also been a cast of *Baby Asleep* from the Paris days, and she wished she could have saved both of these from the rag-and-bone man's clear-out. But that was that – they had gone, had vanished into oblivion with the rest of Mrs Epstein's things, in a blink. The few reminders left of her were handwriting in the 'House Book', in her copy of Epstein's autobiography and one or two jottings elsewhere; and, unforgettably, in Epstein's beautiful studies of her in the studio. Gone, too, was Roche; he went back to Ireland, and Finch left shortly afterwards. When Peggy-Jean returned to New York, Jackie went with her: Epstein thought this best, at least for the time being, and so there was no job for Finch to do – anyway, he had his own life to get on with. While she was in England, Peggy-Jean met Esther, someone she had always wanted to make friends with since once seeing her playing in Hyde Park with her brother, Theo, as children. They did make friends – they spent two weeks together at Baldwin's Hill with Jackie, who took his rubber dinghy for excursions on High Pond, one of Epstein's favourite subjects in the Forest. Esther was, of course, living with her brother and sister in the King's Road at Kathleen's house. Helen had made the break there: it was a wrench but she had

suddenly fallen in love with the elderly Mario Sarfatti, a lawyer who had come to England before the war from Lake Garda, and who was teaching her Italian; she took Cathy with her, all three living in Kensington Church Walk, only to discover, most unexpectedly, she was having a baby. After that, they were married.

With Mrs Epstein gone, the dreadful conflicts of loyalties that had haunted Epstein and had divided the families were gone too: those problems immediately simplified and were resolved at a stroke. What remained, however, was the chaos she left behind, a house full of broken bed-springs and muddle: the back room on the ground floor, once a space for hanging Matthew Smiths and displaying sculpture from the collection, had become a store, heaped with junk. And worse still, there were the chaotic financial problems – money owed to plaster moulders and the bronze foundry, huge sums to income tax and for the mortgage on Hyde Park Gate. Kathleen was shocked to discover this when she started going up there; and shocked, too, by the bad state of the interior of Epstein's fine house, neglected, depressed and blighted by his wife's declining health and piles of debts. Kathleen was an extraordinary creature: a good spring clean was needed and, with her usual energy, she set to at once on the task of restoring order to Epstein's life. This wasn't easy for her – she was travelling to and from the King's Road where there was her house and her son to look after – and it was exhausting, but Epstein's surroundings had to be transformed to give him, at last, somewhere restful and enjoyable after his hard day in the studio; and, equally important, she had to straighten out his financial affairs. Kathleen had, however, a magical touch: while very witty, imaginative, sensitive and cultured, she was, at the same time, business-like and effective. With the same ease that she could reassure friends with some telling joke left hanging, incomplete, in the air, its point accepted and understood, she could miraculously alter the appearance of a room with some tiny adjustments, some strange gift of the lightest sleight-of-hand; and she applied this unique gift to Hyde Park Gate.

When Kathleen took charge, and with all the various helpers who had in the past lived in the house having disappeared (cooks, handymen, models), Epstein resumed work, starting a new stone carving over eight foot high: this was his *Lazarus*, a suitably optimistic subject. In the meantime, *Lucifer* went to Birmingham where a crane had to be used to get it through a window half-way up the building. The unveiling took

place on 26 June and Epstein, accompanied by Kathleen and Esther, was so delighted by the enthusiasm shown for it that he agreed to make a speech, something he had never done before. In this, he took the opportunity to attack the 'closed-shop' approach of the leaders of current fashions with his customary candour:

Today, there is a great danger from artistic cliques, especially in the new surrealist or abstractionist school, with its well-studied literary blurb, pamphlets and books, exhibitions and control of almost all criticism. Recently, vast crowds stood in front of pictures from France, sponsored by official bodies, gaping stupefied at monstrous distortions, dumbfounded at what was hailed as the new art.

He said he mentioned such facts to show what a working sculptor was up against at any time – obstacles.

A sculptor must feel called to his work as a vocation or dedication. He must feel himself borne along on a strong current towards his goal and I have felt this very strongly since my early days. The creative power calls for a concentration of all his faculties, mental and physical. Only an unabating and high seriousness will avail. He must face difficulties such as lack of opportunity and of funds with which to carry out great works. If a sculptor waited for a commission, for the most part he would be kept waiting and would find himself among the ranks of the unemployed.

He went on to talk about the lack of imagination in sculpture, absence of human interest, decorativeness produced by fear of realities – pleasant enough, as he said, but ephemeral and incapable of satisfying those seeking more profound qualities.

In passing, he brought up two of his favourite subjects: there was the 'disaster' of the restoration of the Elgin marbles which had, he claimed, been 'demanded' by the 'late Lord Duveen', and there was the matter of a difference of view over the bust of Bernard Shaw between the playwright and himself. Then, he talked about *Lucifer* and his sources of inspiration; and when thanking Lawrence for 'his imaginative initiative' in offering it to a public gallery, he added: 'I like to think that the work is in some way a fitting memorial to that winged spirit, Lawrence of Arabia.'

Epstein had always wanted really good settings for his work, a crypt

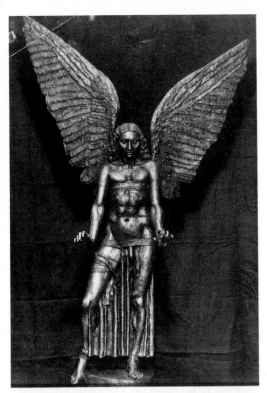

28. 'I like to think that the work is in some way a fitting memorial to that winged spirit, Lawrence of Arabia' – Epstein on the unveiling of *Lucifer* at Birmingham City Art Gallery in June 1947. His brother, A. W. Lawrence, had given the work to the gallery.

29. *Below: Doves*: commissioned by John Quinn, this third version was probably the best of the series, the problem posed by the one sitting on top of the other having been completely solved.

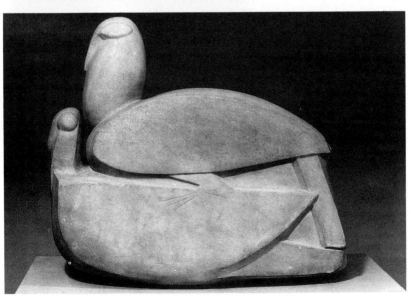

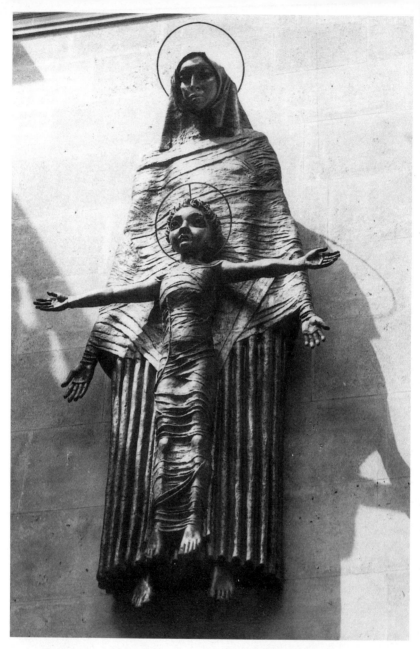

30. *Madonna and Child*, Convent of the Holy Child Jesus (now Theology College, University of London); unveiled in May 1953, it received an accolade; Epstein, who had a picture of it in his passport, described it as his 'passport to Heaven'.

31. Somerset Maugham sitting for his portrait in 1951 at the studio in Hyde Park Gate: the half-finished head is to the left of *Ecce Homo*.

32. Epstein with other honorary doctorates at Oxford, 1953.

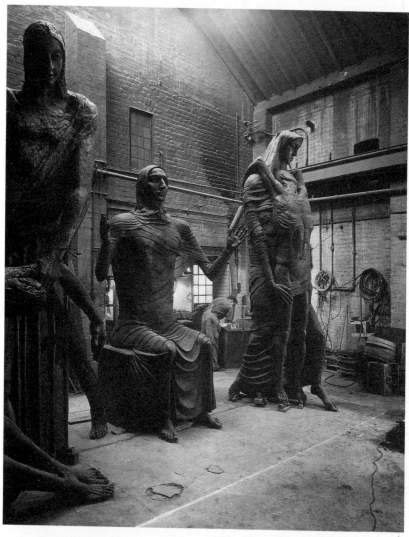

33. *Social Consciousness:* the three mammoth groups for Fairmont Park, Philadelphia, cast in bronze at the Morris Singer foundry, November 1954.

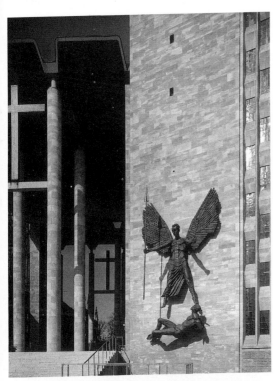

34. *St Michael and the Devil* at Coventry Cathedral after its unveiling in 1960: Epstein's emphatic statement displayed his understanding of the scale of the setting.

35. *Below:* Winston Churchill being presented with the Benjamin Franklin Medal, 11 January 1956, with Epstein looking on anxiously.

36. Epstein, Kathleen and Valerie Cowie during their trip to Italy, in September 1958.

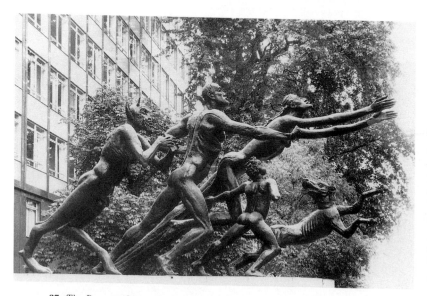

37. *The Bowater Group*, Epstein's last public work, set up in April 1961, after the sculptor's death. Straining to escape the strictures of office life embodied in the lifeless commercial building of the Fifties, the family group is a memorial to Epstein's passion for all things living.

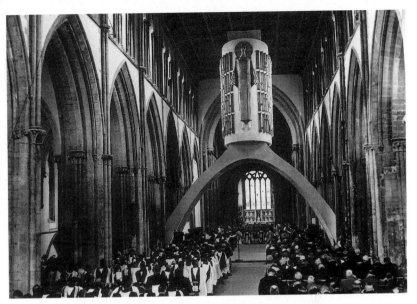

38. *Christ in Majesty:* unveiled at Llandaff Cathedral in 1956, the plaster of which, finished in gold leaf, was given to the Riverside Church in New York by Sally Fortune Ryan in 1966. It serves as a memorial to the artist's birthplace in that city.

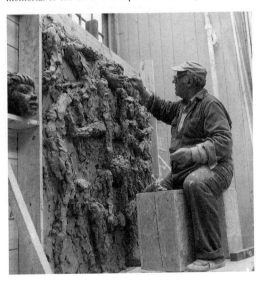

39. Epstein at work in his Royal College of Art studio on the right-hand panel above the entrance of Lewis's store in Liverpool; the subject for the central boy's head was his third portrait of Jackie (*Ragamuffin*), the clay of which is on the shelf, left.

40. Epstein with Frisky; behind them is the first bust of Esther and a flower painting by Theodore; on the mantelpiece, the Egyptian head of a lion (*c.* 850 BC) from his collection. Note that Epstein has moved to the edge to allow Frisky most of the seat.

for *Consummatum Est*, a frame of some visionary cloistered enclosure with the spare clarity and classical simplicity of a Brunelleschi; outside these impossible possibilities, the Round Room at Birmingham Art Gallery was about the most an artist could hope for. Then words were unnecessary: 'Silence,' he said, 'perhaps is best before a visionary work. Sculpture seeks the accompaniment of silence. My Lucifer will find it here in your gallery . . .'

Some years ago, however, *Lucifer* was moved into the tea room. There, seen across the clutter of tables and chairs to the accompaniment of the clatter of cups and the chatter of people, the majesty of the work was horribly diminished; it would be difficult to think of a better argument to prove Epstein's point about the importance of silence than this extraordinary lapse of judgement and taste.

Kathleen came to know John and Susan Lade in the summer of 1944. They met at 5 Bramerton Street where they had a mutual friend – Ethel Calvocoressi, whose husband, M. D. Calvocoressi, the pre-First World War music critic in Paris and assistant to Diaghilev, had just died at this house in Chelsea. John Lade, who lived a few turnings away in Tedworth Square, had known him, and with Kathleen across the road from Bramerton Street, all quickly became acquainted. Through Kathleen, the Lades met the ravishingly beautiful Esther, now seventeen – 'I think we were all rather in love with her,' one admirer said. In 1946, at school in Fulham and already interesting men, she wanted coaching in French, and it was Susan Lade who gave her lessons. Besides her remarkable looks, she was a product of the influence of her mother's profound love of art; writing to Wayland Young on one occasion about a concert, she spoke of the 'horrible contemporary music', the 'dazzling technique of the violinist', and of her experience after a storm that reminded her 'very much of those lovely washy waves of music that one gets in a Beethoven or Brahms symphony following a terrific climax – everything rather spent'; of how she had been to an exhibition in Cork Street and seen 'two beautiful Utrillos and three Modigliani drawings . . . I think Modigliani is just perfect. We have one of his most exquisite drawings . . . a nude drawn in blue chalk – a study for a caryatid'; and about the magnolias in Kew – 'One of the most lovely sights and experiences I have had was picking sprays of those glorious wavy creatures in the moonlight . . . One could almost see the moonlight being distilled in those opalescent goblets . . .' She was too

sensitive for the rough world: 'It's neither pleasant nor right to go through life being hurt at every turn', she wrote, wishing she had been born with 'a little armour round my sensitivities.'

The Lades saw a good deal of her in the grim aftermath of the war of rationing and shortages in a bomb battered country; he was teaching near her school, there were invitations over to '272', and when Mrs Epstein died and Kathleen spent more time at Hyde Park Gate, they helped out in Chelsea by looking after Theodore, hard at work on highly imaginative paintings, but still very ill. For the Lades, meeting the Garmans was the beginning of a trail that led on to their friendship with Helen, the Vivante family from Siena (Professor Leonie Vivante had been interned during the war with Mario Sarfatti), and, via the Vivantes, to Mark Joffé and his baby son, Roland; and finally, of course, to Epstein who acknowledged the arrival of these trusted friends as though they were part of the family (he had a habit of calling John Lade 'Lade' and his wife 'John Lade'), taking them, with his customary generosity, to the Caprice, the restaurant started after the war by the ex-head waiter of the Ivy; when he moved there, the Ivy's clientèle of artists and theatre people followed him; and as it was also favoured by American and other film stars, it proved to be a good source for commissions – Mai Zetterling was one of them.

In the meantime, Kathleen and Epstein's daughter, Kitty, had married Lucian Freud and had gone off to live in St John's Wood; Epstein promptly did a bust of Freud, which was one of his best, and could be regarded as the last work in a trilogy devoted to a certain type of head which interested him, the first being of his other son-in-law, Hornstein, the second of Menuhin; all three having similar lean, classical features. With *Lazarus* under way and Kathleen busy on the house, 1947 was the start of a wholly new phase: for the first time in over twenty years, and at a point when he was beginning to think he would never again be commissioned to do any major public work, he was suddenly so overwhelmed with offers that he wondered if he could manage them all. An invitation to contribute to the 1951 Festival of Britain was the first, and this was followed, in rapid succession, by *Social Consciousness*, a vast group for Fairmont Park in Philadelphia, the *Madonna and Child* for the convent in Cavendish Square, a huge decoration and three reliefs for Lewis's department store in Liverpool, *Christ in Majesty* for Llandaff Cathedral north of Cardiff, the *Franklin Medal*, the *Smuts Memorial* in Parliament Square, the bust of *Bishop Woods* for Lichfield

Cathedral, done posthumously, the *Trades Union Congress War Memorial* at Congress House, *St Michael and the Devil* for Coventry Cathedral, the *William Blake Memorial* for Westminster Abbey, and the *Pan Group* for Bowater House at the Knightsbridge entrance to Hyde Park. He had, moreover, begun an *Ascension of Christ* and designs for stained glass windows for Crownhill Church, Plymouth, before his death in 1959. With *Lazarus*, he had completed fifteen works in ten years, an astonishing achievement that has to be set against an output, on average, of thirteen portraits a year, maquettes of ideas, and hundreds of paintings and drawings. It should be remembered, too, that the majority of the public works were enormous, and that all but one of them were carried out during his seventies, and never with an assistant. Perhaps this was his most prolific period.

Before the first of these commissions came, however, the prospects were bleak in this postwar period, and made all the more so by the fear that Stalin might sweep on through Europe after the blockade of Berlin. In a letter to Peggy-Jean of 6 March 1948, Epstein wrote: 'It would be tragic for Jackie were he to return here where everything is getting worse, and of course the war with Russia which is *no doubt coming* is too awful to contemplate. And then London will certainly be wiped out.' Epstein wanted him to stay in New York during this period when great changes were occurring in his life and Kathleen was moving into Hyde Park Gate, but was worried about the cost of Jackie's keep on hearing of Norman's difficulties in starting up in practice. Epstein naturally promised to help, but things were not made any easier by regulations which permitted no more than five pounds leaving the country at any one time. There were ways of getting round them, though: American friends, some having sat for portraits, who were passing through London could act as messengers for him. He had, for instance, just finished a bust of Isaac Myers from Memphis, an excellent likeness (his eye for national characteristics was as sure as it was for the personality of the sitter); so good that Mr Myers was delighted to pass on part of Epstein's fee to his daughter on his return to the States. David Cohn, one-time friend of Feibleman, was another apparently willing undercover agent in the activity, and he had approached Sally Ryan as well, the young sculptor who had learnt so much from him, and who had just sent him a huge joint of ham (this was in respect of the severe rationing, but he never ate ham and Kathleen had given it to their cleaner, Mrs Pugh). Sayers, the unreliable Dublin dealer, had been over there but, much to

Epstein's annoyance, had forgotten to keep his appointment with Peggy-Jean. With signs that commissions for portraits were picking up, however, this loophole was extremely useful. There were other hopeful possibilities, too: 'I am occupied as usual doing new things,' he wrote. 'I am also exhibiting *The Girl with Gardenias* this summer in Battersea Park.' This new venture in open-air sculpture was to be held intermittently. 'The committee consisting of my friends F. Dobson and H. Moore tried hard to ignore me, but the County Council people want me to show . . .'

A surprising development about this time was the sudden reappearance of Charles Stafford, the associate of William Cartmell who had originally bought *Consummatum Est* for the Parkinsons' Tussaud collection. He had turned up unexpectedly, 'inclined to settle about the bronzes he stole from me. I will believe in them when I see the bronzes here'. A murky story of the familiar methods of a con-man's dealings with artists lay behind this remark – of works of art borrowed on some pretext and never returned. When he did meet Stafford, he did so with a lawyer to see there was 'no hocus-pocus'. It then transpired that Stafford had sold *Consummatum Est, Adam* and *Jacob and the Angel* 'to a fellow called Tony Crisp', he told Peggy-Jean; and that he was taking them to America 'so that sooner or later you'll see them there shown God only knows how'. He had met 'this Tony Crisp', and found him not as bad as Stafford – even felt he might be able 'to do business with him'. Owing £600 to income tax, as Epstein did, any business transaction might, perhaps, have seemed better than none: as Kathleen had discovered, he was in a tight corner, and had decided to give up Deerhurst and the cottage at the end of the summer to save money: in fact, he kept both for a further three years, and even then continued to go to Epping Forest every Sunday. 'The highbrows here disregard my sculpture and I am able to make a living only with characters like Jackson (Sayers's partner) and Stafford! I prefer them with all their faults to the Rothensteins, Kenneth Clarks and Hendys . . .' For simplicity's sake, he lumped the three together as allies of Moore, which they undoubtedly were, but, really, how much did he know of Crisp's credentials, an ice-cream manufacturer in Hall Place off the Edgware Road? What was his connection with Stafford and the slippery Mr Cartmell? And what else would he be doing with these massive alabaster sculptures, weighing tons, in America other than further commercializing them? Surely, after Mrs Bossom's intended expedition there which

had so distressed him, and the excessively adverse publicity from Stafford's tours with *Adam* that must have given his enemies useful ammunition, he could hardly have mistaken the motives of this latest adventurer? If he did, he was soon to be disillusioned: all three works duly made an appearance in a depressingly cheap Oxford Street sideshow that was accompanied by a brash notice guaranteeing sightseers' money back if they were not shocked by the sculpture. The vulgarity of this blatant exposure for crude financial ends naturally infuriated Epstein, but, again, there was nothing he could do about it. This nasty affair opened around the time when I first met Kathleen Garman through her son, Theo, and I remember the disgust I experienced at seeing works of art being abused in such a fashion. Needless to say, the security guard was very threatening when I asked for my money back.

Here was another form of vandalism which, from then on, cropped up with the unpleasant regularity that the earlier, physical attacks on his work had done, and in the face of which he was equally helpless to act. He had, one feels, to depend on the gods to look after it while he applied himself to the tasks of the moment. These were portraits; between March and April, he had been very busy working on various commissions, and on the head of a little Greek boy he had noticed with his mother looking at Egyptian antiquities in the British Museum one day. And then he had been over to Battersea Park to see the site for the first international open-air sculpture exhibition there, an imaginative idea to bring art and people together in a public garden that had been started by a formidable member of the London County Council, Mrs Strauss. He was delighted by what he found in the enclosure of trees, the soft, undulating grass banks melting into mysterious paths round the water of the lake where ducks and swans assemble. Perhaps in this perfect setting he stood a chance of selling a piece for such a place, he thought; it was possible – Mrs Strauss had been very friendly. The May opening, however, turned out to be something rather different to what he had been expecting. He went along with Kathleen, afterwards giving an amusing account of proceedings. It was, he said,

a scream. The whole show was really got up to boost Moore and his absurd work long prepared for. This event was made the centre of the business. It has been bought by the Contemporary Art Society and is to be presented to the nation. It is a question as to whether it will be accepted. It is the only sculpture to be shown in the posters and of

course Moore was made the hero of the opening leading the members of the Cabinet, Cripps and Bevan (Aneurin), straight to this work and ignoring everything else. Bevan avoided me and so did Moore. They rushed round very self-important and posed for the photographers. Nevertheless, the photographers were busy photographing Kathleen and myself ... The show in spite of the monstrosities there looks well. The Rodins and Maillots and my things look I think in harmony with the trees and outdoors.

He had had some friendly and sympathetic letters from sculptors 'protesting against the domination of the "intellectuals"'. 'I think in the end they [the intellectuals] may not have it all their own way. Kenneth Clark and of course that miserable little Rothenstein were much in evidence at the opening ...' He was referring to John Rothenstein: in the meantime, *The Girl with Gardenias* was bought by the Aberdeen Art Gallery.

While he was worrying about getting money to his daughter, Peggy-Jean, and Jackie, he had the constant irritant of Sayers in the background demanding repayments on the loan over the mortgage: Epstein found him so exasperating – partly over this and the complaints Sayers made to Hornstein about him, partly over his failure to deliver the 'allowance', but also because he had, impertinently, taken to calling Kathleen 'darling' and to trying 'to touch her' – that he wouldn't have him in the house. This was at a time when he was in the midst of another rush of portraits – a second portrait of Joan Greenwood; the Lades' daughter, Judith; the bust of his old friend, Franklyn Dyall; his second of Esther; and his seventh and last portrait of Kathleen. He was as busy as ever, despite all the distractions. One of these was a report in a newspaper that spread the story that Epstein and Kathleen were married; and when this reached New York and gave Peggy-Jean a shock (she was about to move to Hatteras Island in North Carolina), Kathleen wrote to her at once:

We are not married. It was a newspaper mistake and a tiresome one as so many people have seen it. It is out of the question we should have done so without letting you know. Please think no more about it. Some day we might but things seem to me best as they are. It went against the grain very much coming here at all, but when you went it seemed the only thing to be done. Epstein has been very well and has done a lot of work and the house is tidied up and painted almost from

top to bottom. It seems ridiculously big just for Epstein and Esther and me but it does give him the feeling of security and isolation that he needs for his work.

She went on to say that Kitty had a little girl in July: 'I know it will amuse you to think of your old schoolfellow' – Peggy-Jean had known Lucian Freud at Dartington – 'as a husband and a father.' She thought her new plan to go to Hatteras 'wonderful'; 'To escape from the petty tyranny of streets and streets and more streets and all that they imply, and to let the children grow up in wild country – how ideal!' Vintage Kathleen: and from the romantic she moved to the business-like – Peggy-Jean must look up Mr Cohn in New York; Mr Wyvern should be held in reserve; she was using the familiar code to indicate sources where money had been deposited by Epstein for her to pick up when problems arose. In London, they always made a point of welcoming American visitors 'remembering the little family in the Yonkers'. On their financial front, the news was better – means had been found to reduce Epstein's immense debts, mainly by putting an accountant to work, partly by cutting overheads, partly by selling bronzes from the house. 'Last Saturday we had 15 to tea. Usually in one way or another this leads to sales.' However effective she was in business, she never failed to relegate it in importance, never allowed it to impinge on her enjoyment of life. 'I make your father laugh quite a bit and we have a lot of fun between times,' she wrote; not only between money worries, but between those over her son's mental state. Her letter ended: 'Wouldn't it be hateful to be a stepmother? Isn't it nicer as it is?'

So at least one crisis had been overcome, and largely through Kathleen's energy. She was very effective: whether she was managing gatherings at Hyde Park Gate like Saturday musical afternoons or writing round to interested collectors – the *Einstein*, *Weissmann* and *Cunninghame Graham* were ready for collection, she told Mr Samuels in a letter of 13 May of that year – or finding people to look after her son. When Anne Champernowne, who lived in Rossetti Mansions in Chelsea, turned up to befriend Theo in his favourite café off the Hemmings bakery across from 272, she was adopted and sent off with him to Florence in September. After that, they went on to the Vivantes' house, the Villa Solaia. Theo wrote home from there on 8 October to ask his mother to post his 'old painting jacket' and some of his tubes of paint which were 'in a canvas bag at 272'. As Kathleen predicted, he was

inspired by the place: 'It is really beautiful here and so much to see . . . There are some remarkable paintings at Siena by a certain Rutilo Manetti. Really very remarkable. The square in Siena is shaped like a pale pink shell.' He was enjoying himself so much he didn't expect to be back until the end of November. 'How beautiful the Italian paintings are,' he wrote, 'especially Fra Angelico whose work is in Florence . . .' At the same time, with equal efficiency, Kathleen was arranging an exhibition of Epstein's sculpture in Edinburgh for the September opening of the second post-war Festival at which she had heard a hundred thousand visitors were expected from all over the world – 'I thought it a good idea that Epstein should be represented,' she remarked with typical diffidence. She selected her favourite pieces, including *Peggy-Jean Asleep* ('the most appealing child study I have seen'), the first *Esther*, *Ragamuffin*, and the *Meum*, *Casati* and *Billie Gordon* masks. The exhibition was, fortunately, a big success, many of the works being sold, and it did much better than another, larger one held in Glasgow the following month. 'I had imagined that the wealthy magnates of the city would rush to purchase, but not a single sale after a week,' Epstein said. It picked up later when three were bought, although his second bust of Nehru, which he was showing, was not among them: a friend had hoped the Indians would have it, but it was turned down. 'It is a tragic bust but Nehru seemed to me like that,' and as though, so soon after Gandhi's assassination, he was exhausted by the cares of office. He found him utterly changed from two years before; it was said that he had a weak heart and that could hardly have been helped by all the air travel to one country after another. From a talkative man, keenly interested in art, he had become silent and embittered, filled with self-doubt and thoroughly disillusioned – 'all this is in my bust,' Epstein said. Nehru had practically fallen asleep during two sittings, making it impossible for work to continue; and he was sure the bust would never sell to the government over there: 'Indians never spend a penny, I've found, on works of art. They only spend on materials things like motor cars, diamonds, prostitutes etc. etc. . . .' The moment Nehru had left for home, a commission arrived from an American named Mrs Mumford – someone, he told his daughter, who would be useful: she and her husband were delighted with the portrait and had taken a *Ragamuffin* cast with them as well. The Mumfords would certainly be contacting her on their return to the States. They had been, he said, brought to him by the painter, Raymond Coxon, 'a great friend of H. Moore,' he wrote. 'But I

had discovered he had fallen out with Moore ... After being a school mate and lifelong intimate of Moore, Moore refused to introduce him to his "influential" friends in the USA when Coxon went there. Always the same story.'

When Oliver Brown heard about the Edinburgh and Glasgow exhibitions he was, Epstein suspected, afraid of him being lured away by other dealers, and immediately offered to put on a show at the Leicester Galleries early in the New Year. Epstein, however, wasn't all that keen. For one thing, he was determined to wait until he had a sufficient quantity of work ready with which he was entirely satisfied; secondly, he wanted a big piece to form the centre of it, and this had to be *Lazarus*. At the same time, selling work from home (as he had found with his Liverpool friend, Samuels, and his connections) he avoided the Galleries' 25 per cent commission which left him with little after moulders and tax were paid, a vital matter with so many debts to meet and with Sayers constantly breathing down his neck. And sales were going well – Abel, the Ivy's head waiter, had bought two works from his studio, including a *Ragamuffin*, and an American had bought *Betty Peters* – a reason, perhaps, why he bought a very fine and powerful *tiki* (a potent symbol of Maori culture) at Sotheby's just then. 'Father is going to bid for it,' Esther wrote to Joffé in Paris, 'He is determined to add to his collection and feels it already his.' At the same time, he had so many offers of commissions that he had to turn some down. He was, however, very interested in two girls who had come his way, half-Belgian nieces of the Abyssinian Empress, and in early January 1949 was working from one of the sisters' heads, despite wanting to get back to carving. He had managed to do a little on *Ecce Homo* (never quite finished) between jobs, but his main concern was, of course, *Lazarus*. He had not had a model for this, and was absorbed with some part of it (while making his bust of the princess) when a half-Chinese boy named Aubrey Grandon turned up on his doorstep looking for a modelling job. Epstein said at once: 'You'll do,' and when he asked him to take his clothes off, Grandon imagined he was going to make a study of him. Not at all: he rushed over to his *Lazarus* and began chiselling away at the stomach with the speed of a young man. Grandon couldn't believe it: Epstein must have been, he thought, around seventy, yet here he was, darting back and forth between the towering statue and model, examining first one, then the other, the carving and then the stomach, and back to the carving again for further work.

He moved like lightning, hammering at the same place for hours. When at last he seemed satisfied, he asked me to come back the following day. At the same time he told me not to have my hair cut – to grow it down to my shoulders. Then he started all over again. This continued at intervals for several months. On one occasion, he set up an armature and began a head of me. Later on, he modelled a complete figure, seven feet high. I think the statue depicted effort – I know it was a hard stance to hold for a long time . . .

Epstein had been promised an exhibition at the Leicester Galleries for March 1950, and he agreed to this because he knew that his *Lazarus* would be finished by then. Naturally it couldn't proceed without interruptions, and there were many anxieties. His son, Theo, showed no sign of recovery; Esther had moved in with Mark Joffé at his flat in 18 Queen's Gate (just round the corner from Epstein's house) where she was looking after Roland (Joffé's wife having disappeared when he was a few months old); his friend, Matthew Smith, was unwell again, constantly under doctors and, Epstein said, 'watched over by Mary Keene', his devoted mistress. Then there were the portraits: one of these, of the composer, Vaughan Williams, was a commission which he did in February. He reminded Epstein 'in appearance of some eighteenth-century admiral whose word was law'. He found him immensely courteous, a man with acute observations and an impressively logical mind, and was made aware 'of his devotion to an art as demanding as sculpture'. Despite his great age, he posed 'with a will', and although Epstein had a cold, he was 'hoping to make something of it'. He made something remarkable of it: two great minds produced a great sculpture – an organic mass like a cliff, a craggy creation of ledges and overhangs, something with a power akin to his head of John years earlier.

In February, he had also completed busts of the Abyssinian sisters, and had started another of the younger of the two. They were in desperate straits (their mother was threatened with deportation, which Epstein managed to stop by writing to the Home Secretary, Chuter Ede, an achievement which he regarded as a 'personal triumph', he having received 'little or nothing from politicians'), lived in one room in a hotel in St Martin's Lane, and, although very good dancers, had no work (Epstein was so worried on their account that he wrote to C. B. Cochrane, recommending them); their mother, he told Peggy-Jean, 'literally depended on the girls for food'. If he wasn't working, he was writing letters (often supporting some cause of his own – these girls,

their mother, the Elgin marbles), or considering the possibility of republishing his autobiography with some additional chapters. As ever, his life was crammed with activity: while on one hand he was invited to join the Battersea Park Committee to arrange the 1951 Festival of Britain Exhibition (he had been to the first meeting and had 'faced up to a few old enemies', his letter to his daughter went on. 'We were all very noble and amiable'), on another, he had been tremendously taken with a newcomer on the Hyde Park Gate scene – Victor, the baby son of an African cook Kathleen had engaged, of whom he had made a beautiful head. At the same time, he was becoming increasingly worried that Hornstein didn't get along with Jackie, and, partly because of this, was planning to take a holiday at their new home on Hatteras Island when he hoped to resolve the problems. But then yet another crisis hit the household: Helen had become very ill shortly before leaving for Lake Garda with her husband and son, now a year old. She had developed terrible headaches and had gone blind: when they finally left in May (seen off at the station by Cathy and the Lades), Esther went with them to help. With Helen unable to see and with a screaming baby, it was a dreadful journey: Esther, who found Helen's illness difficult to bear, couldn't wait to get back to Joffé, and, before long, Cathy, who had fallen in love with Laurie Lee, went out to take her place.

It had been a hectic first few months of the year. He had no luck with *Nehru*; shown at the Leicester Galleries, it had been returned to his studio, unsold; 'I find Indians hopeless,' he remarked. 'They are vague and seem good at fobbing one off with pleasant chatter.' He had further trouble from Stafford, who had turned up like the familiar 'bad penny', and with Jackson; between them they had ordered three busts (*Churchill*, *Shaw* and *Tagore*, the bearded mystic), and then never collected them, leaving him with the bill of the bronze foundry for the castings. The last he had heard of Stafford (for the time being) was in April: he had gone to South Africa where he was exhibiting *Jacob and the Angel* in Durban, where it was damaged. This both mystified and disturbed him, for where was Tony Crisp, the new 'owner'? Yet, through all the crises, Epstein calmly continued with his various tasks. He was in the middle of his figure of Grandon, and went on to do a head of his granddaughter, Anne Freud, one of his loveliest works from babies; and after that there were two commissions, a baby-in-arms which he called *Master Stewart*, and a little girl, Elizabeth Tindall-Lister. But in June the mystery surrounding the ownership of the three great religious

works surfaced once more, and the anguish over their misuse was suffered accordingly. On 8 June, there was an *Evening Standard* news item on the latest sideshow in Blackpool describing an exhibition of a sickeningly macabre and horrifying sort. The journalist said:

My reporter there was attracted to a garishly decorated shop on the sea-front by a loudspeaker blaring swing tunes and a dozen marionettes dancing on strings. In between dance tunes, a recorded barker yelled an appeal to walk up and see 'the strangest thing you have ever seen . . . Come in to see whether you find it beautiful or shocking'. What is the show? It is Jacob Epstein's *Consummatum Est* . . . It rests on a sprinkling of sand with a background of painted 'Middle East' houses. Near the foot of the figure lies Epstein's nude *Eve*. The figure is surrounded by human heads shrunk to the size of apples by Indian head-hunters, moving marionettes and the embalmed body of Siamese twins. Owner and organizer of the show is Mr Charles Stafford, of Berkeley Court, London, W1. He smiles as he watches hundreds pour into the show. 'This is Blackpool; and in Blackpool you must run exhibitions in this manner,' he says. 'Some people are not interested in Epstein or sculpture, but they will pay to see shrunken human heads. So we give them shrunken human heads and Siamese twins, as well as Epstein. What's wrong with that? Perhaps we sow the first seeds of an interest in sculpture.'

This report speaks for itself, although the reference to *Eve* is interesting; it was this work which Lawrence Wright claimed to have commissioned to keep *Adam* company because he was 'lonely' in 1939. In fact, an illustration of *Eve* which appeared in the *Daily Mail* of 3 October 1953, when sensational publicity again hit the headlines, shows that this sculpture of a reclining nude about eighteen inches long was, as he had maintained, not specially done for Wright as a commission; he had sold him one of the series mainly devoted to *Betty Peters* begun a year or so later. Of the new Blackpool event, Epstein had merely this to say: 'People who buy my work are at liberty to do what they like with it. But to say that this is likely to produce artistic appreciation is nonsense; it is more likely to produce artistic mockery'. 'A mockery,' the *Standard*'s writer added, 'made far worse, in my opinion, by the religious subject of the sculpture.'

And so the exploitation of his art continued, bringing the kind of vulgar notoriety normally associated with marital scandals in the gutter

press, and which his enemies regarded as faintly amusing, or embarrassing, or more useful ammunition with which to denigrate his work; but which he was able to ignore because he regarded it, although extremely hurtful, as trivial – frankly, he had far more important things on his mind. For him, tormentors, whatever form they took, were part of life: there were always those who supported him, and they corrected the balance. It so happened, for example, that Sally Ryan, on a visit to London, blew into Hyde Park Gate a week later to tell him she thought the Philadelphia Museum, whose director she knew, was interested in buying some of his sculpture. This news immediately redressed the situation: although she didn't say so, she was aware that some approach to Epstein from this quarter would be made shortly. With this, and the latest odious Blackpool episode behind him, Epstein decided to take his trip to the States: he would go first to Hatteras, then to New York – 'and I'm not looking forward to *that*,' he said; but there it was – he had business to do there, he told his daughter. He settled on mid-August: *Lazarus* was finished, and, from Italy, had come the shocking news that Helen's illness had been diagnosed as a tumour on the brain; she was going into hospital in Milan for an operation (it saved her life), and Kathleen, who naturally wanted to be with her, was going out there then. Yet before she left she had made two plans for her son: with her unfailing skill and imagination, she had interested Nan Kivell in Theo's paintings, and he had agreed to exhibit them at his Redfern Gallery during the coming January; secondly, she had arranged for him to stay at a hospital near Northampton: of course she didn't care for the idea, but at least he would be safe there. The Lades would visit him regularly, and if one thing made her feel better about the hospital, it was the discovery that John Clare had spent time there.

Epstein had contemplated flying to save time, but in the end went by boat. He needed the rest and quite enjoyed being entertained at the captain's table, much as he disliked recognition as a celebrity and constantly being asked for his autograph. At Hatteras, then a sparsely populated island (now largely built over), he had however the pleasure of total anonymity; he found this wonderfully refreshing and relaxing; no one knew who he was, and he could walk along the sands without being stopped or pointed at. He was very glad to be away from his studio, was up at six every morning for a swim, he had a good time arguing about politics with Hornstein, and otherwise did little except

make sketches – his granddaughter, Leda, for instance, remembered going to sleep on the floor and then waking up to see him standing in the doorway drawing Jackie and herself lying on the mattress. He stayed for altogether two months: when he left, he brought Jackie home with him.

He looked back on his stay at Hatteras with astonishment, and only the presence of his son convinced him it was real, so utterly different was the life out there from London where, faraway from the peace of the island, he was at once immersed in work; among the pile of letters that arrived in his absence, there were offers of commissions, one of which, from the Arts Council, was very important – an invitation to contribute to the Festival of Britain Exhibition, to be held on London's South Bank, east of Westminster Bridge, to commemorate the centenary of the Great Exhibition of 1851 and, like that one, to promote British industry, art and design; it was the first truly optimistic and imaginative idea to follow the stark aftermath of the war. Then, at the beginning of November, he received another interesting letter; dated 25 October, it was from R. Sturgis Ingersoll, a lawyer working with Henri Marceau of the Philadelphia Museum of Art to commission sculptors for the Ellen Phillips Samuel Memorial in Fairmont Park – they wanted him to do one of six statues. Perhaps it was because he had only recently returned from America (how convenient it would have been had Ingersoll written a couple of months earlier!) and had so much on his mind, that he didn't reply at once; there was Jackie to settle (he managed to get him into an aeronautical school), Theo's exhibition to think about, and, very important indeed, work to be done for his own exhibition at the Leicester Galleries in March. He had a number of busts still in mind for it – the actress and wife of Cecil Day Lewis, Jill Balcon (a fine head); a new head of Jackie, the fourth; and a portrait of Roland Joffé. And then, purely by chance, he made one of Ernest Bloch, the composer who lived in the States. Epstein and Kathleen had gone to a party to welcome this famous man, but had failed to meet him because he had left almost immediately for a rehearsal of his 'Sacred Service'. When, however, he discovered he had missed Epstein, Bloch came to his studio on the off-chance one Sunday just as he was leaving for Deerhurst. 'Cancelling my plans I at once put him on the stand and started his portrait. I am told that the whole house resounded with the ensuing conversation, carried on in a resonant mixture of several tongues. Nevertheless, the portrait developed rapidly . . .' He found him splendid to do and was hoping

that some American institution would buy it at his show. He had had some luck with his *Sun God*, the relief of 1910 (on the back of which he had carved *Primeval Gods* in the Thirties), which had been bought by Sally Ryan; then he went ahead with the other portraits of Jill Balcon, his son and Roland.

In the meantime, Theo's exhibition had opened at the Redfern with a note in the catalogue by Matthew Smith:

> About the paintings of Theodore Garman, I can only say that I look at them with wonder, admiration, and even astonishment. Surely this is an event unequalled in British painting since Van Gogh. Since Van Gogh was, I believe, not British, we can thank Mr Garman for almost having made him so ... This thesis I beg may be considered a reasonable one, or that at least the intoxication induced by these lovely and impressive paintings may cause it to seem so.

Garman, who was described in the *Evening Standard* as a protégé of Epstein (his father had lent three paintings he had hanging in the living room), had good reviews. Wyndham Lewis wrote in the *Listener*:

> On entering the gallery, you are overwhelmed by a rancid vegetation, tropically gigantic. Such pictures are not seen at their best all around one, in a small room. A little concentration on individual pictures will soon reveal how excellent is the workmanship. The *Villa Solaia* is admirably composed: and what tremendous vitality there is in the *Tamarova*. Vitality is what Garman's pictures essentially possess, these heavy coarse green forms, these long pale faces in which the universal green is reflected. The huge plants are suggestive of daring tapestries, as are even the colours, with their selective monotony. The aforesaid vitality, however (although that is not all), assures this artist of a high place among his contemporaries.

His work had a clear affinity with his father's – apart from its vitality, there was the luminosity of the colour that was so arresting in Epstein's paintings, and there was the gigantic scale of conception and treatment, the passion for all things living. And there was also, perhaps most strikingly strange, the introduction of sculpture to his compositions, and this of course connects with his father; like him, Theo was a collector, but of medieval religious pieces, and he saw these figures – a Madonna, perhaps, a Christ or a monk – that he set among his still-lifes and landscapes as alive. Hence the vitality they brought to the paintings. A scene with vases of flowers around the monk would be transformed

into a vast blossoming avenue of foliage through which a figure is strolling, deep in the Bible he is reading. With this extraordinary invasion of the imaginative world, the son was like an imprint of the father.

When Epstein eventually got round to answering Ingersoll's letter (which may well have become buried in the scores of greetings that habitually arrived in time for his birthday on 10 November), he excused his 'belated' reply on the grounds of being 'frightfully busy' on his 'large things for the Festival of Britain'. 'Sculpture in my case,' he explained, 'is a slow affair and your scheme for Fairmont Park will take time to complete.' There were various expenses to consider – he would have to see the site, there was his fee to agree and, since he would be doing the work in London, there was the cost of transport. One other matter Ingersoll had raised was the possibility of buying an Epstein for himself – he remembered a bird Quinn had owned; about that, Epstein said he could let him have a similar marble group if he was interested. A reply came by return from Ingersoll: unfortunately, not having heard from him before, the committee had given the commissions to other sculptors. However, he still wanted to talk to him about that matter and about buying something, and was coming over shortly with his wife: he did come, fortunately in time for Epstein's exhibition where he bought *Victor* and was tremendously taken with *Lazarus*, and wondered, if the price was right, whether he could obtain it for an American museum.

He was not the only one to be taken with *Lazarus*; almost without exception, the reviewers went overboard for this latest apparition of Epstein's, the miracle of a man Christ raised from the dead. Earp said (*Daily Telegraph*, 9 March): 'It ranks among the sculptor's major achievements.' While some might, he thought, complain that it was 'too static in conception', it was 'perhaps asking too much of the sculptor to demand that the work should express more clearly the tremendous implications of its theme.' Such a task 'would have baffled Michelangelo', he wrote.

Epstein has achieved a moving presentation of mortality, if not of resurrection. His gifts as a carver have rarely been better displayed than in the treatment of the swathing bands, which give the piece as a whole such dynamic force as it possesses. The suggestion of the body, and especially the hands, beneath the covering is masterly. The visage, if somewhat masklike, has a fine gravity. No other living sculptor could come as near to realizing the subject.

He loved many of the bronzes – 'Dr Vaughan Williams is magnificent, as good as any Rodin, and closely rivalled by his Lord Lindsay of Birker', 'the grace and vivacity of *Esther* and the subtle, smiling *Princess Desta* are outstanding successes . . .' And Wyndham Lewis, so recently taken aback by the imagination of Theodore Garman, was now swept off his feet by his father's; writing in the *Listener* on 23 March, he said that Epstein had 'produced perhaps the most impressive of his series of giant carvings.' In works where the story was so important, or which were 'literary', as the fashionable word of the day went then, Epstein was in the grand tradition of *The King of Judah* (Chartres), Rodin's Burghers, or Michelangelo's *Dying Slave* or *Pietà*. 'Epstein in his *Lazarus* is, I believe, celebrating the great power of our blessed Lord,' Lewis continued, 'who *can*, today as much as then, call men back from the dead. But at the least this face rolled back upon a shoulder, the rest of the body still numb, as it stands tied up for the last sleep, is a feat of the creative imagination.'

And so the rush to praise the work continued: this sculpture, this poem in the serenity of dreamless sleep, had captivated the reviewers. Neville Wallis in the *Observer* (12 March) saw in it the symbolism of a spiritual renaissance following the fall of Hitler's Europe. He was full of admiration: an invisible outline preserved the original column of Hoptonwood stone, unseen yet suggested by the form; it was most interesting from several viewpoints, it retained the monumental calm of the material's properties, and it should stand in the big space of some ancient architectural context. 'No photograph,' he wrote, 'can convey the latent, brooding power of Epstein's images in stone, which can only be apprehended by the contemplative spectator prepared to meet, as it were, the sculptor half-way.' Eric Newton picked up the theme of an architectural context in the *Sunday Times* the next week. While his enthusiasm for the *Vaughan Williams* was such that it led him to say that Donatello's reputation 'would go up' if the work had been by him, he condemned architects for neglecting to commission sculpture from Epstein; he was wasting his career, Newton claimed, by having to resort to portrait busts to make a living:

Why has no architect been daring enough to use him as the Egyptian and the Romanesque sculptors were used, or as Donatello and Verrocchio were used to deepen the significance of a cathedral crypt, to stand mysteriously behind an altar, to form the climax of a staircase

or give meaning to an empty niche? His two pieces on the Underground building and the mangled statues in the Strand are not enough. The mid-twentieth century possesses a great sculptor and forces him to dilute his genius.

It would be difficult to conceive of a more startling contrast of interests and values than those exhibited in the simultaneous shows of works in Blackpool and London: at one end of the country, crowds of sightseers gaping at *Consummatum Est* ringed by an obscene collection of shrunken heads and the embalmed bodies of Siamese twins, and, at the other, *Lazarus*, the centrepiece for an exhibition of bronzes of composers, scholars, princesses, children and others, receiving an accolade. Mrs Irene Sidi, a young housewife who dropped in to the gallery when it opened to the public after the private view, put a finishing touch to the critics' comments: 'I know nothing about sculpture. I don't know what the world will say about this. But to me it is fascinating. There is something unearthly about the face. The whole thing seems so simple. Yet – that face seems to alter its expression as you move. If I were a woman of great wealth I would buy *Lazarus*.'

There is something unearthly about the entire figure – wrapped in bandages carved with such care over almost the whole of its body (where do those bandages begin or end?), it appears from the one view to have the abstraction of a wraith, of a shape where the skin surfaces for a moment with the navel, a glimpse of the stomach and knees, the transparent look of the flesh through the material, and the next moment vanishes; and only reappearing with the head from one side as it rests on the shoulder, for a moment seeming to smile down at us, the next lost in an immaculate carving of deep sleep. A genius created this magical figure; no one could deny that. All the same, Epstein would have been irritated by Newton's insistence that studies of people diluted 'his genius', as he would have been had the remark been directed at his paintings from nature, the Old Testament drawings, or those of Jackie and others. Every departure was an essential area of research; in Epstein's comprehension of life, all activities were related, leading into, or out of, each other; as much as he was interested in people for their own sake, his curiosity about their racial characteristics and variations was immense, and in this sense, as with pieces in his collection, they provided material from which to work or develop ideas in his large conceptions – van Dieren did so in the *Risen Christ*, Sunita in *Lucifer*.

Still, what Newton and Wallis had to say helped to bring constructive results. While Ingersoll, for example, was interested in procuring *Lazarus* for an American museum, he went away wondering how he could involve Epstein in the Fairmont Park project, despite the appointment of the six sculptors; luckily for Epstein, his visit to London had been well-timed. Then there had been the announcement that he had been commissioned to do a work for the Festival of Britain, and this, coming just before his exhibition, was also well-timed, attracting, predictably, plenty of attention in the press. The Festival commission, sponsored by the Arts Council for this great, imaginative, publicity-conscious event, set things moving: word went round that the legendary sculptor was in demand again for public works; after that, he never looked back.

An architect named Louis Osman was the first to follow up the news. He was in the middle of drawings for the restoration of the Convent of the Holy Child Jesus, a fine eighteenth-century Palladian piece in two separate buildings on the north side of Cavendish Square. The eastern one had been burnt out in an air-raid in the war, and since there was no connection between them, except in the basement, Osman had suggested that a bridge containing rooms could span the mews that divided the buildings. This link was to be set well back from the street frontage with a blank stone façade facing the square, and since it was on the centreline of that, Osman was anxious to give the composition extra emphasis with the incorporation of a piece of sculpture. He didn't want anything on the lines of a figure in a niche – the recess between the buildings was already designed as such; and he wanted the sculpture to appear free of the stone as though in levitation, unconcerned with gravity, with the means of support hidden. Given the nature of the building, these factors suggested a religious theme, and that could mean the employment of one artist only: Epstein; his *Lazarus*, so recently on exhibition, so beautiful and so praised, settled that.

When Osman approached the sculptor three months later, the building was still under construction. He was so convinced, however, that he must have Epstein that he wrote to him without first asking the nuns for their agreement to either a piece of sculpture or the artist, and without any funds to back up the commission: this he explained in his letter – the money would have to be raised by public subscription later. There was a further condition: while the work was to be modelled, it

was not to be cast in bronze because this could lead to stains on the stone in wet weather; instead, it was to be cast in lead saved from the old roof. Possibly to Osman's surprise, the unconventional nature of the commission – that is, the nuns were unaware of it and no money was available for an advance payment to cover expenses – in no way deterred Epstein: he saw the site, was shown the design for the bridge in its setting and then produced a maquette for the sculpture in only one week. This, with some small changes and at thirteen inches high, was an exact scale model of the thirteen-foot-high finished work. Of course, the problem confronting him, both sculptural and architectural, was one he always found exceedingly interesting, but it was particularly so in this case because, for the first time, he was working within an authentic classical context of true quality: the BMA building, after the style of the Arts & Crafts, had character yet was otherwise unremarkable, and the Broadway headquarters is really rather dull. Here, at Cavendish Square, on the other hand, was a unique opportunity to decorate a beautifully balanced composition.

His idea for the sculpture was, you could say, the perfect solution: he arrived at a form which may well have been derived from an ancient symbol of balance, the Assyrian mandala where two identical isosceles triangles, one pointing up, the other pointing down, overlap. In his conception for the *Madonna and Child* the tips of the Madonna's fingers established the points for the base of the upper triangle, while the outstretched arms of the Child formed the base of the lower one. In this way, he achieved a single object where every element was an integral contribution to the whole. He must have felt impatient to get on with it; Osman was delighted – it was the masterpiece for which he had hoped; and the nuns, suspicious at first when the name 'Epstein' was at last mentioned, fell in love with it. But he had to wait: the money had to be found. And so he went ahead with his portraits, of which there were fourteen that year. Of these, there were the four small children of the Hughes family and two other subjects of rather greater significance. The commission to do the children was through an introduction from Matthew Smith. Starting on one of the daughters, he wrote to his old friend on 11 July for advice: he was worrying about what he should charge. Remembering there would be only one cast taken, he said: 'Do you think 500 guineas is all right? For each one, or shall I ask less, something around 300? I don't know the Hughes of course and I have found that often I've done a terrible lot of work for very little money, considering

the wealth of those who commission portraits. Advise me frankly on these points ...' Whatever Smith advised, five hundred guineas was a small sum for an artist with such a reputation, certainly compared to what many a Royal Academician would have charged: five thousand would have been considered quite normal for a photographically neat and ultra-lifeless painting by a popular RA. But then, Epstein found quibbles over fees highly distasteful: he preferred to offer a modest figure and get on with the job; with his vast experience, he was now extremely quick, and had so many offers of commissions that he would never waste time on details of a hundred here or there. Although his likeness of Christopher Hughes was easily the best of the four, it was the head of his sister, Isobel, which made an appearance on one of his door handles for the Cavendish Square convent two years later.

Here again he was using a study as material for another occasion. After this, he took Jackie and Kathleen away for a short break to the fishing village of Deal on the east coast of Kent. They had a new companion – a Shetland sheepdog puppy, a gift Jackie called Frisky. However, since Jackie was now only interested in cars (he was given his first motor bike that year), the dog soon became the devoted friend of Epstein. The Duke of Devonshire's daughter, Lady Anne Tree, was well aware of this when she was sitting for him in the autumn. He spent three weeks on her, perfecting one of his most exquisite classical works, at the end of which, fearing that he might have exaggerated the length of her neck, he took out his measuring tape and checked the height of her head above the shoulders, the width of her chest, her nose, the measurement across her forehead, to his amazement discovering he wasn't a millimetre out. The *rapport* between them was, however, plain enough; they got on immediately: 'He was very fond of children – particularly *his* children – and animals. He loved his dog Frisky, had bits of food on a plate for him and constantly bent down to talk to him. He said, when I was sitting, don't bother to stay still – just be yourself, talk, do what you feel – ' Her picture of him, snapped in those weeks, remained sharply in focus: 'He talked about Kathleen, about Theo, Kitty and Esther, and endlessly about his life in Paris, about the people he had met there' – he counted Modigliani, Utrillo, Pascin and Brancusi among his closest friends –

and how he couldn't stay there for fear of these artists and their drinking habits taking him over and getting in the way of his work.

He was immensely funny, a wonderful conversationalist, loved an evening out – my husband and I often went with him and Kathleen to the Caprice – and a good dinner, excellent food and plenty of wine. His work mattered above anything else – his life was his work – but that didn't stop him enjoying himself. And he really did like women – nothing in the least salacious, just their company; he felt in sympathy with them. He was, after all, a simple man, disliked the art world, the world of grandeur. I saw his collection, under his bed, round his bed – it was treated as casually as things are treated in a garage, and was as important as things in a garage. He thought his portrait of me was one of the best he had ever done; I thought he was an atheist who was interested in Jewish stories and history; that he was an Old Testament figure, or the reincarnation of one . . .

He went on to a head of the pianist Marcella Barzetti, one of the two subjects which turned out to be so very important: she, like Isobel Hughes, had a part in the convent, in this case as the material for the *Madonna*'s head, and then, yet again, for one of the figures in the Philadelphia group of the same year, 1952. It so happened that Kathleen had heard her play at the Wigmore Hall and was so struck by the performance that she invited her back to Hyde Park Gate to play for their friends. She was, of course, one of many who did: the singer, Victor Carne, an old friend, came and sang Schumann songs, and two foremost Italian composers of the period, Goffredo Petrassi and Luigi Dallapiccola, were frequent visitors. Dallapiccola, who said that he began as an instinctive composer and only late started to think about what he was doing, played his own *Quaderno Musicale di Annalitsera* on their piano. There were many others, like the flautist, Elaine Shaffer, Samuel Kutcher and the pianists Maria Donska and Denis Matthews, both of whom gave lunchtime recitals at the National Gallery during the war. Marcella Barzetti often played, a professional who took the task pleasantly lightly and informally (as she was bound to do with the piano treated as a shelf for sculpture, vases of flowers, tea-cups and other things), never worrying if she played a false note; Epstein, greatly taken with her, asked her to sit.

And after her, from September to October, there was Alic Smith to do, the Warden of New College, Oxford. There were some sitters who were found trying – 'Somerset's coming today,' Kathleen said with a faint groan when expecting Maugham – but not Smith. His visits were anticipated with pleasure. While Epstein made one of his most sensitive

works from Marcella, with Smith he seemed to have this vision of some great bird (Kathleen had had a somewhat different idea, which she passed on to him in a letter later: that 'perhaps Epstein should have "done" you in your mortar board' to suggest a square halo of a sort she had seen in a reproduction of a mosaic of an early monk in one of the Warden's books, *History of Western Man*). This was a chance to do another of his most perceptive works; yet their meeting had a further importance. When the Warden was on the stand in the studio, he noticed *Lazarus*. 'You know,' he said, 'that would look very well in my college.' And with this, the first moves in its journey to the antechapel began. Other sites were discussed first – perhaps in the shade of the huge, evergreen oak in the cloister garden, but Epstein pointed out there was a problem with the weather, which might affect the stone over a long period. And wasn't, Kathleen suggested, sculpture a rather too distinctive object in such a situation? In the end, they settled on the antechapel, and Epstein, of course, was delighted: like a crypt or a church, that was excellent – all thought of the work going to America was forgotten (even though Ingersoll would have found a museum ready to pay far more for it than he ultimately received from the college). A letter from Professor Lawrence to the Warden shortly afterwards (22 November) picks up the story:

> I should be very glad if the Lazarus (which I saw a year or two ago) could find a home in antechapel. The Seven Pillars Trust Deed allows contributions to the purchase of works of art for any public gallery, and the antechapel is certainly one *de facto*. Can you discover from your law don whether it can count as one *de jure*? A precedent would help a lot and I'll hold up discussion with my trustees for a few days in the hope you can cite one . . .

This proves that Smith, very excited by his new idea, had immediately been in contact with Lawrence about the sculpture to seek advice on how to fund it. Could his Trust help? Smith was a lover of art; his sister, to whom he had been devoted, was a singer and a talented painter and watercolourist, and his patronage of artists may have been sparked off by her sudden death in her twenties, a tragedy which upset him profoundly. He bought work himself, appointed advisers to recommend pictures for the college (my father, Clive Gardiner, two of whose paintings he owned, was an adviser at this time and had, by a strange coincidence, bought a large still life by Theodore Garman), and he was

also extremely interested in architecture (for purist reasons, he had considered exchanging the windows in the college quad for copies of the Elizabethan Gothic that had been removed in the seventeenth century). And now he had to have *Lazarus*, he was pressing Lawrence for assistance. The Seven Pillars Trust, he was told in December, could manage £200, possibly £250, but the prospects of raising the rest (there is no record of the sum Epstein was asking) were 'poor', Lawrence wrote on 6 January 1951. The Trust 'might fill a small gap but can't spare a great deal more'. There, for the time being, the matter was left, with Smith struggling to find other sources from which money might be found, such as a subscription raised from past and present members of the college. In the meantime, Epstein had received news from Philadelphia. On 16 February, Ingersoll wrote to him about the Ellen Phillips Samuel Memorial with a new offer. He referred him to arrangements made with the other sculptors, but, it now transpired, there was no artist commissioned for 'the statue to symbolize the Social Consciousness of America' after all, the sculptor who had been invited, Gerhard Marcks, having failed to arrive at a theme 'which would be interpretive of the thought'. Would Epstein be interested?

Not an easy thought to interpret; the conditions, moreover, were somewhat conflicting – the statue, in bronze, had to be about three metres high, but of a width that would not make too vertical a composition. The fee, however, was the best Epstein had ever been offered – $17,500, the Fairmont Park Association to pay for the casting and any other expenses. Ingersoll added that his co-chairman, Henri Marceau, would be in London in May or June and, if he was interested, details could be worked out then. Of course, Epstein was interested, this time replying by return:

> I would be delighted to carry out such a scheme and you can assure
> your committee of this. The idea calls for thoughtful consideration
> and by the time Mr Henri Marceau, your co-chairman, comes to
> London, I will have clarified my ideas and perhaps be able to present
> Mr Marceau with a plan; in any case I could discuss points which are
> not clear in my mind at present: for instance, whether considering the
> scope of the ideas involved a group would not be more suitable than a
> single figure to express all that is implied in the recommendations . . .

By that, he was referring to the condition about height and width, and was already contemplating doing far more for his fee than expected of

him. And so it turned out: five figures instead of one. In America, Ingersoll and Marceau were equally delighted to hear Epstein was willing to undertake the job – this was what they had always wanted, and Ingersoll's meeting with him had been so very pleasant (the sculptor was, he found, a most courteous man) that any misgivings he might have had about him were immediately dispelled. A group rather than a single figure, Marceau wrote in his letter to Epstein of 19 March, was right; he would bring photographs of the other artists' sketches when he came and a plan of the site. And it turned out, too, that Sally Ryan, the New Yorker who irritated Epstein by copying his sculpture, and forgetting to help Peggy-Jean, was the person who had suggested his name for the work in the first place. She had, Marceau said, 'promised to arrange for our meeting when you were last here, but somehow your schedule did not permit. We have shown your works at the Museum on numerous occasions and we have recently received your lovely bronze portrait of Marchesa Casati. You may thus feel that you are dealing with friends and admirers.'

With this comforting news, Epstein continued with many commissions he had lined up, heads of Somerset Maugham, Colville Gray Clarke, Michael Tree and others; at the same time, he had just been put on the Arts Panel at the Arts Council where he had the misfortune to overlap with Moore for a year (by now, Moore had become something of a 'committee man' who cropped up everywhere). Carel Weight, who joined with Epstein, was struck by the contrasting characters of the two sculptors. He didn't much care for Moore. 'But I liked Epstein,' he said. 'While Moore was always careful to gauge what the majority of the members wanted to hear before giving his opinion, and then giving them what they wanted to hear, Epstein said what he thought, and was always constructive and interesting. He was a remarkably intelligent man.' Like Weight, Epstein was on the Panel for another three years, and that certainly helped to raise the £3,600 for the Cavendish Square sculpture: the Council made a contribution that led the way, bringing some money from public subscription. Epstein was, of course, impatient to get ahead with it, not simply because the task was irresistible, but because, now that the Philadelphia commission was a fact, he was afraid these two big jobs would clash, which they did.

Kathleen, who had been in Italy during April for a second operation on Helen (although she only partially recovered her sight, it was otherwise entirely successful), was back in time for Marceau's arrival in

London at the beginning of June 1951, when the Festival of Britain was in full swing. He saw Epstein's *Lazarus* on show at the Battersea Park summer exhibition, and his *Youth Advancing* at the Festival on the South Bank; it was sited outside the vast, flat Dome of Discovery, near the dramatic light in the night, the Skylon, and all the rest of the extravaganzas that pulled in the crowds and inspired Dylan Thomas to write, 'And this is what London should always be like until St Paul's falls down and the sea slides over the Strand.' Kathleen very much enjoyed a really imaginative line of that sort: I remember her saying, 'Life without St Paul's would be like our planet without life.' So Marceau hit a sensational moment to come; the Festival heralded a sudden upsurge of optimism in the country; the war was part of history, its arid aftermath seemed over at last. He returned to the States with the news that Epstein accepted the contract and had told him he wanted to visit the site. When Ingersoll next wrote on 18 June arranging advances and expenses, it was to ask if he could come now, fly over the following week to meet the other sculptors (one of whom, Jacques Lipchitz, Epstein had known in Paris) and see their various proposals. But he couldn't do that – 'My difficulty,' Epstein wrote, 'in coming immediately is that I have started something in clay that I would wish to cast in plaster before leaving here and I can see my way to coming over by the middle of July. Certainly no later than the end of July.' He would stay about a month, he said, ample time to discuss the problems involved. Now he was in the middle of a portrait, earning, as he would have said, a living; if it was the *Maugham*, it was a remarkably good portrait.

It was about then that Beth Lipkin, who had been in Canada since meeting Kathleen before the war, returned to England and came to live at Hyde Park Gate. And when Epstein sailed for America, she went with Kathleen and Theo to Torri del Benaco to see Helen. Meanwhile, Epstein arrived in New York on 5 August. He stayed with his brother, Dr Irving Epstein, on West 78th Street for five days seeing relations and friends like Dr Oko and Gussow, and then went to Philadelphia, spending two nights with Sturgis Ingersoll and his wife. With everything he needed to do there complete, he joined Peggy-Jean at Hatteras Island where he remained for three restful weeks. He was now, however, thinking about *Lazarus* again, and on 2 September wrote to Warden Smith:

I have come to America to consult with a committee for a large

sculpture group which is to made for Fairmont Park, Philadelphia. I have been wondering what is to happen to the *Lazarus*, now at Battersea Park sculpture exhibition. This exhibition will close at the end of September and it is a question as to whether I should have the statue sent back to my studio. If you are still resolved to have the statue at New College, let me know for the statue could be sent directly there from Battersea Park. I have never thought of this resurrection carving as an object of commerce and if a reasonable sum has been contributed I would gladly let it go for whatever has been acquired for its purchase. Would you let me know the situation? The setting up of the statue as a memorial in the chapel so appeals to me that I will do whatever I can on my part to realize this destiny.

He explained he would be back in London on 3 October, and if the Warden cared to airmail a letter to him at his New York address in the middle of September perhaps something could be settled. He stayed with his brother Irving for another two weeks before sailing for home, and during this time saw Ingersoll again, on this occasion to discuss the possibility of selling some of his other works to the Museum.

The Warden did write; unfortunately, only £700 had been raised, mostly from the Lawrence Trust; such a small sum was a setback and it's difficult to believe that Epstein didn't regard the college's inability to manage something far better as quite extraordinary; after all, New College was not poor. He was certainly surprised, and only replied on 30 November:

I have been thinking over the question of the *Lazarus* since coming back from America and I am very much inclined to let the statue be placed in the fore chapel of the New College church for the good reason that this statue I know should have a permanent setting such as only a chapel can give it. I would accept the sum you wrote of what you have in hand, £700, with the hope that something more could be collected at a future date. Also, as I could not afford to send and erect the statue myself, I would hope that the college would pay this expense . . .

When the Warden received this, he wrote immediately to ask when *Lazarus* could be sent: he was overwhelmed with gratitude to hear of Epstein's generous offer, and his letter was so warm that it brought another from Epstein that was equally immediate and very touching: 'Your letter with its wonderful news fills me with joy. At last one of my

sculptures will have a worthy, or most noteworthy setting. I will set about the arrangements for moving the statue ... I am most grateful to you for putting forward this great idea.' However, it was after all too near Christmas to send the work, Epstein told him, writing back on 13 December; at the same time, he said, 'I want to give the statue the last touches of my chisel which it seems to need in the clear vision which going away forever reveals.' Then he said: 'Do you think I could have the sum of money so far obtained for the statue. A very wealthy client whose bust I have made has let me down by departing suddenly for India without paying me her fee for the bust.' This was the Maharanee of Baroda. 'I am frightfully embarrassed by my client's default and if you could see your way to sending me a cheque I would be most thankful ...' It was sent by return of post.

The Warden hoped that *Lazarus* could be installed in the chapel by 18 January when the dedication would take place with Fellows of the college and senior members of the University. Epstein said he would see to that and would of course be accompanying it. 'For the first showing, I know Mrs Garman would love to come with me and if we could bring a small party of my two girls' – Kitty and Esther – 'they would all enjoy the great occasion. I myself look forward to the placing with you of the statue.' This was arranged for 15 January, five days after an announcement in *The Times* that Epstein was working on the large *Madonna and Child* group for the reconstruction of the Cavendish Square buildings, now completed and occupied. And so, first, on the 15th, Epstein decided to go to Oxford with the sculpture on the lorry; then, for the dedication, he and Kathleen, Esther, Kitty and Matthew Smith were driven down by two doctor friends, John and Valerie Cowie. After this enjoyable occasion, Kathleen wrote to the Warden on the 21st: 'Which shall I thank you for most? The Idea, the famous tenacity, the delightful and lavish hospitality, the excellent address you gave? Thank you very warmly for them all.'

In the meantime, while Lawrence had congratulated Warden Smith on his achievement in obtaining *Lazarus* and, struck by Epstein's astonishing generosity, was attempting to persuade his co-Trustees to agree to an increase in the fee, some were not so pleased by the addition to the college: 'It was with feelings of great sorrow and disgust that I saw the picture on the front page of the *Sunday Times*,' A. G. Allen wrote. 'I am one of the oldest living members of the New College Society. It may be a great work of Art, but it is completely out of place

in our beautiful New College Chapel.' This, curiously enough, was exactly what it was not: the statue's stone, scale and form are so perfect a fit with the surroundings that it is difficult to believe *Lazarus* wasn't carved specially for them, as a commission; and many do think exactly that. Smith wrote back that the *Sunday Times* photograph was misleading, failing to convey the relation between the statue and the architecture of the antechapel. 'The impression of height is altered by its relation to the pillars,' he said, 'so that it seems to emphasize the scale of the pillars themselves and to lose its own emphasis. Another point is that the stone harmonizes in colour with the stone of the antechapel, having something of the same quality although it is slightly greyer in colour . . .' To another critic, he wrote that it 'attracts the eye away from the Reynolds window': this was put there in the 1770s and its depiction of various aristocratic ladies as the virtues (hope, charity, prudence and so on), completely at odds with the spare interior, had been a subject of controversy ever since. Nevertheless, the placing does seem questionable: it is slightly strange that, because the figure's back faces the chapel, the front, close to the wall, goes largely unappreciated. This must have had Epstein's agreement, yet, as the housewife at the Leicester Galleries pointed out, it is essential to walk round *Lazarus* if its extraordinary changes in mood are to be experienced; had the front faced the entrance, for example, the dramatic introduction to the piece with its devastating abstraction of the totally 'bandaged' shape would not have been lost. No wonder *Lazarus* has been called the most haunted object in Oxford.

The older Epstein became, the more harassed was he by commitments: the present seemed to be a montage of all his past fame had led to. When he was starting the Philadelphia group in January, he was working on portraits and finishing the modelling of his *Madonna and Child*, and it was about this that word may have reached Ingersoll via the announcement in *The Times*. That prompted a letter to Epstein wanting news of 'progress with respect' to this undertaking, at the same time asking whether *Lazarus* would be available (which it was not) for Philadelphia's Museum of Modern Art's Twentieth Century Sculpture Show in October, to travel on to Chicago and New York later. The *Madonna and Child* was a feat of five months' intensive work since returning from America, and now, with the added anxiety of his son's second exhibition at the Redfern in March on his mind (it contained some very rich paintings of his aunt's home in Torri del Benaco), he

wrote back to Ingersoll to say that he hoped to have the central figure finished and cast in plaster soon. 'This figure is quite a formidable affair as it, although seated, is 10 ft high and takes some looking after in clay.' When this was complete and taken away to be cast, work on the groups on either side, about twelve or thirteen feet high, could begin. 'It would not have been practical to put up all 3 figures in clay as I work singlehanded, without assistants.' With so much under way at once, there was no room in the studio for the complete group, and he told Peggy-Jean that it had been a great help to him when *Lazarus* had gone to Oxford. There was never much room for more than one big commission in the ordinary way. That giant, *Ecce Homo*, which stood facing the entrance to the studio, and which you saw from the end of the hall the moment the front door opened, occupied a vast patch of floor in itself; and there were casts of heads everywhere. Jan Smith, the plaster moulder, said that sometimes he and Epstein had to clear a space about six foot square for a portrait. 'It never became clearer – we'd just push things into corners and hope for the best, climbing over everything. And sometimes he'd work in incredible conditions – balancing on planks, hanging on to ladders or grovelling on the floor.' He found the work there, however difficult, always fascinating. While he, and often his wife, worked on the moulds, and Epstein was intent on a sitter or on some huge commission, music tinkled through the house. 'It was Kathleen,' he said, 'playing the piano in the front room.'

A month later, on 18 April, photographs of the central figure went off to Philadelphia. With these, he sent a picture of his *Madonna and Child*, which, of course, he was impatient to have out of the studio and cast in lead when funds were available. He had made certain changes during the working out of this sculpture; he had emphasized the triangular forms of both upper and lower sections by increasing the angle of the Madonna's arms, and by straightening the Child's to a strictly horizontal line, moves which intensified the geometry of the composition and strengthened the sign of the Cross within it. There was also a change to the Madonna's head: the model for this had, at first, been Kathleen, and its position had been upward looking. However, after the Mother Superior had seen it in the clay, and had then brought various other nuns to view it without the artist present, one alteration was suggested – that the head should look downwards. And it was here that Marcella Barzetti came in: in his portrait of her, she is looking down, as though at the piano, whereas in every study he made

of Kathleen she is looking up; and it was for this reason, without any doubt, that Epstein, when remodelling the head to suit the nuns, decided that Marcella Barzetti would act as the better model for the Madonna – it is a likeness of her pensive, tender and maternal face which gazes down on the Child opening out his arms to the world with the wonderment of innocence.

On 20 May, Kenneth Clark, backed by Lords Crawford and Rosse, and by John Rothenstein, took up the Convent's cause to raise money for the work. Under a picture of the plaster cast of the *Madonna and Child* heading the Letters column of *The Times*, these dignitaries wrote to point out that, while contributions so far received had enabled Epstein to complete the modelling of the group, these were insufficient for the casting in lead to proceed and for 'this great work' to be fixed in position. 'It can now be seen,' their letter ran, 'that the work will be one of arresting beauty and dignity, entirely appropriate to its setting, and that it will certainly be one of the finest pieces of sculpture permanently on exhibition in London.' And so they were launching an Appeal. Epstein must have wondered why appeals for money were such a common occurrence with his work – there had been one for his *Visitation*, one for *Rima* (a commission), one for *Lazarus*, and now there was an appeal for this, another commission. He could not imagine why the wealthy Roman Catholics didn't pay for it; not a penny came from their quarter. At least there was no trouble over the Philadelphia group, however, and about that he had just had some good news – Ingersoll had written to say he was 'delighted' with the Seated Figure shown in the photograph Epstein had sent: 'I wish Walt Whitman was around to see it,' he said. Another wonderful piece of news that month was the birth of Kitty's second daughter, Annabel. Then, after this event, Kathleen had once more had to go to Italy to see her sick sister. 'All this,' Epstein wrote in a letter to Peggy-Jean of 30 May, 'isn't much good for me . . . The 101 things of practical life I am as little prepared to battle with as anyone else.'

He was much less so than most, of course. All was well so long as he was able to carry on with his huge pile of work without distractions. Unfortunately, there were many. Naturally, he was pleased that Clark (on account of his well-publicized promotion of Moore, he was, like Rothenstein, not one of Epstein's favourite people) had written glowingly of the *Madonna* group, but doing it had exhausted him, and for the small sum he had been paid, he was, he said, more or less giving it

to the Convent. The five months he had devoted to it had, moreover, delayed the Philadelphia group for which he was to be paid properly, although advances were slow in coming; and, much as he wanted to have another holiday in America, he had, as a result, to give the whole summer over to work. Then there were domestic distractions: worst of all, there was Theo's illness – 'Kathleen's life in Chelsea is harassing to say the least,' he said. Although living at Hyde Park Gate, she had to be down at '272' in the morning to see her son, back again in the evening to cook him a meal, and then be at Hyde Park Gate for supper with Epstein. And there was Helen: Kathleen was devoted to her younger sister; after she had gone to Milan to be with her for the first operation in 1949, Helen, her husband and their son had come to England in the spring of 1950. And, while they had stayed at '272' for a year before returning to Italy with Kathleen for her second operation, the Lades had taken Theo to their house in Torri for the summer.

'I need a rest badly,' Epstein told Peggy-Jean. 'Rheumatism keeps me from too great activity . . .'

Good news in September took his mind off current anxieties. First, Professor Lawrence wanted to buy a *Paul Robeson*, and Epstein wrote to him on the 17th offering it for £400; this was accepted by Lawrence by return of post. Then, a week later, on the 25th, he had a letter from George Pace, the architect for the restoration of Llandaff Cathedral which had been hit by a land-mine in 1941: Pace explained that, in this restoration,

> the most important work will be the creation of a great parabolic arch at the entrance to the ritual quire which is to carry a small echo organ and to support on its West face a great figure of Christ Reigning from the Cross. Both the Dean and I greatly desire that this figure shall be of outstanding quality and a major work of contemporary sculpture. I am writing to you in the hope that you might be interested in and be prepared to undertake this figure . . .

Epstein may have noted with some relief that Pace added that it was unlikely to be required for about three years; by then, the Philadelphia group would be finished and set up in Fairmont Park. So he wrote back at once, with his accustomed enthusiasm: 'I would be happy to undertake such a work. A work of such profound implications: a sculpture which would call forth the greatest effort I have been called upon yet to make:

embodying deep spiritual truths and make a work of sculpture an act of faith.' He would, he said, have to see the cathedral and consider materials and lighting; and could do this some time in October.

It was on 1 October 1952 that his retrospective, arranged by the Arts Council, opened at the Tate. This didn't, unfortunately, include a selection of his glorious watercolours and was thus incomplete. All the same, he was given three rooms and it was, he told Peggy-Jean, a great success: he was feeling a good deal better generally, having received a letter from Ingersoll promising that the $3,500 needed for him to continue work would be sent shortly. With reference to the exhibition, he said, 'I sense the hostility of Rothenstein, although outwardly he is friendly; also the Arts Council, although they have arranged the show, are equally unfriendly, and were really forced into holding the show as they had exhausted the interest in Moore & Co. And everyone here was completely fed up with the abstractionists.' There had been a huge attendance as usual with an Epstein exhibition, and that would fully compensate the Arts Council's expenses, covered, he pointed out, by public money anyway. 'The critics have had to pay me some kind of recognition, forced out of them by Newton's article.' For Eric Newton, this was certainly extravagant in its praise. The busts and portraits were 'astonishing', he said; they turned out 'to be as convincing as though they had stepped out of a Tolstoyan novel. They are not types. They have the sharp definition of inventions by Dickens, yet they are seen with the deep human sympathy of Rembrandt'. He was 'great as a sculptor and noble as an inventor'; he went on: 'Both aspects of him emerge, in his carving and modelling alike, with a reckless drive, a brutal punch that shocks the philistine who is always offended by whatever is not conventionally pleasing, and puzzles the connoisseur who wants his art to be artistic.' This was good stuff: he admitted that Epstein made him feel 'small', 'smug and uncomfortably refined', and, perhaps partly because of this, mistakenly claimed that the sculptor was 'prone to exaggeration'. That simply wasn't so, as Anne Tree and others could have told him: Epstein himself could never believe his accuracy; the illusion of exaggeration was part of the magic, and, like art, a mystery.

Newton then compared his larger works like *Genesis* and *Lucifer* with Moore's – Epstein's, he said, lacked internal structure, whereas Moore's were concerned solely with the skeleton. Many might dispute this, claiming the reverse is closer to the truth, and could well use

Moore's *Falling Warrior* of 1956, say, as evidence of his total ignorance of anatomy. Nevertheless, Newton went on to say that Epstein's protest against puritanism went further than Rodin's, although belonging to the same school: 'Immense concentration on the expressive fragment – the set of a mouth, the tilt of a head, the hollow of a nostril and an even greater concentration on the underlying message – the mystery of pregnancy, the protective strength of maternity – give Epstein a power that he shares with no other contemporary sculptor.' Epstein, however, had his own say in a broadcast timed to coincide with his retrospective. This was devoted to the modern movement in sculpture 'and I haven't held my punches although I mention no English names'. There was, he told his interviewer, Hubert Wellington, no such thing as 'modern' sculpture.

Realistic work, and also abstract work, is of prehistoric origin, and the striving for originality today has only led to incompetent and pretentious work parading as philosophical and expert. The living art critic has nothing but praise, couched in obscure language, for the fashionable so-called abstract art, and he either decries representation or ignores it. Representation has always, or very nearly always, been the mainstay of great sculpture in the past; all periods prove this, and the horrors of today cannot be exalted into greatness by any amount of sophisticated argument or assertion on the part of the professors. As one art critic of a well-known journal recently said of sculpture now being shown by a world-famous practitioner, 'these are disquieting objects, intoxicating however to those who consider the lumber-room of Renaissance imagery was over-due for clearing.' The Renaissance imagery referred to is that of Donatello, Michelangelo and Verrocchio. The frequent phrase used here as well as in America is that this 'modern' art has international currency – happy financial phrase! Who will clear the Temple of Art of the money-changers who now pollute it?

He certainly pulled no punches.

Yet surely, Hubert Wellington said, he was – at any rate according to Gaudier-Brzeska – part of the modern movement before the First World War? 'Yes, for a time I did work in that direction, but found it arid; it was leading to nothing, and also leading away from what interested me most, which was the human side of sculpture.' He continued: 'The study of the human being is frightfully important. If it were a novelist

like Balzac who was describing a human being it would be taken seriously, but when a sculptor does a portrait it is relegated to the shelf or some obscure part of the Mansion House, or the National Portrait Gallery where nobody goes.' He said what he thought, spoke fearlessly, with complete honesty, and it brought a startling letter from Reg Butler, the young sculptor who had made his name by winning the Political Prisoner competition, and one of whose pieces Epstein had referred to:

> I've just listened to your radio talk with Hubert Wellington; I'm sorry my magic box seemed a suitable example of nonsense for quotation because, believe me, I agree with almost everything you say about sculpture in general. For example, the aridity of abstraction, the importance of humanism. I don't think, you know, we disagree at all on fundamentals. I too believe in the supreme value of academic discipline, I too believe making a portrait is one of the most exciting things in the world, I too believe that 'sculpture' for its own sake is arid nonsense! There are surely two extremes between which every sculptor must attempt to steer? Form and nothing else but, and everything but form? As a mere infant may I send you and will you please accept my very sincere good wishes.

It was the letter of the admiring student to the father-figure of twentieth-century sculpture, the Master, but it was a very nice one.

After the opening, Matthew Smith gave a dinner party to celebrate the show: he 'seemed to be in great form', Epstein said. It was at the Caprice: 'a piquant detail was the proximity of the Maharanee of Baroda and her party who was wearing her £100,000 pearls. She owes me £2,000 for the work I have done for her.' All this information was relayed to Peggy-Jean. He had a good deal to celebrate: besides the retrospective, two massive jobs for the Convent and Philadelphia, and the prospective work for Llandaff, he had been as busy as ever on portraits – altogether, by the time the year was out, he had managed eight, according to the records, or twelve with the four door handles Epstein later gave to the Convent. Among them was a head of Mark Joffé, several commissions – Gina Lollobrigida in July, followed by Anna Neagle and Minda Bronfman – and his enchanting *Annabel Freud*, with a bonnet. At the end of the year came his study of Bertrand Russell, a witty companion, and then, at the beginning of 1953, the *Eliot*. He and Eliot had had, of course, a mutual friend in John Quinn, Eliot having been more of a friend of his than probably Epstein was:

Eliot had offered Quinn the manuscript of *The Wasteland* (with Ezra Pound's suggested alterations to certain parts) as a gift in 1921, an offer which Quinn refused – naturally, he wanted it, but his business ethic prevented gifts of all such things of value, and so he insisted on paying for the manuscript. Now, sitting for Epstein, Eliot became so interested in the mechanics of sculpture that he insisted on visiting the foundry where, at last, the *Madonna and Child* was being cast in lead. The *Eliot* was a powerful piece, as powerful as the poet's mind, but, like the man himself, a picture of reserve, restraint and discipline. Yet, for an epic work in those days around the turn of the year, it is to the door handles one has to look: here was something new, something that required the sculptor's unique brand of invention. He used the heads of four children from whom he had recently worked – *Peter* (laughing), *Ian Hornstein, Isobel Hughes* and *Annabel Freud* – as the centrepiece of each, and had then compressed the arms and shoulders to fit the oval form of the handles in such a way that they resembled angels' wings. At the tiny size of a miniature, there was no loss of draughtmanship, character or inspiration: they were the kind of handle which we might come across in some ancient cathedral like Autun, as part of the fittings for everyday use, yet by Gislebertus. And, as it happened, bronze castings of them ended up in the cathedral at Coventry, built to replace the medieval building which had been flattened in the massive air-raid of 1940.

However, despite the praise his retrospective had received, the thousands of visitors to it, and the coverage from the media (or perhaps because of them), the art establishment had to intervene to put the exhibition in, as its hierarchy would have said, 'proper perspective', or more crudely, to 'cut Epstein down to size'. Possibly it was a response, as Butler's letter had been, to his broadcast. If so, the highbrow heavyweight chosen for the hatchet job was Philip Hendy, who, as one of those to see off *Lucifer* from the Tate, was still the Director of the National Gallery. In the light of this very successful retrospective, he wrote a carefully worded article for the December 1952 number of *Britain Today* that was transparently clear in its intentions – to leave the reader without any positive indication of the artist's worth and importance, one way or the other. Thus, having spent half his space brushing in Epstein's early days with a few negative strokes, he said his temperament was 'best suited for modelling', and that he had 'an extraordinary capacity for catching likenesses' – faint praise that smacks

of condescension from the heavyweight to the lightweight. There was nothing he could find to be really complimentary about, and when he did admit some quality or other, it was followed up with some derisory remark. In the context of a mention of *Isabel* (Nicholas), for instance, he says, 'Epstein has never been afraid of being vulgar' and that 'the turgid sexual expression, the carelessness of form, the lack of concentration have taken the potential strength from the large ideal bronzes of recent years, like Birmingham's *Lucifer* . . .' The emphasis on modelling as opposed to carving was an old ploy, of course; but where Newton was ready to confess he felt disturbingly 'refined' in the company of an Epstein, Hendy remained the inhibited, stiff-upper-lipped Englishman who preferred to stay on the puritan edge of good taste. That is how his piece reads, at any rate. For the rest, it is astonishing that a man in an important position should have written about an internationally famous artist with a very long list of remarkable achievements behind him in such an impertinent manner. Father Vaughan could have been back.

Epstein's reaction is unknown; he may well have brushed it aside as the pretentious essay of an art historian who was not prepared to admit his ignorance. Of course he read it – he kept it among his trunkloads of a lifetime of reviews – and would have regarded it much as he saw the writings of the Bloomsbury set: 'They can never write about me,' he told Arnold Haskell, 'without using the word *but*.' It may, however, have prompted his opening remark in a letter to Peggy-Jean of 25 February 1953: 'No storms reached London although the Thames rose and threatened the Tate Gallery basements. It would have been no loss if the recent acquisitions had got drowned including the precious director . . .' In other words, John Rothenstein. But he had better things to think about than politically inspired attacks on him. In a year marred by the death of his old friend and ally Muirhead Bone, there was plenty to sustain him; he was to have a show during the coronation in June, he had been commissioned by the Office of Works to make a full-length portrait of the South African Prime Minister, Field Marshal Smuts, for a site in Parliament Square (by the time he wrote to his daughter, he had already submitted his estimate of costs); that January, too, he had visited Llandaff with Kathleen; in May, the month he turned down the Royal Society of British Sculptors' offer of the Gold Medal for services to sculpture (they had waited too long, he said), his *Madonna and Child* was to be unveiled in Cavendish Square; in June, with the exhibition of his work opening at the Leicester Galleries, he was to be presented

with a Doctorate of Civil Law by Oxford University. But so far as his visit to Llandaff went, in one way this was disappointing – there was so little money available that it was decided his *Christ* would have to be left as a plaster cast; and that, considering the expense of the concrete arch to be constructed to support the organ and the sculpture, seems extraordinary. He was faced with yet another situation where a work of art took second place; and he disliked the idea of the arch.

This was a few months after I met him. Kathleen had asked me to come up to Hyde Park Gate about something or other and when he answered the door what I saw, for a second, was an image of a late Rembrandt self-portrait – huge, hypnotic eyes in an ancient face. He didn't ask my name – simply waved me in, saying, 'We're listening to a Beethoven sonata.' He had this curious way of accepting one without question. About the arch he told me there was the possibility of Stanley Spencer decorating its underside with a mosaic depicting *The Last Judgement*, but this, he felt and rightly, would do nothing to diminish the bulky, alien form of a parabolic structure spanning the medieval nave. But then, it seems to me, the arch supporting the bridge at Cavendish Square, hailed by art critics at the time as graceful, is most unsatisfactory as well: the relationship between this semicircular affair and the panel for the sculpture above is uncomfortable and distracting; it is a weak shape, and it fails to terminate the design in a positive manner; a shallow arch would have been stronger, and would have allowed the sculpture to assume complete charge of the composition. Still, this didn't affect the great event of the year for Epstein – the unveiling of the *Madonna and Child* on 14 May: he treasured the work, had a photograph of it stuck in his passport ('my passport to heaven', he called it), and was often seen in the square with Kathleen and Frisky, staring fixedly up at it while the finishing touches were put to the building in readiness for the opening. It was another lovely occasion, crowds gathering and blocking traffic when the news went round that Epstein was there with, as the newspapers described Kathleen Garman, 'one of his models'. R. A. Butler, the Chancellor of the Exchequer, made the unveiling speech from a balcony; he said the sculpture was 'a synthesis of beauty' and 'a united conception', and then called down to the man in the black hat and the yellow scarf, 'Come up here, Epstein'. 'No, I think we'll have tea,' Epstein replied, smiling at Kathleen as the driver of a passing bus pulled up to shout, 'Hi, Governor, you've made a good job of it'. There was the familiar mass coverage in the press, Eric

Newton said it was 'a great group', Robert Furneaux Jordan, Principal of the Architectural Association School and architectural critic of the *Observer*, called it the most significant piece of sculpture set up in London for 'hundreds of years', and pictures of Epstein and Kathleen were plastered over all the dailies. It is perhaps understandable that certain of his rivals, however well backed was their work by a network of influential admirers, were envious of the universal recognition which Epstein, often ignored by critics in his later years, received. Of course he did so much, worked so hard, and, through his art, met such a range of people, that the repercussions of some latest achievement – a commission from a public body, an honour, an unveiling, an exhibition, a huge new figure – continually made the headlines. But there was more to his appeal than that, some mysterious touch which reached deeply into the human psyche. Certain incidents draw attention to this. There was, for instance, the unknown chemist who, in 1908, appeared at the end of the BMA saga with a cheque to clear Epstein's debts to the plaster moulder; there was Winant's nocturnal visit to Hyde Park Gate; a soldier who had been in a German prison camp who came to see him after the war to thank him for the interest he had provided by his autobiography of which, by some strange chance, there were two copies in the camp, and which were so avidly passed from hand to hand that they had to be constantly rebound; and there was, after Epstein's death, the call from the wife of a man serving a prison sentence who begged for a photograph of the *Ecce Homo* carving to pin up in his cell, and, when Kathleen produced one, she was told it was received with joy and became the object of widespread interest in the prison. 'One is inclined to ask,' Kathleen wrote in the foreword for the catalogue of the Schinman Collection, the largest private Epstein collection ever made, 'what was the special quality in this man who lived so modestly, usually shut away from the world at work in his studio, yet who had such power to interest others in such diverse circumstances.'

He was shut away, as ever, that year with three big works on his mind, scattered amongst which were some lovely portraits – his second of Annabel, a delicious likeness of Frisky, a rugged head of Professor Macleod – and a maquette for a commission in Singapore which was never realized. He was of course delighted by a midsummer day in Oxford when he was presented with his Doctorate. This honour was probably due to the efforts of Sir Maurice Bowra, the Vice-Chancellor, who was succeeded by Alic Smith the following year ('I have given way

to an older man,' he said). Bowra, about whom John Betjeman said in *Summoned By Bells*

> I wandered back to Magdalen, certain then,
> As now, that Maurice Bowra's company,
> Taught me far more than all my tutors did,

was a passionate lover of the arts. He wrote the address, given in Latin by the Public Orator, and his words made the innuendoes of Hendy and the like vanish to oblivion:

Modeller, worker in bronze, sculptor in marble — you see him before you. There was a time when some would censure the form of his works, others their nudity; and when the Press, by airing both complaints, would rouse a sensation among the ignorant masses. Now, after 'a thirty years' war', he has triumphed and won the fame due to his genius but never deliberately sought. He is classed in his latter days among 'the time-honoured and respectable', and possibly is shocked by a younger generation, whose sculptures are of a 'nature' that does not 'abhor a vacuum'. His problem has been, it seems to me, to express in stone his sense of the vast elemental forces by which Creative Nature urges all things to life and growth; and his sense also of the immensity of those tasks to which she has destined mankind. As we look at his *Genesis* or his *Adam* we are put in mind of that earliest of all human generations, 'hardier', as Lucretius tells, than our own, and 'framed of bigger bone'; and we recall that 'steamy' generative 'heat' of Earth the Mother which is more familiar to African artists than to ours. But none of these thoughts occur to the uninstructed; nor, when they look at *Lazarus*, do they wonder, as they should, what dreams are his and how heavily he sleeps who is still between death and life. The bronzes please all alike, although smoothness of finish has not been the artist's concern, but rather boldness of effect and a studied ruggedness, so that his portraits of young brides and children again suggest that primeval Lucretian world in its 'flower-strewn spring'. How skilful are the touches that make a likeness! How delicately he portrays mind and feeling! How many famous persons his portraits have made more famous still! I present to you for admission to the honorary degree of D.C.L. an artist of rich invention, Jacob Epstein.

And then it was back to the Philadelphia group, well on the way now,

but which had cost a great deal in materials and the plaster casts, and to the *Smuts* commission which involved so many committees (all members of which had to have their say) that had to be brought together (in the summer, an impossibility to arrange) that delays were inevitable. 'I am advised to wait for further *"guidance"*,' Epstein said, 'when that is forthcoming! Also the money must be voted by Parliament so the work could be a matter of years before the statue materializes.' He had been commissioned to do a portrait of the late Sir Stafford Cripps for the St Paul's crypt – 'I have been granted a bit of wall in this dismal underground basement where the memorials of England's mighty dead are placed – Wellington, Nelson, Florence Nightingale etc. etc. etc.' However, he was very excited by Matthew Smith's show at the Tate. 'This exhibition will be a triumph for Smith,' he told Peggy-Jean. 'It is the finest exhibition by any living artist ever held in London and will finally place Smith where he belongs as our foremost painter. Somewhat late but what can you expect if the Tate shows such dull and uninteresting painters as Braque and Léger, and such frauds as Graham Sutherland.'

He was looking forward to next year: then he was determined to come to America and have a rest by the sea. By that time, the Philadelphia group would be largely cast in bronze, a feat so enormous it would take eighteen months to complete, and made him wonder how those paying for the work would react. 'It fills my studio,' he said, 'so I only have a little space left for a portrait and cannot begin a large work again until I move its present inhabitants.' He had to think seriously about this at the end of October 1953 when a letter from George Pace came formally commissioning him for the Llandaff *Christ* and sending him drawings and a model of the arch. This letter came, moreover, shortly after news of those 'bad pennies', Tony Crisp and Charles Stafford (now described as a popcorn maker in Camden Town), turned up again; they were advertising the sale of *Consummatum Est*, *Adam*, *Eve* and *Jacob and the Angel*. 'Offers wanted,' the advertisement read. It transpired a few days later that *Eve*, described as 'Epstein's masterpiece', had been bought for £2,000 from Stafford by a Mr Walter West who claimed he was going to loan it to the Tate. Epstein was, of course, disgusted; besieged by reporters, he dismissed the latest attempt at the commercialization of his art with, 'The time has come for this to stop.' So to have the letter from Pace was a huge relief, for he realized that the revival of this publicity could have affected the outcome of the

commission: there were constant reminders of these disastrous deals –
even Hendy had dragged them up in his essay. Fortunately, nothing of
the kind happened. One day in November, a month after hearing from
Pace, Haskell called wanting his opinion on a piece of sculpture; as
Epstein opened the door to him, he picked up an official looking
envelope that had landed on his mat saying, 'This must be a tax
demand.' He was about to lay it aside for Kathleen to deal with (and so
forget about it) when Haskell said it wasn't anything of the sort – 'This
is your honour, long overdue.' Epstein opened it, found he was being
offered a knighthood, and laughed, saying, 'You're right. I'm respectable
now. And no one can say that I'm not normal.'

When the 1954 New Year Honours List was announced, the papers
were full of his knighthood: the *Daily Graphic* headline was typical –
'REBEL – K.B.E.' 'Now the stormy petrel has come to rest,' the report
said. But Epstein dispelled the 'rebel' talk. 'I have never been a
revolutionary or a Bohemian. A Bohemian is a man who plays all night
and sleeps all day. I have always had to work too hard to do that.' So
much for his interview with the *Graphic*. The excitement was terrific,
and he enjoyed it – the house besieged with reporters and photographers
– he was lucky, he told friends, to be able to escape the back way. 'I
never knew I was so popular. Everybody I know, or don't know, has
written me or sent me telegrams. Impossible to answer them.' The
knighthood gave him enormous pleasure: to be seen to be somebody, to
have recognition obvious to all, was much better than the initials of
some rarer honour after your name. The investiture was on 16 February:
'A dark lounge suit is correct,' he explained to his daughter, Peggy-
Jean. 'Thank goodness no top hat and rubbish of that sort. I am told a
K.B.E. carries a fine decoration for evening wear. Knight Commander
of the British Empire! That sounds fine. I think the whole thing comes
from Churchill: I don't know *anyone* else *who* would be interested, and
the recommendation is from the Prime Minister.'

He was very happy when he wrote this letter: besides the honour, his
Smuts was up in clay at ten feet high, despite all the complications of
committees, visits from people like Clement Attlee and Kenneth Clark,
and those who knew the Field Marshal wanted to tell Epstein how to do
it. He would tolerate some specific requirements, such as the nuns' over
the position of the *Madonna*'s head at Cavendish Square, and would
incorporate the alteration in a manner that would satisfy him, seeing it
as part of his responsibility as an artist to be true to the subject. But, as

an artist, too, he would not tolerate criticisms of his conception, or the details that followed naturally from the conception: these had nothing to do with anyone except himself. He had immense difficulties, in this respect, with committees over the *Smuts*, in particular to do with the minutiae of his uniform, all of which he carried out exactly. With the *Cripps*, which he had completed early in 1954, he complained of constant interruptions from the politician's widow who, he said, wanted 'to come in and guide my hand'. Nevertheless, he had accomplished both these works while the modelling of the Philadelphia group was still under way.

Yet how shockingly momentary happiness can be; how quickly it can be switched off. Two days after writing to his daughter in America, Epstein heard that his son Theo had died, suddenly, of a heart attack.

This remarkable artist was twenty-nine when he died. He meant a great deal to all who came to know him, whether these were local tradesmen like the severe owner of the Chelsea Bookshop or students at the art school. His mind, sensitive in the extreme, was essentially radiant and noble; as a person, he had infinite charm, while his work, splendid though it was in achievement, held such great possibilities for the future. I had become very close to him at this time, partly through my parents who found his company at their home a joy for its refreshing unworldliness, simplicity and true imagination; partly through mutual friends at the art school, but most of all through knowing Kathleen. Many memorable moments were spent at '272' with this real artist; he showed me his studio which had been built for him at the end of the garden (nothing more than the kind of 'sheds' his father had been used to at Pett Level and Baldwin's Hill), his paintings in progress, his large collection of magnificent art books, and the medieval objects and figures that he liked to use in his compositions. He had, it appeared, borrowed a piece of sculpture from the art school's antique room for a still-life he was working on, and it was this which, quite unnecessarily, brought the police to his house. The school had sent them round. Kathleen, to prevent her son being arrested, arranged for him to be certified as insane, and an ambulance was called. Theo, terrified by the horrifying drama which had so suddenly overwhelmed him, and believing that he was being kidnapped, died on the way to hospital from a heart attack, struggling to escape from the male nurses.

Snow was falling heavily as friends and relations waited on the

pavement outside '272' for the fleet of cars to take them to Harting for the funeral. Esther was there, white and shaken, beautiful and sweet; there was John Lade, who was to play the organ, and Cathy wearing scarlet – 'Theo,' she whispered to me, 'would have hated black.' But the cars were black – big black Packards; when Epstein hired a car, it was always a Packard, one of the few things, like certain turns of phrase, that was a legacy of his American days. These black cars seemed to float like ghosts through the white and silent Sussex scene to the tiny church half buried beneath an eiderdown of drifting snow.

14

Ecce Homo

KATHLEEN was far too distraught, and too distracted by the horror of the loss of Theo whom she had devotedly cared for day and night during his worst periods of instability, to attend the Investiture at the Palace in February; Esther, mysteriously described as Mrs Esther Joffé in newspaper reports, went with her father in her place. Theo's death had been an appalling blow to him as well, and it must have taken a tremendous effort of will, at seventy-three and exhausted with overwork, to see the ceremonial proceedings through. He never mentioned the tragedy in his letters to Peggy-Jean until the end of the year, as, he wrote then, 'that was too terrible'. Yet at least he had his commitments to return to, and this he did. By May, the bronze casting of the Philadelphia group had been under way for six months, but would, he anticipated, take a further six to complete. He was in the middle of several portraits, one of which he found very interesting – a bust of Sholem Asch, the Polish-born Jewish writer who was an exact contemporary of Epstein's and an internationally known novelist and playwright. Epstein described him as a 'folk Yiddish writer' who had 'been compelled to leave America on account of persecution by Jews. It seemed he got the backs up of Jewish patriarchs by writing about Christianity! ... At his house in Palm Beach he was attacked and violently assaulted by Jewish thugs. This is a pretty state of affairs. The whole world it seems is just as much upset as ever.' The *Cripps* was being unveiled that month and he hoped to finish *Smuts* by the summer: he had to show the model of the Field Marshal to a committee from the Ministry of Works and another from the Royal Fine Art Commission.

'On this,' he told Peggy-Jean, 'is Henry Moore who, ever since I befriended him years ago, has become a great authority here, and has never neglected to do me harm.'

His work did help him through this horrific period, and here he was so much more fortunate than Kathleen; and there was so much work; so much to do with time so short – always he felt this urgency of limited time available to accomplish all he had to do. With *Smuts* now ready to cast in bronze (the men from the Ministry, to his surprise, were most enthusiastic) and only Clement Attlee yet to give his approval, he had accepted a commission from Lord Woolton to make a sculpture for a position above the high entrance to his Liverpool department store; by July, the work was already begun – he had had a vision of a colossal youth rising as though from the sea, and representing Liverpool's recovery from the wartime Blitz that had hammered the city's docks and centre to rubble; as a figurehead perhaps for the prow of a liner, even as another *Lucifer*. There was that and there was the Llandaff *Christ in Majesty* also under way (the maquette for it finished and delivered for approval), and, despite these vast commissions and the congestion in the studio, he still found room to do at least four portraits that year, apart from the bust of Sholem Asch; one of his sitters, Dr J. J. Mallon, Warden of Toynbee Hall, was so much liked by Epstein that he was offered a copy of the work for the price of the casting, an offer that was unfortunately refused by this remarkable Irishman on the grounds that he didn't care for the likeness. Again, it was in July, on the 6th, that Epstein made one of his last acquisitions for his collection: at an auction at Sotheby's, he bought an extremely rare Sumerian statuette of a woman standing in the attitude of prayer, $3\frac{1}{4}$ inches high, made of zinc in the Third Dynasty of Ur, and thus in the region of four thousand years old.

At the beginning of August, around the time Sir William Keswick, a wealthy collector, bought casts of *Frisky* and *The Visitation*, Attlee had viewed the *Smuts*, said little (but was, apparently, in favour), and Epstein expected a 'directive' to have it cast. He couldn't wait – with that out of the way, there would be more space for portraits, his livelihood. As it was, the Llandaff figure, now set up, was so tall, reaching from floor to ceiling, that he couldn't get the feet in, and he was now looking round for another studio high enough for both this and the Liverpool *Lucifer*. In the midst of this mass of work, there were personal anxieties, mostly to do with his children. After Theo's tragic

death, there was the worry of Jackie, his impending call-up for national service and, worst of all, his passion for motor car racing. While he hoped that the call-up might put a stop to this, the prospect of the army was, 'for Jackie, most upsetting,' he wrote to Norman Hornstein.

> With his freedom gone and under orders, it is impossible to know how he will take it. What for an ordinary boy would be taken perhaps as a matter of course would be taken differently by someone who is as 'spoilt' as Jackie is. His activities for the past two years is something extraordinary and I don't think you would approve of it, for a moment. I don't, but I am so busy trying to get colossal work done that I haven't the time and inclination to play the 'heavy father'. Jackie's interest is of course cars . . . As well, he is a reckless driver. He knows a tremendous lot I know about cars and could build cars under your eyes, but at driving he is hopeless. Of course it is always the other fellow's fault . . .

(He was wrong about Jackie's potential in this direction, since his son, many years later, went on to run the most prestigious racing car drivers school in the country.) Other news was passed on to Peggy-Jean – Isabel had married Constant Lambert, and Meum, back from the country, was living in St John's Wood (she died there in 1957, aged sixty). Then his daughter Kitty had, as he put it, 'divorced the spiv Lucian Freud', although at least this had given him the pleasure of having her two little girls living at Hyde Park Gate, 'and they are delightful'. At the same time, he was worried about Peggy-Jean and her family, so far away across the Atlantic, and he had started once more sending money via American friends, restrictions about it leaving the country still being very tight (Kathleen helped her sister, Helen, always perilously close to huge debts, by sending parcels of books with pound notes between the pages). And there was Esther: her relationship with Joffé had ended miserably, he had left the Queen's Gate flat and she had brought Roland to Hyde Park Gate to stay. She was profoundly disturbed by Theo's death, and her state of mind was worsened by reproaches from Joffé and by the suicide of a young student who, having fallen in love with her, asked her to marry him; when she refused him, he killed himself. Epstein, writing to Peggy-Jean on 3 September 1954, said, 'Esther has been holidaying with friends in Italy . . .' Esther, staying with the Vivantes at the Villa Solaia before going to Rome with their daughter, Charis, wrote her last letter to Joffé on 10 September: 'It is so

difficult for me to sit down and write to you ... I cannot say I read your letters with great enjoyment ...'

Professor Robin Darwin, Principal of the Royal College of Art, gave Epstein a studio in the Sculpture School in Queen's Gate to accommodate the eighteen-foot-high *Christ* and the sixteen-foot *Lucifer*; no sooner had he had this news than he was horrified to hear that Esther, back in London, had attempted suicide. She was saved, had treatment in a home and, on leaving there, took a job at a bookshop with a woman friend. Six weeks later on 13 November Epstein wrote to Peggy-Jean to say his birthday had been marked by tragedy: 'Esther who was so beautiful and well loved by all committed suicide.' For the first time, he felt himself able to write about Theo's death, to explain what had happened and relate details of its agonizing aftermath, and now, on top of his loss, still a vivid and terrifying memory, there was Esther's. Two of their children had died inside ten months; how Kathleen and Epstein managed to carry on in the face of such an appalling experience is difficult to imagine. His letter went on: 'On the first night out in her new room she gassed herself.' He was extremely upset and very worried about Kathleen, he said. 'I hope time will heal so much tragedy ...' Life – his life, their lives – had to go on, and like a quiet reminder of this, a letter had arrived on his birthday from Sir Vincent Tewson, General Secretary of the Trades Union Congress, inviting him to enter for a limited competition for two pieces of sculpture, one for the entrance, the other for the courtyard of the TUC's new building under construction in Great Russell Street; that he did not reply for a month is some slight indication of his feelings of utter desolation following this latest, shocking loss. Instead, he set about moving his two big works to the RCA studio, and starting a portrait of Dr Elias Lowe of Princeton, an old boyhood friend of his; a commission intended for the Morgan Library at Pierpont, New York City. The casting of the Philadelphia group was nearly finished, and his daughter Kitty married Wynne Godley, the economist and Lord Kilbracken's younger brother. Life did go on.

Darwin wanted him to feel part of the Sculpture School, and he was at once accepted as such. He would have liked to have been accepted thirty years before when William Rothenstein was looking for a head of department but, owing to objections from the Board, he had been passed over. Professor Skeaping, now running the department, was extremely welcoming, and all the sculpture students were very excited

when he was getting the two works up (the *Christ* reached the ceiling), popping in and out, sometimes lending a hand. This was an entirely new experience: the studio was just down the road – he slipped out into the mews at the back every morning and was there in five minutes. 'The students,' he said, 'are frightfully interested and often watch me. I don't mind. They do all kinds of work – some realistic and others just fantastic, influenced by Picasso, Moore and surrealists as well. The head, Professor Darwin, I imagine thinks I might have a good influence on the young geniuses! Perhaps.' Probably he did. One thing is certain: the students loved him, as John Norris Wood, in the illustration department then, remembered: 'He was the only member of the staff who ate with us in the canteen. At least, we thought he was on the staff. He was extremely friendly and talked a great deal about art and the work on which he was engaged.'

Epstein replied to the General Secretary of the TUC on 11 December: 'I received your letter of the 9th November and to be frank I have found difficulty in answering it: rather, I am confronted with difficulties.' He was being asked to enter a competition with others, would be judged by the architect ('rightly'), members of the TUC and 'a doubtful art critic, influential as well as distinguished, with whom I have never seen eye to eye, and who has never seen eye to eye with me.' He may have been referring to Herbert Read who was an adviser. 'I have never entered a competition and never will, I might say at the outset. I would be willing to accept a commission and were I asked to do an important work such as you propose for your new building I would give it my earnest consideration, and with my experience of architectural work I am certain I could make a noble work ... I look upon myself as a worker and a long life of hard labour in my art is well known.' He would be glad to advise 'but what you should want from me is sculpture'; and he would be glad to talk to him but only with a 'view to giving me an outright commission such as I have always had'. He then went on to tell him about the *Christ* and the Liverpool decoration, that he had the casting of the Philadelphia group finished, and that if he liked to see these figures he could do so at the Morris Singer foundry before they were shipped to America. No wonder he said at this time that he had enough commissions to last him for five years and that he was 'inundated with prospects for new works and I don't see how I could do them in two lifetimes'.

He was in no mood for Christmas, and nor, of course, was Kathleen.

He worked right through it at his RCA studio (while nobody was there but 'a hidden caretaker') and then learnt, through a reporter from the *Daily Telegraph*, that America's National Arts Foundation Advisory Committee had voted him one of the four outstanding artists of 1954. The others were Pablo Casals, Carl Sandburg and Georges Rouault. The chairman, Dr Carleton Smith, said he was waiting to hear whether Epstein would be prepared to do busts of President Eisenhower and Adlai Stevenson, both of whom were advisers on the award. 'We also want him during his American visit to do busts for us of a number of American artists who belong to the Foundation,' Dr Smith said. They included Ernest Hemingway, Frank Lloyd Wright, Robert Frost, Thornton Wilder and William Faulkner. Arnold Toynbee and a young American actress, Juleen Compton, were other candidates for busts, and all these works, together with paintings, were destined for a museum at Bement which was celebrating its centenary in 1955. Asked for his views on these astonishing proposals, Epstein sounded doubtful: 'I cannot give them a definite answer yet as my movements are so uncertain.' All he could see was the promise of a serene holiday by the sea ebbing like the tide. 'I have so many things to do here and I have only one pair of hands. I have to go to America some time in 1955 to set up my monument for Fairmont Park Art Association in Philadelphia. I do not know exactly when that will be. I would be happy to do the busts then if it is possible. But I must know my movements more clearly before I can say definitely.' No, the first he had heard of being voted one of the four outstanding artists of 1954 was from the *Telegraph* reporter; and no, he was not interested in such awards.

He must have felt, with this piece of news, that he needed not two, but three lifetimes to do the commissions he was offered. Just at the moment, however, having finished his *Christ*, he wanted to get on and complete the 'big Lucifer'; this he managed early in January, only to learn that yet a further offer had come his way – to do a posthumous portrait of Bishop Woods of Lichfield. At first, he felt he couldn't do it – he had just passed on a commission to David McFall, he was so overloaded with work – but Kathleen persuaded him: to please her, he agreed; Kathleen loved the cathedral which she visited as a young girl when she and her father rode on horseback there to see Canon Boddington who lived in the Close – an old family friend. And when she and Epstein went to meet the Dean to choose a suitable site for the bust in the middle of January, he fell in love with the cathedral, too. 'I found

it very beautiful,' he said, 'and spent the afternoon with the Ecclesiastics right out of the Middle Ages.' Kathleen had her own vision of the occasion: 'Snow was falling and lay deep all around, and all the canons who came out to welcome him stood out in their long black cloaks like crows against the white snow.' Epstein was thankful she was there: 'Kathleen,' he said in a letter to Peggy-Jean of 17 January 1955, 'helped me get through the day as she is acquainted with the country and also with cathedral life and its peculiar ways.'

He had changed his mind about the finish of the *Christ* at Llandaff; the original idea – to gild it – he felt was wrong for his conception and had written to the Dean to suggest that 'silvering' would be more sympathetic. 'Silvering' was translated into aluminium casting – Pace wrote to the Dean a fortnight later to confirm he and Epstein were agreed that such a work shouldn't remain in plaster. The preservation of it was one thing, but Epstein was set on aluminium for another reason, and I had the luck to discover this when I met him with Kathleen by chance in his favourite coffee bar in South Kensington. He was having an ice-cream and amusing his granddaughters by making a tiny likeness of Frisky, sitting next to them, in plasticine when he suddenly suggested going to the RCA to see his *Christ*. This immediately became a matter of extreme urgency, and he rushed out to call a taxi which took us round the corner. The scene in the studio was dramatic – two huge clay figures side by side. He stood in that familiar position of his, propped against the wall by his elbow, looking up as though in amazement at his creation of the enormously tall, astonishing *Christ*, in silence, before saying, 'As an architect, what material do you think would be best to cast it in?' Nonplussed by the question, I mumbled something to the effect that he must know what was right. 'Bronze would be too heavy,' he said. 'No, it has to be aluminium. You see, only in aluminium would Christ be light enough to float up to heaven.' The touch of wit made the observation enchanting, yet here, nevertheless, was the true artist speaking – the visionary crossed with good, sound common sense. But it wasn't only that which interested me: here was the innovator. What other sculptor had cast a work in aluminium?

In February, the Philadelphia group went away to America. Rothenstein had wanted to exhibit it at the Tate before it left, but the request was refused, Epstein saying that, after spending two years on it, there should be no further delays. 'The cost and time entailed in moving

the group to the Tate would be too great,' he said. There was a ban on photographs as well, and only the sculpture students at the RCA had been allowed to see it at the bronze foundry. He would have liked to have accompanied it, but there was too much to do in London, and it had all to be set up in his absence. He had just embarked on three panels, each six feet square, for Liverpool; Lord Woolton had wanted ideas for the empty spaces above the entrance to his department store, and Epstein, without a thought for a fee, said of course he could do some reliefs, each with children from the many studies he had made recently – Annabel, Roland Joffé, now living at Hyde Park Gate, Isobel (Hughes) and others, not forgetting Frisky. He was on these at his RCA studio from then until the end of June, and they turned out to be among his most exceptional works – Annabel in her pram with Frisky looking on, children fighting and children playing. Each was a perfect composition. *Annabel and Frisky*, the simplest of the three, and verging on *trompe l'œil*, occupied the central position, the other two, highly complex but no less disciplined in arrangement, on either side. While the 'figurehead' above was cast in bronze, these were in cement fondu, another innovation. Then, in March, he heard from Tewson again that the TUC wanted him to submit proposals for a memorial for the dead of two world wars in their building's courtyard; the General Council had, apparently, ignored the implications of a letter from Herbert Read of January in which, having recommended Bernard Meadows as sculptor for the entrance, he had said: 'As for the courtyard group, if Epstein proves difficult, I think it would still be worthwhile approaching Henry Moore on a direct commission basis.' The wording is interesting, suggesting Epstein was an awkward customer: that he was 'difficult' was one of the rumours commonly put about to block commissions. When Ingersoll initially wrote to Marceau about the Fairmont Park job, for instance, he said he had heard Epstein had a reputation for being 'difficult'. In fact, Ingersoll and others who treated him with ordinary politeness soon discovered he wasn't in the least 'difficult', as proved on this occasion. He visited the site on 29 March and wrote to Tewson the following day to say he would make a maquette for approval. If it wasn't acceptable, he said, he would expect no remuneration; if it was, the fee offered, like that for the group by Meadows, was £5,000 for the entire work, which would be a carving.

In America, *Social Consciousness* had been set up at Fairmont Park, as Epstein wanted, on a height with a background of rocks. He had

asked Ingersoll for photographs (Professor Darwin, he explained, wished to publish them for the RCA) and wasn't in the least surprised that the reception of the work had, in some quarters, been mixed: for example, there had been objections from the 'Veterans of the War', a body which Epstein described as being similar to the British Legion. The 'Veterans', he reported to his daughter, had particularly objected to the seated figure being called 'The American Mother' – 'or something like that. The Sacred "American Mother" depicted by me! Can you imagine that? I would have shown the "American Mother" more like a Hollywood Film Star . . .' The English press was allowed his own interpretation: 'I would describe the central figure as that of Destiny. The figures to her right represent Charity. In the group to her left I have attempted to depict the idea of Death receiving mankind . . . mankind being received by a draped and cowled figure. I don't like describing it really. It describes itself, as all good sculpture should.' It was the perfect job – he had the opportunity and time to put a great deal of work into it, and he had been given a free hand; both were absolutely necessary to the making of art.

The moment a work was finished, he was anxious for it to be cast and sited; he was impatient to move on to the next, already a living being in his head, solid as a tablet in front of him. The Liverpool panels were an example: once the *Lucifer* was done, they were started, the relief of the pictures modelled and put down without hesitation, as if his vision of them was preordained: such was the speed and clarity of eye and mind. Nevertheless, the tasks undertaken, combined with the tragedies of the year before, had exhausted him. He had bronchitis, wanted that holiday he had promised himself, but had to get many things finished, the panels in particular. He had no interest in the various honours bestowed upon him – honorary memberships of the National Foundation of America, the American Academy of Arts and Letters, the Athenaeum (put up by Attlee, Eliot and others); official dinners were out of the question (of the RA's annual affair, he said, 'I am supposed to wait until I am three score and ten until I get invited by a body that has always done its best to ignore me') – he was much too tired in the evening to go anywhere but Ciccio's, the nearby restaurant in Kensington Church Street of which he had become extremely fond. As for Dr Carleton Smith and his massive offer of commissions, Sturgis Ingersoll had advised him to be wary – he was something of a 'mystery',

and Epstein replied, saying, 'I haven't the slightest desire to be used by him.' He passed this on to Peggy-Jean, writing to her in May (he wanted a complete rest when coming to America), the month he sold a cast of *The Visitation* (referred to as *The Annunciation* on this occasion) to Joseph Hirshhorn for Washington's Hirshhorn Museum at the Smithsonian Institution for £1,200; and the month, too, when he had the delight of meeting Maria Donska after one of her concerts devoted to Beethoven sonatas at the Recital Room at the Festival Hall. He was so enthralled by her playing that, at the end, he jumped the queue waiting to meet her (much to its excitement), simply in order to shake her hand. She was spellbound, she said, by what she regarded as this unique honour, and again overjoyed the next morning when Kathleen telephoned to say he wanted her to sit for him. 'It's too marvellous to be true,' she told Wynne Godley whom she had known for many years. He insisted it was true. 'I still can't believe it,' she said.

As he was going away, the sittings had to wait for some months. On 28 June 1955, the date of his sailing fixed for 8 July, he wrote to Peggy-Jean with some news:

> Yesterday Kathleen and I married. I had wanted this for a long time
> but Kathleen could not stand the publicity and so we had to resort to
> a ruse which completely dished all journalists and photographers and
> the event passed off quietly without the least fuss. Our odd position
> has for a long time been a source of embarrassment and now I hope
> things will be better that way . . .

He had been unable to persuade Kathleen to come with him – she was going to see her sister in Italy. While he was aware of the jobs building up – Bishop Woods, a bust of William Blake commissioned by the Blake Society, the TUC carving, the possibility of a *St Michael* for Coventry Cathedral (Basil Spence had called at his RCA studio after showing the Bishop of Coventry the Cavendish Square *Madonna*) – to greet him on his return, a mass of work was going to the foundry to be cast: the *Christ in Majesty*, the Liverpool figure (the plaster of the panels had to be finished by the moulders without his supervision), the four heads he was giving to the Convent to mask the door handles designed by Louis Osman, and the maquette for the General Council at the TUC. He was, as before, staying a few days with his brother, now living on Long Island (there were people he had to see in New York

about a bronze bust), before going to Philadelphia; then on to Southport, the delightful little fishing village where the Hornsteins had moved, for the complete rest . . .

Unfortunately, a journalist caught up with the news of the marriage in mid-Atlantic and the *Daily Mail*'s headline ran on 12 July: 'EPSTEIN WEDS HIS MODEL: SECRET OUT! I'M ASTONISHED!' His wife, it was reported, was on her way to Italy. She said with a laugh: 'The rumour's going round that we've already parted!'

On arrival, there were a barrage of interviews – '"ABSTRACTION, REALISM BOTH AWFUL" – EPSTEIN' was the *Herald Tribune* headline. Interviewed by Emily Genauer, he was reported saying that he deplored 'the welded-iron, acetylene-torch school of sculpture' dominating the scene in America and England. 'It isn't sculpture at all,' he said, picking out the work of David Smith in particular, 'because sculpture is an art of form, of human form.' What these people meant by the 'pure form' they kept talking about he didn't know: they were careerists, 'not creative artists'. The realists were just as bad – their work was 'banal', he said. 'Artists *must* deform what they do to emphasize its emotional essence', yet not in such a way as to lose contact with reality. The publicity which the unveiling of *Social Consciousness* attracted brought a commission to make a medal to commemorate the 250th anniversary of the birth of Benjamin Franklin, 'the first civilized American', as part of the celebrations organized by the Franklin Institute of Philadelphia, to be presented to Churchill and Mrs Roosevelt on 11 January 1956. Work caught up with him as well: when he was at Southport, he had a letter from Mr Parrott of the Morris Singer foundry to say the halo, head and shoulders of *Christ* were cast, that the heads of the door handles were done, looked very sharp and would be fitted to the original handles the following week. On the 24th, there was a cable from Tewson: 'Delighted to inform you General Council appreciate and accept your memorial suggestion.' After Epstein cabled to say he would be back in the middle of September, Tewson cabled again – the press wanted to see the maquette, and so did Congress. This brought the reply (25 August 1955): 'On no account give photo of maquette to press – also unwise to show photo to Congress at this stage. Press will report it and lead to confusion and disagreement.'

Epstein met Kathleen (back from Italy) in Paris and spent ten September days there, his first visit since before the war. When they

arrived in London, he got another shock – a letter from Peggy-Jean to say she and Hornstein had separated: he was stunned and mystified – all seemed well when he was out there, he wrote. However, he then heard, to his delight, that they were attempting a reconciliation, and he told her that he was now making up for the nice time he had in America. He was full of work: with the details of his TUC contract settled in mid-October and an advance of £1,500 on the way, he was busy making, direct in plaster, the model, for casting in bronze, of the prow of a liner (complete with anchors) as a pedestal for his Liverpool figure (he could turn his hand to anything). Then, while he was away, a letter had come from Basil Spence about the Coventry project, and this was followed by another from him (to correct any misapprehensions) to assure Epstein of the admiration he had for his sculpture and to say, 'I await your sketches with very great interest': the sculptor was, apart from Sutherland, the first artist to be offered a commission by Spence.

Still, that had to wait for the moment, as the bust of Bishop Woods had to as well – the clergy at Lichfield were collecting money to pay for it. When the prow was completed, he began the medal which, like the heads for the door handles, was a new adventure. This was a beauty, cast in silver, three-and-a-half inches in diameter, and catching the spirit perhaps of some fifteenth-century French coin: the perfect opportunity for Epstein's originality and invention; Franklin's profile on one side, on the other, a picture of this Renaissance man's imagination in the person of Prometheus, peering through the sun's rays, radiant, his hair ablaze like flames. This was the Epstein of *Rima*, or *Einstein*, or watercolours of flowers, or the drawing of Kitty. It looked, he thought, 'quite handsome' in the blue-lined box he had selected, and when it was presented to Churchill (he sent Peggy-Jean a cutting with a picture of the ceremony from the *Daily Telegraph* of 11 January), 'the old man was pretty shaky but made a gallant effort and was pleased I was present. The company were mostly elderly belonging to all sorts of learned societies and it was difficult to believe that the interest in B. Franklin was at all genuine ... there is to be a copy of the medal given to Mrs Roosevelt in Philadelphia and happily I won't be present. I will be more interested in getting my fee from the city of Philadelphia ...' After a big tea party arranged by the RCA students for him, and a speech by Kenneth Clark in his honour (during which he talked about Moore rather than Epstein), he had left his studio at the school and was on his way to starting the TUC job. But he had some portraits to do

first. He was working on Rosalyn Tureck at present, an American pianist, who, he said, 'plays wonderful Bach . . .'

The *Smuts* awaited a granite base coming from South Africa, but the *Christ* had been cast and was, he thought, most impressive in aluminium. He was looking forward to the big carving for the TUC – it might, he told friends, get his weight down. There had been a note in the *Evening Standard*'s Diary (4 February) which read:

> Ten tons for Epstein: a ten ton block of light buff-coloured Roman stone, brought from Italy, was delivered today on the £1m building site of the Trade Union Congress new headquarters in Bloomsbury. During the weekend, the block, which measured $10' \times 5' \times 4'$, will be placed against the Memorial Wall . . . Next week a wooden studio will be built around the block of stone to enable Sir Jacob Epstein to work unseen . . .

In March, it was ready and he had started on it. He told Peggy-Jean: 'I have let myself in for some devilish hard work as this particular block is as hard as granite and tools just break on it.'

Epstein had plenty to irritate him: working so quickly, constantly, and with such concentration and perseverance himself, he couldn't stand delays. His impatience showed over the two large works he had completed, *Smuts* and the Llandaff *Christ*: there seemed to be no sign of them being erected; what were the authorities doing? After all, he never wasted a free moment: even in the evenings, when he was relaxing, he was developing ideas in plasticine – figure compositions like *The Wave*, *The Muse*, *Young Bacchus*. It seemed easier to make a statue, a huge undertaking involving great thought, imagination and physical energy, than to do some mundane job like clear a site or get a pedestal properly finished and ready. On the other hand, if he didn't meet his deadline there were endless complaints; only recently, he had to throw up two commissions because he couldn't endure being badgered about finishing dates. Yet here he was with enough big commissions for years to come. How different from the old days when he had none.

An American Museum of Modern Art exhibition of New Wave painting and sculpture at the Tate had irritated him, too. He saw it as a flop: everything was abstract or surrealist, giving a bad impression of work over there. Of course, he said, there was 'the same kind of stuff here, perhaps worse. New geniuses of that kind appear every day . . . I seem

to be the only remaining realistic sculptor in the country, apart from the dead academicians, but I imagine even the Academy will be eventually filled with the wild men ...' Perhaps most infuriating of all that April was a comment made by Khrushchev about his *Lazarus*, when being taken on a heritage trail of Oxford during his famous trip to the country with Bulganin: 'A degenerate piece of rubbish!' That was overheard by a journalist and duly reported. *Lazarus* had, however, made a profound impression on him. When Sir William and Lady Hayter met him in the foyer of Claridge's the next morning, he said to his wife: 'Did you sleep well last night?' She said she had and asked him how his had been. 'I had nightmares about that terrible statue at Oxford,' he replied. In the meantime, Epstein had seen the report of his remark in the morning newspaper and immediately rushed to the telephone to send a telegram to New College. He was overheard saying to the operator: 'Tell your guest to keep off art criticism, which he does not understand, and stick to his own business, which is murder.' The operator, mystified, said: 'Mother?' 'No, murder' – he spelt the word – 'M–U–R–D–E–R.' Once more, an Epstein had reached deep into the human psyche, even Khrushchev's.

Despite what seemed to anyone but the sculptor a superhuman task, immense progress had been made on the TUC group by September: he had been at it daily for six months without a break, putting everything else aside, and on the 1st of that month asked for the second instalment of his fee. It was then, during a slight pause, that he did two busts, for his own pure enjoyment: the beautiful heads of Wynne Godley and Maria Donska. The pianist, whose twelve sittings were spread out over two months in breaks from working on the carving, experienced similar sensations to other sitters: like Emlyn Williams, for instance, she felt totally exposed by the artist's scrutiny as he became solely concerned, as it appeared to her, with her mind – it was as though, after a time, she had no secrets left hidden. He talked a great deal and was most preoccupied with the thoughts of Blake, a passion of Maria Donska's, too, and they discussed his art at length. Again, as with Anne Tree, he suspected he might have exaggerated a section of the face, in this case the length of the line of the jaw, but when he took his measuring tape to it, found his work to be exact. His representation of her large, inquiring eyes was specially remarkable, the concave eyeballs in the convex iris producing the mysterious, glistening effect of the 'pupils'; and he was so satisfied with the result, and so grateful to the young pianist for

being kind enough to make time for a pursuit from which he had derived so much pleasure, that he gave a champagne celebration and offered her a copy of the head for the price of the cast. For her part, she couldn't get over her luck and his generosity. Sitting for a great artist had been, she said, the experience of a lifetime; not only had he discussed so many things which, like music, were her profound loves too, but he was very friendly, even 'cosy', and had, after much of the form was in position, asked her what she thought. 'It looks just like my father,' she said. 'It should do,' he replied. After the portrait, she was always at the house playing.

On 7 November, the *Smuts* memorial was at last unveiled, followed two weeks later on the 20th by the unveiling of the *Adventure*, as the Liverpool figure and panels had come to be called. In the meantime, Epstein had, of course, returned to the TUC carving, and was, once again, up at the new building, day after day. I was teaching nearby and saw him often waiting for a taxi in his old cap, covered in dust, from several hours on the stone. 'They won't stop,' he said when I noticed them driving past, and hailed one for him. 'They think I'm a tramp.' The daily routine itself, quite apart from the work, was arduous: up to Great Russell Street by 9 a.m., home for lunch and a half-hour rest at 1 p.m., back to the site for the afternoon, leaving again around 5.30 in the evening. He was, after all, seventy-seven now, yet, as long as he was working, said he felt well; and, by the end of the year, the carving was finished; David du Aberdeen, the architect for the new building, a striking work of modern architecture in its time, confirmed this – as Epstein had promised, the massive task had taken exactly nine months. Its form, governed by the dense, hard stone, is monumental, even, in the best sense, somewhat abstract in its simplicity, and has a telling affinity with the huge volume of space in which it stands, rooted there in its pedestal which Epstein had clad in Roman stone. His eye for the entire conception, of which the pedestal was a part, was unfailing in its accuracy: few would have recognized the importance of the base. In consequence, the sculpture, a continuous column that breaks away towards the top into an image of a godlike figure carrying a dead body, is so solemn, striking and awesome – some have said 'terrifying' – that its presence transcends the multistorey sides around it. The continuity of shape recalls that of some of its predecessors, the extraordinary *Ecce Homo*, *Consummatum Est*, *Adam* and *Lazarus*. There is no doubt that this monument to the massacres

of two world wars is among his greatest works of the imagination.

With that accomplished, he turned to his *St Michael* for Coventry. Spence had had some difficulty in persuading his committee to commission Epstein – there was his 'reputation', he was 'controversial', a Jew – all the historic objections were bandied about. Spence knew differently, had met him, had had lunch with him (after which the Provost, there too, had commented, 'What a charming man, but what a bohemian household – fancy starting lunch with rice pudding', when referring to a very nice risotto prepared by Kathleen), and was aware of his humanity. By early 1956, he had managed to convince his committee Epstein was the artist for the job; the only condition imposed was that he should provide a maquette, a condition which Spence thought insulting to such a great artist. Hadn't Epstein said, when the architect first suggested the idea, 'All my life I have wanted to do Michael'? However, while waiting for the maquette to arrive, Spence saw, to his surprise, a report quoting Epstein as saying that the *St Michael* was going to be his greatest work. That news took him round to Hyde Park Gate to see what was afoot; he discovered that the maquette was done and that Epstein had moved on to the modelling of the figure, in his excitement forgetting all about mundane and, for him, petty matters like committee approvals. When Spence reminded him of such obligations, the reply was terse: 'Am I going too fast? Look, I'm not working for the committee any more, I am working for myself.' He was sick of committees after the Smuts affair: their presence was irrelevant to the making of art, and their interference only led to arguments and confusion, slowing progress. With the work ahead rising up like a mountain range – a mass of private commissions, the bust of Bishop Woods and two more public possibilities in the offing – there was not a moment to waste: now, and for the past few years, his 'life of hard labour' was a story trumpeting on at an accelerating rate, as though focused on some dramatic climax, like the final movement of a Beethoven symphony.

The *Christ in Majesty* was unveiled at Llandaff on 9 April to the predictable controversy – 'tremendous', and 'a monstrosity': if this horrified kind of comment had been directed at the horse-shoe structure, it would have been understandable; perhaps, in reality, it was and, through a misreading of the situation, the *Christ* got the blame. Then it transpired that Epstein had contributed £500 from his already modest £2,000 fee to pay for the aluminium casting. Possibly, extras had led to disagreements over who should be held responsible (on account of its

size, the work had been stored by Morris Singer for six months, awaiting delivery), and these were only resolved by Epstein's generosity in subsidizing the expense of a material which he knew was right for it. Yet, again, it seems astonishing that so much was laid out for a cumbersome and laborious device that was to support so little, and overwhelmed both the cathedral interior and the *Christ*. Of course, this arch, having nothing to do with the form of the medieval stone structure, should one day be demolished and the organ re-sited, perhaps above the entrance, a usual enough position for such equipment; then the sculpture could, say, be suspended between the columns separating the congregation and the choir. It is worth recalling, in this context, that the plaster was hanging in St Paul's for some time after Epstein's Memorial Service, and that it was so fitting and beautiful in these surroundings many hoped it might remain there; and worth recalling, too, that Sally Ryan had decided, against the wishes of Llandaff's Bishop, Dean and architect, to offer the plaster to New York's Riverside Church on the Upper West Side. It had been entrusted to her by Kathleen and, finished in gold leaf, high up among the shadowy vaults, it's breathtaking.

And so the beauty of the work is much diminished at Llandaff; the abstraction of the figure as a column crowned by the circle of a halo (as though drawn from the inspiration of an early Italian Renaissance painting), the simplicity and absolute purity of outline, the artist's vision of the ethereal Christ ascending to heaven are neutralized by the architect's hefty concrete cylinder. Yet, for Epstein, who had disliked the setting from the start, the affair was behind him. He was far too involved with other work to worry about it – there was *St Michael*, thirty-five foot high overall, to complete; the *Blake* to do; two portraits for Oxford, one commissioned by the University, the other, of John Lowe, by Christ Church; Dr Otto Klemperer for the London County Council; the wife of the Marquis of Bath (the twice married beauty, Virginia Parsons) – an impressive list. And besides these, he modelled a baby's head, the third bust of Kitty Godley, an exquisite work, and, of course, the portrait of Bishop Woods, for which, by the end of the year, sufficient had been collected to pay him some sort of fee. As a break from this heavy schedule, he and Kathleen took Roland Joffé and Frisky on a trip to Scotland. She had bought him a new coat which he refused to wear (he felt comfortable only in his working clothes), and, booked in at the Gleneagles Hotel by Cook's Tours, they set off. Unfortunately, Cook's

had informed the management of the importance of the visitor, and on arrival they were horrified to find the entire staff lined up to greet the great artist. Epstein hadn't, as he had hoped, escaped to the peace of the remote Scottish countryside, the splendours of the hotel being the last thing he wanted. 'This place,' he said, 'is full of lounge lizards', an expression which Roland, now ten, had never heard, and imagined that lizards, with whisking tails, were flitting about in the hotel. They decided to leave the hotel, but this wasn't the end of the trip: Kathleen found a bed and breakfast place that was perfect, and where two elderly women were fascinated by Epstein. From here, he hired a car to take them all into the woods where he could paint, and they went several days running. When Kathleen was concerned about the expense he replied, 'Don't be petty. I can sell all my paintings and pay for the overheads easily.' He had no possessive feelings about his work; he was delighted when everything sold, and was most despondent when it didn't. Having finished one task, he couldn't wait to get on with the next.

The last three months of the year were packed with activity. The *William Blake* was cast and on 1 November he wrote to Matthew Smith inviting him to the unveiling on the 24th:

Can you be there about 4 o'clock after evensong and support myself and Kathleen as there will be present to my knowledge sundry evil spirits, in the shape of I won't mention who, and it would be nice to know that friends are there. A poem by the Poet Laureate will be read which I hope will be short. The sculpture is of course by your friend, the old firm 'Jake'.

Kathleen added a PS: 'I see you have been asked to support me. I promise in return to support your dear frail self. We hope you'll come back for a drink afterwards.' That same month he was commissioned by Sir Harold Samuel, the owner of Bowater House, Knightsbridge, to make a sculpture below the building for the Edinburgh Gate to Hyde Park to present to the Crown; and there had been an approach from the Palace to do a portrait of Princess Margaret. He was not all that anxious to undertake it: 'I believe,' he explained to Peggy-Jean in a letter of 12 November, 'a Royal command is not paid for. So where would I be with my time taken up with Royalty and no compensation?' He had plenty to do with the Coventry work and *Bishop Woods* alone. The *St Michael* was far too tall for the studio (nineteen feet high) and had had to be

modelled and cast in the plaster in small sections, making it difficult to move about. Jan Smith, the plaster moulder, said, 'I've seen other sculptors working and by their standards he was quite unorthodox. But his methods came from fifty years of work and training, and he was always right. He would dissect whole faces or even noses, fit them here or pad them out there.' Neither of them saw the *St Michael* group fully, as a whole, with the sections fitted together, until it was in the foundry and put up. 'He had an amazing sense of scale,' Smith said. 'He would model hands and feet right away from the model, but when he put them on they were always right, looked exactly right.' The head of *St Michael*, a beautiful work for which he used his study of Wynne Godley, was cast in plaster and put high up; then he modelled the wings (they were cast and taken away), then the torso (which was propped up), finally the legs; then all plasters were dove-tailed with Roman joints, and the entire work sent off to the foundry to be cast in bronze. This operation of modelling and casting in plaster ran on well into 1958.

He had completed *Bishop Woods* at the turn of the year; the Bishop's son-in-law, the engraver Reynolds Stone, had seen it at the end of January and had reported back to his wife, Janet, that it was 'a splendid, remarkable work, and giving the exact quality and feeling' of her father 'in an amazing and most moving way.' Epstein had combined the head, cassock and hands raised in the position of prayer in an immensely imaginative composition of rhythmic lines. 'There must be a great unveiling,' Janet Stone wrote in her letter thanking Epstein for such a magnificent work, 'which no doubt will give the dear stuffy Close a good shaking up – I can't wait!' It was indeed a magnificent work, and remarkable, too, for having been created from a few snapshots. However, it must have very much disappointed Epstein that insufficient money had been collected to pay the £250 needed for the bronze, and the plaster cast was sent to Lichfield to await the funding of this; not a good omen, but he was now preoccupied with his latest commission, the Bowater group. In January, when he heard from the Palace that arrangements had been made for Princess Margaret to sit for him during the following month, he was already well ahead with his idea. He had made the maquette, and the composition was so complex – mother, father and child, encouraged by Pan and led by the family's prancing dog (Frisky), making a dash for the openness of the Park – that he set it out in a detailed working drawing in which the elevation of the figures established the high point from the base (8'5½") and the plan located

the exact positions of feet, paws and, in the case of Pan, hooves. The idea was so very like him: whereas the *Wilde* of the tomb was in flight, the *Lazarus* so mysterious and the TUC memorial so monumentally grave, here was a vision, as Epstein explained, of people escaping from the prison of offices and hard work to the freedom of nature. 'Getting out there for the lunch break' was how he described it on one occasion: as ever, it was a supremely original thought for a piece of city sculpture, a picture of innocent human pleasures – nothing pretentious, nothing heavy. But, as a work of art, the idea for it was about a good deal else as well. It was a study in movement, a side of the static medium of sculpture he longed to explore further; of figures at, you might say, a gallop, arms, legs and bodies intertwined in such a way that it captured something of the flickering effects of Futurism. Yet that isn't quite right, either – the group is like a memory of Epping Forest, a flashback to some special spot, known and loved in the past, perhaps to where branches stretched out for light and space across the dense woodland path that leads beside Deerhurst down to the stream at the bottom of the slope. Like his watercolours of the Forest, it was descriptive of a place, and, as such, is an expression of the Park, and of Epstein at his happiest, imagining a budding spring and sunny summer.

Those hopes were not altogether fulfilled. No one, according to Kathleen, ever saw the first bust of Princess Margaret; when Epstein completed it, she remarked (so Kathleen said), 'Hardly a portrait of the prettiest girl in England.' This upset him deeply; Kathleen thought it excellent – in it, she said, was a picture of the 'Georges'. Nevertheless, Epstein, whose health was suddenly deteriorating, immediately carried out another study of her which was more plainly flattering and acceptable. The first study was not allowed to remain at Hyde Park Gate, and was taken from the studio, but, before it went, Kathleen had a cast made. In the meantime, the Princess, placated, visited Llandaff to see the *Christ in Majesty* which she thought 'quite lovely'; and Epstein, for his part, said of her, 'She is an extremely interesting character. She is also an extremely intriguing young woman. I will go further: she is mysterious. Her eyes especially are remarkable. You might think the expression and colouring of a face have little to do with a sculptor, but Princess Margaret's light-blue eyes are a vital clue to her character.'

Three weeks later, he was feeling so exhausted and strange that Kathleen managed, with great difficulty, to get him to a doctor who called an ambulance; Epstein was rushed to hospital where a thrombosis

was diagnosed – so bad that the specialist was astonished he was still alive. On 24 March, he wrote to Sir Vincent Tewson: 'Laid up high and dry in hospital by doctors' orders and must perforce miss the great opening. The group carved by me commemorates the dead. I had looked forward to seeing this group in its noble setting . . .' He had practically killed himself with overwork.

Since he had absolutely no regard for personal safety, Kathleen visited him twice a day to make certain he didn't sign himself out of the hospital: once over an illness, he forgot all about it, as if it had never happened. However, on the 26th, between visits and the day before the unveiling, she went to Sotheby's where the seventy-six-year-old Sir Alfred Bossom was putting *Genesis* up for sale. There were some Epstein drawings which she bought, and then, with 'Lot 65 – I am bid £200,' from the auctioneer, there was a sudden commotion as a massive crowd packed the sale room: it was the *Genesis*, and the bidding shot up £100 a time, paused at £2,000, and then sped on until, according to the *Star* reporter, 'a nervous-looking little man made a gesture that meant £4,200'. It went for that, and a crowd of photographers surrounded the buyer as he tried to slip away, saying, 'This completes our collection of Epsteins'. He was, the *Star* reporter said, stopped by Lady Epstein near the door, and asked for his name. 'I am William Cartmell, of Louis Tussaud's waxworks at Blackpool,' he said.

Only nine months before, Cartmell, the shadowy manager behind Stafford, Crisp, West and Wright, all of whose names recurred in the Blackpool affair, had told the *Scotsman* of the success of the collection at Tussaud's: 'I had 17,000 people a day coming through here last autumn, but we're always prepared to sell anything after it's served its purpose. They're going to America if they go.' And to the *Daily Express* man at Sotheby's, he said: 'We are trying to educate the Blackpool holiday-makers to art.' But he wasn't 'the one to talk about the appeal of art'. 'I am purely commercially minded,' Mr Cartmell said.

Kathleen was of course sickened by this latest loss to Tussaud's. She told the reporter afterwards: 'I think it is dreadful that it should go there. I am sure my husband will be most upset. It should have gone into the Tate or some other museum, or to an American collector who wanted it very much.'

On 28 March, the reactions to the TUC unveiling were splashed across

all the newspapers. Terence Mullaly of the *Daily Telegraph* said: 'As a work of art, Epstein's group appears to be almost painfully moving. It is a tragic monument on a grand scale.' At a kerbside controversy, Union workers were delighted – 'brilliant', 'great dignity', 'moving' – and Labour MPs were stunned: 'Superb – powerful' (Hugh Gaitskell); 'Best thing he's ever done' (Aneurin Bevan); 'Deeply satisfying – a masterpiece' (Tom Driberg). The majority of the thirty-five strong TUC Council disliked it: 'It's a shocker, a monstrosity'; 'Sooner it joins *Genesis* in Blackpool the better'; and from Sir Will Lawther, ex-miners' leader: 'I'd rather see Manchester United win the Cup –'

Perhaps, for once, secretly, Epstein was grateful for an enforced rest from all that.

He left hospital on 9 April 1958, about the time *St Michael and the Devil* went off to the foundry. That was the end of the rest: from then on he crammed in as much as he could, including three trips abroad in twelve months to see the art and architecture he had never had the chance to see before. Because, however, he worried about each minute aspect of his work – 'You know,' he told Jan Smith once, 'that every fraction of an eyelid matters to me' – and because of his somewhat suspicious nature, he was probably already worrying about the casting of this huge group for Coventry: he had a theory that foundries got up to all kinds of tricks, claiming they melted down anything going to build up the metal – 'brass doorknobs', for instance. 'The only country where you can get pure bronze castings is France,' he said, and had even considered, after the war, setting up connections with a French foundry, but was unable to organize it. Then there were a number of commissions piling up ahead of him about which arrangements would have to be made – for the new Church of the Ascension at Crownhill, Plymouth (where he had spent horrible months in the First World War), he had been invited to make an *Ascension of Christ* and compositions for twelve hexagonal windows in stained glass; and there were the portraits of Sir Russell Brain, President of the Royal College of Physicians, and Sir William Haley, editor of *The Times*, he had undertaken to do – all these had to wait until after the holiday. And so, on 27 April, Epstein, Kathleen and Beth Lipkin set off from Victoria en route for Venice. They stayed about ten days – Epstein saw Verrocchio's equestrian statue of Colleoni four times, spending hours studying it, enchanted, on each occasion, and then went down the Brenta by boat to

Padua; on the way home, they stopped in Paris for a Modigliani exhibition, and were back in London to Epstein's busy life by 15 May. There, he started his bust of Sir Russell Brain almost immediately, and, while in the middle of this, visited Oxford with Kathleen on Whit Sunday, 25 May, to see Alic Smith at New College, where he was curious to note that *Lazarus* was grubby. Miss Paine-Cox, the Warden's cousin, wrote in a memoir of the afternoon, 'I saw Epstein rubbing the statue. He showed me that with very fine sandpaper he was cleaning the knees and some folds of the bandages where interested visitors touch them. He then gave me several small pieces of what he called "sacred sandpaper" and suggested that I should continue the work the next day. He assured me, "You can do no harm" . . .' She enjoyed herself, but one may wonder why he had sandpaper with him: Epstein never stopped working.

He finished Russell Brain's bust at the end of the following week and went on to Sir William Haley's. At the same time, of course, he was developing the Bowater group — figures were standing round on the studio floor, and, as he was modelling, Jan Smith and his wife were making plaster casts: 'Epstein always opened the front door — he couldn't wait for me to get there,' Smith said. He was as engrossed in his tasks as ever; certainly too engrossed to go up to Lichfield on 26 June for the unveiling of *Bishop Woods*, particularly since the site for it, agreed with the Dean, hadn't been used, and it was placed high up on a stone shelf where it could barely be seen; but he was at New College on 16 July for the Memorial Service to Alic Smith who died suddenly. And, with Kathleen, he was in Plymouth at the beginning of September to visit Crownhill Church to see the sites for his prospective works there. Then, on the 6th, they set off on their travels to the continent again, this time driven by their friends, John and Valerie Cowie.

It sounded an extraordinary and exhausting tour: starting with Amiens, they went on to Arles and Aix, and then to Italy, at the rate of a place a day — Porto Fino, Parma, Milano and Como; it was hardly surprising that, at Parma, where they saw the Antelami reliefs and the Church of S. Antonio, Epstein had a blackout. He recovered, studied the carvings, and the tour went on — to an exhibition of Holbein at Basle, Grünewald's altar at Colmar, the cathedrals of Laon and Rheims ('Not *another* cathedral,' the Cowies said, exhausted); and to Canterbury on 21 September. Then, after getting back to work on the Bowater group, he had a letter from the Vicar of Selby Abbey at the beginning of October about *Ecce Homo* — he and his people would, he wrote, like

to have the statue, and sent Epstein a photograph showing a possible site. He took this up immediately, he and Kathleen going to York on 14 October, and on to Selby the following day. The Abbey was 'magnificent', he said, and felt that his statue would suit 'the austere architecture'. He had recently had many offers for this work from Canada (one for £7,000) but was suspicious of them. 'He would not risk the scandal – that is his own word – of what he calls mishandling by showmen,' reported A. P. Maguire of the *Yorkshire Post*. He was thinking, naturally, of the Blackpool nightmare, and the *Genesis* that had just gone up there to become another 'sideshow spectacle'. 'I would like to see my major religious works in permanent places and not the subject of trafficking among dealers. I wanted to see this work in a fitting setting and Selby Abbey is a beautiful building. That is the reason I have donated it to the Abbey now,' he said. With this new delightful prospect in view where it would be safe from exploitation, Epstein returned home and to his latest commission, Lepele Phipps, the eldest daughter of Lord Normanby. It was finished at the end of November.

The work was still pouring in. The War Office commissioned a statue of Lloyd George for the House of Commons; Crawley New Town's District Society had approached him about a group; a bust of Dr Fisher, Archbishop of Canterbury, was wanted for Lambeth Palace; the Royal Institute of British Architects arranged for a portrait of Basil Spence; Lord Normanby had two other daughters for Epstein to do; Bristol University commissioned a head of the blind professor of Imperial History, Charles Mcinnes; and Ivan Sanderson, the wallpaper magnate, wanted a bust of himself for his company. With the exception of one, all these works, together with the Bowater group, were completed the following year. Although recently so very ill, Epstein's vitality and energy showed no sign of diminishing. Kathleen, in a BBC interview, said that he worked very quickly towards the end of his life. 'He had made so many portraits that technical difficulties didn't seem to exist for him, but he always worked with exactly the same ardour and enthusiasm . . . His excitement when a model was coming to the studio was as if it was his first portrait.'

Epstein's maquette and watercolours for stained glass for the Church of the Ascension were revealed on 16 December. Two of the twelve works for glass (another new venture for the artist) illustrated then – one of James, Son of Thunder, the other of Peter – were bubbling over with

the immediacy of Biblical imagination, just as though Epstein really was a throwback to those ancient times. The church, built and consecrated, awaited the windows which, made in France, would be in position by August 1959. Then, after the ritual of the Christmas party (chiefly for children, but always much enjoyed by Epstein and Kathleen) was over, he modelled a remarkable head of the blind Professor Mcinnes whose vision in all but sight was brilliantly communicated. This was finished by the middle of January, after which Epstein went straight on to the Archbishop, completing that by the beginning of February. However, he had abandoned the project for Crawley; they had irritated him by insisting he kept to a deadline: 'I am not the kind of artist who can work to a time limit,' he was reported as saying. 'They do not seem to understand an artist at all.' He had so much else he wanted to do that he couldn't be bothered with such petty stipulations; in particular, the Bowater group was now progressing so well that he and Kathleen were able to take another trip to the continent in April – first going to Paris with his brother Irving. They spent a week there, mainly in the Louvre. When Irving went off to New York, they continued their journey to Venice which he had very much wanted to visit again, and went over to Torcello to see the mosaics in the little church there. On his way home, they called in at Paris to buy two carvings for his collection from Charles Ratton, one of which was an African 'Parrot Head'. When he did get back, he found that his *Ecce Homo* had stirred up another controversy; an *Observer* report on 19 April said: 'A petition which describes Sir Jacob Epstein's sculpture *Ecce Homo* as "hideous in the extreme" has been sent from Selby to the Diocesan Registrar at York.' The brutal document followed a citation from the registrar inviting parishioners who objected to the placing of the statue to do so in writing, and 414 of them had done just that: the aim was to keep the great *Christ* out of the Abbey. And according to a report in the *Daily Telegraph* the next day, the controversy was deepening – a barrister was to be called in to 'either give an immediate ruling or convene a consistory court to hear evidence'. A decision over a work of art's quality had fallen into the cold bland hands of inscrutable officialdom. This news, cruel and totally unexpected, was devastating.

But there it was: the statue was criticized in the petition as 'too modernistic for the ancient and wonderful beauty of the abbey'. Right at the end of the artist's life, all the tedious old objections that constantly arose from the narrow insularity of English philistinism, and had dogged

his work from the earliest days, were back. And on 23 July, *The Times* reported that the barrister Mr W. S. Wigglesworth, Chancellor of the Diocese of York, 'in London yesterday refused an application by the vicar and churchwardens of Selby Abbey to install Sir Jacob Epstein's 11 ft high marble statue *Ecce Homo* in Selby Abbey.'

Epstein, however, was not one to give up.

Having continued to meet his undertakings during the summer months (after a sketch of Lloyd George, he had started the statue of him, and had completed his other commitments, including his bust of Spence whom he portrayed, interestingly, in terms of some great stage actor), he offered *Ecce Homo*, again as a gift, to C. B. Mortlock. He was an old friend, Canon of Chichester and rector of Wren's City Church, St Vedast, Foster Lane, where Epstein's mysterious and little known carving of Mortlock's profile stands in the churchyard. On 4 August of that summer, one of the hottest and longest of the century, Epstein inspected a site on a piece of land in Cannon Street owned by the church and a few minutes walk east of St Paul's. He was delighted with it and said he placed great store by his work being permanently situated in such a noble setting. Canon Mortlock and the artist shook hands on this agreement in the presence of Kathleen – an incident, Mortlock wrote, that 'was dramatic enough to arouse the curious interest of passers-by'. Mortlock then described the visit he made to Epstein's studio later on, saying, 'It being impossible for me to remove the statue, I laid my hands on it as a gesture of possession.'

On, or around, 14 August, Epstein had dinner with Arnold Haskell at Ciccio's; he was, Haskell said, in good form, doubtless very happy at the outcome of his gift to Mortlock. Then, on the 17th, Epstein and Kathleen visited Matthew Smith: he was so ill – he died a month later – that they lent him a tiny Renoir landscape, a real little gem, to have beside his bed. Nevertheless, both artists were in high spirits at seeing each other, and talked for several hours about painting and sculpture.

In the evening of 19 August, Epstein, Kathleen, Beth Lipkin and Frisky went to Ciccio's. After supper, which he very much enjoyed, he insisted on walking back across Kensington Gardens. He was singing some Schubert songs. Then they sat in the porch 'to watch,' he said, 'the stars come out' – it was still hot, like an evening in Italy. In the middle of

singing, he fell asleep, and when he woke, said, 'I don't know when I've slept so deeply.' He went into the house and Kathleen, wondering after a time where he was, looked into the studio and discovered him under the Bowater group, flat on his back, at work on one of the figures' toes. 'It's finished,' he said, clambering out from among the tangle of legs. 'Now I'm off.'

Kathleen followed him upstairs and listened to him singing as he lay on the bed. Then he said: 'Kitty – *I'm going –*'

15

Aftermath

EPSTEIN was buried quietly at the Vale Cemetery in Putney on 24 August amid media coverage as great as any the artist had experienced in his lifetime. On 10 November, which would have been his seventy-ninth birthday, Canon Mortlock gave the address at the Memorial Service to him held in St Paul's; it was a sunny day, the noonday light filtering through to touch the plaster of the *Christ in Majesty* hanging in the north transept.

In January 1960, the St Paul's Chapter confirmed its agreement to the siting of *Ecce Homo*, shown that summer at Battersea Park's Open Air exhibition.

Among the many commemorative exhibitions that followed his death, those most notable in 1960 were the dramatic *Epstein Collection of Tribal and Exotic Art* at the Arts Council in St James's Square in March, and the Leicester Galleries' giant retrospective which opened on 10 June. On 24 June, *St Michael and the Devil* was unveiled at Coventry Cathedral by Kathleen Epstein.

Epstein's *Bowater group* was erected at the Duke of Edinburgh Gate to Hyde Park in April 1961.

The remarkable Epstein retrospective at the Edinburgh Festival followed in August 1961. Since Tussauds refused to lend their four works, Lord Harewood, the Artistic Director of the Festival at the time, and Mr Jack

Lyons bought them on 6 February 1961, for a reported £30,000, Mr Richard Buckle, the exhibition's designer, arranging the transaction. They were now at last safe from commercial exploitation, and the retrospective was a tremendous success, tens of thousands attending. Lord Harewood kept *Adam*, and it stands in the entrance hall at Harewood House where it looks absolutely at home and at its most beautiful with the perfect geometry, decoration, ceilings and colour of the stupendous Robert Adam surroundings, and with the collection which includes paintings by Titian, Bellini and Giovanni.

The others were sold, *Genesis* and *Jacob and the Angel* to Lord Bernstein in 1962, and *Consummatum Est* to the American collector, Edward P. Schinman, in 1964. *Jacob and the Angel* is on exhibition at the Tate Gallery, Liverpool; *Genesis* is at the Whitworth Gallery, Manchester; and *Consummatum Est* returned to the United Kingdom in 1981 when it was bought for the Edinburgh Museum of Modern Art.

On 3 November 1961, the retrospective opened at the Tate, and on the 10th a memorial concert was given there at which Maria Donska, Raymond Leppard and Christopher Bunting played Beethoven, Brahms, Schubert and Bach with Ilse Wolf, soprano. The exhibition closed on 17 December.

In August 1961, Kathleen gave 200 plaster casts to the Jerusalem Museum of Art. She felt sure her husband would have wanted this, an action which again safeguarded his work from commercial exploitation. A special pavilion for their display was built in 1963.

In 1963, London was denied the great addition to the City of *Ecce Homo* by the intervention of Henry Moore, then a commissioner on the Royal Fine Art Commission. An RFAC minute of the 13 March meeting stated that the statue 'would be out of keeping and out of scale with the surroundings of St Paul's'. It is difficult to follow the reasoning of this extraordinary aesthetic judgement, made the more incomprehensible by the distance of the proposed site from the Cathedral, and communicated to the City Architect in a letter of 21 March which recommended 'that the site proposed by Canon Mortlock and his architect should not be accepted'.

Kathleen completed the exhausting job of dispersing the vast Epstein Collection to various museums, galleries and dealers in Europe and the

United States in 1963, at a time when she was pursuing the idea of preserving her husband's studio at 18 Hyde Park Gate as a museum. This was enthusiastically supported by a number of influential people and a detailed design for the conversion of the house into apartments proved it to be a practical proposition. No developer, however, emerged both generous and imaginative enough to carry through her important proposal. After the house was sold, the studio was eventually demolished and replaced by a pair of bijou 'cottages'.

Because of its uncertain future, *Ecce Homo* remained in Battersea Park, stored in a keeper's garden, until a suitable site could be found for it. This proved so difficult that the statue, nicknamed 'The Foreman' by locals, was still there in 1965, surrounded by creepers, flowers and plant pots. A suggestion to put it in the Barbican came to nothing, and when, in 1967, Canon Mortlock realized he was dying, he became so obsessed about what would happen to it after he had gone (he died on 31 October) that he entrusted it to his friend, Noel Mander, the foremost organ builder in the country and church warden at St Vedast. Mander tried St Margaret's Westminster, and the City of London again, but without success. Then suddenly, in the middle of one night, he thought of Coventry, and, convinced *Ecce Homo* should be sited in the old cathedral's ruins, suggested the idea to Kathleen. She was delighted by it, and in 1969 all was settled: it was removed from Battersea Park and, despite further objections from Moore, was taken to Coventry and dedicated on 22 March. Kathleen, who was at the dedication, presented Mander with a cast of Epstein's maquette of the *Ascension of Christ* for Crownhill Church, Plymouth, as an expression of her gratitude.

Sally Ryan, in the meantime, had presented the plaster of *Christ in Majesty*, finished in gold leaf, to New York's Riverside Church in 1966, despite objections from the Dean of Llandaff. Around this time, too, she and Kathleen began to compile an art collection; selected by Kathleen, this was financed by Sally who, being very ill, wanted to do something worthwhile with part of her wealth before she died.

In 1969, a newspaper reported that Kathleen was multiplying casts of her husband's portraits. She was deeply upset by this accusation and denied doing any such thing, explaining that Epstein set out the numbers of castings to be made of his various heads, and that these

instructions were exactly followed. If indeed castings were being made without her knowledge, there were others who had the means to do this. For one obvious example, a plaster can be made from a bronze, and a cast made from that plaster. Kathleen sold Hyde Park Gate and moved to Elm Park Road, Chelsea, in 1965; it was then that the 300 or so plaster casts which had not gone to Israel were broken up by her before she left.

In 1972, Kathleen offered the Garman Ryan Collection to Walsall; she had hoped her old family home of Oakswell Hall could be used as a gallery, but it was too derelict (it was demolished later), and in 1974 the Collection was opened to the public in the old library, renamed the Walsall Museum and Art Gallery. Besides a nucleus of Epsteins, among which are *Madonna and Child* (Sunita and Enver), *Meum*, *Baby Awake*, the first *Kathleen*, the first *Esther* and *Roland Joffé*, there is a Constable, a Renoir, a Modigliani, a Bonnard, a Van Gogh, three Corots, four Freuds, two Matthew Smiths, several items from the Epstein Collection including the Nefertiti, a number of Theodore Garmans and many other works by notable painters. It is a unique personal collection, and Kathleen's gift of it to her homeland, after Sally Ryan died, for all to enjoy was an act of generosity typical of her.

A carved relief, Epstein's last work to be set up in London, was also a gift from Kathleen, this time to the borough of Chelsea in 1972. The site she chose for this was in the garden below Chelsea Old Church where his studio had been when he modelled the maquettes for the BMA frieze and carved the Wilde tomb. The setting for the sculpture was specially designed for her.

Epstein exhibitions travelled the world during the Sixties and Seventies. Many felt, however, that his centenary exhibition at the Tate Gallery in 1980, shown in a corridor with only thirteen pieces on display, was a singular insult to a great artist. A fitting tribute to his genius had to wait until the magnificent retrospectives at Leeds Art Gallery and at London's Whitechapel Art Gallery in 1987.

Kathleen died twenty years after her husband, at the same age, and within two days of the date of his death, on 17 August 1979. She was buried at Harting.

Notes

Foreword
2. *The modern sculptor* ... *Epstein: An Autobiography*, preface by Richard Buckle, Vista Books, 1963, p. 192.
2. *Jacob and the Angel* ... British Art of the Twentieth Century; Royal Academy, 15 January–5 April 1987.
3. *Goldsmith's College* ... Betty Swanwick, interview.

1: Lower East Side

5. *At least a million* ... *The Spirit of the Ghetto*, Hutchins Hapgood, Funk & Wagnalls Company Inc., 1902/1965 (preface Harry Golden), p. vii.
5. *The New York Ghetto* ... Epstein, op. cit., p. 3.
5. *Max* ... *The Epsteins: A Family Album*, Jane F. Babson, Taylor Hall Publishing, 1984, p. 1.
6. *Harry Golden* ... Hapgood, op. cit., p. x.
6. *Fortresses and prisons* ... Ibid., p. xiii.
7. *Irish* ... Ibid., p. ix.
7. *Mary Solomon* ... Babson, op. cit., p. 2.
7. *Ruled the roost* ... Ibid., p. 1.
8. *Sick one* ... Epstein, op. cit., p. 1.
8. *I cannot remember* ... Ibid., p. 2.
8. *Hester Street* ... Ibid., p. 1.
9. *I imagine that* ... Ibid., p. 9.
9. *Whitman wrote* ... Ibid., p. 4.
10. *Playing truant* ... *The Sculptor Speaks*, Arnold Haskell, Heinemann, 1931, p. 13.

10. *Blizzard of 1888* . . . Babson, op. cit., p. 4.
10. *University* . . . Ibid.
10. *Father thought ugly* . . . Ibid.
10. *Young Chinamen* . . . Epstein, op. cit., p. 5.
11. *Jewish quarter* . . . Ibid., p. 4.
11. *Central Park* . . . Ibid., p. 5.
11. *Frederick Law Olmstead* . . . *The Art of the Olmstead Landscape*, Stephen Rettig, New York City Landmarks Preservation Commission, 1981, p. 79.
12. *Railroad* . . . USA Embassy Library, London.
12. *Brooklyn Bridge* . . . Epstein, op. cit., p. 4.
12. *Henry Street Settlement* . . . Hapgood, op. cit., p. 45.
12. *Cooper Union Drawing Prize* . . . Babson, op. cit., p. 5.
12. *Arts Students League* . . . Arts Students League of New York archives.
14. *Yiddish* . . . Epstein, op. cit., p. 3.
14. *Stuyvesant Fish* . . . Babson, op. cit., p. 5.
14. *Arts League* . . . Arts Students League archives.
15. *A dollar or two* . . . Epstein, op. cit., p. 8.
15. The Ring . . . Ibid., p. 9.
15. *Paul Durand-Ruel* . . . Ibid., p. 5.
15. *Pissarro* . . . *Pissarro*, Ralph E. Strikes & Paula Harper, Quartet Books, 1980, p. 189.
16. *'I observed'* . . . Epstein, op. cit., p. 9.
16. *League* . . . Arts Students League archives.
16. *Bernard Gussow* . . . Epstein, op. cit., p. 8.
17. *Charred drawings* . . . Ibid., p. 3.
17. *Century Company* . . . Ibid., p. 8.
18. *Greenwood Lake* . . . Ibid., p. 9.
18. *Change of direction* . . . Haskell, op. cit., p. 13.
19. *Arts League* . . . Arts Students League archives.
19. *26 Delancy Street* . . . Ibid.
19. *George Grey Barnard* . . . Epstein, op. cit., p. 10.
19. *Hebrew Institution* . . . Hapgood, op. cit., p. 249.
19. *Neighbourhood* . . . Ibid., pp. 247–9.
20. *1661 Madison Avenue* . . . Babson, op. cit., p. 6.
20. *Pestiferous* . . . Hapgood, op. cit., p. 247.
21. Lunch in the shop . . . Garman Ryan Collection, Walsall.
21. $400 . . . Contract for the illustrations, 3.3.1902, Harper & Row archives, New York: see also *A Victorian in the Modern World*, Hapgood, 1939, p. 142.
22. *Self-portrait in red chalk* . . . Garman Ryan Collection, Walsall.
22. *William Macbeth gallery* . . . Library of Congress, Washington DC, dated 1899–1900.

22. *May 1902* ... Arts Student League archives.
23. *Adele Rabinowitz* ... Babson, op. cit., p. 6.
23. *Unthinking heedlessness* ... Epstein, op. cit., p. 11.

2: Montparnasse

24. *Ordway* ... Epstein to Edward W. Ordway (from Paris) 12.4.1903, New York Public Library Dept of Rare Books & Manuscripts.
24. *Immured geniuses* ... Epstein, op. cit., pp. 14–15.
25. *Hurl himself* ... Ibid., p. 12.
25. *Trocadero* ... Ibid.
25. *Zola* ... Ibid; also *The Times*, 5.10.1902.
26. *Julian Academy* ... Epstein to Ordway, 12.4.1903.
26. *Russian students' restaurant* ... Epstein, op. cit., p. 13.
26. *Beaux Arts* ... Epstein to Ordway, 12.4.1903.
26. *Rodin* ... Epstein to Ordway, 12.4.1903.
27. *Independence Committee* ... 1903–14: New York Public Library.
28. *African sculpture* ... Haskell, op. cit., p. 88.
28. *Fifty dollars* ... Epstein to Ordway, 16.4.1903.
28. *Laurens* ... Epstein, op. cit., p. 15.
29. *Bougereau* ... Ibid., p. 15; Haskell, op. cit., p. 14.
29. *Rousseau* ... Epstein, op. cit., p. 16.
29. *Paris is all green* ... Epstein to Ordway, May 1903.
29. *Health and strength* ... Epstein, op. cit., p. 17.
30. *Isadora Duncan* ... Ibid., p. 16.
30. *Celia Jerome* ... *Jacob Epstein*; Richard Buckle, Faber & Faber, 1963, p. 16.
30. *Been to London* ... Epstein to Ordway (from London), 18.8.1903.
30. *Margaret Dunlop* ... Epstein, op. cit., p. 18.
30. *Baring Brothers* ... No trace in bank's archives.
30. *Gods were unwilling* ... Epstein to Ordway (from Paris), 4.9.1903.
31. *Fauve* ... *Modern French Painters*; R. H. Wilenski, Faber & Faber, MCMXL, pp. 140, 168.
31. Salon d'Automne ... Ibid.
31. *Competitions* ... Epstein to Ordway, 19.10.1903.
32. *Atelier* ... Ibid.
32. *Horrors* ... Ibid.
32. *Studio* ... Ibid.
33. *Next letter* ... Ibid., 17.1.1904.
33. *Models* ... Ibid.
33. *Barnard* ... Ibid.
34. *Marble* ... Ibid., undated.

34. *Hands transparent* . . . Ibid.
34. *Mr Stein* . . . Possibly Leo, Gertrude's brother.
34. *Money Order* . . . Epstein to Ordway, undated.
34. *Martinique* . . . Ibid.
35. *Business sculptors* . . . Ibid.
35. Salon . . . Epstein to Ordway, 4.2.1904.
35. *Two excellent models* . . . Ibid. (Kathleen Epstein believed the girl to be Celia Jerome with whom the male model fell in love; see Buckle, op. cit., p. 18.)
35. *May go to London* . . . Epstein to Ordway, 4.2.1904.
36. *Back to New York* . . . Ibid.
36. *Cheaper in England* . . . Ibid.
36. *Generous* . . . Babson, op. cit., p. 8.
36. *Never signed a cheque* . . . *Balletomane At Large: An Autobiography*, Arnold Haskell, Heinemann, 1972, p. 59.
36. *Gussow* . . . Epstein to Ordway, 4.2.1904.
37. *Impasse* . . . Epstein, op. cit., p. 17.
37. *Demeter of Cnidus* Ibid., p. 184.
37. *Begun his group* . . . Epstein to Ordway, March 1904.
37. *Over life-size* . . . Ibid.
38. *Postponements* . . . Ibid.
38. *Fifty dollars* . . . Ibid.
38. *Arrival of the money* . . . Ibid, undated, possibly April 1904.
38. *Cézanne* . . . Wilenski, op. cit., p.212.
39. *Florence* . . . Epstein to Ordway, 16.11.1904.
39. *Michelangelo* . . . Buckle, op. cit., p. 17.
39. *'Calamus'* . . . Epstein to Ordway, 16.11.1904.
39. *Autobiography* . . . Epstein, op. cit., p. 17.
40. *Ethnological works* . . . Ibid., p. 190.
40. *Analytical* . . . *Mr Epstein and the Critics: Further Speculations*; T. E. Hulme, University of Minnesota Press, 1955, p. 104.

3: Chelsea

41. *217 Stanhope Street* . . . Epstein to Ordway, 4.2.1905.
42. *'Calamus'* . . . Ibid.
42. *Royal Academy* . . . Ibid.
42. *Degas* . . . *Since I was Twenty-five*; Frank Rutter, London, 1927, pp. 154, 157.
42. *Durand-Ruel* . . . Ibid., p. 153.
42. *Impressionism* . . . *Autobiography*; Augustus John, Jonathan Cape, 1975, p. 59.

42. *New Sculpture* . . . *New Sculpture*; Susan Beattie, Yale University Press, 1983, p. 3.

43. *Sketches* . . . Epstein to Ordway, 4.2.1905.

43. *A studio which suited him* . . . Ibid.

44. *Queen's Hall* . . . Ibid.

44. *Slade* . . . John, op. cit., pp. 50–51.

44. *Carfax gallery* . . . *Friend of Friends*; Edited by Margery Ross, Jonathan Cape, 1952, pp. 9, 10, 11. John, op. cit., p. 59.

44. *Rothenstein* . . . *Men and Memories*; William Rothenstein, 1872–1938; abridged and edited by Mary Lago, Chatto & Windus, 1978, p. 123.

45. *John's studio floor* . . . Epstein to Ordway, 4.2.1905.

45. *Shaw* . . . Ross (ed.), op. cit., pp. 111–112.

46. *Exhibition at the Carfax* . . . John, op. cit., p. 59.

46. *Nina Hamnett* . . . *The Laughing Torso*; Nina Hamnett, Constable, 1932, p. 27.

47. *Introduction* . . . Rothenstein/Lago (ed.), op. cit., pp. 146–7; see also *William Rothenstein*; Robert Speight, Eyre & Spottiswoode, 1962, p. 187; and *Shaw: Collected Letters 1898–1910*; edited by Dan H. Laurence, p. 521.

47. *Economic* . . . Haskell, op. cit., p. 10.

48. *Paris or Berlin* . . . Rothenstein, op. cit., vol. II, p. 87.

48. *New York on a visit* . . . Epstein, op. cit., p. 19.

48. *His father* . . . Babson, op. cit., p. 9.

48. *His mother* . . . Ibid.

48. *Gaudier-Brzeska* . . . Plaque.

48. *Railway accident* . . . Epstein, op. cit., p. 19.

48. *Snobbishness* . . . Ibid.

49. *Antiquities* . . . Ibid., pp. 19–20.

49. *Ordway* . . . Epstein to Ordway, 24.1.1906.

49. *Poverty* . . . Lady Epstein, conversation; see also James Bone, *Manchester Guardian* 25 May 1935.

49. *Facts of life* . . . Peggy-Jean Lewis (née Epstein), interview.

50. *Hard time* . . . *Years of Innocence*; Michael Holroyd, Heinemann, 1974, p. 222 n.

50. *Engagement* . . . Ibid., p. 222.

51. *Café Royal* . . . John, op. cit., p. 89.

51. *Daniel Nicol* . . . Café Royal archives.

51. *Smoky acres* . . . *Left Hand Right Hand*; Osbert Sitwell, Macmillan, 1948, p. 29.

52. *Exhibited* . . . Epstein did exhibit an oil painting at the New English Art Club in 1906; one other recorded oil, of Meum Lindsell-Stewart, has disappeared.

52. *Rodinesque* . . . Rothenstein, op. cit., p. 146.

53. *Charles Holden ... C. R. Ashbee*; Alan Crawford, Yale University Press, 1985, p. 217.
54. *Danvers Street* ... Ibid., pp. 244–5.
54. *Philistines* ... Quoted by Crawford, p. 217.
54. *Pibworth* ... *Charles Holden*, Eitan Karol & Finch Allibone; Royal Institute of British Architects catalogue, Heinz Gallery, March 1988, p. 12.
54. *White stitching* ... Holden's speech at the opening of the Epstein 1954 exhibition, RIBA archives.
56. *Dodd* ... Holden, op. cit., notes. RIBA archives. Haskell, op. cit., p. 16.
56. *Fulham* ... Holden, op. cit., notes.
56. *Whitman* ... Ibid.
56. *Eighteen figures* ... Ibid.
57. *Epstein's Excitement* ... Ibid.
57. *Side-whiskers* ... Epstein, op. cit., p. 22.
57. *Wildness* ... Epstein, op. cit., p. 21.
57. *Simple movements* ... Ibid., p. 22.
57. *Symbolism* ... Ibid.
57. Primal Energy ... Haskell, op. cit., pp. 17–18.
58. *Mr Rollins* ... Crawford, op. cit., p. 241.
58. *Paradise for Epstein* ... Epstein, op. cit., p. 21; according to Gaudier-Brzeska, the studio was a workshop and nothing else: see *Savage Messiah*; H. S. Ede, Heinemann, 1931, p. 206.
59. *Erection* ... Crawford, op. cit., p. 448, n. 89.
59. *Expenses* ... Epstein, op. cit., p. 21.
59. *Cheyne Walk* ... Holroyd, op. cit., p. 220.
59. *Primal fact* ... Epstein at the BMA, 4.7.1908.
60. *Father Bernard Vaughan* ... Holden, op. cit., notes.
60. *Bold Sculpture* ... *Evening Standard* and *St James's Gazette*, 19.6.1908.
61. *National Vigilance Society* ... Quoted from W. A. Coote, Epstein, op. cit., p. 238.
61. Standard's *campaign* ... *Evening Standard*, 20.6.1908.
62. *Cockneyism* ... Epstein, op. cit., p. 22.
62. *Harold Chaloner Dowdalls* ... Holroyd, op. cit., p. 116 n.
63. *Travesty in paint* ... Ibid., p. 307.
63. *Robert Ross* ... Ross (ed.), op. cit., p. 224.
63. *Dorelia* ... Holroyd, op. cit., p. 221.
63. *Symons* ... Ibid.
64. *Denouncement* ... *Evening Standard*, 23.6.1908; quoted by Frank Harris in *Vanity Fair*, 1.7.1908.

64. *Leader . . . Evening Standard*, 23.6.1908.
64. The Times . . . Leader, 25.6.1908.
65. Maternity . . . *Evening Standard*, 23.6.1908.
65. *Sculpture-conscious* . . . Epstein, op. cit., p. 23.
65. *Tribunal* . . . Ibid.
65. *Funny side* . . . Holden, op. cit., notes.
66. *Indecent* . . . At a meeting of the BMA presided over by Edmund Owen, it was decided to let the work proceed and to invite Holroyd and three or four others, knowledgeable in matters of art, to report to the Committee. BMA archives.
66. *Art critic* . . . *Saturday Review*, 27.6.1908.
66. *Hubbub* . . . Epstein, op. cit., p. 29.
66. *Publicity-seeker* . . . Holden, op. cit., notes.
68 *Tradition* . . . *Men and Memories*, William Rothenstein, vol. II, Faber & Faber, 1932, p. 88.
68. *My dear friend* . . . Ibid., p. 89.
68 *Mr Fels* . . . Buckle, op. cit., p. 38.
68. *Leader*, British Medical Journal . . . BMA archives.

4: Père Lachaise

69. *Dinner* . . . Ross, op. cit., pp. 152–3.
69. *Somerset Maugham* . . . Maugham to Ross, 2.12.1908; Ross, op. cit., p. 157.
69. *Bagneux* . . . *Comoedia*, Georges Bazile, 9.10.1912; Epstein, op. cit., p. 252.
70. *Mrs James Carew* . . . *Loopy*, George Kennard's autobiography, Leo Cooper, 1990, p. 5.
70. *Condition of the gift* . . . Ross, op. cit., p. 157.
70. *Practical joke* . . . Epstein, op. cit., p. 51.
71. *Too timid* . . . Ibid.
71. *Male lover* . . . *Oscar Wilde*, Richard Ellman, Hamish Hamilton, 1987, p. 259.
71. *Greek youth* . . . Haskell, op. cit., pp. 19–20.
72. *Over-life-size* . . . Epstein, op. cit., p. 21.
73. *Analogy of Epstein's* . . . Haskell, op. cit., p. 67.
73. *Formative phase* . . . Epstein, op. cit., pp. 19, 42.
73. *Quarter-inches* . . . Ibid., p. 42.
74. *Fountain-figure* . . . Commissioned by Lady Ottoline Morrell in 1908: Henry Ransome Humanities Research Center, University of Texas at Austin (HRC). Epstein to Morrell 22.10.1908: see Buckle, op. cit., pp. 50–7.

74. *Lady Gregory* . . . Epstein, op. cit., p. 42.

74. *Swinburne* . . . Rothenstein vol. I, p. 236: in view of Epstein's feelings of revulsion about death (see his comments on the morgue in Paris p. 12, and on the dead arm handed round at the Beaux Arts, p. 14) it was perhaps good that the commission was cancelled by Swinburne's minder, Watts-Dunton. Alfred Drury was invited to make the mask instead, and which, unaccountably, he lost.

74. *British Museum* . . . Epstein, op. cit., pp. 19–20.

74. *Euphemia Lamb* . . . *The Weeping and the Laughter*, Viva King, Macdonald and Jane's, 1976, pp. 77–8.

75. *Methods of carving* . . . *Direct Carving*; Jack C. Rich, Oxford University Press, p. 261.

75. *Michelangelo maintained* . . . Sonnet XV, 'Rime', quoted in J. A. Symonds *Life of Michelangelo*, 2nd ed. London, 1893, vol. I, p. 110.

75. *Gill said* . . . Rich, op. cit., p. 268.

76. *Adjuncts* . . . Epstein, op. cit., p. 22.

77. *But a modeller* . . . Haskell, op. cit., p. 61.

77. *Piece of direct carving* . . . Bernard Shaw claimed credit for starting Epstein off as a carver. According to his somewhat supercilious letter to the sculptor of 13 November 1941, Shaw told him when the two first met in 1905: 'Apprentice yourself to a stone mason, and learn how to cut stone with a chisel. Then, if you find you can chisel something more interesting than a flag-stone, by all means do it.' The reaction of the sculptor, who had been learning the craft in his student days in Paris, is unknown.

78. *Rothenstein had convinced* . . . Rothenstein, op. cit., vol. II, p. 195.

79. *Letters and diaries* . . . Gill: Tate Gallery archives.

80. *Stonehenge* . . . Rothenstein, op. cit., vol. II, p. 201.

81. *Importance of copulation* . . . John to Quinn 10.2.1911; Quinn Memorial Collection, New York Public Library.

81. *£8* . . . Gill Diaries.

81. *Naughty schoolmaster* . . . John to Quinn, 10.2.1911.

82. *Before which phenomenon* . . . *Postscript to Adventure*, Ashley Gibson, J. M. Dent & Sons, 1930, p. 103.

82. *Garrulous Gill* . . . Rothenstein, op. cit., vol. II, pp. 213–14. *Letters of Eric Gill* ed. Walter Shewring, Cape, 1947, p. 35.

82. *Regarded Van Gogh* . . . Haskell, op. cit., p. 71.

82. *Naturalized British* . . . Epstein to Quinn, 3.12.1913, Quinn Memorial Collection, New York Public Library.

83. *Critics regarded portraiture* . . . Haskell, op. cit., p. 64; Epstein, op. cit., p. 71.

83. *Poor Aunt Augusta* . . . Epstein, op. cit., p. 43.
83. *Hyde Park Gate studio* . . . *Emlyn*, Emlyn Williams, Bodley Head, 1973, p. 239.
84. *Necessary to accentuate* . . . Haskell, op. cit., p. 67.
86. *A very living thing* . . . Ibid., p. 62.
86. *Mark Gertler* . . . *Mark Gertler Selected Letters*, ed. Noel Carrington, Hart-Davis, 1965. Gertler to Carrington, July 1912, p. 43.
87. *Carfax* . . . Ross severed his connection with the gallery in October 1908; Ross, op. cit., p. 11.
87. *Building of a library* . . . *The Man from New York*, B. L. Reid, Oxford University Press, 1968, p. 111; by 1911 he had amassed 'six or seven thousand volumes'.
88. *James Stephens* . . . Ibid., p. 318.
88. *John drawing* . . . Ibid., p. 53.
88. *Perfect harmony* . . . Ibid., p. 54.
88. *Yeats warned* . . . Yeats to Quinn, 12.1.1909; Reid, op. cit., p. 71.
89. *With a portrait* . . . Reid, op. cit., p. 77.
89. *Annual retainer* . . . Ibid, p. 78.
89. *Relations became strained* . . . Holden, op. cit., notes.
90. *Emotional brainstorm* . . . Haskell, op. cit., p. 65.
91. *Dear Sphinx* . . . *Letters of Oscar Wilde*, Hart-Davis, 1962, p. 342: 'The author of *The Sphinx* will on Wednesday at two eat pomegranates with the Sphinx of Modern Life': his dedication of her copy of *The Ballad of Reading Gaol* (1899) ran: 'To the Sphinx of Pleasure from the Singer of Pain'.
91. *Assyrian* . . . Epstein, op. cit., p. 66
91. *Poet as messenger* . . . Haskell, op. cit., p. 20.
92. *Winged figure* . . . Ibid.
94. *Michelangelo's work* . . . Ibid., p. 86.
94. *Annual visit* . . . Reid, op. cit., pp. 99–100; pp. 104–105.
95. *Stone bust* . . . Epstein to Quinn, 31.10.1911.
95. *Half-way stage* . . . Ibid., 25.11.1911.
95. *Ignoramuses* . . . Ibid.
95. *Nature* . . . Ibid.
96. *T. E. Hulme* . . . See Epstein's foreword to Hulme's *Speculations*, Routledge & Kegan Paul, 1924, pp. vii–viii.
96. *Abstract thought* . . . Hulme, op. cit., p. viii.
96. *Neo-Papuan* . . . Ross, op. cit., p. 224.
96. *Symbolic one* . . . Epstein, op. cit., p. 51.
96. *Public interest* . . . Epstein to Quinn, 18.2.1912.
97. *Battle of the critics* . . . Ibid.
97. *Ashley Gibson* . . . Gibson, op. cit., p. 21.

97. *News in New York* . . . Epstein to Quinn, 18.2.1912.
98. *Creative strength* . . . Ibid.
98. *Exhausted him* . . . Ibid., 22.3.1912.
98. *Mme Frida Strindberg* . . . Gibson, op. cit., pp. 103–5; Epstein, op. cit., p. 113.
98. *Golden Calf* . . . Epstein, op. cit., p. 113.
99. *Futurists* . . . Ibid., pp. 58–9; Haskell, op. cit., pp. 15–16.
100. *The New Sculpture* . . . Epstein, op. cit., p. 59.
101. *Dignified Sculpture* . . . *Evening Standard* and *St James's Gazette*, 3.6.1912.
102. *Epstein's commentary* . . . *Pall Mall Gazette*, 6.6.1912.
102. *My works* . . . Epstein, op. cit., p. 253.
102. *Odd distortions* . . . *Evening Standard* and *St James's Gazette*, 3.6.1912.
103. *Wilbur Wright* . . . Epstein to Quinn, 6.6.1912.
103. *G. M. Solomon* . . . Ross, op. cit., p. 11.
103. *Due by contract* . . . Epstein to Quinn, 28.11.1912.
104. *Dreadful indignities* . . . Hamnett, op. cit., p. 45.
104. *Wrote in desperation* . . . Epstein to Quinn, 16.9.1912.
105. *Henri Pierre Roché* . . . Epstein to Henri Pierre Roché, 19.9.1912, HRC.
105. *Gaudier-Brzeska* . . . *Burning to Speak: The Life and Art of Gaudier-Brzeska*, Phaidon, 1978, p. 25: Gaudier to Sophie Brzeska, 25.11.1912.
105. *To the Luxembourg* . . . Bazile, op. cit., 9.10.1912.
105. *Petition drawn* . . . Ibid., 21.3.1913.
106. *South African* . . . Epstein to Bazile, October 1912.
106. *Expedition to South Africa* . . . Epstein to Quinn, 28.11.1912.
106. *World Magazine* . . . 27.10.1912, Library of Congress, Washington DC.
106. *His sister Susie* . . . Babson, op. cit., p. 25.
107. *Extracting his fees* . . . Epstein to Quinn, 28.11.1912.
107. *Fig-leaf* . . . Epstein, op. cit., p. 54.
108. *Debts and Penniless* . . . Epstein to Quinn, 28.11.1912.
108. *Euphemia Lamb* . . . Ibid.

5. Quinn

110. *T. E. Hulme* . . . Epstein 'was unquestionably Hulme's man (or perhaps I should say Hulme was Epstein's man) upon the social plane. They were great friends . . .' *Blasting & Bombardiering*, Wyndham Lewis, Eyre & Spottiswoode, 1937, p. 107.
110. *Tuesday evenings* . . . Epstein, op. cit., pp. 59–61.
110. *Foremost in the small* . . . *Gaudier-Brzeska*, Ezra Pound, The Marvell Press, 1916, p. 31.

110. *We the moderns* . . . Ibid., p. 23.

110. *Cher Maître* . . . Epstein, op. cit., p. 45.

111. *Rue Compagne Première* . . . Epstein to Quinn, 11.1.1913.

111. *Renaissance style* . . . Crawford, op. cit., p. 252.

111. *Armory Show* . . . Epstein to Quinn, 11.1.1913.

112. *Like Bazile* . . . Comoedia, 23.4.1913.

112. *Favourite Diagnosis* . . . Epstein to Quinn, 3.2.1913.

113. *Personal enmities* . . . Ibid., 11.1.1913.

113. *Woman named Rosalie* . . . Hamnett, op. cit., p. 47.

114. *Rue de Seine and the cafés* . . . Epstein, op. cit., p. 46.

114. *Euphemia Lamb* . . . Epstein to Quinn, 3.2.1913.

114. *Modigliani* . . . Epstein, op. cit., p. 46; *Modigliani*, Franco Russoli, Preface by Jean Cocteau, Thames & Hudson, 1959, p. 10.

114. *Fake artists* . . . Epstein to Quinn, 3.2.1913.

115. *Mixed up with narcotics* . . . Peggy-Jean Lewis, interview.

115. *Late drinking* . . . Epstein to Quinn, 3.2.1913.

115. *Negro art* . . . Haskell, op. cit., p. 91.

116. *2,000 francs* . . . Epstein to Quinn, 3.2.1913.

116. *Beauty of the lines* . . . Ibid.

116. *Making enemies* . . . Ibid., 17.3.1913.

117. *Matter of judgement* . . . Ibid.

117. *Jack London* . . . Ibid.

118. *Telepathic dream* . . . Epstein, op. cit., p. 11.

118. *Three pieces of stone* . . . Epstein to Quinn (undated).

118. *Mrs Lamb* . . . Quinn to Epstein, 30.3.1913.

119. *Christened Flenite* . . . Epstein to Quinn, 10.5.1913.

120. *Stand in for the mortgage* . . . Ibid. (undated).

120. *Bournville* . . . Life of George Cadbury, A. G. Gardiner, Cassell & Co., 1923, p. 136.

120. *Solid security* . . . Epstein to Quinn (undated).

120. *Short shrift* . . . Quinn to Epstein, 13.6.1913.

120. *Puvis de Chavannes* . . . Reid, op. cit., pp. 160–1; raising the money, p. 197.

121. *Whitechapel Gallery* . . . Epstein to Quinn, 22.5.1913; *Vorticism and Abstract Art in the First Machine Age*, vol. I, Richard Cork, London, 1976, p. 82.

122. *Bought by the dealers* . . . Epstein to Quinn, 21.10.1913.

122. *Wilde monument* . . . The Times, 6.11.1913.

122. *Aleister Crowley* . . . Epstein to The Times, 8.11.1913.

123. *Brown remembered* . . . The Memoirs of Oliver Brown, Oliver Brown, Evelyn, Adams & Mackay, 1968, pp. 54–5.

123. *Mrs Smith* . . . Quinn to Epstein, 15.1.1914.

123. *Romilly John head* . . . Epstein to Quinn (undated).

124. *Getting legislation* . . . Reid, op. cit., pp. 157–9.

124. *25 per cent* . . . Quinn to Epstein, 10.2.1914.

124. *Original piece* . . . Epstein to Quinn, 11.2.1914.

125. Doves . . . Ibid.

125. *ss* Olympic . . . Ibid., 17.2.1914.

125. *The Hunekers* . . . Quinn to Epstein, 26.2.1914.

126. *With a cable* . . . Epstein to Quinn, 23.3.1914.

126. *African sculpture* . . . Quinn to Epstein, 17.3.1914.

126. *Collector soon* . . . Epstein to Quinn, 29.3.1914.

126. *Outrageous* . . . Quinn to Epstein, 12.4.1914.

127. *Without blushing* . . . Epstein to Quinn, 1.5.1914.

127. *Easter Island carvings* . . . *New Age*, Hulme, 25.12.1913.

128. Rock-Drill . . . Epstein to Quinn, 1.5.1914.

128. *Frankenstein's monster* . . . Epstein, op. cit., p. 56: Epstein was of course referring to Mary Shelley's terrifying creation of 1818, of which *Rock-Drill* was the natural descendant.

129. New Age . . . *Further Speculations*, Hulme, p. 107.

130. *Western art must* . . . Haskell, op. cit., p. 94.

130. Israfel . . . Ibid., pp. 94–6.

131. *Caught unawares* . . . *The War Lords*, A. G. Gardiner, J. M. Dent & Sons, 1915, p. 63.

132. *Mark Gertler* . . . Gertler to Carrington, July 1914, pp. 71–3.

133. *These birds* . . . Quinn to Epstein, 13.5.1914.

133. *London by car* . . . Epstein to Quinn (undated).

133. *Want a replica* . . . Quinn to Epstein, 8.6.1914.

134. *Ten-ton block* . . . Epstein to Quinn, 8.7.1914.

135. *Version of the* Doves . . . Quinn to Epstein, 27.7.1914.

135. *In advance* . . . Ibid.

136. *A thought to Art* . . . Epstein to Quinn, 12.8.1914.

136. *German sounding name* . . . Ibid., 4.9.1914.

138. *Moratoriums in England* . . . Quinn to Epstein, 8.2.1915.

138. *Anything but normal* . . . Epstein to Quinn, 28.3.1915.

138. *Lillian Shelley* . . . Reid, op. cit., pp. 104–5.

139. *Germinal universe* . . . Exhibition at the Goupil Gallery, Pound, *The Egoist*, 16.3.1914

139. *£100* . . . Epstein to Quinn, 2.4.1915.

139. *Unutterably loathsome* . . . *Observer*, 14.3.1915.

139. *Definite Force* . . . *Manchester Guardian*, 15.3.1915.

139. *Stuck together* . . . Quinn to Epstein, 15.4.1915 (cable).

139. *The Flenite* . . . Ibid. (letter).

140. *Futile over-emphasis* . . . Epstein to Quinn, 28.4.1915.

141. *Terrible* . . . Epstein, op. cit., p. 46.
142. *Address* . . . Epstein to Quinn, June 1915.
142. *Galleries* . . . Brown, op. cit., pp. 54–5.
143. *Transport* . . . Epstein to Quinn, October 1915.
143. *Dissatisfied* . . . Ibid., 10.1.1916 (cable).
143. . . . Ibid., (letter).
143. *Wing tip* . . . Quinn to Epstein, 25.1.1916.
143. *Underlined* . . . Epstein to Quinn, 25.1.1916.
144. *Authorities* . . . Epstein, op. cit., p. 49.
144. *Indomitable* . . . Brown, op. cit., p. 55.
144. *Sculptors* . . . Epstein to Quinn, 29.12.1915.
145. *Hulme* . . . Ibid., 21.2.1916.
145. *Unavoidable* . . . Epstein to Quinn, 10.1.1916.
145. *Smith* . . . Alice Keene, interview.
145. *Lilies* . . . Ibid.
145. *Monograph* . . . Ibid., 21.2.1916.
146. *Somersaults* . . . Ibid., 17.3.1916.
146. *Reviews* . . . Ibid.
146. *Problem* . . . Ibid., 30.3.1916.
147. *Crook* . . . Quinn to Epstein, 8.9.1916.
147. *Pound* . . . Epstein to Quinn, 11.6.1916.
147. *Sophie* . . . Epstein, op. cit., p. 45.
147. *Englishwoman* . . . Quinn to Epstein, 27.4.1916.
147. *Tarnishing* . . . Epstein to Quinn, 11.6.1916.
148 *Fisher* . . . Epstein, op. cit., p. 87, see also *Weekly Dispatch*, 24.12.1916, 'How I sculptured Lord Fisher' by Jacob Epstein.
148. *Nelson* . . . Ibid., p. 87.
149. *Call-up* . . . Epstein to Quinn, 11.6.1916.
149. *Iris Tree* . . . Ibid., 18.8.1916.
149. *Paris* . . . Ibid., 21.9.1916.
149. *Guilford Street* . . . Ibid., 10.11.1916.
150. *Censor* . . . Ibid.
150. *Exemption* . . . Epstein to Quinn, 10.11.1916.
150. *Titan* . . . Brown, op. cit., p. 55.
150. *War artist* . . . Ibid., 19.1.1916.
150. *Birnbaum* . . . Ibid., 10.11.1916.

6: Birth

152. *Miss M* . . . Gibson, op. cit., pp. 150–1.
152. *Typist* . . . Buckle, op. cit., p. 87.

152. *Actress* . . . *Light on a Dark Horse*, Roy Campbell, Hollis & Carter, 1969, p. 250.
152. *Lucas* . . . Dorothy Lindsell-Stewart's niece, Maria Oliver, unpublished notes.
153. *Réjanesque* . . . *Ego 7*, James Agate, George Harrap & Co., 1945, p. 242 (see also *Ego 3*, p. 38, and *Ego 4*, p. 40).
153. *Flair* . . . Maria Oliver, notes.
157. *Right people* . . . *Orpen*, Bruce Arnold, Jonathan Cape, 1981, p. 303, pp. 308–9 (see also *Nuda Veritas*, Clare Sheridan Thornton, Butterworth, 1927, p. 124).
157. *Wangle* . . . *Autobiography*, Eric Gill, Jonathan Cape, 1940, p. 204.
158. *Appeal* . . . Mrs Epstein to Quinn, 10.7.1916.
158. *Newbolt* . . . Ibid.
158. *Marsh* . . . Ibid.
158. *Scott* . . . Ibid.
158. *American connection* . . . Mrs Epstein to Quinn, 25.6.1916.
158. *Tribunal* . . . Quinn to War Office and Exemption Tribunal, 26.6.1916.
159. *Law* . . . Quinn to Director of Recruiting and to Clerk to Exemption Tribunal, 26.6.1916.
159. *Details* . . . Mrs Epstein to Quinn, 10.7.1916.
160. *Newbolt* . . . Mrs Epstein to Quinn, 18.10.1916.
160. *Inexplicably* . . . Epstein to Quinn, 10.11.1916.
160. *Hurt* . . . Ibid., 17.12.1916.
160. *Secret* . . . Mrs Epstein to Quinn, 18.10.1916.
161. *Tithe* . . . Epstein to Quinn, 19.1.1917.
161. *Swansong* . . . Ibid.
161. *Damn* . . . Ibid., 11.2.1917.
161. *Example* . . . W. A. Bristow to Leicester Galleries, 4.5.1917; see Brown, op. cit., p. 193.
162. *Master* . . . *The Times*, 18.2.1917.
163. New Age . . . Van Dieren, 8.3.1917.
163. *Most interesting* . . . Epstein to Quinn, 4.3.1917.
164. *Castings* . . . Quinn to Epstein, 14.3.1917.
165. *Great Push* . . . Epstein to Quinn, 4.3.1917.
165. *Numbers* . . . Ibid., 5.4.1917.
165. *Congratulating* . . . Quinn to Epstein, 28.3.1917.
165. *Acceptance* . . . Epstein to Quinn, 20.4.1917.
165. *Resources* . . . Quinn to Epstein, 28.3.1917
165. *Dismissed* . . . Third Appeal, 6.5.1917.
165. *Rage* . . . Mrs Epstein to Quinn, 20.5.1917.
166. *Practical joker* . . . *Musical Chairs*, Cecil Gray, Hogarth Press, 1985, p. 212.

166. *Cole* . . . Ibid., p. 212.

166. *Several fronts* . . . Ibid., p. 206.

167. *Let him off* . . . John to Quinn, 18.8.1916.

167. *Quoted* . . . Quinn to Epstein, 8.9.1916.

167. *Burne-Jones* . . . *Evening Standard*, 7.6.1917.

168. *Lieutenant* . . . Ibid., 11.6.1917.

168. *So-called* . . . *Sunday Herald*, 10.6.1917.

168. *Chesterton* . . . Ibid.

169. *Winan's* . . . *Evening Standard*, 12.6.1917.

169. *Cowards* . . . Mrs Epstein to Quinn, 10.7.1917.

169. *Correction* . . . Epstein to the *Daily Telegraph*, 12.6.1971.

170. *Commons* . . . Question, 15.6.1917.

170. *Cable* . . . Mrs Epstein to Quinn, 16.6.1917.

170. *Postcard* . . . Epstein to van Dieren, 2.6.1917, HRC.

170. *Wire* . . . Ibid. (undated).

171. *Impossible* . . . Mrs Epstein to Quinn, 20.7.1917.

171. *Enemies* . . . Epstein to Quinn, 20.7.1917.

172. *England* . . . Ibid.

172. *Consulate* . . . Epstein to Quinn, 21.8.1917.

173. *Seconded* . . . Mrs Epstein to Quinn, 21.8.1917.

173. *Criminal waste* . . . Quinn to Mrs Epstein, 6.8.1917.

173. *Vileness* . . . Epstein to Quinn, 21.8.1917.

173. *Derby* . . . Quinn to War Office, 9.8.1917.

174. Vanity Fair . . . Quinn on Epstein Editor, Frank Crowninshield, October, 1917.

174. *Ross* . . . Ross, op. cit., p. 11.

174. *Hulme* . . . Mrs Epstein to Quinn, 21.8.1917.

174. *Marlborough* . . . Ibid.

175. *Trenches* . . . Quinn to Epstein, 12.9.1917.

175. *Astonished* . . . Epstein to Quinn, 1.10.1917.

175. *Disgusted* . . . Quinn to Mitchell Kennerley, 5.10.1917.

175. *Initiative* . . . Mrs Epstein to Quinn, 10.7.1916.

175. *Gratitude* . . . Holden, op. cit., notes.

176. *Soul* . . . Epstein to Quinn, 1.10.1917.

176. *Meum* . . . Epstein to Mrs Epstein: Peggy-Jean Lewis, interview (who read the letter in the Thirties).

177. *Portrayal* . . . Cecil Phillips to Sir Alfred Mond, 9.10.1917.

177. *Conway* . . . Sir Martin Conway to Sir William Robertson, 9.10.1917, IWM.

178. *Behalf* . . . Epstein to Bernard Shaw, 5.12.1917, IWM.

178. *Epstein* . . . Conway to Macready, 17.12.1917, IWM.

178. *Location* . . . Major-General Donald to Conway, 27.12.1917, IWM.

179. *Transfer* . . . Field Marshal Sir Douglas Haig to War Office, 31.12.1917, IWM.
179. *France* . . . Conway to Donald, 3.1.1918, IWM.
179. *Unit* . . . Donald to Charles ffoulkes, 8.1.1918, IWM.
179. *Files* . . . Removal of letter noted by ffoulkes, 17.4.1919, IWM.
179. *Cancellation* . . . Haig to War Office, 21.1.1918; War Office to IWM 2.2.1918, IWM.
179. *Count* . . . ffoulkes to Donald, 23.1.1918, IWM.
179. *Relieved* . . . Donald to ffoulkes, 25.1.1918, IWM.
180. *Jealousy* . . . Maria Donska, interview.
181. *Reginald* . . . Haskell, op. cit., p. 55.
181. *Tregantle* . . . Epstein to van Dieren (undated), HRC.
182. *Ill* . . . Quinn's secretary to Mrs Epstein, 28.3.1918.
182. *Beaverbrook* . . . Epstein to Quinn 2.3.1918: Epstein had good cause for optimism – Wyndham Lewis was transferred from the army to the War Artists immediately after his meeting with Beaverbrook. Lewis, op. cit., p. 189.
183. *Venus* . . . Ibid.
184. *Mesopotamia* . . . Mrs Epstein to IWM, 3.3.1918.
185. *Compliments* . . . Shaw to Conway, 6.3.1918.
185. *Intelligent* . . . Lindsell-Stewart to Conway, 25.3.1918.
186. *Interest* . . . Mrs Epstein to Donald (undated), IWM.
186. *Interfere* . . . Donald to Mrs Epstein, 3.4.1918.
186. *Winston* . . . Lady Randolph Churchill to Lord Beaverbrook, 4.4.1918, IWM.
186. *Postponed* . . . Mrs Epstein to Beaverbrook, 8.4.1918, IWM.
187. *Instalments* . . . Epstein to Quinn, 20.4.1918.
187. *Moore* . . . *The Life of Henry Moore*, Roger Berthoud, Faber & Faber, 1987, p. 16: Moore said, 'On the whole I enjoyed the army.' After two months at the Front, he was sent home with symptoms of mustard-gas poisoning.
187. *Guard* . . . Epstein to van Dieren (undated), HRC.
188. *Ten drawings* . . . Epstein to Quinn, 30.7.1918.
188. *Yockney* . . . Samuel to Yockney, 27.7.1918, IWM.
188. *Bronzes* . . . Epstein to Quinn, 26.7.1918.
190. *Prejudice* . . . Epstein to Quinn, 2.8.1918.
190. *Agreements* . . . Quinn to Epstein, 9.8.1918.
190. *Apologizing* . . . Epstein to Conway, 21.8.1918, IWM.
190. *Commission* . . . Yockney to Conway, 18.9.1918, IWM.
190. *Proposal* . . . Yockney to Epstein, 21.9.1918, IWM.
190. *Confirmed* . . . Epstein to Yockney, 22.9.1918, IWM.
191. *Monuments* . . . Epstein to Quinn, 28.10.1918.

191. *Paris* . . . Peggy-Jean's birth in Paris was referred to in a letter Epstein wrote to a Mr Samuels in August 1940, Tate Gallery archives.

7: Van Dieren

192. *Armistice* . . . Gray, op. cit., p. 207.
193. *Orpen* . . . Arnold, op. cit., pp. 308, 310.
193. *Beginning* . . . Gray, op. cit., p. 207.
193. *Profound* . . . Epstein, op. cit., p. 97.
193. *Confidence* . . . Ibid., p. 96.
194. *Mask* . . . Ibid.
194. *Thoughtfulness* . . . Ibid., p. 97.
195. *Husbands* . . . Gray, op. cit., p. 225.
195. *Methods* . . . Sheridan, op. cit., pp. 124–5.
196. *Lunch parties* . . . Epstein, op. cit., pp. 85–6.
196. *Models* . . . Peggy-Jean Lewis, interview.
197. *Cable* . . . Epstein to Quinn, 3.1.1919.
197. *Tin Hat* . . . Epstein to MoI, 5.1.1919, IWM.
197. *America* . . . Yockney to Epstein, 7.1.1919, IWM.
197. *Friendship* . . . Epstein to Yockney, 15.3.1919, IWM
197. *VCs* . . . Yockney to Epstein, Ibid.
198. *Countermanded* . . . *Morning Post*, 19.4.1919: this news item remains mystifying, no explanation being given regarding 'Meurte' and 'incidents'.
198. *Peggy-Jean* . . . Epstein, op. cit., p. 203: in naming her, 'Peggy' was after Mrs Epstein's christian name and 'Jean' after the cat they owned.
198. *Van Dieren* . . . Epstein, op. cit., pp. 101–2.
200. *Unfinished parts* . . . Gray, op. cit., p. 207.
201. *Evil* . . . Epstein, op. cit., p. 102.
201. *Accuses* . . . Ibid.
201. *Review* . . . *New Age*, 8.3.1917.
201. *Granite* . . . Epstein to Quinn, 26.5.1919.
201. *Retraction* . . . Ibid.
201. *Record* . . . Quinn to Epstein, 16.6. 1919.
202. *Cable* . . . Epstein to Quinn, 25.6.1919.
202. *Inopportune* . . . Quinn to Epstein, 27.6.1919.
202. *Impatience* . . . Epstein to Quinn, 19.7.1919.
202. *Four-page* . . . Quinn to Mrs Epstein, 11.4.1920.
203. *Photographs* . . . Mrs Epstein to van Dieren, 11.9.1919, HRC.
203. *Illustrations* . . . Epstein to van Dieren (undated).
203. *Lane* . . . ibid., 5.11.1919, HRC.

205. *Sensationalism* . . . Ibid.
205. *Anxiety* . . . Epstein to Quinn, 7.11.1919.
205. *Cheered* . . . Ibid., 11.1.1920.
206. *Candle chippings* . . . Epstein to van Dieren, 11.1.1920, HRC.
206. *Talent* . . . *Epstein*, van Dieren, John Lane, 1920, p. 1.
206. *Rembrandt* . . . Ibid., p. 4.
207. *Effigy* . . . Peggy-Jean Lewis, interview.
207. *Blasphemous* . . . Haskell, op. cit., p. 37.
207. *Catalogue* . . . Phillips to Quinn, 4.2.1920.
207. *Gaudier-Brzeska* . . . Reid, op. cit., p. 374.
208. *Wipe off* . . . Pound to Quinn, 6.2.1920.
208. *Christ* . . . Quinn to Phillips, 6.3.1920.
209. *Analysis* . . . Phillips to Quinn, 24.3.1920.
209. *Horrors* . . . *Evening Standard*, 8.2.1920.
209. *Vaughan* . . . *Weekly Graphic*, 14.2.1920.
209. *Deport* . . . Brown, op. cit., p. 141.
210. *Sarcasm* . . . *Graphic*, 21.2.1920.
211. *Sculpture* . . . *Nation*, John Middleton Murry, 14.2.1920.
211. *Intelligentsia* . . . Epstein, op. cit., p. 291.
211. *Marriott* . . . *Outlook*, 21.2.1920.
211. *Constable* . . . *New Statesman*, 20.2.1920.
212. *Cherry-Garrard* . . . Brown, op. cit., p. 71.
213. *Figure* . . . *Daily Graphic*, 18.3.1920.
213. *Un-English* . . . Brown, op. cit., p. 70.
213. *Galsworthy* . . . Epstein, op. cit., p. 127.
213. *Barrie* . . . *London Magazine*, April/May 1989.
214. *Hands* . . . Epstein, op. cit., p. 106.
214. *Jail* . . . Ibid.
214. *Gertler* . . . Carrington, op. cit., p. 179.
214. *Carrara* . . . Gray, op. cit., p. 207.
215. *Zborowski* (sic) . . . Epstein, op. cit., p. 63.
215. *Studio* . . . Russoli, op. cit., p. 10.

8: Green Mansions

216. *August* . . . Lady Epstein, conversation.
216. *Caricaturist* . . . Haskell, op. cit., p. iii.
216. *Antique* . . . Epstein to *The Times*, 2.5.1921.
216. . . . Haskell, op. cit., pp. 145–7.
216. . . . Epstein, op. cit., pp. 180.
217. *Amateur* . . . Haskell, op. cit., pp. 143–5.

217. *Ceased* . . . Ibid., p. 146.

217. *Harlequin* . . . Lady Epstein, conversation.

218. *Douglas* . . . Ibid.

218. *Madness* . . . Ibid.

218. *Helen* . . . Helen Sarfatti (née Garman), conversation.

219. *Calendar* . . . *High Diver*, Michael Wishart, Quartet Books, 1978, p. 2; *Edgell Rickword*, Charles Hobday, Carcanet, 1989, p. 85.

219. *Mrs Garman* . . . Wishart, op. cit., p. 3.

219. *Entanglement* . . . Helen Sarfatti, conversation.

220. *Parties* . . . *Roy Campbell*, Peter Alexander, Oxford University Press, 1982, p. 29.

220. *Passionately* . . . Epstein to Kathleen Garman (undated), Epstein Estate.

221. *Witch* . . . Peggy-Jean Lewis, interview.

222. *Horizon* . . . *The Weeping and the Laughter*, Viva King, MacDonald and Jane's, London, 1976, p. 97.

223. *Oyved* . . . Agi Katz, Boundary Gallery, interview.

223. *Dejection* . . . King, op. cit., p. 97.

224. *Keyhole* . . . Roy Campbell, *Light on a Dark Horse*, p. 249.

224. *Extraordinary* . . . Mrs Epstein to Meum, 23.2.1922.

224. *Café Royal* . . . Campbell, op. cit., p. 249; Maria Oliver, notes.

225. *Detestable* . . . Epstein to Kathleen Garman (undated), Epstein Estate.

225. *Ménage* . . . King, op. cit., p. 98.

227. *Gun* . . . Helen Sarfatti, conversation; Beth Lipkin, interview.

227. *Pattern* . . . Peggy-Jean Lewis, interview.

228. *Bizarre* . . . Helen Sarfatti, conversation; John Lade, interview.

228. *Skye* . . . Peggy-Jean Lewis, interview.

228. *Dolores* . . . Epstein, op. cit., p. 90.

228. *Beautiful* . . . Ibid., p. 90.

228. *Affronted* . . . 'Her Story', *American Weekly* 1930; the wild inventions of models like Dolores about life in Guilford Street and, in particular, at Baldwin's Hill in Epping Forest, helped to create the fictitious pictures of free love which others then exaggerated, either for amusement or to damage his character; as a result, many grew up, for instance, with the vision of Epstein enjoying riotous camping outings in the woods, surrounded by girls, all of which was untrue.

229. *Devoted model* . . . Epstein, op. cit., p. 90.

229. *Collection* . . . Haskell, op. cit., p. 87.

229. *Earliest* . . . Peggy-Jean Lewis, interview.

230. *House hunting* . . . *American Weekly*, Dolores.

230. *Shrine* . . . Ibid.

231. *Business* . . . Ibid.

231. *Job lots* . . . Peggy-Jean Lewis, interview.

232. *Classical* . . . Epstein, op. cit., p. 90.

233. *Todds* . . . Epstein to Kathleen Garman (undated).

233. *Epsteins* . . . Quinn to Roché, 20.5.1922; Reid, op. cit., p. 560.

233. *Hudson* . . . *The Green Mansions*, W. H. Hudson, Duckworth, 1904, republished in the USA in 1920 (where the book was a bestseller) and by Duckworth in 1926.

233. *Appeal* . . . 28.11.1922, RSPB.

233. *Chairman* . . . Cunninghame Graham said of Hudson: 'Few men have left a monument more permanent than is left in his own books.' *Everyman Encyclopaedia*, J. M. Dent.

234. *Bone to report* . . . 6.12.1922, RSPB.

234. *Birds* . . . Letters from the Committee to *The Times* and *Manchester Guardian* appealing for funds, 21.3.1924, RSPB.

234. *Pool* . . . Design of, 28.12.1922, RSPB.

234. *Model* . . . Approved 10.1.1923; also Hyde Park site, RSPB.

235. *Representation* . . . Bone to Cunninghame Graham and Mrs Lemon, 2.2.1923, RSPB.

235. *Imaginative* . . . Meeting of 14.2.1923, RSPB.

235. *Approval* . . . Mrs Lemon to Epstein confirming commission, 15.2.1923, RSPB.

235. *Galsworthy* . . . Insisted on access to meetings, 10.1.1923, RSPB.

235. *Fears* . . . Bone to Mrs Lemon, 2.2.1923, RSPB.

236. *Doubts* . . . Bone to Cunninghame Graham, 2.2.1923, RSPB.

236. *Ideas* . . . Haskell, op. cit., p. 28.

237. *Enchanting* . . . Epstein, op. cit., pp. 88–9.

238. *Conciliation* . . . Bone to Mrs Lemon, 19.6.1923 (from New York), RSPB.

238. *Question* . . . Sir Lionel Earl to Mrs Lemon, 26.6.1923, RSPB.

239. *Lutyens* . . . Mrs Mackenna to Cunninghame Graham, 10.7.1923, RSPB.

239. *Devil* . . . Epstein to Kathleen Garman, 16.2.1923.

241. *Wretched* . . . Epstein to Kathleen Garman, 16.2.1923, Epstein Estate.

242. *Drawings* . . . Leeds City Art Gallery.

243. *Congratulations* . . . *The Times*, 24.1.1924.

243. *Fry* . . . *New Statesman*, 26.1.1924; reprinted from the *Dial*, 24.6.1920.

243. *d'Art* . . . Epstein, op. cit., p. 195.

243. *Head* . . . Ibid.

244. *Sentimentalist* . . . *Speculations*, Hulme, p. 105.

244. *Dieren* . . . Epstein to van Dieren (undated), HRC.

244. *Amateurs* . . . Epstein, op. cit., p. 195.

244. *Hatred* . . . Ibid.

245. *Rusticus* . . . *New Age*, 14.2.1924.

245. *Jew* . . . *Hidden Hand or The Jewish Peril*, February 1924, pp. 22–3.

247. *Birdsong* . . . W. H. Hudson, op. cit., p. 45, pp. 72–75.

247. *Exterminated* . . . *Great Friends*, David Garnett, Macmillan, 1979, p. 32.

248. *Rhythms* . . . Ibid.

248. *Fund* . . . Letters to the *Manchester Guardian*, *The Times* etc. from Grey and Buxton appealing for £2,000, 21.3.1924.

249. *Friend* . . . Epstein, op. cit., p. 73.

249. *Crippled* . . . Ibid., p. 74.

249. *Ep* . . . Ibid., p. 77.

249. *Stephen* . . . Epstein to Bone (undated, possibly May 1924), HRC.

250. *Governing Board* . . . *Since Fifty*, Rothenstein, vol. III, Faber & Faber, 1939, p. 38.

250. *Rendezvous* . . . Helen Sarfatti, conversation; Beth Lipkin, interview.

250. *Embryonic* . . . Epstein to Kathleen (undated).

250. *Break* . . . Epstein, op. cit., p. 107.

251. *Dreamer* . . . Haskell, op. cit., p. 29.

251. *Detached* . . . Bone to Lord Peel, Commissioner of Works, 29.11.1925; Epstein, op. cit., p. 268.

252. *Fuss* . . . Haskell, op. cit., p. 27.

252. *Thorndyke* . . . *Evening Standard*, 27.5.1925.

253. *Extremist* . . . *British Guardian*, 12.6.1925 (*Hidden Hand/British Guardian*, British Library Main Reading Room, Shelf Mark, pp. 3611 AB1).

253. *Echoes* . . . Gill's comments in a Catholic journal were particularly unpalatable – 'his work is what you'd expect – dull, mechanical, lifeless – making the sculpture look as though Epstein had gnawed it with his teeth.' Epstein, op. cit., p. 204.

253. *Commons* . . . Between 27 July 1925 and 14 May 1928, *Rima* was raised at Question Time on seven occasions.

254. *Rima* . . . *Daily News*, 7.10.1925.

254. *Blythe* . . . Ibid.

254. *Speech* . . . *Star*, 7.10.1925.

254. *Paint* . . . 12.11.1925.

254. *Pieces* . . . *Morning Post*, 7.10.1925.

254. *Signatures* . . . Ibid., 18.11.1925.

256. *Anarchy* . . . *Nation*, 21.11.1925.

256. *Astonished* . . . Bone interview, *Observer*, 21.11.1925.

256. *Signatories* . . . *The Times*, 23.11.1925: while it is not surprising that Gill's name was missing from the list of hundreds, it is surprising that Henry Moore's was too.

257. *A.B.C.* . . . *Morning Post*, 25.11.1925.
257. *Hooliganism* . . . *Nation*, 28.11.1925.
258. *Brookes* . . . Quoted by the *Morning Post*, 28.11.1925.
258. *Unhealthy* . . . Dicksee's letter to the *Morning Post*, 24.11.1925.
259. *Inscription* . . . *Spectator*, 30.5.1925.
259. *Voluminous* . . . Leonard Noble 13.6.1925; at the same time he wrote to Mrs Lemon to point out the obvious: 'The ideal from the birds point of view is a very gradual slope . . .'

9: New York City

260. *Death* . . . Quinn on, 28.7.1924: Reid, op. cit., p. 610.
260. *Gregory* . . . Reid, op. cit., p. 634.
260. *Transaction* . . . Herman Walthausen's bill, dated 6.2.1924. (Confirming the arrangement Epstein cabled Quinn 15.11.1923: 'Have cabled brother Louis Epstein'; and again 22.11.1923.) See also Quinn to Louis Epstein, 9.6.1924, threatening legal action.
261. *Scott & Fowler* . . . 1.4.1924: Reid, op. cit., pp. 616–17.
261. *Sunita* . . . Peggy-Jean Lewis, interview.
261. *Girlfriend* . . . Alice Keene, interview.
261. *Dolores* . . . *American Weekly*, 1930, HRC.
262. *America* . . . Epstein to Kathleen from New York, 1927 (undated), Epstein Estate.
262. *Duveen* . . . Epstein, op. cit., 124.
263. *Riverside Church* . . . Presented to the church in 1927.
263. *Garman Ryan* . . . Selected by Lady Epstein, financed by Sally Ryan.
263. *Feibleman* . . . *Philosophers Lead Sheltered Lives*, James Feibleman, George Allen & Unwin, 1952, pp. 97–104.
263. *ism* . . . Epstein, op. cit., p. 125.
264. *Gangster* . . . Peggy-Jean Lewis, interview.
264. *Business* . . . Feibleman, interview.
264. *Sell-out* . . . Leicester Galleries, June to July 1926; Feibleman, interview.
264. *Wyndham* . . . Epstein, op. cit., 112.
264. *Barnard* . . . Ibid.
265. *Kitty* . . . Named after Kathleen, whom Epstein called 'Kitty'.
265. *Quickness* . . . Feibleman, op. cit., p. 98.
265. *Golden* . . . Feibleman, interview.
265. *Bookseller* . . . Ibid.
265. *Shaw* . . . Ibid.
266. *Bible* . . . Peggy-Jean Lewis, interview.

266. *Wavertree* . . . Epstein, op. cit., p. 118.
266. *Bullying* . . . Ibid.
267. *Bohemia* . . . Feibleman, op. cit., p. 102.
267. *Blackbirds* . . . Buckle, op. cit., p. 153.
267. *Pugh* . . . Peggy-Jean Lewis, interview.
267. *Conrad* . . . Feibleman, interview.
268. *New York* . . . Peggy-Jean Lewis, interview.
268. *Journey* . . . Epstein to Kathleen (undated), Epstein Estate.
268. *Duveen* . . . Epstein, op. cit., 124.
268. *Stepmother* . . . Ibid.
269. *Downhearted* . . . Epstein to Kathleen (undated), Epstein Estate.
269. *Afford* . . . Ibid., 13.10.1927.
269. *Mid-Victorian* . . . Ibid., 14.10.1927.
270. *Bombshell* . . . Babson, op. cit., p. 8.
270. *Commissions* . . . Epstein to Kathleen, 22.10.1927, Epstein Estate.
271. *Nightmare* . . . Ibid. (undated).
271. *Brancusi* . . . Epstein, op. cit., pp. 132–3.
272. *Balderdash* . . . Epstein to Kathleen (undated), Epstein Estate.
272. *Boozer* . . . Ibid.
272. *Spicy* . . . Epstein, op. cit., p. 125.
272. *Reassurance* . . . Epstein to Kathleen (undated), Epstein Estate.
273. *Trip* . . . Ibid.
273. *Humbugs* . . . Ibid.
274. *Tipsy* . . . Ibid., 18.11.1927.
274. *Roses* . . . Ibid. (undated).
274. *Roost* . . . Epstein, op. cit., 125.
275. *Relief* . . . Epstein to Kathleen (undated), Epstein Estate.
275. *League* . . . Ibid. also Epstein, op. cit., p. 148.
275. *London* . . . Ibid., 22.11.1927.
276. *Longings* . . . Ibid.
276. *Bitternesses* . . . Epstein to Kathleen, 8.1.1928, Epstein Estate.
277. *Fire* . . . Ibid., 9.1.1928.
278. *Decision* . . . Ibid., 12.1.1928.
278. *Expert* . . . Ibid. (undated).
279. *Pseudo-classical* . . . Epstein, op. cit., p. 130.
279. *Power* . . . Epstein to Kathleen (undated), Epstein Estate.
279. *Gaiety* . . . Epstein, op. cit., p. 129.
280. *Playing* . . . Epstein to Kathleen, 17.1.1928, Epstein Estate.
280. *Crowninshield* . . . Epstein, op. cit., p. 128.
282. *Cézannes* . . . Epstein to Kathleen, 20.1.1928, Epstein Estate.
282. *Fogies* . . . Ibid. (undated).
283. *1669* . . . Epstein, op. cit., p. 130.

283. *St Paul's Crescent* ... Peggy-Jean Lewis, interview.
283. *Situation* ... Epstein to Kathleen, 20.1.1928, Epstein Estate.
283. *Fine* ... BBC Home Service radio discussion, 7.8.1960.
284. *Démarche* ... Epstein, op. cit., p. 135.
284. *Quickly* ... Epstein to Kathleen, 21.1.1928, Epstein Estate.
284. *Cable* ... Ibid., 23.1.1928.

10: 18 Hyde Park Gate

285. *Eyes* ... Peggy-Jean Lewis, interview.
287. *Cooke* ... *Survey of London*, Kensington, Athlone Press, 1983, p. 56.
287. *Sayers* ... Peggy-Jean Lewis, interview.
287. *Dramatis personae* ... Roland Joffé, interview.
288. *Jamboree* ... Peggy-Jean Lewis, interview.
288. *Anita* ... Feibleman, op. cit., p. 103.
288. *July* ... Babson, op. cit., p. 30.
288. *Cats* ... Ibid., p. 29.
288. *Visitors' Book* ... HRC.
289. *Wodehouse* ... Epstein, op. cit., p. 79.
289. *Essential* ... Ibid., p. 140.
290. *Suitcase* ... Peggy-Jean Lewis, interview.
290. *Dolores* ... Feibleman, interview.
290. *Matchsticks* ... Feibleman, p. 101.
291. *Smith* ... Feibleman, interview.
291. *Modeller* ... *The Life of Henry Moore*, Roger Berthoud, Faber & Faber, 1987, p. 79; see also p. 78 for Moore's comments on Donatello.
291. *Writer* ... Haskell, op. cit., p. 8.
291. *Value* ... *In His True Centre*, Arnold Haskell, Adam & Charles Black, 1951, p. 87.
292. *Vicious* ... Feibleman, interview.
292. *Hardy* ... John, op. cit., p. 153.
292. *Lawrence* ... Epstein, op. cit., p. 72.
293. *Alarm* ... John, op. cit., p. 153.
294. *Adamant* ... Holden, op. cit., notes.
295. *Client* ... Ibid.
295. *Obligation* ... Ibid.
295. *Phillips* ... October–November 1928.
296. *Introduction* ... Epstein, op. cit., p. 136.
296. *Canyon* ... Ibid.
296. *Plastic idea* ... *Manchester Guardian*, 15.7.1929; also *Public Opinion*, 9.8.1929.
296. *Milan* ... *The Sculptor Speaks*, Arnold Haskell, p. 47.

297. *Elemental* ... *Daily Mail*, 15.7.1929.

298. *Clothes* ... *Daily Mirror*, 21.3.1929.

298. *Peace* ... *Daily Express*, 23.5.1929.

299. *Dreamy air* ... *Sunday Dispatch*, 23.6.1929.

299. *Cautious* ... Holden, op. cit., notes.

300. *Nonsense* ... Lawrence Campbell, letter to author.

300. *Chesterton* ... *Illustrated London News*, July 1929.

300. *Sculptures* ... *London Mercury*, Hannay, July 1929.

301. *Awful* ... Holden, op. cit., notes.

301. *Wilenski* ... *Evening Standard*, 1.7.1929.

301. *Bone* ... *Manchester Guardian*, July 1929.

302. *Bestiality* ... Sir Reginald Blomfield, Past President of the Royal Institute of British Architects, *Manchester Guardian*, 27.7.1929.

302. *Simplicity* ... Epstein, *Manchester Guardian*, 3.8.1929.

303. *Ridiculing* ... *Print Collectors' Quarterly*, R. E. Walker, 6.8.1929.

303. *Jew go home* ... Peggy-Jean Lewis, interview.

305. *Outrages* ... *Jewish Chronicle*, 18.10.1929.

305. *Masterpieces* ... Swinnerton, *Manchester Guardian*, 3.8.1929.

306. *Religious* ... *Daily Dispatch*, 1.8.1929.

306. *Postman* ... Haskell, op. cit., p. 51.

307. *Opinions* ... Epstein to the *Daily Telegraph*, 11.1.1930.

307. *Masterpieces* ... Haskell, op. cit., p. 58.

307. *Banned* ... *Evening News*, 2.7.1929.

307. *Amazed* ... Ibid.

307. *Flowerpiece* ... Mrs Epstein to Matthew Smith, 9.1.1929, Alice Keene Collection.

308. *Château Noir* ... Anne Martin, interview.

308. *Recognized* ... Quoted from Lady Epstein's foreword to the catalogue of the Matthew Smith Arts Council exhibition, 1966, Cardiff.

309. *Champagne* ... Ibid.

309. *Nudes* ... Haskell, op. cit., p. 1.

309. *Admirer* ... *Confessions and Impressions*, Ethel Mannin, Jarrolds, 1930, pp. 149–51.

310. *Beauty* ... Haskell, op. cit., p. i.

310. *Generation* ... *Further Speculations*, Hulme, p. 134.

310. *Shorthand* ... According to Tsapy Britneff, a friend.

311. *Rimaphobia* ... Haskell, op. cit., p. 8.

311. *Riddles* ... Ibid., p. 9.

311. *Martineau* ... Notes on the Epstein Collection, Malcolm McLeod, University of Glasgow.

312. *Flower* ... Haskell, op. cit., p. 25.

312. *Renoir* ... Ibid., p. 117.

312. *Esther* . . . Named after Kathleen Garman's middle name.

312. *Energy* . . . Hulme, op. cit., p. 134.

312. *Mouvement* . . . Haskell, op. cit., p. 6.

313. *Collection* . . . From information in *Jacob Epstein Collector* (unpublished), Ezio Bassani and Malcolm McLeod.

314. *Fatale* . . . Helen Sarfatti, conversation.

315. *Auction rooms* . . . Peggy-Jean Lewis, interview.

315. *Jeeves* . . . Ibid.

316. *Hairpin* . . . Ibid.

316. *Genesis* . . . Epstein to Kathleen (undated).

317. *Israfel* . . . Haskell, op. cit., p. 94.

317. *Motherhood* . . . Epstein, op. cit., p. 139.

318. *Generation* . . . Ibid.

318. *Imagined* . . . Professor Bernard Williams, interview; his mother's view contrasts interestingly with the reaction of an abstract painter who, on hearing the name of the work, clasped his stomach involuntarily and said, 'I find it most unpleasant.' There is little doubt that women, perhaps for organic reasons, have in general a greater sympathy for, and understanding of, Epstein's sculpture than men.

318. *Pregnancy* . . . Brown, op. cit., p. 111.

318. *Sex-appeal* . . . Epstein, op. cit., p. 163.

318. *Temper* . . . Haskell, op. cit., p. x.

319. *Shots* . . . *Star*, 5.2.1931.

319. *Verbiage* . . . *Daily Express/Daily Mail/Daily Telegraph*, 7.2.1931.

319. *Cool* . . . *Manchester Guardian*, 7.2.1931.

319. *Tate* . . . Epstein, op. cit., p. 140.

320. *Pomposity* . . . *Weekend Review*, Paul Nash, 18.4.1931.

320. *Post-mortem* . . . Ibid., Epstein, 25.4.1931.

321. *Genesis* . . . Wilenski, *Observer*, 8.2.1931; *Neptune*, 26.2.1931.

321. *Generosity* . . . Brown, op. cit., p. 110.

322. *Testament* . . . Redfern Galleries, Cork Street, W1, February-March 1932.

323. *Cooke* . . . *Emlyn*, Emlyn Williams, The Bodley Head, 1973, pp. 238–41.

325. *Penniless* . . . Isabel Rawsthorne (née Nicholas), interview.

326. *Disgraceful* . . . Epstein to the *Manchester Guardian*, 13.12.1931, heading a detailed report of the Bossoms' activities and the sculpture's tour of cities, together with future plans.

327. *Blasphemy* . . . Epstein, op. cit., p. 143.

327. *Magnificent* . . . *Architectural Review*, Cyril Connolly, vol. LXXI, 1932.

331. *Gorgeous* . . . *Lincolnshire Herald*, Epstein explains, 1.12.1933.

332. *Passion* . . . Epstein, op. cit., p. 142.

332. *Watercolours* . . . Tooth Gallery archives.

332. *Gielgud* . . . Sir John Gielgud, letter to author, 2.11.1988.

333. *Einstein* . . . Epstein, op. cit., pp. 77–8.

333. *Play* . . . Einstein also 'scraped away' on a violin, Epstein said. He wasn't much good: Schnabel told him he couldn't count because he came in at the wrong place.

334. *Exhibition* . . . Dudley Tooth to Epstein, 26.9.1933.

334. *Poster* . . . Epstein to Dudley Tooth, 11.12.1933.

335. *Wonderful* . . . Epstein to the *Lincolnshire Herald* reporter.

335. *Lazy* . . . Epstein to the *Western Morning News* reporter, 27.11.1933.

336. *Horrifying* . . . Shaw to Mrs Epstein, 29.12.1937, ref. British Library (British Museum Students Room). Ms no. 50521 (a bound collection of letters).

336. *Amuse* . . . Epstein, op. cit., pp. 82–3.

337. *Collection* . . . Bassani and McLeod.

337. *Deerhurst* . . . Mrs Epstein to Matthew Smith (undated), Alice Keene collection.

11: The Forest

338. *Blacksmith* . . . Lady Epstein conversation

339. *Subiaco* . . . Epstein, op. cit., p. 145.

339. *Heavier* . . . Ibid.

339. *Chesterton* . . . Epstein, op. cit., p. 146.

339. Daily Mirror . . . Ibid.

340. *Magnificent* . . . *Epstein* Camera Study by Geoffrey Ireland/Introduction by Laurie Lee, André Deutsch in association with the Royal College of Art (no date given nor page number – probably 1954).

340. Catholic Times . . . Ibid.

340. *In the supporters* . . . *Dance till the Stars Come Down*, Frances Spalding, Hodder & Stoughton, 1991, p. 11: The teenager Minton made the following comment when still at school: 'There are still many people who think that the sole purpose of sculpture is not to be a thing in itself, or a medium of emotion, but an imitation of something . . . In other words these people want no strain on the imagination, nothing new presented to it, no stimulus, no disturbance. They should realize that artists are creators and not cameras.'

340. Daily Telegraph . . . Ibid., p. 147.

340. Sunday Pictorial . . . Ibid., p. 282–5.

340. *Understatements* . . . Manchester Guardian, Bone, 7.3.1935.

340. *Aesthetes* . . . Blunt, *Spectator*, 15.3.1935.

341. *Civilization* . . . Epstein, conversation.

341. *Insulted* . . . Epstein, op. cit., p. 151.

342. *Baffling* . . . Ibid.

342. *Brummer* . . . Ibid., p. 189.

342. *Bombshell* . . . *Observer*, 28.4.1935.

342. *Protest* . . . Epstein to *Observer*, 5.5.1935.

343. *Report* . . . *Manchester Guardian*, 25/31.5.1935.

343. Daily Telegraph . . . Epstein, op. cit., p. 30.

343. *Maclagan* . . . *The Times*, 16.5.1935.

343. *Llewellyn* . . . *Evening Standard*, 10.5.1935.

343. *Holden* . . . *Manchester Guardian*, 15.5.1935.

343. *Dicksee* . . . Epstein, op. cit., p. 32.

344. *Election* . . . Epstein to the Secretary of the Royal Academy, 17.5.1935.

344. *Academy* . . . Goodhart-Rendel to *The Times*, 21.5.1935.

344. *Moore* . . . Lady Epstein, conversation; Peggy-Jean Lewis, interview.

344. *Hurt* . . . Epstein owned at least four Moores, all of which he sold.

344. *RFAC* . . . Secretary to Epstein, 19.7.1935.

345. *Disfigured* . . . Police Report, 8.10.1935.

345. *Ballet of David* . . . Mrs Epstein to Tooth's, 22.11.1935. Tooth's archives.

345. *Interview* . . . Haskell, *Daily Telegraph*, 18.11.1935.

346. *Production* . . . *Daily Telegraph*, 14.1.1936.

346. *Movement* . . . Earp, Ibid.

346. *Soaring* . . . *Dancing Times*, 18.1.1991.

347. *London Playhouse* . . . George Bishop, *Observer*, 8.1.1936.

347. *Flowers* . . . Peggy-Jean Lewis, interview.

347. *Garden* . . . Epstein, op. cit., pp. 142–3.

348. *Arrangements* . . . Epstein to George Macy, Limited Editions Club, 595 Madison Avenue, New York City, 15.5.1936, HRC.

348. *Market* . . . Letters cross: Macy to Epstein, 18.5.1936, cable, HRC.

348. *Agreement* . . . Epstein to Macy, 18.5.1936, HRC.

348. *2000* . . . Epstein to Macy, 19.5.1936, cable, HRC.

348. *Paintings* . . . Macy to Epstein, 20.5.1936, HRC.

350. *Dartington* . . . Mrs Epstein to Sylvia Press, 6.8.1936, Babson, op. cit., p. 43.

350. *Meum's* . . . Peggy-Jean Lewis, interview.

350. *Hitler* . . . Ibid.

351. *Storms* . . . Mrs Epstein to Macy, 10.9.1936, HRC.

351. *Consummatum Est* . . . Epstein, op. cit., p. 152.

352. *Many imagine* . . . Ibid., p. 153.

353. *Miracle* . . . *Jewish Chronicle*, 9.12.1936.

353. *Sincerest* . . . *Illustrated London News*, 13.12.1936.

353. *Explosive* . . . *Daily Telegraph*, 9.12.1936.
354. *Expression* . . . Epstein, op. cit., p. 152.
355. *Exciting* . . . Ibid.
355. *Morning/afternoon* . . . Jan Smith, Epstein's plaster moulder, interview.
355. *Lion Brand* . . . Peggy-Jean Lewis.
356. *Plates* . . . Epstein, op. cit., p. 38.
356. *Earp* . . . *Daily Telegraph*, 23.6.1937.
356. *Bone* . . . *The Times*, 28.6.1937.
356. *Lutyens* . . . *Daily Telegraph*, 23.8.1937.
357. *Decoration* . . . Epstein, op. cit., p. 41.
357. *Suspected* . . . Macy to Epstein, 5.7.1937, HRC.
357. *Stiffer* . . . Ibid., 29.7.1937.
357. *Momentous* . . . Norman Hornstein, interview.
357. *Criminal* . . . Epstein to Macy, 26.8.1937, HRC.
358. *Romance* . . . Mrs Epstein to Sylvia Press, 13.10.1937, Babson, op. cit., p. 49.
358. *Plasticine* . . . Roman Catholic *Universe*, 5.11.1937.
358. *Imaginative* . . . *Star*, 1.11.1937.
358. *Suicide* . . . *News Chronicle*, 28.10.1937.
358. *Anonymously* . . . *The Times*, 1.11.1937.
359. *Impertinent* . . . Epstein, op. cit., p. 159.
359. *Distortions* . . . Ibid.
360. *Correspondence* . . . Mrs Epstein to Shaw, 14.12.1937, British Library, MS no. 50521.
360. *Ishmael* . . . Shaw's reply, 29.12.1937.
361. *Fleurs du Mal* . . . Epstein to Macy, 6.5.1938, HRC.
361. *Masterpieces* . . . Ibid., 1.7.1938.
361. *Derain* . . . Macy to Epstein, 12.8.1938 (from London), HRC.
361. *Reproduction* . . . Epstein to Macy, 15.8.1938, HRC.
362. *Text* . . . Ibid., 1.9.1938.
362. *Superficial* . . . Brian Reade, interview.
363. *Meaningless* . . . Mrs Epstein to Macy (in London), 4.9.1938, HRC.
363. *English* . . . Macy to Mrs Epstein, 8.9.1938, HRC.
363. *Rascal* . . . Peggy-Jean Lewis, interview.
364. *Paulie* . . . Epstein to Mrs Robeson undated, probably late November 1938, Robeson archives, RCHU.
365. *Horror* . . . *Daily Mail*, December 1938.
365. *Macabre* . . . *The Times*, Ibid.
365. *Highbrow* . . . Epstein, op. cit., p. 167.
365. *Support* . . . L. B. Powell, *Birmingham Mail*, December 1938.
366. *Anti-semitism* . . . Epstein interview with *Referee*, December 1938.
366. *Catalogue* . . . Tooth's archives.

366. *New York* ... *Time* magazine, 19.12.1938.
367. *Connoisseurs* ... Epstein, op. cit., p. 188.
367. *Omission* ... Macy to Epstein, 19.12.1938.
367. *Unhappy* ... Hornstein, interview.
368. *Globe* ... Epstein to Macy, 15.2.1939.
368. *Discourtesy* ... Macy to Epstein, 22.2.1939 (from London).
368. *Bathos* ... Epstein to Macy, 23.2.1939.
368. *Custodians* ... Epstein to *The Times*, 19.5.1939.
368. *Hill* ... Sir George Hill to *The Times*, 20.5.1939.
368. *Epstein* ... Epstein to *The Times*, 22.5.1939.
368. *Hill* ... Hill to *The Times*, 25.5.1939.
369. *Experience* ... Epstein, op. cit., pp. 204–5.
370. *Elemental* ... *News Chronicle*, 15.7.1939.
370. *Veronese* ... Epstein, op. cit., pp. 171–2.
371. *Terrific* ... *Picture Post*, William McCance, 24.6.1939.
371. *Mankind* ... Quoted by Powell, *Birmingham Mail*, 9.6.1939.
371. *Yearning* ... Epstein interviewed by the *Yorkshire Post*, 24.6.1939, and *Leeds Mercury*, 18.7.1939.
372. *Street* ... *Birmingham Mail*, 9.6.1939.
372. *Sonnet* ... *The Times*, 8.6.1939.
372. *£7,000* ... *The Times*, 8.7.1939.
372. *Stafford* ... *Daily Sketch*, 15.7.1939.
373. *£750* ... Epstein, op. cit., p. 172.
373. *Shilling* ... Mr Wright interviewed by *The Times*, 17.7.1939.
373. *Hobby* ... Mr Stafford interviewed by *News Chronicle*, 15.7.1939.
373. *£20,000* ... Mr Wright quoted by *Glasgow Herald*, 8.7.1939.
373. *Eve* ... Mr Wright quoted by *Daily Mail*, 17.7.1939; denial by Epstein, *Sunday Dispatch*, 21.1.1940.
373. *America* ... Mr Stafford quoted by *Daily Sketch*, 15.7.1939.
374. *Stafford/Wright* ... Parkinson archives.
374. *Jackie* ... Beth Lipkin, interview.

12: Mrs Epstein

375. *Showdown* ... Helen Sarfatti, conversation.
376. *Immortalising* ... Hornstein, interview.
376. *Nature* ... Lady Epstein, conversation.
376. *Children* ... Epstein, op. cit., p. 202.
376. *Fleurs du Mal* ... Macy to Epstein, 24.8.1939.
377. *Desires* ... Epstein, op. cit., p. 177.
377. *Anatomy* ... Jackie Epstein, interview.

377. *£60* . . . Epstein to Mrs Robeson, 26.8.1939.
377. *Terrible* . . . Ibid., 11.9.1939.
377. *Period* . . . Ibid., 25.10.1939.
377. *£100* . . . Ibid. (undated), possibly November 1939.
378. *Africa* . . . Bussani and McLeod.
378. *Curtis Brown* . . . Peggy-Jean Lewis, interview.
378. *Peters* . . . Buckle, op. cit., p. 249: Betty Peters kept a hostel for seamen in the East End.
379. *Mistress* . . . Peggy-Jean Lewis, interview.
379. *America* . . . Epstein to Mr S. Samuels, 28.8.1940, Tate Gallery archives, 9012.3, seventeen letters 1940–2 relating to the sale of *The Visitation*, *Einstein* and *Cunninghame Graham*, and the discussion of other works.
379. *Deerhurst* . . . Jackie Epstein, interview.
379. *Shelter* . . . Ibid.
379. *Sirens* . . . Peggy-Jean Lewis, interview.
380. *Harting* . . . Kitty Godley, interview.
380. *Oakeswood* . . . Cathy Lee, interview.
380. *Lawrence* . . . Ibid.
380. *Recall* . . . Helen Sarfatti, conversation.
381. *Expeditions* . . . Jackie Epstein, interview.
381. *Clowsen* . . . Royal Academy archives.
381. *Piccaninny* . . . Epstein, op. cit., p. 177.
382. *Cheque* . . . Tate Gallery archives.
382. *Bag of coke* . . . Mrs Epstein to Mr Samuels, 18.6.1941, 9012.22.
382. *Mourlets* . . . Macy cables Paris, July 1940, HRC. Balance of 1,500 copies shipped November 1946, HRC.
382. *Quantity* . . . Cane cables Macy, 21.8.1940, HRC.
383. *Genius* . . . Lynd, *News Chronicle*, 25.11.1940.
383. *Attacked* . . . *Daily Herald*, 25.11.1940.
384. *Immediately* . . . Shaw to Epstein, 13.1.1941; he was complimentary about Epstein's writing, however: in a note at the end he said: 'Your book was very well written to get this out of me.' And signed it: 'Too faithfully, G. Bernard Shaw'.
385. *Intelligent* . . . Babson, op. cit., p. 55.
386. *Nefertiti* . . . Epstein, op. cit., pp. 192–3.
386. *Presence* . . . Ibid., p. 192.
387. *Inspiration* . . . Lady Epstein, conversation.
387. *Task* . . . *Sunday Dispatch*, 1.2.1942.
387. *Incomprehensible* . . . *Daily Telegraph*, 10.2.1942.
389. *Mountains* . . . Epstein to Quinn, 22.3.1912.
389. *Candour* . . . BBC Home Service, *Sir Jacob Epstein Sculptor and Humanist*, 7.8.1960.

390. *Canterbury* ... Epstein to Samuels, 21.5.1942, 9012.16, Tate Gallery archives.

390. *Visitation* ... Margulies, 10.6.1942, Tate Gallery archives.

390. *Consummatum Est* ... Ibid.

390. *Imaginative works* ... Quoted from Epstein's speech at the unveiling of *Lucifer* in Birmingham on 26.6.1947.

392. *Imagination* ... Ibid.

392. *Proud Lucifer* ... Ibid.

393. *Sunita* ... The model for the body was David Roche, the Epsteins' Irish cook.

394. *Extraordinarily well* ... Lady Epstein, conversation.

394. *Eye for proportion* ... Jan Smith, interview.

395. *Accepted unanimously* ... E. C. Gregory to Epstein, 14.9.1945.

395. *Son of the Morning* ... Epstein quoted by the *Star*, 15.11.1945.

395. *Seen at his best* ... *Daily Telegraph*, 15.11.1945.

396. *Lighting his cigar* ... Epstein, op. cit., p. 230.

396. *Struck by his humility* ... John Finch, interview.

396. *Diplomat and sculptor* ... Recalled in Lady Epstein's foreword for the catalogue of the 1967 Fairleigh Dickenson University Epstein Exhibition.

397. *Waited half-an-hour* ... John Finch, interview.

397. *In three days* ... Epstein, op. cit., p. 233.

398. *Offer it to the Tate* ... Ibid., p. 231.

398. *Rejected unseen* ... Quoted by John Finch in *Illustrated*, 15.2.1947; see *News Chronicle* report 16.1.1947.

398. *Nothing personal* ... Ibid.

398. *I'm disgusted* ... Ibid.

398. *Discouraging performance* ... *Manchester Guardian*, 27.1.1947.

398. *Once abusively critical* ... *Illustrated*, 15.2.1947.

399. *Urgent message* ... David McFall to Trenchard Cox, Birmingham Art Gallery, 29.1.1947.

399. *By return of post* ... Cox to McFall, 30.1.1947.

399. *Express my regret* ... John Rothenstein to Epstein, 31.1.1947; on the back of this letter, Epstein drafted his reply, beginning: 'Your letter astonishes me. You do not seem to understand that the rejection of *Lucifer* by the Trustees of the Tate Gallery has caused widespread condemnation of your action. I enclose one of several letters I have expressing this alarm and disgust. As one of the prime movers in the rejection of *Lucifer* it is grotesque of you to "condole" with me ...'

399. *Contrasted interestingly* ... Cox to McFall, 17.2.1947.

400. *Trouble all round* ... Epstein to Matthew Smith, 8.1.1947. Alice Keene Collection.

400. *Heard a cry* ... John Finch, notes.

13: Resurrection

402. *Rag-and-bone man* . . . Peggy-Jean Lewis, interview.

402. *Two weeks together* . . . Ibid.

403. *Elderly Mario Sarfatti* . . . Cathy Lee, interview.

403. *Heaped with junk* . . . John Finch, interview.

403. *Financial problems* . . . John Lade, interview.

403. *Wasn't easy for her* . . . Ibid.

403. *Half-way up* . . . *Daily Mail*, 21.6.1947.

403. *Unveiling* . . . *Gazette*, 27.6.1947: Epstein recorded a note about the picture locating his, Kathleen's and Esther's positions in the audience.

404. *Artistic cliques* . . . Epstein's unveiling speech, 26.6.1947.

405. *Silence perhaps is best* . . . Ibid.

405. *5 Bramerton Street* . . . John Lade, interview.

405. *Contemporary music* . . . Esther to Wayland Young (undated, her letters to him started in 1946 when she was seventeen).

406. *John Lade 'Lade'* . . . John Lade, interview.

407. *Blockade of Berlin* . . . Epstein to Peggy-Jean, 6.3.1948, Tate Gallery Archives, 8716.1.

407. *Act as messengers* . . . Peggy-Jean Lewis, interview.

408. *Girl with Gardenias* . . . Epstein to Peggy-Jean, 6.3.1948, 8716.1.

408. *A surprising development* . . . Ibid., 21.3.1948, 8716.2.

408. *This Tony Crisp* . . . Ibid.; see also *Daily Mail* report, 30.9.1953.

409. *Chance of selling* . . . Ibid., 18.4.1948, 8716.3.

409. *His absurd work* . . . Ibid., May 1948. Epstein's verdict on Moore's *Three Standing Figures* made good sense: it transpires that five sculptors carved them – apart from Moore's contribution, Bernard Meadows did most of the left-hand figure, Reg Butler did 'three weeks of hard labour' on the right-hand figure, Shelley Fausset, an assistant, did the basic carving of the middle figure, and a stone cutter from Yorkshire also helped out. Berthoud, op. cit., p. 209.

410. *We are not married* . . . Kathleen Garman to Peggy-Jean, 24.8.1948, 8716.58.

411. *Ready for collection* . . . Kathleen Garman to Mr S. Samuels, 13.5.1948, 9012.23, Tate Gallery archives.

411. *The Hemmings bakery* . . . John Lade, interview.

411. *Old painting jacket* . . . Theodore Garman to Kathleen, 8.10.1948.

412. *Epstein should be represented* . . . Kathleen Garman to Peggy-Jean, 24.8.1948, 8716.58.

412. *Filled with self-doubt* . . . Epstein to Peggy-Jean Lewis, 21.10.1948, 8716.10.

412. *Friend of H. Moore* . . . Ibid., 4.11.1948, 8716.11.

413. *Fine and powerful tiki* ... Esther to Mark Joffé, 18.12.1948, Roland Joffé Collection.

413. *The speed of a young man* ... Aubrey Grandon, interview.

414. *Constantly under doctors* ... Epstein to Peggy-Jean, 23.1.1949, 8716.15.

414. *Posed with a will* ... Ibid., 9.2.1949, 8716.16.

414. *A personal triumph* ... Ibid.

415. *Republishing his autobiography* ... Ibid.; 8716.16, republished in 1955; 23.1.1949.

415. *Another crisis* ... Cathy Lee, interview.

415. *A dreadful journey* ... Esther to Joffé from Torri del Benaco, 18.5.1949: 'If I could I would leave tomorrow but things are very difficult here, heartbreaking at moments. The pathos of the whole situation is unbearable ...' Roland Joffé Collection.

415. *No luck with Nehru* ... Epstein to Peggy-Jean, 3.4.1949, 8716.17.

415. *Proverbial bad penny* ... Ibid., 23.1.1949, 8716.15.

415. *Where was Tony Crisp* ... Ibid., 4.1.1949, 8716.14.

416. *Anguish over their misuse* ... *Evening Standard* report, 8.6.1949.

416. *Eve* ... *Daily Mail*, 3.10.1953.

416. *Merely this to say* ... *Evening Standard*, 8.6.1949.

417. *Not looking forward to that* ... Epstein to Peggy-Jean, 18.6.1949, 8716.18.

417. *John Clare* ... John Lade, interview.

418. *Another interesting letter* ... Ingersoll to Epstein, 25.10.1949, FPAA.

418. *Aeronautical school* ... In Sydney Street, Chelsea, on the racing-driving side of the course.

418. *Bloch came to his studio* ... Epstein, op. cit., p. 233 (Vista).

419. *Theo's exhibition* ... 10.1.1950.

419. *Good reviews* ... *Listener*, 19.1.1950.

420. *Answering Ingersoll's letter* ... Epstein to Ingersoll, 15.2.1950, FPAA.

420. *By return* ... Ingersoll to Epstein, 20.2.1950, ibid.

420. *Reviewers went overboard* ... *Daily Telegraph*, 9.3.1950.

421. *Wyndham Lewis* ... *Listener*, 23.3.1950.

421. *Captivated the reviewers* ... *Observer*, 12.3.1950.

421. *Eric Newton* ... *Sunday Times*, 19.3.1950.

422. *A young housewife* ... *Daily Herald*, 9.3.1950.

424. *To his old friend* ... Alice Keene Collection, 11.7.1950.

425. *Short break* ... Jackie Epstein to Peggy-Jean Lewis, 6.11.1950, 8716.62.

425. *Wasn't a millimetre out* ... Lady Anne Tree, interview.

426. *Struck by the performance* ... John Lade, interview.

426. *Faint groan* ... Ibid.

427. *In a letter later* ... Kathleen Garman to Alic Smith, 21.1.1952.

427. *Well in my college* . . . Lady Epstein, conversation.
427. *Picks up the story* . . . A. W. Lawrence to Warden Smith, 22.11.1950.
428. *Windows in the college* . . . New College archives.
428. *Could manage £200* . . . Lawrence to Warden Smith, 11.12.1950, New College Archives.
428. *Prospects of raising* . . . Ibid., 6.1.1951.
428. *Ellen Phillips Samuel* . . . Ingersoll to Epstein, 16.2.1951, FPAA.
428. *Replying by return* . . . Epstein to Ingersoll, 27.2.1951, ibid.
429. *Rather than a single figure* . . . Marceau to Epstein, 19.3.1951, ibid.
429. *Sally Ryan* . . . Ibid.
429. *Moore for a year* . . . Arts Council archives.
429. *I liked Epstein* . . . Carel Weight, interview.
430. *Dylan Thomas* . . . BBC Radio talk.
430. *Advances and expenses* . . . Ingersoll to Epstein, 18.6.1951, FPAA.
430. *The middle of July* . . . Epstein to Ingersoll (undated), ibid.
430. *Wrote to Warden Smith* . . . Epstein to Smith, 2.9.1951, New College Archives.
431. *And only replied* . . . Epstein to Smith, 30.11.1951, ibid.
431. *Equally immediate* . . . Ibid., 7.12.1951.
432. *Too near Christmas* . . . Ibid., 13.12.1951.
432. *For the first showing* . . . Ibid., 15.12.1951.
432. *Enjoyable occasion* . . . Kathleen Garman to Smith, 21.1.1952, New College Archives.
432. *Congratulated Warden Smith* . . . Lawrence to Smith, 15.1.1952, ibid.
432. *Sorrow and disgust* . . . A. G. Allen to Smith, 22.1.1952, ibid.
433. *Photograph with misleading* . . . Smith to Allen, 30.1.1952, ibid.
433. *Progress with respect* . . . Ingersoll to Epstein, 20.2.1952, FPAA.
434. *Cast in plaster soon* . . . Epstein to Ingersoll, 14.3.1952, FPAA.
434. *Had to clear a space* . . . Jan Smith, BBC Home Service, 7.8.1960.
435. *This great work* . . . The Times, 20.5.1952.
435. *Delighted* . . . Ingersoll to Epstein, 6.5.1952, FPAA.
435. *Her sick sister* . . . Epstein to Peggy-Jean, 30.5.1952, 8716.21.
436. *Theo's illness* . . . Ibid., 24.1.1952, 8716.22.
436. *I need a rest badly* . . . Ibid., 2.7.1952, 8716.26.
436. *Paul Robeson* . . . Epstein to Lawrence, 17.9.1952.
436. *By return of post* . . . Lawrence to Epstein, 18.9.1952.
436. *In this restoration* . . . George Pace to Epstein, 25.9.1952, Llandaff archives.
436. *Accustomed enthusiasm* . . . Epstein to Pace, 26.9.1952.
437. *Retrospective* . . . Tate Gallery, 1.10.1952.
437. *A great success* . . . Epstein to Peggy-Jean, 5.10.1952, 8716.27.
437. *Extravagant in its praise* . . . *Listener*, Eric Newton, 2.10.1952.

438. *Broadcast* ... BBC Third Programme, 3.10.1952: Jacob Epstein discusses modern sculpture with Hubert Wellington.

438. *Haven't held my punches* ... Epstein to Peggy-Jean, 5.10.1952, 8716.23.

439. *Political Prisoner* ... January 1952.

439. *I've just listened* ... Butler to Epstein, card, 12.10.1952 *re* BBC repeat.

439. *Matthew Smith gave* ... Epstein to Peggy-Jean, 5.10.1952, 8716.27.

440. *Carefully worded article* ... Hendy, *Britain Today*, 12.1952.

441. *Writings of the Bloomsbury set* ... *Balletomane At Large*, Haskell, p. 54.

442. *Unveiling* ... 14.5.1953.

443. *Most significant piece* ... *Phoenix at Coventry*, Basil Spence, Geoffrey Bles, 1962, p. 68.

443. *Catalogue* ... Lady Epstein (undated).

443. *Doctorate* ... 22.6.1953, Encaenia Address of the Public Orator, Oxford University.

443. *Bowra* ... *Summoned by Bells*, John Betjeman, John Murray (Publishers), 1960, p. 103 (reproduced by kind permission of the publishers).

445. *Delays were inevitable* ... Epstein to Peggy-Jean, 31.8.1953, 8716.29.

445. *Paying for the work* ... Ibid.

445. *Bad pennies* ... *Daily Mail*, 3.10.1953.

445. *This to stop* ... Ibid., 30.9.1953.

445. *Letter from Pace* ... 28.10.1953.

446. *Official looking envelope* ... Haskell, op. cit., p. 61.

446. *Rebel – K.B.E.* ... *Daily Graphic*, 1.1.1954.

446. *I was so popular* ... Epstein to Peggy-Jean, 20.1.1954, 8716.30.

447. *Heart attack* ... 22.1.1954.

447. *Borrowed a piece of sculpture* ... Kathleen Garman, conversation.

14: Ecce Homo

449. *Investiture* ... *Daily Mail*, 17.2.1954.

449. *Folk Yiddish writer* ... Epstein to Peggy-Jean, 19.5.1954, 8716.31.

450. *To do me harm* ... Ibid.

450. *Didn't care for the likeness* ... Dr J. J. Mallon, conversation.

450. *Sumerian Statuette* ... McCulloch, notes.

451. *Prospect of the army* ... Epstein to Hornstein, 20.1.1954, 8716.54.

451. *Two little girls* ... Epstein to Peggy-Jean, 4.8.1954, 8716.33.

451. *Pound notes between pages* ... Helen Sarfatti, conversation.

451. *Holidaying with friends* ... Epstein to Peggy-Jean, 3.9.1954, 8716.34.

452. *With great enjoyment* . . . Esther to Joffé, 10.9.1954.
452. *Committed suicide* . . . Epstein to Peggy-Jean, 13.11.1954, 8716.35.
452. *Limited competition* . . . Sir Vincent Tewson, Secretary TUC, to Epstein, 9.11.1954, TUC archive.
453. *On the young geniuses* . . . Epstein to Peggy-Jean, 12.12.1954, 8716.37.
453. *Students loved him* . . . John Norris-Wood, interview.
453. *Epstein replied* . . . Epstein to Tewson, 11.12.1954, TUC archive.
453. *Two lifetimes* . . . Epstein to Peggy-Jean, 12.12.1954, 8716.37.
454. *Through a reporter* . . . *Daily Telegraph*, 31.12.1954.
454. *Fell in love with the cathedral* . . . Note by Lady Epstein to Janet Stone's letter, 1.2.1958.
455. *Thankful she was there* . . . Epstein to Peggy-Jean, 17.1.1955, 8716.38.
455. *Silvering* . . . Epstein to the Dean of Llandaff, 8.12.1954, Llandaff archive.
455. *Fortnight later* . . . Pace to the Dean, 21.12.1954, ibid.
455. *As an architect* . . . Epstein, conversation.
455. *No further delays* . . . Epstein interviewed, date and paper not known.
456. *Heard from Tewson* . . . Tewson to Epstein, 30.3.1955, TUC archive.
456. *Implications of a letter* . . . Herbert Read to Tewson, 30.1.1955, ibid.
456. *Visited the site* . . . Epstein to Tewson, 30.3.1955, ibid.
457. *The Veterans of the War* . . . Epstein to Peggy-Jean, 23.3.1955, 8716.40.
457. *RA's annual affair* . . . Ibid.
458. *To be used by him* . . . Epstein to Ingersoll, 16.12.1954, FPAA.
458. *The Visitation* . . . To the Hirshhorn Museum, 31.5.1955. Described as 'The Annunciation' in the sale and sold for £1,200. Smithsonian Institute, Hirshhorn Museum and Sculpture Garden archives.
458. *Too marvellous to be true* . . . Maria Donska, interview.
458. *With some news* . . . Epstein to Peggy-Jean, 28.6.1955, 8716.43; Epstein and Kathleen Garman married 27.6.1955.
459. *Abstraction, Realism* . . . *Herald Tribune*, New York, 24.7.1955.
459. *Letter from Mr Parrott* . . . Albert L. Parrott to Epstein, 9.8.1955.
459. *Delighted to inform you* . . . Tewson to Epstein, 24.8.1955, cable, TUC archive.
459. *Middle of September* . . . Epstein to Tewson, ibid.
459. *The maquette* . . . Tewson to Epstein, 25.8.1955, ibid.
459. *Brought the reply* . . . Epstein to Tewson, ibid.
460. *With very great interest* . . . Basil Spence to Epstein, 20.10.1955.
460. *Fifteenth-century French coin* . . . Chartwell, archives.
460. *Presented to Churchill* . . . *Daily Telegraph*, 12.1.1956; Epstein to Peggy-Jean, 12.1.1956, 8716.48.
461. *Ten tons for Epstein* . . . *Evening Standard*, 4.2.1956.

461. *Devilish hard work . . .* Epstein to Peggy-Jean, 1.3.1956, 8716.50.

461. *Easier to make a statue . . .* Ibid.

461. *As a flop . . .* Ibid.

462. *Terrible statue . . .* *The Kremlin and the Embassy*, William Hayter, Lindon, Hodder & Stoughton, p. 137.

462. *Tell your guest . . .* Epstein to Hayter; Sir William Hayter, interview.

462. *Murder . . .* Lady Epstein, conversation; Beth Lipkin, interview.

462. *No secrets left hidden . . .* Maria Donska, interview: Epstein asked her if she had any pictures of Blake he could work from, which she hadn't. It was her belief that his head of Blake was his imagined vision of the artist, that he worked from nothing else.

463. *Daily routine . . .* Lady Epstein, conversation.

464. *Historic objections . . .* Spence, op. cit., pp. 67–71.

464. *Predictable controversy . . .* *Daily Mirror*, 10.4.1957; *The Times*, 9.4.1957.

465. *Bishop, Dean and architect . . .* Dean Thomas to Sally Ryan, 5.4.1966, Ibid.

465. *Hefty concrete cylinder . . .* Eryl Thomas was aggrieved that the cast reappeared at Riverside and considered the *Christ* out of place there. In his letter to Alun R. Davies of 4.5.1989 he made it clear he was annoyed with Lady Epstein for not destroying the cast as had been agreed with Epstein; but she, like others, may have felt the great work was so diminished by its setting that she was happy to think the cast might have a new and much better presentation elsewhere. Llandaff archive.

466. *Lounge lizards . . .* Roland Joffé, interview.

466. *William Blake . . .* Epstein to Matthew Smith, 1.11.1957, Alice Keene Collection.

466. *Princess Margaret . . .* Epstein to Peggy-Jean, 12.11.1957, 8716.52.

467. *St Michael . . .* Jan Smith, BBC Home Service, 7.8.1960.

467. *This astonishing operation . . .* Jan Smith, interview.

467. *Reynolds Stone . . .* Janet Stone to Epstein, 1.2.1958.

468. *Escaping from the prison . . .* Epstein, conversation.

468. *Bust of Princess Margaret . . .* Lady Epstein, conversation.

468. *Christ in Majesty . . .* *Daily Mail*, 27.2.1958.

468. *Specialist was astonished . . .* Jackie Epstein, interview.

469. *Laid up high and dry . . .* Epstein to Tewson, 24.3.1958, TUC archives.

469. *That meant £4,200 . . .* *Star*, 26.3.1958.

469. *The shadowy manager . . .* *Scotsman*, 7.6.1957.

469. *The appeal of art . . .* *Daily Express*, 27.3.1958.

469. *TUC unveiling . . .* *Daily Telegraph*, 28.3.1958.

470. *Each minute aspect . . .* Jan Smith, interview.

470. *He had a theory . . .* Jackie Epstein, interview.

470. *On 27 April . . .* Lady Epstein's 1958 diary.
471. *By 15 May . . .* Ibid.
471. *To see Alic Smith . . .* Ibid.
471. *Lazarus was grubby . . .* Miss Paine-Cox, memoir; New College archives.
471. *Couldn't wait for me . . .* Jan Smith, interview.
471. *Memorial Service . . .* Lady Epstein's 1958 diary.
471. *In Plymouth . . .* Ibid.
471. *To the continent again . . .* Ibid., 6.9.1958.
471. *Starting with Amiens . . .* Ibid.
471. *Not another cathedral . . .* Buckle, op. cit., p. 410.
472. *To York on 14 October . . .* Lady Epstein's 1958 diary.
472. *The austere architecture . . .* *Yorkshire Post*, 31.10.1958.
472. *Worked very quickly . . .* Lady Epstein and Gordon Snell, BBC Dateline, London, 15.11.1961.
472. *Church of the Ascension . . .* Illustrations in a catalogue, untitled but dated 16.12.1958, record that the stained glass was being made in France and that the windows would be in position, August 1959.
473. *Abandoned the project . . .* Tate Gallery archives.
473. *Another trip to the continent . . .* Beth Lipkin, interview.
473. *Carvings for his collection . . .* Buckle, op. cit., p. 413; Jan Smith, interview.
473. *Another controversy . . .* *Observer*, 19.4.1959.
473. *Controversy was deepening . . .* *Daily Telegraph*, 20.4.1959.
474. *Refused an application . . .* *The Times*, 3.7.1959.
474. *Dramatic enough . . .* C. B. Mortlock to Barnet Janner, Epstein's solicitor, 17.9.1959.
474. *Laid my hands on it . . .* Ibid.
474. *Epstein had dinner . . .* Haskell, op. cit., p. 62.
474. *Went to Ciccio's . . .* Lady Epstein, conversation; Beth Lipkin, interview.

15: Aftermath

477. *Stated that the statue . . .* RFAC minute, 13.3.1963: the heading to the file, *St Paul's Precinct*, is misleading: the land, owned by St Vedast Foster Lane, is across the road from the precinct.
 Mr John Piper to the Secretary, RFAC, 7.3.1963: 'As to Ecce Homo, I went to look at the site and think it quite inappropriate. I agree with Henry Moore that it should be seen low down in a jungle of leaves or undergrowth – if that *is* what he said. I feel that Canon Mortlock thinks its time as sculpture is *to come*, whereas I think it is past.'

The reference to 'jungle' suggests that Moore would have preferred it not to be seen at all; it is worth remembering that it was about this time little or no resistance was put up to stop the gigantic Paternoster Square scheme of concrete slab blocks and the additions to the St Augustine-with-St Faith tower, both of which are in the St Paul's precinct and do considerable aesthetic damage to the cathedral.

478. *Despite further objections* ... Noel Mander to the author, 7.6.1991: 'Even then the shadow of Henry Moore loomed. The Provost [of Coventry Cathedral] asked that the whole matter be left in abeyance until a Moore exhibition being held in Coventry was over; he was not explicit, but told me later that Moore had said the proposal was inappropriate.'

479. *Specially designed for her* ... By the author.

Bibliography

Agate, James, *Ego 3, 4 & 7*, George G. Harrap & Co Ltd, 1938, 1940, 1945.

Alexander, Peter, *Roy Campbell: A Critical Biography*, Oxford University Press, 1982.

Arnold, Bruce, *Orpen: Mirror of an Age*, Jonathan Cape, 1981.

Babson, Jane F., *The Epsteins: A Family Album*, Taylor Hall Publishing, 1984.

Berthoud, Roger, *The Life of Henry Moore*, Faber & Faber, 1987.

Betjeman, Sir John, *Summoned by Bells*, John Murray, 1960.

Braun, Emily (ed.), *Italian Art In the 20th Century 1900–1988*, Prestel-Verlag, 1989.

Brown, Oliver, *Exhibition: The Memoirs of Oliver Brown*, Evelyn, Adam & Mackay, 1968.

Buckle, Richard, *Jacob Epstein, Sculptor*, Faber & Faber, 1963.

Campbell, Roy, *Light on a Dark Horse*, Hollis & Carter, 1951.

Carrington, Dora, *Letters & Extracts from her Diaries*, chosen and with an introduction by David Garnett, Jonathan Cape, 1970.

Cork, Richard, *Art Beyond the Gallery in early twentieth-century England*, Yale University Press, 1985.

Cowen, Anne & Roger, *Victorian Jews Through British Eyes*, Oxford University Press, 1986.

Crawford, Alan, *C. R. Ashbee: Architect, Designer & Romantic Socialist*, Yale University Press, 1985.

Davidson, Basil, *Africa in Modern History*, Allen Lane, 1978.

Ede, H. S., *Savage Messiah*, Gaudier Heinemann Ltd, 1931.

Ellman, Richard, *Oscar Wilde*, Hamish Hamilton, 1987.

Epstein, Jacob, *Epstein: An Autobiography*, Vista Books, 1955; republished with an introduction by Richard Buckle, 1963.

Epstein catalogues: *Illustrations to the Old Testament*, Redfern Gallery Ltd, 1932, February-March; Watercolours of Epping Forest, Arthur Tooth & Sons Ltd, 1933, December; Flower Paintings, Arthur Tooth & Sons Ltd, 1936, December; Exhibition of Drawings, *Les Fleurs du Mal* (Charles Baudelaire), Arthur Tooth & Sons, 1938, December; The Epstein Collection of Tribal and Exotic Art, The Arts Council of Great Britain, 1960; *Jacob Epstein* Sculpture and Drawing, Leeds City Art Galleries, Whitechapel Art Gallery, London, 1987.

Feibleman, James K., *Philosophers Lead Sheltered Lives*, George Allen & Unwin, 1952.

Fishman, William J., *East End Jewish Radicals*, Duckworth, 1975.

Gardiner, A. G., *The War Lords*, J. M. Dent & Sons Ltd, 1915.

Gardiner, A. G., *The Life of George Cadbury*, Cassell & Co. Ltd, 1923.

Garnett, David, *Great Friends*, Macmillan, 1979.

Gertler, Mark, *Selected Letters*, edited by Noel Carrington, Rupert Hart-Davis, 1965.

Gibson, Ashley, *Postscript to Adventure*, J. M. Dent & Sons Ltd, 1930.

Gray, Cecil, *Musical Chairs*, Home & Van Thal, 1948.

Hamnett, Nina, *Laughing Torso*, Constable, 1932.

Hapgood, Hutchins, *The Spirit of the Ghetto*, Funk & Wagnalls, NY, 1902.

Hapgood, Hutchins, *A Victorian in the Modern World*, Funk & Wagnalls, NY, 1930.

Harries, Meiron & Susie, *The War Artists*, Michael Joseph, 1983.

Haskell, Arnold, *Balletomane at Large*, Heinemann, 1972.

Haskell, Arnold, *Black on White*, Arthur Barker, 1933.

Haskell, Arnold, *In His True Centre*, Adam & Charles Buck, 1951.

Haskell, Arnold, *The Sculptor Speaks*, Heinemann, 1931.

Hibberd, Howard, *The Metropolitan Museum of Modern Art*, Faber & Faber, 1980.

Hobday, Charles, *Edgell Rickword*, Carcanet, 1989.

Holmes, Colin, *Anti-semitism in British Society 1876–1939*, Edward Arnold, 1979.

Holroyd, Michael, *Augustus John Vol. I: The Years of Innocence*, Heinemann, 1974.

Hooker, Denise, *Nina Hamnett: Queen of Bohemia*, Constable, 1986.

Hudson, W. H., *Green Mansions*, Duckworth, 1926.

Hulme, T. E., *Speculations*, with a foreword by Epstein, Routledge & Paul Ltd, 1924.

Hulme, T. E., *Further Speculations*, edited by Sam Hynes, Minnesota Press, 1955.

Ireland, Geoffrey, *Epstein: A Camera Study of the Sculptor at Work*, with an introduction by Laurie Lee, André Deutsch, 1957 (in association with the Royal College of Art).

John, Augustus, *Autobiography*, introduction by Michael Holroyd, Jonathan Cape, 1964.

King, Viva, *The Weeping and the Laughter*, MacDonald & Janes's, 1976.

Laver, James, *Museum Piece*, André Deutsch, 1963.

Leslie, Anita, *Cousin Clare*, Hutchinson, 1976.

Leverson, Ada, *Letters to the Sphinx from Oscar Wilde*, Duckworth, 1930.

Lewis, Wyndham, *Blasting & Bombardiering*, Eyre & Spottiswoode, 1937.

Mannin, Ethel, *Confessions and Impressions*, Jarrolds, 1934.

Pound, Ezra, *Gaudier-Brzeska*, The Marvell Press, 1916.

Reilly, C. H., *Scaffolding in the Sky*, Routledge, 1930.

Reid, B. L., *The Man from New York: John Quinn & his Friends*, Oxford University Press, 1968.

Rettig, Stephen, *The Art of the Olmstead Landscape*, New York City Landmarks Preservation Commission, 1981.

Rich, Jack C., *Direct Carving*, Oxford University Press, 1947.

Ross, Robert, *Friend of Friends*, Jonathan Cape, 1952.

Rothenstein, William, *Men and Memories*, vol. I, 1872–1900, Faber & Faber, 1931 vol. II, 1900–1922, Faber & Faber, 1932; *Since Fifty*, Faber & Faber, 1938; see also Lago (ed.), 1872–1938, Chatto & Windus, 1978.

Russoli, Franco, *Modigliani*, preface by Jean Cocteau, translated by Isabel Quigley, Thames & Hudson, 1959.

Rutherston, Albert, *Contemporary British Artists: Epstein*, Ernest Benn, 1900.

Rutter, Frank, *Since I was Twenty-five*, London, 1927.

Sheppard, F. H. W., *Survey of London*, vol. XXXVIII, The Athlone Press and University of London, 1975.

Sheridan, Clare, *Nuda Veritas*, Thornton Butterworth Ltd, 1936.

Silber, Evelyn, *The Sculpture of Epstein*, Phaidon, 1986.

Sitwell, Sir Osbert, *Left Hand Right Hand!*, Macmillan, 1945.

Spalding, Frances, *British Art Since 1900*, Thames & Hudson, 1986.

Spalding, Frances, *Dance Till The Stars Come Down*, Hodder & Stoughton, 1900.

Spence, Sir Basil, *Phoenix at Coventry*, Geoffrey Bles, 1962.

Symonds, J. A., *Life of Michelangelo*, vol. I, London, 1893.

Van Dieren, Bernard, *Epstein*, John Lane, 1920.

Whitman, Walt, *Leaves of Grass*, Doubleday, Doran & Company Inc., 1929.

Wilde, Oscar, *The Letters of Oscar Wilde*, Rupert Hart-Davis, 1962.

Wilenski, R. H., *Modern French Painters*, Faber & Faber, 1940.

Williams, Emlyn, *Emlyn*, The Bodley Head, 1973.

Wishart, Michael, *High Diver*, Quartet, 1978.

Zangwill, Israel, *Melting Pot*, a nineteenth-century play.

Zilczer, Judith, *The Noble Buyer*, John Quinn, Patron, Hirshhorn Museum, Smithsonian Institute, Washington, 1978.

Index